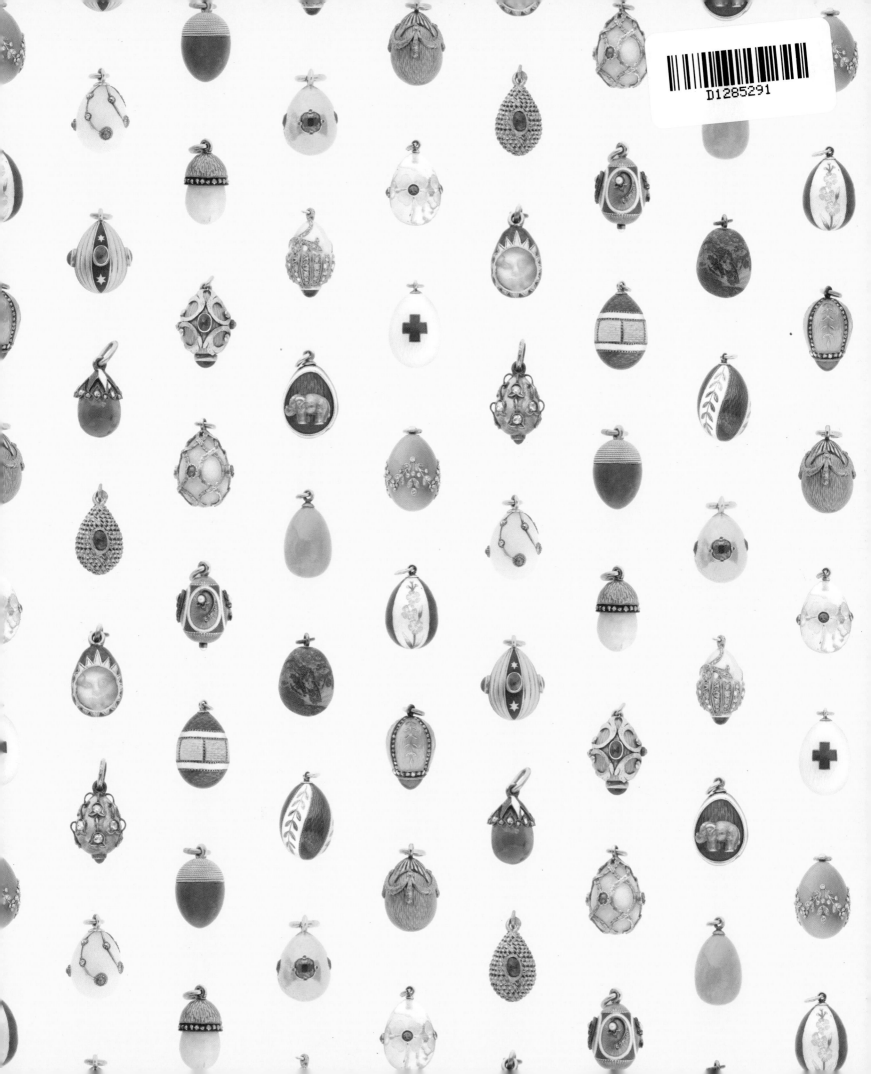

FABERGÉ
REVEALED

AT THE VIRGINIA MUSEUM OF FINE ARTS

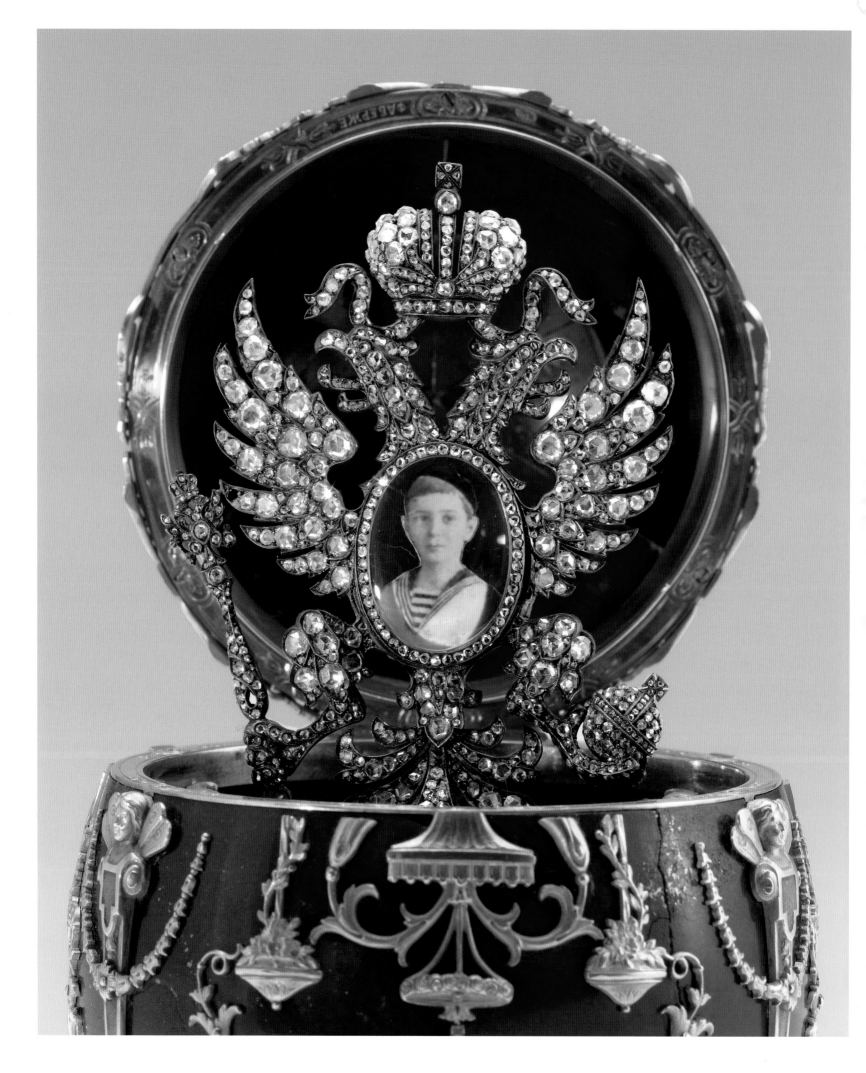

FABERGÉ
REVEALED

AT THE VIRGINIA MUSEUM OF FINE ARTS

Géza von Habsburg

with contributions by Carol Aiken, Christel Ludewig McCanless,

Mark Schaffer, Alexander von Solodkoff, and Ulla Tillander-Godenhielm

VIRGINIA MUSEUM OF FINE ARTS

Virginia Museum of Fine Arts, Richmond

in association with Skira Rizzoli Publications, Inc., New York

VMFA's Banner Exhibition Program is made possible by the Julia Louise Reynolds Fund with additional support provided by the Lettie Pate Whitehead Evans Exhibition Endowment.

Library of Congress Cataloging-in-Publication Data
Virginia Museum of Fine Arts.
Fabergé revealed : at the Virginia Museum of Fine Arts / Géza von Habsburg ; with contributions by Carol Aiken ... [et al.]. — 1st ed.

 p. cm.
 Includes index.
 ISBN 978-0-917046-90-2 (VMFA hardcover : alk. paper) —
 ISBN 978-0-917046-91-9 (VMFA limited ed. in slipcase : alk. paper) —
 ISBN 978-0-8478-3738-0 (Skira Rizzoli hardcover : alk. paper)
 1. Fabergé, Peter Carl, 1846–1920 — Catalogs. 2. Fabergé (Firm) — Catalogs. 3. Jewelry — Russia — Catalogs. 4. Art objects, Russian — Catalogs. 5. Jewelry — Virginia — Richmond — Catalogs. 6. Art objects — Virginia — Richmond — Catalogs. 7. Virginia Museum of Fine Arts — Catalogs. I. Habsburg, Géza von. II. Aiken, Carol A. III. Title.
 NK7398.F32A4 2011
 739.2092 — dc22 2011016388

Front Cover: *Peter the Great Egg*, cat. no. 189; Back Cover: *Tsesarevich Egg*, cat. no. 190; Spine: *Ring Box*, cat. no. 162; Frontispiece: *Tsesarevich Egg*, interior, cat. no. 190; Endpapers: Miniature Eggs, cat. nos. 160–86, design by Patrick Bell.

Produced by the Department of Publications
Virginia Museum of Fine Arts
200 N. Boulevard, Richmond, Virginia 23220-4007 USA

in association with Skira Rizzoli Publications, Inc.
300 Park Avenue South
New York, New York 10010
www.rizzoliusa.com

Mitchell Merling, curatorial coordinator
Rosalie West, editor in chief
Anne Adkins and Stacy Moore, project editors
Sarah Lavicka, chief graphic designer
Patrick Bell, book designer
Jean Kane, Brandon Robertson, and Ern Bernhardi, production assistants
Katherine Wetzel and Travis Fullerton, photographers, except as noted on pages 2–123.
Composed in Adobe InDesign with Simoncini Garamond and Futura fonts. Printed on acid-free 150 gsm LumiSilk text by Artegrafica, Verona, Italy.

Contents

Foreword

The exquisite objects created by Karl Fabergé and his studio in the late nineteenth and early twentieth centuries for the aristocracy and nobility of imperial Russia are considered to be some of the most refined examples of the jeweler's art of any age. The array of enameled picture frames and clocks, gold cigarette cases and cane tops, rock-crystal animals and flowers, and jewel-encrusted brooches and boxes still evoke the same fascination today that they did when displayed in the windows of Fabergé's stores in St. Petersburg, Moscow, and London. Of greatest fascination are the extraordinary Easter eggs created as special commissions for the Russian imperial family and other notable patrons—works that remain unparalleled in their ingenuity of construction and sheer beauty.

Thanks to the connoisseurship and generosity of Virginia collector Lillian Thomas Pratt, the Virginia Museum of Fine Arts owns the finest collection of Fabergé objects outside Russia, including five of the imperial Easter eggs that were produced annually by the Fabergé studio for tsars Alexander III and Nicholas II. Consisting of more than three hundred objects, the Pratt collection has been augmented over the years by numerous gifts from these generous donors: Col. Henry W. Anderson, Mrs. M. N. Blakemore, Mr. and Mrs. Benjamin Berkowitz, Ailsa Mellon Bruce, the Jerome and Rita Gans Collection of Russian Enamel, Mr. and Mrs. Harry Grandis, the Grandis family, Furman Hebb, the estate of Ernest Hillman Jr., Forrest Mars Jr., John F. Mars, and Jacqueline B. Mars, Clifford C. Matlock, Alice and Lewis Nelson, Leslie Blair Northrop, Elizabeth A. Rousitzky, Gerard de M. de Syvlar, Dr. and Mrs. Henry S. Spencer, and Dimitry Troubs.

As part of VMFA's seventy-fifth anniversary, the museum has undertaken a three-part project to reassess and redisplay its unparalleled Fabergé collection: this catalogue; a complementary exhibition that will be on view from July 9 to October 2, 2011; and, finally, an expanded and newly designed gallery that will show more of the collection than ever before. *Fabergé Revealed* is a project that has been led by the preeminent scholar of Fabergé, Géza von Habsburg, who has curated numerous exhibitions on the topic worldwide and is the author of several catalogues and books.

The current catalogue represents a landmark for the museum and for Fabergé scholarship. The scholarly essays present new findings on Fabergé, his workshops, and the creation of these extraordinary objects. For the first time it scientifically catalogues all items by or attributed to Fabergé in VMFA's collection as well as our significant holdings of

other Russian decorative arts. Thanks to Dr. von Habsburg's expert connoisseurship, many items have been reattributed to other makers, and archival research has confirmed other attributions. A section on forgeries bravely confronts this vexing question. Every object has been splendidly rephotographed for this book by VMFA Chief Photographer Katherine Wetzel and Assistant Photographer Travis Fullerton—and the detailed photography alone should provide inestimable value for future Fabergé scholarship.

Dr. von Habsburg has been assisted in this project by numerous individuals who are thanked in the acknowledgments, but special mention should be made of the departments of Publications, Photography, Registration, Exhibitions, and Objects Conservation, as well as VMFA's Margaret R. and Robert M. Freeman Library. In-house curatorial leadership was ably provided by Mitchell Merling, Paul Mellon Curator and Head of the Department of European Art, under whose purview the collection falls. Thanks also to Robin Nicholson, Deputy Director, Art and Education; Stephen Bonadies, Deputy Director, Collections and Facilities; and Sylvia Yount, Chief Curator and Louis B. and J. Harwood Collection Curator of American Art, for their leadership in bringing this exhibition and volume to reality. May you enjoy Fabergé's great treasures and the Virginia Museum of Fine Arts soon and often.

Alex Nyerges
Director, Virginia Museum of Fine Arts

Acknowledgments

The production of this ambitious catalogue was made possible thanks to the unwavering support of the energetic and farsighted director of the Virginia Museum of Fine Arts, Alex Nyerges. The impetus for the publication came from VMFA's Paul Mellon Curator and Head of the Department of European Art, Mitchell Merling, who has overseen the project from the first to the last day and has with much forbearance and wisdom steered it through all it vicissitudes. In addition to the many VMFA staff members recognized and thanked below, I would like to single out those with whom I interacted on an almost daily basis, and to whose angelic patience and ability to cope with myriads of minutiae this publication owes a huge debt of gratitude. They are the unflagging editors Anne Adkins (catalogue) and Stacy Moore (essays); Traveling Exhibitions Coordinator Sarah Porter; Deputy Director of Art and Education Robin Nicholson; Editor in Chief Rosalie West; and Graphic Designer Patrick Bell. A special word of thanks must go to Tim Boettger, who painstakingly combed through the entire manuscript, spotting errors and providing what may turn out to be the definitive system of transliteration of Russian names for future Fabergé authors.

The publication of yet another major catalogue about Fabergé would be a foolhardy endeavor without the continuing collaboration of a number of well-seasoned scholars belonging to a small, tight-knit, and often-solicited group. Those who were approached, as usual, generously agreed to provide essays as well as their precious time to discuss the issues raised by many of the intriguing objects in the Lillian Thomas Pratt Collection. Most valuable input came from the book's contributors. Dr. Ulla Tillander-Godenhielm, the great specialist on all matters pertaining to the imperial award system for items having been presented (or allegedly presented) by the tsar, in particular on the two table portraits, is here author of a fundamental essay on the workshop system at the Fabergé firm. We are also indebted to her for the definite spelling of the Finnish workmasters' names. Christel McCanless, guardian of a great store of information about the auction history of Fabergé objects, patiently answered questions about auctions of bulldogs and tables and in her essay delves into the history of the Pratt sailor figure. My colleague Alexander von Solodkoff, with whom the authenticity of a number of animals and flowers was much debated, discusses the rich collections of Grand Duchess Vladimir, Maria Pavlovna, inspired by a thrilling auction of recently discovered treasures belonging to her. Carol Aiken's essay on the museum's five imperial Easter eggs underlines yet again her profound knowledge of the technical aspects of Fabergé objects. Mark Schaffer writes

on a treasure trove of letters from Mrs. Pratt addressed to his grandfather Alexander Schaffer and on his ancestor's letters to Mrs. Pratt, which in turn are preserved in Richmond. Kieran McCarthy, a tireless researcher, discovered and recounts the history of a frame taken by the imperial family into exile and which, of all their valuables, appears to be the sole survivor of their massacre in Ekaterinburg. May they all be warmly thanked!

As coordinator of this catalogue and accompanying exhibition, Mitchell Merling joins me in thanking the following VMFA departments and staff members. *Conservation*: Kathy Z. Gillis, Conservator of Sculpture and Decorative Arts; Katherine Ragan, Intern; Jennifer Bridges, Technician; Sheila Payaqui, Assistant Conservator of Sculpture and Decorative Arts. *Collections*: Sylvia Yount, Chief Curator; Susan J. Rawles, Assistant Curator of American Decorative Arts; Corey Piper, Curatorial Associate; Caryl Burtner, Administrative Coordinator; Allison Frew, Research Assistant; Jamie Staples, Caroline Nichols, and Sara Desvernine-Reed, Interns. *Exhibitions*: Sarah Porter, Traveling Exhibitions Coordinator; Carol Casstevens, Assistant to the Deputy Director; Aiesha Halstead, Acting Manager; Courtney Burkhardt, Fabergé Exhibition Officer. *Library*: Suzanne Freeman, Chief Librarian Emeritus; Lee Viverette, Chief Librarian; Courtney Yevich, Archivist. *Photography*: Katherine Wetzel, Chief Photographer and Manager; Travis Fullerton, Assistant Photographer; Susie Rock, Coordinator of Photography; Howell Perkins, Manager, Photographic Resources and Rights and Reproductions. *Publications*: Alexis Vaughn, Deputy Director, Sales and Marketing; Sarah Lavicka, Chief Graphic Designer and Acting Manager; Jean Kane, Brandon Robertson, and Ern Berhardi, Graphic Designers, Libby Causey-Hicks, Marketing Representative. *Registration*: Stephen Bonadies, Deputy Director, Collections and Facilities; Nancy Nichols, Project Registrar; Lisa Hancock, Chief Registrar.

Additional thanks go to Charles Miers, Margaret Chace, and Jessica Napp of Skira Rizzoli, Svetlana Chestnykh, Karen Kettering, Elena Lioubimova, Anne Odom, Marilyn Sweezey, and Mollie Storey.

Géza von Habsburg
VMFA Fabergé Guest Curator

Mitchell Merling
*Paul Mellon Curator and Head
of the Department of European Art*

Introduction

In the United States, admirers of Russian art have the enviable opportunity to view many of Karl Fabergé's finest creations — thirteen imperial Easter eggs and more than 350 other artifacts are preserved in public collections. This experience is not available to museum visitors in Europe. No Western European museum has a single imperial Easter egg on permanent display. With the exception of a recently opened Fabergé museum in Baden-Baden, Germany, no more than a handful of other objects are publicly exhibited. Russia, the fertile soil on which Fabergé's objects of art, jewels, and silver grew, has two museums with major holdings of the master's objects of art: the Kremlin Armory Museum in Moscow and St. Petersburg's State Hermitage Museum. Together they own ten imperial eggs and some two hundred other objects, a small remainder of the fifty imperial Easter eggs and the many thousands of Fabergé articles that once belonged to Russia's aristocracy and its moneyed classes. Virtually every valuable was confiscated between 1917 and 1918 and sold over the next two decades by the Bolsheviks through Antikvariat, the authorized intermediary for such transactions. America was the main beneficiary of much of this bonanza.

Since the dispersal of the Forbes Magazine Collection in 2004, the Virginia Museum of Arts has been the premier location in the United States to view works of art by Karl Fabergé. With its five imperial Easter eggs and 323 other objects by or attributed to Fabergé, all lovingly assembled by Lillian Thomas Pratt in the 1930s and 1940s, and a further fifty Russian works from other Virginian collectors, the museum easily surpasses all other American holdings. The leading sources of Russian art for American collectors recovering from the Depression in the early 1930s were L'Hermitage Galleries, the Imperial Collection of Russian Art, the Russian Imperial Exhibition from the Hammer Galleries, or the Hammer Galleries, all companies formed by brothers Armand and Victor Hammer. The Hammers were joined by Alexander Schaffer in 1932, who with his wife, Ray, founded Russian Imperial Treasures in 1933, also known as The Schaffer Collection of Russian Imperial Art Treasures, Inc., or simply The Schaffer Collection, which was merged with A La Vieille Russie in 1941. These two firms provided most of the objects of art for America's four major collectors — Lillian Pratt of Virginia; Matilda Geddings Gray of Louisiana; Marjorie Merriweather Post, whose art objects are on view at her former estate, Hillwood, in Washington, D.C.; and India Early Minshall, who donated her collection to the Cleveland Museum of Art. As chief purveyors of Russian treasures in the United States, the Hammers and Schaffers prospected the Russian

market until 1938, when a law was issued forbidding the export of works of art. Turning next to France and Britain, where genuine objects were still available, the dealers formed business associations with Emmanuel Snowman's firm of Wartski in London and with Jacques Zolotnitzky's and Léon Grinberg's A La Vieille Russie in Paris.

Mrs. Pratt specialized in six main areas, each of which comprised superlative examples of its kind: Easter eggs, which included five glorious imperial examples as well as an extraordinary seventy-six egg-shaped pendants; fifty-four frames; thirty-eight animal figures; thirty-eight cane or parasol handles; twenty-two flowers; twenty icons; and an additional sixty-one diverse objects of vertu. In sheer numbers, each of these categories surpasses those of her fellow American collectors. Mrs. Pratt's fascination with the Romanovs and her numerous purchases of their mementoes takes on a certain poignancy when her relatively modest means are compared to those of Post, founder of General Foods; Gray, who built up her family's petroleum fortune; and Minshall, widow of a Cleveland oil executive. Extant invoices show that between 1934 and 1945 Lillian Pratt spent $108,534 with A La Vieille Russie. The sum does not include the $16,500 she spent for the *Peter the Great Egg* (at a time when a car cost $1,100 and an average yearly salary was $2,400). She paid for the egg in thirty-three monthly installments of $150 to $750 from February 2, 1942, to December 1, 1944. This significant purchase certainly contradicts the touching tale that she secretly acquired her entire Fabergé collection with her pocket money, unbeknown to her husband, John Lee Pratt, a General Motors executive.

Also not included in that figure, of course, are Lillian Pratt's expenditures at the Hammer Galleries; the company's records of the 1930s and 1940s no longer exist. Such information would have provided a capital fund of data for an understanding of the relationship of Armand Hammer with his Communist suppliers and of his sales of Russian art into the 1940s. On the other hand, the records of A La Vieille Russie, which cover the period from 1933 to the present, are in the hands of the sons and the grandson of the original owners. The correspondence between the Schaffers and Lillian Thomas Pratt, of which half is preserved at VMFA, is a rich illustration of the warm friendship between A La Vieille Russie and one of their best clients. In contrast, Hillwood, the Matilda Geddings Gray Foundation Collection, and the Cleveland Museum of Art have not yet published in detail the provenances of their Fabergé holdings nor the correspondence pertaining to their respective collectors.

As any objects with a Romanov provenance could be sold at a substantial premium, the Hammers and Schaffers both benefited from the cunningly engendered thirst of the four abovementioned collectors for anything connected with the Russian imperial family. While supply was plentiful, incomparable treasures by Fabergé could be obtained. They included such masterpieces as the imperial Easter eggs and the *Lilies of the Valley Basket*, the pride and major attractions of their respective museums.

The descriptions supplied with the invoices to Mrs. Pratt by the two dealers—in particular those from the Hammer Galleries, which are far more detailed and fanciful—allow valuable insight into the sentimental ideas they instilled in their client. As many collectors were mesmerized by the Russian imperial family and its tragic fate, the dealers recognized the necessity to feed their seemingly insatiable interest. By virtue of the fervent desire of their clients, every item, down to each spoon they acquired, had to have been part of the furnishings of one of the imperial palaces or must have been owned by a member of the imperial family. As a result, every frame sold to Mrs. Pratt included a photograph of a Romanov family member, another essential marketing tool that helped maintain the fantasy. Furthermore, with a handful of exceptions, each object was sold as an original by the Russian imperial jeweler Karl Fabergé, or was at least tacitly understood as such, the only author worthy of being associated with the purported imperial owners of these objects. Never mind that half the objects sold were not signed, or if so, were hallmarked by one of the other numerous distinguished goldsmiths or jewelers of St. Petersburg. As if by the touch of a magic wand they all became Fabergé's workmasters, or were at least associated with him.

The Pratt collection now provides what appears to be indisputable evidence of the veracity of Victor Hammer's claim in 1992 that his brother Armand had an understanding with Anastas Mikoyan, head of the Commissariat for Foreign Trade. Mikoyan is said to have supplied Hammer with a set of hallmarking tools acquired from Fabergé's workshop, with which Armand was to mark unsigned objects, including fraudulent pieces, and then send back to Russia a percentage of their sales proceeds. Such hallmarking tools were repeatedly used by Hammer in order to authenticate a series of sixteen newly made flowers, as well as some hardstone animals and objects sold to Mrs. Pratt. With this catalogue, VMFA is the first museum to address openly the questions of Hammer's activities. A close-up study of each object now allows us to separate the wheat from the chaff.

Two monographs have been dedicated to Lillian Pratt's collection, in 1960 and in 1976, both by Parker Lesley and both understandably long outdated. For the 1996–97 five-city tour of *Fabergé in America*, which showed fifty-five Fabergé objects from the museum's holdings, VMFA curator David Park Curry published a charming, selectively illustrated booklet in 1995, vividly recounting Mrs. Pratt's life and acquisitions. Fabergé specialists and admirers alike have long awaited a scholarly, up-to-date publication of Richmond's hidden treasures. While the present book does not pretend to be the final word on the subject of attributions and forgeries, we hope it will open the door to further scholarship.

Géza von Habsburg
VMFA Fabergé Guest Curator
Faberge Company Curatorial Director

Note on Transliteration

Russian personal and place names in this book have been transliterated by Timothy F. Boettger according to the Modified Library of Congress system. The only exceptions are names that appear in quoted material written in a Latin alphabet, for which original spellings have been retained. The names of jewelers, goldsmiths, and other individuals of foreign origin resident in Russia (German, French, etc.) have been spelled according to how they appear on original invoices of the firms in question and/or in the pertinent genealogical records in the collection of Mr. Boettger.

In addition, the Russian "tsar" and its derivatives are used interchangeably with the English equivalents, "emperor" and its various forms, throughout the text.

Fabergé Revealed

CHAPTER 1

The House of Fabergé

GÉZA VON HABSBURG

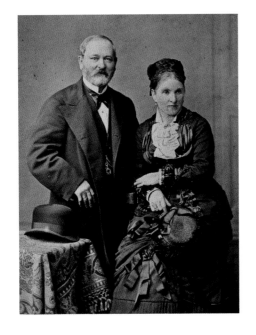

FIGURE 1.1: Gustav and Charlotte Fabergé, parents of Karl Fabergé, in Dresden, Germany, ca. 1850. Courtesy of Wartski.

FIGURE 1.2: Karl Fabergé, ca. 1900. Courtesy of Alexander Gunst.

A short history of the extraordinary House of Fabergé begins with its founder, Gustav Fabergé (1814–1893) (fig. 1.1).[1] A descendant of French Huguenots who had resettled in Germany and then Russia, Gustav was born in Livonia, on the eastern shores of the Baltic Sea. In 1842, at age twenty-eight, he opened a small jewelry firm with an in-house workshop in St. Petersburg. Though the business was successful, the few early items that can be identified as Fabergé products are only of scant interest. Some of the shop's articles were retailed wares from France, and others were produced in the company workshop of August Holmström.[2]

Gustav's eldest son, Karl Gustavovich, or Peter Karl (better known today as Karl Fabergé, or simply Fabergé) (fig. 1.2), was born in 1846. He was first schooled in St. Petersburg and, after his father's retirement in 1860, in Dresden. An educational Grand Tour of Europe in the mid-1860s broadened his education substantially, allowing him on his return to Russia to take over the reins of his father's business in the late 1860s.

Young Fabergé specialized mainly in conventional jewelry for more than a decade. The firm experienced a breakthrough, however, in 1882 with its first major success at the Pan-Russian Industrial Exhibition in Moscow, where Empress Maria Feodorovna acquired a small piece of archaeological jewelry. Honors accumulated in rapid succession: a Gold Medal at the Moscow Pan-Russian Industrial Exhibition (1883); the title of Supplier by Special Appointment to the Imperial Court, the first commission of an imperial Easter egg, and a Gold Medal at the Nuremburg International Exhibition of Precious Metals (1885); the Order of St. Stanislas, 3rd Class (1889); the title of Appraiser to the Imperial Cabinet and a Hereditary Honorary Citizenship (1890); the Order of St. Anne, 3rd Class (1892); the State Emblem and the Order of St. Stanislas, 2nd Class (1896); a Royal Warrant to the courts of Sweden and Norway (1897); a Gold Medal *hors concours* at the Universal Exposition in Paris and the prestigious

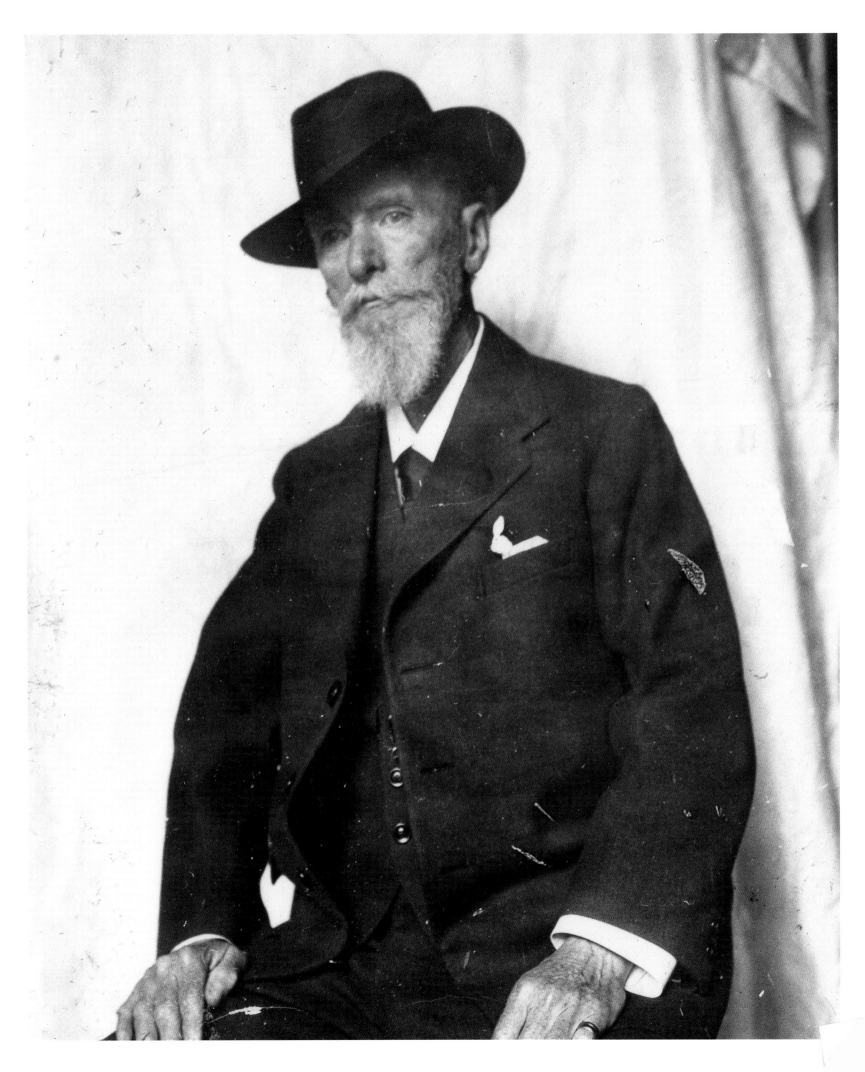

Cross of the Legion of Honor (1900); the Bulgarian Commander's Cross for Civil Services and an invitation to exhibit artistic objects and miniatures mainly owned by members of the imperial family at a charity event sponsored by Empress Alexandra Feodorovna in St. Petersburg (1902); and the titles of Jeweler to the Court and Manufacturing Councilor (1910).

This continuous string of recognitions in Russia and abroad was paralleled by the opening of branches in Moscow (1887) and Odessa (1901); the acquisition of new premises in St. Petersburg (1898–1900); and the opening of additional branches in London (1903) and Kiev (1906–10). Highlights marking Fabergé's exceptional career include the 1896 coronation ceremonies, for which he supplied many of the finest gifts; the 1903 imperial costume ball and the jewels that he created for Tsaritsa Alexandra Feodorovna, wife of Nicholas II, and no doubt many other courtiers; and the 1913 Romanov Tercentenary celebration, which, with its large number of orders, was the culminating and last major event of Romanov rule. A year later, Russia entered World War I after Austria invaded Serbia, and many of Fabergé's craftsmen were enlisted. The firm itself was obliged to produce base-metal objects and hand grenades. Fabergé, forestalling the ominous end, converted the business into a joint stockholding company in 1916 and formed the Committee of the Employees of the Company K. Fabergé the following year. Finally, in 1920, he fled, handing the keys of his premises to a member of the city's Hermitage Museum.

Within forty years of its humble beginnings, Karl Fabergé's firm had eclipsed all local competition, acquiring world fame. The great craftsman died in Switzerland as a refugee in 1920, some say of a broken heart. Today he is arguably the most famous jeweler of all time.

The Businessman

Within this sparse framework of the company's history is the legacy of Karl Fabergé, a remarkable man who, together with his brother Agathon (1862–1895) and his four sons, Eugen Gottlieb (1874–1960), Agathon Theodor (1876–1951), Alexander Julius (1877–1952), and Nikolai Leopold (1884–1939), transformed his father's small jewelry firm into the world's largest enterprise of its kind. With more than five hundred employees, the company produced over 150,000 objects of art, jewels, and silver articles—a large number of them one of a kind and each a work of exquisite design and craftsmanship. No creation by Karl Fabergé himself seems to have survived. Yet the large majority of the objects made in St. Petersburg are unmistakably imbued with his personality. His highly original choice of objects and his supervision of their design, style, and perfect execution marked them as Fabergé's. The popular image of the jeweler—hammer in hand, meticulously examining every single article and mercilessly smashing any imperfect object—might be apocryphal, but it speaks to

his demand for excellence. Unless flawless in every respect, pieces were sent back to the workbench.

Beginning in 1869, after returning from his Grand Tour, Fabergé wisely ingratiated himself with the powerful Imperial Cabinet. He offered his services and know-how free of charge, appraising and restoring jewelry and objects of art in the treasury of the Hermitage Museum. This Imperial Cabinet[3] had the responsibility of administering the crown jewels and the contents of the treasury as well as controlling the commission of presentation gifts. It was thus of capital importance to the career of any aspiring jeweler. After sixteen years of service, Fabergé in 1884 applied for the position of Supplier to the Imperial Court. Initially rejected, he was granted the title in 1885. His sponsor, Hermitage antiquities curator Ludolf Stephany, stressed that "Mr. Fabergé has (since) permanently participated in all technical, at times quite laborious, researches relating to numerous objects of the Hermitage archaeological collection . . . he would spend days and days . . . repairing broken objects, bringing them back to their original shape. . . . None of this work has been properly rewarded. Never has Fabergé, in spite of the many days he gave to the Hermitage presented a bill."[4] Over the years, the long hours spent at the treasury also afforded Fabergé the rewarding opportunity to study closely its historic riches, providing an almost inexhaustible supply of ideas in later years.

The multifaceted persona underlining Fabergé's business acumen is evident in his illustrated pamphlets, *Prix-Courants,* of which he published three: one in 1893, another in 1899, and a smaller volume in 1903. Produced "in response to the ever increased number of enquiries from provincial Russia concerning the firm's products," they were far ahead of their time. Each includes a preface outlining Fabergé's most important tenets:[5] (1) every object sold had to be in perfect condition (even if parts were prefabricated, the piece was exactingly finished by hand); (2) pieces were unique and of the latest fashion and unsold goods destroyed every year so that visitors would always find enchanting new *objets* for sale; (3) objects were not "marked up" but priced according to their true value (Fabergé's profit margin was 100 percent[6]), and prices were kept attractively low, aided in part by the frequent use of materials of small intrinsic value—wood, lacquer, leather, cork, and semiprecious stones of local origin; and (4) his stock was always vast so as to offer something to please each customer. (Interestingly, concerns of copies or forgeries were already prevalent at the time, as Fabergé expresses regret that he is unable to include some of his best works in the pamphlets "for fear of imitations by our competitors.")

If Fabergé, more than any other jeweler, became a household word throughout Russia—thanks to four branch offices at home—he was also ahead of most of his local competitors in prospecting a new clientele abroad. His London branch (see Chapter 4) catered to many of the royal houses of Europe, the nobility, artists, the

demimonde, and the newly rich—including bankers and numerous Americans who arrived in London for the season. The firm's London Sales Ledgers from 1907 to 1917 are a veritable register of elegant society. Beginning in 1909, Fabergé also sent teams of salespeople to Paris, the Côte d'Azur, and Rome. With the exception of the firm of Cartier, which was generally ahead of its Russian competitors, no other jeweler was farsighted enough at the time to look to the Far East as a potential source of business. Financed by his London office, Fabergé sent representatives twice a year to Siam (now Thailand) and India. He was invited to Siam in 1904 by King Chulalongkorn (Rama V) and was instrumental in building up a collection of beautiful Siberian jade works and objects of art, which still grace the royal palace in Bangkok. Fabergé's objects were sent by the tsar as diplomatic presents to Turkey, Saudi Arabia, China, and Japan. The enterprising jeweler also made regular sales trips to the maharajas of the Indian Subcontinent.

At home, the practical businessman worked on streamlining his rapidly growing operation, rendering it more efficient and productive. Initially, the diverse workshops supplying the company were spread throughout St. Petersburg, and therefore difficult to supervise. By 1900, however, most of the main workshops were centralized under one roof in the firm's vast new premises, a quadrangle with an imposing pink granite front facing fashionable Bol'shaia Morskaia Street (fig. 1.3). This close-knit system of workshops has been described by Ulla Tillander-Godenheilm as "the first multifunctional business complex in Russia."[7] The noisy and dusty hardstone-carving factory, which was later acquired from Carl Woerffel, and the major silver workshops of Julius Rappoport and of the Wäkevä family remained on the outskirts of the city. Outworkers, such as Andrei Gur'ianov, Anders Mickelsson, Fedor Ringe, Eduard Schramm, and Vasilii Solov'ev, worked from their own ateliers but not under exclusive contracts.

Fabergé and the Imperial Court

With the recent discovery of a 1919 memoir by the Swiss-born Franz Birbaum, Fabergé's chief designer between 1893 and 1917, illuminating details have emerged about Fabergé's relationship to the imperial court. Initially, he was obliged to rely exclusively on orders from the imperial family and the court in St. Petersburg, channeled through His Majesty's Cabinet. Only later did the moneyed Moscow financiers and merchants, whose patronage he preferred, become the backbone of Fabergé's business. The cabinet, which was run by military or civil generals who generally had little or no knowledge of art, often aimed to place its orders with the lowest bidder. The tsaritsa, who in fact considered herself an artist, would impose her wishes as to the design and cost of certain objects. Birbaum writes caustically (perhaps the 1917 revolution had quickly removed any sign of due respect): "Her grasp of artistic

FIGURE 1.3: Fabergé's St. Petersburg premises at Bol'shaia Morskaia, ca. 1910. Courtesy of Wartski, London.

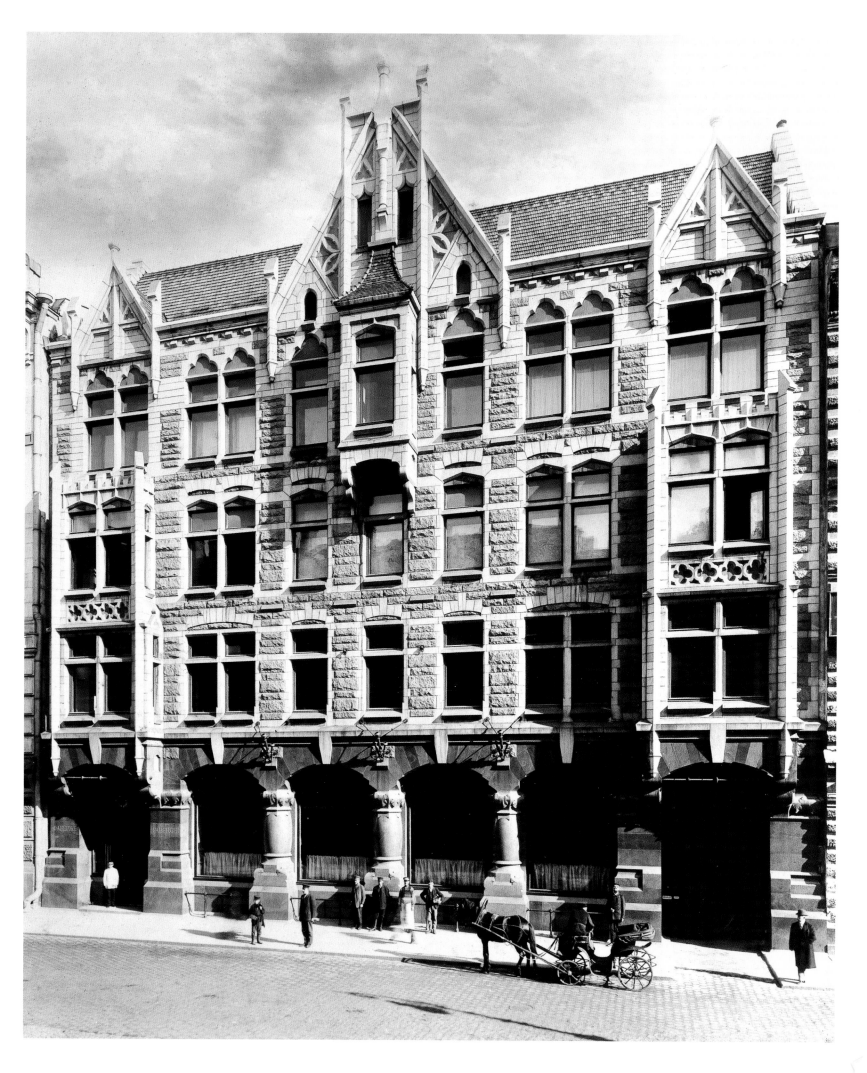

concepts was meager, her meanness was not in keeping with her royal status."[8] Fabergé must have disliked having to ingratiate himself with His Majesty's Cabinet, as he "stopped visiting in person. Of course the number of orders was reduced still further as a result, but this was compensated by the increase of other clientele and orders from abroad." The nouveaux riches gladly accepted Fabergé's designs and undoubtedly paid his invoices without demurring.

Nicholas II strove for fairness toward all suppliers to the imperial court. They were encouraged to submit objects from which cabinet functionaries selected what they deemed appropriate. A sizeable stock of snuffboxes was necessary. During his twenty-year reign, Tsar Nicholas presented 424 snuffboxes, fifty-four of which were set with his portrait—fourteen newly made and forty from stock.[9] Of the thirty boxes made by identified craftsmen, nineteen came from Fabergé, eight from Karl Hahn, two from Friedrich Koechly, and one from Carl Edvard Bolin. The finest of these boxes were sometimes made with a central oval panel that was left undecorated. They were submitted by one artist only to be consigned by the cabinet to another (generally Hahn and, after 1911, Carl Blank) who would then upgrade the work by setting the oval wih a supplied miniature and adding diamonds commensurate with the rank of the intended recipient.

According to Birbaum, many members of the court had a "blind admiration for everything foreign. They did not hesitate to pay huge sums for works that were often inferior to Russian works." Supporting this claim are the quantities of jewelry acquired by Grand Duchess Maria Pavlovna; Grand Duke Pavel Aleksandrovich and his morganatic wife, Countess von Hohenfelsen; Grand Duke Aleksandr Mikhailovich and his wife, Grand Duchess Ksenia, who spent fortunes with Cartier; and Prince Feliks Iusupov, who chose the Chaumet firm as his main supplier (see Chapter 4). Only when the job was "urgent or very complicated" would they come to the Fabergé offices, "knowing that the results would be good and produced in time." Indeed, Fabergé was often put under great pressure when "only a few hours were given for the execution of a commission, and these were at night."

Making up for these difficult demands were a number of welcome members of the imperial family who were faithful to Fabergé. Birbaum considered Grand Duke Aleksii Aleksandrovich[10] "the greatest connoisseur and judge." Another, Grand Duke Mikhail Mikhailovich,[11] was equally enamored of Fabergé's art, even if from a distance. For many royals, Fabergé objects also functioned as gifts of a very personal nature in St. Petersburg. Thus Matylda Krzesińska,[12] for example, an outstanding dancer in the Russian Imperial Ballet, received a large number of objects and jewels by Fabergé from her youthful paramour, Heir to the Throne Nikolai Aleksandrovich (later Tsar Nicholas II), as well as from another suitor, Grand Duke Andrei, her future husband.

Jewelry

The imperial court and its members spared no expense on splendid parures of diamonds or precious stones and on sumptuous pearl necklaces. Their staggering prices were commensurate with the fabulous riches of their wearers and demonstrated the social standing of each family. The legendary jewels of Grand Duchess Maria Pavlovna (see Chapter 7), Russia's leading collector of precious gems, underlined her uniquely exalted rank at court. They were largely commissioned from foreign jewelers. Many of the jewels of Princess Zinaida Iusupova, whose fortune surpassed that of the imperial family, were of historic origin and included the famous 111½-grain Peregrina pearl, the black pearls of Empress Catherine the Great, the black Azra pearl, and the earrings of Queen Marie Antoinette.

The most extraordinary display of jewelry at the imperial court took place at the 1903 masquerade ball, at which all invited, including the men, adorned themselves with untamed abandon.[13] The most important jewelry commissions, however, came from the imperial family itself, through the intermediary of the Imperial Cabinet, and marked the two main events in a young woman's life — betrothal and marriage. Furthermore, grand dukes and princes vied with each other to acquire ever-more expensive baubles with which to spoil their wives and mistresses. Karl Fabergé, though he ostensibly looked down on such jewelry as being of little artistic value, must have nevertheless in his early days craved the favors lavished by the Imperial Cabinet.

At the 1882 Pan-Russian Industrial Exhibition in Moscow, which was staged under the significant patronage of Tsar Alexander III, Karl Fabergé presented his pioneering copies of ancient gold jewelry unearthed in the south Russian seaport of Kerch. He had studied and restored the originals, which were preserved in the imperial treasury. According to the press, Fabergé's gold pieces opened "a new era in the art of jewelry. We wish him all the best in his efforts to bring back into the realm of art what once used to be a part of it. . . . We hope that from now on, thanks to our renowned jeweler, the value of the objects will be measured not only by the value of the precious stones, not by wealth alone, but by their artistic form as well."[14] From among these gold jewels, Fabergé sold a token pair of cicada-shaped cuff links to Empress Maria Feodorovna. Undoubtedly the sales of *haute joaillerie*, as opposed to jewelry of lesser artistic merit but with valuable precious stones, were more profitable to Fabergé. The press reported that "Fabergé's showcase abounds with stones, among others Cape diamonds (up to 23¼ carats), as well as stones from India and Brazil." Exhibits also included "a hibiscus flower priced at 8.500 rubles: around a large yellow diamond there are flower petals made of tiny pink diamonds . . . a necklace, a diamond parure of flowers, another with opals, a *Sevigné* out of various stones and a leaf brooch," presumably all of reasonable value when compared to the expensive creations of his main competitor, the House of Bolin jewelers. Fabergé's sales to the Imperial Cabinet, too,

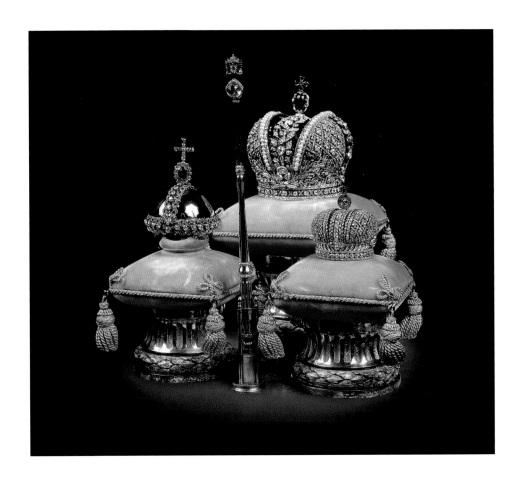

FIGURE 1.4: Fabergé, *Miniature Replicas of the Imperial Crown Jewels,* 1899–1900, workmaster August Holmström; gold, silver, platinum; diamonds, spinel, pearls, sapphires, velvet, rhodonite; scepter height 6 3/16 in. (15.7 cm), base not shown, workmaster Julius Rappoport. State Hermitage Museum, St. Petersburg.

were initially modest, at a time when other more established St. Petersburg jewelers such as Bolin, Butz, Koechly, and Saefftigen were fulfilling the majority of the cabinet's orders.

In 1894, twelve years after the Moscow exhibition, Fabergé — by then Supplier to the Imperial Court, Appraiser to the Imperial Cabinet, and Hereditary Honorary Citizen — received his first major commission: a lavish pearl necklace costing 165,500 rubles. The necklace was a betrothal gift for Princess Alix of Hesse and by Rhine, the fiancée of Tsesarevich Nikolai, from her in-laws. (She appears in many an official photograph and painting wearing the necklace.)

The earliest extant drawings from the Fabergé jewelry workshop reveal a close affinity with the floral jewelry of Oscar Massin, Frédéric Boucheron workmaster Octave Loeulliard, and Henrí Vever as well as the early creations of René Lalique. They are preserved in a scrapbook of approximately one thousand designs, mostly drawings in white gouache on black ground, which cover the output of the August Holmström workshop between about 1870 and 1900.[15] These folios also contain the only extant evidence of the activity of Agathon Fabergé, Karl's younger brother (who was in St. Petersburg from 1882 to 1895), reportedly a major source of inspiration for the firm.[16] He was described by a contemporary as "by nature more lively and impres-

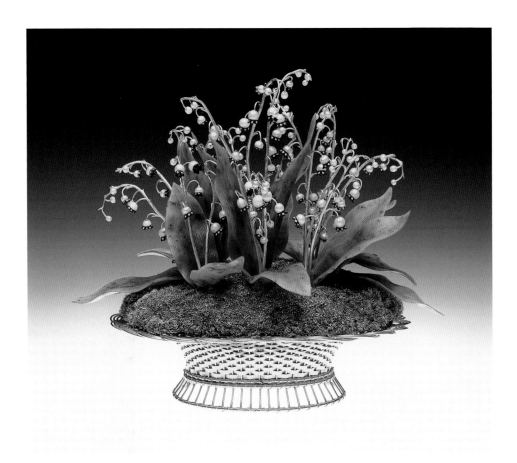

FIGURE 1.5: Fabergé, *Lilies of the Valley Basket,* 1896, workmaster August Holmström; gold, pearls, diamonds, nephrite; length 8½ in. (21.6 cm). Matilda Geddings Gray Foundation Collection.

sionable. . . . His extant drawings are evidence of constant and ceaseless questing." Four detailed watercolor designs for emerald-and-diamond bib necklaces in the French Deuxième Empire style and a number of floral brooches bear his signature or initials.

The workshop of jeweler August Holmström (see fig. 2.1),[17] who was active in the firm from 1858 until his death in 1903 and may have mentored the young Fabergé, was likely responsible for the jewelry designs bearing the company's signature or stamp. They are conservative in style, representing a transition between Louis XV and Louis XVI designs. They all have tied bows or panels of trelliswork surrounded by rococo scrolls, a manner favored by St. Petersburg society at the turn of the nineteenth century.

According to Franz Birbaum, Holmström made only jewelry. Another source close to Fabergé, however, writes that "he was equally successful in goldsmithery pure and simple."[18] The most celebrated of August Holmström's surviving jewels are the miniature replicas of the Russian crown jewels (fig. 1.4) created as Fabergé's centerpiece for the 1900 Paris Universal Exposition. Set with an incredible 1,728 brilliant-cut and 4,541 rose-cut diamonds, they were acclaimed as masterpieces of craftsmanship. Holmström was also responsible for the exquisite *Lilies of the Valley Basket* of 1896 (fig. 1.5), arguably the craftsman's finest accomplishment. After his father's death in

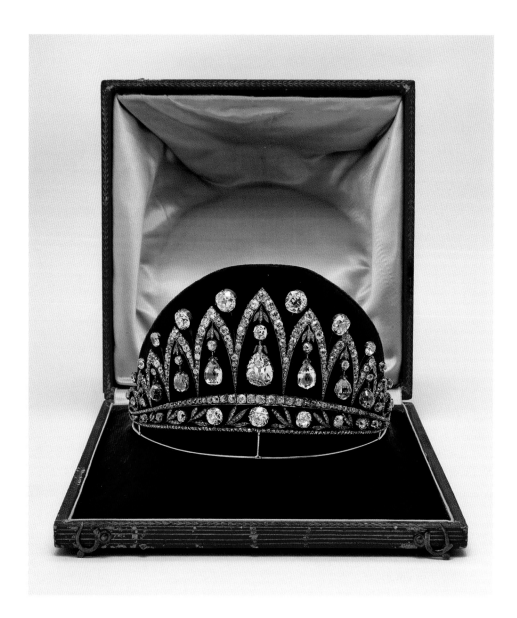

FIGURE 1.6: Fabergé, *Diamond Tiara,* ca. 1900, workmaster August Holmström; briolette, pear-shaped, and old-cut diamonds, gold, platinum; width 5 ³⁄₁₆ in. (13.2 cm). Arthur and Dorothy McFerrin Foundation Collection, photograph courtesy of Houston Museum of Natural History.

1903, Albert Holmström was responsible for further peerless creations, including Fabergé's 1913 *Winter Egg*[19] and his 1914 *Mosaic Egg.*[20]

A small handful of August Holmström's *joyaux* have survived the Russian Revolution, chiefly because they were sent or taken abroad as presents or acquired at Fabergé's London salesroom. These rare and costly productions of the jewelry workshop include a number of tiaras, two of which are in the collection of the dukes of Westminster.[21] Recent discoveries include a lavish *kokoshnik*-shaped tiara with seven pendant briolette diamonds, formerly the property of the dukes of Leuchtenberg and more recently of Queen Marie-José of Italy (fig. 1.6), and a chain-link diamond necklace in a European princely collection.[22] Only photographic evidence survives of Fabergé's early large creations, which formed part of the Russian crown jewels. They were reproduced in 1924–26 by the academician Aleksandr E. Fersman.[23] All of these

were broken up by the Bolshevik rebels in the late 1920s and sold for the value of their stones.

The sparse knowledge of Fabergé's *joaillerie* has led many to underrate his role among St. Petersburg's jewelers. Existing evidence suggests that in the second decade of the twentieth century, Albert Holmström's workshop (see fig. 2.4) was well equipped to compete against both local jewelers and French newcomers. Two surviving stock books that record the jewelry workshop's output between 1909 and 1915 with some four thousand drawings of executed works[24] firmly establish Fabergé's claim to a place of honor among twentieth-century Russian jewelry designers. The majority of the larger *joyeaux* and the smaller bijoux illustrated are French in style. A number are lavish diamond creations in platinum settings, many of which attest to Fabergé's adoption of the eighteenth-century "garland style" launched by Cartier in Paris. Examples include diaphanous diadems in diamonds, pearls, or rubies; a lavish platinum-mounted diamond necklace in the eighteenth-century manner (fig. 1.7); and a cabochon-emerald-and-diamond fringe necklace (fig. 1.8).

While the stock books offer proof of a few belated attempts at Art Nouveau, a number of Fabergé's smaller bijoux are highly original and unexpectedly daring in design, having geometric shapes set with semiprecious stones in contrasting colors (fig. 1.9). Still other angular pendants and brooches with caliber-cut rubies and curious curved Mecca-stone pendants with perpendicular trelliswork (fig. 1.10) hint at Fabergé's peripheral involvement with modernism. In addition to these pictorial documents, numerous small jewels by Fabergé have survived the Russian Revolution because of their minimal intrinsic value.

FIGURE 1.7: *Drawing of a diamond necklace,* 1909, from Albert Holmström workshop jewelry ledger. Photograph by Prudence Cummings, courtesy of Geoffrey Munn, Wartski, London.

FIGURE 1.8: *Drawing of a diamond-and-cabochon-emerald necklace,* 1912, from Albert Holmström workshop jewelry ledger. Photograph by Prudence Cummings, courtesy of Geoffrey Munn, Wartski, London.

FIGURE 1.9: *Drawing of a geometric pendant set with colored sapphires,* 1907–17, from Albert Holmström workshop jewelry ledger. Photograph by Prudence Cummings, courtesy of Geoffrey Munn, Wartski, London.

FIGURE 1.10: *Drawing of a triangular pendant set with caliber-cut rubies,* 1907–17, from Albert Holmström workshop jewelry ledger. Photograph by Prudence Cummings, courtesy of Geoffrey Munn, Wartski, London.

Much of Fabergé's jewelry was manufactured in Moscow, where production costs were lower and operations better equipped and manned to execute the often-urgent orders of the court. Two hundred craftsmen were employed in this single shop alone (by comparison, three hundred worked at the large St. Petersburg factory). The Moscow branch also specialized in small trinkets, often in the Art Nouveau taste, which generally came from the workshop of S. N. Andrianov.[25]

Silver and Cloisonné Enamels

Because of huge demand, the majority of the Fabergé household silver was also produced in Moscow.[26] These pieces differ from the silver sold by competitors: their design is frequently more original, their finish crisper, the silver alloy often higher, and their weight more substantial. Typical products of this branch were tea sets, cutlery in various historicist designs, dishes, cigarette cases, cigar boxes, silver-mounted decanters, and crystal water and wine jugs, as well as individual pieces like presentation *kovshi* and prizes. Fabergé's Moscow silver of the early twentieth century was often of Art Nouveau design, following the tenets of the prevalent Russian-folk style, depicting legendary heroes or mythological figures (cat. nos. 4 and 5).

Moscow was also the source of virtually all of the firm's cloisonné enamels (one rare exception is a *bratina* by St. Petersburg silversmith Julius Rappoport in the Pratt collection at the Virginia Museum of Fine Arts [cat. no. 159]). Initially these articles were either commissioned or retailed from competing houses such as the factories of Maria Semenova, Ivan Saltykov, or Antip Kuzmichev. Fabergé's leading specialist, German-born Fedor Rückert,[27] supplied the firm from 1887 to 1917 with large numbers of his signature creations: *kovshi*, *bratiny*, tall beakers, cigarette and cigar cases, and tea and punch sets, many decorated with pictorial painted enamels copying celebrated paintings. Rückert also marketed his own wares independently, selling to other large firms like Pavel Ovchinnikov and Orest Kurliukov. Rückert's style evolved from placid shaded cloisonné enamels in the nineteenth and early twentieth centuries to audacious creations in the Russian-folk manner (cat. nos. 216–22), with shapes and decoration attuned to the then-new artistic movement known as World of Art (Mir iskusstva) and the avant-garde creations of the Abramtsevo and Talashkino artist colonies.

The main St. Petersburg silver workshop, located at 65 Ekatarininskii Canal, was run by Julius Rappoport.[28] It was responsible for special commissions, many from the Imperial Cabinet, which included *surtouts de table* and services for the grand duchesses' weddings, as well as individual or specially ordered pieces. The workshop also specialized in animals and custom-made mounts for vases of hardstone, earthenware, Art Nouveau glass, and ceramic, a number for Tsaritsa Alexandra Feodorovna. Other silversmiths for the firm were Wäkevä family members and First Silver Artel craftsmen, who took over the workshop after Rappoport's resignation in 1909.

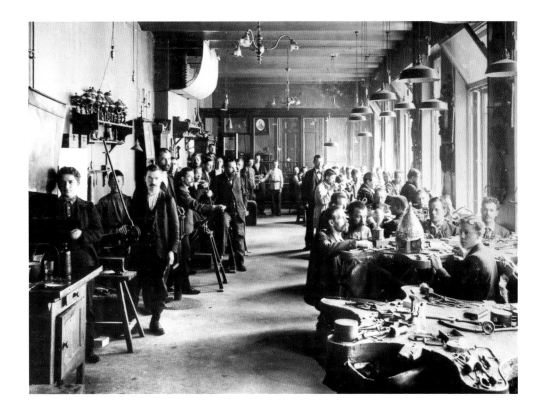

Objects of Art

As Karl Fabergé entered the scene in the 1870s, Russia was still reveling in its past. His travels in the West opened his mind to Western fashions, particularly archaeological jewelry (as represented in the creations of the Castellani family in Italy and London and Eugène Fontenay in Paris) and art of the Renaissance, the baroque period, and eighteenth-century France. Though Fabergé returned full of novel ideas, he bade his time. Jewelry remained the mainstay of his business for the next fifteen years.

In order to diversify, and to veer away from the company's expensive diamond-encrusted jewels, Fabergé hired one of Albert Holmström's journeymen, Erik Kollin,[29] in 1870 with the intention of starting a new line of gold jewelry inspired by Greek and Roman archaeological finds. Kollin, who would work exclusively for Fabergé until 1886 and later as an independent outworker until his death in 1901, also furnished gold mounts for the firm's first hardstone objects supplied by the Woerffel and Peterhof lapidary factories.

The rapid ascent of Fabergé's renown for his innovative objets d'art in the eighteenth-century style can be dated to 1885–86 with the simultaneous arrival from Dresden of Fabergé's twenty-two-year-old brother, Agathon; the replacement of the fifty-year-old Kollin by the brilliant twenty-four-year-old Mikhail Perkhin[30] (fig. 1.11), a former apprentice of Kollin; and the employment by Perkhin (initially as a journeyman) of

FIGURE 1.11: Workshop of Mikhail Perkhin, ca. 1903. The bearded man standing at left near the center is Perkhin. His young assistant, Henrik Wigström, is before him in a white shirt. Photograph courtesy of Wartski, London.

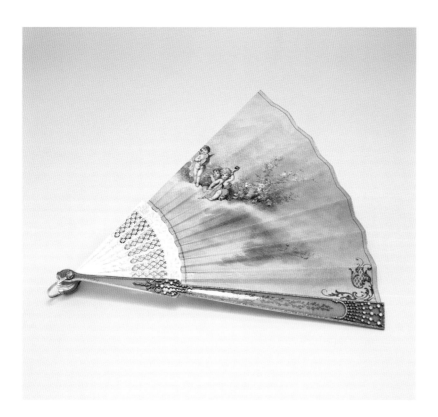

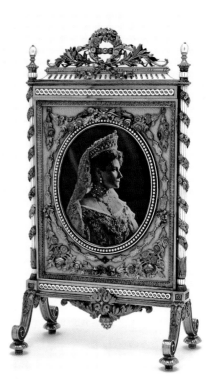

FIGURE 1.12: Fabergé, *Fan,* ca. 1890, workmaster Mikhail Perkhin; gold, enamel, mother-of-pearl, diamonds, pearls; length 13 ¾ in. (39.4 cm). Arthur and Dorothy McFerrin Foundation Collection, photograph courtesy of Houston Museum of Natural History.

FIGURE 1.13: Fabergé, *Fire-Screen Frame,* ca. 1910, workmaster Henrik Wigström; varicolored gold, platinum, enamel, pearls, photographs; height 7⅛ in. (18.4 cm). Arthur and Dorothy McFerrin Foundation Collection, photograph courtesy of Houston Museum of Natural History.

the twenty-two-year-old Henrik Wigström.[31] While production of jewelry and silver followed the established pattern of fulfilling numerous orders from the insatiable imperial court and from Russian society, these freshly arrived craftsmen, under the tutelage of Karl Fabergé, steered the firm in a new direction. The Russian master began to carve out a niche in the St. Petersburg applied-arts trade with his production of superbly designed and executed, novel, and affordable objects of art.

The French-style series that ensued was initially inspired mainly by eighteenth-century artworks in the imperial collections at the Hermitage, to which the Fabergé brothers and their craftsmen had access. The firm's chief designer, Franz Birbaum, wrote in 1919: "After the Kerch collection, they studied all the ages that are represented there, especially the age of Elizabeth and Catherine II (1750s–90s). Many of the gold and jewelry exhibits were copied precisely and then used as models for new compositions. . . . The compositions preserved the style of the past centuries, but the objects were contemporary."[32] The success of their pastiches is demonstrated by an oval enameled-gold snuffbox by Perkhin directly inspired by a 1777 example from Joseph-Étienne Blerzy of Paris[33] in the tsar's possession. According to legend, the tsar was unable to distinguish between the two and thereupon exhibited them side by side in his treasury to demonstrate the excellence of Russian craftsmanship.

Birbaum also noted significantly that "foreign antique dealers frequently suggested making series of objects without hallmarks or the name of the firm. This is one of

the best proofs of the perfection of these works, but the proposals were, of course, rejected." Interestingly, this suggestion of selling Fabergé's works as eighteenth-century originals has today been turned on its head, with French or Swiss eighteenth-century boxes being hallmarked and passed off as Fabergé works.

Objects produced by the Perkhin workshop, most of them in choice enamel colors and decorated in the rococo or Louis XV taste, were many and various: snuffboxes; countless cigarette cases; frames to showcase the new craze for photographs (the Pratt collection at VMFA has over thirty Fabergé frames); opera glasses; fans (fig. 1.12); numerous original desk clocks; *carnets de bal;* card cases; parasol and cane handles (of which the Pratt collection counts over fifty examples); and "innumerable small objects, perfectly executed, capable of impregnating the imagination of hundreds of people the world over who delighted in seeing, handling, and enjoying nice things,"[34] including delightful miniature pieces of furniture. In the most general terms—and perhaps the most accurate—Perkhin's objects "give pleasure and procure good," a sentiment shared by Queen Mary, who wrote, "There is one thing about Fabergé pieces, they are so satisfying."[35] Contrary to common belief, Fabergé's celebrated floral studies and animal carvings first appeared during Perkhin's tenure.

Following the death of Mikhail Perkhin in 1903, assistant Henrik Wigström became the new head workmaster. Between 1906 and 1916, Wigström was responsible for producing the majority of imperial Easter eggs, designed by Franz Birbaum. Also during his term, the prevalent Louis XV and Art Nouveau styles were replaced by a drier, more stereotyped neoclassical Louis XVI style, attuned to the latest Parisian taste. Throughout Wigström's leadership, the quality of the firm's production gold-smith work remained superlative; a lavish Louis XVI fire-screen frame formerly in the possession of Dowager Empress Maria Feodorovna stands as sufficient proof (fig. 1.13). Many of the company's objects gradually became simpler in shape and decoration. Some themes tentatively initiated under Perkhin, including hardstone animal carvings and floral compositions, were produced in sizeable numbers, to which can be added the novel and expensive composite hardstone figures, many of which were acquired by Tsar Nicholas II.

Enamels

At the 1900 Paris Universal Exposition, Fabergé's greatest achievement in the eyes of his Parisian colleagues was the quality and diversity of his transparent guilloché enamels. For Prince Iusupov, they "defied all imagination."[36] The firm reportedly was able to create enamels in 145 various hues, including such exquisite novelties as opalescent pinks and whites; a sumptuous deep purple; steel gray; shades of blue, yellow, and burnt sienna; and, most difficult to achieve, dark red. Their quality easily surpassed the capabilities of even the most sophisticated Frenchmen of the time. It is

not surprising that the Russian jeweler was therefore acclaimed by French goldsmiths at the exposition: "Louis Quatorze, Louis XV, Louis XVI — where are they now? . . . In St. Petersburg, for we now call them 'Fabergé.'"[37]

One of the period's foremost Parisian firms of enamellers was the Husson workshop, which collaborated with a number of leading jewelers, including Tiffany and Frédéric Boucheron, to achieve Renaissance-style cameo effects and rich, dark enamels. Toward the turn of the century the workshop of Menu & Fils, working for Boucheron, was able to produce dazzling imitations of pleated silks in pastel-yellow tones with underglaze painted effects.[38] With his French eighteenth-century-style objects and guilloché enamels, Boucheron was Fabergé's main competitor at the Paris world's fair. His Russian firm's leading enamellers were the legendary Aleksandr Petrov and son Dmitri, to whom the incomparable quality of Fabergé's enamels is ascribed, as well as craftsman Vasilii Boitsov. Together, these masters of enameling were responsible for the company's technical and artistic innovations (see Chapter 4).

Fabergé's guilloché enamels were achieved through an intricate process: several coats of a vitreous compound were very evenly applied and fired at ever-decreasing temperatures on a silver or gold surface that had been mechanically engraved or engine-turned with a chosen pattern by a *tour à guillocher.* The finest such objects received up to six or seven layers of enamel, sometimes achieving shimmering, opalescent, oysterlike effects. Some have an underglaze scene or decoration painted *en camaieu* on the penultimate coat, imitating certain late–Louis XVI snuffboxes. Others are decorated with underglaze gold-leaf motifs or *paillons,* also inspired by eighteenth-century French originals. A final colorless coat called *fondant* was applied for protection and buffed with a wooden wheel and a chamois cloth with particular care, thus achieving the immaculate surface inherent in Fabergé's objects. The ability to achieve certain colors with such apparent ease verges on the miraculous in view of the fairly rudimentary technical means at the disposal of these enamellers.

Between 1908 and 1917, coinciding with Cartier's arrival in St. Petersburg, the enamels from the Wigström workshop show increasing evidence of Parisian influence. Cartier's opaque-white enamel borders surrounding panels of guilloché enamel become more prevalent. His juxtaposed vivid colors, once avoided by the Russian firm, make an appearance as well. The French firm's signature *émail Pékin* — thin opaque-white enamel stripes, sometimes alternating with green or blue stripes, on gold ground — are also found on some of Fabergé's most elegant creations produced after 1910.[39] Other "Parisian" elements in this late style are opalescent enamels painted in underglaze with *camaieu* swags incorporating entwined ribbons and flower garlands[40] as well as spinach-green articles, the mounts enameled in stark-white enamel with rose-cut diamond borders. Certain of Cartier's creations heralding Art Déco, as seen in the drawings of his chief designer, Charles Jacqeau, also left their mark on Fabergé's oeuvre.

Hardstones

It was Fabergé's good fortune to be born in a land of immense mineral wealth, but it was his business acumen that led him to make such uniquely good use of this bonanza. During the reign of Peter the Great, the Ural and the Altai mountains began to reveal their treasures of precious and semiprecious stones.[41] Tsar Peter founded the first stone-carving factory in Peterhof near St. Petersburg in 1721. Under empresses Elizabeth and Catherine the Great, the quest for objects and furnishings in Russian hardstones verged on mania. This passionate pursuit led to the development in Ekaterinburg of Russia's first large-scale stone-carving enterprise in 1765, followed in 1802 by Kolyvan in the Altai Mountains. These three cities remained celebrated stone-carving centers throughout the nineteenth century. The imperial palaces of St. Petersburg, with their monumental hardstone vases of gray Kalgan jasper, red jasper, and porphyry, as well as applied inlay work in malachite and lapis lazuli, are proof of the rapid growth of the industry. A personal interest of Faberge's, semi-precious stones became a growing, integral part of his business. According to Franz Birbaum, many of Fabergé's hardstone objects derived from Carl Woerffel's factory in St. Petersburg and from the Peterhof factory. Chosen for the quality of their stones, they often had to be recarved at substantial expense.[42] The company archives abound with commissions for the imperial family, some of which instructed Fabergé to mount the stones in silver or gold.[43] As orders accrued after 1900, Fabergé acquired the Woerffel factory but was nevertheless obliged to place orders abroad, especially for agates. These particular hardstones may have been frequently supplied by specialists in Idar-Oberstein, Germany.

Fabergé's earliest hardstone artifacts can be traced back to the 1880s in the work-shop of Erik Kollin and include objects in rock crystal, nephrite, jasper, agate, and purpurine carved into eggs, cane handles, boxes, and bowls mounted with gold or silver gilt. Fabergé's direct link to Ekaterinburg supplied him with finished articles to be mounted, such as the 1890 rhodonite cigarette case with the monogram of Tsar Alexander III, now in the Kremlin Armory Museum.[44] By the 1890s many varieties of agate, bowenite, smoky quartz, rhodonite, obsidian, and green and pink aventurine quartz had also appeared in Mikhail Perkhin's workshop. In addition, novel hardstone frames, seals, bell pushes, clocks, paper knives, and presentation platters were also then part of the firm's assortment. These were often accorded pride of place, the mounts and settings frequently reduced to a bare minimum of hinges and clasps.

The two stones used most by the firm were nephrite and bowenite. According to Birbaum, nephrite was found in boulders in the Onot River: "It is both firm and malleable, free of cracks that make cutting other stones so difficult, and it gives the possibility of a very high finish. . . . The dark green nephrite, when cut into sheets

becomes translucent and acquires a wonderful dense green color." Bowenite, a milky-green serpentine or jadeite named after its discoverer, G. T. Bowen, is of a "marvellous green grape-like color which makes up for its defects."[45]

During the tenure of head workmaster Henrik Wigström, hardstones represented up to one-third of the firm's production. While originally many of the stone objects were acquired from Carl Woerffel, Fabergé decided to open a stone-carving work-shop in 1908, which existed until 1917. This coincided with the arrival of a highly skilled stone carver, Petr M. Kremlev, under whose management the artistic level of the firm's production was said to have improved considerably. He was later joined by Petr Derbyshev from Ekaterinburg, another gifted craftsman. After working at the Woerffel and the Idar-Oberstein carving facilities and with René Lalique in Paris, Derbyshev was able to use his talents during the firm's last years. The workshop, located on the ground floor of 44 Angliiskii Prospect, employed thirty craftsmen in 1912 and registered intense activity between 1912 and 1914, to a point where fulfilling the orders for its popular products proved difficult.

Flowers

Fabergé's popular hardstone flowers were directly inspired by several eighteenth-century jeweled bouquets in the imperial treasury that were accessible to the young Russian master. Attributed to Swiss jewelers Jérémie Pauzié and Louis-David Duval, these splendid multigem compositions were originally worn fastened to corsages, but as fashions changed, they were displayed standing in rock-crystal vases.[46] Birbaum attributed the Fabergé firm's invention of flowers in semiprecious stones to Chinese hardstone floral compositions that appeared in St. Petersburg about that time:

> It was our acquaintance with them that first stimulated us to produce work of this kind. The manufacture of stone flowers, which has recently occupied a leading place in our work, has the same origin. We first noticed this branch of Chinese art when a bouquet of chrysanthemums was brought in for repair. It had been taken from the Court of the Chinese Emperor when it was occupied by a European landing force. The chrysanthemums were made of corals, white nephrite, and other stones, leaves from grey nephrite. . . . Each petal was imperceptibly strengthened with wire attached to the cup of the flower. . . . Narcissi, jasmine, branches of white lilac and hyacinths were made in white quartz, sweet peas and other flowers in rhodonite, quartz, carnelian and agate. The leaves are mainly in nephrite, sometimes green jasper or quartz. Sometimes the flowers stood in a little glass of rock crystal, half hollow, so that the flowers appeared to be standing in water . . . sometimes in a little pot of jasper. . . . The cost of these flowers was considerable and depended on the complexity of the flowers, and was sometimes as much as several thousand rubles.[47]

The large majority of Fabergé's flowers[48] are single sprays or small combinations of assorted varieties standing at an angle, resting against the rim of a rock-crystal vase that simulates water content with a trompe l'oeil effect. Typically these flowers have gold stems, nephrite or enameled leaves, and enameled blossoms or hardstone fruits or berries. Even combinations of different varieties invariably grow together from a single stalk, as in the popular pairing of a double cornflower with a spray of oats.[49] The most striking of these groupings is two cornflowers and several sprays of portulaca issuing from one stalk, adorned with a diamond-set bee.[50] Rather than representing botanical precision, some of these specimens exhibit different stages of their development simultaneously—closed buds, open blossoms, and fruit both mature and immature. Such interpretations surely contradict criticism voiced in 1900 by a French source accusing Fabergé of merely producing "photographs of nature without the artist having impressed his own style upon it."[51]

Fabergé's most celebrated multiple-floral composition is the *Lilies of the Valley Basket* (see fig. 1.5) of 1896, one of Tsaritsa Alexandra's favorite objects, which, with its pearl blossoms and petals lined with rose-cut diamonds, shows the full mastery of the Holmström jewelry workshop. A more modest bouquet of the same flower, with similar pearl-and-diamond blooms but standing in a bloodstone vase, is in the Pratt collection at VMFA (cat. no. 10). An elaborate study of a jeweled and enameled bouquet of wildflowers forms the surprise in the Easter egg presented by Tsar Nicholas II to his wife in 1901.[52] One of the few individual flowers considered worthy of specific praise by Birbaum in 1919 was the dandelion: "Their fluff was natural and fixed on a golden thread with a small uncut diamond. The shining points of the diamond among the white fluff were marvelously successful."[53]

Animals

It was long customary to date the appearance of Fabergé's animalier world[54] to an initial massive order from King Edward VII in 1907, which required the modeling or portraiture of a large number of specimens in Queen Alexandra's Sandringham zoo. The account, vividly related by Fabergé's London representative,[55] explains how the animals were secretly modeled in wax by the firm's Boris Frödman-Cluzel and Frank Lutiger, and how the wax models were then sent to St. Petersburg for translation into hardstone. The king, who had insisted on "no duplicates" and who thought that the result of the work was "splendid," had unwittingly unleashed a collecting passion in his queen and his daughter-in-law, Queen Mary, which was to result in the finest surviving collection of Fabergé animals. Queen Alexandra received numerous animal sculptures from the royal courtiers and friends, as these small and relatively inexpensive (their cost was approximately £50) objects were deemed acceptable as presents. Her sister, the tsaritsa and later dowager empress, Maria Feodorovna,

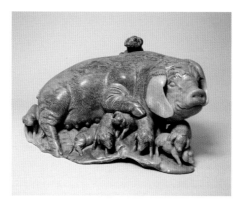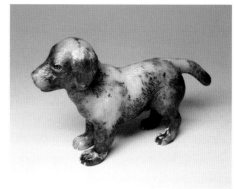

FIGURE 1.14: Avenir Sumin, *Recumbent Sow Suckling Thirteen Piglets,* 1897; soapstone; length 8 in. (20.3 cm). Russian National Museum, Moscow.

FIGURE 1.15: Peterhof Stone-Cutting Factory, *Puppy,* ca. 1900; agate, emeralds, gold; length 3⅞ in. (9.8 cm). Russian National Museum, Moscow.

is known to have owned over one hundred such little animals. Other avid collectors included Prince Iusupov and actress Elisabeth Balletta.

In actuality, Faberge's earliest animal figures date to the 1890s, when they appeared on invoices of the Imperial Cabinet. Some bear the hallmarks of Mikhail Perkhin on their silver-gilt mounts, but the large majority date from the last fifteen years of the firm's existence. These sculptures follow a tradition of animalier hardstone carvings originating in the Urals in the 1870s (fig. 1.14) and continued at Peterhof (fig. 1.15). Fabergé was not the only source in St. Petersburg for hardstone animal sculptures (see Chapter 3). Other craftsmen or retailers included Woerffel, Ovchinnikov, Sumin, Britsyn, and Karl Bock.

In contrast to the competition's offerings, Fabergé's animals are clever observations of nature, superbly carved and instantly recognizable as figures of the master's oeuvre. They are akin to Japanese netsuke carvings, of which Fabergé owned a substantial collection.[56] They are generally one of a kind, although rare repetitions occur. Fabergé's insistence on perfection led him to choose his hardstones with great care, with an eye to striations and other features that could suggest an animal's specific characteristics. Some Fabergé models—such as elephants and rabbits—were obviously in great demand, and were generally more superficially executed. Fabergé's London representative, Henry C. Bainbridge, described their appeal, a sentiment that has echoed through the decades: "Fatness and finish are two good words to start with . . . all his animals are well fed. . . . Who is going to buy a lean, sad thing when he can have a fat and jolly one? . . . all Fabergé models . . . have had a good meal and are comfortable looking. This is why so many collected them and do still." These miniature works of art were not meant to be taken seriously; they were simply intended to give "a pleasure over and above their perfect workmanship."[57]

With an eye to debunking forgeries, Bainbridge advised that in Fabergé's animals, "the workmanship, top and bottom equally, is without blemish, never slip-shod or hastily passed over. Every model is highly polished and right down to the bottom of every carved line." Since these hardstone animals were very rarely signed and have generally

been separated from their fitted cases, attributions are a thorny subject, compounded by the familiar practice of artists buying from and copying one another. Even when supported by the most august provenances, only superlative quality, humorous characterization, or an original fitted case can be considered final proof of authenticity.

Hardstone Figures

The inspiration for Fabergé's composite hardstone figures[58] appears to derive from Saxon or Florentine figures of seventeenth-century saints produced for the chapels of Medici or Wettin princes. Both sources were undoubtedly familiar to Fabergé. The original idea for their creation, however, is attributed to Grand Duke Nikolai Nikolaevich, who is said to have asked Fabergé for a caricature of Queen Victoria.

Agathon, Karl Fabergé's son, believed that thirty folkloristic figures were produced in all.[59] Specialists have counted forty-seven statuettes,[60] but their actual number may well exceed sixty. These figures, which have been called "*completely* Russian," fall into three main groups. The largest and earliest is made up of Russian national types and folkloristic statuettes, often based on porcelain figures from the Gardner Factory or on contemporary engravings. These include peasants, street vendors, peddlers, musicians, coachmen, officers, cooks, boyars, merchants, and policemen. A contemporary and smaller group comprises special commissions and portrait figures. Among them are John Bull; Uncle Sam; a Chelsea pensioner; Lewis Carroll's Tweedledum and Tweedledee; a caricature of Queen Victoria; Vara Panina, a gypsy singer; Fabergé's *dvornik* (houseboy); Tsaritsa Alexandra's palace guard Kamer-kazak Putsynnikov; and the dowager empress's Kamer-kazak Kudinov. The sailor figure in VMFA's Pratt collection (cat. no. 88 and Chapter 6) belongs to this group. The average height of these pieces is approximately five to six inches, and they are all composed of polished semiprecious stones, with delicate agate features and hands. The genre of these two groups, some of which date from before 1908, might be labeled as "romantic." The third and latest set dates from the years preceding the revolution, around 1914. Typically modeled by sculptor Boris Frödman-Cluzel, they have exaggeratedly realistic rough surfaces and cachalon (a soft opal) features. The firm was particularly proud of the painterly effects achieved by various ingeniously chosen hardstones, which added to the figures' heightened realism.[61]

Fabergé's figurines are composed mostly of Siberian hardstones, including lapis lazuli, rhodonite, obsidian, chalcedony, various agates, and gray Kalgan jasper. They are invisibly glued together, and, if hallmarked, their silver-gilt mounts sometimes bear the initials of head workmaster Henrik Wigström, thus dating them to sometime after 1903. Many are clearly engraved with "Fabergé," generally in Cyrillic script, sometimes in Latin, and dated under a boot or a shoe. The statuettes were expensive, costing between 1,000 and 2,000 rubles (roughly $500 to $1,000) apiece.

The leading collector was the tsar himself, who kept his statuettes in his private cabinet. Another equally passionate collector was Emanuel Nobel, a scion of a Swedish family of leading oil magnates in Russia. Many of the Nobel figures belong to the late, realistic type.

Easter Eggs

The tradition of giving painted eggs dates back to pre-Christian times and was part of the ceremony celebrating rebirth, and thus fertility and abundance, each year at the spring equinox, March 20 or 21. The early Christian Church and later the Russian Orthodox Church adopted this approximate date for Easter, retaining the meaning of the blessed egg as a symbol of rebirth, identified with the Resurrection of Christ. By the eighteenth century, the presentation of more lavish eggs, initially of painted wood, or lacquer, and later of glass or porcelain, was replaced at court by jeweled, enameled silver or gold examples. Some egg-shaped objects dating from the late eighteenth century are preserved in the Hermitage Museum and must have been known to Fabergé.

Among Russia's upper classes, the presentation of precious miniature Easter eggs to adorn ever-longer necklaces and bracelets was a popular custom. These necklaces were much cherished, as each miniature egg was often the equivalent of a poignant souvenir. The charms—of which the Pratt collection has seventy-eight examples— were sold by the thousands and are a perfect demonstration of Fabergé's incredible versatility and capacity to reinvent himself constantly.

Even though they represent less than one-half of one percent of the firm's production, imperial Easter eggs have become synonymous with the name of the Russian master. With no doubt, they are superlative creations, showing Fabergé's creative genius at its best (fig. 1.16). In the words of Henry Bainbridge in 1949, "it is quite safe to say that nothing which has so far come from a goldsmith's workshop surpasses these productions in craftsmanship and ingenuity."[62]

The *First Egg* of 1885 is early proof of the capability of the firm's young craftsmen to transform an original eighteenth-century French royal Easter egg with a surprise inside—a hen opening to reveal a crown that in turn hid a ring—into a delightful and novel object of art. Correspondence from 1885 mentions the direct intervention of the tsar, who requested that the original ring be replaced by two ruby drops to be worn on a chain (they were worth more than half of the egg's price of 4,151 rubles). The success of this charming pastiche gave birth to the series of fifty celebrated Easter eggs, the apogee of Russian prerevolutionary artistry and craftsmanship. Over a period of approximately thirty-one years, Fabergé became the beneficiary of the last major example of royal largesse.

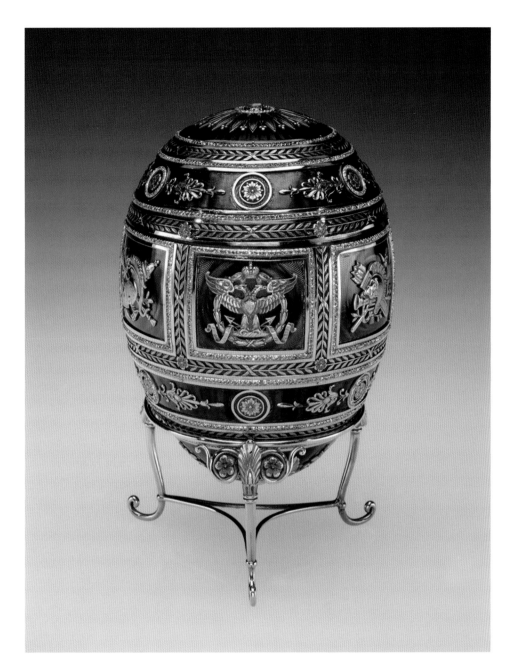

FIGURE 1.16: Fabergé, *Napoleonic Egg*, 1912, workmaster Henrik Wigström; gold, enamel, diamonds, platinum, ivory, velvet, silk; height 4⅝ in. (11.7 cm). Matilda Geddings Gray Foundation Collection.

Initially Fabergé's eggs were understated, but they gradually gained momentum in complexity and price, perhaps attaining a highest recorded individual cost of 24,600 rubles (roughly $12,000) for the *Winter Egg* of 1913. With the exception of three eggs created in Albert Holmström's jewelry workshop, all were produced in the atelier of head workmaster Mikhail Perkhin between 1885 and 1903 and in Henrik Wigström's between 1906 and 1916. The firm made ten eggs during the reign of Alexander III, 1885–94, as gifts for his wife, Empress Maria Feodorovna. Following the premature death of the tsar, his son Nicholas II continued this Easter tradition, presenting both his mother, the dowager empress, and his wife, Tsaritsa Alexandra Feodorovna,

with a yearly egg. It appears that no eggs were given during the two years of the Russo-Japanese War and that the eggs for 1917 were begun but not finished due to the tsar's abdication before Easter.[63]

Of the fifty imperial Easter eggs, forty-two[64] have miraculously survived, including all those presented to Empress Alexandra Feodorovna. Eight among the thirty eggs given to Maria Feodorovna disappeared during the revolution. Ten eggs are preserved in the Kremlin Armory Museum in Moscow, nine in the Link of Times Foundation Collection of oligarch Viktor Veksel'berg, and six in European collections (three in British Royal Collection, two in the Sandoz Foundation, Switzerland, and one in the collection of Prince Albert of Monaco). Thirteen eggs are in public collections in the United States: five in the Virginia Museum of Arts; three in the Matilda Geddings Gray Foundation Collection; two in the Hillwood Museum, Washington, D.C.; two in the Walters Art Museum in Baltimore; and one in the Cleveland Museum of Art. Four eggs are in private collections.

According to Franz Birbaum, the Russian master himself was responsible for the design of more than half of the eggs: "The designs for these eggs did not have to be approved. Fabergé was given a completely free hand in the choice of them and in the execution itself. . . . We tried to make use of family and other events in the Imperial household to give some meaning to the gift, but political events were, of course, avoided."[65] Birbaum also writes that the eggs required approximately one year in production, beginning just after Easter each year, and that they were usually presented on Good Friday. In the days preceding their presentation, initially by Karl Fabergé and later also by Fabergé's chief assistant or eldest son, Eugen, the craftsmen "remained at their places of work until Fabergé returned from Tsarskoe Selo" standing by in case "anything unexpected" happened to these fragile works of art.

The most time consuming of any artwork created by Fabergé, the eggs generally involved the cooperation of several workshops and a team of highly specialized craftsmen. From preliminary sketches, the head workmaster and a team of designers would collaborate to create highly finished drawings representing various options. Once the final selection was made, the workmaster allocated each task to the workshops involved with the project. Over the years, many specialized technical skills were honed: modeling; goldsmithing (raising, casting, chasing, engraving, tooling, and embossing); enameling; lapidary work (selecting, cutting, polishing, setting, and mounting of stones); painting of miniatures; and making of fitted velvet cases.

The empress and later dowager empress, Maria Feodorovna, kept all of her eggs at the Anichkov Palace, although she sometimes took one or the other egg on her travels. The young Empress Alexandra exhibited all her Easter eggs received before 1905 — the year of the first revolution, which led to her increasing isolation in the Alexander Palace in Tsarskoe Selo — in her private study in the Winter Palace.

She kept seven of the later eggs in a corner cabinet in her Mauve Sitting Room at the Alexander Palace, including the VMFA 1912 *Tsesarevich Egg* (cat. no. 190), without doubt one of her favorites. The eggs were shown publicly only twice and were thus unknown to the large majority of Russians. A selection created between 1885 and 1900 was exhibited at the 1900 Paris world's fair, and the only public showing in Russia was in 1902 at the charity exhibition *Artistic Objects and Miniatures by Fabergé* held at the von Derwies Mansion in St. Petersburg under the patronage of the young tsaritsa. A commemorative photographic volume dedicated to the empress clearly shows a number of Fabergé's best-known eggs displayed in pyramid-shaped vitrines. The ticket price to this event was one ruble and ten kopecks, unaffordable to the large majority of St. Petersburg's inhabitants. During World War I, a group of seven Fabergé imperial Easter eggs were illustrated in the December 15, 1916, edition of the fashionable magazine *Stolitsa i usad'ba,* offering Russia a last admiring glance at a splendor that was soon to disappear.

All of Fabergé's imperial Easter eggs were confiscated under order of Kerenskii's Provisional Government and temporarily stored at the Anichkov Palace and then, with the exception of eight eggs belonging to the dowager empress, dispatched for safekeeping to the Moscow Kremlin Armory in September 1917. Despite the strong resistance of its curators, only ten eggs remained in Russia. The others were sold between 1925 and 1933 by order of the Bolsheviks through Antikvariat, a state organization in charge of Russian art sales. The eggs were valued at between 500 and 8,000 rubles apiece. Ten eggs consigned to Armand Hammer were advertised for sale in the United States at seven to ten times the original asking price. With one exception, they all found homes in American museums. Meanwhile, Fabergé's imperial Easter eggs have become the world's most expensive objects of art, with some recent estimates surpassing $25 million.

NOTES

1. Still the best introduction, albeit superseded in many details, is the pioneering book by A. Kenneth Snowman, *The Art of Carl Fabergé* (Snowman 1953). For the complete Fabergé bibliography (until 1994), see McCanless 1994. For publications since 1994, see Bibliography. A useful time line can be found in Habsburg 2000, 12–18.
2. Three from among the handful of known jewels retailed by Gustav Fabergé, recognizable only by the addresses on their fitted cases, are illustrated in Habsburg 2003, 107.
3. Harrison, Ducamp, and Falino 2008, 220–24.
4. Quoted in Habsburg and Lopato 1993, 54–56.
5. Illustrated in Habsburg 2000, 390. For the best English translation of the relevant text, see Solodkoff and Forbes, 1984, 35–36.
6. Habsburg and Lopato 1993, 129.
7. Habsburg 2003, 36–42, and Chapter 3 in this catalogue.
8. Habsburg and Lopato 1993, 447.

9. Tillander-Godenhielm 2005, 166–90.

10. The unmarried Grand Duke Aleksii (1850–1908), who was sent on a good-will mission to the United States, was a general admiral of the fleet and was known for his love of "fast women and slow ships" due to his womanizing and the defeat of the Russian fleet by the Japanese. One of his mistresses was Elisabeth Balletta, a famous actress at the Imperial Theater. She was the recipient of some of Fabergé's finest creations, including a rock-crystal vase now in the Brooklyn Museum of Art. Habsburg 1996, 202, cat. 188.

11. Grand Duke Mikhail Mikhailovich (1861–1929), married morganatically to Sofia, Countess von Merenberg (later Countess de Torby), formed a premier collection of Fabergé, later housed at Luton Hoo, near London.

12. For Matylda Krzesiňska, see Habsburg and Lopato 1993, 142–47.

13. Photogravures and phototypes of the participants were published in 1904 in a commemorative album. They have been reproduced in *Costume Ball in the Winter Palace* 2003.

14. Quoted in Habsburg and Lopato 1993, 56–58.

15. The State Hermitage Museum, St. Petersburg. For these early Fabergé jewelry designs, see Welander-Berggren 1997, 39–45; Habsburg and Lopato 1993, 30–35 and 420–25; and Habsburg 2003, 54, ill. 3 and 4.

16. Habsburg and Lopato 1993, 420–21, cat. 348–50.

17. For a biography and for a selection of works by August and Albert Holmström, father and son, see Habsburg 2000, 242–53, and Habsburg 2003, 218–22, cat. 210–30.

18. Quoted from Bainbridge 1968, 125. For examples of enameled wares from the Holmström workshop, see Habsburg 2000, 244–53.

19. Fabergé, Proler, and Skurlov 1997, 210–11.

20. Ibid., 220.

21. Habsburg 2003, 145, cat. 131; Habsburg 2000, 251, cat. 620.

22. Habsburg 2003, 269, cat. 401.

23. Fersman 1925.

24. Snowman 1993.

25. Welander-Berggren 1997, 46–52.

26. For the Moscow workshops, see Habsburg and Lopato 1993, 104–15. For examples of Moscow silver, see Habsburg 2003, 95–147.

27. For examples of Rückert's production and his sales to other Moscow firms, see Habsburg 2000, 80–87 and 92–95.

28. For illustrations of Rappoport's works, see Habsburg 2000, pp. 111–19.

29. Bainbridge 1968, 123. For illustrations of Kollin's works, see Habsburg 2000, 150–57, and Habsburg 2003, 148–49*ff*.

30. Bainbridge 1968, 123–24. For illustrations of Perkhin's works, see Habsburg 2000, 158–95, and Habsburg 2003, 149–73.

31. Bainbridge 1968, 124; Tillander-Godenhielm et al. 2000, 13–40. For illustrations of Wigström's works, see Habsburg 2000, 198–223, and Habsburg 2003, 174–211.

32. Quoted in Habsburg and Lopato 1993, 446.

33. For both boxes juxtaposed (Link of Times Foundation Collection), see Solodkoff and Forbes 1984, 52; Habsburg 1986, 223; Forbes and Tromeur 1999, 145.

34. Bainbridge 1968, 124.

35. Ibid., 109.

36. Iusupov 1998 (in Russian), 325.

37. Bainbridge 1968, 38.

38. Two examples of Menu & Fils enamels for Boucheron are illustrated in Habsburg 2003, 423, cat. 905, and 424, cat. 910.

39. Habsburg 2000, 217, cat. 536, and 218, cat. 539; Habsburg 2003, 186.

40. Habsburg 2003, 204, cat. 194; 206, cat. 200, 201.

41. Houston Museum 1994; Muntian, Guitaut, and Krog 2005, 107–32.

42. Habsburg and Lopato 1993, 456.

43. Habsburg 2000, 297–316.

44. Muntian, Guitaut, and Krog 2005, 107–8.

45. Quoted in Habsburg and Lopato 1993, 457.

46. Habsburg 1986, 312–13; 2000, 48–49 and 89. The most lavish such bouquet to survive is by the Austrian jeweler Grosser, ca. 1760; it was presented by Empress Maria Theresia to her husband, Emperor Franz Stephan (Museum of Natural History, Vienna).

47. Quoted in Habsburg and Lopato 1993, 457–58.

48. For Fabergé's flowers, see Swezey 2004 and Guitaut 2003, 102–21.

49. Habsburg 1986, cat. 398, 399; Guitaut 2003, cat. 132.

50. Habsburg 1986, 216; Guitaut 2003, cat. 133.

51. Habsburg and Lopato 1993, 122.

52. Fabergé, Proler, and Skurlov 1997, 156–58.

53. Habsburg and Lopato 1993, 458.

54. Fabergé's animal world is comprehensively discussed in Johnston 2003.

55. Bainbridge 1968, 101–2.

56. For a comparison between Japanese Netsuke and Fabergé's animal sculptures, see Habsburg 1986, 307–8*ff.*, cat. 636–47, and *Japonisme: From Falize to Fabergé: The Goldsmith and Japan* exhibition, Wartski, London, March 10–20, 2011.

57. Bainbridge 1968, 107.

58. Fabergé's composite hardstone figures are discussed in ibid., 1968, 110–13, and Habsburg 1986, 25–85.

59. Bainbridge 1968, 110–13.

60. Ibid.

61. Habsburg and Lopato 1993, 459–60.

62. See Bainbridge 1968, 66–77. The eggs have been published in great detail, with all existing invoices, by Fabergé, Proler, and Skurlov 1997. Two eggs have been convincingly redated since this publication, the *Blue Serpent Egg* from 1887 to 1895 (pp. 98–99) and the *Twelve Monogram Egg* from 1895 to 1896 (pp. 118–19); For the eggs in the Link of Times Foundation Collection, see Habsburg 2004.

63. See Habsburg 2003, 141–43 and 144–45, Muntian, Guitaut, and Krog 2005, 80–81.

64. This number does not allow for eggs that were probably produced by Fabergé as Easter gifts for other members of the imperial family, to which may belong to the *Spring Flower Egg* (Link of Times Foundation Collection, Fabergé, Proler, and Skurlov 1997, 80; Habsburg 2004, 280–87), listed in 1917 as the property of the dowager empress. Fabergé's Easter eggs were not an imperial prerogative. At least twelve other eggs are known to have been acquired by other members of society.

65. Habsburg and Lopato 1993, 452.

Behind the Scenes at Fabergé: The St. Petersburg Workshops

ULLA TILLANDER-GODENHIELM

From 1880 to 1900, Karl Fabergé transformed his goldsmith business from a modest jewelry shop into an important, large-scale manufactory and retail emporium. In order to accommodate the titanic expansion and ensure more efficient administration and production, the company acquired a property at 24 Bol'shaia Morskaia in central St. Petersburg and constructed a new building to house the majority of its operations. On completion in 1900, Russia's first multifunctional business complex (see fig. 1.3) boasted a large ground-floor showroom facing the main street, with offices on several stories above. The designers' studios were on the top floor in order to take advantage of the natural light. An in-house reference library, unique in a business establishment at that time, contained almost every known book on goldsmith and lapidary work. In the tradition of the old guild system, under which the master lived in close proximity to the workshop, Karl Fabergé moved his home into this building.

In the courtyard behind the main building were two five-storied wings. Five of the firm's workshops were located in the right wing and additional offices in the left. Direct access from the wings to offices and studios of the main building facilitated frequent communication between the various departments. Despite this design, the inadequacies of the complex—due to the swift expansion of the enterprise—were evident before it was even completed. There was space only for the main workshops. Several close collaborators, therefore, remained at their old locations. The chief workmaster's accommodations were in a spacious second-floor apartment of the left courtyard wing in immediate proximity to his own workshop, a unique arrangement due to the importance of his function.[1] He was expected to be on his post at all times as he had the ultimate responsibility for the production.

Fabergé understood that an important key to success in any business is choosing the right collaborators, and in this he excelled. He employed talented designers with whom he worked in close alliance. From 1882 to 1895 his younger brother Agathon

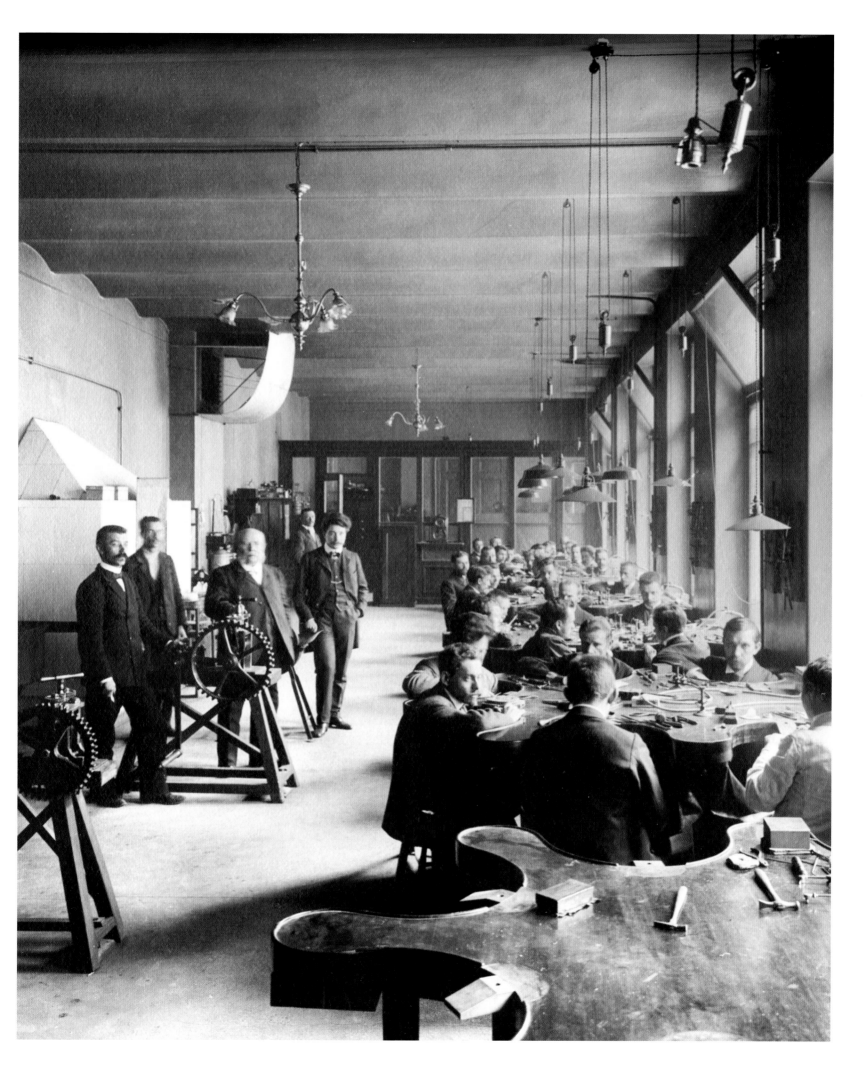

worked at the firm, formulating design strategies. Following Agathon's premature death, Franz Birbaum was offered this important post.

Fabergé's workshops were managed by highly accomplished master goldsmiths, and great care was taken in selecting the head of the principal workshop, where the most important commissions were crafted. More importantly, Fabergé developed new ideas and evaluated design innovations in this particular atelier. The principal master goldsmith, or chief workmaster, therefore, had to be experienced in working closely with the firm's management. The workmasters of the various ateliers, with Fabergé's assistance, became independent entrepreneurs. The idea of offering masters ownership of their workshops within a collaborative system was an ingenious one. It provided many advantages, both for the firm itself and for the individual workmasters, securing a long-term cooperation between the parties involved.

The system of outsourcing freed the management of Fabergé from the burden of trivial day-to-day problems. For the master, it guaranteed a steady outlet for his production, quite apart from the motivation of being his own boss. Long before the modern concept of industrial democracy was conceived, its prototype was thus at work at Fabergé. Paradoxically, it came to the fore during the reign of the most powerful autocracy the world has ever known.

Workmasters assumed a number of responsibilities at the firm. They recruited and trained employees and were accountable for the quality of their workmanship. The masters also ensured that the terms and times of delivery were respected. In return, they were granted the right to mark their products with their own initials.

The first of Karl Fabergé's chief workmasters was Erik Kollin, a day laborer's son from the well-known estate of Brödtorp, in Pohja, Finland.[2] He held the position for sixteen years, from 1870 until 1886. Kollin's tenure at Fabergé resulted in highly finished chased-gold jewelry in the antique style. There are fine examples of Kollin's work in the Lillian Thomas Pratt Collection at the Virginia Museum of Fine Arts (cat. nos. 38–43).

At the request of Count Sergei Grigor'evich Stroganov, a well-known collector of arts and crafts and president of the Imperial Archaeological Commission, Fabergé undertook the task of making replicas of selected items unearthed in the opulent Scythian hoards at Kerch. The work was carried out in Kollin's atelier. The collection received favorable attention at the 1882 Pan-Russian Industrial Exhibition in Moscow and three years later at the Nuremberg Exhibition of Applied Arts, winning Fabergé gold medals at both events. In 1884, Emperor Alexander III commissioned Fabergé to create an Easter egg in gold as a very special gift for the empress. The result was the first of fifty imperial Easter eggs made by Fabergé. The crafting of this prestigious order was also entrusted to Erik Kollin and his atelier.[3]

Mikhail Perkhin succeeded Kollin as head workmaster and served as such until his premature death in 1903. He was a highly gifted self-taught craftsman, the son of a freed serf from Outer Karelia, Russia. With Perkhin's aid, Fabergé transformed the traditional concept of a goldsmith. The company introduced a new range of products: objets d'art in gold and silver combined with decorative hardstone and enameling. Karl Fabergé had spent the better part of his formative years in Dresden, home of the Green Vaults, the wondrous treasury of the electors of Saxony. There he discovered the works of the goldsmith Melchior Dinglinger and the artistry of Saxon and Florentine lapidaries, enamellers, and jewelers. He also found inspiration at home in St. Petersburg among the vast imperial collections housed at the Hermitage Museum and Winter Palace: precious eighteenth-century snuffboxes, jeweled flower studies, scent bottles, fans, and cane handles, created by the court jewelers of the empresses Elizabeth and Catherine the Great. Fabergé's adaptations of these marvels received an immediate and enthusiastic response from the St. Petersburg aristocracy.

Perkhin's death at age forty-three was a severe blow to the House of Fabergé. Fortunately, his top assistant, Henrik Wigström, was a most proficient craftsman. Wigström had worked with the firm since 1884, first as a journeyman and then, after receiving his master's certificate, as Perkhin's chief subordinate. During the decade preceding World War I, Wigström employed some sixty craftsmen in the lofty workshop, a space described as "truly of a luxury class."[4] Each traditionally shaped workbench was placed by a window to benefit from the daylight, which from March until late August was sufficient for most of the working day. During the fall and winter months, the craftsmen worked under the light of large electric lamps (an extravagance at the time) that were lowered from the ceiling. The benches seated seven or eight craftsmen in precise order. Those engaged in manual labor were assembled in groups according to the particular nature of their work. Goldsmiths sat together, and next to them were the workers who mounted hardstone objects, gem setters, embossers, and engravers. The machinery and equipment necessary for daily operations were placed along the opposite wall. The Wigström workshop was equipped with its own oven for melting small quantities of gold, a large draw plate for drawing and twisting wire, a steel-rolling mill for thinning and stretching metal, and anvils for working sheet metal. One of the most important tools was the guilloché machine, which required a highly proficient operating crew, as the turning process was very demanding. The room also held a number of polishing machines, manned by specially appointed polishers, and opposite the embossers and engravers was a shelf to store the wax models of ancient classical motifs used extensively by the ornamenters in their work.

The office occupied by the workmaster, his assistant, and clerks was situated at the front end of the workshop, with a table furnished for the designer. The sorting, measuring, and weighing of gemstones was also completed there. The workmaster was constantly busy minding the production of his atelier. Much of his time and

energy was devoted to the famous group discussions instituted by Karl Fabergé, at which all the key figures in the production process came together to hammer out the firm's manufacturing strategies.

The guild system had lost its importance in Russia at the end of the nineteenth century, but the traditions and working practices that it had established were so deeply entrenched in the routines of workshops dependent largely on manual labor that the masters continued to observe them. An important legacy from the earlier system was the custom of training apprentices. These young craftsmen-to-be were appointed to the workshops at a very young age. Ten- or eleven-year-old apprentices were not an unusual sight at a St. Petersburg workbench at that time. A boy would sit next to his instructor, a master goldsmith or journeyman, where he would remain for the next six years, the average length of an apprenticeship in a goldsmith's workshop. The teaching method was simple. From the outset, apprentices were expected to watch their instructors at work and then try their hand at simple tasks, learning by their own inevitable mistakes. The method required a great deal of patience on both sides, as the instructors were principally concerned with completing their jobs, the teaching of their apprentices taking second place.

Each workshop of the House of Fabergé had its own specialty, with production divided among them accordingly. The main shop was allocated the most exacting commissions, especially important pieces for the imperial family. Before he became chief workmaster, Henrik Wigström assisted Perkhin in making twenty-six imperial Easter eggs, and after his promotion, he supervised a further twenty to twenty-one.[5] This workshop also crafted the most significant imperial presentation pieces, which the sovereign regularly bestowed on foreign statesmen and dignitaries, as well as on Russian subjects, for meritorious and loyal service to the empire. These included jeweled snuffboxes, frames, and *kovshi,* decorated either with the emperor's miniature portrait, his cypher, the imperial crown, or the double-headed eagle. One of these regal objects—a miniature gold column with the jeweled portrait of Emperor Nicholas II suspended from the center—has been preserved in the collections of the Virginia Museum of Fine Arts (cat. no. 27). The column, crowned by a laurel wreath, the symbol of a war hero, was specially commissioned by Nicholas II for Count Dmitrii Alekseevich Miliutin, Russian field marshal general, for his seventy-fifth anniversary as an officer (see cat. no. 27 for more details on this particular piece).

The mainstay of the firm's output was its functional pieces and *objets de fantaisie*. By pure chance, two albums of drawings from the Wigström workshop have survived, showing a cross-section of the production there. They illustrate some 1,300 pieces produced for Fabergé between 1911 and 1916, the majority from 1911 to 1913 (figs. 2.2 and 2.3). The pieces are drawn to actual size in pencil, pen, and ink and, in nearly all cases, colored with watercolors. The accuracy and detail of these

drawings are remarkable; the technique and material of every piece is clearly evident, whether it be engine turning (guilloché) or enameling, a cabochon ruby set in the thumbpiece of a cigarette case, a Siberian hardstone, or multicolored gold. Most of the sketches include a date of completion, indicating that the drawing corresponds to a finished object. This knowledge has sparked a fascinating treasure hunt among experts and scholars for existing objects. Quite a number have already been located in museums and private homes throughout the world. Beneath most drawings in the albums is a production number. This number, used internally by the workshop, is not to be confused with the stock number, which was scratched on each object as it was entered into the sales ledgers.

The albums served as a reference catalog for the atelier. The finely rendered and detailed illustrations of models made previously by the workshop were useful samples for future production. For the purposes of the craftsmen at the bench, however, there were separate designs and working drawings. Today the albums permit an analysis of the production at Fabergé's principal workshop. They include up to sixty different types of objects. Models were only rarely repeated, which highlights the truly impressive organizational genius of Fabergé's manufacturing methods.

One of Wigström's specialties was boxes—snuffboxes, pillboxes, bonbonnières, and, in particular, the numerous cigarette cases that constituted the largest single line of production. A steady stream of these *porttsigary*, a term used to designate boxes for both cigarettes and cigars, passed through the workshop. According to the young engraver Jalmari Haikonen, who worked in the atelier: "Ten men were concentrated

FIGURE 2.2: *Drawings of two column portraits*, 1911–12, from Henrik Wigström workshop album, no. 1, plate 165. Private collection.

FIGURE 2.3: *Drawings of cigarette cases*, 1912–13, from Henrik Wigström workshop album, no. 2, plate 101. Private collection.

FIGURE 2.4: Albert Holmström's workshop, 1903. Holmström stands in the the rear of the shop with his assistant workmaster Lauri Ryynänen in front of him to the right. Courtesy of Laura Ryynänen.

on producing nothing but cigarette cases. Different models and shapes, most of them 56 *zolotnik*, the equivalent of 14-carat gold; some in 72, the equivalent of 18-carat; some in multicolored gold. Some were engraved by hand, others engine turned. At times there were a good forty cases waiting in our engravers' line. One man did the guilloché work. We engravers repaired and corrected the traces of the machine. The polishers gave the cases a final rub."[6]

One constant and vital duty of the chief master was to develop new manufacturing methods. Semimanufactured products proved one important way of decreasing production time and reducing material and labor costs, so they were increasingly introduced into the predominantly manual working processes. Subcontractors prefabricated fittings and findings of all kinds, including all attachments for pinning or fastening, such as hinges, loops, catches, snaps, and clasps. Chain work and gold mesh for jeweled evening bags, very much in vogue at the time, were produced by the workshop of Fedor Andreevich Rutsch. Strips and bands of delicate laurel or acanthus leaves, palmettes in multicolored gold, garlands, ribbons, rosettes, and miniature roses used in ornamentation were all pressed in molds. Small figurines were cast in gold or silver using the *cire perdue*, or lost-wax, process. Such methods of speeding up and facilitating production were by no means an invention of the Fabergé workshops; they had been used by goldsmiths for centuries. However, in St. Petersburg they were honed to perfection.

The company's workshop wing accommodated a number of important individual spaces. August Holmström had his workshop on the third floor in the courtyard wing

on the right, one floor above the main workshop (fig. 2.1). He had been appointed principal jeweler by Karl Fabergé's father, Gustav, in 1857. His nearly fifty years as part of the Fabergé team ended only with his death in 1903. He was the sole master to see the company develop from a modest goldsmith shop into a large-scale enterprise known worldwide.

August Holmström was succeeded by his son Albert, during whose time the workshop became a "family affair," as had Wigström's (fig. 2.4). Alina Holmström, Albert's sister, and Alma Pihl, his niece, worked with him as in-house designers. The fabulous talent of these two women has only recently come to light. Alina was the designer of the elegant garland-style collection of jewelry that became a trademark of Fabergé in the years before World War I, and Alma Pihl is known for her designs featuring winter motifs. Although the principal production of this workshop was clearly fine jewelry of precious stones, the extraordinarily skillful Holmström team also completed a number of large and impressive commissions during the two generations of its influence. Among them were three exquisite imperial Easter eggs: the *Diamond Trellis Egg* (1892), the *Winter Egg* (1913), and the *Mosaic Egg* (1914).

In the same wing was August Hollming's atelier, situated on the first floor (fig. 2.5). He is known primarily for his gold and gem-set jewelry, often in astonishingly avant-garde styles. Hollming also crafted a number of gold and silver presentation cigarette cases, mainly commissions for the Imperial Cabinet. Karl Fabergé appears to have experimented with novelties and prototypes in Hollming's workshop, perhaps with a limited series in mind. There are indications that the master jeweler—always zealously

innovating—was planning to expand his production into a line of "everyday" jewelry for the gradually "emancipated" woman of the new century.

After August Hollming's death in 1913, Fabergé continued the collaboration for at least two years with his son Väinö and Otto Hanhinen, a longtime close assistant of Hollming. The partnership, however, did not prove successful. Väinö Hollming apparently did not possess the proficiency and flexibility of his father, and Fabergé eventually discontinued his contract. The premises were vacated in 1916 and offered to workmaster Hjalmar Armfelt, whose atelier was at an impractical distance from Bol'shaia Morskaia. As the commissions that were allocated to Armfelt's workshop had become of utmost importance, a closer collaboration with the main office was deemed necessary.

Hjalmar Armfelt had entered the realm of Fabergé in 1891. Employed by Antti Nevalainen, an exclusive supplier for the company, he soon became his superior's assistant. In 1904, Armfelt received an offer to buy the workshop of goldsmith Viktor Aarne, another Fabergé supplier, after Aarne had obtained Fabergé's consent to the proposal. Armfelt's fifteen years of collaboration with Nevalainen had given the colleagues and the head office proof enough that he was a skillful craftsman. Armfelt specialized in making important official presentation objects, often combining silver with hardstone or exotic wood. In his memoirs he lists commissions from Fabergé's important clients, such as the Nobel and Iusupov families and the minister of the imperial court Count B. V. Freedericksz. One large group of commissions consisted of objects commemorating anniversaries of the various military regiments and the imperial guards. The tercentenary of the Romanov dynasty in 1913 flooded Armfelt's workshop with orders. He produced a fair number of congratulatory silver objects for the imperial family, gifts from both private and state institutions.

Alfred Thielemann operated a workshop on the top floor in the same courtyard wing where August Holmström's and August Hollming's workshops were located. He received his master's certificate in 1858 and from 1877 to 1882 taught at St. Petri School in St. Petersburg. He thereafter worked for Fabergé making small jewelry and other gold items, such as miniature Easter eggs and *jetons*. His brother Otto Thielemann was also a jeweler in the city.

On the ground level of the same wing was the workshop of case maker Simon Käki, which was managed by his widow, Matilda, after his death in 1896. This workshop was of particular importance as each piece sold at Fabergé was placed in a specially fitted handmade case. Matilda Käki and her journeymen, therefore, were a familiar sight in the goldsmiths' workshops and the retail store, where they busily measured newly or nearly completed objects.[7] Karl Fabergé had realized at an early stage in his career that an elegant product must be presented and sold in an equally elegant package. Thus he designed cases for his wares that immediately identified them as

products by his firm. The ubiquitous holly-wood box lined in honey-colored velvet and silk soon became a trademark. The Käki workshop efficiently produced these handmade cases by the hundreds, many no doubt at very short notice.

In addition to Fabergé's on-site workers, the firm relied on a number of craftsmen who were located elsewhere in St. Petersburg. One of these was Viktor Aarne, whose skills as a goldsmith were highly appreciated by Karl Fabergé. Aarne produced a wide range of objects in a variety of styles and was particularly noted for his miniature table frames of multicolored gold decorated with garlands, miniature roses, and guilloché enamel. Aarne's products also included objects in the Art Nouveau style, some of which were purchased by the imperial family, thereby earning Aarne the name "our Lalique" at Fabergé. His versatility is evidenced by his adeptness in making sacred objects. An *oklad* for a triptych of the Resurrection is included in the Pratt collection at VMFA (cat. no. 16).

In 1904, Aarne left Fabergé to establish himself independently in his homeland of Finland, a decision prompted by the unsettling political situation in Russia. His relocation in the relatively cosmopolitan town of Viipuri proved successful. By leaving Russia before the final collapse, Aarne was one of the few St. Petersburg goldsmiths to secure his property and savings from Bolshevik confiscation. At the time of the revolution, and for many years afterward, Aarne was able to assist his former colleagues — including Hjalmar Armfelt — who fled Russia totally penniless and without prospects of work. Aarne enjoyed a prosperous relationship with the local clientele until the early 1920s.

Like many workmasters at Fabergé, Antti Nevalainen arrived in St. Petersburg as a young apprentice. He received his master's certificate in 1885 and was first employed by August Holmström. He later set himself up independently — albeit working exclusively for Fabergé — producing small gold and silver objects such as frames and cigarette cases. One of his specialties was a range of small drinking vessels — *kovshi*, *charki*, and beakers — in gilded silver decorated with guilloché enamel. Such vessels were popular gift items in the early twentieth century, and judging from the large number surviving, they were indeed a bestseller at Fabergé. Several of his frames, two vessels, and a parrot are at VMFA (cat. nos. 105 and 144–49).

Little is known about the goldsmith Afanas'ev who was apprenticed to the Finnish silversmith Enok Sistonen in St. Petersburg between 1883 and 1888. He presumably worked for the jeweler Karl Bock from 1888 to 1907. Upon joining the Fabergé team in 1913, Afanas'ev produced miniature Easter eggs; small jewelry set with precious stones; small articles of gilded silver with guilloché enamel, such as parasol handles, seals, perfume bottles, and pillboxes; and cigarette cases of Karelian birch with gold ornamentation.

Gabriel (Kaapro) Nykänen[8] came to St. Petersburg on the heels of his older brother, Matts Nykänen, who was working as a goldsmith in the city. Nykänen apprenticed in Erik Kollin's workshop and remained there until 1889 when he received his master's certificate at age thirty-five. Soon thereafter he set up his own workshop and signed a contract with Fabergé to work solely with him. Nykänen produced objects in gold, mainly cigarette cases with the imperial emblems to be presented as awards to state servants and foreign officials on state visits. Large gold pectoral crosses were also produced in his workshop.

Julius Rappoport arrived in the city in 1884 and started his own workshop, serving as a supplier for Fabergé until 1908. Rappoport made large important silver pieces, such as centerpieces, flatware, and animals that were either simply decorative or to be used as table lighters. His former journeyman formed the First Artel, a cooperative that worked for Fabergé until 1911.

Stefan Väkevä[9] received his master's certificate in 1856 and opened his own workshop the same year. His articles included silver, hollowware, flatware, coffee and tea services, trays, and silver-trimmed coffee tables. Two of his sons joined the family business. Alexander Väkevä, the younger son, took over the workshop after his father's death. His older brother, Konstantin, whose health was frail, worked there until his own death in 1902. Each Väkevä marked his works with his own initials, and following Konstantin's death, his widow, Jenny, obtained the right to mark one part of the company's production with hers. Using parallel masters' marks was unusual in workshops. There is no tradition of fathers and sons using individual marks, but perhaps Stefan wished to encourage his sons to work independently within the family atelier and thus take pride in their accomplishments. Jenny Väkevä's acquisition and use of her own mark was a means of securing financial support for herself and her two small children.

Fabergé and his workmasters were well supplied with hardstones through Russia's natural treasure trove of decorative minerals from mines in the Ural Mountains and Siberia. These hardstones, which were cut, carved, and polished at various lapidary works, quickly became an important aspect of the company's output. Karl Fabergé initially collaborated with Carl Friedrich Woerffel and Alexander Meyer on the production, but in order to ensure supplies of the highest quality, he established his own lapidary workshops. These were headed by workmaster Petr Mikhailovich Kremlev, who employed some twenty craftsmen in the years leading up to World War I. When the lapidaries had completed their work to precise designs, which were supplied by Fabergé's artists, mounters at the goldsmiths' workshops assembled the objects and added precious metals. Well over 30 percent of Fabergé pieces produced in the chief workmaster's atelier between 1911 and 1916 incorporated these all-important hardstones.

Another very important area in which Fabergé excelled—and a major concern and special interest of Karl Fabergé himself—was the art of enameling, which he developed with the help of highly skilled craftsman Nikolai Aleksandrovich Petrov. Unlike the other workmasters, Petrov carried out the most demanding work himself, with the assistance of his brother Dmitrii. The pressure on this workshop, which soon became of central importance to Fabergé, must have been enormous, for among the objects made in Wigström's workshop from 1911 to 1916, half were decorated with enamel. The exquisite quality of Petrov's enameling required not only superb craftsmanship but also tremendous patience. In this painstaking process, five to six layers of transparent enamel were applied over an engraved background, each one separately fired in the oven. Petrov's ability to meet the enormous demand for his work remains a mystery to this day.

NOTES

1. For details and floor plan see Kaurinkoski et al. 1991.

2. For additional biographical details on Fabergé's workmasters, see Tillander-Godenhielm et al. 1980, 28–51; Kaurinkoski et al. 1991; and Tillander-Godenhielm 2008. Lesser masters collaborating with Fabergé but not discussed here include: Wilhelm Reimer, Gustav Fabergé's first master goldsmith; Andrei Gerasimovich Gur'ianov, second goldsmith master and specialist in cigarette cases; Friedrich (Fedor) Ringe, maker of gold and silver objects; Anna Karlovna Ringe, widow of Friedrich who continued the business; Eduard Schramm, maker of cigarette cases and gold objects; and Anders Mickelsson, later operator of Ringe's workshop with Vasilii Fedorovich Solov'ev.

3. There is no written evidence that Kollin produced the egg, and the object is not marked, but the specific style and technical solutions employed speak for themselves. This egg has survived to the present day and is now part of the Link of Times Foundation Collection.

4. Hjalmar Armfelt, memoirs, in possession of his descendants.

5. Emperor Nicholas II abdicated on March 2, 1917 (Old Style). Easter eggs commissioned for that year were therefore never completed. The egg for Empress Alexandra, known as the Constellation Egg, was well under way. The partially finished egg was recently discovered in the storerooms of the Fersman Mineralogical Museum.

6. Author's communication with Jalmari Haikonen, 1980.

7. For more details on the case makers, see Tillander-Godenhielm 2008.

8. Until now, Gabriel Nykänen's surname has been erroneously spelled Niukkanen in the literature on Fabergé. Most likely an early author attempted to transcribe it from its Russian version and simply chose the wrong spelling, as both Nykänen and Niukkanen (a surname that does exist) are transcribed from the same word in Russian. Subsequent authors simply followed suit. I was recently able to track down members of Nykänen's family in Finland and thereby discovered the actual spelling of the surname. For more information on Gabriel Nykänen and his descendants, see Tillander-Godenhielm 2008.

9. In Finnish, the letter *W* frequently appeared during the nineteenth century as an alternative to *V*, an allograph of *W*, especially as the initial letter in surnames. According to Eila Joukamo, Stefan's great-granddaughter, Stefan thought a *W* looked "finer" than a *V* and so adopted *S. W.* as his maker's mark. However, in this chapter, I have retained the *V*.

Fabergé and His Russian Competitors

GÉZA VON HABSBURG

FIGURE 3.1: Bolin, *Necklace*, 1874; gold, rubies, diamonds. Photograph courtesy of Christie's, New York.

Contrary to early assumptions, Karl Fabergé did not live in an artistic vacuum but was, in fact, surrounded by Russian jewelers and craftsmen of high stature. Indeed, he was initially outclassed as a jeweler by Carl Edvard Bolin. Though Fabergé's status as a creator of objects of vertu was *primus inter pares*—first among equals—the local competition was significant. This realization has particular relevance for the Lillian Thomas Pratt Collection at the Virginia Museum of Fine Arts, as virtually every object sold to Mrs. Pratt in the 1930s and 1940s was optimistically certified as a Fabergé original. A number of these, however, can now be traced to workshops of some of the country's other excellent masters.

Jewelry

Gustav Fabergé, Karl's father, faced stiff opposition as he opened his jewelry firm in St. Petersburg in 1842. His main competitors were the well-established court jewelers Kaemmerer & Saefftigen and Bolin & Jahn.[1] At the 1851 Great Exhibition in London, where the world's leading jewelers displayed their wares, the Russian contingent was highly praised. Of Kaemmerer & Saefftigen it was said: "The importance of the articles in this collection, the superior taste in composition, and, above all, the perfection of settings, [was] not excelled by the works of any jeweler in the Exhibition." And Bolin & Jahn's jewels, one critic raved, "with their perfect mountings, surpass absolutely everything else at the exhibition, even the Spanish Queen's tiara, which is exhibited by the famous Parisian jeweler, Mr. Lemonnier."[2] That was praise indeed, as the queen's tiara was the most admired jewel at the exhibition. The jury opined that "as a setter of stones [Lemonnier] is exceeded by many other jewelers," but "in point of invention and decoration he stands unrivalled." No mention was made of Gustav Fabergé, who was still a recent arrival in St. Petersburg.

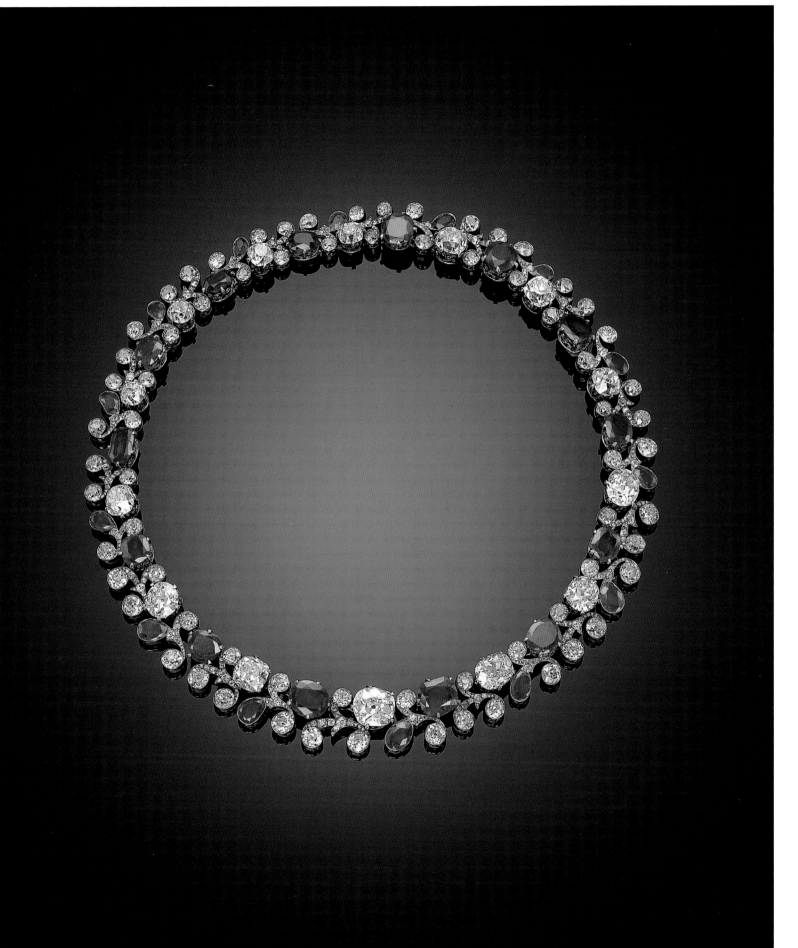

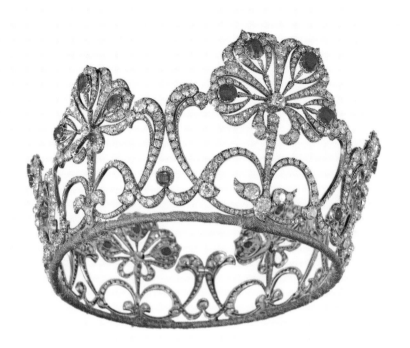

FIGURE 3.2: Bolin, *Tiara,* 1874; gold, rubies, diamonds. Photograph courtesy of Christie's, New York.

As young Karl Fabergé was establishing himself in St. Petersburg nearly twenty years later, Bolin was Russia's leading jeweler. The firm exhibited at the prestigious 1870 Pan-Russian Industrial Art Exhibition and was awarded the right to use the imperial warrant. The company's principals—Edvard Bolin (1842–1926) and Gustaf Bolin (1844–1916)—created a sumptuous ruby-and-diamond parure for the 1874 marriage of Grand Duchess Maria Aleksandrovna to Alfred, Duke of Edinburg (fig. 3.1). The parure's diadem is one of the few such jewels to have survived (at least temporarily) the Russian Revolution (fig. 3.2). In the same year, the brothers acquired premises at 12 Bol'shaia Morskaia, where the firm, then named Court Jewelers C. E. Bolin, remained until 1916. At a pan-Russian exhibition held in Moscow in 1892, Bolin exhibited exquisitely crafted objects and jewels, including a fan studded with rows of rubies and pearls and a glorious diamond-and-pearl-drop tiara, which was sold to Grand Duke Vladimir Aleksandrovich for the staggering price of 120,000 rubles. The firm was described as "enjoying unprecedented fame having existed for nearly 100 years," and their jewels were particularly lauded for their nearly invisible settings.

Of his 1894 wedding to Ksenia, Grand Duke Aleksandr Mikhailovich recounted that the bride's parents, Tsar Alexander III and his wife, presented her with sumptuous jewelry comprised of "a five strand pearl necklace, a diamond necklace, a ruby necklace, an emerald necklace, an emerald and ruby tiara, a diamond and emerald bracelet, a diamond stomacher, brooches and more. All of the jewellery was made by Bolin, the best jeweler in St. Petersburg."[3] The grand duke's memory, however, was not entirely accurate, as demonstrated by the bride's drawings of the jewelry, which

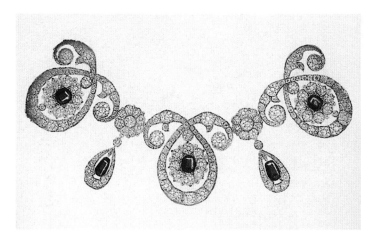

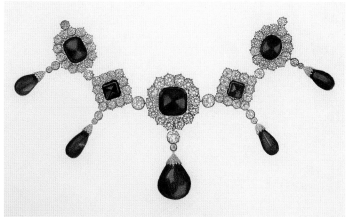

have survived in a privately owned album.[4] Among these, a diamond diadem and necklace "from Sandro" (the family's nickname for Ksenia's new husband) and a ruby-and-diamond parure (fig. 3.3) "from Papa and Mama," costing a total of 84,700 rubles, were indeed by Bolin, as was the five-strand pearl necklace mentioned by the grand duke. However, a very lavish cabochon-emerald-and-diamond parure (also "from Papa and Mama") was by Nicholls & Ewing and cost 99,306 rubles (fig. 3.4). The Imperial Cabinet spent 229,685 rubles on jewelry alone for this grand affair.

In 1889 fifty-two jewelry firms were active in Russia, mainly in St. Petersburg, employing 2,500 craftsmen with an annual production worth 2,800,000 rubles, much of it due to imperial commissions. Imports from abroad amounted to only 809,000 rubles.[5] By 1893 the local annual production had risen to 7 million rubles. Vast sums were spent by the Imperial Cabinet on the obligatory parures and *corbeilles de mariage* of the grand duchesses and on the thousands of presentation gifts bestowed by the all-powerful rulers of Russia. These commissions included Fabergé's first major sale to the imperial family—a sumptuous triple-strand pearl necklace costing 166,500 rubles that was presented in 1894 upon the betrothal of Heir to the Throne Nicholas to Princess Alix of Hesse and by Rhine.

The insatiable desire for costly extravagant jewelry is illustrated by the apparently endless number of imperial commissions to Bolin, which also included three jeweled ornaments acquired by Nicholas and Alexandra in 1901 for 339,400 rubles; a 35,000-ruble diamond parure for the ill-fated wedding of Grand Duchess Maria Pavlovna to Prince Wilhelm of Sweden in 1908; and a black-pearl-and-diamond brooch costing 29,500 rubles for Nicholas II in 1909.

By the end of the nineteenth century, with the rapid growth of Fabergé's business empire, Bolin was occasionally obliged to share some commissions with its competitor. Thus, when a costly parure of emeralds and diamonds was commissioned at short notice for Empress Alexandra Feodorovna in about 1900, Bolin created the tiara

FIGURE 3.3: Grand Duchess Ksenia Aleksandrovna, *Drawing of a ruby-and-diamond necklace by Bolin,* 1894. Private collection.

FIGURE 3.4: Grand Duchess Ksenia Aleksandrovna, *Drawing of an emerald-and-diamond necklace by Nicholls & Ewing,* 1894. Private collection.

and necklace, while Fabergé's Moscow workshop produced a waist-long *chatelaine*. In 1906 Fabergé and Bolin together offered one million rubles for a collection of unmounted precious stones that the Imperial Cabinet was selling in order to replenish its shaky finances following the Russo-Japanese War. This offer was initially accepted. Their bid, submitted on Bolin's stationery, stated that Fabergé and Bolin, "the oldest jewelers in St. Petersburg," hoped to retain these valuables in Russia. Instead, the jewels were sold to French competitor Georges Sachs, a jeweler and dealer in precious stones, for an additional 75,000 rubles and a further 5,000-ruble donation to an imperial charity.

Bolin and Fabergé were by then the leading jewelers in St. Petersburg, with Bolin employing one hundred craftsmen against Fabergé's three hundred. Together they had largely eclipsed the local competition. Between 1900 and World War I, they were likely in discussion about a possible closer partnership in order to parry the threatening activities of the French jewelers Boucheron, Cartier, and Chaumet. They actively sought means to bar their competitors' entry onto Russian soil, accusing them of evading payment of duty (see Chapter 4). It is in this context that Fabergé voiced his often-quoted disparaging opinion of his foreign rivals, recorded in 1914: "Clearly if you compare my things with such firms as Tiffany, Boucheron, Cartier, of course you will find the value of their things greater than mine. With them it is possible to find a ready-made necklace for 1.5 million rubles. But of course, these are merchants not artist jewellers. Expensive things interest me little if the cost is only in so many diamonds or pearls."

A contest in 1894 to create various parures for the young future empress, Alexandra Feodorovna, drew entries from a number of St. Petersburg jewelers—all competitors of Fabergé and Bolin. Images of their tantalizingly beautiful submissions, preserved at the Hermitage Museum,[6] offer a rare insight into high-quality jewelry production at the turn of the last century. The designs are all the more valuable since no major piece of jewelry by any of these masters is known to survive.

Julius Otto Saefftigen (1859–1914) submitted three fine designs for an emerald-and-diamond parure (fig. 3.5).[7] The Saefftigens operated one of the city's oldest and most respectable jewelry firms. Konstantin Saefftigen, Julius Otto's uncle, was an Appraiser to the Imperial Cabinet and worked for Alexander II and Tsaritsa Maria Aleksandrovna. He had also participated in the 1851 Great Exhibition in London. Julius Otto's father, Leopold, considered the wealthiest jeweler in St. Petersburg, was Supplier to the Imperial Court, Appraiser to the Imperial Cabinet, and Jeweler to Her Imperial Majesty. Julius Otto continued his uncle's business, located at 16 Bol'shaia Morskaia.

Friedrich Butz submitted four highly original designs for two emerald-and-diamond necklaces and diadems (fig. 3.6).[8] A master in 1849 and Appraiser to the Imperial

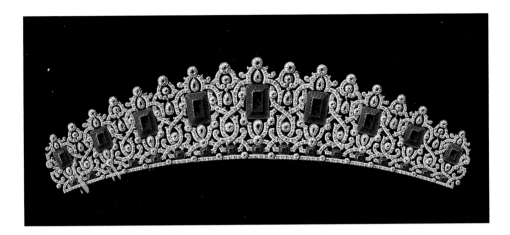

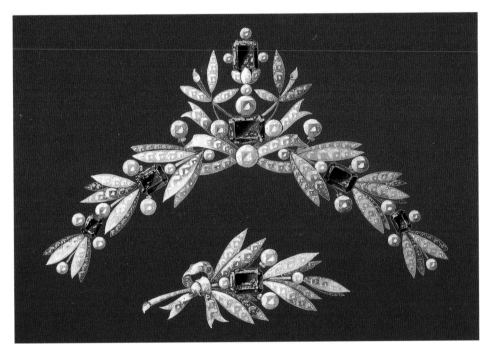

Cabinet, he was awarded, together with Bolin and Saefftigen, the Order of St. Anne, 3rd Class, in 1869 (which Fabergé was to receive in 1894). Butz's address was also Bol'shaia Morskaia (Eliseev house). His son Julius (1847–1912), who studied with Fabergé at St. Annen-Schule and traveled with him throughout Europe from 1864 to 1866, was also Appraiser to the Imperial Cabinet and co-owner of a firm at 25 Bol'shaia Morskaia. Butz was known to have collaborated with Bolin.

Nicholas Nicholls-Ewing (born 1839), another supplier to the court in 1880, owned a jewelry shop at 47 Bol'shaia Morskaia and also occasionally collaborated with Bolin. He submitted designs for a sapphire-and-diamond parure, as well as for an almost identical emerald-and-diamond diadem and necklace.[10] His name also appears in the accounts of the Imperial Cabinet as the author of a lavish three-piece cabochon-emerald-and-diamond parure illustrated in the jewelry inventory of Grand Duchess

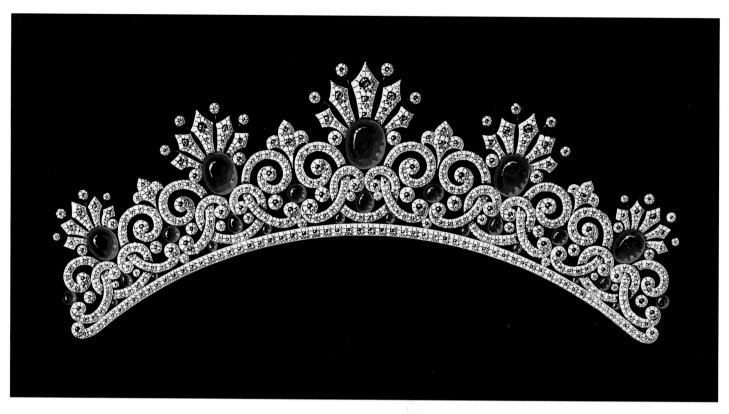

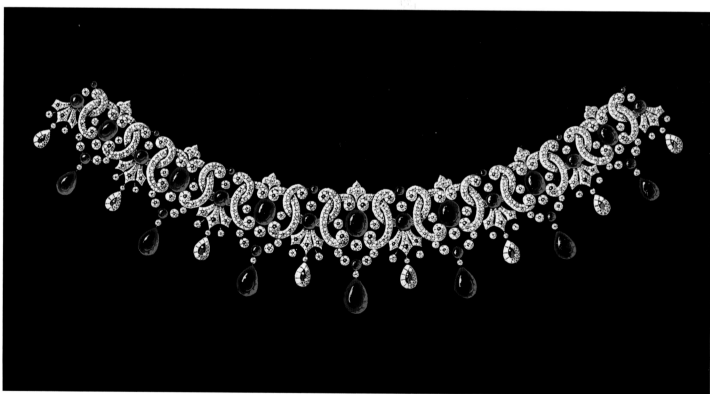

Ksenia among the presents she received in 1894 "from Papa and Mama for the wedding" (fig. 3.4). The cost of this parure was 99,306 rubles.

A specialist of gold boxes, Austrian Karl Hahn (1836–1899) is represented by three faceted-emerald-and-diamond necklaces and three brooches.[11] He was the owner of a workshop located at 26 Nevskii Prospect in 1873 with thirty craftsmen and an annual turnover of 100,000 rubles. Supplier to the court and appraiser to the cabinet, he was, like Fabergé, awarded the Order of St. Stanislas, 3rd Class, in 1896. Also, among the entries is a single exquisite design for a sapphire-and-diamond tiara and brooch signed "N. Schildknecht,"[9] of whom nothing more seems to be known.

The competition for the sapphire-and-diamond parure was won by Friedrich Koechly with magnificent designs for a diadem (fig. 3.7) and necklace (fig. 3.8), two brooches, and two pairs of earrings.[12] These found favor with the imperial couple and bear the mention: "chosen by their Majesties 17. August 1894." Koechly also supplied designs for two emerald-and-diamond diadems and a necklace.[13]

Hardstones[14]

Fabergé has often been credited with reviving the art of stone carving in Russia. More recent research, however, shows that while he perfected many products of indigenous lapidaries by recarving and later developed an in-house production of superlative hardstone objects and animals, a number of other excellent craftsmen of repute were active in Russia at the same time. All apparently collaborated with one another.

Aleksei Kuz'mich Denisov-Ural'skii[15] was Fabergé's neighbor and leading competitor in St. Petersburg in the field of semiprecious stones (he was probably also one of Fabergé's suppliers). This well-known hardstone specialist from the Ural Mountains (as his name suggests) was born in 1864, the son of a successful Ekaterinburg lapidary who operated a workshop in 1856 with two craftsmen and a turnover of 600 to 800 rubles. A. K. Denisov received his master's certificate in sculpture from the Ekaterinburg guild of sculptors in 1884 and exhibited his works in Scandinavia, Paris, Reims (Silver Medal in 1903), and St. Louis (Silver Medal in 1904). At the 1882 Moscow Industrial Art Exhibition, where he displayed a map of the Urals made of semiprecious stones, he received distinction for the "creative use of Ural gems in objects of art, models and collections." In 1887 he was awarded a large Silver Medal for carvings shown at the Siberian Exhibition of Science and Industry in Ekaterinburg, which was followed by a prize at the 1889 Paris Universal Exposition and a small Silver Medal at the Kazan Exhibition of Science and Technology.

As supplier to the court, he founded the Denisov (Ural'skii) & Company Mining Trading Agency in 1903. He sold Russian industrial minerals in St. Petersburg, first at 42 Moika Embankment and, beginning in 1910, from his shop, Ural Gems, at

FIGURE 3.7: Friedrich Koechly, *Design for a sapphire-and-diamond diadem,* 1903–4. State Hermitage Museum, St. Petersburg.

FIGURE 3.8: Friedrich Koechly, *Design for a sapphire-and-diamond necklace,* 1903–4. State Hermitage Museum, St. Petersburg.

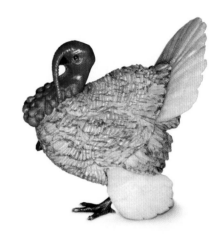

FIGURE 3.9: Fabergé, *Turkey,* 1908–17, workmaster Henrik Wigström; hardstone, gold, diamonds; height 2 in. (5.1 cm). Photograph courtesy of Christie's New York.

FIGURE 3.10: Denisov-Ural'skii, *Turkey,* ca. 1914; hardstone, bronze; height 4⅛ in. (10.6 cm). Photograph courtesy of Perm State Art Museum.

27 Bol'shaia Morskaia, close to Fabergé. At a time when Fabergé's lapidary workshop was flooded with commissions, he must have turned to Denisov as a supplier. Two of the animal sculptures in the Pratt collection—a polar bear (cat. no. 263) and an obsidian owl (cat. no. 96)—sold to Mrs. Pratt as Fabergé figures can be attributed to Denisov. In 2010 a turkey with gold legs bearing the marks of Fabergé workmaster Henrik Wigström was sold at auction (fig. 3.9); its hardstone body was surely by Denisov, known to have carved similar birds (fig. 3.10).[16]

Interestingly, Cartier acquired sixty-two animals and thirty-nine other hardstone articles from Denisov between 1911 and 1913, some of which were later mounted in Paris in the workshop of Varangoz or Lavabre or both (see Chapter 4). This exceptional craftsman was also celebrated for his series of large composite hardstone caricatures of World War I figures, eleven of which survive at the National Gallery in Perm.[17] The dowager empress acquired one of Denisov's largest sculptures, a composite hardstone parrot, in 1913.[18]

Avenir Ivanovich Sumin,[19] supplier to the dowager empress and the imperial court, was awarded a prize for his hardstones at the 1882 Pan-Russian exhibition. He was proprietor of a stone-carving workshop, Stones from Siberia and Urals, founded by his father in 1869 at 42 Nevskii Prospect (which moved later to 60) in St. Petersburg. A number of his little animal figures in their fitted cases have surfaced at auctions and exhibitions, including a bowenite hippopotamus and a nephrite chimpanzee. Both could easily be mistaken for Fabergé carvings. Sumin, who also produced or retailed objects in guilloché enamel, died in 1913. His workshop was taken over by S. Osmolovskii.

Prokopii Ovchinnikov,[20] perhaps a member of the notable Pavel Ovchinnikov family of Moscow silversmiths and enamellers, was an Ekaterinburg craftsman specializing

in Siberian hardstones, highly regarded in his time but only barely known today. In 1904–5 and in 1911 Cartier acquired twenty-nine animal figures and fifty-one other articles in semiprecious stones from Ovchinnikov (see Chapter 4). Hardstone objects of vertu and miniature Easter eggs by Ovchinnikov have appeared at auction more recently. One of his suppliers or craftsmen was Aleksandr Iakovlevich Svechnikov, a modeler and gem carver also from Ekaterinburg who specialized in animal sculptures. Svechnikov was an apprentice and then a master in the Trapeznikov workshop and may have owned a workshop in St. Petersburg that supplied both Fabergé and Cartier (in whose Russian acquisition ledger he appears as "Sviechnikov"), to whom he sold a number of animal figures in 1904 (see Chapter 4).

Objects of Art and Enamels

Objects of art played an important part in the Russian imperial award system.[21] Presented at suitable occasions, these included important jeweled gifts for heads of state or other high-ranking dignitaries, mostly in the form of diamond-set snuff-boxes (or less frequently frames or nephrite *kovshi*) with the emperor's portrait or cypher. The Pratt collection includes several such examples (cat. nos. 27, 62, and 298). Presentation cigarette cases in gold or silver or enamels applied with imperial emblems were produced in large numbers and were either presented to family members or taken by Nicholas and Alexandra on their frequent travels abroad to recompense those who rendered them significant service. Lesser items of commemorative jewelry were similarly given to singers, dancers, and musicians and often marked anniversaries as well. These gift objects were held at the disposal of the Imperial Cabinet in a specially designated room, with the stock replenished whenever necessary. The main contenders for such commissions from the cabinet were Fabergé, Koechly, Hahn, Blank, Tillander, Bolin, and Butz, but also included lesser firms such as Marshak and Morozov.

Among all of Faberge's innovations in Russia, his unsurpassed mastery of guilloché enamels based on eighteenth-century originals found in the Hermitage Museum was the most envied in St. Petersburg. These objects found favor with the imperial family and the court and were therefore often imitated by local competitors.

The Craftsmen

A number of great craftsmen of Fabergé's day stand out by their important roles in St. Petersburg, as demonstrated by surviving records and by the distinctive styles of their production. Fabergé's main competitor in the field of objects of art was arguably Karl August Ferdinand Hahn (1836–1899),[22] who founded his jewelry business in St. Petersburg in 1874 and became a merchant in 1882 at 26 Nevskii Prospect.

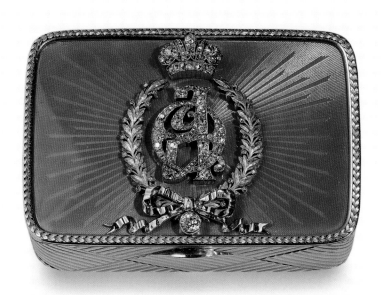

He acquired Russian citizenship in 1892 and hereditary honorary citizenship in 1898. He exhibited at the World's Columbian Exposition in Chicago in 1893 and 1896 after being named Supplier to the Imperial Court and then Appraiser to the Imperial Cabinet. After Hahn's death, the firm was run by his widow, Adele Marie, and, beginning in 1901, by his son Alexander (Dmitrii Karlovich), merchant of the first guild in 1905 and another supplier to the court. In 1900 the shop "traded in gold and silver items of the best St. Petersburg masters and foreign factories."[23]

In addition to the firm's jewelry, Hahn's gem-set and enameled objects of art were also celebrated for their high quality. His imperial presentation boxes (fig. 3.11), cigarette cases, and photograph frames are the best examples. Many of these were executed bearing the portrait or cypher of the tsar for him to present to members of the Imperial Cabinet. The number of new snuffboxes acquired from Hahn by the cabinet indicates his rank as second only to Fabergé as a creator of objects of vertu. Six (against Fabergé's five) of fourteen boxes with the portrait of the tsar and fifty-nine (against Fabergé's sixty-eight) of 178 boxes with the diamond-set cypher came from his workshop.[24] The Pratt collection has two bearing the hallmark of Hahn that are similar in concept to those of Fabergé. Both of these are considered to be forgeries.

Hahn's chief workmaster was Carl Blank,[25] whose initials grace some of the finest enameled objects made in St. Petersburg at the time. Born in Helsinki, Finland, in 1860, Hahn was owner of a workshop with eight workers and three apprentices. Blank became merchant of the second guild in 1894 and exhibited at the Nizhnii-Novgorod Fair in 1896, where he was awarded the right to use the state emblem and

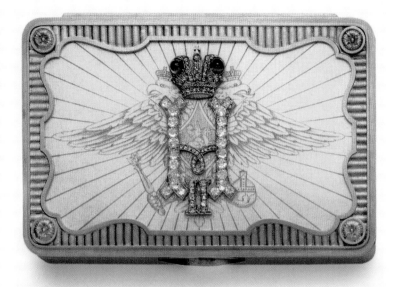

was named appraiser to the cabinet after twenty-two years of service. In 1900 his workshop was located at 4 Zimin Lane. Blank worked for Hahn between 1892 and 1909 and then became his business partner until Hahn's death in 1911. Thereafter, Blank worked independently for the Imperial Cabinet making badges for members of various orders and for ladies-in-waiting. In 1915 he became an honorary citizen, with a workshop located at 23 Ekaterininskaia Canal. In 1917 he returned to Finland.

The famous Swiss jeweler Friedrich Christian (Fridrikh Ivanovich) Koechly (1837–1919)[27] opened a jewelry firm in St. Petersburg in 1864 and is known to have produced jewelry and gold objects at 7–10 Gorokhovaia Street in 1874. He received a first Bronze Medal at the 1870 Pan-Russian Industrial Art Exhibition in St. Petersburg and another at the 1900 Paris Universal Exposition, where he, like Fabergé, exhibited *hors concours* as a member of the jury. In 1902 he was named Appraiser to the Imperial Cabinet and a supplier to the dowager empress's court. He was joined by his son, Theodor Friedrich, from 1903 until his death in 1911, when the business was closed. Koechly supplied the Imperial Cabinet with gold presentation snuffboxes, many of them with the imperial cypher (fig. 3.12), as well as cigarette cases and small jewels, including miniature Easter eggs and objects of vertu. He produced two presentation snuffboxes with a portrait of the tsar and ten with his cypher.

A chased-gold vodka cup in the Pratt collection is signed with the initials of Alexander Edvard (Aleksandr Gustavovich) Tillander (1837–1918),[28] who founded his business in St. Petersburg in 1860. A specialist in fine jewelry, Tillander sold his wares initially through other leading jewelers, including Bolin. In 1890 he established his own business on Bol'shaia Morskaia, where he was joined by his son Alexander (1870–1943),

FIGURE 3.12: Friedrich Koechly, *Imperial Presentation Box with Cypher of Tsar Nicholas II*, 1899–1908; gold, enamel, diamonds, sapphires; length 3 7/16 in. (8.8 cm). Photograph courtesy of Alexander von Solodkoff.

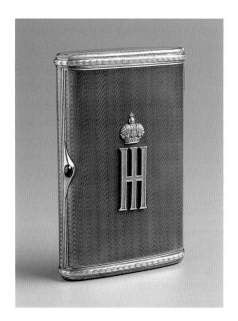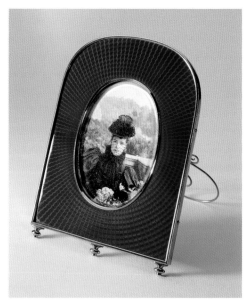

FIGURE 3.13: Ivan Britsyn, *Cigarette Case,*
1908–17; silver gilt, enamel, sapphire; length
4 in. (10.2 cm). Photograph courtesy of the
late John Traina.

FIGURE 3.14: Alexander Treyden, for
Alexander Tillander, *Frame*, before 1899;
gold, enamel. Photograph courtesy of Ulla
Tillander-Godenhielm.

who had been apprenticed in his father's workshop and was a well-traveled journey-man, venturing as far afield as London, Paris, and Dresden. Their production in-cluded gold jewels inspired by the archaeological finds from the fourth century BC at the Greek site of Kerch. Unlike Fabergé's faithful replicas, however, these were set with precious stones. Tillander's inventory also included badges, *jetons*, and com-memorative pins. In the late 1800s and early 1900s the firm also specialized in objects of art such as signature gold cigarette cases and cups and frames coated in a spectac-ular deep-red translucent enamel (fig. 3.14), many for the Imperial Cabinet. Imperial family members ordered small jewels emblazoned with the double-headed eagle or a personal monogram, including cuff links, tie pins, and brooches.

After relocating to the fashionable Nevskii Prospect in 1911, the Tillanders ceded their atelier to workmaster Theodor Weibel, who continued to work exclusively for them. The same year, they benefited from the closing of French rival Boucheron, whose representatives had been murdered (see Chapter 4). The Tillanders were entrusted with the sale of the remaining stock, a task they accomplished with success. World War I had disastrous effects on luxury trade. Precious metals were no longer available, craftsmen were sent to the front, and inflation was rampant. In 1917 the Tillanders closed shop. After the demise of Alexander Edvard, his son settled in Finland, where the firm exists today.

Another exceptional craftsman, employed by both Hahn and Tillander, signed his pieces "AT" (fig. 3.14). These objects have been identified as the work of goldsmith Alexander (Aleksandr Adolfovich) Treyden (born 1857),[26] whose address in 1894 was 5 Kaznacheiskaia Street. A merchant of the second gild, he was elected treasurer of the society of jewelers, goldsmiths, silversmiths, and merchants in 1912.

The fourth of the grand old jewelry firms, Bolin[29] had a branch in Moscow producing fine silver articles and objects of art. St. Petersburg was the source not only of the firm's superlative jewels but also of its high-quality vertu objects. Bolin, which has a somewhat convoluted history, was founded in 1790 in St. Petersburg by Andreas Roempler, whose son-in-law, Gottlieb Jahn, became his partner. In 1833 Carl Edvard Bolin (1805–1864) of Sweden entered the practice. After Roempler's death in 1834, Bolin married Roempler's daughter Ernestine and with Jahn's death in 1836, he partnered with Jahn's widow to form Jahn & Bolin. He was joined that year by his brother Henrik Conrad Bolin (1818–1888), who with Englishman James Shanks would run the Moscow branch for over thirty years, from 1852 to 1888, under the name Shanks & Bolin, Magasin Anglais. Carl Bolin was named a court jeweler in 1839 and Appraiser to the Imperial Cabinet in 1854.

After Carl Bolin's death in 1864, the St. Petersburg firm, later named Court Jewelers C. E. Bolin, was run by two of his sons, Edvard Ludvig and Gustaf Oscar. Edvard, an appraiser to the Imperial Cabinet since 1864, was awarded the Order of St. Vladimir, 3rd Class, in 1900. He was made commercial councilor in 1905 (an honor Fabergé obtained in 1910) and, together with his brother, was awarded honorary citizenship with the right to a coat of arms in 1912. Meanwhile, the Moscow branch was run by Wilhelm, a son of Henrik. As appraisers to the Imperial Cabinet, the Bolins, then St. Petersburg's most famous jewelers, also received commissions for objects destined for the imperial court.[30]

The most prolific among St. Petersburg's craftsmen competing with Fabergé in the firm's last years may have been Ivan Savel'evich Britsyn (1870–1952),[31] a peasant from the Moscow region who reportedly trained at Fabergé and perhaps later became one of his suppliers. Beginning in 1903 he was actively producing gold and silver objects of fine quality, most of them enameled, with a workshop at Spasskaia Street, which was moved to 12 Malaia Koniushennaia in 1910. His enamels earned him a Gold Medal at an international exhibition in 1903. His numerous surviving cigarette cases (fig. 3.13) are stylistically very close to Fabergé's but simpler in design and easily recognizable by their colors—generally dark and pale blue, pink, and white—and their simple borders.[32] Some of his wares, especially frames and clocks, stand out by their use of opalescent-white and pale-blue enamels,[33] while a small number of them are unexpectedly audacious in design (fig. 3.15).[34] Apparently Britsyn worked for the imperial court[35] and had connections with the jeweler Marshak in Kiev. He also sold his goods in London through the retail outlet Nobel & Company, run by Arthur Bowe, brother of Fabergé's former partner in Moscow, Allan Bowe.

Numerous enameled objects survive bearing the hallmark of the St. Petersburg's Third Artel (fig. 3.16).[36] Headed by Vasilii Nikolaevich Ivanov, this association consisted of approximately thirty craftsmen who were active between 1908 and 1917,

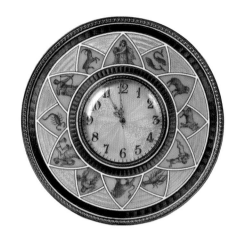

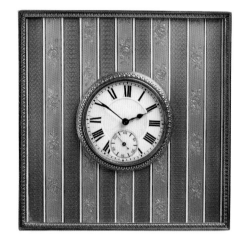

FIGURE 3.15: Ivan Britsyn, *Clock with Signs of the Zodiac,* 1908–17; silver gilt, enamel; diameter 5 ⅛ in. (13.3 cm). Photograph courtesy of Alexander von Solodkoff.

FIGURE 3.16: Third Artel, St. Petersburg, *Clock,* 1908–17; silver gilt, enamel, ivory; 4 ½ in. (11.4 cm) square. Collection of Andre Ruzhnikov, California.

with premises at 48 Ekaterininskii Canal. Apparently they were former members of the company who possessed many of the master's skills and also supplied the firm. Some of their products were simple—ashtrays, miniature eggs, and cigarette cases in hues of pale blue and white, pink, and green.[37] Others were more refined, using unexpected color combinations and fine-quality gold chasing.[38]

Other firms producing objects in guilloché enamels in the manner of Fabergé include Andrei Adler,[39] whose initials appear on one of the Pratt miniature Easter eggs (cat. no. 347); Avenir Sumin;[40] Bock; and Glazov. The enameled objects of these companies were modest—miniature Easter eggs, pencils, frames, and clocks in a restricted palette of white, pink, green, yellow, and pale- and dark-blue guilloché enamel hues.

Finally, among the goldsmiths and lesser jewelers in St. Petersburg, Vasilii Finnikov,[41] a supplier of Bolin, Marshak, and perhaps Fabergé, deserves mention. His characteristic gold objects and jewels are usually set with cabochon sapphires of irregular shape. The Pratt collection has a gold vodka cup (cat. no. 250) and three miniature Easter eggs by this workmaster (cat. nos. 352, 353, and 354).

NOTES

1. Ribbing 1996.
2. Ibid., 42.
3. Ibid., 70.
4. The relevant pages are illustrated in Krog et al. 2002, 252–65 and Habsburg 2003, 59–61.
5. Ribbing 1996, 64.
6. The State Hermitage, St. Petersburg, inventory nos. EROz1259; 1760–64; 1766–77; 1779; 1781–84; 1789; 1790–92.
7. Habsburg 2003, p. 335, cat. 626–28.
8. Ibid., 330, 331, cat. 613–16.
9. Ibid., 329, cat. 609.
10. Ibid., 329, cat. 610–12; 336, cat. 629–30.
11. Ibid., 332–33, cat. 617–22.
12. Ibid., 328, cat. 604–7.
13. Ibid., 334, cat. 623–25.
14. Muntian, Guitaut, and Krog 2005, 106–31; Houston Museum, 1994.
15. Muntian, Guitaut, and Krog 2005, 117–21.
16. See the Fabergé model of a composite hardstone turkey with gold legs recently sold at auction (Christie's London, June 8, 2010, lot 177), of which there is a similar version with bronze legs in its original fitted case stamped with Denisov's name and address at 27 Bol'shaia Morskaia. It is also quite likely that the Pratt obsidian owl (cat. no. 96), despite its Fabergé fitted case, is by Denisov (see Chapter 4).
17. Muntian, Guitaut, and Krog 2005, 178–81, cat. 78–88; 189, cat. 12.
18. Habsburg 2000, 335, cat. 898, invoiced in January 1914 for 2,000 rubles.
19. Muntian, Guitaut, and Krog 2005, 116; Habsburg 2000, 324, figs. 2 and 4, and 898.
20. Muntian, Guitaut, and Krog 2005, 116.

21. Tillander-Godenhielm 2005.

22. Habsburg 2003, 327, cat. 601–3. A white enamel presentation snuffbox by Hahn was sold at Sotheby's Geneva November 14, 1985, lot 527, and another on May 15, 1986, lot 320.

23. Ivanov 2002, 190.

24. Tillander-Godenhielm 2005, 167 and 179.

25. For examples of imperial presentation snuffboxes and other objects of vertu by Carl Blank, see Habsburg 2000, 323, 336, cat. 907–12; and Habsburg 2003, 324–27, cat. 595–99, 600–603. For one of the most outstanding cigarette cases made in St. Petersburg, see Blank's pale-green case studded with ruby-and-diamond bees formerly in the Forbes Collection (Habsburg 2000, 337, cat. 911).

26. For an Easter egg by Hahn with the workmaster initials "AT," containing miniatures of members of the imperial family, see Habsburg 2000, 335, cat. 903 (Wartski, London); a cigarette case by the same workmaster is illustrated on 336, cat. 904.

27. For Friedrich Koechly as goldsmith, see Habsburg 2000, 323–24 and 338–39, ill. 914–21. A yellow enamel presentation snuffbox by Koechly with the cypher of Nicholas II was sold at Sotheby's New York, June 20 and 21, 1984, lot 308a. See also Tillander-Godenhielm 2005, 86, ill. 63, for a ribbed gold snuffbox.

28. Habsburg 2000, 320, 322. For objects by Tillander, see Habsburg 1986, 297, cat. 615; Habsburg 2000, 343, cat. 942–43; Habsburg 2003, 323–24, cat. 591–94.

29. Ribbing 1996; Habsburg 2000, 328–29.

30. Ribbing 1996, 99, illustrates the finest surviving example of an imperial snuffbox by Bolin. A frame with a portrait of Nicholas II presented by the tsar to the French prime minister R. Viviani at the occasion of the state visit of President Poincaré in 1914 is illustrated in Tillander-Godenhielm 2005, 154.

31. Habsburg 2000, p. 324; Lowes and McCanless 2001, 189, 190; Habsburg 2003, 70.

32. Habsburg 1986, p. 295, cat. 606–8; p. 296, cat. 610; p. 299, cat. 619; Habsburg 2003, p. 321, cat. 585.

33. Habsburg 1986, 293, cat. 593; Habsburg 2000, 333, cat. 887; Habsburg 2003, 320, cat. 581.

34. For a clock of very original design by Britsyn see Habsburg 2003, 320, cat. 580.

35. The fact that he also worked for the Imperial Court is attested by a mauve cigarette case applied with the crowned monogram NN (Habsburg 1986, 297, cat. 611) and a frame enameled with the orange and black band of the Order of St. George containing an original photograph of the young tsesarevich on horseback (Habsburg 2003, 321, cat. 583).

36. Although many of its works have survived, little is known of the Third Artel. See Habsburg 2000, 324; Lowes and McCanless 2001, 182; Habsburg 2003, 70.

37. Habsburg 1986, 295, cat. 600–602, 605; Habsburg 2000, 330, cat. 871–74; Habsburg 2003, 319, cat. 574–75, 577.

38. Habsburg 2003, 330, cat. 870, for a clock in the Ruzhnikov collection, which has translucent pale-green stripes over a background engraved with flowers next to stripes of blue guilloché enamel. That the Third Artel also had the favor of at least one European royal family is attested by a fine raspberry enamel frame with chased applications containing a photograph of Queen Eleonore of Bulgaria (Habsburg 1986, 297, cat. 612).

39. Lowes and McCanless 2001, 178.

40. Habsburg 2003, 324.

41. For jewels and objects by Vasilii Finnikov see Habsburg 2000, 335, cat. 899 and 901; Habsburg 2003, 305, cat. 528; 306, cat. 526; 308, cat. 529–30.

Fabergé and His Foreign Competitors

GÉZA VON HABSBURG

Fabergé Abroad

FIGURE 4.1: Cartier, *Imperial Egg Frame,*
1906; workmasters Picq, Césard, and
Guesdon; gold, fluorite, pearls, platinum,
enamel; height 4 9/16 in. (11.7 cm). Metro-
politan Museum of Art, New York.

Karl Fabergé's association with his foreign competitors provides an important key to understanding the development of his late style. His vigorous defense of his home turf against intruders also offers valuable insight into the business practices, sometimes unsavory, of the period.

The relationships of the Romanovs with the ruling houses of Denmark, Great Britain, Sweden, and numerous Protestant princely families of Germany provided Fabergé with an all-important entry into European society. His elegant, highly original, often witty, exquisitely crafted, and relatively inexpensive objects of art were seen as the ideal presents for all occasions. At Easter, Christmas, birthdays, and weddings, or as appreciation and welcoming gifts, a little frame, bonbonnière, or small animal carving accompanied by a signed penciled note and nestled in a pretty fitted case were highly appreciated within the extended royal families and have survived in fair numbers.[1] These delightful objects were also a reminder of the supremacy of Russian applied arts, an important feature for gifts to and from imperial family members, who thereby became Fabergé's best ambassadors.

Karl Fabergé and Carl Edvard Bolin were the foremost jewelers in Russia at the end of the nineteenth century. As such, Fabergé was invited to participate in the 1900 Paris Universal Exposition as a member of the jury,[2] having obtained special permission from the tsar's cabinet in 1899 to create miniature replicas of the Russian crown jewels (see fig. 1.4). Fashioned by his chief jeweler, August Holmström, they were reserved for the tsar, to be displayed later in the Diamond Room of the Hermitage in St. Petersburg. Fabergé also exhibited a selection from sixteen imperial Easter eggs created for Dowager Empress Maria Feodorovna between 1885 and 1900 and the six eggs made for the young Empress Alexandra Feodorovna between 1895 and 1900.[3]

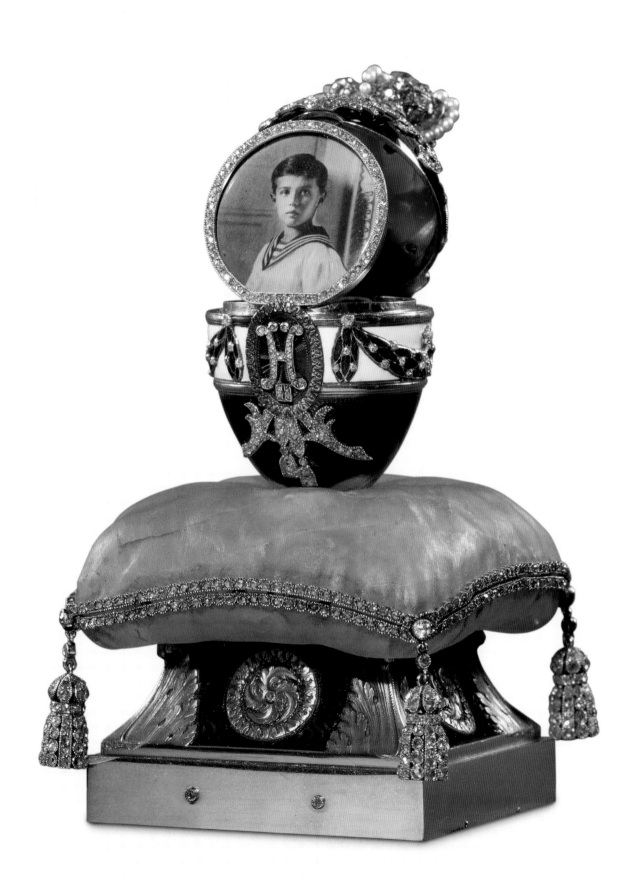

The jury members deemed the majority of these works to be "little *chefs d' oeuvres* of execution and taste which rejoiced the *connoisseurs.*" They also wrote: "This is craftsmanship at the very limits of perfection, the transformation of a jewel into a true object of art. The perfect execution, as well as the irreproachable setting, distinguishes all objects exhibited by the House of Fabergé, whether it is this tiny imperial crown set with 4,000 stones, or these enameled flowers so perfectly imitated that they seem natural, or these numerous objects of fantasy, which have been examined at length by the Jury."[4]

Interestingly, there was some dissent. Well-known critic René Chanteclair, under the spell of the extraordinary Art Nouveau jewels by René Lalique shown to great acclaim at the exposition, opined that some of Fabergé's eggs were too dependent on earlier styles, stating derogatively that "since Mr. Fabergé remains a faithful admirer of French styles, we think that he could have easily chosen in each one of them, ornaments less obvious and more felicitous." According to the same detractor, Fabergé's flowers were "without artistic or decorative feeling, a color photograph of nature, without the artist having impressed his own style on it." Fabergé was also accused of being too much "imbued with national traditions [and] ignores the principles of a new decoration [Art Nouveau], so that his ingenuity remains confined in reminiscences. We regret that such perfection in craftsmanship was not employed in the creation of more original works of art." The public, however, which included numerous Americans who traversed the Atlantic in their yachts, was apparently enchanted, as Fabergé sold every available piece from his stock and was never short of commissions thereafter.

While the formidable Grand Duchess Maria Pavlovna, wife of Grand Duke Vladimir, encouraged French jewelers to establish themselves in Russia, introducing them to the imperial family and granting them her protection (see Chapter 3), Dowager Empress Maria Feodorovna played a similar role for Fabergé abroad. It was probably upon her suggestion that he opened an office in London in 1903,[5] chiefly to cater to her sister, Queen Alexandra, and husband, King Edward VII, as well as their circle. Arthur Bowe, a manager of Fabergé's Moscow office, originally established this London branch at Berners Hotel. It was then moved to Grosvenor Square and in 1906 to 48 Dover Street. That year Bowe was replaced by Nikolai, the youngest of Fabergé's sons, who together with Henry Bainbridge ran the office until 1915. A final move to 173 New Bond Street in 1911 made Fabergé a next-door neighbor to Cartier.

The British king and queen were the firm's best and foremost London clients, often bringing relatives and friends with them during their numerous visits. The pair had first pick from among any new arrivals of objects from St. Petersburg. After the king first gave his wife a group of hardstone carvings in 1907 based on her favorite

animals in the zoo at Sandringham, it became a common (and permitted) custom to add to her collection.[6] Sharing her sister's love of Fabergé's work, the queen was always delighted when presented with some novelty by the Russian master and would invariably exclaim, "Oh, how lovely!"[7] The Prince and Princess of Wales (later King George V and Queen Mary) were both equally keen collectors of Fabergé's objects both before and after the death of King Edward VII in 1910. Russian royals among the firm's regular clientele at its London branch were Dowager Empress Maria Feodorovna; Grand Duchess Maria Pavlovna; Grand Duke Boris; and Grand Duke Mikhail Mikhailovich and his morganatic wife, Countess de Torby. Members of the Russian, Greek, Norwegian, Danish, Spanish, Italian, Romanian, and Serbian royal families also visited Faberge's London showrooms, as did Empress Eugénie, the wife of Napoleon III.

Americans, too, who traveled to St. Petersburg often followed the local practice of shopping at Fabergé's.[8] Henry C. Walters from Baltimore, visiting with Princess Kantakuzina in 1900, acquired a group of animals (the first extant dateable examples of their kind) and parasol handles; Consuelo Vanderbilt, Duchess of Marlborough, commissioned a pink enamel Easter egg in 1902; and J. P. Morgan patronized the shop in 1905, purchasing two miniature pieces of furniture. Wealthy American brides, married off to impoverished English nobility, likewise emulated British society by visiting Fabergé's London shop with their husbands. The numerous Americans listed in the firm's London sales ledgers include Maud Burke, wife of Sir Bache Cunard; Cornelia Bradford Martin, wife of the Earl of Craven; Clara Prentice Huntington, wife of Prince Hatzfeld; Helena Zimmerman, wife of the Duke of Manchester; and Mary Wilson Goelet, wife of the Duke of Roxburghe. Other Fabergé clients included members of the Astor, Drexel, McCormick, and Vanderbilt families. Fabergé's best London customers abroad were Lady Paget, Princess Hatzfeld, and Mrs. William Bateman Leeds (née Nancy Stewart, later Princess Christopher of Greece), who between 1915 and 1916 acquired sixty-five objects and jewels.[9] The list of English clients reads like a social register of the Edwardian "smart set": Cassel, Curzon, Dudley, Duff, Dufferin, Greville, de Grey, Keppel, Portland, Revelstoke, Sackville-West, Scaramanga, Sassoon, and Westminster, as well as five members of the Rothschild family.[10]

One of the very few Russian jewelers with an office abroad, Fabergé used his London branch to organize and finance various sales trips within Europe, encroaching on his French competitors' territory. His representatives traveled to Paris in 1909 and 1911, to Rome in 1910–11, and to Paris, Rome, and the Côte d'Azur in 1914, staging the equivalent of today's "trunk shows." The London office also financed annual trips to the Far East between 1908 and 1917 to call upon a number of Indian maharajas and the King of Siam.[11]

French Jewelers in Russia

Beginning in the 1890s, the leading Parisian jewelers, silversmiths, and furniture makers sought to infiltrate the Russian market.[12] The earliest jewelers to arrive were Louis Aucoc, Frédéric Boucheron, and Coulon & Cie, exhibiting in Moscow in 1891 at a Franco-Russian show. Boucheron opened a branch office next to Fabergé in 1898 at Kuznetskii Most. A year later some of René Lalique's jewels were displayed in St. Petersburg at the first World of Art (Mir iskusstva) exhibition. Boucheron and Lalique were present at shows held in St. Petersburg in 1902 or 1903. The House of Cartier began activities in Russia in 1904 and opened a provisional office in St. Petersburg in 1908, participating in several charity bazaars. Joseph Chaumet, however, preferred to operate from a distance, with a representative in Russia but no office. Of the contingent of French jewelers vying for the lucrative Russian market, Cartier, Boucheron, and Chaumet were the most outstanding.

In an often-quoted interview of 1914, Fabergé referred to these foreign companies and their unwelcome presence in Russia: "Clearly if you compare my things with such firms as Tiffany, Boucheron, Cartier, of course you will find the value of their things greater than mine. With them it is possible to find a ready-made necklace for 1.5 million rubles. But of course, these are merchants not artist jewellers. Expensive things interest me little if the cost is only in so many diamonds or pearls."[13] Thus Fabergé, though obliged to execute the orders of the Imperial Cabinet for similar works of pure craftsmanship, saw himself as the true artist jeweler at a time when jewelry and the applied arts were still labeled as works without artistic merit.

Cartier

Among Fabergé's foreign competitors, the House of Cartier[14] was the foremost. Founded in Paris in 1847 by Louis-François Cartier, the company was managed by his son Alfred beginning in 1874. Alfred's sons Louis, Pierre, and Jacques later established the Cartier name and products worldwide. The firm's foray into the Russian market and its well-documented relationship to Fabergé is illuminating,[15] and Cartier's art and animal sculptures are especially pertinent to the Lillian Thomas Pratt Collection at the Virginia Museum of Fine Arts. Eleven out of the thirty-seven animal studies sold to Mrs. Pratt as Fabergé objects are here attributed to Cartier. It is quite possible that at the time, the dealers were unaware of the existence of such works by the French craftsman. In view of the above, the automatic attribution of the large majority of hardstone animal sculptures to Fabergé needs to be reexamined (see Chapter 9).

The House of Cartier was not represented at the overcrowded 1900 Paris world's fair, preferring to receive clientele at its new discrete and elegant showrooms. René

Lalique's Art Nouveau jeweled creations caused a furor at the exposition, but Cartier, with only a few exceptions, refused to follow this trend. Instead, the firm began to specialize in daring and elegant platinum-and-diamond pieces of a Louis XVI, or "garland," design. This signature style became the preferred idiom of the international high society during the first two decades of the twentieth century, beloved both at home and abroad. Fabergé, forever in the forefront, had been a keen adherent since 1898 of Russia's World of Art movement, with its close ties to European Art Nouveau. However, by 1903 he, too, veered away from its constricting embrace and adopted the Louis XVI style.

The Cartiers were obviously familiar with Fabergé's exhibits at the world's fair, which, alongside the miniature crown jewels, the imperial Easter eggs, and the celebrated *Lilies of the Valley Basket* (see fig. 1.5), also included flowers and enameled objects as well as miniature animal sculptures. Indeed, the French firm's sole imperial egg frame (fig. 4.1) was plagiarized from Fabergé's miniature crown jewels. Fabergé's success may have encouraged Cartier to prospect the Russian market. In 1904 and again in 1905, the Cartiers decided to send young Pierre, the third of Alfred's sons, to Russia with instructions to familiarize himself with the market and to obtain and commission works of art similar to Fabergé's in St. Petersburg—presumably with a view to developing a parallel market in Paris. A file of correspondence between Cartier Paris and representatives in St. Petersburg and Moscow[16] begins January 7, 1904, with a letter to "Svietchnikov" (probably Ekaterinburg gem cutter Aleksandr Iakovlevich Svechnikov). The inquiry concerns some animal figures and the acquisition of amethyst bead necklaces from Carl Woerffel, one of Fabergé's main sources of hardstone objects and animals. A letter written three weeks later to an M. Yahr (also spelled "Yarh") at "Liubianka, Malyi Kisel'nyi street, Ovchenikov house, apt. 7" in Moscow discusses molds sent from Paris and mentions the stone objects acquired from Svechnikov that were to be sent to Moscow for mounting by Yahr. There follows a request for samples of his enamel colors and further letters regarding electric bells and paper knives, cigarette cases, frames (Yahr was to engrave "Cartier" on their ivory backs), and match cases. The correspondence also discusses drawings to be mailed from Paris for a broad array of objects, including an "appareil photo [camera]" frame (fig. 4.2). Later letters confirm the list of thirty-six hardstone objects being sent from St. Petersburg, including paper knives, seals, electric bells, circular nephrite frames, pen rests, *charki,* ashtrays, and inkwells, all to be mounted by Yahr.

Cartier's Paris stock books[17] listing acquisitions from Russia begin in February/March 1904 with a series of fourteen enameled silver-gilt frames from Yahr, which read like descriptions of articles by Fabergé: an "upright rectangular frame, white enamel on silver, silver-gilt strut, gold border, applied with 4 arrow motifs and wreaths" (869) and a "circular silver frame, gold ribbon knot and border, purple enamel on silver, ivory back, silver-gilt strut" (873).[18]

The orders sent from Paris to Yahr, who in 1905 had moved to 2nd Meshchanskaia house 22, all date from 1904 to 1907 and include fifty-one boxes (mostly cigarette cases, but also bonbonnières and *boites à cachou*), thirty frames, twenty-nine ashtrays, ten lighters, eight moustache combs, seven loupes, seven cane handles, five erasers, and a number of other articles—a total of about 165 pieces. Throughout Cartier's relationship with Yahr, the Paris firm complains of late deliveries, faulty enamels, and high prices. Cartier apparently had every intention of entrusting Yahr with the production of all enameled wares, sending numerous models and designs to Moscow. Yahr's procrastinations, however, as well as many damages incurred during transport obliged the firm to turn to Parisian suppliers.

The Yahr workshop in Moscow, of which nothing else is apparently known, poses something of an enigma. The workmanship of the only Cartier object identified with certainty as a Yahr product—the photograph frame shaped as a camera (fig. 4.2)—is strongly reminiscent of Fabergé's Moscow pieces, in particular a frame shaped as a painting on an easel (fig. 4.3) and another on a tripod foot in the royal Danish collection dating from 1890–1908.[19] Unlike craftsmen in St. Petersburg, Moscow

FIGURE 4.3: Fabergé, *Frame in the Shape of a Painting on an Easel,* 1899–1908; gold, enamel, diamonds; height 6 1/16 in. (15.4 cm). Woolf Family Collection.

artisans did not sign their pieces. Thus only a few workmaster's names can be connected with Moscow. One important example is Gustav Jahr, originally of the Baltic region, who supervised one of Fabergé's Moscow workshops (evidently dedicated to the production of objects of art) and created "very many cigarette cases . . . in gold, silver and enamel."[20] Moscow cigarette cases by Jahr probably include such exceptional examples as the *Aesthetic Movement Case* in the Link of Times Foundation Collection[21] and the well-known blue enamel case entwined by a snake in the Royal Collection.[22] Interestingly, Jahr's oeuvre for Fabergé shows motifs reminiscent of Cartier. In a letter dated October 27, 1905 (p. 106), Cartier advises Yahr to "remain independent of Faberg [*sic*]." Although Yahr affirmed that he had never worked for other houses (p. 151), this was obviously not the case.

It is likely that Yahr and Jahr were one and the same workmaster, who, probably not under an exclusive contract, produced enameled works for both Fabergé and Cartier, and mounted hardstone objects for both as well. Randomly chosen objects ordered from Yahr, as recorded in Cartier's stock books, read like descriptions of Fabergé models: an "electric bell for office, dark wood, silver-gilt mount, garnet push-piece in

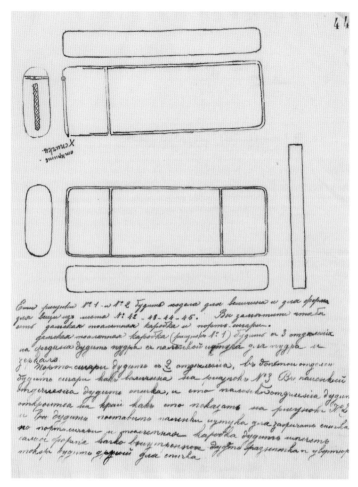

FIGURE 4.4: Cartier, *Sketches for cigarette cases,* 1904–6. Cartier Archives, Paris.

laurel-leaf mount" (877); a "pear brush-pot, jade, silver mount" (937); a "paper-knife, nephrite, blue enamel, painted garlands, ½ pearl border, 1 cabochon ruby" (989); and an "ashtray, heart-shaped, red enamel border with white enamel ties" (540).

The Cartiers sent designs to Moscow for a cigar case (fig. 4.4), *necessaires,* cigarette cases, writing implements, and ornaments for wooden boxes (pp. 43–45). They then criticized the quality of Yahr's white and pink enamels (pp. 47, 51), asking him to reduce his costs, and requested two articles in gold in order to compare his prices with those in Paris (p. 65). Cartier did, however, proceed with an order for three card cases and nine cigarette cases and carried through with its shipment of Sèvres porcelain, presumably for Yahr to mount. During the Russo-Japanese War of 1904–5, Yahr suggested having the ordered enamels executed in Paris instead of Moscow, presumably because his enamellers were all enlisted. Cartier refused. In October 1904 Cartier inquired about his January order for 160 to 170 objects, of which seventy to eighty had not yet been made.[23]

Another letter in 1907 questioned Yahr about a cigarette case that was designed for him by Cartier three years earlier and never delivered; it had since appeared in the

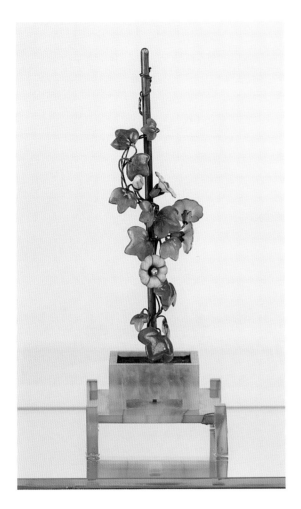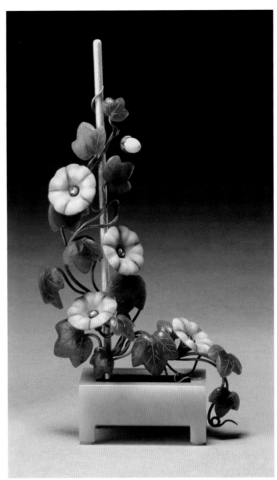

showcase of a rue de la Paix competitor (pp. 155–57). Finally, in August 1907, Cartier complained to the Russian workmaster: "The [Fabergé] factory in Moscow continues to make novelties. It would be interesting for us that you keep yourself informed of this and that you send us drawings of these newest productions as often as possible" (p. 157). By that time Cartier had found craftsmen in Paris to fulfill all orders, and the correspondence with Yahr ceased.

An unexpected find in the early Cartier ledgers is the firm's record of a "liseron," or *convolvulus* (morning glory), in a glass vitrine (fig. 4.5) purchased from Yahr between 1907 and 1914 (though probably closer to the earlier date). This transaction indicates that such plants in glass cases, hitherto associated exclusively with Cartier, were actually being created in Russia and might have served Cartier as prototypes for his earliest flowers. A very similar *convolvulus* was sold by Fabergé's London branch in 1908 and is today in the Royal Collection (fig. 4.6). Another Russian acquisition of Cartier's links the firm even closer to Fabergé. An entry in the same ledger describes a glass case containing a gold-and-enamel cornflower and oat spray in a rock-crystal vase bought by Albert Stopford from Fabergé on behalf of Cartier in 1910 (fig. 4.7).

FIGURE 4.5: Cartier, *Convolvulus,* ca. 1907, workmaster Yahr; silver, enamel, jade basalet, agate, wood, glass; case height 7 ½ in. (19.1 cm). Property of a descendant of Lazare Weiller.

FIGURE 4.6: Fabergé, *Convolvulus,* ca. 1908; bowenite, gold, nephrite, enamel, diamond; height 4 ⁷⁄₁₆ in. (11.3 cm). Royal Collection Enterprises, London.

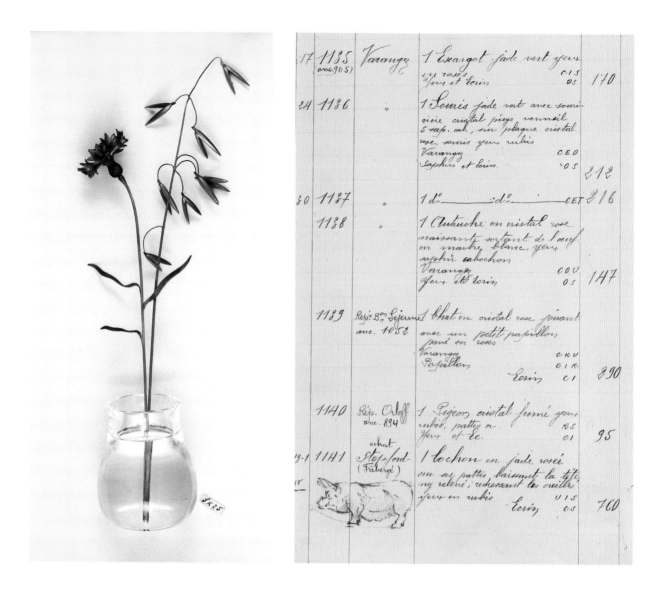

FIGURE 4.7: Fabergé, *Cornflower and Oat Spray*, ca. 1910 photograph. Cartier Archives, Paris.

FIGURE 4.8: Page from Cartier's stock book of Russian acquisitions, 1909–10. Cartier Archives, Paris.

The entry is labeled with the firm's stamp "MODÈLE" — proof, if need be, of the influence of Fabergé on the French master's output at that time.

Another interesting account was reported in 1914 by Cartier's agent in St. Petersburg, Désiré Sarda, who had seen a daisy in a crystal vase in a glass case, presumably a Russian creation, that resembled "those from the rue de la Paix, except that it is less fussy, simpler and more lifelike." A "white sweet pea, stalk in nephrite, blossom in white quartz, small rock crystal vase, in a case of facetted glass mounted in silver-gilt on an amaranth wood base" appears among thirty-four flowers included in an inventory of Grand Duchess Maria Pavlovna's belongings at her St. Petersburg palace five days after the 1917 October Revolution[24] — was it from Cartier or from Fabergé?

Besides obtaining other jewelers' designs or actual objects for copying, the practice of acquiring items from competitors to sell under one's own name was also common. Cartier, for example, purchased six hardstone animals from Fabergé in 1910 (also

FIGURE 4.9: Page from Cartier's stock book of Russian acquisitions, 1909–10. Cartier Archives, Paris.

through the intermediary of Stopford) and sold them in Paris as Cartier creations. In the firm's ledgers these appear as "a pink jade pig with lowered head and raised snout, perked up ears and ruby eyes" (1141) and a "watchful red cornelian fox, his body half-turned, with rose-cut diamond eyes" (1142). Both are drawn in the ledger's margin (figs. 4.8 and 4.9).[25]

The Prokopii Ovchinnikov firm[26] of Ekaterinburg sold about ninety hardstone objects to Cartier from its St. Petersburg premises, most of these in 1904–5 with a few later additions in 1911. They were primarily parasol or cane handles but also included twenty-nine animal figures. One such animal, a "gros elephant néphrite yeux brilliants" (large nephrite elephant, circular-cut diamond eyes) (148), was acquired by Cartier from Ovchinnikov in 1904. It was purchased by J. P. Morgan as a gift for his companion, Mrs. Adelaide Douglas, and is today in the collection of a descendant (fig. 4.10). The figure would normally have been automatically ascribed

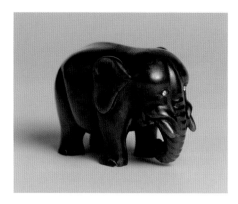

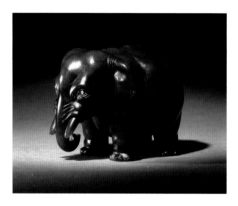

FIGURE 4.10: Cartier, *Elephant,* acquired from Ovchinnikov in 1904; nephrite, diamonds; height 2⅜ in. (6.1 cm). Private collection, Paris.

FIGURE 4.11: Fabergé, *Elephant,* ca. 1900–1910; nephrite, diamonds; height 2¾ in. (7 cm). Private collection.

FIGURE 4.12: Three pages from Cartier's stock book of Russian acquisitions from Ural'skii in 1911. Cartier Archives, Paris.

to Fabergé, who indeed produced or retailed virtually identical elephants (fig. 4.11), illustrating the problems raised by this type of cross-fertilization. Curiously, there is no mention in Cartier's sales ledgers of the thirty-six hardstone articles ordered from "Svietchnikov" in St. Petersburg in early 1904 and referred to in the firm's correspondence with Yahr. This was probably the lapidary Aleksandr Iakovlevich Svechnikov from Ekaterinburg.

Cartier's acquisitions from A. K. Denisov-Ural'skii,[27] the celebrated Siberian hardstone specialist and Fabergé's neighbor on Bol'shaia Morskaia Street, date from 1910 to 1913. Among the impressive total of almost one hundred pieces were sixty-two animal figures, eight vegetable brush-pots, seven vases, and six ashtrays. Twelve of the animal figures are illustrated in Cartier's ledgers: a jasper hare, a jadeite pig, two owls, a jade frog, a jadeite cat, a tigereye tiger, a nephrite goat, a nephrite dromedary, a white onyx bear, an eagle, and a composite head of a cockerel (fig. 4.12).[28] Two of these are very similar to figures in the Lillian Thomas Pratt Collection, an "ours onyx blanc, yeux émeraudes" (white onyx bear, emerald eyes) (cat. no. 263) and an "hibou obsidienne rose, yeux en oeuil de tigre" (pink obsidian owl, tigereye eyes) (cat. no. 96).

The firm of Carl Woerffel sold twenty-seven hardstone articles to Cartier in 1911 and 1912, including eleven ashtrays, nine flacons, and six vegetable-shaped brush pots. Cartier also bought two cloisonné enamel boxes from Kharitonov in 1904 and, in 1906, a miniature version of the gold Crown of Saitaphernes, the original of which was acquired by the Louvre in 1896 amid great celebration of its attributed third-century BC date. In reality, it was a forgery fabricated by the Odessa goldsmith Israel Rouchomovsky.

On February 20, 1904, Cartier acquired a special group of what appear to have been Japanese Meiji bronze and ivory sculptures, intended to "serve as models." These included an ivory elephant, a rabbit, an owl, a mouse with lowered head, a mouse with raised head, a bronze charging elephant, a young dog scratching, a cat playing with a butterfly, a reclining cow, a reclining stag, and a reclining tiger. A same such "furious elephant (large), nephrite, ruby eyes" (275) supplied to Cartier by J. P. Worth in November 1905 was sold to the Duke de Montpensier. Another nephrite elephant of similar description was fashioned by Varangoz for Cartier (278). In VMFA's Pratt collection, there is a large rogue elephant in nephrite with diamond eyes (cat. no. 264). Though sold as a Fabergé work, it is probably a Cartier model based on a Japanese original.

Following the first Russian shopping spree in 1904, Cartier began acquiring or commissioning such objects, mostly in Paris from a variety of sources. In all, some 1,300 animal figures were retailed by Cartier between 1904 and 1919. Of 410 animals listed in the ledgers (items 101–511), 265 were commissioned from Varangoz,

11		
i 11	1199 bis	Varangoz
18	1200	S. Layabro
	1201	Varangoz
23	1202	Achat Boggis Londres
26	1203	Dénissof Petersbourg
δ	1204	δ.

26	1205	Dénissof Petersbourg
δ	1206	δ
δ	1207	δ
δ	1208	δ
δ	1209	δ
δ	1210	δ

1911 Mai 26	1211	Dénissof Petersbourg
δ	1212	δ
δ	1213	δ
δ	1214	δ
δ	1215	δ°
δ	1216	δ°
δ	1217	δ°

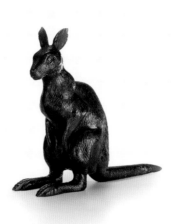
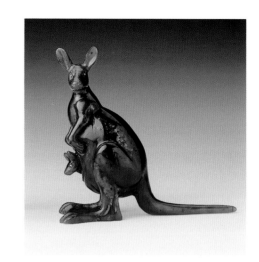

FIGURE 4.13: Cartier, *Kangaroo,* ca. 1905–10; nephrite, diamonds; height 2 15/16 in. (7.4 cm). Musée des Arts Décoratifs, Paris (Inv. 36247.64, 65).

FIGURE 4.14: Fabergé, *Kangaroo,* ca. 1913; nephrite, diamonds; height 3 7/16 in. (8.8 cm). Royal Collection Enterprises, London.

twenty-seven from J. P. Worth, fifteen from Césard, ten from Langweil, seven from London, four from both Mathey and Duchet, three from Févrille and from Chazalou, two from Piking, and one each from Lavabre and Tallerie de Royal. One may well ask what has become of these Fabergé look-alikes, since only a handful have yet been identified thanks to their original Cartier cases. These include a pair of kangaroos, one in agate and the other in nephrite (fig. 4.13), in their original green Morocco case, part of a bequest made by Consuelo, Duchess of Manchester. They are very similar both in aspect and size to a kangaroo in the collection of Queen Elizabeth II acquired by King George V from Fabergé's London branch in November 1913 (fig. 4.14). Other examples illustrating the comparable relationship between the two jewelers' animals are a 1907 Cartier agate mouse by Varangoz (fig. 4.15) that resembles numerous mice by Fabergé (fig. 4.16) as well as a Cartier agate squirrel and a toucan that both exist as identical Fabergé models. An obsidian hornbill labeled "condor" (cat. no. 267) was sold as a Fabergé animal to Mrs. Pratt, but is here identified as a Cartier work.

Cartier's French suppliers apparently copied Russian animal carvings based on the firm's acquisitions in St. Petersburg. Thus, "seal, mobile, on block of rock crystal" (131), bought from Ovchinnikov in December 1904, is replicated as "obsidian seal on rock crystal base, diamond eyes" (240) by Varangoz in 1905. A 1906 "kangaroo grey agate, green olivine eyes" (458) from Ovchinnikov becomes a "kangaroo, grey agate, diamond eyes" by Varangoz (379).[29] Such revelations raise further questions about other animal carvings in the Pratt collection sold as Fabergé creations. Some are evidently by Cartier. They include a chalcedony hummingbird on a purpurine base (cat. no. 269); a pair of amethyst lovebirds on a nephrite base (cat. no. 273); and a quartz owl on a lapis base (cat. no. 274). All three have forged Fabergé signatures that were applied later. To these could be added a lapis lazuli pig (cat. no. 265), a serpentine rabbit (cat. no. 266), and the series of three smoky-quartz bulldogs (cat. nos. 268, 270, and 271).[30]

Cartier's ties to Russia were strongly enhanced by Grand Duchess Ksenia's visit to rue de la Paix in 1906 and Dowager Empress Maria Feodorovna's in 1907. Correspondence[31] between the firm's own Paul Cheyrouze and Désiré Sarda mentions sales of a *collier serre-cou* to Prince Iusupov, a *bayadière* for Countess Sheremeteva, and "a parcel which I entrust into your good hands for Her Majesty" (vol. I, p. 178, September 14, 1908). There is also correspondence between Pierre Cartier, Cheyrouze, and Grand Duchess Maria Pavlovna regarding an important diadem (vol. I, pp. 182, 184, November 1908) as well as letters about another diadem for Count Moy[32] that was being dispatched though the German Embassy. Additionally, a letter to Prince Iusupov discusses the princess's *collier de chien*, which had not yet been received. The first volume closes with a list of Cartier's Russian clients. On December 2, 1908, Paul Cheyrouze departed Paris by train to St. Petersburg in the company of Karl Fabergé. Upon his arrival six days later, Cheyrouze rented premises at 28 Quai de la Cour from Grand Duchess Maria Pavlovna at a cost of 900 rubles for two months.[33]

The second volume in the Cartier archives, containing copies of correspondence sent from St. Petersburg to Paris, begins with a letter from Cheyrouze dated December 8/9, 1908, only a week after he had left. "We are fully installed at quai de la Cour," he reports, mentioning his first visitor, a M. Westrach, director of Northern Bank, who was "just about to go to Faberger [*sic*]." "I am only buying something for 400 fr., but I will send you my friends, and I will return," Westrach promised (vol. II, p. 1). A letter from Cheyrouze to Dowager Empress Maria Feodorovna at Gatchina refers to three boxes of jewels that he had sent on approval, one containing items chosen by Grand Duchess Ksenia (vol. I, p. 187). Another letter asks for her protection as well as her influence with Louis Cartier in hopes of installing a permanent office (vol. II, p. 3), and a third requests her help in being received by the tsaritsa.

The same month, Cartier sent 562 personal invitations to potential clients for an exhibition of the firm's stock, apparently angering the local competition, which proceeded

FIGURE 4.15: Cartier, *Mouse,* 1905–10; agate, peridots; length 1¹¹⁄₁₆ in. (4.3 cm). Private collection.

FIGURE 4.16: Fabergé, *Mouse,* ca. 1910; chalcedony, silver, diamonds; length 2¹⁄₁₆ in. (5.2 cm). Private collection.

to "set about spreading rumors of Cartier's fabulous prices" (vol. II, p. 11). Correspondence contains a proud declaration from Cheyrouze to Cartier: "I am in order with the Government, the Police, Customs, with the Foreign Police, with the Owner, and with everyone" (vol. II, p. 21). On December 21, Cheyrouze was received by the tsar and tsaritsa in Tsarskoe Selo, though they selected only a brooch from the stock, apparently because they "first had to consider their own jewelers." Two days later Cheyrouze reports on a charity bazaar held at the Cercle de la Noblesse (Club of Nobility) by Grand Duchess Maria Pavlovna (vol. II, p. 30). Cartier was represented there by the most modern and finely crafted platinum-and-diamond jewelry, tiaras, a ruby-and-diamond necklace from the French crown jewels, thirty-five watches and clocks, fifteen egg-shaped fobs, and a green-and-blue enameled egg-shaped frame inspired by Fabergé (fig. 4.1). A visit was then made to the unmarried Grand Duke Nikolai Mikhailovich ("is very rich and pays very well"). The Christmas season closed with a deficit of about 6,500 rubles despite sales of 29,534 rubles.

Accounts from Cartier Paris list numerous acquisitions by imperial family members as well as the highest of St. Petersburg society. Dowager Empress Maria Feodorovna's purchases included an onyx-and-diamond brooch (935 francs) on April 18, 1914, and a fluorine carving of a duck (375 francs) on December 31, 1908. Her son, Tsar Nicholas II, bought three pieces in December 1903: a crown-shaped pearl-and-diamond brooch (1,050 francs); a ruby-and-diamond brooch (3,100 francs); and an emerald-and-diamond brooch (2,900 francs). He added a bow-shaped diamond brooch (2,600 francs) in 1911. Tsaritsa Alexandra Feodorovna paid 5,300 francs for a necklace with two pearls in 1908 and 550 francs for a pendant watch with three pearls in 1910. Their daughter Anastasia spent 1,400 rubles on a diamond-set watch in 1913.[34]

On July 11, 1907, Cartier wrote to the chancellery of the Russian Embassy presumably seeking the designation of "Supplier to the Court," listing all the members of the imperial family with "open accounts," including the dowager empress; Grand Duchess Ksenia; Grand Duke Kirill; Grand Duchess Maria Pavlovna; and the grand dukes Aleksandr, Vladimir, Kirill, Boris, Aleksii, Pavel, Nikolai, and Georgii. Nearly a year later the firm made a second appeal—for the title of "Supplier to His Majesty the Emperor of all the Russias, having already received a similar distinction from the Dowager Empress." The chancellery responded the next year, declaring that such a title was nonexistent in Russia and that the correct title of "Supplier to the Court of H. M. the Emperor" had already been awarded to Cartier on August 18, 1907, by request of the dowager empress.

In January 1909 there was talk of the possible sale of a 71,000-ruble necklace to Countess Sheremeteva: "The Count and Countess Cheremetieff are considered here by all as the richest in St. Petersburg. She is very much courted by Faberger [*sic*],

Bolin and others" (vol. II, pp. 61–63). Louis Cartier traveled to St. Petersburg in March to deliver Grand Duchess Maria Pavlovna's valuable cabochon-sapphire-and-diamond tiara. While there, he corresponded with her about an order totaling 175,000 francs (65,000 rubles) for a stomacher with a large central sapphire supplied by Cartier and various changes to her *collier de chien*, with diamonds worth 75,000 francs, leaving 100,000 francs to be paid over three years (vol. II, p. 136). In January of the following year, the grand duchess received the magnificent stomacher and necklace from Cartier's agent Léon Farinès (vol. II, p. 156). "Delivery made to W. Highness delighted in all points," Farinès reported. He also recorded her high compliments: "Cartier has always made the most ravishing things for me, which suited me best, and which I wear with the greatest pleasure" and, to the agent himself, "You can be proud of the work of your firm" (vol. II, p. 157).

On December 15, 1910, Louis Cartier arrived again in St. Petersburg, laden with exhibits for Grand Duchess Maria Pavlovna's Christmas Bazaar. The following day, part of his stock (forty-four watches and two large jewels) was confiscated by customs officials due to a denunciation made by local competitors. He sent a reassuring telegram to Paris: "Have bad calumnious accusation by Russian colleagues for smuggling—innocence recognized, but part of stock with the *Controle*" (vol. II, p. 235). On December 22, Louis Cartier wrote to a Captain Savourski at 27 Millionnaia, "I learn this very evening that in spite of . . . a favorable opinion from Customs, the jewelers of St. Petersburg are trying to obtain against me a decision forbidding me to return to Russia. They are also trying to confuse the case, which is good, with that of the house of C. [Chaumet], which, I fear, is not . . . yet another ugly maneuver against me" (vol. II, pp. 241–42). Cartier sent increasingly desperate letters to the customs agency and the minister of the interior: "I can explain the incoherence of this matter only by the wish to harm an unaware foreign colleague" (vol. II, pp. 256, 260). Jealous, competing jewelers, presumably Bolin and Fabergé, had somehow learned that Cartier had omitted to pay duty on gold items (the majority of his exhibits were platinum jewels not subject to such fees). Thanks to Cartier's official title and presumably the influence of his patrons, the dowager empress and Grand Duchess Maria Pavlovna,[35] the objects were released. "Ninety brooches, nineteen necklaces, including one in the Arabian style, thirteen tiaras, including a *kokoshnik* with seven drop diamonds, a winged tiara and sixty-nine timepieces of varying sizes, of which twenty-seven were wristwatches" were displayed with great success, and sales totaled 22,435 rubles (vol. II, p. 259), of which 10 percent was to be distributed to the poor. After his initial troubles, Louis had also written to Paris concerning a diadem for Madame Aubrezat: "This project should not cost more than 2000 rubles salesprice, or 5,300 fr. We give you an idea of Fabergé's design for 1500 rubles" (vol. II, p. 246). Undercutting Faberge's price was a small revenge on the local competitor. Finally, another telegram was sent to Paris: "Contradict all disquieting news. Have had certain

pieces confiscated by customs based on calumnious accusation of Russian colleagues, but not for smuggling. Be reassured, will clearly establish facts with ministers and will stop press campaign [against me]" (vol. II, p. 258). There is mention of Pierre Cartier and Chaumet having to leave St. Petersburg precipitously that month.

From this Russian trip, Cartier took home photographs of Fabergé's Easter eggs. The most important sale during the 1911 Christmas season was a sapphire necklace suspending a 311-carat star sapphire to Grand Duke Kirill. In 1912 the Paris City Council acquired from Cartier the firm's sole attempt at an imperial "Easter egg," or rather the egg-shaped frame, crafted in 1906 (fig. 4.1). It was ceremoniously presented to Tsar Nicholas II at Tsarskoe Selo the same year.

In early 1912 the St. Petersburg newspapers printed an announcement issued by the city's traders: "The business community of St. Petersburg intends to file a complaint about foreign competitors with the Ministry of Trade and Industry. The individuals concerned have been involved in illegal private transactions [in hotel rooms], have not paid taxes or patent annuities, and their merchandise has not been cleared through customs." Although couched in general terms, the statement may well have been published at the request of Bolin and Fabergé and aimed in particular at Cartier and Chaumet. Was the notice engendered by another rash of invitations sent out by Cartier on February 26 for an exhibition at the Hotel de l'Europe opening March 12?

The year of the Romanov family's tercentenary celebrations, 1913, saw the sale of a large diamond to Grand Duchess Maria Pavlovna and a series of platinum-mesh evening bags, including one to Prince Iusupov. Early in the fateful year of 1914, Grand Duchess Vladimir acquired a 39.25-carat pear-shaped diamond for 45,600 rubles with deferred payment over three years. The last grand imperial wedding of tsarist Russia, between Princess Irina, eldest daughter of Grand Duchess Ksenia and Grand Duke Aleksandr Mikhailovich, and the fabulously wealthy Prince Feliks Iusupov, took place on February 22. The attribution of the *corbeille de mariage* must have been hotly disputed between all jewelers. Chaumet was awarded the lion's share, but Cartier created the rock-crystal wedding tiara, of which the Paris workshops were extremely proud.

Despite the pleadings of Louis Sarda, the farsighted Louis Cartier did not give his accord for the opening of a full-fledged office in St. Petersburg. Instead, he set his sights on America, opening an office in New York City in 1909 at 712 Fifth Avenue, directed by Pierre Cartier (transferred to 653 Fifth Avenue in 1917). Boucheron, too, opened an office in New York, at 705 Fifth Avenue. In the year following the October Revolution in Russia, Fabergé and two of his sons fled, leaving all behind. Karl Fabergé died in Pully, Switzerland, near Lausanne in 1920. In 1924 two of his sons, Eugen and Alexander, age fifty and forty-seven respectively, attempted to revive the famous Russian brand in Paris together with two former employees of the

company, Andrea Marchetti and Giulio Guerrieri. They advertised for both acquisitions and sales of works by Karl Fabergé and presumably continued with a much reduced production, apparently concentrating on hardstone animals and flowers executed for them in Idar-Oberstein, Germany, based on models of Alexander Fabergé. Meanwhile Cartier advanced from strength to strength, finding his stride with the great exhibition at the Musée des Art Décoratifs in 1925, a time of novel strident colors, jazz, and flappers. Fabergé's historic reminiscences were no longer in vogue. Charles Jacqeau, Cartier's gifted designer, rose to the occasion, creating objects of art and jewels in the new taste, many of them deftly executed by the same Lavabre who had played such an important role during Cartier's Russian years.

While Louis Cartier was Fabergé's main competitor in Russia, he was by no means the only one. The other major French jewelers around 1900—Chaumet, Boucheron, and, to a lesser degree, Lalique—also vied for Fabergé's clientele in St. Petersburg, Moscow, and Kiev.

Boucheron

Frédéric Boucheron[36] made his first important sale to a member of the Russian imperial family in 1871 when Tsesarevich Aleksandr Aleksandrovich (the future Tsar Alexander III) purchased a diamond-set watch and chain with his monogram. The same year, Boucheron supplied Tsar Alexander II with a lavish fitted case for a crown. In 1882 Grand Duchess Maria Pavlovna made her first purchase from Boucheron—a diamond-set vine with three leaves, one of the firm's signature pieces, for 3,450 francs. In 1883, the firm sold a diamond corsage to Prince Feliks Iusupov. Boucheron began to contemplate opening a branch office in Moscow, entrusting Georges Delavigne with the task. The firm participated in the 1891 Moscow exhibition of French art and in 1898 opened an office at Kuznetskii Most, on the same street as Fabergé, thereby brazenly planting the first French flag on Russian soil.

Meanwhile, thanks to his exhibits at the 1889 Paris Universal Exposition, Boucheron advanced to the rank of officer of the French Legion of Honor. During 1893 the jeweler reached a number of personal landmarks: he moved to 26 Place Vendôme, the mansion of Countess de Castiglione; he exhibited at the World's Columbian Exposition in Chicago; he created jewelry for the wedding of King Ferdinand I of Bulgaria and Princess Maria Luisa of Bourbon-Parma, one of many such royal commissions he received; and he sold two button earrings with very large pearls of 95 and 105 grains to Grand Duke Vladimir for 65,000 francs. The following year he sold a "couronette fleurette brilliants and pearls" (a small diadem with diamond and pearl flowers) for 27,500 francs to Tsesarevich Nikolai Aleksandrovich as a gift for his fiancée, Princess Alix of Hesse and by Rhine. She wore it often and, as tsaritsa, also acquired from Boucheron a *sautoir* of diamonds and rubies in 1898.

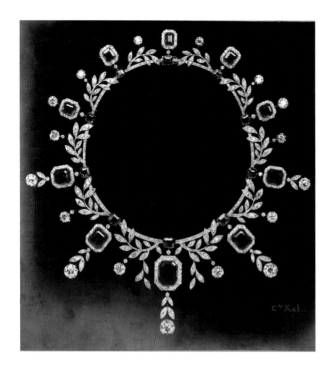
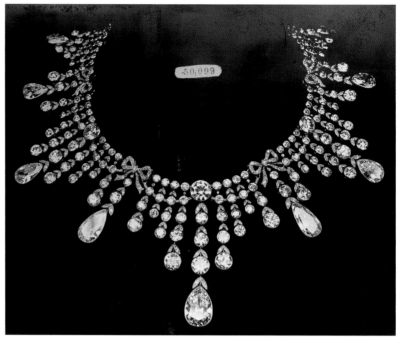

FIGURE 4.17: Emerald-and-diamond necklace by Boucheron for Varvara Kelch, photograph 1906. Boucheron Archives, Paris.

FIGURE 4.18: Diamond necklace by Boucheron for Varvara Kelch, photograph 1906. Boucheron Archives, Paris.

The 1900 Paris world's fair was the crowning moment of Frédéric Boucheron's last years. His extraordinarily lavish jewels in the eighteenth-century style and his extravagant Art Nouveau jewels and objects of art[37] attracted much admiration, earning him a Grand Prix and the rank of commander of the Legion of Honor. His innovations included the use of steel, wood, and ivory and new experiments in jewelry of intrinsically small but highly artistic value, as was also pioneered by Fabergé. Boucheron's choice of objects—handles for canes and parasols, rococo-style clocks, thermometers, cigarette cases, snuffboxes, and bell pushes—also paralleled those of the Russian master, as did their decoration in guilloché enamels (those of Boucheron's often imitating rare textiles).

The Delavignes, father and two sons, were Boucheron's Russian representatives and invested heavily in numerous trips to St. Petersburg, Baku, Kiev, Odessa, and Tiflis to prospect a new clientele, traveling to and from Paris five times. Reportedly, during their 1901 exhibition of jewelry in Baku, a large number of Boucheron's pieces were impounded, presumably because of some alleged infringement of the law governing payment of duty.

A sole register of the activities of the Moscow branch has survived,[38] covering the period of 1901 to 1905. Disappointingly small sales were made during the first year to prestigious clients such as Grand Duchess Elisaveta Feodorovna (sister of the tsaritsa) and her husband, Grand Duke Sergii, governor of Moscow. Fortunately, Boucheron made other sales: Prince Iusupov spent 10,408.25 rubles; Rachel Poliakova, 10,900 rubles; and a Mr. Tagniev, 34,647.75 rubles. In spite of these promising figures, the

year closed with a deficit of 16,130 rubles. The following year's successes included sales to a Mr. S. C. Zubalov (10,900 rubles) and a Mr. S. A. Nazarov (31,875 rubles). Boucheron also exhibited in St. Petersburg in 1902 and 1903, together with Chaumet and Lalique. On October 31, 1904, the firm of Boucheron sold a rich assortment of jewels to Varvara Kelch for 70,000 rubles. Varvara, daughter of a wealthy Moscow mining and railway magnate, and her husband, Aleksandr Ferdinandovich Kelch, furnished their new St. Petersburg mansion with a grand neo-Gothic silver service from Fabergé costing 125,000 rubles. She also received seven grand Fabergé Easter eggs from her husband between 1898 and 1904, all of which have survived.[39]

Boucheron's photographic archives allow further interesting insights into the firm's sales to Russian clients. A signature floral chain with *en tremblant* flowers was sold to Princess Shcherbatova in 1901. Photographs dated 1906 show other extravagant jewels for Varvara Kelch, including an emerald-and-diamond bracelet (the emeralds weighing a total of 10.75 carats), a Louis XVI–style diamond necklace set with ten emeralds (fig. 4.17), and a chain with twenty pendant pear-shaped stones (fig. 4.18). In 1907, one of the firm's most lucrative years, Varvara Kelch purchased two diamond bracelets and a diamond-and-ruby necklace (the latter using her own rubies). In 1910 she acquired a flexible diamond bracelet and another set with five emeralds totaling 7.25 carats. All of these acquisitions were made after her separation from her husband and her move to Paris in 1905 — a departure that must have aggrieved Fabergé some-what, as Kelch's appetite for jewelry was considerable, easily eclipsing her investment in her Fabergé silver service and her Easter eggs. She also acquired a great blue dia-mond from Fabergé that was originally destined for Tsar Nicholas II and reportedly owned a Fabergé diamond necklace with a 30-carat center stone.

Despite these sales, Boucheron's Russian enterprise was not financially successful, mainly because of the high taxes levied on imports by the Russian State. Results peaked in 1903 with sales of 700,000 francs and plummeted to 100,000 francs in 1906, surely due to the aftereffects of the Russo-Japanese war. Only 1903 resulted in a paltry profit of 43,000 francs, while the firm registered its maximum loss, 200,000 francs, in 1906. A final disaster in 1911 sealed the fate of Boucheron's venture in Russia: in 1911 Alfred Delavigne and his son Henri were robbed of jewelry worth 500,000 rubles and murdered on their return journey from a wedding in Kiev. Louis Boucheron, Frédéric's son, closed the Russian operation, entrusting the remaining stock to Alexander Tillander for sale. The photographic archives, however, show evidence of further Kelch acquisitions as late as 1912 (a lavish diamond-set diadem and three ruby-emerald-and-diamond brooches). A marble street sign, presumably dating from 1911 though apparently never used, proudly displays three foreign addresses for the firm of Boucheron: 69 Piccadilly Street, 705 Fifth Avenue, and 26 Nevskii Prospect.[40]

Chaumet

The prestigious House of Chaumet[41] was proud of its early connections to Russia's nobility. Its successes included sales to Princess Bagration, who was faithful to the firm for forty years, and Princess Volkonskaia. The fabulously wealthy Prince Anatolii Demidov; his wife, Princess Mathilde Bonaparte; and his brother, Pavel Demidov, were also loyal customers. In later years Chaumet served an ever-growing Russian clientele, in particular Prince Iusupov and his wife, Tatiana. The Marquise de Païva, a famous courtesan who slept between two safes containing her sumptuous Chaumet jewelry, gold, diamonds, emeralds, and pearls, was a major client of the firm, rivaling Empress Eugénie in her lifestyle. Forever on the quest for new clients, Joseph Chaumet exhibited his creations at the 1900 Paris world's fair, where he won a medal, as well as at fairs in St. Petersburg (1902), St. Louis (1904), Milan (1906), and Buenos Aires (1910). Like Fabergé, he was encouraged by King Edward VII and opened a branch in 1905 in London at 154 New Bond Street, close to Cartier and Fabergé, also moving in 1907 to 12 Place Vendôme. Chaumet shared with Fabergé a client list of virtually every person of social standing in London and Continental Europe.

The wealthiest Russians spent their spring months in France—Biarritz or Deauville or the Riviera—arriving in Paris in early summer. While husbands passed time at the Jockey Club, the women enjoyed regular shopping sprees at the best Parisian jewelers and couturiers. In 1901 Paris reportedly counted some six thousand Russian residents. These temporary visitors included most of Fabergé's Romanov clientele, of which the grandest (and wealthiest) was undoubtedly the formidable Grand Duchess Maria Pavlovna, whose husband was an uncle of Tsar Nicholas II. Her three sons, Boris, Kirill, and Andrei, were faithful patrons as well.[42] Much attracted by Parisian elegance, Maria Pavlovna patronized both Cartier and Chaumet abroad. This patronage and her protection in Russia assured that both Joseph Chaumet and Louis Cartier were awarded the Order of St. Anne and were, presumably to Fabergé's great annoyance, introduced to St. Petersburg society. She was a faithful client of Chaumet from 1898 until 1914. Her first major acquisition, in 1899, was a spectacular "Waterfall Tiara" with nineteen diamond-set "strings" weighing 75 carats, for 75,000 francs.[43] The Francophile grand duchess must have encouraged Chaumet to participate in the 1902 St. Petersburg International Artistic Exposition with Boucheron and Lalique. For this occasion he designed a sumptuous platinum ruby-and-diamond stomacher in the form of a double-headed eagle suspended by strings of pearls from a large *navette*-shaped diamond at each shoulder (fig. 4.19). Chaumet's sales books between 1900 and 1911 list great quantities of jewelry sold to Russian clients.

To cater to this overindulged and distant society, Chaumet dispatched his salesman, a Mr. Farein, as a representative of the firm in St. Petersburg and Moscow beginning in 1902. Farein enjoyed much success due to his apparent capacity for outdrinking

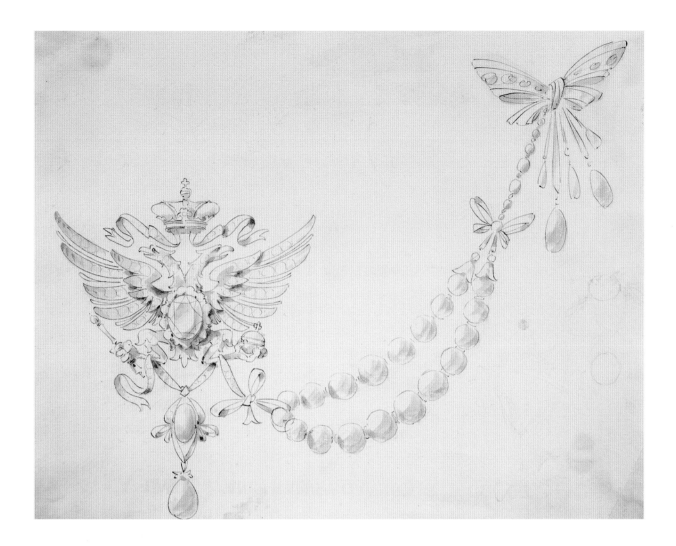

his Russian clients. Following the great demand for *kokoshnik*-shaped diadems or tiaras, one of the firm's specialities, Joseph Chaumet devised an ingenious method of presenting his patrons with a preliminary model in nickel, silver, and colored stones, allowing for any desired modifications. Hundreds of such maquettes line one of Chaumet's salons at Place Vendôme.

In Chaumet's archives is an illustration dated 1912 of a series of miniature Easter eggs created especially for the Russian market.[44] Despite the murder and robbery of Boucheron's representatives the previous year, a Mr. Berthelot was sent in 1912 to Kiev, where he exhibited his wares in a hotel room. The high import duties gave the leading Kievan jeweler and goldsmith, Iosif Marshak (supplier to the court and a Fabergé competitor who founded his firm in 1878), a major advantage over this French intruder. Berthelot complained bitterly about the difficulty in obtaining stock from Paris and was not very successful.

Chaumet's greatest and last triumph in Russia was the January 1914 commission for resetting the Iusupov family jewels for the wedding of Prince Feliks and Princess

FIGURE 4.19: Chaumet, *Design for a ruby-and-diamond stomacher,* 1902. Chaumet Archives, Paris.

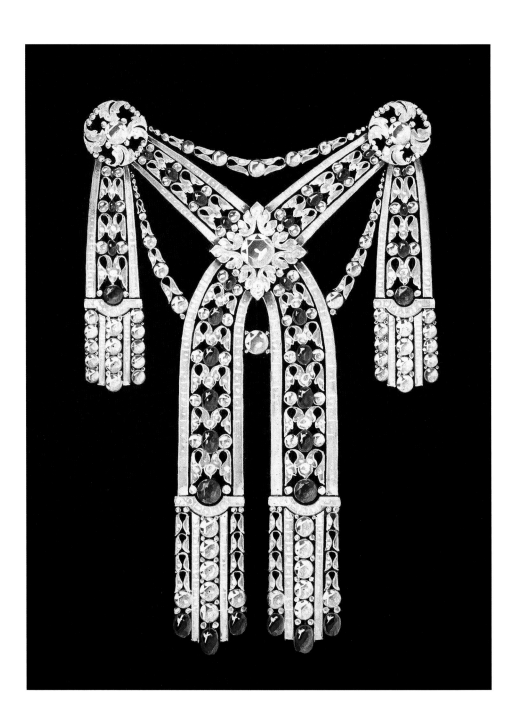

Chaumet, *Design for a stomacher brooch for the Iusupov commission,* 1902. Chaumet Archives, Paris.

Irina, daughter of Grand Duchess Ksenia (sister of Nicholas II) and of Grand Duke Aleksandr Mikhailovich (grandson of Nicholas I). Some of the modifications were completed before the wedding, while others were created in record time by Chaumet beginning in March, when the young couple stopped off in Paris on their honeymoon. Upon their return from Egypt a few months later, they were able to collect five parures of diamonds, pearls, rubies, emeralds, and sapphires on their way to London, where these jewels created a furor. Photographs and colored designs support the popular claim that they are the finest jewels ever produced for the Russian market (fig. 4.20).

Lalique

At the Paris Universal Exposition of 1900, the *dernier cri* was the movement launched by Siegfried Bing in 1895 at his gallery La Maison de l'Art Nouveau. The new style, inspired by Japanese art, negated the influence of any previous idiom. René Lalique[45] was widely recognized as its leading exponent. His incomparable genius and superb craftsmanship were discovered by multimillionaire Calouste Gulbenkian, who from 1899 until World War I financed the jeweler through numerous acquisitions. Many of these, which were included in Lalique's extravagant vitrines at the Paris fair, were acclaimed by a rapturous public. His semiclad females, sphinxes, peacocks, bats, and dragonflies, in horn, ivory, glass, and enamels, engendered a huge following both in France and abroad. The creations earned Lalique a Grand Prix and the Legion of Honor.

Lalique's jewels were well known and admired in Russia. Grand Duke Aleksii Aleksandrovich was apparently one of the first to buy from him and to bring his work to Russia. According to Fabergé designer Franz Birbaum, "it was on [Grand Duke Aleksii's] commission that Lalique made the large *bratina* that was presented to the Moscow Regiment."[46] Early sales to the imperial family included cane knobs and an Art Nouveau fan that was often used by Tsaritsa Alexandra Feodorovna. A show-case with Lalique jewels was included in the first exhibition held in St. Petersburg by the artists of the World of Art movement in 1899. In 1903, Lalique traveled to St. Petersburg, where he participated in the *Contemporary Art* exhibition and was received by the tsar and tsaritsa on February 10, 1903. The travails he endured during this trip, having forgotten his passport, are well documented in a long letter to his wife, Augustine-Alice,[47] which gives a fascinating account of Russian bureaucracy during tsarist times.

The same year, Lalique sold more than seven jewels to the statesman and patron of the arts Aleksandr Aleksandrovich Polovtsov. Additional sales included three jewels to the Stieglitz Museum of Decorative and Applied Arts. Fabergé probably met Lalique in Russia and Paris and was obviously familiar with his jewelry. He was intrigued by Lalique's work, but declared that: "while we recognized the artistic merit of an individual artist's work such as Lalique, we nevertheless considered it would be useless to imitate him, and we were right. Imitators have left nothing that equals his work, but simply lost their own identity. With very few exceptions, which were special commissions, the firm did not produce any significant work in this genre. In a short time, enthusiasm for the modernist style, with the vulgarity of its endless repetitions and the absence of content, began to wane."[48] Despite obvious differences, both artists eschewed objects covered in precious stones and shared an affinity for materials of little intrinsic value such as tortoiseshell, wood, and ivory.

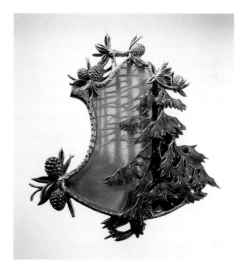

FIGURE 4.21: René Lalique, *Belt Buckle with Stag Beetles,* 1901–2; gold, enamel; height 2 ½ in. (6.4 cm). State Hermitage Museum, St. Petersburg, photograph © The State Hermitage Museum / photo by Vladimir Terebenin, Leonard Kheifets, Yuri Molodkovets.

FIGURE 4.22: René Lalique, *Pendant with Depiction of Winter Landscape,* 1900–1901; gold, enamel, glass; height 6 ¾ in. (17.1 cm). State Hermitage Museum, St. Petersburg, photograph © The State Hermitage Museum / photo by Vladimir Terebenin, Leonard Kheifets, Yuri Molodkovets.

1. For Fabergé works that have been preserved in the royal collections of Continental Europe, see Habsburg 1986, a catalogue of the first exhibition of hundreds of such objects on the Continent. For an auction of Fabergé objects from the Hannover collection, see Sotheby's London, *Imperial and Royal Presents,* November 24, 2008.

2. Habsburg and Lopato 1993, 116–25. Other Russian craftsmen who participated in the Paris world's fair were the jeweler Koechly, the silversmith Ovchinnikov, and the stone carver Denisov-Ural'skii.

3. Those known with certainty to have been included are the 1891 *Pamiat Azova Egg,* the 1898 *Lilies of the Valley Egg*, the 1899 *Pansy Egg,* and the 1900 *Trans-Siberian Railway Egg* (Fabergé, Proler, and Skurlov 1997, illustrated pp. 107, 137, 141, and 151 respectively).

4. Habsburg and Lopato 1993, 121. The actual number of stones set in these jewels is 1,728 brilliant-cut and 4,541 rose-cut diamonds.

5. Bainbridge 1968, 22; Solodkoff and Forbes 1984, 18–31; and Habsburg and Lopato 1993, 124–31.

6. Guitaut 2003. The Royal Collection, easily the largest of its kind, appears to comprise over 500 objects by Fabergé (of which perhaps 350 are animal sculptures).

7. Bainbridge 1968, 53. Bainbridge named Queen Alexandra Fabergé's "Great Patroness in the West."

8. Habsburg 1996, 339–55.

9. Part of her collection is now shown at Middlebury College in Vermont.

10. Cartier's clients from England included the Curzons, the de Greys, the Devonshires, Mrs. Keppel, and the duchesses of Manchester, Roxburghe. and Marlborough; from Russia, the dowager empress, Grand Duchess Ksenia, Grand Duchess Maria Pavlovna, and Grand Duke Mikhail; and from America, Mrs. Goelet, McCormick, J. P. Morgan, and five members of the Vanderbilt family.

11. Habsburg and Lopato 1993, 130. For the collection of the Thai royal family, see Krairiksh 1984.

12. Harrison, Ducamp, and Falino 2008, 152–229.

13. *Stolitsa i usad'ba*, January 15, 1914, pp. 13–14, quoted in McCanless 1994, 26.

14. Still the best publication about Cartier is the pioneering study of Hans Nadelhoffer (Nadelhoffer 1984). For a more recent study, see Rudoe 1997. Cartier's Russian years are specifically covered in Habsburg 2003, 73–87, on which this chapter is partially based. The author was granted free access to the Cartier archives at rue de la Paix and was allowed to publish the information relevant to Cartier's Russian years. He wishes to thank Mme. Betty Jais, Cartier's archivist, for this privilege and also to acknowledge all the help she offered in 2002. All quotes are from two volumes of letters exchanged between Cartier Paris and Cartier St. Petersburg. The French entries for Cartier's acquisitions in Russia are to be found in Habsburg 2003, 441–47.

15. Numerous parallels connect the history of the two illustrious houses of Fabergé and Cartier. Gustav Fabergé, Karl's father, founded his firm in St. Petersburg in 1842; Louis-François Cartier, Alfred's father and Louis's grandfather, began his business in Paris in 1847. Louis's son, Alfred Cartier, was born in 1841, Gustav's son, Karl Fabergé, in 1846. In 1872 Karl officially took over the reigns of his father's firm, and Alfred followed suit in 1874. Fabergé's four sons, Eugen, Agathon, Alexander, and Nikolai, were born in 1874, 1876, 1877, and 1884 respectively. The three Cartier sons, Louis, Pierre, and Jacques, were born in 1875, 1878, and 1884. Alfred Cartier moved to his new premises at 13 rue de la Paix in 1899, the same year that Karl Fabergé acquired land and built his prestigious house at 24 Bol'shaia Morskaia, where he moved in 1900. In 1902 Alfred Cartier opened a branch in London; it was taken over by his youngest son, Jacques, in 1906, who in 1908–9 moved to premises at 175–76 New Bond Street. Fabergé began his London business tentatively from a hotel room in 1903; named his youngest son, Nikolai, as the head of this branch in 1909; and moved to new

premises at 173 New Bond Street in 1911. From 1904 to 1917 both Karl Fabergé and the Cartiers produced or sold works of art that were very similar, including animals and flowers of semiprecious stones, enameled objects, and Easter eggs. Moreover, they soon shared the same clientele. Karl Fabergé and Louis Cartier probably met in Paris in 1900 at the world's fair and also in St. Petersburg between 1908 and 1911. Both firms successfully made use of their London offices to prospect the Near and Far East, in particular the Indian Subcontinent. Both were passionate collectors of Indo-Persian miniatures. Karl Fabergé and Alfred Cartier died within five years of each other, Karl in 1920, Alfred in 1925. The comparison between the two firms ends there.

16. "Correspondence with Russia" (Correspondence Russie), vol. 1, 1904–9 (215 pages of 500), Cartier Archives, Paris (Habsburg 2003, 438–40). Original page numbers are noted in text throughout this chapter.

17. Ibid., "Acquisitions, Russia,"(Achats, Russie). Original stock-book item numbers are noted in text throughout this chapter.

18. The listings continue with: a "rectangular frame, white enamel border, oval aperture with ½ pearl bezel, chased gold, laurel leaf and tied ribbon, mauve enamel ground, gold mount, silver-gilt strut" (941); a "green enamel loupe, opalescent white enamel handle painted with laurels, suspension ring" (1537); a "mushroom-shaped yellow enamel parasol handle, grey camaieu decoration, gold mount" (1859); and a "rectangular nécessaire, 3 compartments, mauve enamel, opalescent white enamel border painted with Louis XVI laurels, 3 diamond thumb-pieces in Louis XVI mounts, silver-gilt mount" (1907).

19. Habsburg 2000, 125.

20. Bainbridge 1968, 131.

21. Habsburg 2000, 126, cat. 200A.

22. Ibid., 132, cat. 224.

23. In October further orders were sent to Yahr for three cigarette cases, two *nécessaires*, eighteen lipstick tubes, two loupes, four electric bells, four seal cases, three clocks, seven loupes, six powder compacts, five match cases, and five pin cases. Paris was to send models for clocks (p. 87). Further orders were sent for double bell pushes, flacons vases, eggs, and paper knives (pp. 92, 94, 96. 102).

24. Habsburg 2003, 104–117; see also Chapter 7 in the present catalogue.

25. Other animals listed among the acquisitions from Fabergé are an "obsidian penguin with raised beak and rose-cut diamond eyes, perched on a rock crystal cracked ice slab" (1143); a "petrified wood owl with olivine eyes" (1144); a "standing bear in brown jade with front paws lowered and crossed with olivine eyes" (1145); and a "pink jade duckling, head cocked to the right, emerald eyes and gold feet"(1146).

26. Prokopii was perhaps a member of the celebrated Pavel Ovchinnikov family, who ran a branch of their Moscow firm in St. Petersburg at 35 Bol'shaia Morskaia until 1915. Prokopii Ovchinnikov, whose hardstone animal figures appear in boxes stamped St. Petersburg, was well known in his time (see Muntian, Guitaut, and Krog 2005, 117).

27. For Denisov-Ural'skii, see ibid., 117–120.

28. Animals listed but not illustrated include a jasper aurochs; a jasper turtle; pigeons; swallows; a series of mice in quartz, jade, obsidian, and rock crystal; a jasper marabou; sparrows; and various composite animal figures for which Denisov was famous, such as a purpurine, lapis, nephrite, and jasper parrot and a quite sizable cockerel, "13 cm from bead to tail, orletz and jasper head, tiger eye crest and back pegmatite, obsidian and tiger-eye wings and labradorite tail, grey Ural granite front, yellow jasper feet."

29. Ovchinnikov's 1905 "green jade frog, brilliant eyes" (200) was revived as a 1905 or 1908 model by Varangoz: "frog, brown agate, ruby eyes" (259) or "frog, grey agate, olivine eyes" (896). Ovchinnikov's "head of an owl made into electric bell with red enamel eyes" (328) is known both in a Cartier and a Fabergé version. Descriptions of numerous early Cartier animals in the firm's ledgers can easily be confounded with carvings by Fabergé. Thus there is a 1905 "pink agate wild boar, brilliant-cut eyes"(205); a "squirrel, pink and white agate, 2 brills"; an "owl, striated agate on silver-gilt perch, emerald eyes (220); a 1905 "pelican, pink agate, brilliant-cut eyes, silver-gilt feet" (224); a 1905 "mouse, yellow topaz, holding its tail, rose-cut diamond eyes" (262); a 1905 "basset hound, pink agate, diamond eyes" (315); and a "bulldog, milky agate, ruby eyes" of 1908 (ill. 972) sold to Grand Duke Mikhail Mikhailovich. These are all by Varangoz, Cartier's main supplier of animal carvings. There are also rabbits in rhodonite, chalcedony, pink quartz, amethyst, various hues of agate, aventurine quartz, and amazonite and pigeons with silver-gilt feet and diamond eyes in jasper, aventurine quartz, sapphirine, sunstone, and jade.

30. Cartier's own creations obviously appealed to Fabergé's Russian clientele. Sales included a "pair of parrots, cornelian, silver-gilt feet, ivory perch, 2 sapphires at ends, on grey agate base" sold to Grand Duke Pavel (350) and a "chrysophrase frog on nephrite lily" from Fréville in 1907, sold to Prince Iusupov (572). Cartier's signature figurine of a "chick (large) hatching from a broken egg," based on a model possibly first produced in Ekaterinburg, appears as a 1907 figure from the Varangoz workshop, sold to Grand Duke Aleksii; a "pink quartz swimming (?) stork with rose-cut diamond eyes" from Varangoz was sold to Grand Duchess Ksenia in 1903 (830); while Varangoz's "3 pink agate chicks, green jade feeding trough, gold feet, diamond eyes" were acquired by Grand Duke Aleksandr in 1909. Also by Varangoz was Cartier's popular model of a "kingfisher, pink quartz, seated on bamboo, looking at rock crystal block, cabochon sapphire eyes" (909) sold to Grand Duke Nikolai in 1909; and a "fluorine duck, Japanese model, 2 rose-cut diamonds" sold to the dowager empress in the same year.

31. The letters, copies of which are glued into two volumes in the Cartier Archives ("Correspondence Russie") cover the period from December 9, 1908 to December 31, 1910.

32. Illustrated in Habsburg 2003, 411, cat. 870.

33. The exchange rate between the ruble and the British pound, U.S. dollar, and French franc was unchanged from 1897 to 1913 (1 ruble = £0.43 = $2.1 = 2.5 francs).

34. Among the rich Russian grand dukes and grand duchesses, Grand Duke Pavel began a large-scale buying spree in 1902–3, with two necklaces, a large stomacher brooch, and a diadem. In 1903–4 this brother of Alexander III acquired twenty-nine items and a further sixty-nine articles between 1903 and 1906. On January 22, 1908, he was recorded as having spent an incredible 420,000 francs on a diadem with seven pear-shaped diamonds; on April 13, 100,000 francs. on a sapphire and diamond diadem. His morganatic wife, Countess von Hohenfelsen, another great jewelry buff, acquired sixty-seven items between 1908 and 1914, including three necklaces. Grand Duke Aleksandr, son of Grand Duke Mikhail and husband of Grand Duchess Ksenia, whose name appears between 1906 and 1913, bought a sapphire-and-diamond brooch for 36,000 francs. Ksenia was a frequent client in 1908, acquiring a "swimming stork," a Japanese goat, a large agate rabbit, a rock-crystal hen, an agate mouse, an agate elephant, and a bow brooch for 3,400 francs, as well as a poppy flower in 1911. In 1911 Prince Iusupov acquired a Renaissance diadem for 31,655 francs, and figures of a cat and a goose in 1915.

35. According to Birbaum (Habsburg and Lopato 1993, 455), "The Grand Duchess Maria Pavlovna was, of all the members of the imperial family, a particular patron of foreign jewelers, and they made use of

this all-powerful protection to bring their works to Petrograd every year without paying customs and assay duties. The intention was to sell them in Moscow and Petrograd. This trick was discovered and proved by several Petrograd jewelers, who saw to it that the pieces of jewellery were sequestered until tax on them had been paid in full."

36. Néret 1988; Snowman 1990, 77–92; Meylan 2009. For Boucheron's activity and sales in Russia and to his Russian clients in Paris, see Habsburg 2003, 126–131; Meylan 2009, 147–76.

37. Habsburg 2003, cat. 902, 904, and 911.

38. *Journal Grand Livre, Moscou I,* Boucheron Archives, Paris.

39. Fabergé, Proler, and Skurlov 1997, 70–77.

40. Illustrated in Habsburg 2003, 127.

41. A full account of the House of Chaumet is given by Scarisbrick 1995. For Chaumet in Russia, see Habsburg 2003, 118–125.

42. For Grand Duchess Maria Pavlovna and her Chaumet jewels, see Habsburg 2003, 112 and 114, and Chapter 7 in this catalogue.

43. Ibid., 111.

44. Scarisbrick 1995, 342.

45. Recent publications include Brunhammer 2007 and Leite 2009. For Fabergé and Lalique, see Habsburg 2000, 379 and 380.

46. Quoted from Franz Birbaum's memoir of 1919 in Habsburg and Lopato 1993, 454.

47. "René Lalique. Correspondence d'un Bijoutier Art Nouveau," *La Bibliothèque des Arts,* 2007, 135–39 (letter dated February 19, 1903).

48. Habsburg and Lopato 1993, 447.

Mrs. Pratt's Imperial Easter Eggs

CAROL AIKEN

FIGURE 5.1: Fabergé, *Peter the Great Egg,* 1903, workmaster Mikhail Perkhin; egg: gold, platinum, diamonds, rubies, enamel, bronze, sapphire, watercolor, ivory, rock crystal; statue: gilt bronze, sapphire; height 4¼ in. (10.8 cm). Bequest of Lillian Thomas Pratt, Virginia Museum of Fine Arts.

Lillian Thomas Pratt, a Virginia-based collector of Russian art, purchased five Fabergé imperial Easter eggs between 1933 and 1946, each clearly reflecting her taste for elegantly refined objects. All of the eggs had been commissioned by Tsar Nicholas II as Easter gifts for his wife and his mother. In 1947 Mrs. Pratt's entire Fabergé collection was bequeathed to the Virginia Museum of Fine Arts in Richmond. More than fifty years later, in 2004, her original group of Easter eggs became the largest in the United States when the Forbes Magazine Collection of nine eggs was sold and transferred from New York City to Russia.[1]

The Forbes and Pratt collections were displayed together in 1983 at a special exhibition hosted by VMFA. In preparation, the Pratt eggs were cleaned and repaired. The stone and metal surfaces were cleared of dirty, dulling films accumulated through many years of handling, display, and exposure to the environment. Aged and deteriorating fills and restorations on some of the damaged enamel surfaces were replaced. A broken mechanism that prevented one surprise from functioning was repaired. When the eggs were taken apart during this necessary work, the mechanics of their assembly were revealed: numerous individual parts had been combined, joined by simple fastening devices that included minute screws, malleable pins, metal tabs, and tiny threaded nuts on slender matching bolts.

The design of each imperial Easter egg incorporated a theme of special significance to its recipient, which was represented by small paintings or three-dimensional models mounted in and on the shells and surprises of the eggs. The originality of the themes and the variety and diversity of the designs and materials are well-known attributes of the Fabergé imperial Easter eggs. The devices and techniques that facilitated the assembly of the eggs, and made the richly decorated facades possible, are equally characteristic but less recognized features.

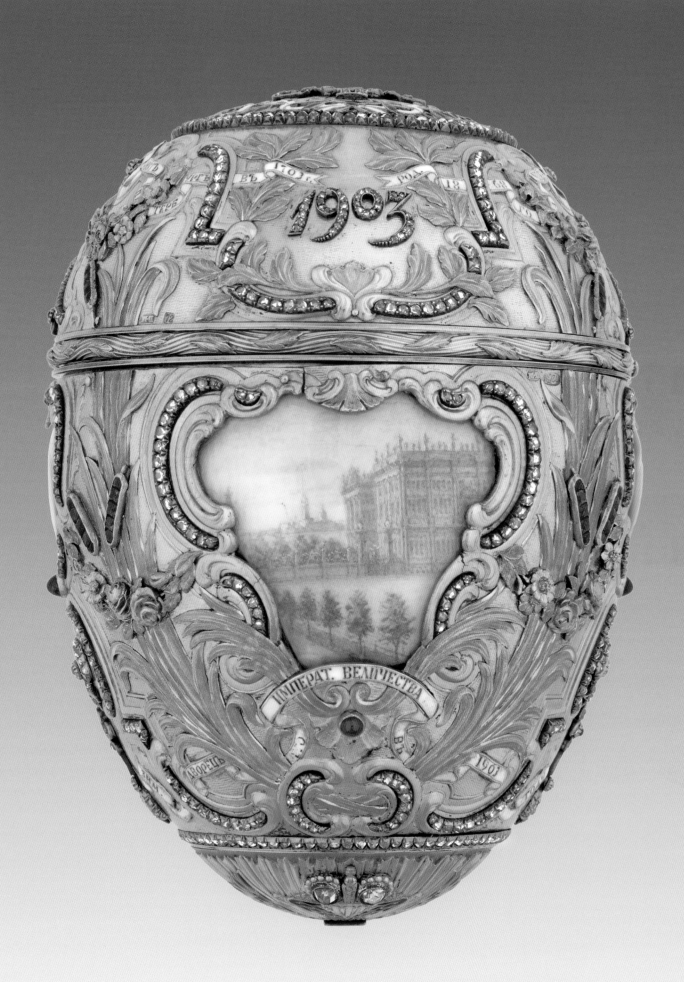

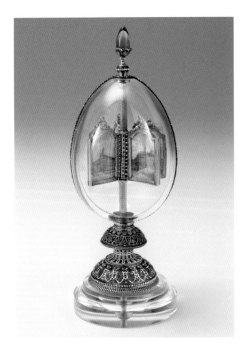
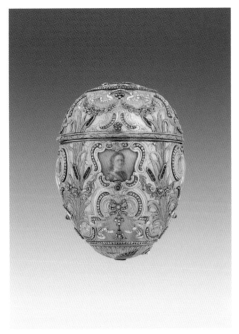

FIGURE 5.2: Fabergé, *Egg with Revolving Miniatures,* 1896, workmaster Mikhail Perkhin; rock crystal, gold, enamel, sapphires, diamonds, emerald, watercolor, ivory; height 10 in. (25.4 cm). Bequest of Lillian Thomas Pratt, Virginia Museum of Fine Arts.

FIGURE 5.3: Fabergé, *Peter the Great* Egg, 1903, workmaster Mikhail Perkhin; egg: gold, platinum, diamonds, rubies, enamel, bronze, sapphire, watercolor, ivory, rock crystal; statue: gilt bronze, sapphire; height 4 ¼ in. (10.8 cm). Bequest of Lillian Thomas Pratt, Virginia Museum of Fine Arts.

The production of every imperial egg required the collaboration of many highly skilled specialists, including goldsmiths and silversmiths, enamellers and jewelers, stone cutters and lapidary workers, and the artists who painted the small images displayed in the shells and surprises. The Pratt eggs all contain miniature paintings executed in watercolors on ivory, materials that both define traditional miniatures and distinguish them from every other art form. Displayed in the rock-crystal shell of the 1896 Renaissance-style *Egg with Revolving Miniatures*—presented to Alexandra Feodorovna the year her husband became tsar—are miniature paintings of twelve royal residences set back-to-back in frames that pivot around a central column (fig. 5.2, cat. no. 187).[2] Miniature portraits of Peter the Great and Nicholas II as well as pictures of Peter's hut and the Winter Palace are mounted in the multicolored gold shell of the rococo-style *Peter the Great Egg,* made in 1903 for the tsaritsa in commemoration of the two-hundredth anniversary of the founding of St. Petersburg (figs. 5.1 and 5.3, cat. no. 189).[3] The blue lapis lazuli shell of the third Pratt egg commissioned for the tsaritsa, the 1912 rococo-style *Tsesarevich Egg,* contains a double-sided portrait of her seven-year-old son, Aleksei, heir to the imperial throne (fig. 5.4, cat. no. 190). The child's figure was cut from a piece of flat ivory and painted on both sides to portray the front and the back of the young boy wearing a sailor suit.[4]

Groups of associated miniature paintings are featured in both of the Pratt eggs designed for Tsar Nicholas II's mother, Dowager Empress Maria Feodorovna. The empire-style *Pelican Egg* of 1897 celebrated a centennial of patronage by Russia's dowager empresses for institutions associated with educating the daughters of the nobility (fig. 5.5, cat. no. 188). The shell unfolds to become an eight-paneled frame

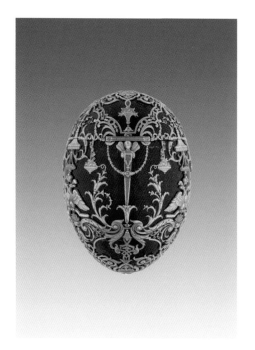
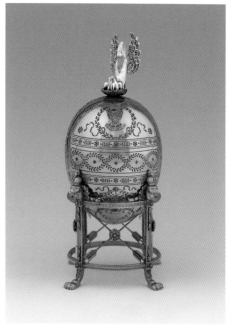
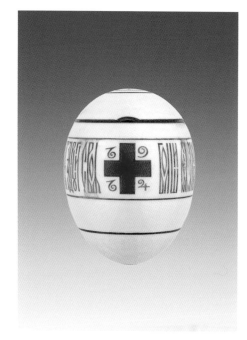

with paintings of the buildings that housed those institutions.[5] The 1915 *Red Cross Egg* was a tribute to the dowager empress's service as president of the Russian Red Cross (fig. 5.6, cat. no. 191). The shell contains a removable folding frame with five miniature portraits of her close female relatives dressed in their Red Cross uniforms.[6]

The design of each egg ultimately determined the materials for its shell and the associated supporting and decorative elements. The three basic shell types—metal, enamel on metal, and hardstone—are all represented in the Pratt collection. The metal shells of the *Peter the Great Egg* and the *Pelican Egg* are executed in gold. The *Red Cross Egg* has a silver shell covered in smoothly polished translucent-white enamel decorated with two small brilliant-red enamel crosses. The hardstone shells in the Pratt collection are each physically very different, both in the characteristics of materials and manner of construction. The two halves of the transparent rock-crystal shell of the *Egg with Revolving Miniatures* were carved from blocks of stone. The opaque, deep-blue lapis lazuli shell of the *Tsesarevich Egg* was constructed from wedge-shaped segments, six to form the lid and six for the body of the shell. Divisions between the segments are concealed on the outside of the shell by strategically positioned surface decoration, though they can be seen on the interior of the shell.

The silver shell of the *Red Cross Egg* is decorated with five bands of guilloché engraving based on three distinct repetitive line-based patterns cut into the metal. A skilled operator, the *guillocheur*, used a lathelike machine to engrave the decorative patterns line by line. Controlling the depth of each cut required both artistry and technical mastery. To complete the surface of the shell, multiple layers of enamel were applied on top of the prepared metal. Under the enamel surface of the *Red Cross Egg*, the

FIGURE 5.4: Fabergé, *Tsesarevich Egg*, 1912, workmaster Henrik Wigström; egg: lapis lazuli, gold, diamonds; picture frame: platinum, lapis lazuli, diamonds, watercolor, ivory; height 4 15/16 in. (12.5 cm). Bequest of Lillian Thomas Pratt, Virginia Museum of Fine Arts.

FIGURE 5.5: Fabergé, *Pelican Egg*, 1897, workmaster Mikhail Perkhin; gold, diamonds, enamel, pearls, ivory, watercolor; height (with stand) 5 1/4 in. (13.3 cm). Bequest of Lillian Thomas Pratt, Virginia Museum of Fine Arts.

FIGURE 5.6: Fabergé, *Red Cross Egg*, 1915, workmaster Henrik Wigström; silver, gold, enamel, mother-of-pearl, watercolor, ivory; height 3 in. (7.6 cm). Bequest of Lillian Thomas Pratt, Virginia Museum of Fine Arts.

engraved patterns catch and reflect light from multiple angles, creating the sensation of lively movement that enriches the smoothly polished surface.

In addition to providing decoration, the engraved lines create a texture that helps secure the attachment of the enamel to the metal surface. When applied, unfired enamel was essentially finely ground pigmented glass, which in a furnace melted and fused to the metal. Six to eight layers of enamel, and sometimes more, were required to achieve the color, opacity or transparency, and thickness desired in a finished surface. To create a particular appearance, layers might differ in their physical characteristics. The color of the metal under the enamel also influenced the look of the finished surface. The white enamel on the *Red Cross Egg* was applied over the silver shell. The red-enamel crosses decorating this white surface were applied over a gold ground, achieved by gilding the silver shell in the areas where gold would enhance and enrich the red color. A sample of the enamel colors and guilloché patterns that Fabergé used survive in charts made of small numbered squares of silver.[7]

After each successive layer of enamel was added and fired, the new surface was carefully polished. To help prevent stresses that could cause the surface to crack or chip, the back of the metal support was also coated with enamel. The appearance of that layer, the counter-enamel, was usually of little or no importance, and the surface was rarely polished. Beneath the interior velvet lining of the *Red Cross Egg*, for example, transparent counter-enamel covers the inside surface of the shell.

The decorative details on the empire-style red-gold *Pelican Egg* were also engraved directly into the metal shell. The pattern is composed of classical motifs with commemorative dates, 1797 and 1897, and a Cyrillic inscription, "Visit this vine" and "Ye shall dwell also." When closed, the shell's bold surface decoration and unusual color provide an effective diversion from the vertical lines that mark the egg's independent sections. Each section becomes an individual frame when the shell is fully open. The graduated sizes of the frames mark their relative positions as slices in the egg.

Colored gold was a favored material of Fabergé workmasters. It was produced by combining pure gold with other pure metals to create alloys. The elemental composition of an alloy determined its specific color and working properties, including strength or brittleness. Some alloys were more appropriate than others for specific applications. For example, strength was not required in purely decorative elements but was essential in parts that were structural. The actual quantity of pure gold in an alloy established its "fineness," or gold standard. In prerevolutionary Russia, gold standards were expressed in *zolotniki,* and fine or pure gold was 96 *zolotnik*, equivalent to the gold standard used in the United States based on 24 carat for pure gold. Russian 56-standard gold represented a mixture of 40 parts by weight of another metal or metals with pure or 96 gold. Gold used by Fabergé was very often 56 or 72 *zolotniki*, identified in the works by small stamps. The *Pelican Egg* bears a 56-gold

mark next to a stamp with the Cyrillic initials of the master who oversaw the work on the egg, Mikhail Perkhin. Gold-standard marks are readily visible on the exterior of the shell of the *Peter the Great Egg:* to the right of the Winter Palace miniature, on top of the shell to the right of the date 1903, and on the top of a removable platform under the surprise that is inside the egg.

Russian silver standards were also expressed using 96 parts by weight. The most frequently used proportions for Fabergé silver were 84, 88, and sometimes 91. The mark for 88 silver is stamped under the counter-enamel on the interior of the silver shell of the *Red Cross Egg*, next to the mark of workmaster Henrik Wigström ("HW"), who oversaw the work on that egg. Every part fabricated in precious metal was stamped as it was made, so each separate piece in a single object bears its own mark, even if all the parts were made of the same metal. Objects that have different marks incorporate parts that were made from more than one alloy of gold or silver. Platinum, another precious metal used by Fabergé, was not marked by stamping.[8]

Representative compositions of colored gold are listed in many jewelers' handbooks. Generally, an alloy of gold and copper creates a red gold, and an alloy of gold and silver produces green or white gold. Alloying gold and platinum also creates white gold. Garlands and other motifs made from metals of several distinct hues of gold, usually white, red, yellow, and green, were used to decorate eighteenth-century gold boxes and other luxury items. Combining several different colors of gold in a single object was a favored technique in the Fabergé workshops.

One of the most striking examples of the use of multicolored gold by Fabergé is the shell of the *Peter the Great Egg.* The four traditional gold colors form floral swags that link the scalloped openings in the shell where the miniature paintings are displayed. These openings are framed by bulrushes with green-gold foliage. The surfaces of the colored gold are enhanced by chasing, in which punches and stamps were used to create a variety of textures, and by burnishing, the use of tools to remove all surface texture and create a smooth, sometimes brilliantly reflective finish.

The majority of gold decorations on the shells, including the delicate cage work on the *Tsesarevich Egg* and the multicolored gold swags and leaves and flowers on the *Peter the Great Egg*, are decorative, not structural or supportive. They are attached by small straight pins that protrude from the backs of the mounts. The pins were inserted into precisely positioned, carefully drilled holes in the shells and then bent against the interiors to hold the decorations in place.

Precious stones, too, were important decorative elements, adding subdued sparkle and flashes of color. The manner in which gemstones were used was apparently determined by requirements of the designs more often than by an overt desire for ostentation. Table-cut or portrait diamonds, large thin clear stones with flat parallel

surfaces, were mounted in the tops and bottoms of shells to cover dates and tiny images. A table diamond is set in the top of the *Tsesarevich Egg*, over the initials of Tsaritsa Alexandra Feodorovna surmounted by the imperial crown, with the year 1912 below. In contrast, a large brilliant-cut diamond is set in the bottom of the egg. When drama was appropriate, it was embraced. A good example is the stunning and very large cabochon Siberian emerald that sits as the finial atop the *Egg with Revolving Miniatures*.

The most ubiquitous stones that Fabergé used were rose diamonds, especially favored to outline and embellish those bezels that marked the transitions between individual pieces and sections made from differing materials. Rose diamonds decorate the vertical bezels between the halves of the rock-crystal shell of the *Egg with Revolving Miniatures*. Faceted rubies, sapphires, and emeralds were also used as integral design elements. The heads of the green-gold bulrushes on the *Peter the Great Egg* are formed by lines of square-cut rubies.

Rock crystal is yet another material that was used in a novel way in the *Peter the Great Egg*. Each of the miniature paintings within the shell is displayed under a transparent cover carved from rock crystal. The covers match the curvature of the shell as well as the unusual shape of the miniatures. Traditionally miniatures were presented and protected by convex glasses, and most were painted on thin flat sheets of ivory. The miniatures in the *Peter the Great Egg* are painted on thick pieces of ivory that, like the rock-crystal covers, were carved to match the curve of the shell and the shape of the openings in which the miniatures are displayed.

The designs of many imperial Easter eggs, including four in the Pratt collection, are based on historic or artistic styles that were adapted, interpreted, and subtly transformed under the Fabergé influence. The conventions of a particular style determined the shape and proportion of a shell, and sometimes the orientation or axis of the presentation. The difference in shapes, proportions, and orientations become more obvious when profiles and related details are consciously compared.[9] The elongated shell of the Renaissance-style *Egg with Revolving Miniatures*, which is oriented with the pointed end up, is divided vertically by the narrow bezel set with rose diamonds. The other Pratt eggs are broad and bluntly rounded, oriented with the pointed end down, and each is supported by an independent stand that holds it in an upright position. The only surviving original independent stand belongs to the *Pelican Egg*, which is marked on the bottom with a Fabergé stamp in Cyrillic. The other stands are accepted as later replacements.

The rock-crystal base of the *Egg with Revolving Miniatures* is permanently attached. It is a structural as well as highly decorative feature in the design of the egg, embellished with enameled borders formed by monograms used by Alexandra Feodorovna before and after she became empress of Russia. Both monograms are surmounted

by their respective crowns. Brightly colored opaque enamels provide an antique reference in keeping with the style of the egg. The selective use of opaque enamel is also a feature on the *Peter the Great Egg*. Encircling the shell are opaque-white ribbons, some of which serve as banners inscribed with relevant historical details for each of the miniature paintings. A double-headed eagle executed in opaque-black enamel adds drama to the bottom of the shell. Its body is positioned so that the tiny shield-shaped enamel of St. George and the Dragon set in the chest of the eagle, under a table diamond, is mounted in the center bottom of the egg.

No matter how glorious, the decorations on the shells rarely provoke the same interest as the ingenious surprises for which the Easter eggs are known. Some surprises are immediately visible, displayed in transparent shells that do not open, like those of the *Egg with Revolving Miniatures*. Other surprises, including the frames in the *Red Cross Egg* and the *Tsesarevich Egg*, remain hidden from view until completely removed from their shells. It is not always possible to make a strict distinction between some of the shells and their surprises. For example, the *Pelican Egg* shell extends into a linked line of self-contained frames in graduated sizes, and the *Peter the Great Egg* components are so completely integrated that even though the small statue surprise within can be removed and displayed alone, it is conceptually inseparable from the shell.

The monumental statue that inspired the surprise in the *Peter the Great Egg* portrays the tsar dressed as a Roman hero astride a rearing horse. Commissioned by Catherine the Great as a tribute to her famous predecessor, the monument sits on a thousand-ton granite base inscribed in Russian and Latin, "To Peter the First [from] Catherine the Second."[10] The base of the small replica is reproduced by a roughly finished sapphire. A platform in the shell moves the statue up and into display position when the lid is raised and lowers it back into the shell when closed. Before the 1983 Fabergé exhibition at the Virginia Museum of Fine Arts, the mechanism that controls the platform did not function, thus the surprise remained down in the shell, out of view. The mechanical failure was not unexpected, after so many years on display. To address the problem and make the necessary repair, the shell of the egg was opened.

The apparatus that controls the movement of the statue is operated by a simple pin located at the hinge between the body of the shell and the lid. The pin is attached to a lever joined to one end of a small length of chain. The other end of the chain is connected to the center of a simple platform set on four springs (figs. 5.7 and 5.8). An open hinge releases the pin, permitting the lever and a wheel to act together to lengthen the chain. As the chain becomes longer, four depressed springs are released to push the platform upward. When the lid is closed, the depressed pin shortens the chain, pulling the platform down. As the model descends the springs are compressed. Tube-shaped guides keep the springs in alignment as they expand and contract.

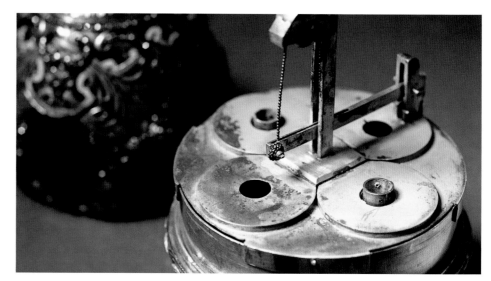

FIGURE 5.7: Detail of springs and tube-shaped guides for the platform in the *Peter the Great Egg.*

FIGURE 5.8: Detail of the chain that raises and lowers the platform with the surprise in the *Peter the Great Egg.*

When the mechanism was removed for repair, the interior side of the egg's shell was exposed and details of its construction were revealed (fig. 5.9). The ends of the pins used to attach the various decorative mounts were visible, tightly bent against the inner surface of the shell. It was evident that the floral decorations in colored gold, the white-enameled banners with descriptions of the pictures, and the rose diamond–set rococo curves around the openings in the shell were made independently and then applied to the shell. The backs of the square-cut rubies that form the bulrush heads were covered by squares of bright-silver foil coated in a transparent red film on the sides that were set toward small holes behind each stone. The reflective foil was intended to brighten the stones and the red coating to enhance and deepen their color. The top, central, and bottom sections of the egg were also made independently and then joined by metal tabs mounted on the rear of narrow rose diamond–set bezels between the sections. A tiny cup-shaped backing covers the

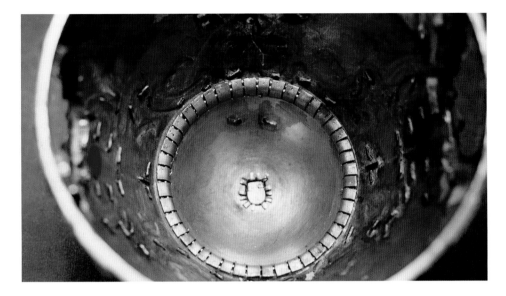

shield-shaped enamel of St. George in the bottom of the egg (fig. 5.10). The enamel and backing are held by tabs set on the rear of the narrow shield-shaped bezel that provides a simple rimmed edge around the front of the enamel. The interior of the lower shell is normally blocked from view by the platform that supports the equestrian model. A gold liner coated in brilliant-yellow transparent enamel applied over a radiating guilloché pattern covers the interior of the lid.

When the shell was disassembled, the surfaces of its many components were cleaned to remove dirty films and discolorations that had formed over many years. Although pure gold does not discolor, gold alloys and plated metals exhibit changes characteristic of the metals associated with the gold. Some changes are not obvious without making direct comparisons to similar cleaned surfaces. Other changes can be striking. For example, gold-plated silver will tarnish and turn completely black. Solders that join metals discolor differently from those metals. Even a solder that was initially a good color match to the metal would have had a different composition that ensured its lower melting point. Perhaps the recognition that aging causes the solders and the metals they join to discolor differently is one reason Fabergé used mechanical fastening devices. The desire to avoid heating and possibly damaging delicate or carefully prepared parts by exposing them to the temperatures necessary to melt solder is another.

Although the transparent shell of the *Egg with Revolving Miniatures* provides an unobstructed view of the twelve miniature paintings displayed inside, in order to take clear photographs, the egg needed to be opened. The miniatures are mounted back to back in gold frames that revolve around a fluted gold shaft set vertically through the center of the egg. When the large emerald finial on top of the egg is depressed, it can be turned to control a small attached hook that moves the framed

FIGURE 5.9: Detail of the interior bottom of the *Peter the Great Egg.* The metal tabs attach the bottom section of the egg; the clenched pins attach the surface decorations.

FIGURE 5.10: Detail of the exterior bottom of the *Peter the Great Egg.* The shield portraying St. George is in the center of the double-headed eagle.

FIGURE 5.11: Detail of discolored repairs, losses, and discolored metal on the pelican figure of the *Pelican Egg.*

FIGURE 5.12: Detail of the pelican figure after conservation treatment.

pictures, arranging them so two at a time are fully in view, like the open pages of a book.[11] To gain access to the interior, a flush-set nut in the bottom of the rock-crystal stand was released. The crystal base and enamel border, with an inner structure that stabilizes the base, were slipped off the end of the shaft. Encircling rings that support the bottom of the shell were removed, together with their decorative covers, so the crystal halves of the egg shell could be lifted away.

Inside the shell each miniature was individually covered with a protective glass. All of this glass was covered in a moist surface film that is symptomatic of glass deterioration, an unstable condition caused by a chemical imbalance in its original composition. The filmy deposits made the pictures look slightly out of focus and the colors less bright than they proved to be when the glasses were removed. Initially the miniatures and frames were presumed to have been made in a uniform size. However, each is actually slightly different, probably a carefully considered feature of the design. While the shell was open, the pink- and yellow-gold frame surfaces were also lightly cleaned to enhance the contrast between the two colors.

The pictures in the *Pelican Egg* become visible only when the shell of the egg disappears, transformed into eight ovoid-shaped frames linked by hinges. The frames are held upright by a flat gold stand, engraved with symbols of science and the arts, hinged between the fourth and fifth frames. The enamel-covered gold-and-diamond-set pelican that gives the egg its name balances at the top, standing in a nest that holds three chicks. The pelican was a personal symbol of the dowager empress for whom the egg was made, as well as a recognized symbol of maternal care.[12] Although actually affixed to the stand, the bird is a prominent feature at the top of the closed shell. Assertions that the pelican itself was not an integral part of the design do not seem to be supported by the construction of the egg or the quality of the figure.[13]

The miniature paintings displayed in the open *Pelican Egg* were executed in watercolor of a slightly higher-than-normal ratio of gum arabic, the traditional binding medium that is mixed with the pigments to create the paints. The enriched medium adds a slight shine to the painted surfaces, so they resemble little oil paintings. Each work is signed by imperial court painter Johannes Zehngraf.

Pearl-set bezels on the front of each frame provide access to the pictures and the covering glasses. Like those in the *Egg with Revolving Miniatures*, these glasses were unstable. All were made with a slight convex lift at the front and a flat surface at the rear, and the filmy deposits on the flat surfaces were in direct contact with the paintings. Minor blemishes in the paint could be matched to spots on the glasses. The gold-plated borders on the front of the pelican's wings were black with tarnish. Metal polish residues from past cleanings disfigured the shallow engraved inscriptions on the backs of the frames.

The borders of the wings were cleaned to remove tarnish, restoring the original gold color. Discolored repairs in the enamel surfaces were removed, and new repairs were completed using modern materials that will not discolor with age. Dirty residues were removed from all the other surfaces, making the egg's appearance brighter and fresher overall (figs. 5.11 and 5.12).

Dulling films from years of handling and display had formed around the yellow-gold cage work on the lapis lazuli shell of the *Tsesarevich Egg*, although the gold surfaces of the pattern of shells, scrolls, floral baskets, and cherubs exhibited almost no discoloration. The decoration of the egg includes a rectangular portrait diamond at the top of the shell over the imperial monogram "AF," for Alexandra Feodorovna, and the year 1912, as well as a large brilliant-cut decorative diamond at the bottom of the egg. The shell contains a frame in the shape of a double-headed eagle made of diamonds set in platinum, which sits on a lapis lazuli base with diamond-set rims on the top and bottom edges.[14] The border around the top edge of this base was made in two sections. At the lower edge of the metal frame where it rests on the lapis base, pins are inserted at two points to hold the frame in place. An oval opening in the center of the frame displays a double-sided miniature portrait of the tsesarevich at age seven.

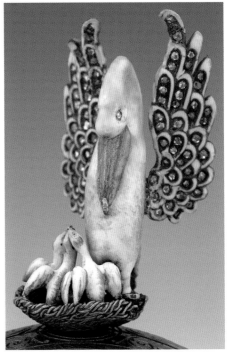

The original miniature has survived but in an irreparably damaged condition caused by contact with water. Color photographs taken when the miniature was less damaged were copied and are now used in the frame for the purposes of display. The front and rear frame openings are covered by rock-crystal cabochons. The artist of the miniature is unknown, but earlier double-sided miniatures of children in the imperial family may have provided the inspiration for this example.

The interior of the egg shell is not lined. To support the diamond-set frame, a beautifully engraved gold disc creates a flat surface in the bottom of the shell. A simple gold band circles the shell slightly above the platform. Attached to the gold bezel joining the lid and the body of the shell are gold brackets with velvet-covered channels. These brackets accept the upper section of the frame when it is placed inside the egg. A partial lining may have once covered the midsection of the shell and the lid interior. If so, no trace of the material remains, but the exposed ends of the pins that attach the gold cage to the shell and the visibility of the segments that form the shell, as well as the likelihood that the frame had more conspicuous padded support, suggest there was some form of lining.

The velvet lining in the body of the *Red Cross Egg* provides a pocket for the storage of its folding frame. Stiffened by heavy paper on the rear, the liner can be removed from the shell in one piece. The interior of the lid is covered with a smooth gold dome that offers a perfect complement to the decoration on the exterior of the shell. The serenely simple but flawlessly executed patterns that make the egg a technical

masterpiece are the work of Fabergé workmaster Henrik Wigström (1862–1923). The *Red Cross Egg* is the only egg in the Pratt collection with a design that is not based on the style of an earlier artistic or historic period.

The shell of the egg is smooth; all the decorative elements are beneath the enamel surface or set flush in it. Thin gold lines circle the shell to create borders between the engraved guilloché patterns on the metal shell. The uppermost band of gold is formed by the two narrow bezels that join the lid and body of the shell. Stylized Cyrillic characters in gold circle the center of the egg with the words "Greater love hath no man than this, that a man lay down his life for his friends." Two small crosses enameled in brilliant transparent red, adjacent to the dates 1914 and 1915, give the shell its only color. The crowned monogram of Dowager Empress Maria Feodorovna is set in the top, while a six-petal rosette decorates the bottom.

The surprise in the egg is a five-panel folding frame with oval miniatures of female relatives of the dowager empress dressed in their Red Cross uniforms. Each portrait is set under a convex glass surrounded by a thin gold bezel in a rectangular panel of translucent-white enamel. Small enameled red crosses are at the top of each panel. The frame backs are made of mother-of-pearl, decorated with small gold monograms of the individual on the front and topped by separate gold crowns. The bottom edges of the gold-plated frames are marked "HW" and "silver 356" and stamped with the Cyrillic "Fabergé."

The enamel on the exterior of the shell in several areas had serious damages, including losses that exposed the silver base. In spots where the enamel was completely missing, the exposed metal was deeply tarnished. The gold-plated lid lining was also tarnished, and the velvet lining in the lower part of the egg was loose. After cleaning the exposed metal surfaces, the enamel damages were repaired using stable modern materials that will not discolor in the future. Then the lining was reattached to the interior of the shell. The intricate work completed on this egg, and on each of Mrs. Pratt's imperial Easter eggs, was focused on returning it, as much as possible, to its original appearance. That work provided a rare opportunity to examine the eggs from the inside out and learn more about the methods and the materials that were used by Fabergé.

NOTES

1. The former Forbes Magazine Collection, including nine imperial Easter eggs and additional eggs of imperial quality, became the collection of the Link of Times Foundation. For more information, see www.treasuresofimperialrussia.com/e_home.html.

2. The residences are as follows: in Great Britain, Windsor Castle, residence of Queen Victoria, the tsaritsa's grandmother; Balmoral Castle, Scotland, summer home of Queen Victoria; and Osborne House, Isle of Wight, site of visit during couple's engagement; in Germany, the Neues Palais,

Darmstadt, the tsaritsa's birthplace; Kranichstein, Hesse, her childhood summer residence; Altes Palais, Darmstadt, seat of her father, Ludwig IV, Grand Duke of Hesse; Wolfsgarten, Hesse, family hunting lodge; Palace Church, Coburg, site of consent to marry Nicholas; and Schloss Rosenau, Coburg, site of visit the day after engagement; in Russia, Winter Palace, St. Petersburg, site of wedding; Anichkov Palace, St. Petersburg, residence of Maria Feodorovna; Alexander Palace, Petersburg, winter residence of imperial family. All but two of the miniatures are signed by Johannes Zehngraf, the court miniature painter.

3. The miniatures are the work of the court miniature painter Vasilii Zuev, whose signature in Cyrillic is on the front of the Peter the Great miniature.

4. The artist is unknown, but double-sided miniatures of children in the imperial family are known. A set of seven double-sided miniatures of the children of Tsar Alexander II and Maria Aleksandrovna, marked St. Petersburg 1858, is illustrated in the Christie's sale publication *Fine Russian Works of Art,* April 12, 1988, #86.

5. The institutions are the Kseniinski Institute, Moscow Nikolaevskii Orphanage, Patriotic Institute, Smol'nyi Institute, Ekaterininksii Institute, the Pavolvskii Institute, the St. Petersburg Nikolaevskii Orphanage, and the Elisavetinskii Institute. The miniatures were painted by the court miniaturist Johannes Zehngraf.

6. The miniatures, painted by Vasilii Zuev, include Grand Duchess Olga Aleksandrovna, daughter of the dowager empress; Grand Duchess Olga Nikolaevna, eldest granddaughter; Tsaritsa Alexandra Feodorovna, daughter-in-law; Grand Duchess Tatiana Nikolaievna, second eldest granddaughter; and Grand Duchess Maria Pavlovna, niece.

7. Snowman 1953, color plate III.

8. For a discussion of platinum and platinizing, or plating a gold and silver alloy with platinum, see Snowman 1993, 14–15.

9. Numerous websites show images of all of Fabergé imperial Easter eggs; comparisons of styles and shapes are easily made.

10. The statue was designed and made by the French sculptor Etienne-Maurice Falconet. The monument base, thirty-seven feet long by twenty-two feet high, was moved from Finland by four hundred men who worked from December 1768 to October 1770. The monument was unveiled in August 1782.

11. All but two of the miniature paintings are signed by court miniature painter Johannes Zehngraf.

12. When the egg was displayed in a charity exhibition, a report in the St. Petersburg newspaper *Novoe Vremia* stated that the pelican was Marie Feodorovna's personal symbol. See Lowes and McCanless 2001, 57.

13. Ibid.

14. Although the material of the frame has been consistently identified in the published literature as platinum, because the surface discolors over time, it is more likely to be a platinum-plated silver alloy; see endnote 8. The metal has not been analyzed.

The Zarnitsa Sailor and His Place in History

CHRISTEL LUDEWIG MCCANLESS

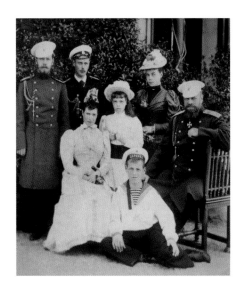

FIGURE 6.1: The imperial family, May 1883. From left to right: Tsesarevich Nicholas II, Grand Duke Georgii, Empress Maria Feodorovna, Grand Duchess Olga, Grand Duke Mikhail (in sailor suit), Grand Duchess Ksenia, and Emperor Alexander III. Photograph from Wikimedia Commons.

FIGURE 6.2: Fabergé, *Zarnitsa Sailor,* 1913; agate, obsidian, aventurine quartz, lapis lazuli; height 4⅝ in. (11.8 cm). Bequest of Lillian Thomas Pratt, Virginia Museum of Fine Arts.

The hardstone sailor in the Lillian Thomas Pratt Collection at the Virginia Museum of Fine Arts (fig. 6.2) is one of only fifty known human figure carvings by Fabergé, a group that is as rare and sought after as the firm's renowned imperial Easter eggs. Recent research disclosing the historical connection between the sailor and Grand Duke Mikhail Aleksandrovich and his morganatic wife, Natasha, offers a fascinating account while illustrating the value and reward of ongoing scholarship in the field of Fabergé studies.[1]

The story begins with the 1913 sale at Fabergé's London store of a sailor carved in St. Petersburg. The company's sales ledgers record that the white agate figure, which stands a mere 4⅝ inches (11.8 cm) tall, was purchased by a "Mme. Brassow" for fifty-three pounds. As it happened, the miniature sailor traveled back to Russia the very next year.

The Cyrillic engraving on the sailor's cap translates as "Zarnitsa," the name of a steam yacht constructed by Scotts' Shipbuilding and Engineering Company in Scotland and launched on June 9, 1891. Built according to the highest standards of the era, the yacht was 239 feet in length at the waterline and thirty feet wide. The elegant interior was designed by Thomas Lennox Watson, a Glasgow yacht architect. Russian tea millionaire Alexander Grigor'evich Kuznetsov was the original owner of the vessel, and its home port was Sevastopol on the Black Sea. Kuznetsov named the yacht *Foros,* after the town in the Crimea where he owned a large estate.[2]

Grand Duke Georgii Aleksandrovich (1871–1899) purchased the ship in 1895, the year after his father, Tsar Alexander III, died and his brother Nicholas II ascended to the throne. He renamed it *Zarnitsa* (Summer Lightning).[3] Just four years later, on July 10, 1899, Georgii died suddenly from complications of tuberculosis at age twenty-eight.[4] Although no historical record of the yacht's legal ownership has

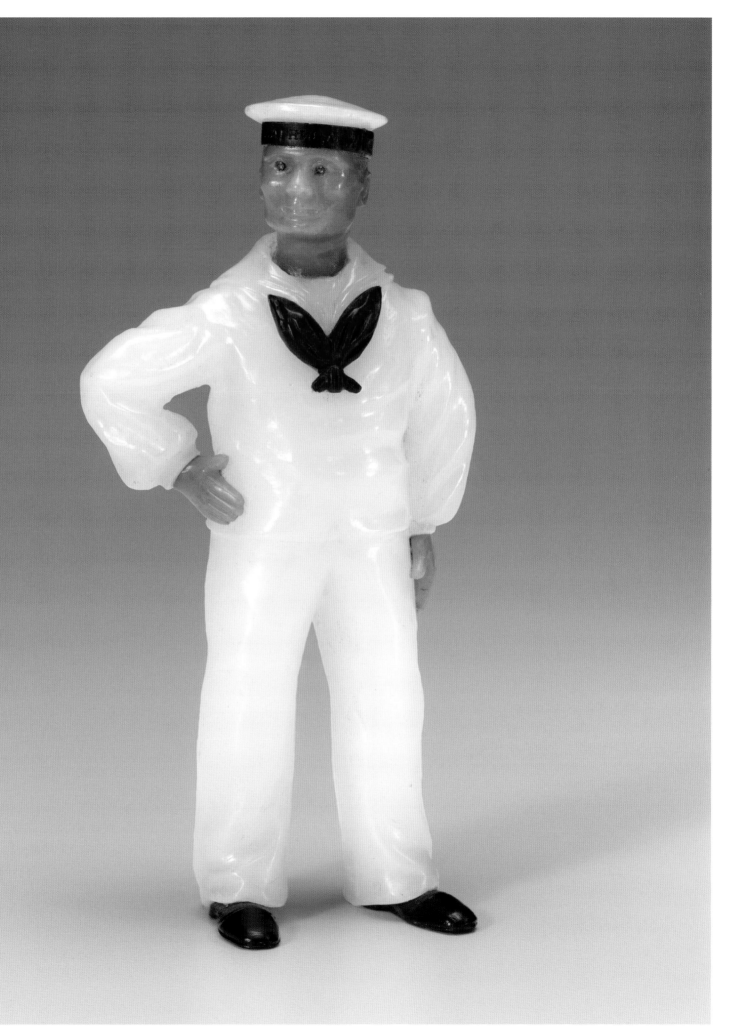

FIGURE 6.3: The steam yacht *Zarnitsa.* Mariners' Museum, Newport News, Virginia.

been discovered, Georgii's younger brother, Grand Duke Mikhail Aleksandrovich (1878–1918), appears to have assumed command of the *Zarnitsa* after Georgii's death. In the summer of 1902 he sailed the yacht to England to attend the coronation of King Edward VII[5] and, on his return, oversaw its care and maintenance. From November 1906 to April 1907 he had the yacht refurbished in Inverclyde, Scotland, at the same shipyard where it had been built nearly twenty years earlier. The improvements included a new deck, steel masts, electric lights, and enlarged and renovated staterooms. The updated *Zarnitsa* weighed 1,086 tons and was captained by Prince Putiatin with a crew of fifty sailors (fig. 6.3).[6]

By that time Grand Duke Mikhail, who received an enormous annual income, owned two large country estates. His Brasovo property encompassed 430 square miles near Orel, 210 miles south of Moscow. He inherited the estate from Grand Duke Georgii, who had purchased it in 1882 for the immense sum of 4.3 million rubles. The second property was located in Poland, then part of Russia. Mikhail's other assets included homes at the Gatchina and Anichkov palaces as well as an imperial railway carriage (lavishly furnished). Known to be exceptionally kind and good natured, the twenty-nine-year-old grand duke was still unmarried, despite at least two serious but failed romantic relationships. He was widely considered to be the most eligible bachelor in Europe.

Mikhail was introduced to Natasha Wulfert (1880–1952), the wife of fellow officer Vladimir Wulfert, in December 1907. Born Natalia Sergeevna Sheremet'evskaia, the youngest of three daughters of a Moscow lawyer and his wife, she was described by contemporaries as an immensely charming and clever woman with impeccable taste. When Natasha, then in her second marriage, met the grand duke, it was reportedly love at first sight for both parties.

In June 1909 Grand Duke Mikhail entertained aboard the *Zarnitsa,* which was docked at Peterhof. His guests were Natasha and Vladimir Wulfert; his sister, Grand Duchess Olga, and her husband, Duke Peter of Oldenburg; and Olga's lover, Captain Nikolai Kulikovskii (fig. 6.4). Two months later, while staying on the yacht*,* Mikhail romanced his inamorata in secret for ten days in Copenhagen without being discovered by Olga,

FIGURE 6.4: First known photograph of Grand Duke Mikhail and Natasha, at a picnic near the Gatchina Palace, May 1909. (Grand Duchess Olga and her future husband, Captain Nikolai Kulikovskii, are in the background). Photograph courtesy of Leeds University Archives.

Peter, or his mother, Dowager Empress Maria Feodorovna, who sailed on the imperial yacht *Polar Star* alongside the *Zarnitsa.* On August 13, 1909, Mikhail wrote to Natasha, "Our stay here will be always the brightest memory of my whole existence."[7]

By year's end, the two lovers, who had not been granted Tsar Nicholas's permission to marry as law required, were living in an eight-room apartment in a large country house in Moscow. The tsar's denial of their union was based on the obvious fact that Natasha had been divorced once and was still married to her second husband. She also was not of royal lineage. A son, Georgii, named in honor of Mikhail's older brother, was born to the couple in July 1910. In May 1911 the three of them and Natasha's daughter from her first marriage, Natalia (Tata) Mamontova, moved to the self-sufficient country estate at Brasovo. Reportedly preferring country to court, Grand Duke Mikhail employed his management skills to the property to earn a yearly income of one million rubles, or almost four times his annual allowance from the imperial purse. (By comparison, it was possible during this period for three people to live on about three rubles a month. The annual salary of the court architect to a grand duke was 500 rubles.) By 1912 the estate encompassed nine villages and hamlets as well as farms, forests, saw mills, chemical plants, distilleries, brickyards, schools, hospitals, and churches.[8]

Despite Mikhail's promise to the tsar not to marry Natasha and the couple's constant surveillance by the Okhrana, the tsar's dreaded secret police, Mikhail and Natasha were wed. The service took place at the Serbian Orthodox Church of St. Savva in Vienna on October 16, 1912. Two weeks later Mikhail's news met with horrified reactions from his mother and brother. Maria Feodorovna pronounced the union "unspeakably awful in every way," and for Nicholas, in an age when honor between gentlemen was of utmost importance, Mikhail "broke his word—his word of honour." It was a grave indictment of the grand duke and his actions.[9]

The timing of the marriage no doubt involved Mikhail's position in the line of ascension to the throne. When Georgii died in 1899, Mikhail had become the new heir presumptive, a title that he held until the birth of Tsar Nicholas's long-awaited son, Aleksei Nikolaevich, in 1904. Realizing that the hemophiliac Aleksei would likely die young, however, Mikhail feared that he would be named heir again and thus unable to marry Natasha. In September 1912, a month before the secret marriage ceremony, Aleksei had become ill while at the family retreat in Spala, Poland, following a fall in a boat. By October his condition was so serious that both his doctors and his immediate family feared he was going to die. Count Freedericksz, minister of the imperial court, was even permitted to publish medical bulletins reporting on the health of the young tsesarevich.

By removing himself from the sequence of succession through a forbidden marriage, Mikhail solved the immediate problem. However, a series of imperial decrees in late

1912 and early 1913 presented other consequences: Tsar Nicholas relieved Mikhail of his military command, banished him from Russia, froze all of his assets, seized control of his estates under a trusteeship, removed him from the regency, and appointed himself as Mikhail's guardian. By imperial edict on March 26, 1915, their son was legitimized.[10]

During the couple's exile, their lavish life style was *not* reduced. Even though Tsar Nicholas continued to control all of Mikhail's assets, the family resided in a staffed stately home, Knebworth House, twenty-nine miles north of London. Both Mikhail and Natasha became frequent Fabergé customers while there, sometimes visiting the London shop together. The grand duke had actually acquired his first Fabergé piece from the store some years earlier. On November 25, 1908, he purchased a cigarette case with a view of the Houses of Parliament, cuff links, and buttons. The price of more than 213 pounds was substantial (well over twice the annual salary of a British police constable at the time). Natasha's Fabergé purchases reflected her desire to furnish Knebworth extravagantly. For example, the London Sales Ledgers list a purchase by "Madame Brassow" on December 9, 1913: "Table silver, 579 pieces in 'Kings' pattern, each having engraved 'N.B.', surmounted by a crown, n.n. [no stock number]. Selling price *nett* £318 10s, cost price 2,273 rubles 23 copecks."[11]

Two months earlier, on October 14, 1913, Natasha had purchased Fabergé's *Zarnitsa* sailor for fifty-three pounds (the cost of making the piece in Russia was 273 rubles). The date of the sale—two days before her first wedding anniversary—suggests that the figure was an anniversary present from Natasha to her husband, perhaps a touching reminder of their times on the imperial yacht. According to her granddaughter Pauline Gray, "Natasha would afterwards describe (the time at Knebworth) as the happiest year of her life"; it was certainly the most tranquil.[12]

After the lease expired at Knebworth, the couple had intentions to move to Paddockhurst, a much larger estate in Sussex, for an annual rent of 3,460 pounds. However, Russia's entry into World War I in 1914 changed their plans. Out of a sense of duty to his nation, Mikhail requested and was granted permission to return to Russia with his family. He served in the imperial army commanding the "Savage Division," made up of volunteer Muslim recruits, rather than the elite troops he had commanded previously. A more popular leader than his brother Nicholas, he earned the military's highest honor, the Cross of St. George.

Russia's involvement in the war evolved into a bitter fight with heavy losses. As unrest grew in the country, the populace became increasingly discontent, giving rise to the Bolshevik party, headed by Vladimir Lenin. With his promise to pull Russia out of the war, Lenin was able to gain power in the early months of 1917. The tsar was deposed, and in October the Bolsheviks took control of the government. On March 3, 1918, the treaty of Brest-Litovsk with Germany ended the war for Russia.

Soon after, Count Brasov was smuggled out of the country, and Natasha, fifteen-year-old Tata, and Princess Viazemskaia, Natasha's lady-in-waiting, fled to the southern coast. On June 13, 1918, Mikhail was murdered at the war front near Perm by the Bolsheviks. In December, Natasha and her party were evacuated by the British Royal Navy on the HMS *Agamemnon*.[13] Count Brasov — Natasha's last connection to the Grand Duke Mikhail and the imperial family — was killed just before his twenty-first birthday in an automobile accident in southern France. Natasha died penniless in 1952 at a charity hospital in Paris.

From his exile, on November 16, 1912, Mikhail had inquired of his brother Tsar Nicholas, "what was to happen to the *Zarnitsa*?"[14] There was no reply from Tsarskoe Selo. In 1915 the vessel was converted into a hospital ship to serve in World War I and was eventually broken up for scrap in 1927.

The *Zarnitsa* sailor surfaced again in 1937 during a New York City Fabergé exhibition.[15] Mrs. Lillian Thomas Pratt bought the figure from Armand Hammer, whose marketing description of the little sailor in his traditional summer uniform reads:

> Standing solidly on his two feet of black onyx slightly spread apart . . . of courageous appearance . . . [he] is dressed in a spotless, freshly laundered suit of milky white jade. His piercing blue eyes, each set with a cabochon sapphire, sparkle with loyalty and sincerity. Flesh-toned aventurine quartz makes up his interesting face, finely moulded with high cheek bones and sharp nose — typically Slavic characteristics. His sturdy hands are also of aventurine. This unusual portrayal, viewed from any angle, is singularly lifelike and attractive.[16]

Among the fifty extant folkloristic hardstone figures made by Fabergé, the *Zarnitsa* sailor appears to be the only one that traveled back to Russia. On August 14, 1914, the original owners had boarded the SS *Venus*, and a week after leaving Knebworth they were back in St. Petersburg. Details of the acquisition of the sailor by Hammer, a dealer in Russian decorative art objects in the West, are not known.

Russian archival records also indicate that Grand Duke Mikhail had unfinished commissions pending at the Fabergé shop in St. Petersburg amounting to 53,000 rubles between July 1, 1914, and October 1, 1916.[17] History and fate, however, intervened. Today the Fabergé sailor, preserved at the Virginia Museum of Fine Arts, stands silently in remembrance of ten romantic and turbulent years in the lives of Grand Duke Mikhail and his Natasha.

NOTES

1. The story of Grand Duke Mikhail and Madame Brasova has been gleaned from the following publications: Crawford and Crawford 1997, which is based on private diaries, letters, documents long hidden in the Soviet archives; two biographies by granddaughters, Majolier 1940 and Gray 1976; and lastly, the reminiscences of a contemporary of the couple and frequent guest in their home detailed in Abrikosov and Lensen 1964.

2. My thanks to Martin Black, G. L. Watson & Co., Liverpool, England, who patiently answered all questions relating to the identification of the yacht *Foros/Zarnitsa,* and my research colleagues Tim Adams and Annemiek Wintraecken, who helped put the pieces of the puzzle in place.

3. The name Zarnitsa has been used on a subsequent naval vessel launched in 1914 for the commander of the Kronstadt fortification. The imperial yacht in this essay sailed under the blue-and-white St. Andrews ensign of the Russian Imperial Navy and imperial yachts.

4. *New York Times,* July 11, 1899, 10B.

5. Crawford and Crawford 1997, 26.

6. Nikolai Sergeevich Putiatin was commander of the yacht *Zarnitsa* from 1903 to 1906; *Greenock Telegraph and Clyde Shipping Gazette,* January 5, 1907, n.p., and April 20, 1907, n.p. Courtesy of Betty Hendry, Watt Library, Inverclyde Council, Greenock, Scotland.

7. Crawford and Crawford 1997, 76–79.

8. Ibid., 48.

9. Ibid., 128–31.

10. Ibid., 203–4 and 212–13.

11. When abroad, Natasha rendered the Cyrillic Brasov as "de Brassow," using the German *w* for the Russian *v* (ibid., 410 n17). Thanks to Kieran McCarthy of the Wartski firm (London) for discussing the sales ledger entry with the author, and pointing out the selling prices of two comparable Fabergé hardstone objects: The *Chelsea Pensioner* bought by King Edward for £49 15s in 1909 (now in the Royal Collection of Queen Elizabeth II), and a large study of a French bulldog sold for £90 in 1916.

12. Crawford and Crawford 1997, 150.

13. *The Times* (London), March 30, 1971, 15D; detailed accounts of their escape are in family biographies by Majolier and by Gray cited above.

14. Crawford and Crawford 1997, 135.

15. Hammer Galleries 1937, no. 158.

16. The description is dated December 9, 1937. Curatorial Archives, Virginia Museum of Fine Arts, Richmond.

17. Habsburg and Lopato 1993, 29.

Fabergé and Grand Duchess Maria Pavlovna

ALEXANDER VON SOLODKOFF

FIGURE 7.1: Grand Duchess Maria Pavlovna, wearing a pearl necklace decorated with a diamond-set imperial eagle. Portrait photograph by Otto, Paris, ca. 1895. Ducal Archives Mecklenburg, Hemmelmark.

The Lillian Thomas Pratt Collection at the Virginia Museum of Fine Arts reflects both the artistic mastery of the House of Fabergé and the patronage of the Russian imperial family during the Bell Époque era. At the same time, it reveals the taste of Lillian Pratt, who assembled the Fabergé collection of more than 320 pieces between 1933 and 1946. She seems to have especially liked the elegant Fabergé flowers standing in rock-crystal vases, of which she acquired an unusually large number. Among the members of Russia's imperial family, Grand Duchess Maria Pavlovna (1854–1920) (fig. 7.1), a passionate collector of objets d'art and jewelry, was also known to have been particularly fond of Fabergé's flowers—delicate creations made of gold, hardstone, enamel, and jewels.

Born Duchess Marie of Mecklenburg-Schwerin in 1854, Grand Duchess Maria Pavlovna was the daughter of Grand Duke Friedrich Franz II, who ruled a small state in northern Germany on the coastline of the Baltic Sea. In 1874 she married Grand Duke Vladimir Aleksandrovich (1847–1909) of Russia, the third son of Tsar Alexander II and the brother of Alexander III. In Russia she was known as Maria Pavlovna, or sometimes Grand Duchess Vladimir, and within her own family she was called by her childhood nickname, Miechen. During her lifetime she witnessed the economic rise and industrialization of Western Europe and Russia, followed by the culturally important Belle Époque around 1900, World War I (1914–18), and the Russian Revolution in 1917. She fled the country early in 1920, traveling from the Crimea through Italy and Switzerland to France, where she died in Contrexéville on September 6 of that year.[1]

As a sister-in-law, and later aunt, of Russian tsars, she played an important role in the country's affairs. In St. Petersburg she had her own "small court" and was known for her ambitions to influence the reign of Tsar Nicholas II. In contrast to the introverted Tsaritsa Alexandra Feodorovna, the grand duchess introduced energy and

Paris

radiance into the social life of St. Petersburg.[2] As early as 1883, the grand ducal couple had arranged a costume ball at Vladimir Palace, at which Maria Pavlovna was dressed as a seventeenth-century boyar lady in a costume studded with real jewels and pearls.[3]

As a son of the ruling emperor, Grand Duke Vladimir served as commander-in-chief of the Russian army for many years. He was also interested in art, theater, and ballet—especially the new Ballets Russes of Sergei Diagilev, which he and his wife supported from its beginnings. In 1874 he had a sumptuous palace built next to the Hermitage Theatre on the Palace Embankment in St. Petersburg. At the grand duke's death in 1909, his widow inherited his estates and appanages. Her pension of about one million francs a year was easily enough to accommodate her acquisitions of jewelry and objets d'art.

For court jeweler Karl Fabergé, St. Petersburg's creative genius in jewelry and gold-smith work, the grand duchess's patronage was especially sought after. Their relation-ship was mutually efficacious: the grand duchess benefited from an invaluable source of important jewelry and trinkets both for herself and as presents, and Fabergé not only gained a keen collector and buyer of his works but also spontaneous publicity from a member of the imperial family.

Archival records directly linking Grand Duchess Maria Pavlovna to Fabergé are scarce, but there are several contemporaneous accounts that make references to their relationship. The grand duchess's younger brother, Duke Johann Albrecht, visited her for six weeks with his wife in 1903 and described in his diary the extravagant balls and other festivities they attended, likening them to fairy-tale events. On February 10 he recorded a visit with his sister to the Fabergé shop, where his wife chose an umbrella handle made of jade.[4]

Another guest was Maria Pavlovna's English friend Albert (Bertie) Stopford, a rather flamboyant figure who single-handedly saved most of the grand duchess's jewelry from the Vladimir Palace during the 1917 revolution[5] and, as a diplomatic courtier, brought it to England. In his personal journal on September 5, 1915, he wrote: "On Friday I was invited to be at the Vladimir Palace at six, to motor down to Tsarskoe with the Grand Duchess Vladimir. Exactly at six I was there dressed. I found M. Fabergé, the famous Court jeweller, who had been waiting since half-past five."[6] Evidently the master jeweler attended to business personally with such an important client.

Henry C. Bainbridge, manager of the London branch of Fabergé, also acknowledged the significance of Maria Pavlovna's patronage: "In fact I may call her the Lady of Europe of her time. With St. Petersburg her capital city where her court outstripped that of the Empress, every other capital city knew her well and none better than London. . . . Many were the gifts she gave from Fabergé."[7] In the company's London Sales Ledgers, an entry for the purchase of a clock on June 8, 1912, reads: "Grand

Duchess Vladimir of Russia—Clock, jade brilliants, roses in platinum, white opaque enamel—Inventory No. 21657—£65—Cost Roubles 328."[8]

Franz Birbaum, Fabergé's chief designer from 1893 to 1917, admitted in his memoirs, with a hint of criticism, that Maria Pavlovna more than any other member of the imperial family actually favored foreign jewelers. This preference was especially evident in her support of Louis Cartier, for whom she opened many doors and even hosted a jewelry show in her own palace in 1908. Birbaum, however, also revealed details of the grand duchess's special appreciation of Fabergé's flower still lifes:

> Narcissi, jasmine, branches of white lilac, and hyacinths were made in white quartz; sweet peas and other flowers in rhodonite, quartz, carnelian, and agate. The leaves are mainly nephrite, sometimes green jasper or quartz. Sometimes the flowers stood in a little glass of rock crystal, half hollow so that the flower appeared to be standing in water. . . . There was a specially successful series of dwarf cactuses in flower. Most of these were bought by Grand Duchess Marie Pavlovna or presented to her by her entourage.[9]

These delicate artistic inventions of Fabergé were surprisingly realistic renderings of nature with rock-crystal vases that looked as if they were half-filled with water. Unfortunately, Maria Pavlovna's collection disappeared after the revolution, probably sold by the Soviets for hard currency in the 1920s and 1930s. However, it was listed with the contents of the Vladimir Palace by a revolutionary committee only five days after the overturn.[10] The grand duchess's collection of thirty-four flowers (a full list of which appears at the end of this chapter) reflects the wide range of these charming decorative objects, one of which was especially noted as having a Tiffany vase. They not only comprised the typical lily of the valley made with diamond-studded pearl blossoms but also a sapphire-and-diamond-encrusted forget-me-not as well as a nephrite cactus in a solid jasper flowerpot on a bench of jadeite. Other arrangements included enameled cornflowers, dandelions, a hardstone cyclamen, and a sweet pea flower. A young relative of Maria Pavlovna, Count Georg von Carlow of the ducal Mecklenburg-Strelitz family, described the Easter reception at the Vladimir Palace in 1916, which imparts a sense of the magnificence of a typical St. Petersburg society event. Like Birbaum, he noted the grand duchess's "entourage" and the presentation of costly gifts. One can assume that most of the objects he described were made by Fabergé:

> After Easter supper Grand Duchess Vladimir distributed fabulous presents. She herself received beautiful things, for instance small flowerpots made from hardstone with imitations of flowers on stems of precious materials, all fantastic jeweller's work. Mama and my sisters were wearing very elegant light-coloured dresses and had one or more necklaces with small eggs made of precious stones. These eggs were made by the jewellers of St. Petersburg from widely differing

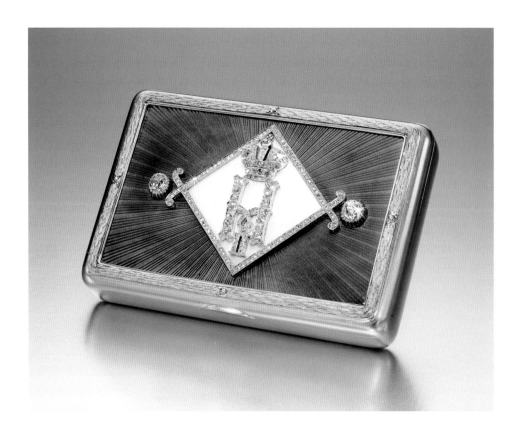

Fabergé, *Imperial Presentation Box with Crowned Monogram of Nicholas II*, ca. 1896, workmaster Mikhail Perkhin; gold, enamel, diamonds; width 3¾ in. (9.5 cm). Photograph courtesy of Sotheby's London.

types of stone. They were the size of a cherry or a grape and were suspended by small gold links from a chain. It was a custom at Easter to give them as presents not only to members of the family but also to distant cousins and old friends. My sisters each had two or three long chains studded with these eggs which hung down to their waists.[11]

In 2009, the discovery of a hidden collection of objets d'art that had belonged to Grand Duchess Maria Pavlovna shook the world of Fabergé scholars and enthusiasts. The items had been saved from Maria Pavlovna's palace in St. Petersburg by Richard Bergholz during the revolutionary days of 1917. A professor who served as head of the Union of Artists, Bergholz managed to put 108 items into two pillowcases, which he marked "Appartient à S. A. I. la Gr. Duch. Wladimir" and brought to the Swedish Consulate for safekeeping. They were later transferred to the Swedish Foreign Office in Stockholm, where they remained for nearly ninety years. The ministry finally traced the heirs of the grand duchess, and the collection was put up for sale at auction in London.[12]

All of the stored items turned out to be personal souvenirs of Grand Duke Vladimir Aleksandrovich kept by his wife after his death in 1909. Fabergé collectors were fascinated that such a collection of undisputable provenance—most pieces had monograms, cyphers, or inscriptions of the owners—had remained unseen and untouched for over ninety years. Many of the objects commemorated family celebrations such as

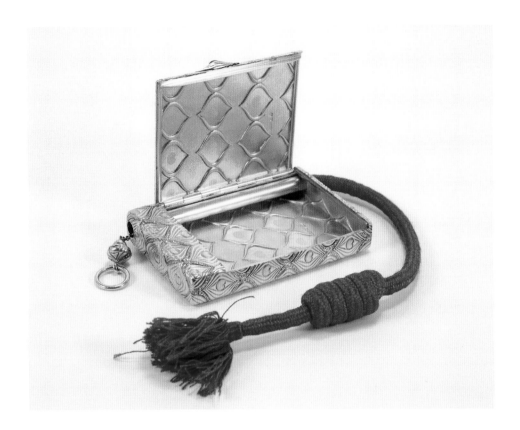

the couple's anniversaries and their children's birthdays and weddings. Others were personal items like cuff links and shirt studs, small pieces by various Russian and foreign jewelers, all eagerly acquired by contemporary collectors at the London sale. However, there was also a small group of Fabergé objects that not only had an imperial provenance but also excelled in their outstanding, pristine quality. These included magnificent boxes, gold cigarette cases, etuis, unusual cuff links, and, surprisingly, a decorative miniature green-enameled tankard set with coins.

Among the Fabergé boxes was a gold table cigarette case decorated with the crowned monogram of Tsar Nicholas II in diamonds on a green guilloché-enamel ground (fig. 7.2). It was signed by workmaster Mikhail Perkhin and dates to about 1896. The original card it contained is particularly touching. In the handwriting of the last tsar, it reads (in Russian): "Alix and I ask you to accept this present as a souvenir of this day—Nicky." Apparently the imperial couple visited the Vladimir Palace in 1896 on the day of the patron saint of Grand Duke Andrei Vladimirovich, and the card probably refers to that day. The inscription demonstrates the close personal relationship of the grand ducal couple to the tsar and Empress Alexandra.

Another eye-catching piece dating from about 1900 was the jeweled, three-color-gold cigarette case by Fabergé workmaster August Hollming, a specialist of etuis in fine gold work and enamel (fig. 7.3). The case is decorated with a wavy trellis of rose-cut diamonds enclosing yellow-gold hearts within alternating rose- and green-gold lobes

FIGURE 7.3: Fabergé, *Three-Color-Gold Cigarette Case,* ca. 1900, workmaster August Hollming; gold, diamonds, cabochon-ruby thumbpiece, red tinder cord; width 3⅞ in. (9.8 cm). Photograph courtesy of Sotheby's London.

in soft relief, with a cabochon-ruby push piece. When open, it displays a three-color heart pattern similar to the outside but with a shiny, flat, polished surface.

Among the cuff links by Fabergé was a fine heart-shaped pair of jeweled gold and mauve guilloché enamel by workmaster Mikhail Perkhin (fig. 7.4). These were made to commemorate the twenty-third wedding anniversary of Grand Duke and Grand Duchess Vladimir in 1897. The Old Slavonic characters for the numeral *23,* "KG," demonstrate Fabergé's use of Old Russian motifs, which became popular in art during the reign of Tsar Alexander III.

In his album of watercolor drawings, which is now in the archives of the Moscow Kremlin Museum, Tsar Nicholas II kept a record of the jeweled cuff links and tie pins he received as presents. On seven occasions between 1889 and 1898, he illustrated his gifts from Vladimir Aleksandrovich and Maria Pavlovna. These paintings include a circular cuff link of pink enamel with a diamond center and border, with the note "From Aunt Miechen, Christmas 1893," and a pair of cuff links set with oval moss-agate plaques surrounded by rose-cut diamonds (fig. 7.5). Although the tsar did not mention the maker, comparison strongly suggests they were also made by Fabergé. These, he recorded, were a gift from "Uncle Vladimir and Aunt Miechen" on the occasion of his thirtieth birthday, on May 6, 1898.[13]

The fabulous jewelry collection of Maria Pavlovna that was taken out of Russia by Bertie Stopford during the revolution contained large necklaces, tiaras, and brooches. Before being distributed among the children of the grand duchess—she stipulated in her will that each child would receive one type of colored stone or pearls—they were taken to Cartier in Paris for valuation. Cartier made an album with large photographic plates of the pieces in the collection, which is still kept in the archive of the Paris firm.[14] While most of the jewelry, according to archival records or stylistic attributions, was made by the Bolin, Cartier, or Chaumet firms, one item can be safely ascribed to Fabergé: an impressive brooch in the shape of the imperial Russian crown set with diamonds. It belongs to a group of diamond crown brooches that

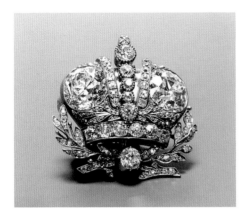 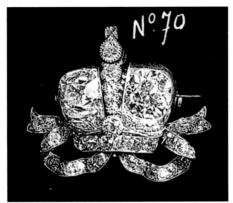

were created by Fabergé's workmaster and chief jeweler August Holmström for Tsar Nicholas II to commemorate his coronation in 1896.

The tsar had ordered the brooches to be made as presents for all of the Russian grand duchesses who attended the coronation. Eighteen were delivered by Fabergé to the tsar on May 25, 1896, the day before the ceremony in Moscow. The event was one of great pageantry involving the entire imperial family, the court and church officials, army generals and admirals, and the diplomatic corps—all watched by thousands of Russian people as well as the international press. The diamond brooches were presented to the grand duchesses as emblems of their status as members of the imperial family. According to the original Fabergé invoices, the cost of each brooch was about 4,000 rubles and those for the empresses Alexandra and Maria Feodorovna, 10,000 and 12,500 rubles respectively (for comparison, the prices for the imperial Easter eggs delivered in 1896 were 3,575 and 6,750 rubles and for the 1897 coronation egg, 5,500 rubles).[15]

Recently such a brooch was discovered in the jewelry chest of a member of the Danish royal family (fig. 7.6).[16] It is also in the shape of the imperial Russian crown, set with two large cushion brilliant-cut diamonds totaling about 6 carats each, and surrounded by smaller diamonds—twelve brilliants, sixty smaller brilliants, and eighty rose-cut diamonds—together weighing about 4¾ carats. The brooch had previously belonged to the great-grandmother of the present queen of Denmark, Anastasia of Mecklenburg-Schwerin, grand duchess of Russia, who was the sister-in-law of Maria Pavlovna after she married her eldest brother.

The brooch that was presented to Grand Duchess Maria Pavlovna appears in Cartier's album in a photograph with her other jewelry (fig. 7.7). In typical fashion, Fabergé did not merely make multiple copies of the same brooch design, but styled each one individually. While the Anastasia brooch incorporates crossed laurel- and oak-leaf branches held by a circular-cut brilliant diamond, the one for Maria Pavlovna has two diamond-set ribbons. The settings of silver and gold and the diamonds in various

FIGURE 7.6: Fabergé, *Diamond Crown Brooch,* ca. 1896, workmaster August Holmström; diamond, silver, gold; width 1½ in. (3.7 cm). Private collection, Copenhagen (Danish Royal Collections, courtesy Ole Villumsen Krog).

FIGURE 7.7: Diamond crown brooch, from Cartier photograph album, Paris, ca. 1920.

styles are characteristic of the extraordinary craftsmanship of Russian jewelers, especially Fabergé. The two important cushion-shaped stones on each brooch are held in box settings with closely fitted mounts (as opposed to open-claw fittings, used mainly in Western Europe), a style dating to the eighteenth-century *chatons,* but with open backs to let the light shine through the diamonds. Russian jewelers excelled in the precise setting of the very small rose-cut diamonds (tiny diamond chips cut with few triangular facets producing a sparkling effect) that were used on the brooches. The larger circular-cut brilliants in the middle row of the crown are set in *millegrain* mounts. They are closely surrounded by a band of minute silver pellets, which enhance the brilliance of the stones. This style, however, which was introduced mainly by French jewelers in the late nineteenth century, was rarely used by Fabergé.

NOTES

1. Habsburg 2003, 105–4*ff.* The research for this served as basic information for the present article.
2. Russian Court Memoirs 1914–16 by a Russian, London 1917, 171–72*ff.*
3. Velichenko and Miroliubova 1997, 7.
4. Letters (Briefnachlass) of Herzog Johann Albrecht, no. 9, Landeshauptarchiv Schwerin.
5. Clarke 2009, 96.
6. [Stopford] 1919, 21.
7. Bainbridge 1968, 89.
8. Habsburg 1986, 40.
9. Birbaum, Fabergé, and Skurlov 1992, 35 and 43.
10. Korneva, G. N., and T. N. Cheboksarova, "Opis' veshchei raboty Faberzhe, RGIA," Antikvarnoe Obozrenie 3 (2001): 38.
11. Solodkoff 1988, 62 and 58.
12. *Romanov Heirlooms, the Lost Inheritance of Grand Duchess Maria Pavlovna,* sales catalogue, Sotheby's London, November 30, 2009.
13. Solodkoff 1997, nos. 32, 51, 71, 91, 118, 135, and 183.
14. *Photographies des Bijoux de la Grande Duchesse Vladimir, no. 70,* Archives Cartier, Paris, by kind permission of Mme Betty Jay.
15. Fabergé, Proler, and Skurlov 1997, 123, 124, and 130.
16. Keiserinde Dagmar, *Maria Feodorovna Empress of Russia,* exhibition catalogue, Copenhagen 1997, no. 264; Krog et al. 2002, no. 63 (H. H. Princess Elisabeth of Denmark).

Appendix

A list of flowers by Fabergé from the collection of Grand Duchess Maria Pavlovna

Compiled on October 30, 1917, five days after the October Revolution, now preserved in the State Russian Historic Archives RGIA.

Cyclamen, nephrite stem, flower of white quartz with one diamond, in a small rock-crystal vase

White sweet pea, nephrite stem, flower of white quartz, small vase of rock crystal, in a case of mirrored glass with silver-gilt mount on wooden amaranth base

Lily-of-the-valley, nephrite leaves, gold stem, the flower of pearls and rose-cut diamonds, in a small rock-crystal vase

Dog rose, gold stem, nephrite leaves, enameled flower with one diamond, in a small rock-crystal vase

Whortleberry, gold stem, nephrite leaves, berries made of various stones, in a small rock-crystal vase

Forget-me-not, gold stem, nephrite leaves, enameled flower with a brilliant-cut diamond, in a small vase of rock crystal

Wild strawberry, gold stem, nephrite leaves, enameled berries, flower made of pearls and rose-cut diamonds, in a small rock-crystal vase

Bilberry, gold stem, nephrite leaves, stone berries

Forget-me-not, gold stem, nephrite leaves, flower of sapphires, brilliant- and rose-cut diamonds, in a small rock-crystal vase

Yellow wildflower, gold stem, enameled flower with diamonds, in a small rock-crystal vase

Yellow wildflower, gold stem, enameled flower with diamonds

Cornflower, gold stem, enameled flowers with diamonds in a small rock-crystal vase

Lily, gold stem, enameled leaves and flower with rose-cut diamonds, in a small rock-crystal vase

Wildflower, gold stem, gold flowers with rose-cut diamonds, in a small nephrite vase

Chamomile, gold stem, nephrite leaves, enameled flowers with rose-cut diamonds, in a small rock-crystal vase

Forget-me-not, gold stem, nephrite leaves, with two brilliant-cut diamonds, in a small rock-crystal vase

Wildflower, gold stem, enameled leaves and flowers, in a small rock-crystal vase

Cornflower, enameled stems and flowers in a small "Tiffany" vase

Flower, red enameled with rose-cut diamonds, gold stem and bud, nephrite leaves, in a small rock-crystal vase

Wildflower, gold stem, enameled flowers with rose-cut diamonds, nephrite leaves, in a small rock-crystal vase

Gold stem, enameled flower with diamonds, nephrite leaves, in a small rock-crystal vase

Dog rose, gold stem, nephrite leaves, flower of rose quartz with one chrysolite

Whortleberry, gold stem, nephrite leaves, berries of various stones, in a small rock-crystal vase

Dandelion of gold and rose-cut diamonds, gold stem, nephrite leaves, in a small rock-crystal vase

Cactus of nephrite, flowers of rhodonite with rose-cut diamonds, in a small rhodonite vase on a stand of white onyx

Cactus of nephrite with enameled flower, small vase of white onyx, stand of jasper on a small bench of jadeite

Wild strawberry, gold stem, nephrite leaves, enameled berries, flowers of pearls, in small rock-crystal vase

Bleeding heart, gold stem, flowers of rhodonite, nephrite leaves, stone berries

Pansies, gold stem, nephrite leaves, flower of sapphires, with one brilliant-cut diamond, in a small rock-crystal vase

Yellow wildflower, gold stem, nephrite leaves, enamelled flower, in small rock-crystal vase

Hyacinth, of white quartz, stems and leaves of nephrite, in a jasper pot pink enamel flowerhead with one brilliant-cut diamond, enameled leaves, gold stem, in a small jasper vase, work by Fabergé

Forget-me-not of turquoise with rose-cut diamonds, enameled leaves and stem, in a small rock-crystal vase, work by Fabergé

Wildflower, enameled purple with two brilliant-cut diamonds, gold stem, nephrite leaves, in a small jasper vase, work by Fabergé

Lillian Thomas Pratt and A La Vieille Russie: A Personal Relationship

MARK SCHAFFER

FIGURE 8.1: Alexander Schaffer in Russian Imperial Treasures, ca. 1934. Photograph courtesy of A La Vieille Russie.

Mark Schaffer is a director of A La Vieille Russie, a family art and antiques business founded in Kiev in 1851 and specializing in jewelry and Russian works of art. Schaffer's grandparents opened Russian Imperial Treasures in 1933. It became A La Vieille Russie in 1941 upon merging with the Paris branch. The Schaffers have helped form many major Fabergé collections.

A collection derives from the passions and circumstances of the collector. In the case of Lillian Thomas Pratt (fig. 8.2), her close and personal relationship with my grandparents Alexander and Ray Schaffer nurtured that passion while facilitating her collection's formation. Mrs. Pratt loved artworks by Fabergé, and she purchased a great number of pieces from the Schaffers' New York City shop. She made these acquisitions in an era that was challenging for art dealers and collectors alike.

During the 1920s and 1930s, with the dramatic change in the market for Russian works of art, Alexander Schaffer (fig. 8.1) helped link American consumers to the burgeoning offerings of the young Soviet government. After several years of shuttling between New York, Paris, Berlin, and Russia, he opened his own store in 1933 in the newly constructed Rockefeller Center, on West Fiftieth Street. The relationship with Mrs. Pratt began there the following year.

Records in my family's archives and the correspondence files at the Virginia Museum of Fine Arts — the recipient of Lillian Pratt's bequest — offer us a small window into the world of a Fabergé collector in America during this period. Letters passed frequently between New York and Fredericksburg, Virginia, where Lillian Pratt lived with her husband, John Lee Pratt. Their correspondence, though significantly diminished by 1945, continued until 1947, the year of Mrs. Pratt's death.

Beyond discussions of the nuts and bolts of business, which included acknowledgments of payments received or enclosed, Lillian Pratt's letters also mentioned the

weather and her garden in Fredericksburg. Her local garden club apparently took much of her time. Particularly revealing are the longer letters or stray remarks that shed light on the thoughts of a collector and the details of her life.

Lillian Pratt made regular, though infrequent, trips to New York. Initially her visits to the Schaffers were squeezed in between dental and optician appointments in the city, but ultimately a trip was not complete without her stopping by. In many cases, music brought Mrs. Pratt to New York, such as her quick trip in 1938 to the opera *Parsifal*. In 1934, unable to make the journey as planned, she offered her seats to the Don Cossacks performance at Town Hall to my grandparents; apparently her interest in things Russian extended also to music. Other trips to New York were delayed due to illness, money, or other constraints of everyday life, such as the need to vote (presumably in the presidential election between Franklin D. Roosevelt and Alf Landon) in late 1936. Mrs. Pratt's signature features prominently in A La Vieille Russie's *Livre d'or*, our guest book initiated in the Paris shop in the 1920s, likely signed by her in New York in the early 1940s. The book is a veritable register of the collectors and cultural elite during the first half of the century, and "Lillian Thomas Pratt" appears between explorer Lincoln Ellsworth and the Duke and Duchess of Windsor.

Pervasive among the letters is Mrs. Pratt's excitement about her purchases, both actual and coveted. She loved her collection. In August 1937, she writes, "My cabinet is full, but I find I gaze at my new jade egg and the blue enamel one — they are too beautiful." Not only did Mrs. Pratt enjoy her visits to the store in New York, but she also followed current advertising in magazines and retained an active memory of the Fabergé pieces she spotted. "In the June 1934 *Connoisseur* is an Egg No. 111 — I wish you would ask Mr. Bainbridge [Henry Charles Bainbridge was former manager of Fabergé's London branch] about it," she posted in June 1936. Other correspondence concerns works under consideration, and there seems to have been a steady stream of orders and packages traveling back and forth via the Railway Express Agency between Virginia and New York. In November 1935 Mrs. Pratt writes, "the little frame with the diamonds seems to haunt me so, if you still have it. I think I must possess it," and in June 1937, "They tell me the box from you has arrived, and . . . will unpack them myself. I have longed for them." Her August 5, 1937, note reads, "The scarab is very beautiful and very expensive," and a week later, she praises a jade desk calendar as "exquisite" and "lovely."

Mrs. Pratt mentions certain pieces repeatedly, most notably a true star of her collection — the *Imperial Peter the Great Easter Egg* of 1903 — one of Fabergé's most beautiful works and considered by my grandfather as the most important he ever sold. The egg was exhibited and illustrated by us in New York in 1936 upon the gallery's move from 36 to 15 West Fiftieth Street. On May 5, 1938, Lillian Pratt

writes: "Replying to your letter of May 2nd—I hope you can sell the Peter the Great Egg to the collector of Fabergé. While it breaks my heart to lose it, I cannot possibly pay for it this year." By September 1939, however, the egg had been shipped to her and a bill rendered for $16,500. Personal accounting logs among the papers at the Virginia Museum of Fine Arts[1] indicate that Mrs. Pratt began monthly payments in 1942 and continued through 1944. Even the smallest installments of $150 were a significant sum of money in that era. Of course, a few years earlier, in June 1936, she had written, "Here's hoping for one of the Eggs. You are much more of an optimist than I am." Referring to an egg sold by Schaffer in Berlin in 1932, she continues, "Hitler will probably never allow the lily egg to leave the country."

Schaffer was not Pratt's sole source of Fabergé. As is well known, part of her collection was purchased from Hammer Galleries. Mrs. Pratt's correspondence reveals her sensitivity to this subject. She understood that Hammer was a competitor, and her mentions are circumspect.

Mrs. Pratt collected the gamut of top-quality Fabergé artworks. Most of the pieces she acquired cost a few hundred dollars at the time: handles, $250 to $350; frames, $350 to $750; miniature Easter eggs, $20 to $50. She often purchased pieces in groups, some as large as seventeen items.

An overriding concern for Mrs. Pratt was money. Perhaps mutual worries about the Depression-era economy helped solidify her relationship with Mr. Schaffer. Her common practice of time payments appears to have stemmed from her careful and

FIGURE 8.2: Lillian Thomas Pratt with her husband, John Lee Pratt, at their Fredericksburg, Virginia, home. Photography courtesy of Scharchburg Archives, Kettering University, Flint, Michigan.

conscientious money management. She specifically blamed the "Market Crash" in 1937 for her limited means. She hated to spend money she did not have, yet Alex Schaffer insisted that she not make interest payments. She saved for works she particularly desired: referring to a parasol handle, in June 1939 she writes, "I have saved many pennies to pay for this, and am happy to possess it at last." Her ability to spend was dictated by her modest personal income, the limited extent of funds received through her husband, and whatever she could borrow. John Pratt, an engineer and businessman, was employed by General Motors, and company trends may have also influenced expenditures. Taxes and insurance were among her biggest expenses, with leftover monies apparently allotted to artworks. She occasionally sold pieces, principally non-Russian, to allow additional cash. Money seemed particularly tight for her in 1938, when she would not buy even a dress, and so too it must have been for the world at large, since her bank had declined her loan request the previous year. Later in 1938, after a $500 payment, she commented: "Business in the Automobile Industry seems to be picking up." She needed money not only for works of art but also for travel to New York, and beyond: "I am not going to buy anything more until my bill is paid," she had promised in August 1936, "It worries me more than you know. I have suddenly decided I cannot exist unless I can go to the Coronation [of George VI] next May, and then on the North Cape Cruise in June — so, I want to get out of debt, if possible, and I *have got to save* to do it."

Business was difficult during this period for the Schaffers as well. In May 1938 Alex Schaffer writes, "I hope that conditions will improve very soon now. . . . This depression did hit everybody I think. It's worse than in 1932, because now one cannot buy anything, yet it is very hard to sell or to collect money. At least in 1932, even if it was hard to sell, one could buy fine things at reasonable prices, and eventually good things always find a market." And rent continued to rise. Schaffer ultimately moved from Rockefeller Center. He opened A La Vieille Russie with Paris friends and colleagues Léon Grinberg and Jacques Zolotnitzky at Fifth Avenue and Sixtieth Street in 1941, on the same block where we are today. That year he offered Mrs. Pratt pieces he had not purchased outright, at a small margin, since he was in need of money to fix up the store and could not predict business at the new location. Yet he always understood the importance of paying high prices when times were good, rather than getting bargains when times were bad.

Another serious topic arising in many letters is Mrs. Pratt's concerns about her own health. She worried about her diabetes, and made efforts to keep her collection organized for the benefit of those who would handle it in the future without her. The collection always seemed to provide her happiness.

Although Mrs. Pratt was discreet about her collecting in the eyes of her husband, who apparently did not share her interest, she did not hide her art objects. On the

contrary, Schaffer helped her plan a display cabinet, a topic of much discussion, and a source of fear of shelves collapsing. She expressed her anxiety over the possibility of burglary as well and took care to have proper insurance.

Lillian Pratt and the Schaffers exchanged Christmas cards, and Mrs. Pratt did not limit herself to correspondence from home. There are frequent exchanges on hotel stationery, for instance her letters from Yuma, Arizona, at Christmas of 1935 or those of a few weeks later from Tacoma, Washington, her home as a young adult. Likewise, we find personal stationery from Schaffer, who on occasion visited Mrs. Pratt in Virginia, taking the Greyhound bus.

In September 1935, Mrs. Pratt sent a letter of appreciation for a card from Moscow. Those years, after all, remained active for the Soviet government's sale of artworks created or acquired during the imperial period, and Alex Schaffer was often a purchaser. Ray Schaffer continued the correspondence while her husband traveled, describing herself in a 1937 letter as a "grass widow."

A frequent and very personal thread of conversation in these records relates to the birth of my father ("the great event"), the wonders of his subsequent infancy ("the little rascal is growing so fast"), and eventually the birth of my uncle. Perhaps the most important piece for me among Mrs. Pratt's acquisitions is in fact the jade triple seal presented by Mrs. Pratt to my father on his birth in 1936. It remains a cherished treasure in our collection today.

My grandparents and Mrs. Pratt helped define the new market for Fabergé in the West through their quite personal and remarkably open relationship. The friendship spanned many years over two locations in the new Rockefeller Center followed by a move to Fifth Avenue. Mrs. Pratt, one of America's foremost early collectors of Fabergé alongside Marjorie Merriweather Post and India Early Minshall, pursued her passion through challenging times and worked closely with the Schaffers to build one of this country's greatest Russian art collections. After her death, her husband initially resisted when asked by VMFA for funds sufficient to secure and display the collection. However, my grandparents' offer to repurchase the group at a 50 percent profit so relatively soon after its acquisition was enough to convince him of the collection's great importance, and he made the necessary arrangements that benefit us all today.

NOTES

1. Curry 1995.

CHAPTER 9

Fauxbergé

GÉZA VON HABSBURG

Fauxbergé is a word coined by this author to denote the myriad of Fabergé look-alikes, or faux (forged) objects, that have inundated the Western art market since the 1930s.[1] A number of these have landed in American public collections with substantial Fabergé holdings. The great Russian art collection bequeathed by Lillian Thomas Pratt to the Virginia Museum of Fine Arts in 1947 — today the most important of its kind in the United States — is no exception. Formed between 1933 and 1945, when the romance of a Russian imperial provenance was deemed an essential prerequisite for a sale, it reflects the cunning of the suppliers: virtually each object sold came with a written statement declaring an august provenance of having originally belonged to either the tsar or tsaritsa, one of their five children, or the dowager empress — or at least a "Member of the Imperial Family." Further evidence of such manipulated origins is available in the form of framed images. For example, in the Pratt collection only two of fifty-four frames contain their original photographs. The remainder hold other photographs or reproductions of imperial family members, chosen at random and cut to size, or, if such photographs were not readily available, newspaper images. All this, too, was a form of sophisticated forgery, not of the objects themselves but of their purported origins. The willful misattribution of objects by other companies, including Cartier, was a common practice. Passionate collectors demanded objects by Fabergé only and those that had belonged to a member of the tragically murdered imperial family, or to one of their closest relatives. It would seem that the most ardent of these collectors were four American women who felt more personally linked to the Romanovs with each and every object they acquired.[2]

The forging of Fabergé objects began during Karl Fabergé's own lifetime. His works of art found numerous close imitators, at home and abroad, at a time when hallmarks were not yet scrutinized. As early as the 1900 Universal Exposition in Paris, the flowers he exhibited apparently engendered quite a following in Germany.[3] When

Fabergé himself convincingly plagiarized eighteenth-century works of art, he, too, was encouraged by unscrupulous operators to leave off his signature in order to allow his version to be passed off as the genuine article.[4] Shortly after his death, his sons in Paris continued the production of objects in the Russian style, which have sometimes been mistaken for originals.

There was virtually no demand for Fabergé immediately after the Russian Revolution, except in Britain. Fabergé was still a familiar word there thanks to the existence of a London office between 1903 and 1915 (the firm's only branch abroad) and the British royal family's leading role as collectors. Emmanuel Snowman of the Wartski firm catered to this clientele as early as 1927, acquiring seminal works of art and other treasures by Fabergé during his pioneering buying trips to Russia. If Fabergé objects in the 1920s were still generally considered as secondhand goods, by the end of the Great Depression, in the mid-to-late 1930s, both the British and Americans began collecting seriously. Supply was plentiful, and the young Soviet Union was glad to be rid of all the trappings of the hated tsarist regime. World War II put a stop to the influx of genuine Fabergé objects from Russia to the West and marked the beginnings of serious forgery. In Paris two talented forgers, Silvio Marucelli and a certain Monsieur Stiquel, are alleged to have been active, producing objects of high quality.

The spate of early publications on Fabergé, beginning with Kenneth Snowman's 1953 *The Art of Carl Fabergé* (and its enlarged editions of 1962 and 1964), were instrumental in inspiring a number of Russian forgers of hardstone animals and figures. The gifted stone carver Naum Nikolaevskii, a celebrated master forger in Moscow, and his brother-in-law Vasilii Konovalenko in Leningrad[5] sold copies of genuine one-of-a-kind objects on a large scale to Western and African diplomats in the Union of Soviet Socialist Republics who shamelessly used the diplomatic pouch to smuggle their acquisitions to the West. Forgers also made use of unsuspecting auction houses, particularly those in the United States, to offload their wares.

Also in Leningrad, the highly successful Mikhail Monastyrskii[6] was the source of a great number of hardstone forgeries from the mid-1970s to the 1990s. Even major Russian museums were taken in by his craftsmanship. His carvings were either straight copies of one-of-a-kind, well-known subjects derived from Snowman's books or his own inventions of "folksy" characters or fairy-tale animals. Typical is the case of a Russian émigré, one of Monastyrskii's numerous dupes, who had paid his way out of the Soviet Union and smuggled suitcases full of hardstone animals and figurines. His "collection" was frequently offered as a unit in Switzerland in the 1980s, deceiving none other than Armand Hammer, who hoped to negotiate its sale in order to benefit Prince Charles's United World Colleges.

Henry Bainbridge, Fabergé's London representative, who therefore must have actually handled many of the twenty-five flowers now owned by Queen Elizabeth, warned

of the complexities inherent in identifying any forgeries in that genre. In 1949, with the American forgeries in mind, Bainbridge wrote:

> So successful was [Fabergé] with his flowers, that it behooves collectors to see that they get the right thing, for they have been imitated, not in great numbers, but to such an extent as to call for care when purchasing them. . . . The collector of Fabergé flowers must forget hall-marks and maker's marks altogether, and if he is not sufficiently acquainted with their chief characteristics, which *in toto* make up something which to the experienced eye can be seen at a glance, then let him seek guidance. . . . genuine pieces are in short supply. Collectors who have not developed a Fabergé sense of their own should be guided by the advice of dealers of repute.[7]

Bainbridge's admonitions of years ago remain fully valid today:

> Always keep in mind the superb finish of the original natural flower and keep the critical sense at this pitch. Examine the stalks minutely and note that for the most part they . . . are evenly lined, even if sometimes the lines are hardly to be seen. Let him notice that the surface of the stalks is, in varying degree, mat. Let him examine the back of the leaves, as well as the front and take note that the veinings are correspondingly ribbed on the back. Of the flower blooms one can only say that their delicacy is indescribable, the only thing he can do is to take a microscope and on bended knee saturate himself with their unending detail. . . . [T]he delicacy and intricacy of the natural flower has been faithfully reproduced up to the point where further reproduction is no longer possible owing to the limitations of the material employed and the mechanical devices necessary.

Specialists seem to agree that Fabergé flowers were rare; some claim as few as sixty were made while others say eighty.[8] Thus, the appearance of over sixty flowers on the American market between 1938 and 1942 is, to say the least, somewhat suspect. The Royal Collection, with its twenty-five flowers, is by far the largest extant group of its kind[9] and should be used as a benchmark by which to judge other flowers.[10] Because of Bainbridge's warnings in 1949, even the flowers that entered the Royal Collection in the 1940s and later, though almost certainly genuine, should at least be scrutinized.

Genuine Fabergé cut flowers are always depicted naturalistically, generally as single sprays leaning at an angle, the stalk "grounded" in the rock-crystal vase's base and resting against the rim of the vase — never standing upright and never with stems "floating" halfway in the simulated water. The large majority of early flowers have enameled blossoms, gold stems, and nephrite leaves and stand in transparent rock-crystal vases.[11] They are generally unmarked, because of the fragility of the stalks.[12] Of those that are hallmarked, all but two bear the initials of head workmaster Henrik Wigström, dating them to 1903–17. A few, mostly later, examples are set in bowenite

or nephrite vases. An album with original Fabergé photographs shows late flowers in the Japanese taste, many in hardstone pots with simulated gold soil or on Japanese-style bases.

The primary source of Fabergé flowers in the United States was Armand Hammer (1898–1990),[13] son of a Russian Jewish emigrant. Hammer first traveled to the USSR in 1921, when American contacts with Russia were still forbidden. He became the purchasing agent for American agricultural machinery and exclusively represented up to three dozen U.S. companies in the Soviet Union. Between 1925 and 1930 he owned a pencil-manufacturing concession, which is said to have grossed 8.5 million rubles, about $4 million. Dispossessed of his factory, Armand and his brother, antique dealer Victor Hammer, were apparently authorized by the Soviet officials to represent them as sole agents for the disposal of Russian imperial treasure in the United States. Arriving in New York in the middle of the Depression, laden with trunks full of Russian artworks and memorabilia including ten imperial Easter eggs, the entrepreneurial brothers set about marketing their wares across America. They began by improvising a six-month traveling show in 1932, which they staged at the leading department stores in twenty-three cities. The Hammers settled in New York City at 3 East Fifty-second Street with a three-year contract for a semipermanent display entitled *Russian Imperial Exhibit* at the city's Lord & Taylor store in 1933–34. They also exhibited their treasures at Marshall Fields in Chicago, concurrent with the Chicago World's Fair. Business thrived. The USSR's commissar for foreign trade, Anastas Mikoian, saw to it that the brothers were kept supplied with Russian artifacts, until World War II broke out in September 1939 and their primary source dried up.

Having created, together with Alexander and Ray Schaffer of A La Vieille Russie, a demand for Fabergé (in particular the floral compositions) in the United States, the Hammers embarked upon finding new sources and means of continuing their lucrative business. The origin of this new generation of flowers is yet unclear. Perhaps they were produced in Idar-Oberstein in Germany, Western Europe's chief hardstone-carving center. Another option, mentioned by Victor Hammer, is Paris, where a craftsman was said to have been capable of "knocking off new objects" that were then hallmarked with a set of original Fabergé tools supplied by the Soviets. In 1949 Bainbridge wrote: "the imitating was done with malice aforethought, the flowers in every case being stamped on the gold stalk with the forged mark of Fabergé and the Russian hallmark for gold."[14]

Of the twenty-two flowers in VMFA's Pratt collection, all but one — the genuine *Cornflower Spray* (cat. no. 111) purchased in 1935 — were acquired by Mrs. Pratt between January 9, 1939, and January 9, 1940, from Armand Hammer. Fifteen of these are most probably forgeries. Their styles vary: some are more finely crafted, perhaps denoting a French origin, while others are cruder, possible indicating a

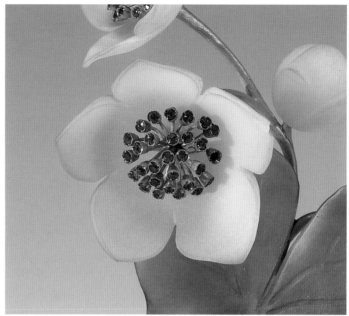

German provenance. However, they all share the Fabergé and Wigström hallmarks that were added later.

Flowers similar to those in the Pratt collection exist in other museums and private holdings in the United States. Hammer's charm and clever marketing attracted a number of well-heeled collectors. One of these was the fashionable wife of Harrison Williams, Mona Williams, later Countess von Bismarck. Named the "Best Dressed Woman in the World" by the leading French couturiers, she had a cabinet full of such forged flowers in her Paris Salon. All were hallmarked, and their fitted cases were Fabergé look-alikes stamped with Hammer's address (this author recalls some twenty examples in her elegant salon).

Keeping in mind Henry Bainbridge's enthusiastic remarks about genuine flowers, the majority of the Hammer flowers look lifeless; their quality is poor, their carving summary, and their wire pistils rigid (compare figs. 9.2 and 9.3). With six exceptions, all of the Pratt flowers bear identical marks of Fabergé in Cyrillic, that of head work-master Henrik Wigström, as well as the 72-*zolotnik* gold mark. The same hallmark-ing tools were used for each flower (the exceptions are the lilies of the valley in a bloodstone vase, cat. no. 110, which bears a forged Fabergé incised signature; and a forged pansy, cat. no. 108, which may have a mark hidden by leaves). Of the remain-ing flowers, accepted here as genuine, *Globeflowers* (cat. no. 106) bears Fabergé's Moscow hallmark, and a cornflower (cat. no. 111); a violet (cat. no. 109); and a pansy (cat. no. 108) are unmarked.

The Pratt Collection includes thirty-four hardstone animal figures together with a silver rabbit pitcher (genuine) and three elephants (forgeries) made of silver or gold.

FIGURE 9.2: Fabergé, *Wild Rose Brooch*, ca. 1910; gold, enamel; diameter 1½ in. (2.8 cm). Bequest of Lillian Thomas Pratt, Virginia Museum of Fine Arts.

FIGURE 9.3: *Water Lily*, ca. 1940; agate, rock crystal, nephrite, gold rubies; height 6⅜ in. (16.2 cm). Bequest of Lillian Thomas Pratt, Virginia Museum of Fine Arts.

However, new evidence presented in Chapters 3 and 4 calls into question the validity of their attributions, further complicated by 1,300 known Cartier look-alikes and the close proximity to Fabergé of sculptures by at least five St. Petersburg contemporaries. Fifteen of the animal figures in semiprecious stones are considered here to be by, or attributed to, Fabergé; nine by Cartier (five of the animals bear forged Fabergé marks and are attributed here to Cartier); and four to other Russian craftsmen.

Lillian Pratt fared much better with her fifty-four frames. Of these, forty-two are clearly genuine, two can be attributed to Fabergé, five are by other masters, or unmarked, and only two are forgeries. It should not be forgotten, however, that virtually all fifty-four frames are misrepresented as far as their photographic contents and their spurious provenances are concerned. The two forged frames are of poor quality and bear the unevenly struck hallmarks of Fabergé's competitor Karl Hahn. They lack the obligatory marks of one of his two leading workmasters, Carl Blank or Alexander Treyden, whose initials appear on all of Hahn's later productions. The frames are applied with the Russian state emblem in the form of a jeweled double-headed eagle, allegedly denoting an imperial presentation. This emblem, however, only appears on cigarette cases and small jewels: no presentation frames with photographs are recorded among the invoices of the Imperial Cabinet.[15] The other extant presentation frames, two by Fabergé and the others by Bolin and by Koechly, have hand-painted miniatures of the tsar. The apocryphal photographs only further corroborate the fact that both objects are of postrevolutionary, probably French, fabrication.

Armand Hammer praised the firm of Karl Hahn to Lillian Pratt as equal in fame to Fabergé. Interestingly, two allegedly French-made imperial snuffboxes in the Cleveland Museum of Art in Ohio and the Walters Art Gallery in Baltimore, the former of which has a Hammer provenance, also bear questionable Hahn hallmarks.[16] Mystery also surrounds the so-called Romanov Tercentenary Frame, formerly in the Forbes collection.[17] This lavish object, which appeared on the American market in the 1930s, has the same Hahn hallmark but is dated 1913, two years after the Hahn workshop closed. No such object, set with miniature portraits of the tsar, tsaritsa, and young Aleksei, is among the surviving files of imperial commissions.

One of the showiest objects in the Pratt collection, a circular jeweled and enameled presentation box (fig. no. 9.1, cat. no. 363) sold as a Fabergé original, is an interesting forgery. Its maker was unaware of the hallmarking system used in the Fabergé workshops. The box is struck with the initials of workmaster Mikhail Perkhin (who practiced exclusively in St. Petersburg) as well as Fabergé's imperial warrant mark, "K. Fabergé" in Cyrillic and the Russian double-headed eagle. This imperial mark was used only for objects produced in Moscow. With its finely enameled interior cover and its sides and base lacking their usual enamel coating, this box is stylistically closer to works by Fabergé's competitors. It is therefore at best a misattribution.

1. Fabergé forgeries are discussed at length in Habsburg and Solodkoff 1979, 149–50; Habsburg 1986, 334–35*ff.*; Habsburg and Lopato 1993, 165–66*ff.* Habsburg 1996, 329–38; Solodkoff 1995, 42–43*ff.*; Habsburg 2000, 385–88.

2. The quartet of American collectors was Matilda Geddings Gray of New Orleans; Marjorie Merriweather Post of Hillwood, Washington, D.C.; India Early Minshall of Cleveland, Ohio; and Lillian Thomas Pratt of Virginia.

3. For German and Austrian forgeries of flowers, see Habsburg and Lopato 1993, 458.

4. Ibid., 446.

5. Brokhin 1975, 163–85.

6. Habsburg 2000, 386–87*ff.*

7. Bainbridge 1968, 105–6.

8. Swezey 2004. The London sales ledgers list forty flowers out of a total of some ten thousand items sold. Research in Russia has shown that between 1896 and 1908 only six flowers were acquired by the empresses and between 1908 and 1915 only eight more.

9. Guitaut 2003, 102–21.

10. Of Queen Elizabeth II's flowers five can be traced to Fabergé's London sales room; seven were bought by Queen Alexandra, date unknown; eleven were "probably acquired by Queen Alexandra," first mentioned in the collection in 1953; one was acquired by Queen Mary in 1934; and two were acquired from Wartski in 1944 and 1947 respectively.

11. Of the twenty-five flowers in the British Royal Collection, twenty-two stand in rock-crystal vases, and, with one exception, all have enameled petals. According to Bainbridge these were the work of the firm's chief enamellers, Aleksandr and Nikolai Petrov and Boitsov. Of the thirty-four flowers owned by Grand Duchess Maria Pavlovna, twenty-three stood in rock-crystal vases. Of the sixty-two flowers illustrated in Swezey 2004, fifty-six stand in rock-crystal vases. On the other hand, of the over forty flowers in American public collections, thirty-two have hardstone blossoms and two-thirds stand in hardstone pots. Birbaum recorded that "the dandelions were particularly successful: their fluff was natural and fixed on with a golden thread with a small, uncut diamond. The shining points of the diamonds among the white fluff were marvelously successful and prevented this artificial flower from being too close to a reproduction of nature."

12. Of the twenty-five flowers in the collection of Queen Elizabeth II, only eight are hallmarked, with two exceptions, all by head workmaster Henrik Wigström (one exception in the Royal Collection is the *Catkin*, which as the sole apparent surviving example, is signed with the initials of Fabergé goldsmith Fedor Afanas'ev). Of the sixty-two flowers illustrated in Swezey 2004, only twelve are hallmarked, of which several are here considered to be forgeries.

13. Epstein and Hammer 1996, 135–142. For Armand Hammer's involvement with Fabergé, see Blumay and Edwards 1992, 95–108; Habsburg 1996, 57–61.

14. Bainbridge 1968, 105.

15. Tillander-Godenhielm 2005, 149–78 and 179–90.

16. Cleveland Museum of Art, bequest of India Early Minshall (Hawley 1967, 91, cat. 43), a nephrite box set with diamond-encircled, crowned miniature portraits of Tsar Nicholas II and Tsaritsa Alexandra Feodorovna, bearing a Paris restricted guarantee mark for 1838 through the present as well as marks of St. Petersburg before 1899; Walters Art Gallery, Baltimore, bequest of Henry C. Walters. The pink enamel frame with the Russian emblem in the Lillian Thomas Pratt Collection (cat. no. 362) also bears the same *petite garantie* mark.

17. The frame is illustrated in Forbes and Tromeur 1999, 261.

Catalogue: Fabergé

Note to the Reader

This catalogue records the Virginia Museum of Fine Arts Fabergé collection as well as additional items by other jewelers of Russia's late imperial age. Also included are items by foreign jewelers such as Cartier, which were erroneously attributed to Fabergé in previous publications. A number of ephemeral and non-Russian decorative arts pieces from the Lillian Thomas Pratt collection—the primary collection of Fabergé at VMFA—have intentionally been omitted. All objects have been newly photographed for this volume and are reproduced to scale unless otherwise indicated as reduced or enlarged. Provenances for all objects have been transcribed exactly from original invoices in VMFA's archives—spellings and inconsistencies have been retained. All marks, inventory numbers, inscriptions, and materials have been verified. Carat weight is given in the Russian standard *zolotnik*. Dimensions refer to height unless otherwise indicated.

Exhibition Abbreviations

ALVR—A La Vieille Russie

FA—*Fabergé in America* 1996

FAFE—Fabergé Arts Foundation Exhibition 1995

L&T—Lord & Taylor

NCMA—North Carolina Museum of Art

PFAC—Peninsula Fine Arts Center

RIT—*Russian Imperial Treasures* 1934

SAM—Seattle Art Museum

V&A—Victoria and Albert Museum

VMFA—Virginia Museum of Fine Arts

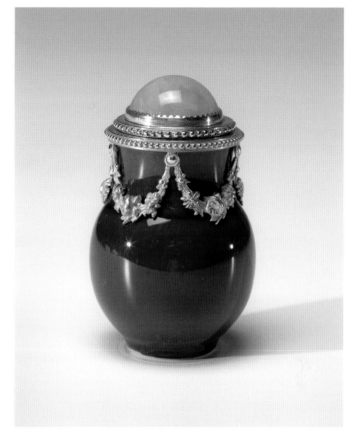

1 enlarged

2

Base Materials

1 World War I Ashtray

Copper

The cavetto of the bowl is repoussé with the imperial double-headed eagle and bears the Cyrillic words for *war, 1914,* and *K. Fabergé.*

UNMARKED

DIMENSIONS: D 1¼ in. (3.2 cm)

PROVENANCE: The Schaffer Collection of Russian Imperial Art Treasures, #2675; Lillian Thomas Pratt

EXHIBITED: VMFA 1983

NOTE: As precious metals became scarce, Fabergé produced numerous commemorative ashtrays in copper (many for soldiers at the front), as well as cigarette cases and beakers in brass, silver, and nephrite. Many of them have survived (see Habsburg and Lopato 1993).

BEQUEST OF LILLIAN THOMAS PRATT: 47.20.495

2 Gum Pot

Ceramic, silver, jade

The brown-glazed, vase-shaped gum pot has flower swags applied to its neck, a beaded border, and a domed green chrysoprase cover.

MARKS: Initials of workmaster Anna Ringe, 88 zolotnik, scratched Fabergé inventory number 11630, ceramic marked 1567

DIMENSIONS: 2¾ in. (7 cm)

PROVENANCE: Furman Hebb

GIFT OF FURMAN HEBB, 85.593

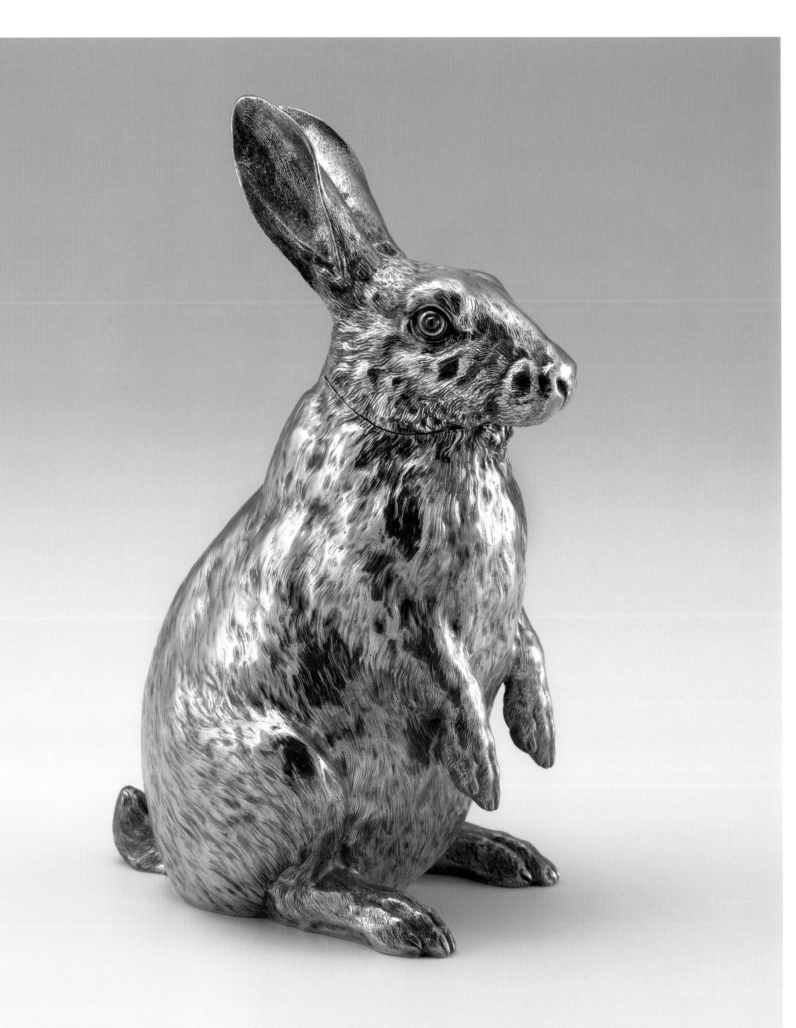

Silver

3 Rabbit Pitcher

Silver, garnets

The upright seated silver rabbit with
a hinged head and gilded interior has
naturalistically chased fur.

MARKS: Imperial warrant of K. Fabergé, assay
mark of Moscow before 1899, Cyrillic mark of
assay master *LO*, 88 zolotnik, scratched inventory
number 4639

DIMENSIONS: 10 in. (25.5 cm)

PROVENANCE: Russian Imperial Treasures Inc.
December 4, 1934, #558, $720 (from the "Alexander
Palace"); Lillian Thomas Pratt

EXHIBITED: *RIT* 1934; ALVR 1983; *FA* 1996

BIBLIOGRAPHY: Lesley 1976, cat. no. 22, p. 15 (ill.);
ALVR 1983, cat. no. 401, p. 111, p. 113 (ill.);
Curry 1995, cat. no. 112, p. 119 (ill.); Habsburg
1996, cat. no. 100, p. 128 (ill.)

NOTE: For another example of this very popular
model see Habsburg 2000 and Habsburg 2003.
See cat. no. 7 for the same, though smaller, model
that served as a bell push. Another was sold at
Christie's Geneva, May 12, 1980, lot 230.

BEQUEST OF LILLIAN THOMAS PRATT, 47.20.214

3 (left) reduced

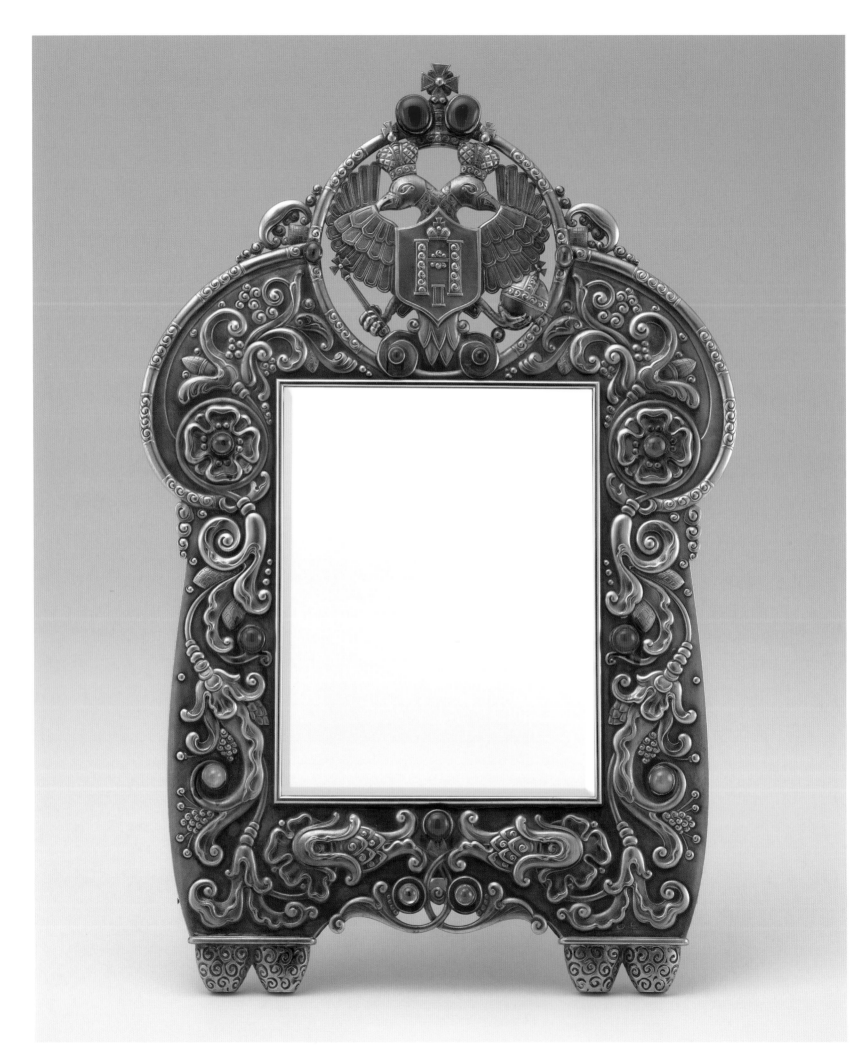

4 Imperial Silver Frame

Silver, cabochon agates, sapphires, chalcedonies, wood

The Old–Russian style frame of irregular outline is shaped as a doorway decorated with repoussé swirling stylized foliage and rosettes around the rectangular aperture. It is set with cabochon agates, sapphires, and blue-tinted chalcedonies and stands on two pairs of peg feet. The frame is surmounted by a crowned openwork double-headed eagle with the cypher of Tsar Nicholas II in an escutcheon. Its holly-wood back has an elaborate shaped, pierced, and ornamental silver strut.

MARKS: Imperial warrant of K. Fabergé, assay mark of Moscow 1899–1908, assay master Ivan Lebedkin, 88 and 84 zolotnik

DIMENSIONS: 17 ½ in. (44.3 cm)

PROVENANCE: The family of Audrey M. and Forrest E. Mars Sr.

EXHIBITED: VMFA 2005

GIFT OF FORREST E. MARS JR., JOHN F. MARS, AND JACQUELINE B. MARS IN HONOR OF THEIR MOTHER AND FATHER, AUDREY M. MARS AND FORREST E. MARS SR., 99.50

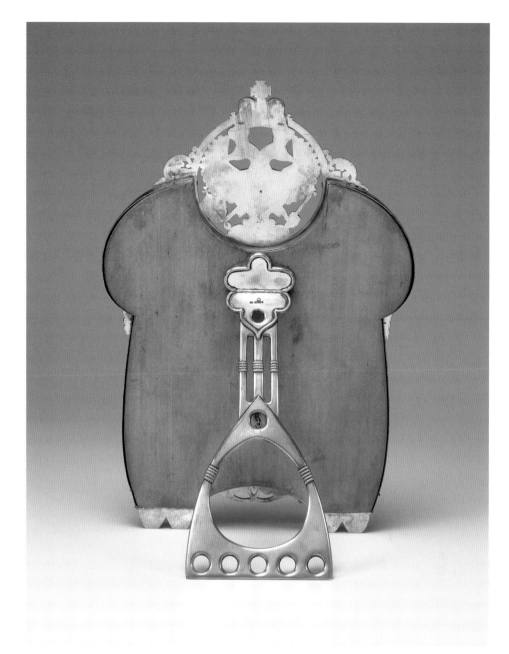

4 verso, reduced

4 (left) recto, reduced

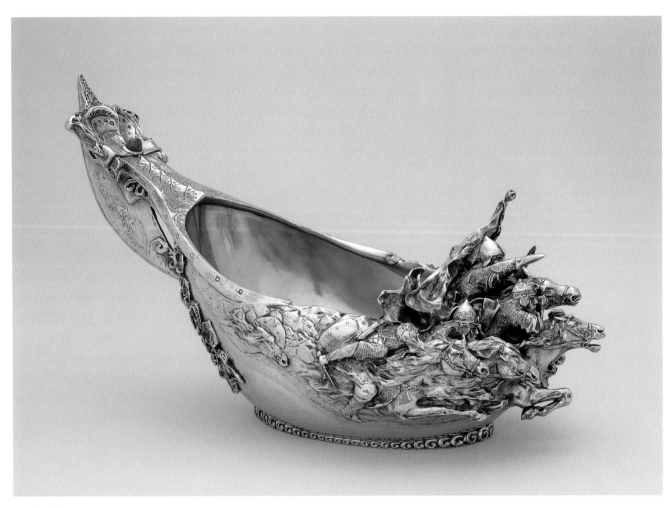

5 reduced

5 Monumental Kovsh

Silver, chrysoprase, amethysts

The prow of this huge sloping Old-Russian *kovsh* is modeled with a charging group of *bogatyri*, or legendary heroes. Its body is repoussé with Russian Art Nouveau motifs and set with chunky semiprecious Siberian stones.

MARKS: Imperial warrant mark of K. Fabergé, assay mark of Moscow 1899–1908, French import mark
DIMENSIONS: L 28½ in. (69.9 cm)
PROVENANCE: Christie's New York, October 18, 1994, lot 642; Jerome and Rita Gans Collection of Russian Enamels
EXHIBITED: *FA* 1996
BIBLIOGRAPHY: Christie's sale catalogue, 1994; Habsburg 1996, cat. no. 156, p. 169 (ill.)
NOTE: The *bogatyr'* (plural *bogatyri*) is a medieval heroic warrior or a brave knight, harking back to the Kievan period. The most famous three bogatyri, often shown together (as in Viktor Vasnetsov's 1898 painting in the Russian Museum, St. Petersburg) were Il'ia Muromets, Alësha Popovich, and Dobrynia Nikitich. These figures were often subjects of paintings on enamel during the Old-Russian Revival.
JEROME AND RITA GANS COLLECTION OF SILVER, 97.93

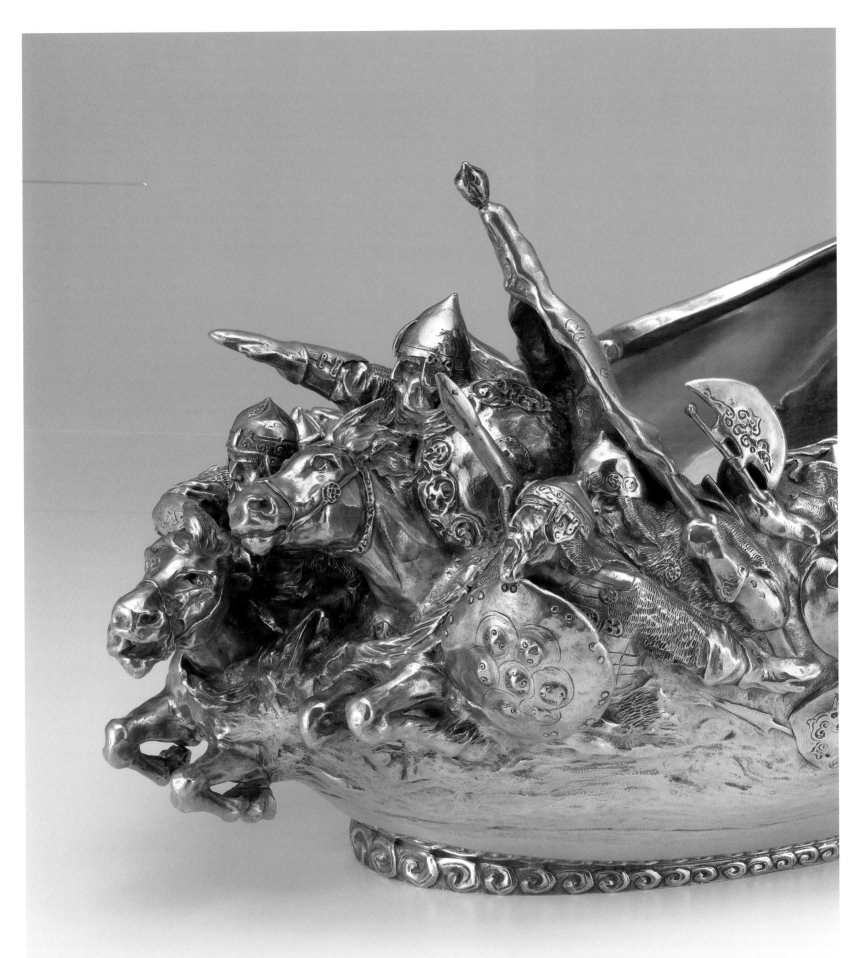

6 Frame

Silver, ivory

The plain octagonal silver frame with a reeded circular aperture and a reed-and-tie outer border is surmounted by the crowned enameled coat of arms of the city of Moscow. The dates *1891–1904* appear beneath the photograph and the crowned Cyrillic signatures *Sergii* and *Elisaveta* at either side. The photograph of the imperial couple is original to the frame.

MARKS: Initials *K. F.* for Karl Fabergé, assay mark of Moscow 1899–1908, 84 zolotnik
DIMENSIONS: W 6 ¹³⁄₁₆ in. (17.3 cm)
PROVENANCE: Hammer Galleries, New York, 1933 (from the "Winter Palace, St. Petersburg"); Lillian Thomas Pratt
EXHIBITED: L&T 1933; NCMA 1979; VMFA 1983; *FA* 1996
BIBLIOGRAPHY: Lesley 1976, cat. no. 197, p. 91, p. 89 (ill.); ALVR 1983, p. 48, pl. 85; Curry 1995, cat. no. 38; Habsburg 1996, cat. no. 101, p. 129 (ill.); Kurth 1995, p. 35 (ill.)
NOTE: Grand Duke Sergii Aleksandrovich (1857–1905) was married in 1884 to Princess Elisaveta of Hesse and by Rhine (1864–1918). Sergii was a son of Tsar Alexander II, a brother of Tsar Alexander III, and an uncle of Tsar Nicholas II. Elisaveta was an elder sister of the late Tsaritsa Alexandra Feodorovna. The date refers to the fourteenth anniversary of Sergii's governorship of the city of Moscow, which began in 1891 and ended with the grand duke's assassination in 1905. This frame was the first Fabergé item acquired by Mrs. Pratt. A nearly identical frame, differing only by the missing crown over the coat of arms, is in the India Early Minshall Collection at the Cleveland Museum of Art (Hawley 1967).
BEQUEST OF LILLIAN THOMAS PRATT, 47.20.355

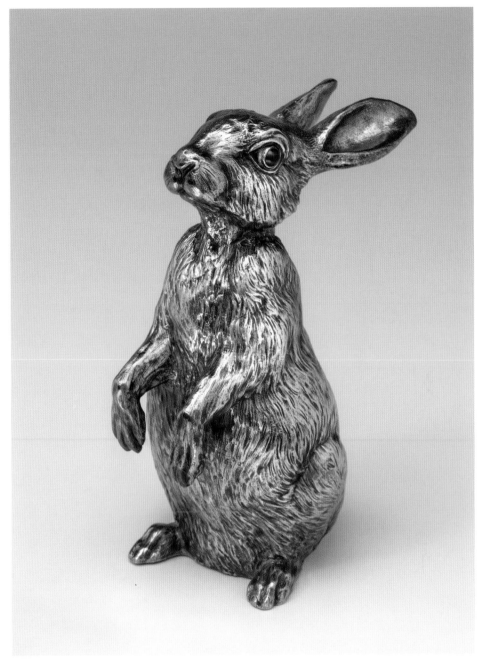

7

7 Rabbit Bell Push

Silver, rubies

The upright seated silver rabbit is chased with naturalistic fur and its cabochon-ruby eyes act as push pieces for an electric table bell.

MARKS: *K. Fabergé*, assay mark of Moscow, 1908–17, 88 zolotnik

DIMENSIONS: 5 ¼ in. (13.3 cm)
PROVENANCE: Hammer Galleries (from the "Property of Nicholas II in the Alexander Palace, Tsarskoie Selo"); Lillian Thomas Pratt
EXHIBITED: NCMA 1979
BIBLIOGRAPHY: Lesley 1976, cat. no. 21, p. 22 (ill.); Curry 1995, cat. no. 40, p. 119 (ill.)
NOTE: The model appears to have been very popular, both as a bell push and as a taller pitcher.
BEQUEST OF LILLIAN THOMAS PRATT, 47.20.213

6 (left)

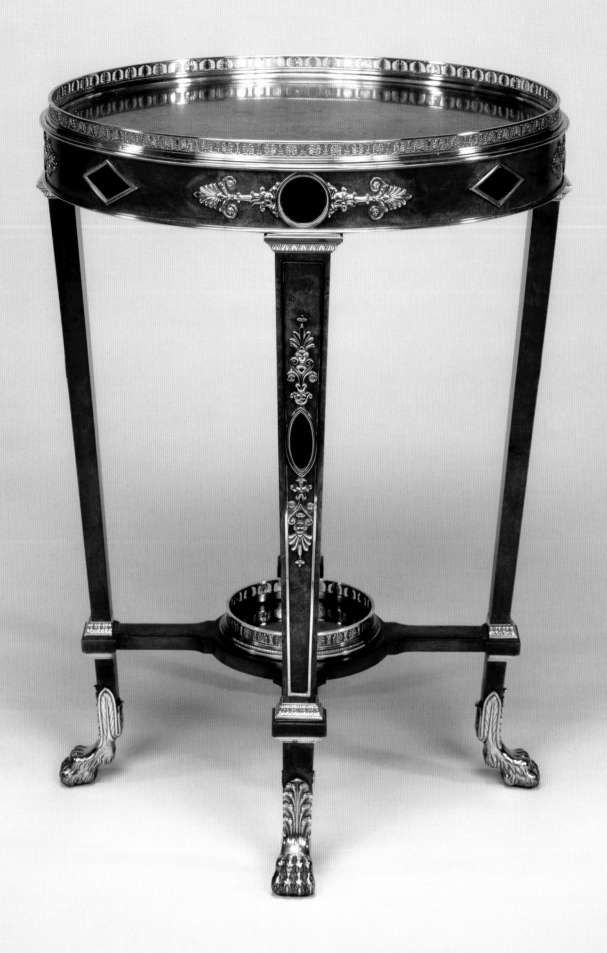

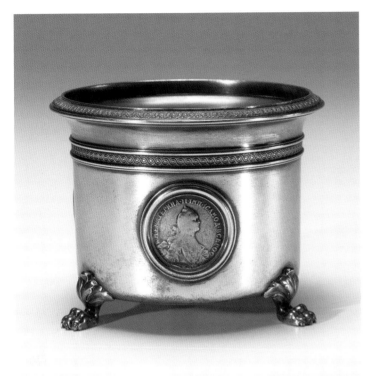

9 reduced

10

8 Silver-Mounted Gueridon

Palisander wood, nephrite, silver

The circular nephrite top is framed by a silver gallery of pierced anthemions above a frieze of silver and nephrite lozenges with alternating néo-Grec mounts. The table is supported by four tapering columns mounted with silver capitals and plinths. Each column has molded edges with silver banding, a néo-Grec silver mount with an elliptical nephrite reserve, and silver anthemion-cast lion-paw sabots. These are joined by a shaped quatrefoil shelf bearing a diminutive version of the galleried top.

MARKS: *K. Fabergé*, initials of workmaster Hjalmar Armfelt, assay mark of St. Petersburg 1908–17, scratched inventory number 24918
DIMENSIONS: H 33½ × D 25½ in. (85 × 64.8 cm)
PROVENANCE: The family of Audrey M. and Forrest E. Mars Sr.
NOTE: Full-size furniture by Fabergé is rare. For further examples that have appeared at auction, see sales catalogues from Parke-Bernet, New York, April 22–23, 1960, lot 366; Sotheby's London, July 23,

1962, lot 106; Christie's Düsseldorf, March 20–21, 1972, lot 451; Christie's Geneva, November 19, 1979, lot 301; Sotheby's Parke-Bernet New York, June 23–24, 1980, lot 879; Sotheby's Geneva, May 17 & 19, 1994, lot 247; Christie's London, November 11, 2003, lot 082.
GIFT OF FORREST E. MARS JR., JOHN F. MARS, AND JACQUELINE B. MARS IN HONOR OF THEIR MOTHER AND FATHER, AUDREY M. MARS AND FORREST E. MARS SR., 99.49

9 Coin Vase

Silver

Shaped as the body of a tankard, this coin vase is set with three silver half-ruble coins of Empress Anna (1732), Tsar Peter III (1762), and Empress Catherine the Great (1764). Its plain silver sides have a chased acanthus-leaf rim, twisted borders, and three paw feet.

MARKS: Imperial warrant of K. Fabergé, initials of workmaster J. Wäkevä, assay mark of St. Petersburg 1908–17, 88 zolotnik, scratched inventory number 24066
DIMENSIONS: 4 in. (10.2 cm)

PROVENANCE: Hammer Galleries, December 4, 1939; Lillian Thomas Pratt
BIBLIOGRAPHY: Lesley 1976, cat. no. 327, p. 157, p. 156 (ill.)
BEQUEST OF LILLIAN THOMAS PRATT, 47.20.385

10 Beaker

Silver gilt

The commemorative beaker bears the blue enamel dates of *1894–1904* (representing the tenth wedding anniversary of Nicholas and Alexandra) with a diamond-set crown above.

MARKS: Imperial warrant mark of Fabergé, assay mark of Moscow 1908–17, 88 zolotnik
DIMENSIONS: 2½ in. (6.3 cm)
PROVENANCE: Lillian Thomas Pratt
EXHIBITED: VMFA 1983
BIBLIOGRAPHY: Lesley 1976, cat. no. 310, p. 147 (ill.)
BEQUEST OF LILLIAN THOMAS PRATT, 47.20.284

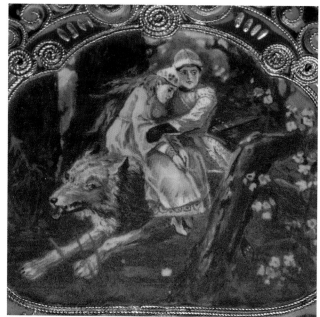

11

11 detail

Cloisonné

11 Enamel Pictorial Box

Silver gilt, enamel

The cover of the circular hinged box is painted *en plein* with Tsesarevich Ivan riding on a gray wolf, holding Princess Elena in his arms. The cover and sides are also decorated in the Old-Russian style with shaded cloisonné enamels in muted green, blue, and gray tones.

MARKS: Imperial warrant mark of K. Fabergé, assay mark of Moscow 1908–17, 88 zolotnik
DIMENSIONS: D 2 1/16 in. (5.2 cm)
PROVENANCE: Jerome and Rita Gans Collection of Russian Enamel
NOTE: The scene, most likely from the workshop of Fedor Rückert, is inspired by the Russian fairy tale of the Firebird (the story of Tsesarevich Ivan and his quest to find Princess Elena). The scene is a copy of Viktor Vasnetsov's celebrated 1889 painting in the Russian Museum in St. Petersburg.
JEROME AND RITA GANS COLLECTION OF RUSSIAN ENAMEL, 98.14

12 Eighteen Demitasse Spoons

Silver, enamel

Each spoon is decorated slightly differently in shaded cloisonné enamels in the manner of workmaster Fedor Rückert.

MARKS: Imperial warrant of K. Fabergé, assay mark of Moscow 1908–17
DIMENSIONS: L 4 3/8 – 5 13/16 in. (11.11–14.76 cm)
PROVENANCE: Mr. Clifford C. Matlock
GIFT OF MR. CLIFFORD C. MATLOCK IN MEMORY OF HIS LATE WIFE, NINA SYOLYPIN(A) MATLOCK, 72.28.1–18

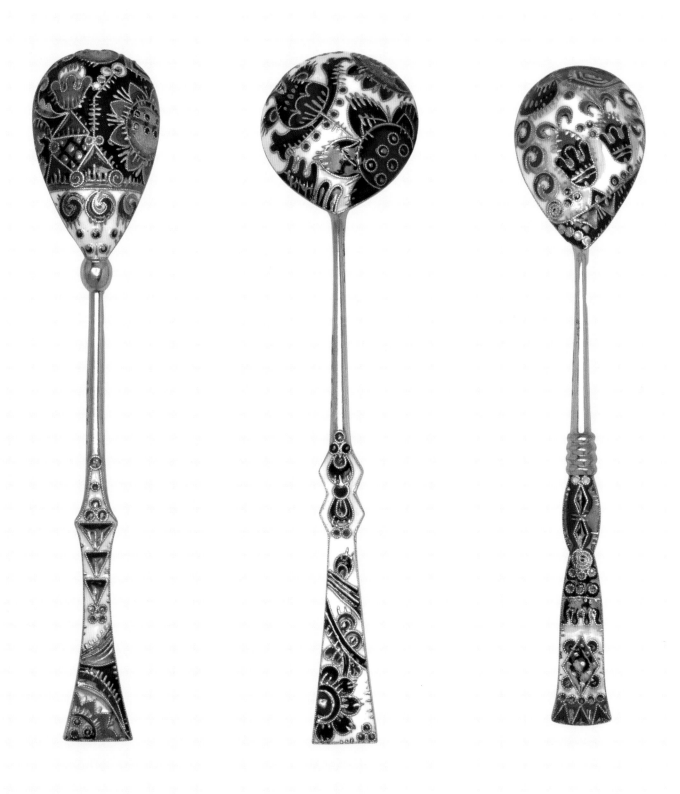

12 72.28.1, enlarged 12 72.28.3, enlarged 12 72.28.6, enlarged

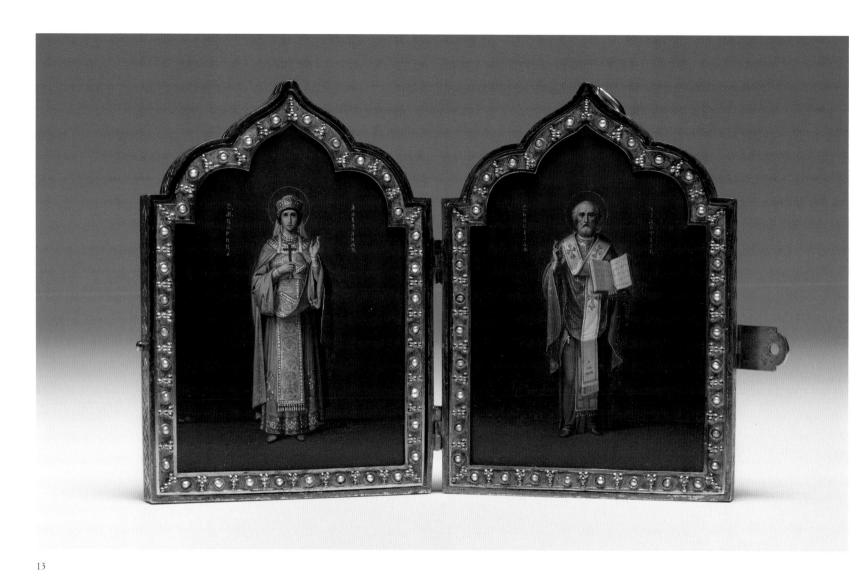

13

Icons

13 Princess St. Alexandra, St. Nicholas the Miracle Worker Diptych

Oil on panel, silver, semiprecious stones, pearls

The two panels painted with the figures of the saints have borders of scrolling foliage set with four turquoises, five cabochon garnets, and two pearls. Their suspension ring is in the shape of a *XB* for *Christos Voskrese* (the traditional Russian Easter greeting).

MARKS: *Fabergé*, initials of workmaster Erik Kollin, assay mark of St. Petersburg before 1899, 84 zolotnik
DIMENSIONS: 4 ⅜ in. (11.2 cm)
PROVENANCE: Tsar Nicholas II; Russian Imperial Treasures. "The Schaffer Collection," n.d., #1956,

$900; Lillian Thomas Pratt
BIBLIOGRAPHY: Lesley 1976, cat. no. 262, p. 131, p. 130 (ill.)
EXHIBITED: VMFA 1983
NOTE: Based on the inscription, the hallmarks, and the choice of saints, this icon was probably presented to or made for Tsar Nicholas II and Tsaritsa Alexandra Feodorovna around 1895. The names of the donors include Prince and Princess Iusupov; Princesses Golitsyna, Lobanova-Rostovskaia, and Vasil'chikova; Count and Countess Shouvalov; and Count G. G. Stenbock and his wife.
BEQUEST OF LILLIAN THOMAS PRATT, 47.20.21

14 Christ Pantocrator

Oil on panel, silver gilt, enamel, seed pearls

The icon has a silver *oklad*, frame, and a halo of mat two-tone green cloisonné

enamel. Its *cloisons* are bordered with seed pearls.

MARKS: Imperial warrant mark of K. Fabergé, assay mark of Moscow 1899–1908, assay master Iakov Liapunov, 88 zolotnik, scratched inventory number 39658
DIMENSIONS: 9 in. (22.9 cm)
Original fitted case lining stamped with gilt imperial warrant mark of Liubavin
PROVENANCE: Confiscated from Fabergé's Moscow shop in 1919, priced at 2,700 rubles (listed as 540 rubles in 1913); Hammer Collection at Lord & Taylor, #5528, January 4, 1934; Lillian Thomas Pratt
BIBLIOGRAPHY: Lesley 1976, cat. no. 253, p. 125, p. 124 (ill.)
NOTE: This is an unusual example of a Fabergé work retailed by another firm.
BEQUEST OF LILLIAN THOMAS PRATT, 47.20.3

14 (right) reduced

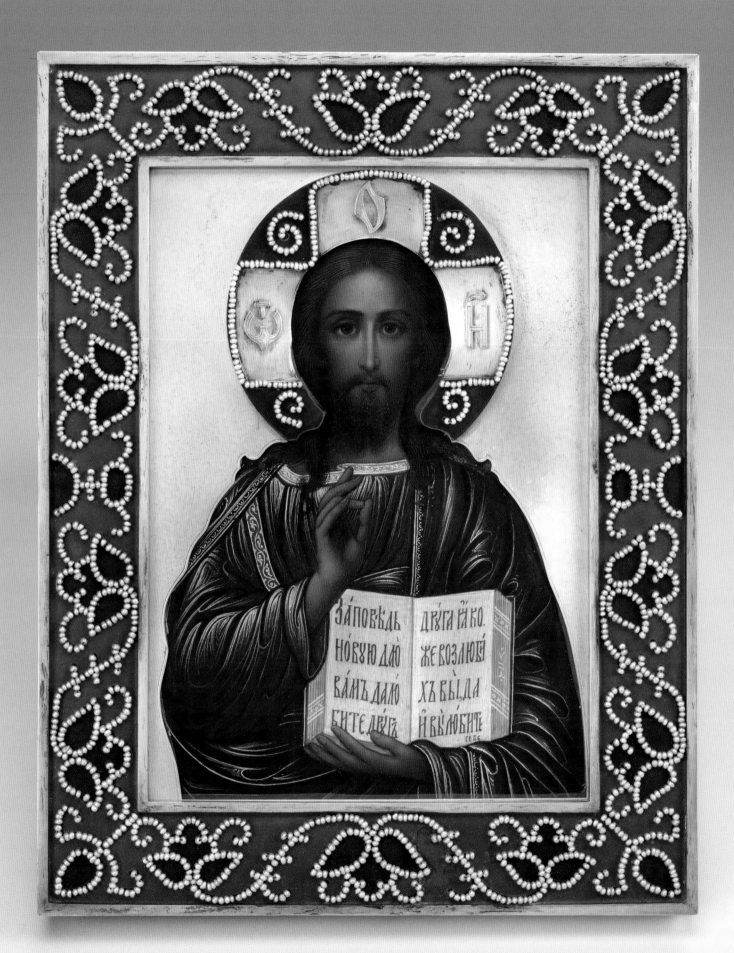

16 reduced

15 Christ Transfigured

Oil on tin, silver, enamel, precious stones, wood

The gray guilloché enamel frame is applied with stylized foliage and set with cabochon emeralds at the corners, sapphires at the sides, a ruby above, and a garnet below.

MARKS: *Fabergé*, initials of workmaster Hjalmar Armfelt, assay mark of St. Petersburg 1899–1908, assay master Iakov Liapunov, 88 zolotnik, scratched inventory number 14938
DIMENSIONS: 9¾ in. (24.7 cm)
PROVENANCE: Lillian Thomas Pratt
BIBLIOGRAPHY: Lesley 1976, cat. no. 256, p. 127, p. 126 (ill.)
NOTE: This icon was possibly made for Grand Duke Sergii Alexandrovich, who was Chief of the Preobrajensky (Transfiguration) Regiment.
BEQUEST OF LILLIAN THOMAS PRATT, 47.20.12

16 The Resurrection Triptych

Oil on gold, gold, precious stones, seed pearls

The icon is painted with the Risen Christ and two angels below within an ogee-shaped aperture bordered with pearls, further applied with filigree scrolls, and set with emeralds and sapphires. The side panels are inscribed *Thy Resurrection, O Christ our Saviour, the angles in Heaven sing and enable us on earth to glorify Three in purity of heart.* The icon is surmounted by a cross set with cabochon emeralds and a ruby, and the filigree clasp has a square-cut emerald.

MARKS: *Fabergé*, initials of workmaster Viktor Aarne, assay mark of St. Petersburg 1899–1908, 56 zolotnik, scratched inventory number 15724
DIMENSIONS: 4 × 2¾ in. (10.2 × 7 cm)
PROVENANCE: Confiscated from Fabergé's Moscow shop in 1919, priced at 5,750 rubles together with cat. no. 18 (listed at 1,150 rubles in 1913); "Countess Brassova" (?); The Schaffer Collection; Lillian Thomas Pratt
EXHIBITED: VMFA 1983
BIBLIOGRAPHY: Lesley 1976, cat. no. 260, p. 129, p. 128 (ill.)
NOTE: Natalia Sergeevna Sheremet'evskaia (1880–1952), was created Countess Brasova after her morganatic marriage to Grand Duke Mikhail Aleksandrovich, and then in emigration received the title of Princess Romanovskaia-Brasova from Grand Duke Kirill.
BEQUEST OF LILLIAN THOMAS PRATT, 47.20.19

17 reduced

18 reduced

17 The Iverskaya Mother of God

ILLUSTRATED ON PAGE 154

Oil on panel, silver gilt, filigree silver, precious and semiprecious stones, seed pearls

The silver-gilt oklad, border, and halo of this icon are applied with filigree scrolls and set with cabochon garnets, pale-blue and pale-pink sapphires, and citrines.

MARKS: Imperial warrant mark of K. Fabergé, assay mark of Moscow 1908–17, 88 zolotnik, scratched inventory number 42563

DIMENSIONS: 11⅞ in. (30.2 cm)

Original fitted case lining stamped in Cyrillic: *Imperial Jeweler K. Fabergé, Petrograd, Moscow, Odessa, Kiev*

PROVENANCE: Confiscated from Fabergé's Moscow shop in 1919, priced at 5,750 rubles together with cat. no. 18 (listed as 1,150 rubles in 1913); Hammer Galleries at Lord & Taylor #5524; Lillian Thomas Pratt

BIBLIOGRAPHY: Lesley 1976, cat. no. 254, p. 125, p. 124 (ill.)

NOTE: This icon and *Christ Pantocrator* (cat. no. 18) make a pair. Both can be dated to between 1914 (when St. Petersburg was renamed Petrograd) and 1917.

BEQUEST OF LILLIAN THOMAS PRATT, 47.20.2

18 Christ Pantocrator

ILLUSTRATED ON PAGE 155

Oil on panel, silver gilt, filigree silver, precious and semiprecious stones, seed pearls

The silver-gilt oklad, border, and halo of this icon are applied with filigree scrolls and set with garnets, pale-blue and pale-pink sapphires, and citrines.

MARKS: Imperial warrant mark of K. Fabergé, assay mark of Moscow 1908–17, 88 zolotnik, scratched inventory number 42563

DIMENSIONS: 11⅞ in. (30.2 cm)

Original fitted case lining stamped in Cyrillic: *Imperial Jeweler K. Fabergé, Petrograd, Moscow, Odessa, Kiev*

PROVENANCE: Confiscated from Fabergé's Moscow shop in 1919, priced at 5,750 rubles together with cat. no. 17 (listed as 1,150 rubles in 1913); Hammer Galleries at Lord & Taylor, #5523; Lillian Thomas Pratt

BIBLIOGRAPHY: Lesley 1976, cat. no. 251, p. 125, p. 123 (ill.)

NOTE: This icon and *The Iverskaya Mother of God* (cat. no. 17) make a pair. They can both be dated to between 1914 (when St. Petersburg was renamed Petrograd) and 1917.

BEQUEST OF LILLIAN THOMAS PRATT, 47.20.1

19 Pendant of St. George Slaying the Dragon

Silver gilt, enamel, rubies, holly wood

The rectangular wooden panel has chamfered corners and is applied with a square enamel plaque painted with St. George. It is set within a shaped silver-gilt surround applied with filigree scrolls and four clusters of four cabochon rubies.

MARKS: Imperial warrant mark of K. Fabergé, assay mark of Moscow 1908–17, 88 zolotnik, miniature signed *Borozdin*

DIMENSIONS: 3⅞ in. (9.9 cm)

Original fitted box lining stamped *Fabergé, Petrograd, Moscow, London*

PROVENANCE: Hammer Galleries (as having belonged to "Czarina Alexandra Feodorovna from Alexander Palace at Tsarskoye Selo"); Lillian Thomas Pratt

BIBLIOGRAPHY: Lesley 1976, cat. no. 264, p. 131, p. 130 (ill.)

EXHIBITED: VMFA 1983

NOTE: The Arts and Crafts style of this icon is typical for the period around the 1913 Romanov Tercentenary.

BEQUEST OF LILLIAN THOMAS PRATT, 47.20.30

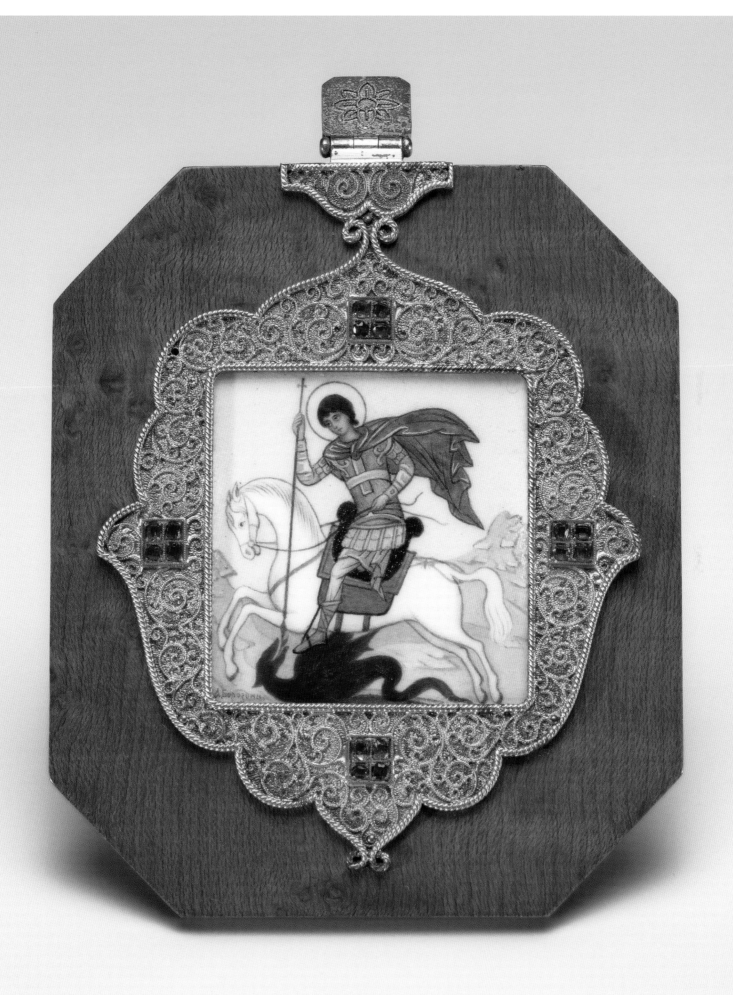

21

Gold

20 Terrestrial Globe

Rock crystal, gold

The rock-crystal globe is engraved with the continents, longitudes, and latitudes, and stands on a gold tripod foot with a compass in its base. It can be tilted at an angle, and is encircled by wide gold bands that show the months of the year and the signs of the zodiac. The gold caps at the poles also show the hours of the day.

MARKS: Initials of workmaster Erik Kollin, assay mark of St. Petersburg before 1899, 56 zolotnik
DIMENSIONS: 5½ in. (14 cm)
PROVENANCE: Hammer Galleries, New York, #5550-1, January 5, 1940, $2,500 (from the "Imperial Russian Collection"); Lillian Thomas Pratt
EXHIBITED: VMFA 1983; ALVR 1983; FA 1996

BIBLIOGRAPHY: Hammer Galleries catalogue 1940; Lesley 1976, cat. no. 302, p. 147, p. 145 (ill.); ALVR 1983, pp. 91–93, pl. 293; Curry 1995, cat. no. 10, pp. 17, 108 (ill.); Habsburg 1996, cat. no. 115, p. 137 (ill.)
NOTE: A number of other rock-crystal and gold globes by Kollin are known. An elaborate example is in the collection of Queen Elizabeth II (see Guitaut 2003); another is in a private New York collection. A globe mounted on a nephrite base combined with a clock, formerly in the Forbes Magazine Collection (see Forbes and Tromeur 1999), is in the Link of Times Foundation Collection.
BEQUEST OF LILLIAN THOMAS PRATT, 47.20.285

21 Frame

Gold, ivory, glass

The smooth ivory frame has a beaded oval bezel with chased red-gold concentric ribbing entwined by a continuous laurel-leaf band. The outer border consists of palm leaves and the back is ivory. The reproduction photograph of Grand Duchess Maria was added later.

MARKS: Initials of workmaster Mikhail Perkhin, assay mark of St. Petersburg before 1899, 56 zolotnik
DIMENSIONS: 3⅛ in. (8.6 cm)
Original bird's-eye maple case with red velvet and satin lining and with imperial warrant, St. Petersburg, Moscow
PROVENANCE: Lillian Thomas Pratt
EXHIBITED: VMFA 1983; FA 1996
BIBLIOGRAPHY: Lesley 1976, cat. no. 199, p. 97, 96 (ill.); Habsburg 1996, cat. no. 142, p. 151 (ill.)
BEQUEST OF LILLIAN THOMAS PRATT, 47.20.316

23

22 Trefoil Cup

Gold

The cup is formed of three intersecting bowls with ribbed exteriors and burnished-gold interiors. Its three loop-shaped handles are set with gold rubles of Catherine the Great dated 1766, 1773, and 1783.

MARKS: *Fabergé*, initials of workmaster Erik Kollin, assay mark of St. Petersburg before 1899, 56 zolotnik
DIMENSIONS: 1 ¼ × 4 ¾ in. (3.2 × 12.1 cm)
PROVENANCE: Lillian Thomas Pratt
BIBLIOGRAPHY: Lesley 1976, cat. no. 318, p. 152 (ill.)
BEQUEST OF LILLIAN THOMAS PRATT, 47.20.374

23 Kovsh

Gold, diamonds

The oval pink-gold *kovsh* has a five-ruble coin of Catherine the Great dated 1776 set in its base and a diamond-set double-headed eagle at the handle.

MARKS: Initials of workmaster Erik Kollin, assay mark of St. Petersburg before 1899, 56 zolotnik, scratched inventory number 40297
DIMENSIONS: L 3 ½ in. (9 cm)
PROVENANCE: Russian Imperial Treasures. "The Schaffer Collection," #2786, January 31, 1945, $1,250; Lillian Thomas Pratt
EXHIBITED: VMFA 1983; *FA* 1996
BIBLIOGRAPHY: Lesley 1976, cat. no. 321, p. 153, p. 154 (ill.); Habsburg 1996, cat. no. 102, p. 130 (ill.)
BEQUEST OF LILLIAN THOMAS PRATT, 47.20.298

26

25

24 Pair of Champagne Flutes

Gold, glass

The flutes stand on horizontally ribbed, tapering bases, and their stems form the shape of an *L* in laurel wreaths. The glasses are held in ribbed cups with openwork laurel-leaf sprays.

MARKS: *Fabergé*, initials of workmaster Mikhail Perkhin, assay mark of St. Petersburg 1899–1903, 56 zolotnik

DIMENSIONS: 7⅜ in. (18.7 cm)

Original fitted wooden box lining stamped with imperial warrant, St. Petersburg, Moscow

PROVENANCE: Hammer Galleries; D. M. Blair; Lelia Blair Northrop

BIBLIOGRAPHY: Curry 1995, cat. no. 7, pp. vii, 108; Habsburg 1996, cat. no. 154, p. 167, p. 166 (ill.)

EXHIBITED: VMFA 1983; FAFE 1995; *FA* 1996

NOTE: The *L* has been identified as the initial of Queen Louise of Denmark, mother of Dowager Empress Maria Feodorovna.

BEQUEST OF LELIA BLAIR NORTHROP, 78.78.1–2

25 Cigarette Case

Gold, rubies

The mat gold case is chased with two laurel leaf sprays with five cabochon rubies, and has a cabochon-ruby thumbpiece.

MARKS: Imperial warrant mark of Karl Fabergé, assay mark of Moscow 1899–1908, 56 zolotnik

DIMENSIONS: 3⅞ in. (9.9 cm)

PROVENANCE: Alexander Schaffer, November 1, 1935, #10178, $450; Lillian Thomas Pratt

BIBLIOGRAPHY: Lesley 1976, cat. no. 296

BEQUEST LILLIAN THOMAS PRATT 47.20.281

26 Cigarette Case

Gold, agate, diamonds

The oval gold case has agate ends and a thumbpiece set with rose-cut diamonds.

MARKS: *Fabergé*, initials of workmaster August Hollming, assay mark of St. Petersburg before 1899, 56 zolotnik

DIMENSIONS: L 3½ in. (8.9 cm)

PROVENANCE: Ailsa Mellon Bruce

EXHIBITED: VMFA 1983

GIFT OF THE ESTATE OF AILSA MELLON BRUCE 70.9.75

24 (left) enlarged

Imperial Presentation Gift
A Column Portrait Frame with a Miniature of Nicholas II

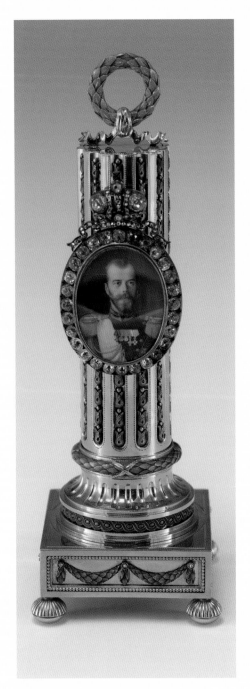

This column portrait frame, crowned by a laurel wreath, the symbol of a war hero, was specially commissioned by Emperor Nicholas II for Field Marshal-General Count Dmitrii Alekseevich Miliutin (1816–1912) for his seventy-fifth anniversary as an officer. It was completed by the Wigström workshop on October 17, 1908, at a cost of 2,000 rubles.

A jeweled object bearing a miniature portrait of a sovereign was the epitome of a monarchial gift, and as such had a long tradition in Western civilization. In Russia, from the reign of Peter I onward, emperors and empresses presented gifts embellished with their images. In this instance, as a courtesy to the recipient, the emperor is depicted wearing the uniform of the First Artillery Brigade of the Guards, the regiment in which the count commenced his service.

Count Miliutin was minister of war between 1861 and 1881. He completely reorganized the Russian army during the reigns of Alexander II and Alexander III following the Crimean War. The victorious outcome of the Russo-Turkish War of 1877–78 was largely due to Miliutin's reforms.

It can be safely assumed that in 1908 the approaching seventy-fifth anniversary of the ninety-two-year-old count presented the emperor with a problem. In the course of his long and outstanding career, Miliutin had received the entire array of prestigious imperial awards. Therefore, something new and extraordinary had to be prepared for him, and a jeweled column portrait frame was the ultimate choice. Two years previously, in 1906, Fabergé had submitted to the Ministry of the Imperial Court designs for four new column portrait frames, all of which were approved by the emperor and Minister of the Court Baron V. B. Freedericksz. One of these was a fluted Greek column in gold hung with a miniature of Nicholas II surrounded by diamonds.

The choice of a column in combination with a portrait had a special symbolism. In ancient Rome the gods, especially Jupiter, were depicted on a pillar to indicate that they dwelt in the sky. In addition, busts of Roman emperors were also frequently displayed on half columns.

There are only five known examples of column portrait frames, all of them made by Fabergé in the workshop of Henrik Wigström. The first one was presented to Miliutin, followed in 1910 by one to Count August zu Eulenburg, grand marshal of the German court (now in the collection of A La Vieille Russie, New York), and in 1911 by a third to Aide-de-Camp-General Konstantin Ustinovich Arapov. Nicholas II was obviously very pleased with the new design as he personally acquired two column portrait frames from the stock of the Imperial Cabinet in 1913.

—Ulla Tillander-Godenhielm

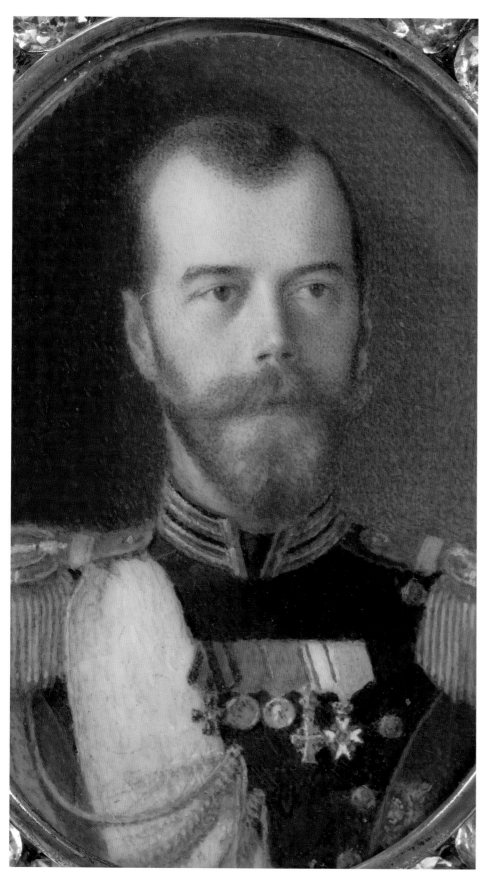

27 detail

27 Imperial Column Portrait Frame

Gold, diamonds, ivory

The framed miniature portrait of Emperor Nicholas II is set with twenty-eight circular-cut diamonds surmounted by a diamond-set crown. It is suspended from a fluted gold column with chased husks in the flutes and chased laurel wreathes at the base and above the column. The square base has four peg feet.

MARKS: *Fabergé*, initials of workmaster Henrik Wigström, assay mark of St. Petersburg 1899–1908, 56 zolotnik; the miniature is signed by Vasilii Zuev
DIMENSIONS: 6 in. (15.2 cm)
Original fitted case lining stamped with imperial warrant, St. Petersburg, Moscow, London
PROVENANCE: Presented by Tsar Nicholas II to Field Marshal-General Count Dmitrii Alekseevich Miliutin in 1913; *Russian Imperial Exhibit*, from the Hammer Collection at Lord & Taylor, #4765, January 4, 1934 ("Characteristic of Fabergé who made the bibelot for the Czarina to present to Nicholai II on his birthday in 1907. It was found in the Alexander Palace."); Lillian Thomas Pratt
EXHIBITED: HG 1933, VMFA 1983, ALVR New York 1983, *FA* 1996
BIBLIOGRAPHY: Hammer 1932, pp. 216–17; Hammer Galleries catalogue, 1933, cat. no. 4765, p. 4; Lesley 1976, cat. no. 196, p. 95, p. 93 (ill.); ALVR 1983, cat. no. 89, pp. 50–1 (ill.); Curry 1995, cat. no. 13, pp. 28, 168 (ill.); Habsburg 1996, cat. no. 106, p. 132 (ill.)
BEQUEST OF LILLIAN THOMAS PRATT, 47.20.303 WITH MINIATURE; 47.20.367 WITHIN

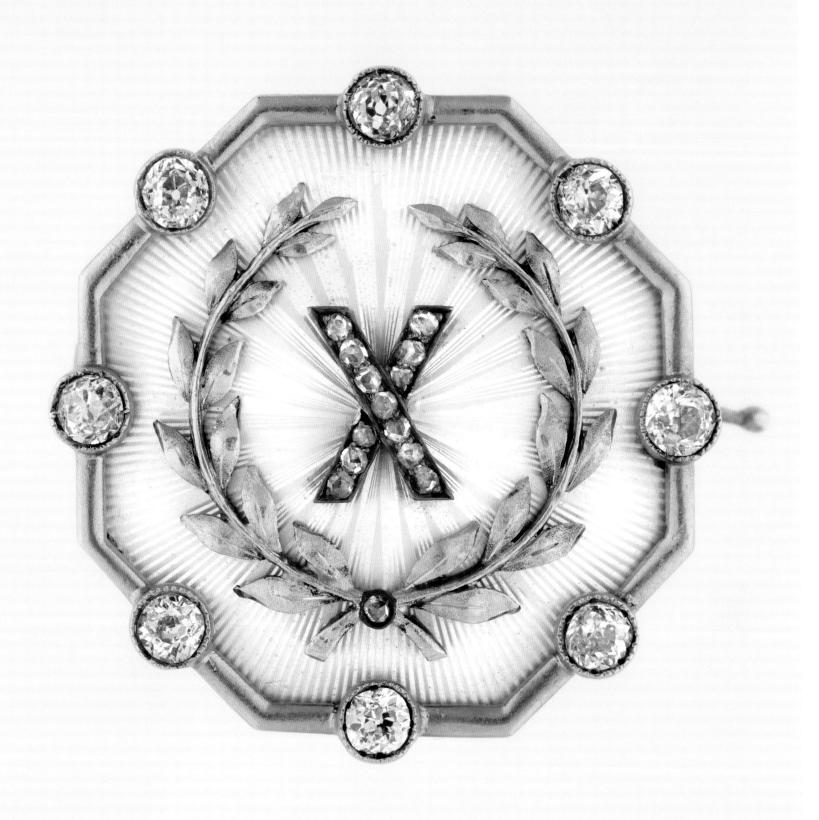

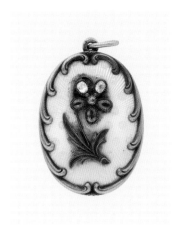
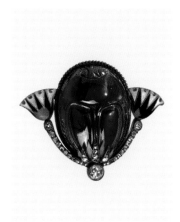
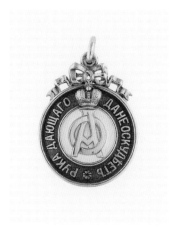
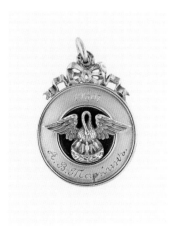

29 30 31 recto 31 verso

Jewels

28 Tenth-Anniversary Brooch

Gold, enamel, diamonds

The octagonal brooch, created to commemorate a tenth-wedding anniversary, has a diamond-set Roman numeral *X* within a laurel wreath. Its borders are set with ten brilliant-cut diamonds.

MARKS: Initials of workmaster Fedor Afanas'ev, assay mark of St. Petersburg 1899–1908, 56 zolotnik
DIMENSIONS: D 1⅛ in. (2.8 cm)
PROVENANCE: Lillian Thomas Pratt
EXHIBITED: VMFA 1983
BIBLIOGRAPHY: Lesley 1976, cat. no. 269, p. 134 (ill.)
BEQUEST OF LILLIAN THOMAS PRATT, 47.20.142

29 Locket

Gold, diamonds, rubies, enamel

The oval pendant locket is applied with a flower spray of five cabochon-ruby and two brilliant-cut diamond petals on an opalescent translucent white enamel ground.

MARKS: Initials of workmaster Mikhail Perkhin, 1899–1903, assay master A. Romanov, 56 zolotnik
DIMENSIONS: L 1½ in. (3.8 cm)

PROVENANCE: Hammer Galleries, #RH-845/1, $275 (from the "apartments of the Grand Duchess Olga Nikolaevna, eldest daughter of Tsar Nikolai II in the Aleksandr Palace, Tsarskoye Selo."); Lillian Thomas Pratt
BIBLIOGRAPHY: Hammer Galleries catalogue 1941; Lesley 1976, cat. no. 274, p. 136 (ill.)
BEQUEST OF LILLIAN THOMAS PRATT, 47.20.155

30 Scarab Brooch

Rhodolite garnet, gold, diamonds, rubies, enamel, silver

The gold-mounted purpurine scarab is flanked by two diamond-set blue-and-white enamel lotus flowers issuing from a brilliant-cut diamond.

MARKS: Initials *K. F.* for Karl Fabergé, 56 zolotnik
DIMENSIONS: 1⅛ × 1½ in. (2.9 × 3.8 cm)
PROVENANCE: The Schaffer Collection of Russian Imperial Treasure, 1937 (as having belonged to "Czarina Alexandra Feodorova"); Lillian Thomas Pratt
BIBLIOGRAPHY: Lesley 1976, cat. no. 270, p. 134 (ill.); Curry 1995, cat. no. 6, pp. v, 108; Habsburg 1996, cat. no. 108, p. 133 (ill.)
EXHIBITED: VMFA 1983; *FA* 1996

NOTE: This is a truly original Egyptian-style brooch, probably from the Moscow jewelry workshop.
BEQUEST OF LILLIAN THOMAS PRATT, 47.20.143

31 Badge of the Imperial Orphanage

Gold, enamel

The recto of this jeweled pendant bears the crowned cypher of Tsaritsa Alexandra Feodorovna and is inscribed in Cyrillic: *May the hand of charity not grow scarce.* The verso carries a Pelican in Her Piety image with the Cyrillic inscription: *12.17.1907 A. V. Tarkin.*

MARKS: Initials of workmaster Alfred Thielemann, 56 zolotnik
DIMENSIONS: L 1¼ in. (3.1 cm)
Fitted leather case
PROVENANCE: Furman Hebb
NOTE: For the charities of the Russian imperial family, including the Imperial Orphanage and the symbolism of the pelican, see the *Imperial Pelican Egg* also in the Pratt collection, cat. no. 188.
GIFT OF FURMAN HEBB, 83.150

28 (left) enlarged

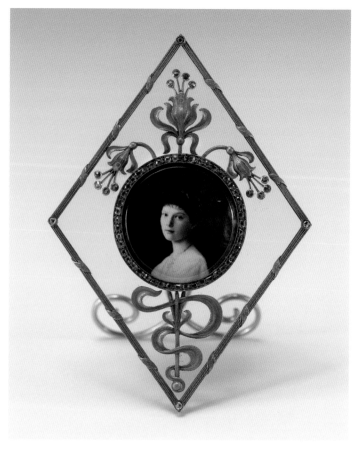

32

33

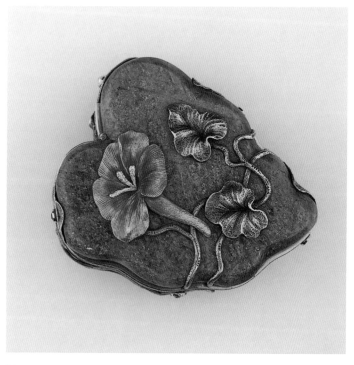

34

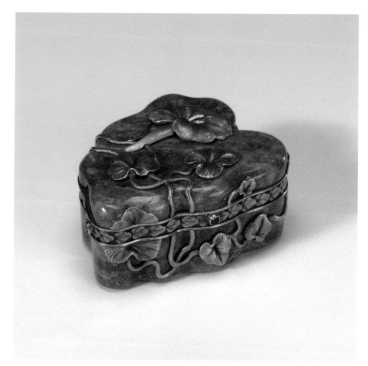

34

Hardstones: Moscow

32 Art Nouveau Frame

Gold, rock crystal, emeralds, rubies, glass, ivory

The upright lozenge-shaped frame with its outer reed-and-tie border has a circular aperture with an emerald-set bezel. It is applied with stylized chased-gold lilies, their stamens set with cabochon rubies. The reproduction photograph of Grand Duchess Tatiana was added later.

MARKS: Initials *K. F.* for Karl Fabergé, assay mark of Moscow before 1899, 56 zolotnik
DIMENSIONS: 4 in. (10.2 cm)
PROVENANCE: Russian Imperial Treasures. "The Schaffer Collection," #25G, September 3, 1940, $750; Lillian Thomas Pratt
EXHIBITED: VMFA 1983
BIBLIOGRAPHY: Lesley 1976, cat. no. 208, p. 101, p. 100 (ill.); Curry 1995, cat. no. 30, pp. 97, 110 (ill.)
BEQUEST OF LILLIAN THOMAS PRATT, 47.20.351

33 Cane Handle

Rock crystal, gold, enamel, diamonds

The ferrule of the *T*-shaped rock-crystal handle is of pale-blue moiré guilloché enamel, is studded with three rows of rose-cut diamonds, and has beaded-gold borders.

MARKS: Initials *K. F.* for Karl Fabergé, assay mark of Moscow 1899–1908, 56 zolotnik
DIMENSIONS: 1¾ in. (4.4 cm)
PROVENANCE: The Schaffer Collection of Russian Imperial Art Treasures, 1936 (from the "apartments of Czarina Alexandra Feodorovna, Alexander Palace, Tsarskoie Selo." Described as "worthy of the most discriminating taste"); Lillian Thomas Pratt
EXHIBITED: *FA* 1996
BIBLIOGRAPHY: Lesley 1976, cat. no. 236, p. 114 (ill.); Habsburg 1996, cat. no. 130, p. 145 (ill.)
BEQUEST OF LILLIAN THOMAS PRATT, 47.20.177

34 Snuffbox

Aventurine quartz, feldspar, diamond, ruby, emerald, sapphire, pearl, enamel

The hinged box in the Art Nouveau style is shaped as a trumpet-vine leaf. It is of reddish-brown feldspar and is applied with a chased-gold flower of pink-and-yellow enamel with gold leaves. The lip is chased with leaves and set at intervals with a diamond, a ruby, an emerald, a sapphire, and a pearl.

MARKS: Initials *K. F.* for Karl Fabergé, assay mark of Moscow 1899–1908, 56 zolotnik, scratched inventory number 16795
DIMENSIONS: L 2½ in. (6.3 cm)
PROVENANCE: Lillian Thomas Pratt
EXHIBITED: NCMA 1979; VMFA 1983; ALVR 1983; *FA* 1996
BIBLIOGRAPHY: Lesley 1976, cat. no. 290, p. 143, p. 142 (ill.); Curry 1995, cat. no. 31, pp. 98, 110 (ill.); Habsburg 1996, cat. no. 110, p. 134 (ill.)
NOTE: Another Moscow-made bloodstone box of similar concept, shaped as a chestnut leaf, is in the Hillwood Museum in Washington, D.C. (see Habsburg 1996).
BEQUEST OF LILLIAN THOMAS PRATT, 47.20.274

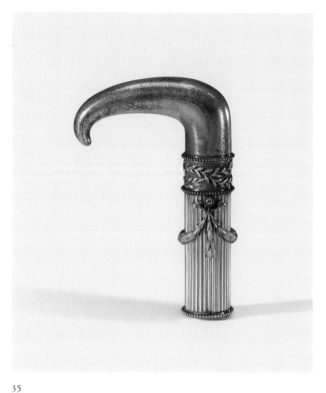

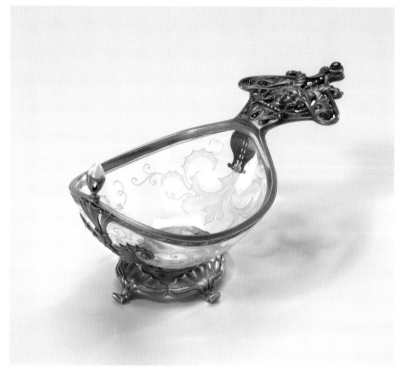

35

36 reduced

35 Parasol Handle

Bowenite, gold, diamonds, pearls, enamel

This burnished-gold hook handle has a reeded ferrule applied with chased-gold laurel swags suspended from rose-cut diamonds. A band of chased-gold foliage runs above.

MARKS: Initials *K. F.* for Karl Fabergé, assay mark of Moscow 1899–1908, inventory number 20636

DIMENSIONS: 2 ½ in. (6.4 cm)

PROVENANCE: The Schaffer Collection of Russian Imperial Art Treasures, 1936 (as having belonged to "Czarina Alexandra Feodorovna"); Lillian Thomas Pratt

BIBLIOGRAPHY: Lesley 1976, cat. no. 217, p. 107 (ill.); Habsburg 1996, cat. no. 121, p. 140 (ill.)

EXHIBITED: VMFA 1983; *FA* 1996

BEQUEST OF LILLIAN THOMAS PRATT, 47.20.185

36 Kovsh

Rock crystal, gold, rubies, diamonds, pearl

The oval rock-crystal *kovsh* of traditional shape is embellished in the Art Nouveau style with engraving and a foliate foot and handle. Its handle is chased with a woman's head and neck adorned with a diamond necklace, as well as rubies and more diamonds.

MARKS: Initials *K. F.* for Karl Fabergé, assay mark of Moscow 1899–1908, assay master Ivan Lebedkin, 56 zolotnik

DIMENSIONS: H 2 ½ × L 5 ½ × D 3 in. (6.4 × 13 × 7.6 cm)

PROVENANCE: Russian Imperial Treasures. "The Schaffer Collection," #2279, September 3, 1940, $1,500; Lillian Thomas Pratt

EXHIBITED: VMFA 1983; *FA* 1996

BIBLIOGRAPHY: Lesley 1976, cat. no. 320, p. 153, p. 154 (ill.); Habsburg 1996, cat. no. 103, p. 130

BEQUEST OF LILLIAN THOMAS PRATT, 47.20.297

37 World War I Dish

Nephrite, silver gilt

The cavetto of the bowl is set with a silver-gilt medallion repoussé with the Russian imperial eagle and bears the Cyrillic words for *war* and *1914*.

MARKS: Stamped *K. Fabergé, Moscow, 1908–1917*, dated 1914

DIMENSIONS: D 8 in. (20.3 cm)

PROVENANCE: Sotheby's Parke-Bernet New York, June 6–11, 1981, lot 518; Furman Hebb

EXHIBITED: VMFA 1983

NOTE: Since precious metals were scarce during World War I, Fabergé produced numerous articles in nephrite with silver-gilt mounts, as well as in copper, brass, and silver, all bearing the Romanov eagle and a date (see cat. no. 1).

GIFT OF FURMAN HEBB, 82.198

37 (right) enlarged

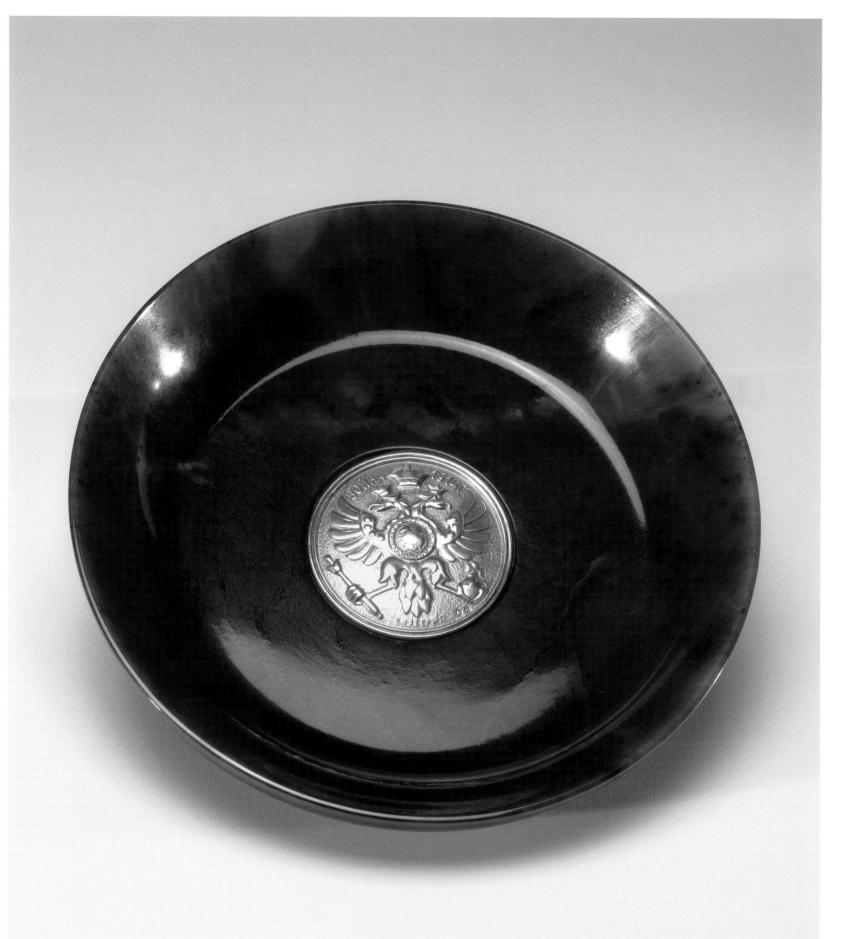

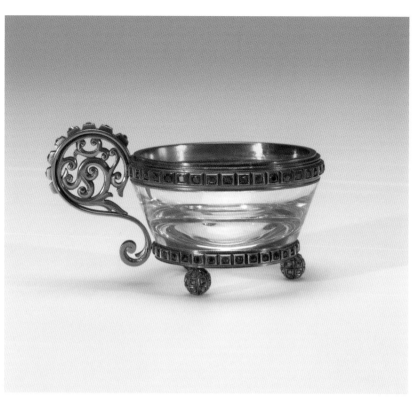

38 reduced

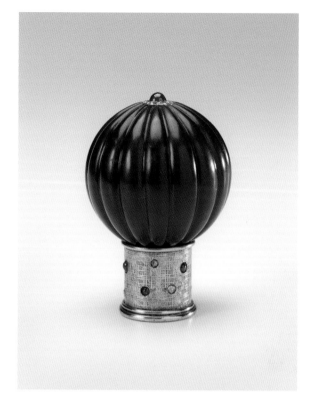

39

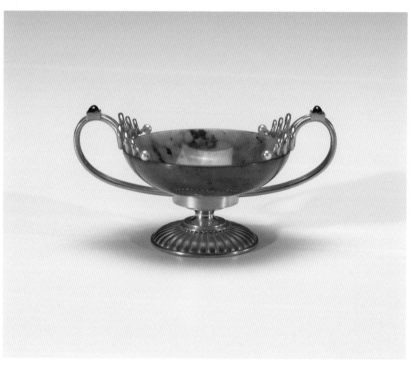

40

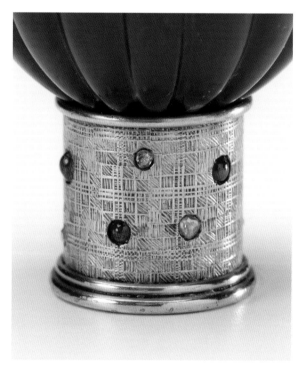

39 detail

Hardstones: Erik Kollin

38 Charka

Rock crystal, gold, rubies, diamonds

The tapered rock-crystal body of this *charka* has a gold rim and a base set with rubies in square mounts, an openwork scroll handle, and three ball feet.

MARKS: *Fabergé*, initials of workmaster Erik Kollin, assay mark of St. Petersburg before 1899, 56 zolotnik, scratched inventory number 40312
DIMENSIONS: D 2 ½ in. (6.4 cm)
PROVENANCE: Lillian Thomas Pratt
EXHIBITED: VMFA 1983
BIBLIOGRAPHY: Lesley 1976, cat. no. 314, p. 151 (ill.)
BEQUEST OF LILLIAN THOMAS PRATT, 47.20.293

39 Parasol Handle

Nephrite, gold, diamonds, rubies

The segmented nephrite ball handle has a ruby finial in a rose-cut diamond surround. Its trompe l'oeil gold ferrule is chased to simulate cloth and is set with diamonds and rubies.

MARKS: Initials of workmaster Erik Kollin, assay mark of St. Petersburg before 1899, 56 zolotnik
DIMENSIONS: 2 ¼ in. (5.7 cm)
PROVENANCE: Lillian Thomas Pratt
BIBLIOGRAPHY: Lesley 1976, cat. no. 228, p. 112 (ill.)
BEQUEST OF LILLIAN THOMAS PRATT, 47.20.190

40 Miniature Tazza

Nephrite, gold, sapphires, pearls

The nephrite tazza is shaped as a Greek *skyphos* with gold-wire handles ending in spirals set with cabochon sapphires and seed pearls. It stands on a domed, gadrooned base of gold.

MARKS: Initials of workmaster Erik Kollin, assay mark of St. Petersburg before 1899, 56 zolotnik, scratched inventory number 40166
DIMENSIONS: W 2 ¾ in. (7 cm)
PROVENANCE: Fitted case stamped *The Schaffer Collection, Rockefeller Center, New York;* A La Vielle Russie; Ernest Hillman Jr.
GIFT OF THE ESTATE OF ERNEST HILLMAN JR., 2003.187

41

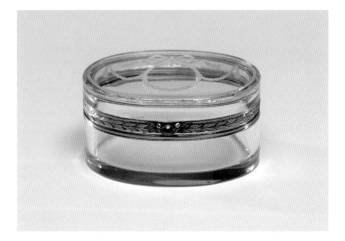

42

43

41 Bowl

Rock crystal, gold, diamonds, rubies

The rim of this basket-shaped bowl is set alternately with diamonds and rubies.

MARKS: *Fabergé*, initials of workmaster Erik Kollin, assay mark of St. Petersburg 1899–1908, 56 zolotnik
DIMENSIONS: 1½ in. (3.8 cm)
PROVENANCE: Lillian Thomas Pratt
EXHIBITED: VMFA 1983
BIBLIOGRAPHY: Lesley 1976, cat. no. 323, p. 157, p. 156 (ill.)
BEQUEST OF LILLIAN THOMAS PRATT, 47.20.288

42 Bonbonnière

Rock crystal, gold, diamonds, ruby

The cover of this rock-crystal bonbonnière is engraved with an oval cartouche and laurel swags. Its gold rim is chased with palm leaves and has a ruby and diamond thumbpiece.

MARKS: Initials of workmaster Erik Kollin, assay mark of St. Petersburg 1899–1908, assay master Iakov Liapunov, scratched inventory number 5882
DIMENSIONS: 1⅞ in. (4.8 cm)
PROVENANCE: Fensmark Becker, Copenhagen, 1972; Dr. and Mrs. Henry S. Spencer
GIFT OF DR. AND MRS. HENRY S. SPENCER, 99.198

43 Seal

Aventurine quartz, gold, silver

The Louis XVI–style gold-and-silver hand seal stands on a column; its handle is a horizontally placed egg held by floral swags.

MARKS: Initials of workmaster Erik Kollin
DIMENSIONS: L 3¼ in. (8.3 cm)
PROVENANCE: Lillian Thomas Pratt
BIBLIOGRAPHY: Lesley 1976, cat. no. 309, p. 148 (ill.)
BEQUEST OF LILLIAN THOMAS PRATT, 47.20.205

43 (right) enlarged

44

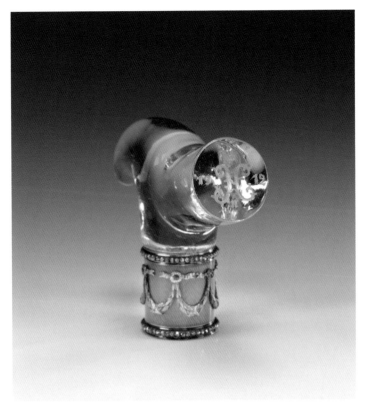

44

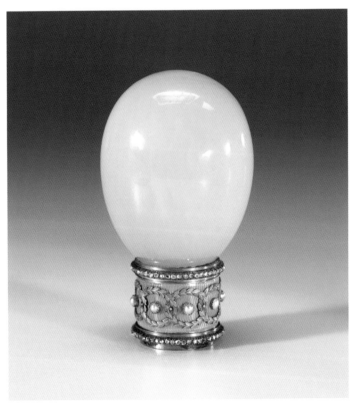

45

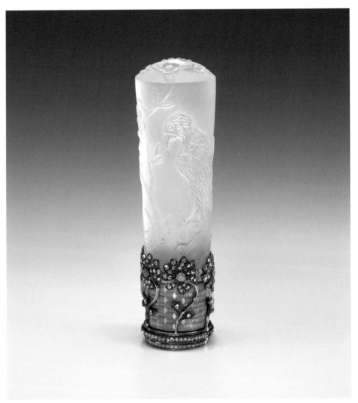

46

Hardstones: Mikhail Perkhin

44 Cane Handle

Rock crystal, gold, enamel, diamonds

The derby-shaped, rock-crystal handle has a flat end engraved (later) with the monogram of Tsar Nicholas II and the date 1912. Its pink moiré guilloché enamel ferrule is applied with chased-gold laurel swags suspended from emeralds within borders of rose-cut diamonds.

MARKS: Early initials of workmaster Mikhail Perkhin, assay mark of St. Petersburg before 1899, 56 zolotnik

DIMENSIONS: 2¾ × 1¾ in. (7 × 4.4 cm)

PROVENANCE: Lillian Thomas Pratt

EXHIBITED: *FA* 1996

BIBLIOGRAPHY: Lesley 1976, cat. no. 237, p. 114 (ill.); Habsburg 1996, cat. no. 126, p. 143 (ill.)

BEQUEST OF LILLIAN THOMAS PRATT, 47.20.188

45 Cane Handle

Bowenite, gold, enamel, diamonds, seed pearls

The ferrule of the egg-shaped handle is of pink moiré guilloché enamel applied with entwined chased-gold palm-leaf garlands centered on a seed pearl. The borders are set with rose-cut diamonds.

MARKS: Early initials of workmaster Mikhail Perkhin, assay mark of St. Petersburg before 1899, 56 zolotnik

DIMENSIONS: 2½ in. (6.4 cm)

PROVENANCE: Lillian Thomas Pratt

EXHIBITED: *FA* 1996

BIBLIOGRAPHY: Lesley 1976, cat. no. 245, p. 119 (ill.); Curry 1995, cat. no. 17, pp. 33, 109 (ill.); Habsburg 1996, cat. no. 131, p. 145 (ill.)

BEQUEST OF LILLIAN THOMAS PRATT, 47.20.175

46 Parasol Handle

Rock crystal, gold, enamel, diamonds

The Art Nouveau handle is a frosted rock-crystal shaft carved with birds and foliage. Its sleeve is of mauve guilloché enamel applied with silver-and-gold blossoms and diamond-set petals and leaves.

MARKS: *Fabergé*, initials of workmaster Mikhail Perkhin, assay mark of St. Petersburg before 1899, 56 zolotnik

DIMENSIONS: 3 in. (7.6 cm)

Original fitted case lining stamped with imperial warrant, St. Petersburg, Moscow

PROVENANCE: Lillian Thomas Pratt

EXHIBITED: *FA* 1996

BIBLIOGRAPHY: Lesley 1976, cat. no. 305, p. 148 (ill.); Curry 1995, cat. no. 28, pp. 96, 110 (ill.)

BEQUEST OF LILLIAN THOMAS PRATT, 47.20.201

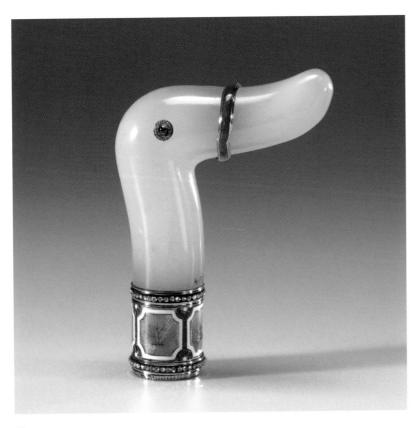

47

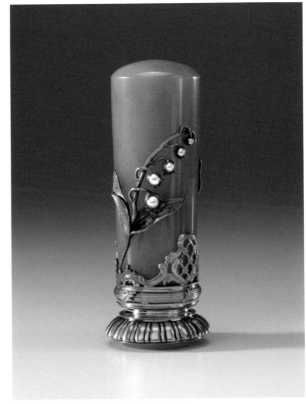

48

47 Parasol Handle

Bowenite, gold, rubies, diamonds, enamel

The duck's-head handle has cabochon-ruby eyes and a green enamel ring around the beak. The ferrule has dendritic pink guilloché enamel panels edged with opaque-white enamel bands. The borders are set with rose-cut diamonds.

MARKS: Initials of workmaster Mikhail Perkhin, assay mark of St. Petersburg before 1899, 56 zolotnik

DIMENSIONS: 3 ¼ in. (8.2 cm)

PROVENANCE: The Schaffer Collection, 1936 (as having "belonged to Czarina Alexandrovna"); Lillian Thomas Pratt

BIBLIOGRAPHY: Lesley 1976, cat. no. 243, p. 117 (ill.); Curry 1995, cat. no. 16, pp. 32, 109 (ill.); Habsburg 1996, cat. no. 123, p. 141 (ill.)

EXHIBITED: FA 1996

BEQUEST OF LILLIAN THOMAS PRATT, 47.20.169

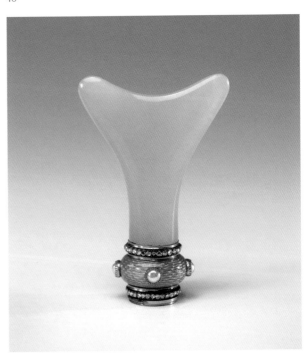

49

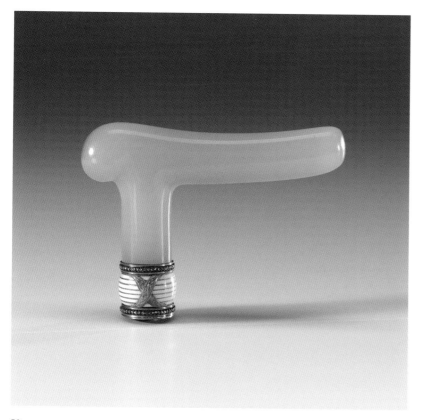

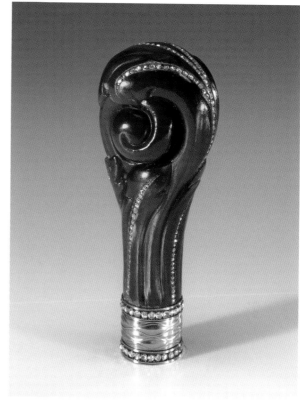

50

51

48 Seal

Bowenite, gold, pearls, chalcedony

The cylindrical bowenite shaft of this seal is applied with two lily-of-the-valley sprays with pearl buds. Its rococo-style openwork sleeve is chased with scrolls and trelliswork, and has a gadrooned foot and a chalcedony matrix.

MARKS: Initials of workmaster Mikhail Perkhin, assay mark of St. Petersburg before 1899, 56 zolotnik
DIMENSIONS: 3 in. (7.6 cm)
PROVENANCE: The Schaffer Collection of Russian Imperial Art Treasures, 1937; Lillian Thomas Pratt
EXHIBITED: FA 1996
BIBLIOGRAPHY: Lesley 1976, cat. no. 308, p. 148 (ill.); Curry 1995, cat. no. 29, p. 110 (ill.); Habsburg 1996, cat. no. 124, p. 142 (ill.)
BEQUEST OF LILLIAN THOMAS PRATT, 47.20.204

49 Parasol Handle

Bowenite, gold, diamonds, pearls, enamel

The bowenite fishtail handle has a salmon-colored bombé guilloché enamel ferrule

set with seed pearls. The borders are set with rose-cut diamonds.

MARKS: Initials of workmaster Mikhail Perkhin, 56 zolotnik
DIMENSIONS: 2⅛ in. (5.4 cm)
PROVENANCE: Lillian Thomas Pratt
EXHIBITED: VMFA 1983
BIBLIOGRAPHY: Lesley 1976, cat. no. 249, p. 118 (ill.)
BEQUEST OF LILLIAN THOMAS PRATT, 47.20.184

50 Parasol Handle

Bowenite, gold, diamonds, enamel

The slightly bombé ferrule of the L-shaped handle has horizontal opaque-white enamel bands between diamond-set borders, and two crossed, chased-gold ribbons on a translucent-orange ground.

MARKS: Initials of workmaster Mikhail Perkhin
DIMENSIONS: 2¼ in. (5.7 cm)
PROVENANCE: The Schaffer Collection of Russian Imperial Art Treasures, 1936 (as having "belonged to Czarina Alexandra Feodorovna"); Lillian Thomas Pratt

EXHIBITED: FA 1996
BIBLIOGRAPHY: Lesley 1976, cat. no. 242, p. 116 (ill.); Habsburg 1996, cat. no. 122, p. 141 (ill.)
BEQUEST OF LILLIAN THOMAS PRATT, 47.20.168

51 Parasol Handle

Nephrite, gold, diamonds

The nephrite handle is shaped as a fiddle-head fern and is set with bands of rose-cut diamonds. The red-gold ferrule has rose-cut diamond borders.

MARKS: Fabergé, initials of workmaster Mikhail Perkhin, scratched inventory number 1225
DIMENSIONS: 3⅜ in. (8.5 cm)
PROVENANCE: Hammer Galleries, #E23, January 5, 1940 (from the "apartments of Czarina Alexandra Feodorovna, Alexander Palace, Tsarskoie Selo"); Lillian Thomas Pratt
BIBLIOGRAPHY: Lesley 1976, cat. no. 226, p. 111 (ill.); Habsburg 1996, cat. no. 129, p. 144 (ill.)
EXHIBITED: NCMA 1979; FA 1996
BEQUEST OF LILLIAN THOMAS PRATT, 47.20.178

52 enlarged

53

52 Cane Handle

Nephrite, gold, enamel, chalcedony

The red guilloché enamel ferrule of the bowenite knob handle is decorated with swirling chased-gold bands and rose-cut diamond borders.

MARKS: Early initials of workmaster Mikhail Perkhin, assay mark of St. Petersburg before 1899, 56 zolotnik, scratched inventory number 45643

DIMENSIONS: 2 ¾ in. (7 cm)

PROVENANCE: Acquired by Tsaritsa Maria Feodorovna, May 22, 1893, for 140 rubles ("handle, jade, red enamel"); Lillian Thomas Pratt

EXHIBITED: VMFA 1983

BIBLIOGRAPHY: Lesley 1976, cat. no. 246, p. 119 (ill.)

BEQUEST OF LILLIAN THOMAS PRATT, 47.20.181

53 Parasol Handle

Nephrite, gold, enamel

The ferrule of the tapering nephrite handle is of opaque-white enamel with orange guilloché enamel flutes and has chased palm-leaf borders.

MARKS: Initials of workmaster Mikhail Perkhin, assay mark of St. Petersburg before 1899, 56 zolotnik

DIMENSIONS: 4 ¼ in. (10.8 cm)

PROVENANCE: Hammer Galleries, #5625-11, January 5, 1940; Lillian Thomas Pratt

EXHIBITED: VMFA 1983

BIBLIOGRAPHY: Lesley 1976, cat. no. 233, p. 113 (ill.)

BEQUEST OF LILLIAN THOMAS PRATT, 47.20.198

54 enlarged

55

54 Cane Handle

Serpentine, gold, diamonds

The tapering knob-shaped bowenite handle is encased in gold rococo scrolls and trellis patterns, and has a rose-cut diamond border.

MARKS: Early initials of workmaster Mikhail Perkhin, assay mark of St. Petersburg before 1899, 56 zolotnik, scratched inventory number 46856
DIMENSIONS: 2 ½ in. (6.4 cm)
PROVENANCE: Russian Imperial Treasures. "The Schaffer Collection," 1936 (from the "apartments of Czarina Alexandra Feodorovna, Alexander Palace, Tsarskoie Selo"); Lillian Thomas Pratt
BIBLIOGRAPHY: Bainbridge 1968, pp. 87–90, pl. viii; Lesley 1976, cat. no. 248, p. 119, p. 118 (ill.); Habsburg 1996, cat. no. 128, p. 144 (ill.)
EXHIBITED: FA 1996
BEQUEST OF LILLIAN THOMAS PRATT, 47.20.183

55 Frame

Aventurine quartz, metal

The frame has an arched top, crimped and ribbed gold borders, peg feet, and a metal back. The photograph (added later) is of Grand Duchess Anastasia.

MARKS: Initials of workmaster Mikhail Perkhin, assay mark of St. Petersburg before 1899, 84 zolotnik, scratched inventory number 45196
DIMENSIONS: 3 ¼ in. (8.3 cm)
Original fitted wooden case with green-velvet and white-silk lining
PROVENANCE: Hammer Galleries, January 27, 1938, #A-6; Lillian Thomas Pratt
BIBLIOGRAPHY: Lesley 1976, cat. no. 206
BEQUEST LILLIAN THOMAS PRATT 47.20.327

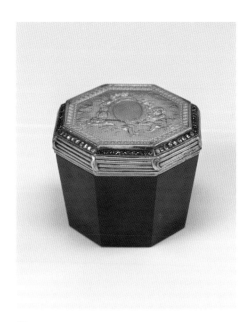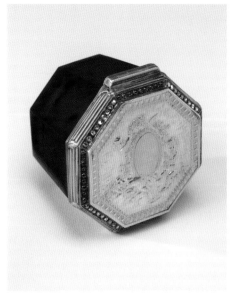

56

56

57

56 Bonbonnière

Nephrite, gold, rubies, diamonds

The gold cover of the hinged and tapering octagonal Louis XVI–style nephrite box is chased with three cherubs and flower garlands surrounding an unadorned shield within a gadrooned border. The reeded lip is set with alternating lines of rubies and diamonds.

MARKS: *Fabergé*, early initials of workmaster Mikhail Perkhin, assay mark of St. Petersburg before 1899, 56 zolotnik

DIMENSIONS: D 1½ in. (3.8 cm)

PROVENANCE: Russian Imperial Treasures 1936 (from the "apartments of Czarina Alexandra Feodorovna, Alexander Palace, Tsarskoie Selo"); Lillian Thomas Pratt

EXHIBITED: NCMA 1979; VMFA 1983

BIBLIOGRAPHY: Lesley 1976, cat. no. 291, p. 143, p. 142 (ill.)

BEQUEST OF LILLIAN THOMAS PRATT, 47.20.275

57 Bookmark

Bowenite, rubies, diamonds, gold

The egg-shaped bowenite bookmark is applied with a conjoined diamond-set *X* and ruby-set *W* (the traditional abbreviation for the Russian Orthodox Easter salutation "Christ is risen"), and has a gold clip that fastens to the book's page.

MARKS: Initials of workmaster Mikhail Perkhin, assay mark of St. Petersburg before 1899, 56 zolotnik

DIMENSIONS: L 1½ in. (3.8 cm)

Original fitted case lining stamped with the imperial warrant, St. Petersburg, Moscow

PROVENANCE: Russian Imperial Treasures. "The Schaffer Collection," #1085, $150; Lillian Thomas Pratt

EXHIBITED: VMFA 1983

BIBLIOGRAPHY: Lesley 1976, cat. no. 299, p. 145 (ill.)

BEQUEST OF LILLIAN THOMAS PRATT, 47.20.154

58 Frame

Bowenite, gold, glass, ivory

The square frame has a rounded aperture and is applied with radiating flutes and a twisted ribbon outer border. The photograph is an original postcard of an unidentified child.

MARKS: *Fabergé*, initials of workmaster Mikhail Perkhin, assay mark of St. Petersburg before 1899, 56 zolotnik

DIMENSIONS: 3 in. square (7.6 cm)

PROVENANCE: Hammer Galleries, #5839-9, December 4, 1940 (as representing Irina, the daughter of Prince Feliks Iusupov); Lillian Thomas Pratt

EXHIBITED: PFAC 1981; VMFA 1983

BIBLIOGRAPHY: Lesley 1976, cat. no. 211, p. 103, p. 102 (ill.)

BEQUEST OF LILLIAN THOMAS PRATT, 47.20.335

58

59 Double Frame

Bowenite, gold, rock crystal

The egg-shaped bowenite double frame has gold borders and is held upright by two gold easels. The reproduction photographs (later additions) under rock-crystal covers are of Grand Duchesses Maria and Anastasia.

MARKS: Initials of workmaster Mikhail Perkhin, assay mark of St. Petersburg before 1899, 56 zolotnik, French import mark *ET*

DIMENSIONS: 2 ¼ in. (5.8 cm)

PROVENANCE: The Schaffer Collection of Russian Imperial Art Treasures, New York, 1940; Lillian Thomas Pratt

EXHIBITED: VMFA 1983; FA 1996

BIBLIOGRAPHY: Lesley 1976, cat. no. 210, p. 103, p. 104 (ill.); Habsburg 1996, cat. no. 112, p. 135 (ill.)

BEQUEST OF LILLIAN THOMAS PRATT, 47.20.306

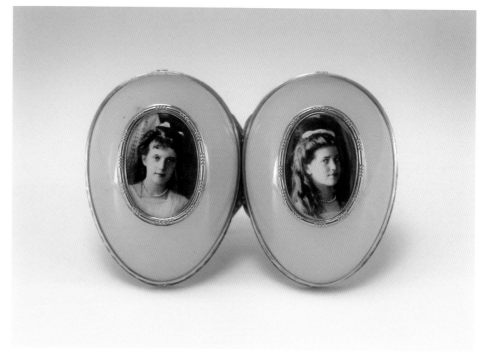

59

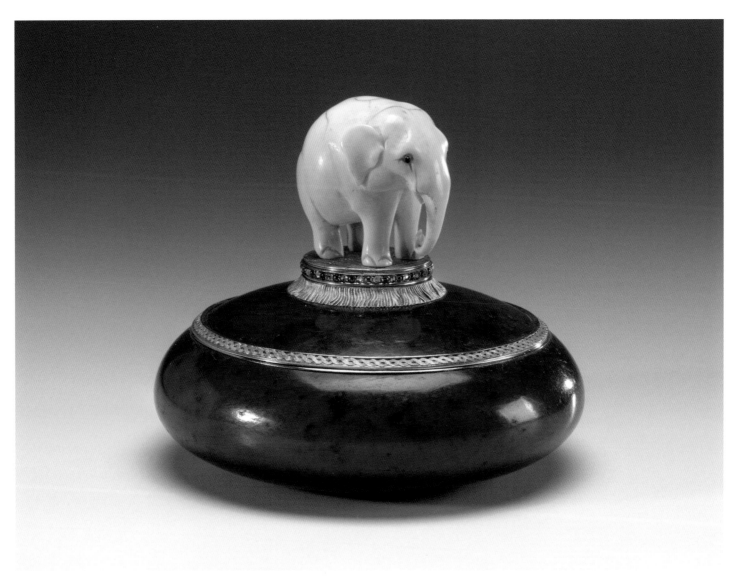

60

60 Elephant Box

Nephrite, ivory, gold, rubies, diamonds

The cover of the bombé nephrite box is surmounted by an ivory elephant standing on a fringed drum that is circled by a gold band set with rubies and diamonds.

MARKS: *Fabergé*, early initials of workmaster Mikhail Perkhin, assay mark of St. Petersburg before 1899, 56 zolotnik

DIMENSIONS: D 4 in. (10.2 cm)

PROVENANCE: Hammer Galleries, #E-327, May 1936 (from the "personal quarters of the Czarina Alexandra Feodorovna, wife of Nicholai II,

in the Alexander Palace, Tsarskoye Selo"); Lillian Thomas Pratt

EXHIBITED: VMFA 1983

BIBLIOGRAPHY: Lesley 1976, cat. no. 293, p. 143, p. 142 (ill.)

BEQUEST OF LILLIAN THOMAS PRATT, 47.20.277 a–b

61 Cup and Cover

Nephrite, silver gilt, rubies, sapphires

The tall tapered cup stands on three hippocampus feet. The cover is surmounted by Neptune's trident, and the rim is chased with scrolling foliage and set with cabochon rubies and sapphires.

MARKS: *Fabergé*, initials of workmaster Mikhail Perkhin, assay mark of St. Petersburg before 1899, 56 zolotnik

DIMENSIONS: 11 in. (28 cm)

PROVENANCE: Hammer Galleries, 1939; Lillian Thomas Pratt

EXHIBITED: VMFA 1983; *FA* 1996

BIBLIOGRAPHY: Lesley 1976, cat. no. 312, p. 151, p. 150 (ill.); Habsburg 1996, cat. no. 114, p. 136 (ill.)

BEQUEST OF LILLIAN THOMAS PRATT, 47.20.300 a–b

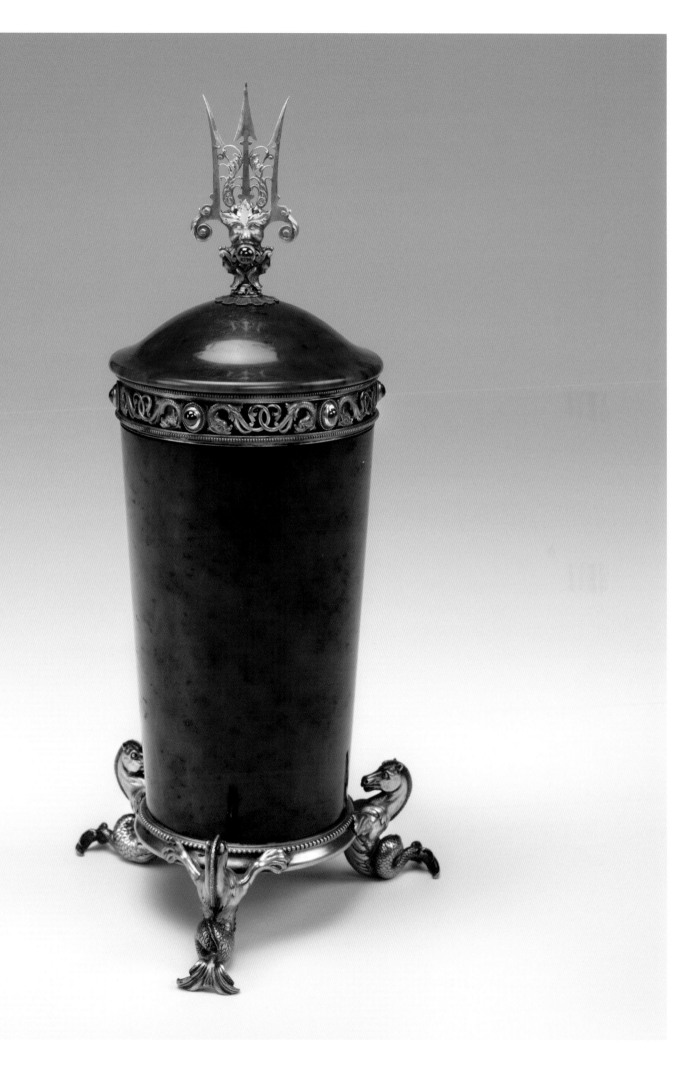

62 enlarged

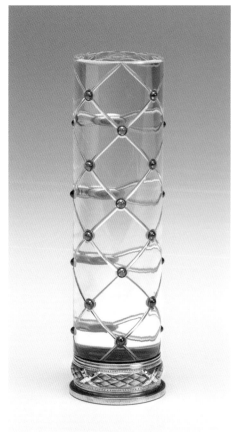

63

62 Imperial Presentation Box

Nephrite, gold, diamonds

The hinged cover of the circular nephrite box is applied with the diamond-set crowned Cyrillic initial *NII* (for Tsar Nicholas II) flanked by two diamond-set laurel sprays. Its borders are rimmed in green- and red-gold, and its lip with a palm-leaf border.

MARKS: *Fabergé*, initials of workmaster Mikhail Perkhin, assay mark of St. Petersburg 1899–1908, assay master Iakov Liapunov, 56 zolotnik
DIMENSIONS: D 3 in. (7.6 cm)
PROVENANCE: Hammer Galleries #ME-1249, February 8, 1937 (from the "collection of Nicholai II, last Czar of Russia in the Alexander Palace, Tsarskoye Selo"); Lillian Thomas Pratt
EXHIBITED: VMFA 1983; ALVR 1983; *FA* 1996
BIBLIOGRAPHY: Lesley 1976, cat. no. 287, p. 143, p. 141 (ill.); ALVR 1983, cat. no. 220, pp. 81, 132, 80 (ill.); Habsburg 1996, cat. no. 116, p. 138
BEQUEST OF LILLIAN THOMAS PRATT, 47.20.271

63 Parasol Handle

Rock crystal, gold, enamel, diamonds

The engraved gilt trelliswork of the rock-crystal shaft is set with rubies at the pattern's intersections. The ferrule is chased with a laurel-wreath band.

MARKS: Initials of workmaster Mikhail Perkhin, assay mark of St. Petersburg 1899–1908, 56 zolotnik
DIMENSIONS: 3 ½ in. (8.9 cm)
PROVENANCE: Hammer Galleries, #5416, February 17, 1939 ("Originally a parasol handle in the possession of Tsarina Alexandra Feodorovna of Russia. From the personal effects of the Tsarina in the Aleksandr Palace, Tsarskoye Selo.");
Lillian Thomas Pratt
EXHIBITED: VMFA 1983
BIBLIOGRAPHY: Lesley 1976, cat. no. 306, p. 148 (ill.)
NOTE: The handle has been transformed into a seal.
BEQUEST OF LILLIAN THOMAS PRATT, 47.20.202

64 Cup and Cover

Nephrite, silver gilt, ruby

The bowl and cover of this chalice-shaped cup are of ribbed nephrite, the tapering cylindrical foot and rim have reed-and-tie bands, and the cover is set with a tall cabochon-ruby finial.

MARKS: *Fabergé*, initials of workmaster Mikhail Perkhin, assay mark of St. Petersburg 1899–1908, 88 zolotnik
DIMENSIONS: 5 ¼ in. (13.3 cm)
PROVENANCE: The Schaffer Collection of Russian Imperial Treasure, #1524; Lillian Thomas Pratt
BIBLIOGRAPHY: Lesley 1976, cat. no. 315, p. 151 (ill.)
BEQUEST OF LILLIAN THOMAS PRATT, 47.20.294 a–b

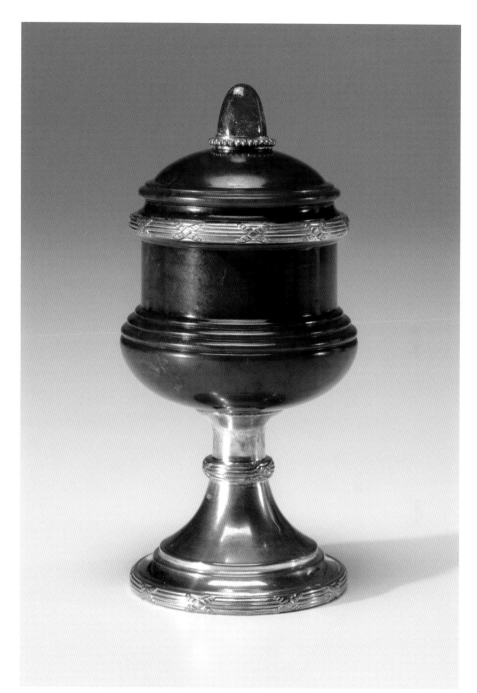

64

65

66

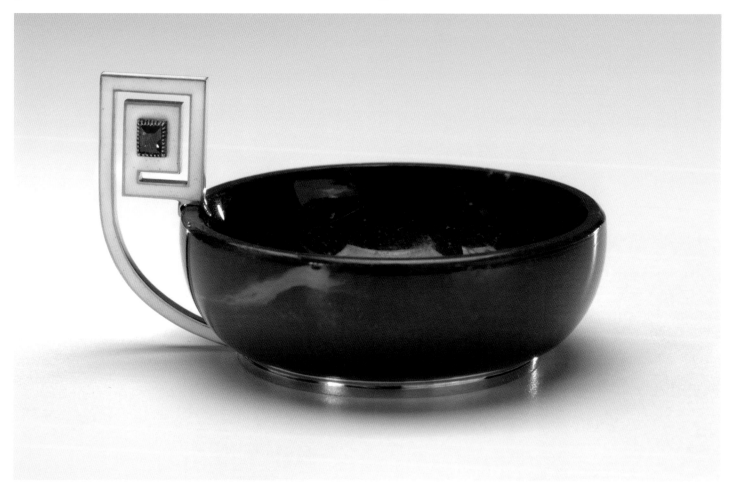

67 enlarged

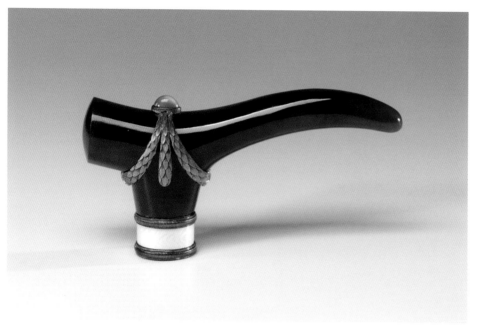

68

Hardstones: Henrik Wigström

65 Box

Nephrite, gold, diamonds

The elongated nephrite box has plain gold mounts and a thumbpiece set with rose-cut diamonds.

MARKS: Initials of workmaster Henrik Wigström, assay mark of St. Petersburg 1899–1908, 72 zolotnik
DIMENSIONS: L 2¾ in. (7 cm)
PROVENANCE: Ailsa Mellon Bruce
GIFT OF THE ESTATE OF AILSA MELLON BRUCE, 70.9.72

66 Box

Gold, diamonds

The elliptical box is lined with gold, and its cover is applied with an imperial double-headed eagle set with rose-cut diamonds.

MARKS: *Fabergé*, initials of workmaster Henrik Wigström, assay mark of St. Petersburg 1899–1908, 56 zolotnik

DIMENSIONS: L 2½ in. (6.2 cm)
PROVENANCE: Ailsa Mellon Bruce
GIFT OF THE ESTATE OF AILSA MELLON BRUCE, 70.9.71

67 Charka

Jasper, gold, enamel, ruby

The jasper *charka* has an opalescent-white enamel handle shaped as a Greek key centering on a faceted ruby. The plain base is gold.

MARKS: Initials of workmaster Henrik Wigström, assay mark of St. Petersburg 1899–1908, assay master A. Romanov, 56 zolotnik, scratched inventory number 13807
DIMENSIONS: D 2¼ in. (5.7 cm)
Original fitted case lining stamped with imperial warrant, St. Petersburg, Moscow, Odessa
PROVENANCE: Acquired by Dowager Empress Maria Feodorovna, December 31, 1906, for 150 rubles (listed as an ashtray); Queen Olga of Greece; Prince Christopher of Greece; Georges and Alice

Lurcy; Alice Nelson; Sotheby's New York, June 10–11, 1981, lot 137a; A La Vielle Russie; COLLECTION OF GEORGES AND ALICE LURCY; GIFT OF ALICE AND LEWIS NELSON IN CELEBRATION OF VMFA'S 75TH ANNIVERSARY, 2010.117

68 Parasol Handle

Nephrite, gold, enamel, chalcedony

The derby-shaped nephrite handle is tied with chased-gold laurel wreaths topped by a pinkish-tinted cabochon chalcedony. The translucent-white enamel ferrule is decorated with gadrooned borders.

MARKS: Initials of workmaster Henrik Wigström, 56 zolotnik
DIMENSIONS: 1¾ × 3½ in. (4.5 × 8.4 cm)
PROVENANCE: Lillian Thomas Pratt
EXHIBITED: VMFA 1983
BIBLIOGRAPHY: Lesley 1976, cat. no. 227, p. 112 (ill.)
BEQUEST OF LILLIAN THOMAS PRATT, 47.20.180

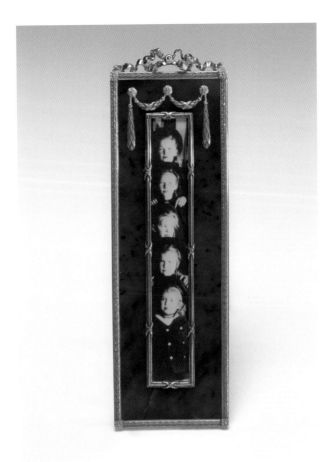

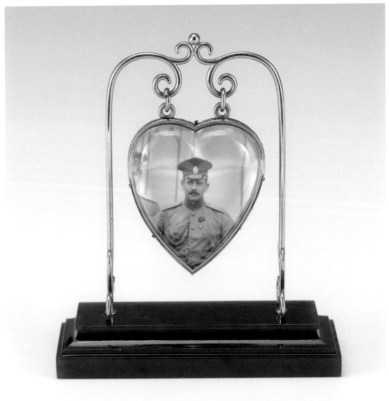

69 reduced

69 Frame

Nephrite, gold, ivory, glass

The upright nephrite frame is applied
with laurel swags hung from rosettes,
and has an inner reed-and-tie border, an
outer palm-leaf border, and a tied-ribbon
cresting. The group photograph of the
imperial children is a later addition.

MARKS: *Fabergé*, initials of workmaster Henrik
Wigström, assay mark of St. Petersburg 1899–1908
DIMENSIONS: 5 ½ in. (14 cm)
PROVENANCE: Lillian Thomas Pratt
EXHIBITED: VMFA 1983
BIBLIOGRAPHY: Lesley 1976, cat. no. 202, p. 97,
p. 98 (ill.)
NOTE: This object was originally a thermometer
(for other examples of thermometers, see
Habsburg 2003).
BEQUEST OF LILLIAN THOMAS PRATT, 47.20.320

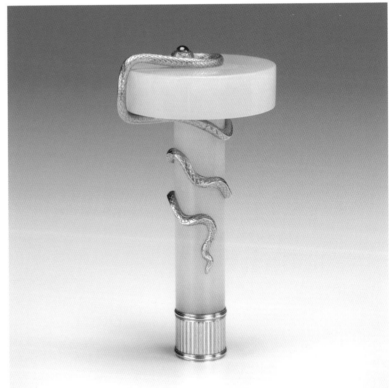

71 reduced

72

70 Heart Frame

Nephrite, gold, rock crystal

The heart-shaped gold frame with an original photograph of Grand Duke Boris Vladimirovich is suspended by rings from a curved gold-wire stand and is set on a stepped nephrite plinth.

MARKS: Initials of workmaster Henrik Wigström, 56 zolotnik

DIMENSIONS: 3 ⅜ in. (8.6 cm)

PROVENANCE: Hammer Galleries, #4776, November 12, 1936, $375 (from the "Alexander Palace, Tsarskoye Selo"); Lillian Thomas Pratt

BIBLIOGRAPHY: Lesley 1976, cat. no. 207, p. 101, p. 100 (ill.)

NOTE: Grand Duke Boris Vladimirovich (1877–1943) was the son of Grand Duke Vladimir Aleksandrovich and Grand Duchess Maria Pavlovna (see Chapter 7). He was a major general in the Russian Army and took part in the Russo-Japanese War and World War I. With many connections in and out of the country, he managed to escape revolutionary Russia. In 1919, he morganatically married his mistress, Zenaida Rachevskaia.

BEQUEST OF LILLIAN THOMAS PRATT, 47.20.305

71 Parasol Handle

Chalcedony, bowenite, gold, ruby

The bowenite handle is a cylindrical shaft with a flat circular top. A chased-gold snake with a cabochon-ruby head is entwined around the shaft and top. The ferrule is of fluted gold.

MARKS: Initials of workmaster Henrik Wigström, assay mark of St. Petersburg 1899–1908, assay master A. Richter, 56 zolotnik, scratched inventory number 14939

DIMENSIONS: 4 ³⁄₁₆ in. (10.6 cm)

PROVENANCE: Inventory of Fabergé's Moscow branch 1919, 775 rubles (155 rubles in 1913); The Schaffer Collection of Russian Imperial Art Treasures, 1936 (as having "belonged to Czarina Alexandra Feodorovna"); Lillian Thomas Pratt

EXHIBITED: FA 1996

BIBLIOGRAPHY: Lesley 1976, cat. no. 250, p. 119; Habsburg 1996, cat. no. 127, p. 143

BEQUEST OF LILLIAN THOMAS PRATT, 47.20.187

72 Double Frame

Bowenite, gold, silver, enamel, ivory

The plain bowenite double frame has two oval apertures. The silver bezels are of black pellets and white fillets with a red enamel ground between. Original photographs are of Karl and Augusta Fabergé.

MARKS: Fabergé, initials of workmaster Henrik Wigström, 88 zolotnik

DIMENSIONS: 3 in. (7.6 cm)

PROVENANCE: Hammer Galleries #5364/2, February 17, 1939 (acquired from "Nikolai Fabergé, son of the renowned jeweler"); Lillian Thomas Pratt

EXHIBITED: PFAC 1981; VMFA 1983

BIBLIOGRAPHY: Lesley 1976, cat. no. 203, p. 97, p. 98 (ill.)

BEQUEST OF LILLIAN THOMAS PRATT, 47.20.324

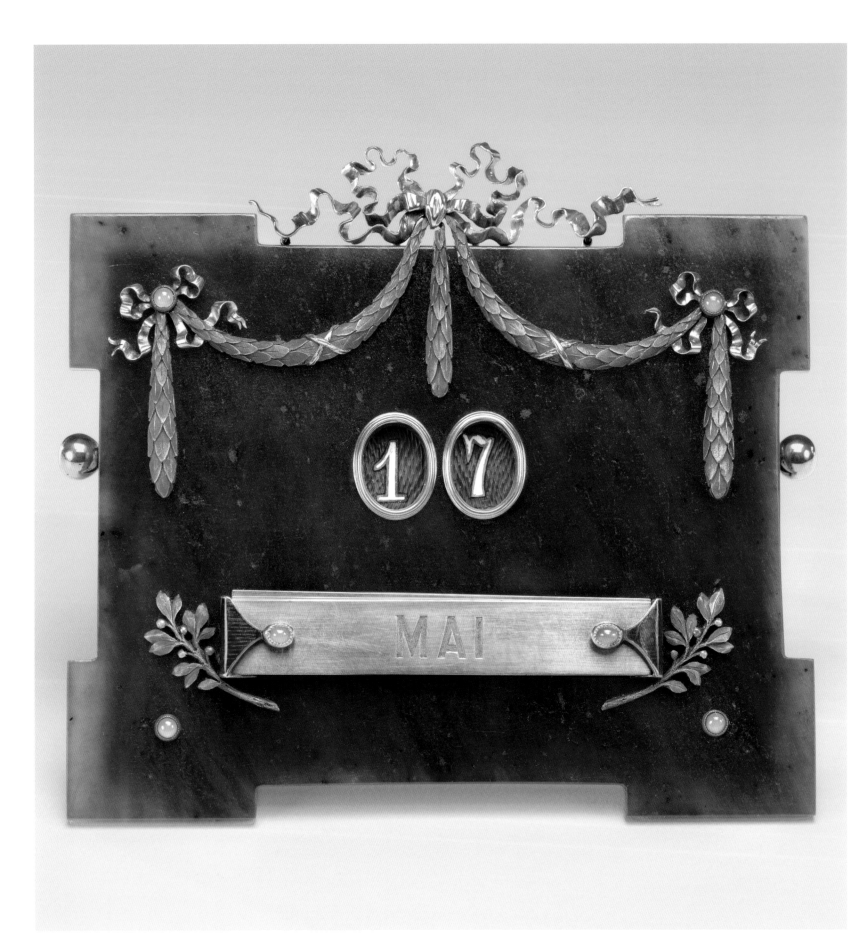

73 enlarged

73

73 Perpetual Calendar

Nephrite, gold, silver gilt, enamel, pearls, agate

The gold numbers on a red guilloché ground are set on the nephrite face of this calendar and can be turned using knobs on either side of the piece. Separate gold nameplates bearing the French names of the months are held onto the calendar by brackets. Laurel sprays are set on either side. The calendar has chased laurel swags suspended from gold ribbons above, and a silver back.

MARKS: *Fabergé*, initials of workmaster Henrik Wigström, assay mark of St. Petersburg 1908–17, assay master Iakov Liapunov, 88 zolotnik, inventory number 23033
DIMENSIONS: 3 ½ × 3 ¼ in. (8.9 × 8.3 cm)
Original fitted case lining stamped with imperial warrant, St. Petersburg, Moscow, London
PROVENANCE: Russian Imperial Treasures Inc. "The Schaffer Collection," #G14, August 18, 1937, $1,200; Lillian Thomas Pratt
EXHIBITED: VMFA 1983; *FA* 1996
BIBLIOGRAPHY: Lesley 1976, cat. no. 300, p. 147, p. 145 (ill.); Habsburg 1996, cat. no. 111, p. 134 (ill.)
BEQUEST OF LILLIAN THOMAS PRATT, 47.20.286

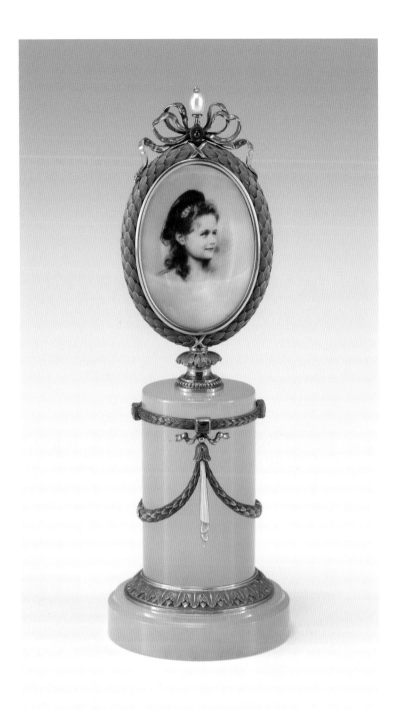

74 enlarged

74 Column Frame

Bowenite, gold, rock crystal, rubies, pearl

The bowenite column is applied with chased-gold laurel swags suspended from rubies. It is surmounted by an oval double frame containing photographs under rock-crystal covers of pastel portraits by Friedrich von Kaulbach of Grand Duchesses Olga and Tatiana. Their chased laurel-leaf borders are surmounted by a red-gold bowknot and a pearl.

MARKS: Initials of workmaster Henrik Wigström, assay mark of St. Petersburg 1908–17, 56 zolotnik, scratched inventory number 17259
DIMENSIONS: 4 ½ in. (11.4 cm)
PROVENANCE: The Schaffer Collection of Russian Imperial Art Treasures; Lillian Thomas Pratt
EXHIBITED: VMFA 1983; *FA* 1996
BIBLIOGRAPHY: Lesley 1976, cat. no. 209, p. 101 (ill.); Habsburg 1996, cat. no. 113, p. 135 (ill.)
NOTE: The photographs are of two pastels that hung in Tsaritsa Alexandra's Mauve Room on either side of a corner cabinet that contained Fabergé Easter eggs (Habsburg and Lopato 1993). A similar frame is in the Hillwood Museum in Washington, D.C.
BEQUEST OF LILLIAN THOMAS PRATT, 47.20.304

75 Cup

Nephrite, silver gilt, rubies, sapphires

The *cuppa* of the nephrite chalice-shaped cup is applied with abstract motifs and rosettes, its rim with alternating rubies and sapphires, and its foot with raised whorls set with rubies and sapphires.

MARKS: Initials of workmaster Henrik Wigström, assay mark of St. Petersburg 1908–17, 88 zolotnik, scratched inventory number 12880
DIMENSIONS: 3 ½ in. (8.9 cm)
PROVENANCE: Lillian Thomas Pratt
EXHIBITED: NCMA 1979; VMFA 1983
BIBLIOGRAPHY: Lesley 1976, cat. no. 316, p. 153, p. 152 (ill.)
NOTE: This cup is said to be a copy of a Byzantine chalice in the Hermitage Museum in St. Petersburg.
BEQUEST OF LILLIAN THOMAS PRATT, 47.20.295

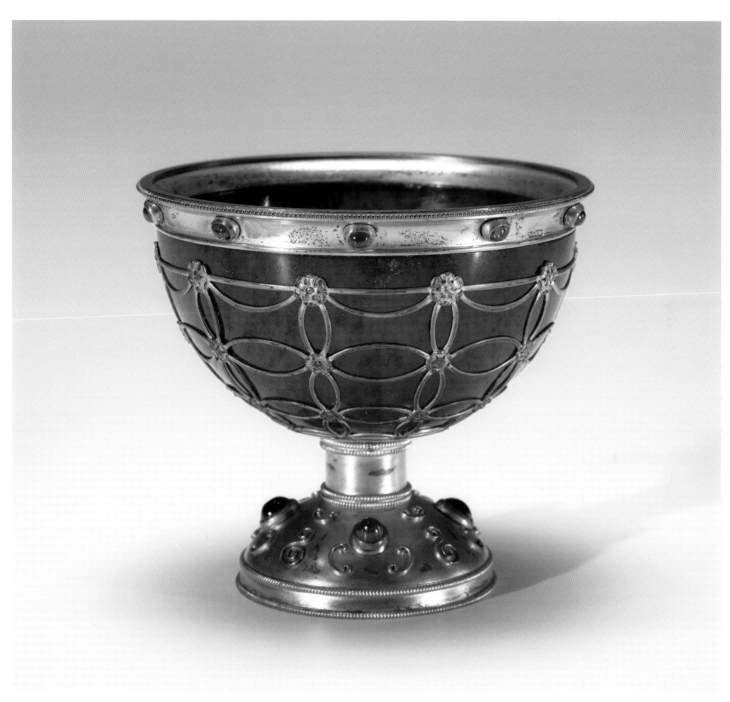

75 enlarged

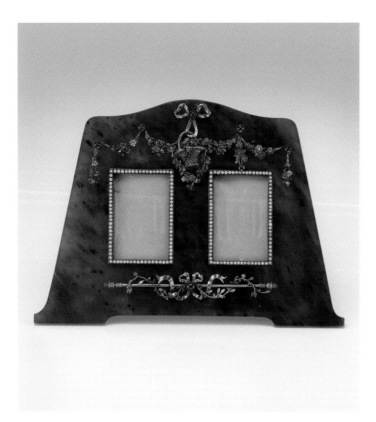

76 reduced

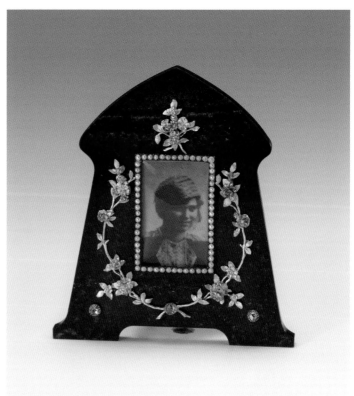

77 enlarged

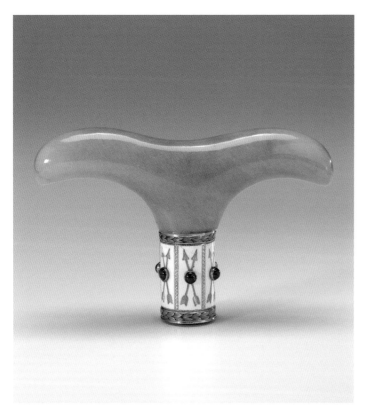

78 reduced

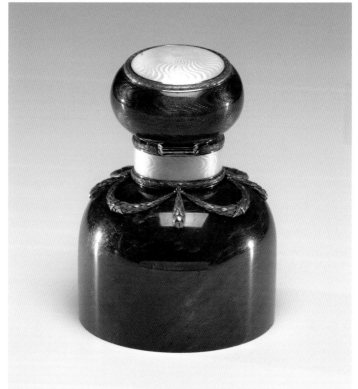

79 reduced

Hardstones: Other Makers, Uncertain Attributions

76 Double Frame

Nephrite, gold, silver, pearls, rubies, glass, mother-of-pearl

The *A*-shaped frame has two rectangular apertures with seed-pearl borders. It is applied above the apertures with vari-colored-gold floral swags suspended from cabochon rubies and a chased-gold basket suspended from a bowknot set with a ruby. A horizontal maenad's staff beneath is entwined with ribbons and laurel sprays, and has a bowknot set with a cabochon ruby.

MARKS: *Fabergé*, initials of workmaster Hjalmar Armfelt, assay mark of St. Petersburg 1899–1908, 88 zolotnik
DIMENSIONS: 3 ½ in. (8.9 cm)
PROVENANCE: The Schaffer Collection of Russian Imperial Treasure, January 27, 1938; Lillian Thomas Pratt
EXHIBITED: VMFA 1983
BIBLIOGRAPHY: Lesley 1976, cat. no. 205, p. 97, p. 99 (ill.); Curry 1995, cat. no. 25, p. 109 (ill.)
NOTE: Armfelt is known for his hardstone miniature frames applied with intricate multicolored gold swags and mother-of-pearl backs (see Habsburg 2000).
BEQUEST OF LILLIAN THOMAS PRATT, 47.20.354

77 Frame

Lapis lazuli, gold, pearls, diamonds, glass, mother-of-pearl

The aedicule-shaped frame is applied with three-colored-gold sprays issuing from a diamond with two diamond-set rosettes at the lower corners. The reproduction photograph was added later.

MARKS: Unmarked, attributed to workmaster Hjalmar Armfelt
DIMENSIONS: 2 ½ in. (6.4 cm)
PROVENANCE: The Schaffer Collection of Russian Imperial Art Treasures #1464, March 19, 1937; Lillian Thomas Pratt
EXHIBITED: VMFA 1983
BIBLIOGRAPHY: Lesley 1976, cat. no. 201, p. 97, p. 93 (ill.)
BEQUEST OF LILLIAN THOMAS PRATT, 47.20.353

78 Cane Handle

Aventurine quartz, gold, enamel, rubies

The ferrule of the *T*-shaped handle has opaque-white guilloché enamel panels decorated with crossed arrows, rubies, and laurel-leaf borders.

MARKS: Assay mark of St. Petersburg before 1899, 56 zolotnik; attributed to Fabergé
DIMENSIONS: 2 ½ in. (6.3 cm)
PROVENANCE: Lillian Thomas Pratt
EXHIBITED: NCMA 1979; VMFA 1983
BIBLIOGRAPHY: Lesley 1976, cat. no. 220
BEQUEST OF LILLIAN THOMAS PRATT, 47.20.173

79 Inkwell

Nephrite, gold, enamel, rock crystal

The nephrite inkwell is shaped as a flask with rounded shoulders and is applied with laurel swags. Both the white guilloché enamel neck and the mauve-and-white guilloché enamel stopper have palm-leaf borders. The interior conceals a rock-crystal well.

MARKS: *Fabergé*, initials of workmaster Fedor Afanas'ev, assay mark of St. Petersburg 1899–1908, assay master Iakov Liapunov, 56 zolotnik
DIMENSIONS: 4 in. (10.2 cm)
PROVENANCE: Hammer Galleries, December 4, 1939 (from the "famous jade collection of Agathon Fabergé, illustrious son of the court jeweler, known throughout Europe during the Imperial regime as one of the greatest gem experts of the world"); Lillian Thomas Pratt
EXHIBITED: VMFA 1983
BIBLIOGRAPHY: Lesley 1976, cat. no. 303, p. 147, p. 146 (ill.)
BEQUEST OF LILLIAN THOMAS PRATT, 47.20.301

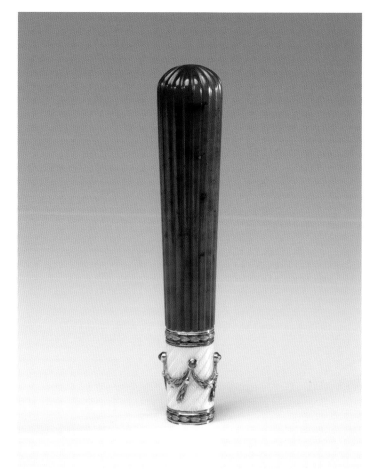

80 enlarged

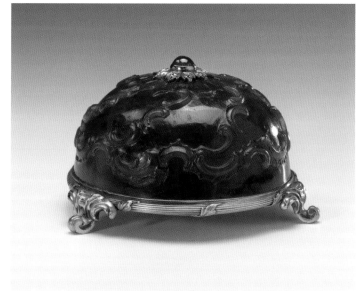

81

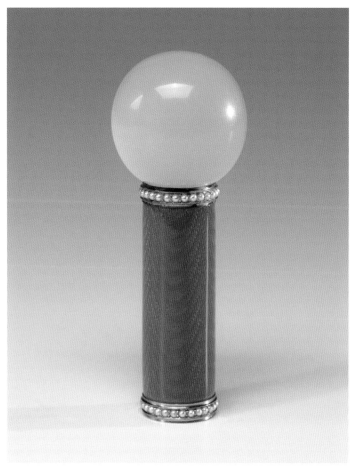

80 reduced

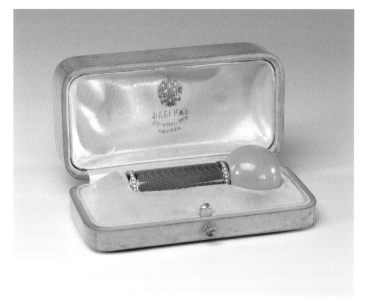

82

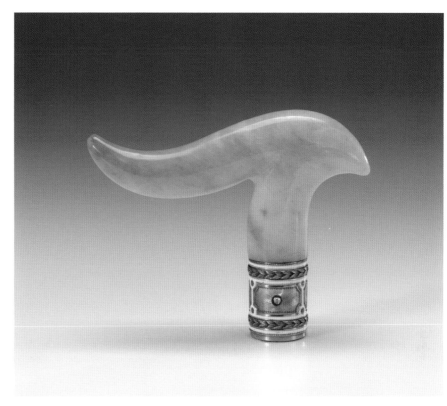

83 reduced

80 Parasol Handle

Bowenite, gold, enamel, seed pearls

The spherical bowenite knob has an elongated ferrule of pink moiré guilloché enamel with seed-pearl borders.

MARKS: Unidentified workmaster's initials (possibly Cyrillic *IG*), 56 zolotnik
DIMENSIONS: 2 ⅝ in. (6.7 cm)
Original fitted case lining stamped with imperial warrant, St. Petersburg, Moscow
PROVENANCE: Hammer Galleries, #5448, April 19, 1939 ("Of great charm and simplicity, the little object was made for one of the daughters of the late Nikolai II. It is from the children's apartments in the Aleksandr Palace, Tsarkoye Selo"); Lillian Thomas Pratt
EXHIBITED: VMFA 1983
BIBLIOGRAPHY: Lesley 1976, cat. no. 244, p. 119 (ill.)
BEQUEST OF LILLIAN THOMAS PRATT, 47.20.171

81 Parasol Handle

Nephrite, gold, rubies

The tapered nephrite handle is fluted and has a ferrule of white guilloché enamel applied with green- and red-gold swags suspended from rubies and chased-gold laurel-leaf borders.

UNMARKED: Attributed to Fabergé
DIMENSIONS: 3 ¾ in. (9.5 cm)
PROVENANCE: Hammer Galleries, 1940?, $525; Lillian Thomas Pratt
EXHIBITED: VMFA 1983
BIBLIOGRAPHY: Hammer Galleries catalogue 1940?; Lesley 1976, cat. no. 231, p. 112 (ill.)
BEQUEST OF LILLIAN THOMAS PRATT, 47.20.194

82 Bell Push

Nephrite, gold, ruby, diamonds, rosewood

The domed nephrite bell push is carved with rococo-style scrolls and cartouches. Its cabochon-ruby button has a rose-cut diamond surround, and its gold base has three curved feet.

MARKS: Scratched inventory number 50056
DIMENSIONS: D 2 ½ in. (6.3 cm)
PROVENANCE: Acquired by Dowager Empress Maria Feodorovna, March 10, 1895, for 295 rubles ("electric bell-push, nephrite, Louis XVI"); The Alexander Schaffer Collection of Russian Imperial Art, #1546, March 19, 1937; Lillian Thomas Pratt
EXHIBITED: VMFA 1983; FA 1996 (VMFA only)
BIBLIOGRAPHY: Lesley 1976, cat. no. 298, p. 147, p. 145 (ill.)
BEQUEST OF LILLIAN THOMAS PRATT, 47.20.282

83 Parasol Handle

Aventurine quartz, gold, enamel, diamonds

The ferrule of the derby-shaped handle has panels of green guilloché enamel framed in opaque-white and palm-leaf borders.

MARKS: Workmaster's initials illegible, assay mark of St. Petersburg 1899–1908, 72 zolotnik, scratched inventory number 16986
DIMENSIONS: 2 ¾ in. (7 cm)
PROVENANCE: Lillian Thomas Pratt
EXHIBITED: VMFA 1983
BIBLIOGRAPHY: Lesley 1976, cat. no. 221, p. 109, p. 108 (ill.)
BEQUEST OF LILLIAN THOMAS PRATT, 47.20.174

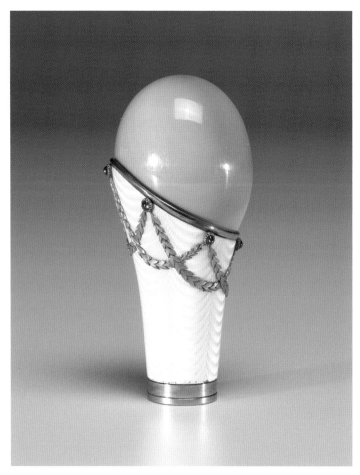

84 reduced

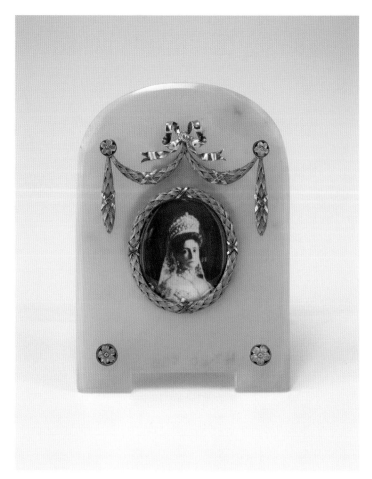

85 enlarged

84 Cane Handle

Agate, gold, enamel, rubies

The egg-shaped milky-agate knob of this handle is encased in a sleeve of white moiré guilloché enamel and is applied with chased-gold laurel swags suspended from rubies.

UNMARKED: Attributed to Fabergé
DIMENSIONS: 3 ¾ in. (9.5 cm)
PROVENANCE: Lillian Thomas Pratt
EXHIBITED: VMFA 1983
BIBLIOGRAPHY: Lesley 1976, cat. no. 304, p. 148 (ill.)
BEQUEST OF LILLIAN THOMAS PRATT, 47.20.200

85 Frame

Bowenite, silver gilt, ivory, glass

The frame has an arched top and a laurel-leaf bezel to the circular aperture. It is applied with laurel swags suspended from a gold bowknot above and two rosettes below. The reproduction photograph of Tsaritsa Alexandra was added later.

MARKS: Maker's mark illegible, 88 zolotnik
DIMENSIONS: 2 in. (5 cm)
PROVENANCE: Hammer Galleries, #754, January 27, 1938, $325 (from the "apartments of Tsarina Alexandra Feodorovna, in the Alexander Palace, Tsarskoye Selo"); Lillian Thomas Pratt
BIBLIOGRAPHY: Hammer Galleries catalogue, 1941?; Lesley 1976, cat. no. 204, p. 97, p. 99 (ill.)
BEQUEST OF LILLIAN THOMAS PRATT, 47.20.328

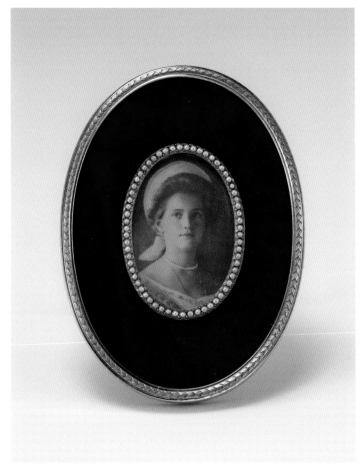

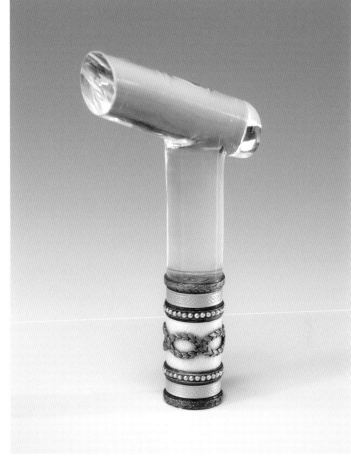

86

87

86 Frame

Lapis lazuli, gold, pearls, glass, ivory

The lapis lazuli frame has a pearl-set bezel and a palm-leaf outer border. The reproduction photograph of Grand Duchess Maria is a later addition.

MARKS: *Fabergé*, assay mark of St. Petersburg 1908–17, 56 zolotnik, scratched inventory number 26318

DIMENSIONS: 3 ⅜ in. (8.6 cm)

PROVENANCE: The Schaffer Collection of Russian Imperial Treasure, #894, November 1, 1935, $425; Lillian Thomas Pratt

EXHIBITED: VMFA 1983

BIBLIOGRAPHY: Lesley 1976, cat. no. 200, p. 97, p. 96 (ill.)

BEQUEST OF LILLIAN THOMAS PRATT, 47.20.342

87 Parasol Handle

Rock crystal, gold, enamel, pearls

The handle is of a slanted *T*-shape and has a gold neck of pale-blue and white guilloché enamel. It is also applied with two intertwined laurel-leaf bands, pearl-set fillets, and laurel-leaf borders.

MARKS: Maker's mark illegible, assay mark of St. Petersburg 1908–17, 56 zolotnik, scratched inventory number 17148

DIMENSIONS: 3 ½ in. (8.9 cm)

PROVENANCE: Inventory of Fabergé's Moscow branch, April 30, 1919, for 745 rubles (149 rubles in 1913); Lillian Thomas Pratt

EXHIBITED: VMFA 1983

BIBLIOGRAPHY: Lesley 1976, cat. no. 238, p. 115 (ill.)

BEQUEST OF LILLIAN THOMAS PRATT, 47.20.196

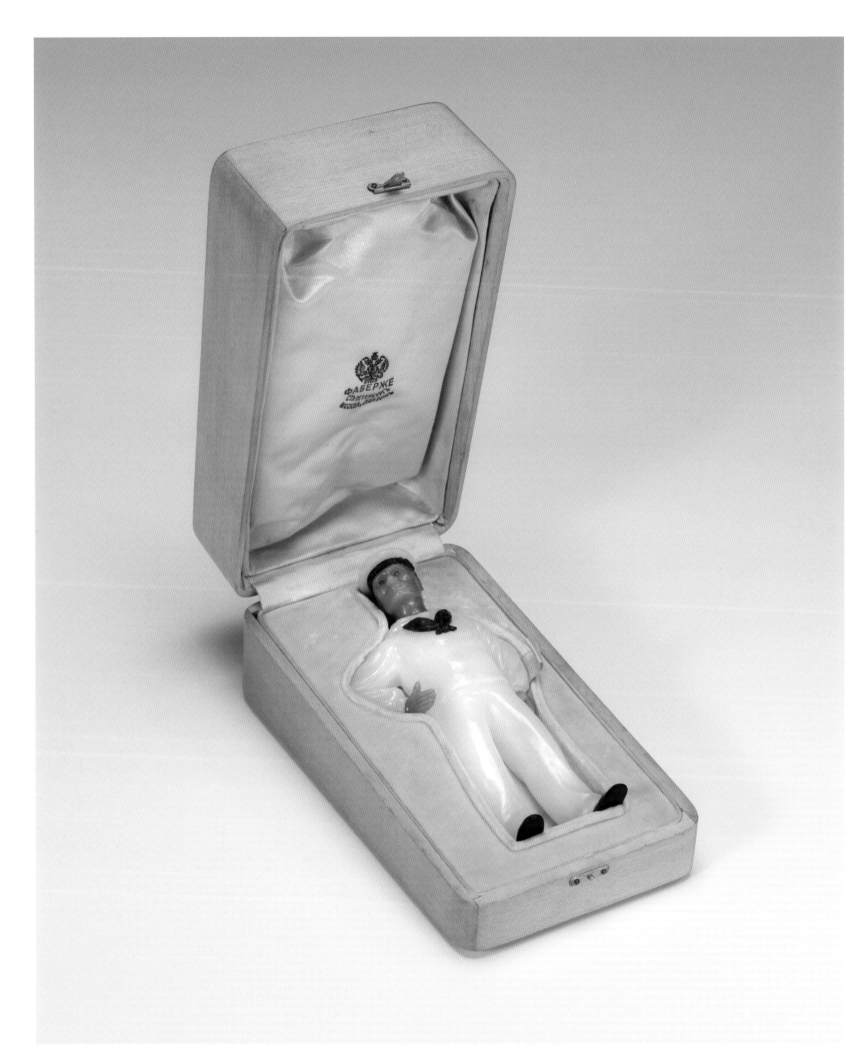

88 Statuette of a Sailor

Agate, obsidian, aventurine quartz, lapis lazuli, sapphire

The composite hardstone figure of a sailor wears a milky-white agate uniform and has a brownish aventurine quartz face with sapphire eyes. His agate cap has a lapis lazuli brim with the gilt inscription *ZARNITSA,* which links him to the imperial yacht. He wears a lapis tie and obsidian shoes.

UNMARKED
DIMENSIONS: 4 ⅝ in. (11.8 cm)
Original fitted case lining stamped with imperial warrant, St. Petersburg, Moscow, London
PROVENANCE: Acquired by Countess Brasova (née Natalia Sheremet'evskaia) at Faberge's London branch, October 14, 1913, as a present for her husband, Grand Duke Mikhail Aleksandrovich; Hammer Galleries #RH 1815, December 9, 1937; Lillian Thomas Pratt
EXHIBITED: Hammer Galleries 1937 (described as: "His piercing eyes each set with a . . . sapphire sparkle with loyalty and sincerity"); VMFA 1983; ALVR 1983; *FA* 1996
BIBLIOGRAPHY: Lesley 1976, cat. no. 301, p. 147, p. 146 (ill.); ALVR 1983, cat. no. 481, p. 134, 132 (ill.); Curry 1995, cat. no. 19, pp. 37, 109 (ill.); Habsburg 1996, cat. no. 120, p. 140 (ill.)
NOTE: See Chapter 6, pp. 102–19
BEQUEST OF LILLIAN THOMAS PRATT, 47.20.268

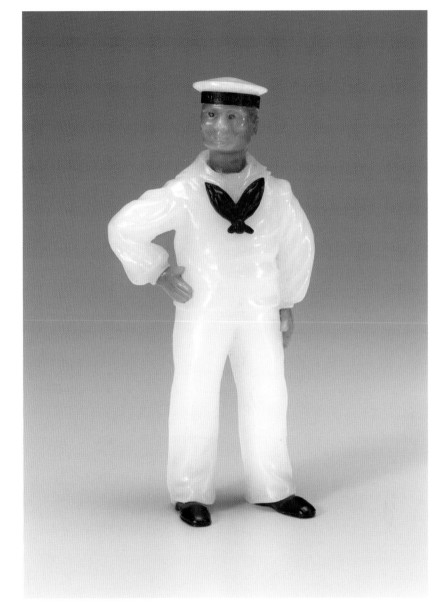

88

88 (left) reduced

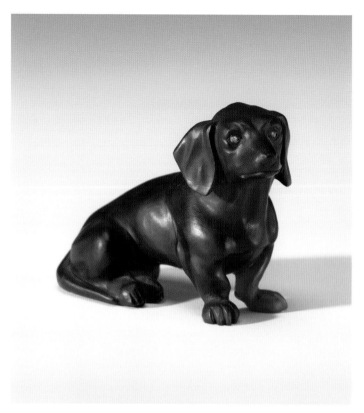

89

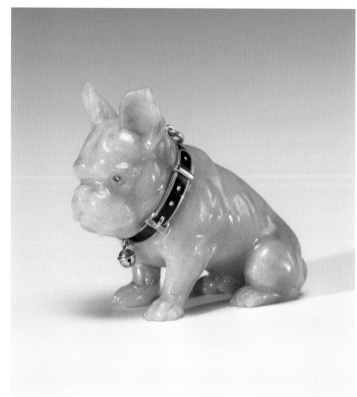

90 enlarged

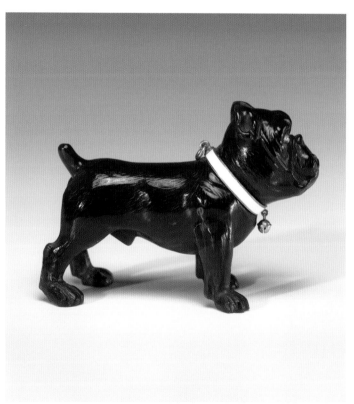

91 enlarged

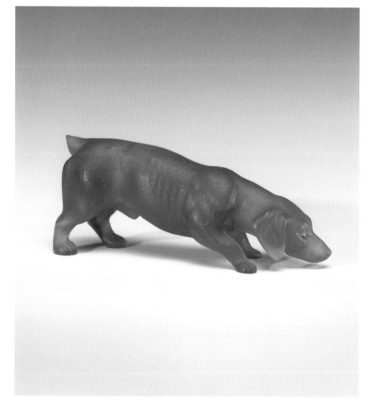

92

Animals

89 Dachshund

Smokey agate, rubies

The well-modeled, smoke-colored dachs-hund has cabochon-ruby eyes and is seated on its hindquarters.

UNMARKED
DIMENSIONS: L 2½ in. (6.3 cm)
Original fitted case lining stamped with imperial warrant, St. Petersburg, Moscow
PROVENANCE: Hammer Galleries, #5449, April 19, 1939 (from the "apartments of the Dowager Empress in the Anitchkov Palace"); Lillian Thomas Pratt
EXHIBITED: VMFA 1983
BIBLIOGRAPHY: Lesley 1976, cat. no. 13, p. 18 (ill.)
BEQUEST OF LILLIAN THOMAS PRATT, 47.20.244

90 French Bulldog

Aventurine quartz, gold, enamel, emeralds

This bulldog of pink aventurine quartz has emerald eyes and wears a gold collar enam-eled in black, from which is suspended a gold bell.

UNMARKED
DIMENSIONS: 1¾ in. (4.4 cm)
Original fitted case lining stamped with imperial warrant, St. Petersburg, Moscow, London
PROVENANCE: John Davis Skilton Jr.; sold Christie's New York, April 21, 1998, lot 32; Ernest Hillman Jr.
NOTE: This piece is one of a number of such bulldogs, each slightly different. The best-known example was formerly owned by Elisabeth Balletta (Christie's Geneva, November 19, 1974, lot 282). For another similar bulldog, see Snowman 1962.

Yet another related bulldog was sold by Fabergé's London branch on November 16, 1916, for £90.
GIFT OF THE ESTATE OF ERNEST HILLMAN JR., 2003.188

91 English Bulldog

Obsidian, diamonds, gold, enamel

The standing sheen-obsidian bulldog has rose-cut diamond eyes and wears an opaque-white enameled collar from which is suspended a bell.

MARKS: Initials of workmaster Henrik Wigström, 56 zolotnik
DIMENSIONS: L 3 in. (7.6 cm)
PROVENANCE: Lillian Thomas Pratt
EXHIBITED: VMFA 1983
BIBLIOGRAPHY: Hammer Galleries catalogue, 1939 ("From the collection of Prince Aleksandr Romanovski, Duke of Leuchtenberg"); Lesley 1976, cat. no. 11, p. 118 (ill.)
BEQUEST OF LILLIAN THOMAS PRATT, 47.20.246

92 Dachshund

Agate, rubies

Nose to the ground, this honey-colored dachshund has ruby eyes.

UNMARKED
DIMENSIONS: L 3 in. (7.6 cm)
PROVENANCE: Hammer Galleries, #5478–5, January 10, 1940 ("Beautiful, detailed figure of a dachshund created by Karl Fabergé."); Lillian Thomas Pratt
BIBLIOGRAPHY: Lesley 1976, cat. no. 14, p. 18 (ill.)
BEQUEST OF LILLIAN THOMAS PRATT, 47.20.245

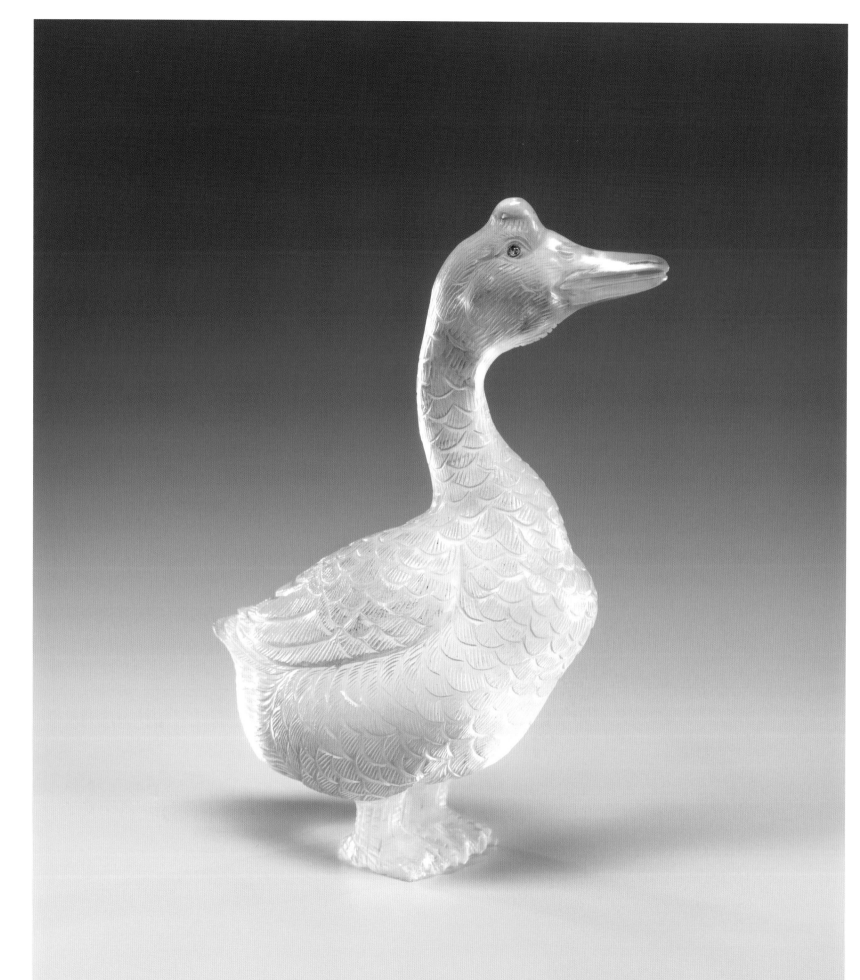

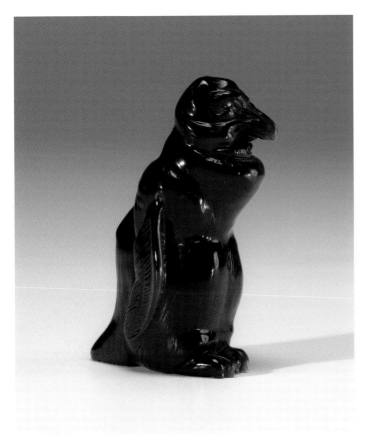

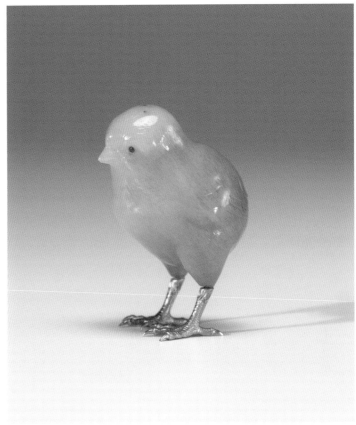

94

95 reduced

93 Chinese Swan Goose

Rock crystal, diamonds

The Chinese swan goose (*Anser cygnoides*), recognizable by the hump on its head, is carved in frosted rock crystal and has diamond eyes.

MARKS: *K. Fabergé* engraved under one foot
DIMENSIONS: 4 ½ in. (11.5 cm)
Original fitted case lining stamped with imperial warrant, St. Petersburg, Moscow, Odessa
PROVENANCE: Russian Imperial Treasures Inc. "The Schaffer Collection" #650, June 1, 1940, $650; Lillian Thomas Pratt
EXHIBITED: VMFA 1983; *FA* 1996 (VMFA only)
BIBLIOGRAPHY: Lesley 1976, cat. no. 29, p. 25 (ill.); Curry 1995, cat. no. 34, p. 103, pp. 102, 110 (ill.)
NOTE: A pair of geese of similar style is in Moscow's Fersman Mineralogical Museum (Habsburg

2003). Cartier acquired an *oie debout quartz blanc*, (standing goose of white quartz) from Denisov-Ural'skii in 1913.
BEQUEST OF LILLIAN THOMAS PRATT, 47.20.259

94 Humboldt Penguin

Obsidian, diamonds

The standing Humboldt penguin (*Sphenicus humboldti*) has rose-cut diamond eyes.

MARKS: *K. Fabergé* in Latin script engraved under one foot, scratched inventory number 17760
DIMENSIONS: 3 in. (7.6 cm)
PROVENANCE: Lillian Thomas Pratt
EXHIBITED: ALVR 1983
BIBLIOGRAPHY: Lesley 1976, cat. no. 32, p. 26 (ill.); ALVR 1983, cat. no. 410, p. 115 (ill.)
BEQUEST OF LILLIAN THOMAS PRATT, 47.20.255

95 Chick

Aventurine quartz, gold, rubies

The pinkish-hardstone chick has cabochon-ruby eyes and chased-gold feet.

MARKS: Workmaster's initials illegible, assay mark of St. Petersburg 1899–1908, 72 zolotnik
DIMENSIONS: 7 ½ in. (19.1 cm)
PROVENANCE: Hammer Galleries. #5791-10, December 4, 1940, $350 ("It bears the original blue enameled number G21632 under which it was inventoried in the Gatchina Palace"); Lillian Thomas Pratt
BIBLIOGRAPHY: Lesley 1976, cat. no. 25, p. 24 (ill.)
NOTE: A similar chick is in the Woolf Family Collection (Habsburg 2000).
BEQUEST OF LILLIAN THOMAS PRATT, 47.20.254

93 (left) enlarged

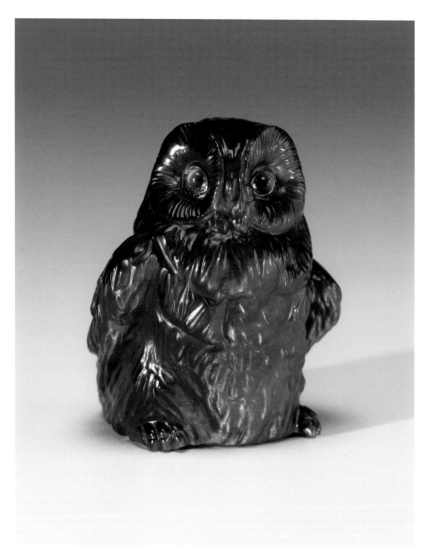

96

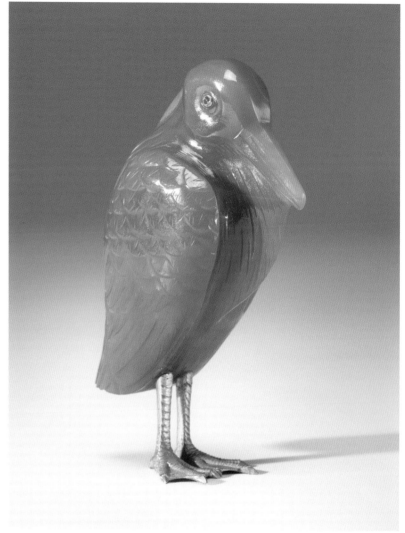

97

Drawing of an owl as seen in Cartier's
acquisition ledger.

96 Owl

Obsidian, tigereyes, diamonds

The obsidian Northern Saw-whet owl
(*Aegolinus acadicus*) has realistic yellow
cabochon-tigereye eyes flanked by rose-
cut diamonds.

UNMARKED
DIMENSIONS: 3 ½ in. (8.9 cm)
Original fitted case lining stamped with imperial
warrant, Petrograd, Moscow, Odessa, London
PROVENANCE: Russian Imperial Treasures, Inc.
"The Schaffer Collection" #2340, December 28,
1939, $1,500; Lillian Thomas Pratt
EXHIBITED: VMFA 983
BIBLIOGRAPHY: Lesley 1976, cat. no. 39, p. 31 (ill.)

NOTE: The sheen-obsidian owl can be dated by
the imprint on the fitted case between 1914 (the
year St. Petersburg became Petrograd) and 1917.
It looks virtually identical to a drawing of an owl
sold by Denisov-Ural'skii to Cartier in 1911, illus-
trated as no. 1209 in the French firm's acquisition
ledger *Animaux* (see Chapter 4, p. 75, ill. 4.12).
It is described there as *hibou obsidienne rosée yeux
oeuil de tigre* (pink obsidian owl with tiger eyes),
which might bolster the assumption that Denisov,
Fabergé's neighbor on Bol'shaia Morskaia, also
supplied Fabergé at a time when his stone-carving
facility had difficulty in keeping up with orders
(see Chapter 3).
BEQUEST OF LILLIAN THOMAS PRATT, 47.20.265

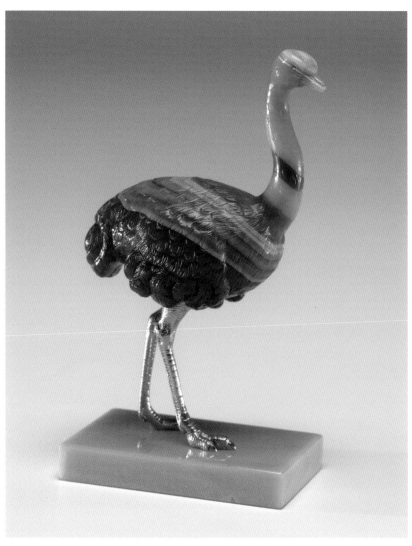

98

97 Heron

Agate, diamonds, gold

The caricatured bird of grayish agate has diamond eyes, short gold legs, and webbed gold feet.

MARKS: *Fabergé*, initials of workmaster Henrik Wigström, 72 zolotnik
DIMENSIONS: 4½ in. (11.4 cm)
PROVENANCE: Hammer Galleries, #VD 5399/5, March 2, 1939, $950 (from the "collection of Tsar Nikolai II in the Aleksandr Palace, Tsarskoye Selo"); Lillian Thomas Pratt
EXHIBITED: NCMA 1979
BIBLIOGRAPHY: Hammer Galleries catalogue 1940?; Lesley 1976, cat. no. 31, p. 31, p. 26 (ill.)

NOTE: This is an authentic Fabergé animal; the Fabergé marks were possibly added later.

98 Ostrich

Agate, demantoid garnets, gold, quartzite

The banded brown-and-white agate bird has green eyes, red-gold legs and feet, and poses on a honey-colored quartzite base.

UNMARKED
DIMENSIONS: 4⅝ in. (11.7 cm)
PROVENANCE: Hammer Galleries, #5409/25, June 1, 1939 ("It was created by Carl Fabergé, world famous jeweler to the Imperial family of Russia, court jeweler and designer in precious substances to nearly all the royal houses of Europe and Asia."); Lillian Thomas Pratt
EXHIBITED: NCMA 1979; ALVR 1983
BIBLIOGRAPHY: Lesley 1976, cat. no. 35, p. 31, p. 29 (ill.); ALVR 1983, cat. no. 435, pp. 118–19 (ill.)
NOTE: Another Fabergé ostrich, which is in the collection of Queen Elizabeth II, can be seen in Guitaut 2003.

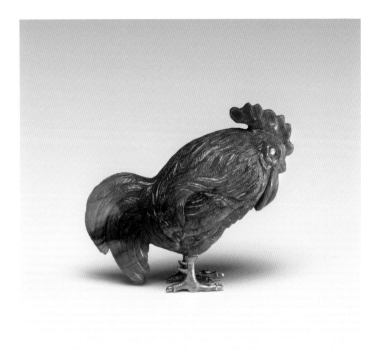

99 enlarged

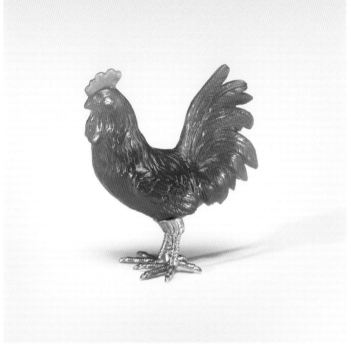

100 enlarged

99 Rooster

Agate, gold, diamonds

The Rhode Island rooster is of reddish-brown agate and has rose-cut diamond eyes and gold feet.

UNMARKED

DIMENSIONS: 1¼ in. (3.2 cm)

PROVENANCE: Hammer Galleries, September 25, 1939 ("Designed by the celebrated court jeweler to Nikolai II, Carl Fabergé, and was executed by his talented young sculptor, Kremlev"); Lillian Thomas Pratt

EXHIBITED: VMFA 1983

BIBLIOGRAPHY: Lesley 1976, cat. no. 44, p. 31, p. 35 (ill.)

BEQUEST OF LILLIAN THOMAS PRATT, 47.20.266

100 Rooster

Carnelian, diamonds, gold

The red carnelian cockerel has rose-cut diamond eyes and gold feet.

UNMARKED

DIMENSIONS: 1½ in. (3.9 cm)

PROVENANCE: Russian Imperial Treasures Inc. "The Schaffer Collection" of Russian Imperial Art, #2325, May 1, 1940, $210; Lillian Thomas Pratt

EXHIBITED: VMFA 1983

BIBLIOGRAPHY: Lesley 1976, cat. no. 45, p. 35 (ill.)

BEQUEST OF LILLIAN THOMAS PRATT, 47.20.267

101 Eagle

Agate, gold, diamonds

The finely carved red- and honey-colored eagle has rose-cut diamond eyes and gold feet.

MARKS: Initials of workmaster Henrik Wigström, assay mark of St. Petersburg 1899–1908, 72 zolotnik

DIMENSIONS: 1¾ in. (4.5 cm)

PROVENANCE: Russian Imperial Treasures Inc. "The Schaffer Collection," February 1, 1940, #2323, $750; Lillian Thomas Pratt

EXHIBITED: VMFA 1983; FA 1996

BIBLIOGRAPHY: Lesley 1976, cat. no. 27, p. 124 (ill.); Habsburg 1996, cat. no. 118, p. 139 (ill.)

BEQUEST OF LILLIAN THOMAS PRATT, 47.20.257

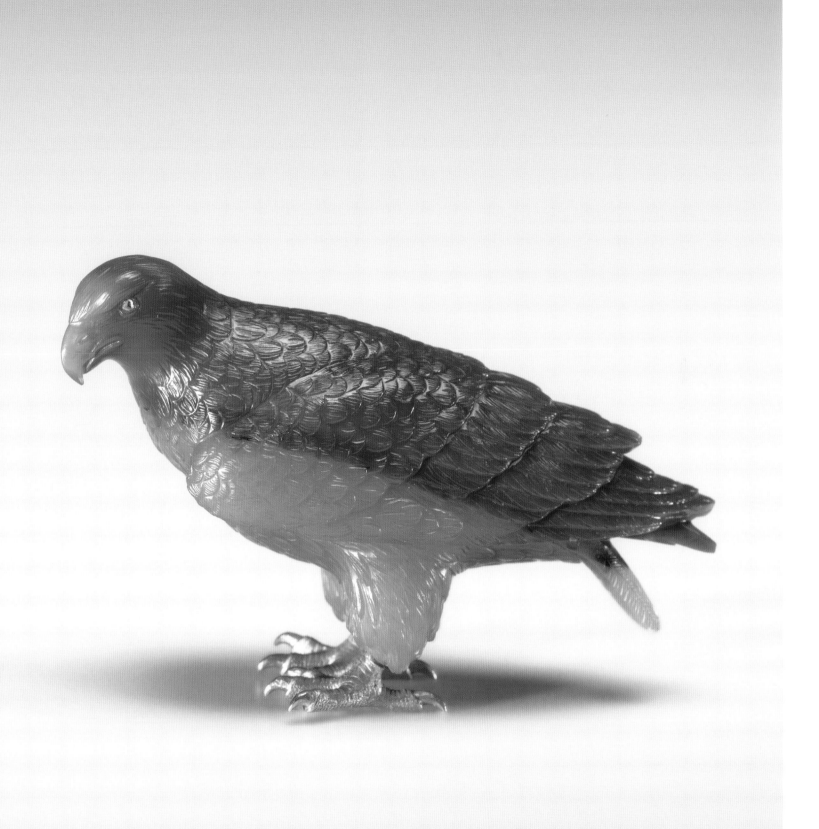

102

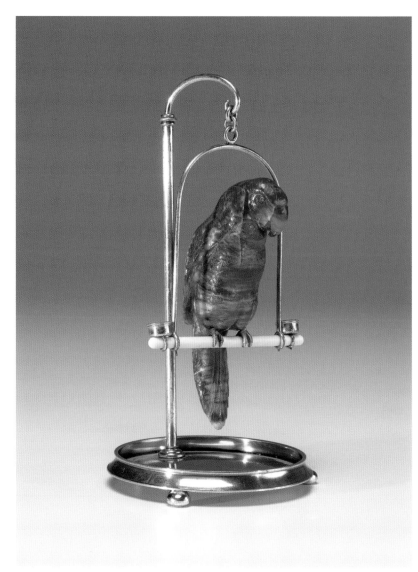

103 reduced

102 Parrot in a Cage

Agate, aventurine quartz, rubies, gold

The pinkish-agate parrot with ruby eyes is seated on a crossbar with two feeding cups. The cage has gold bars and stands on a circular base of aventurine quartz.

MARKS: *Fabergé*, initials of workmaster Mikhail Perkhin, assay mark of St. Petersburg before 1899, 56 zolotnik

DIMENSIONS: 4½ in. (11.5 cm)

PROVENANCE: Lillian Thomas Pratt

BIBLIOGRAPHY: Lesley 1976, cat. no. 42, p. 35, p. 34 (ill.)

NOTE: Parrots were favorite pets in Russia. At least a dozen such Fabergé compositions have survived—single birds or two birds in different sizes and of varying hardstones (see Snowman 1962; Christie's Geneva sale catalogue, November 17, 1981).

BEQUEST OF LILLIAN THOMAS PRATT, 47.20.210

103 Parrot on a Perch

Carnelian onyx, silver gilt, ivory, peridots

The large, mottled, reddish-agate parrot with peridot eyes is seated on a silver-gilt perch. The crossbar with ivory terminals has two feeding cups containing silver-gilt seeds. Three stud feet support the circular silver-gilt tray.

MARKS: *Fabergé*, initials of workmaster Henrik Wigström, assay mark of St. Petersburg, 1899–1908, 88 zolotnik, inventory number 11966

DIMENSIONS: 7¾ in. (19.7 cm)

Original fitted case lining stamped with imperial warrant, St. Petersburg, Moscow, London

PROVENANCE: Russian Imperial Treasures Inc. "The Schaffer Collection" #1364, October 2, 1939, $1,500; Lillian Thomas Pratt

BIBLIOGRAPHY: Lesley 1976, cat. no. 40, p. 35, p. 32 (ill.)

NOTE: A number of such Fabergé parrots on perches have survived. For an example in the India Early Minshall Collection of the Cleveland Museum of Art, see Hawley 1967. Two other examples were sold at Christie's Geneva, April 28, 1976, lot 154; and November 18, 1980, lot 137.

BEQUEST OF LILLIAN THOMAS PRATT, 47.20.208

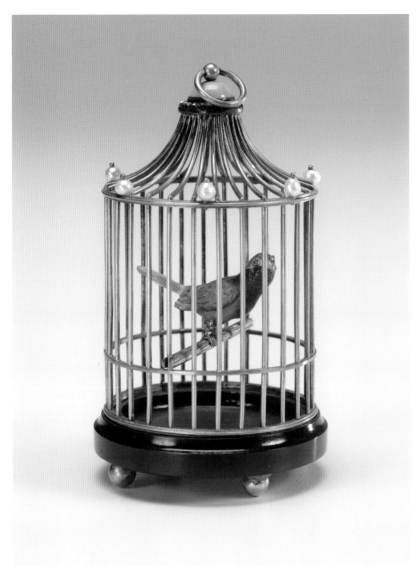

104

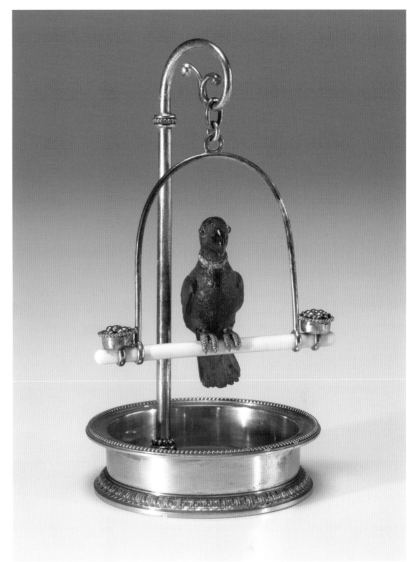

105 reduced

104 Songbird in a Cage

Gold, fluorite, pearls, turquoise

The green fluorite songbird is seated on a crossbar in a circular gold cage. A pearl is surmounted between each fourth bar, and the "roof" rises up to meet a cabochon turquoise. The nephrite plinth stands on four gold stud feet.

MARKS: *Fabergé*, initials of workmaster Henrik Wigström, 72 zolotnik
DIMENSIONS: 4 ¼ in. (10.8 cm)
PROVENANCE: Hammer Galleries, #RH 5408-17, February 4, 1939; Lillian Thomas Pratt
BIBLIOGRAPHY: Lesley 1976, cat. no. 24, p. 24 (ill.)
NOTE: The bird is probably a replacement.
BEQUEST OF LILLIAN THOMAS PRATT, 47.20.207

105 Parrot on a Perch

Tourmaline, emeralds, diamonds, ivory, silver gilt

The pink-and green-tourmaline bird with emerald eyes and a rose-cut diamond collar is seated on an ivory crossbar with a feeding cup at each end. The crossbar is suspended from a hook attached to a silver tray that is decorated with stylized-leaf and gadrooned borders.

MARKS: *Fabergé*, initials of workmaster Antti Nevalainen, assay mark of St. Petersburg, 1899–1908, separate imperial warrant mark, 88 zolotnik
DIMENSIONS: 5 ¾ in. (14.6 cm)
PROVENANCE: Russian Imperial Treasures Inc. "The Schaffer Collection" #2278, April 1, 1939, $1,200; Lillian Thomas Pratt
BIBLIOGRAPHY: Lesley 1976, cat. no. 41, p. 35, p. 32 (ill.)
NOTE: The bird is probably a replacement. Compare with cat. no. 103.
BEQUEST OF LILLIAN THOMAS PRATT, 47.20.209

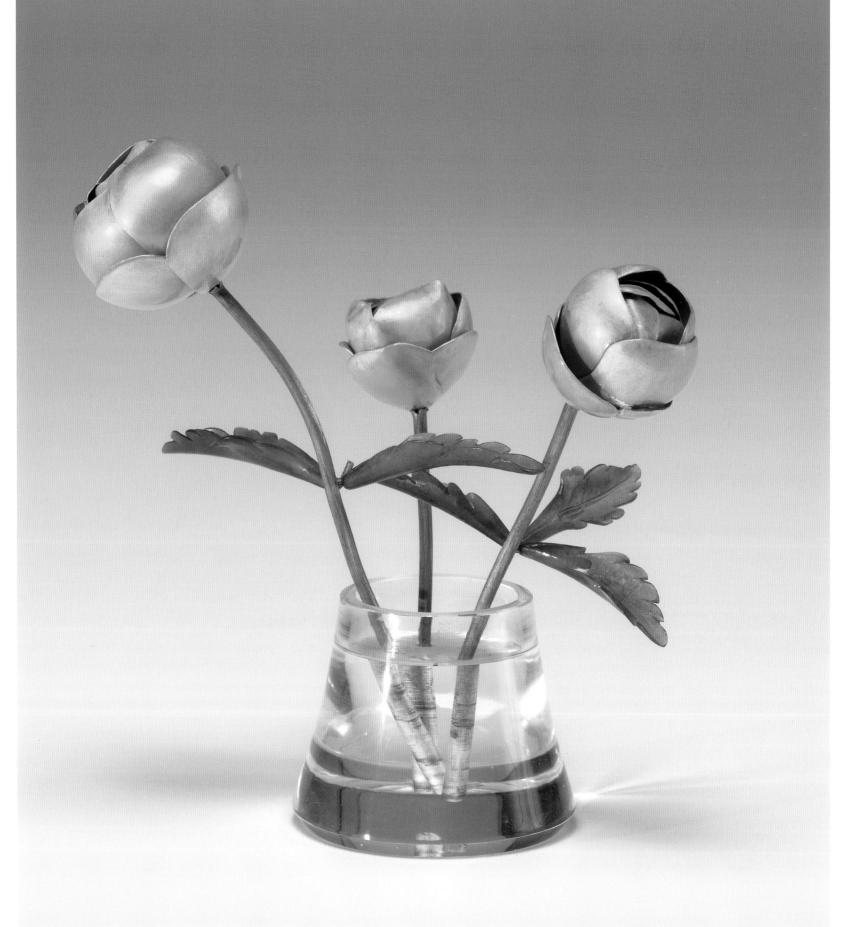

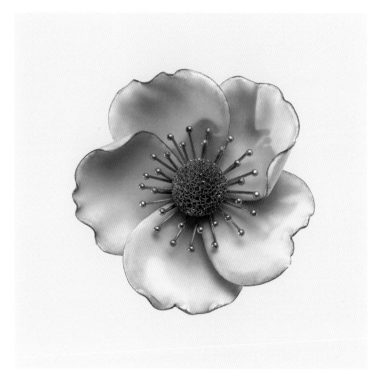

107 enlarged

Flowers

106 Globeflowers

Gold, enamel, nephrite, rock crystal

The three sprays with bulbous buds enameled in yellow have serrate leaves and stand in a conical rock-crystal vase.

MARKS: Imperial warrant mark of K. Fabergé
DIMENSIONS: 5 in. (12.7 cm)
PROVENANCE: Lillian Thomas Pratt
BIBLIOGRAPHY: Lesley 1976, cat. no. 141, p. 63, p. 64 (ill.)
NOTE: The globeflower (*Trollius europaeus*), or buttercup, is a rare product of Fabergé's Moscow workshop run by Gustav Jahr (see Chapter 4, pp. 63–67). A single globeflower, formerly in the Robert Strauss Collection, is in the Stockholm National Gallery (see Sweezey 2004). Another is illustrated in an original Fabergé photograph album in the Fersman Mineralogical Museum in Moscow (Ivanov 2002).
BEQUEST OF LILLIAN THOMAS PRATT, 47.20.233

107 Wild Rose Brooch

Gold, enamel

The rose blossom of opalescent-pink enamel has a gold spongelike ovary and gold ball-tipped stamens.

UNMARKED
DIMENSIONS: D 1½ in. (2.8 cm)
PROVENANCE: Lillian Thomas Pratt
EXHIBITED: VMFA 1983
BIBLIOGRAPHY: Lesley 1976, cat. no. 271, p. 134 (ill.)
NOTE: An unmarked wild-rose spray with a similar bloom is in the India Early Minshall Collection at the Cleveland Museum of Art (Hawley 1967). Compare also the two very similar unmarked wild-rose sprays in the collection of Queen Elizabeth II (see Guitaut 2003). For a revealing close-up image, see Sweezey 2004.
BEQUEST OF LILLIAN THOMAS PRATT, 47.20.144

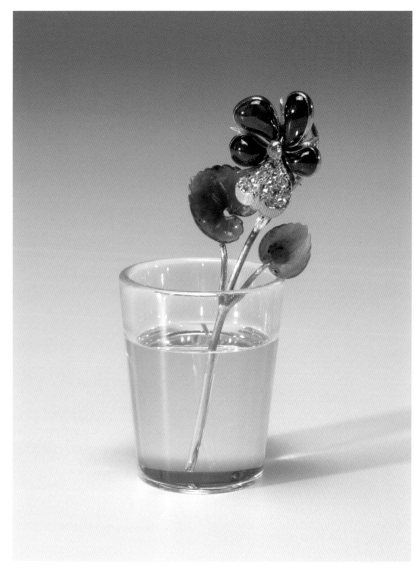

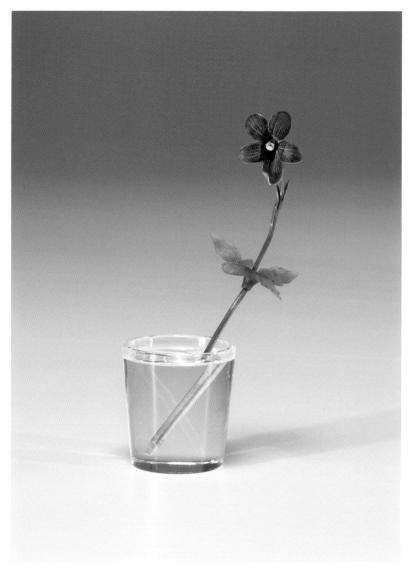

108

109

108 Pansy

Agate, nephrite, rock crystal, sapphires, diamonds, enamel

The stylized flower has a blossom comprised of four large cabochon sapphires, a petal of yellow guilloché enamel studded with rose-cut diamonds centering on diamond, a gold stem, and two carved nephrite leaves. It stands in a tapering cylindrical rock-crystal vase.

MARKS: Scratched inventory number 46978
DIMENSIONS: 3 ⅞ in. (9.9 cm)
PROVENANCE: Lillian Thomas Pratt
BIBLIOGRAPHY: Lesley 1976, cat. no. 156, p. 71, p. 70 (ill.)
NOTE: The quality of craftsmanship, the originality of design, and the scratched inventory number point toward the authorship by Fabergé.
BEQUEST OF LILLIAN THOMAS PRATT, 47.20.236

109 Violet

Gold, enamel, diamond, nephrite, rock crystal

The single violet with five mat-enameled purple petals centering on a diamond, a gold stem, and two jagged leaves stands at an angle in a cylindrical rock-crystal vase.

MARKS: London import mark of 1908
DIMENSIONS: 3 ½ in. (8.9 cm)
Original fitted case lining stamped with gilt imperial warrant, St. Petersburg, Moscow
PROVENANCE: Hammer Galleries #5756-19, December, 4, 1940, $500 ("Made by Karl Fabergé, and in the master's best style."); Lillian Thomas Pratt
BIBLIOGRAPHY: Lesley 1976, cat. no. 157, p. 71, p. 70 (ill.)
EXHIBITED: VMFA 1983
NOTE: A similar single violet spray is in the India Early Minshall Collection at the Cleveland Museum of Art (see Sweezey 2004); four violet sprays in a vase were with ALVR (see Sweezey 2004).
BEQUEST OF LILLIAN THOMAS PRATT, 47.20.238

110 Lilies of the Valley

Nephrite, gold, pearls, diamonds, bloodstone

Five sprays of lilies of the valley with pearl buds bordered in rose-cut diamonds encased in five veined nephrite leaves stand in a bloodstone vase.

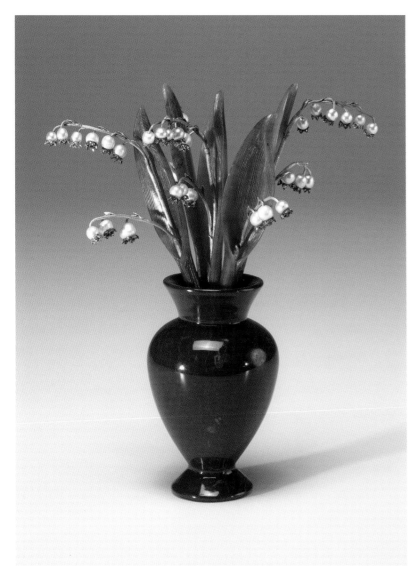

110 reduced

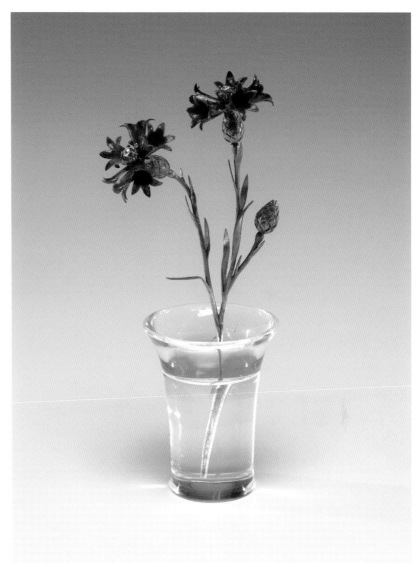

111 reduced

MARKS: Engraved (later) *Fabergé* under the vase
DIMENSIONS: 7 ½ in. (19 cm)
PROVENANCE: Lillian Thomas Pratt
BIBLIOGRAPHY: Lesley 1976, cat. no. 146, p. 67, p. 66 (ill.); Sweezey 2004, p. 59 (ill.)
NOTE: The quality of the pearl blooms with their rose-cut diamond borders as well as of the carved nephrite leaves is similar to those of other generally accepted Fabergé lily-of-the-valley sprays. The *Lilies of the Valley Basket* in the Matilda Geddings Gray Foundation Collection has multiple similar sprays (See Chapter 1, p. 11).
BEQUEST OF LILLIAN THOMAS PRATT, 47.20.237

111 Cornflowers

Gold, enamel, diamonds, rock crystal

The blue-enamel flower is a double spray with two translucent gold blossoms, gold stamens and pistils set with rose-cut diamonds, and chased-gold buds, stems, and leaves. It stands at an angle in a tapering rock-crystal vase.

UNMARKED
DIMENSIONS: 5 ¾ in. (14.6 cm)
PROVENANCE: Hammer Galleries, #5547, June 21, 1935; Lillian Thomas Pratt
BIBLIOGRAPHY: Lesley 1976, cat. no. 139, p. 63, p. 62 (ill.); Curry 1995, cat. no. 32, pp. 99, 110 (ill.)
EXHIBITED: VMFA 1983; *FA* 1996 (VMFA only)
NOTE: A number of very similar versions of this obviously popular flower have survived. They vary from single sprays (Christie's Geneva, November 9, 1977, lot 219) to triple sprays (Christie's Geneva, November 18, 1980, lot 103) to examples of cornflowers combined with sprays of oats (the Royal Collection and the State Hermitage Museum; see Habsburg 1986 and Guitaut 2003). A multiple cornflower spray in an Art Nouveau glass vase is in the Matilda Geddings Gray Foundation Collection (see Keefe 2008).

BEQUEST OF LILLIAN THOMAS PRATT, 47.20.222

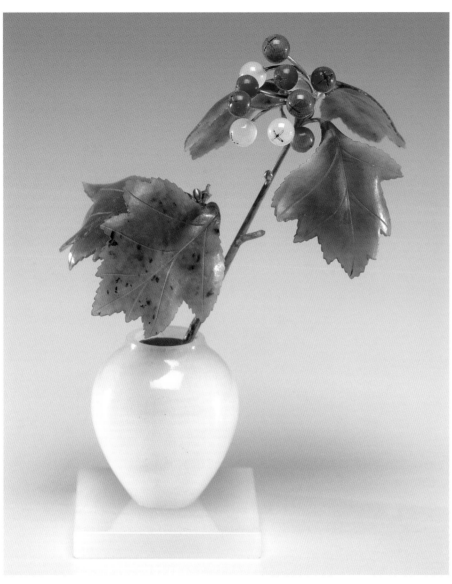

112

112 English Hawthorn

Nephrite, agate, gold

The plant with white- and red-dyed berries, five carved-nephrite leaves (one missing), and a gold stem is planted in gold "earth" in a vase of agate on an agate plinth.

MARKS: *Fabergé, H. W.,* 72
DIMENSIONS: 5 ½ in. (14 cm)
PROVENANCE: Hammer Galleries, #RH 5380/3, February 17, 1939, $1,450 (from the "collection of a member of the Imperial Family"); Lillian Thomas Pratt
EXHIBITED: VMFA 1983; *FA* 1996 (VMFA only)
BIBLIOGRAPHY: Hammer Galleries catalogue 1940?; Lesley 1976, cat. no. 142, p. 63. p. 64 (ill.); Curry 1995, cat. no. 24, p. 109, p. 94 (ill.)
NOTE: Several versions of this plant exist, all very similar if not identical. They have all hitherto been considered genuine. For an identical plant in its original fitted case, see Christie's Geneva, November 11, 1975, lot 263. Another plant with the same Hammer provenance and an identical signature is in the Matilda Geddings Gray Foundation Collection (Keefe 2008). This leads one to think that at best these hawthorns were replicated a number of times by Fabergé and that perhaps the forged hallmarks were added later.
BEQUEST OF LILLIAN THOMAS PRATT, 47.20.228

113 Dandelion

Nephrite, rock crystal, gold, diamonds, asbestos fiber

The seed ball is formed of platinum wires with rose-cut-diamond terminals, around each of which is entwined a tuft of asbestos filaments. The stem is gold, the leaves are nephrite, and it stands in a faceted rock-crystal vase.

MARKS: *Fabergé, H. W.*, 72
DIMENSIONS: 6½ in. (16.5 cm)
PROVENANCE: Hammer Galleries, #RH 5380/2, January 31, 1939 (from the "collection of a member of the Imperial Family"); Lillian Thomas Pratt
EXHIBITED: VMFA 1983; *FA* 1996/97 (VMFA only)
BIBLIOGRAPHY: Lesley 1976, cat. no. 140, p. 63, p. 62 (ill.); Curry 1995, cat. no. 21, p. 109, pp. 44, 105 (ill.)
NOTE: Numerous examples of this plant with their original fitted cases are known; some are genuine and unmarked (see Sweezey 2004; Christie's Geneva, November 11, 1975, lot 262; and Habsburg 1996). Others, although hallmarked, are less certain (Christie's Sale, Geneva, November 11, 1972; Sweezey 2004; Keefe, 2008). This flower appears to be the one advertised by the Hammer Galleries (in 1940?) at $1,600.
BEQUEST OF LILLIAN THOMAS PRATT, 47.20.235

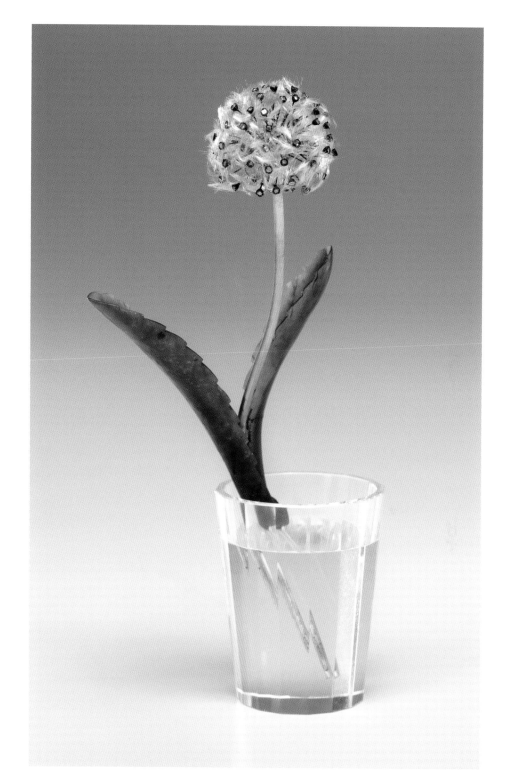

113

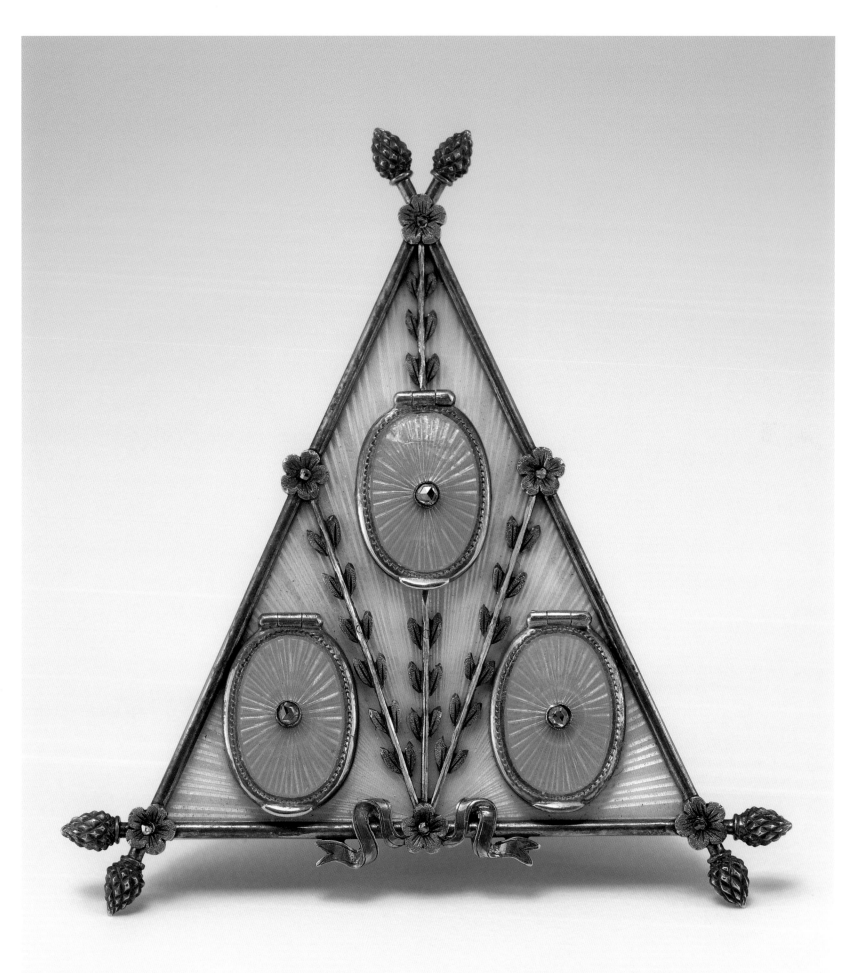

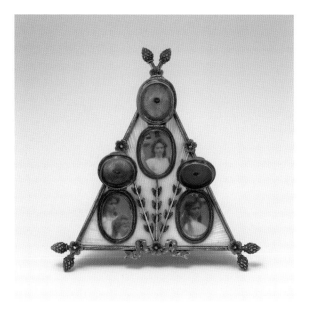

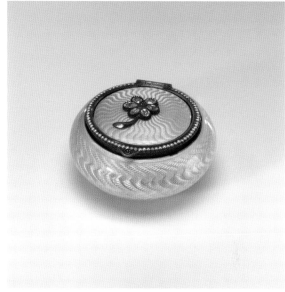

114

115 enlarged

Enamels: Moscow

114 Triple Frame

Red, yellow, and green gold; enamel; diamonds; glass; ivory

The triangular frame is of translucent opalescent-white enamel over a sunray guilloché ground. Three miniatures are concealed under hinged oval covers of pink sunray guilloché enamel set with rose-cut diamonds. The outer border is formed of three maenad's staffs intersecting at the angles, two of which form the frame's feet. The frame is applied with three straight laurel sprays issuing from a tied ribbon. The three original photographs are of Grand Duchesses Olga (above), Anastasia (left), and Maria (right).

MARKS: Initials *K. F.* for Karl Fabergé, assay mark of Moscow 1899–1908, assay master Ivan Lebedkin, 56 zolotnik
DIMENSIONS: 2 ½ in. (6.4 cm)
PROVENANCE: Russian Imperial Treasures. "The Schaffer Collection"; Lillian Thomas Pratt
EXHIBITED: VMFA 1983; ALVR 1983; *FA* 1996
BIBLIOGRAPHY: Lesley 1976, cat. no. 188. p. 91, p. 89 (ill.); ALVR 1983, p. 48, pl. 45; Curry 1995, cat. no. 38, pp. 112, 117 (ill.); Habsburg 1996, cat. no. 148, p. 156 (ill.)
NOTE: The concept of frames with miniatures concealed under flaps was first used by Fabergé in the 1899 *Imperial Pansy Egg* (see Fabergé, Proler, and Skurlov 1997). It also appears in another Moscow-made circular frame with three (empty) apertures in the Woolf Family Collection (Habsburg and Lopato 1993).
BEQUEST OF LILLIAN THOMAS PRATT, 47.20.347

115 Bonbonnière

Silver gilt, enamel, diamonds, rubies

The cover of the yellow guilloché enamel bonbonnière is applied with a rosette set with six rose-cut diamonds.

MARKS: Imperial warrant of K. Fabergé, assay mark of Moscow 1899–1908, 88 zolotnik, scratched inventory number 17239
DIMENSIONS: D 1⅝ in. (4.1 cm)
PROVENANCE: Russian Imperial Treasures. "The Schaffer Collection," #1591, n.d., $300; Lillian Thomas Pratt
EXHIBITED: VMFA 1983; *FA* 1996
BIBLIOGRAPHY: Lesley 1976, cat. no. 295, p. 147, p. 144 (ill.); Curry 1995, cat. no. 9, pp. 5, 109 (ill.)
BEQUEST OF LILLIAN THOMAS PRATT, 47.20.279

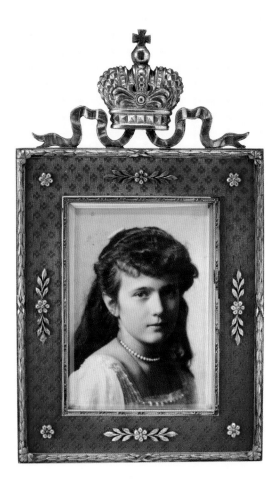

116

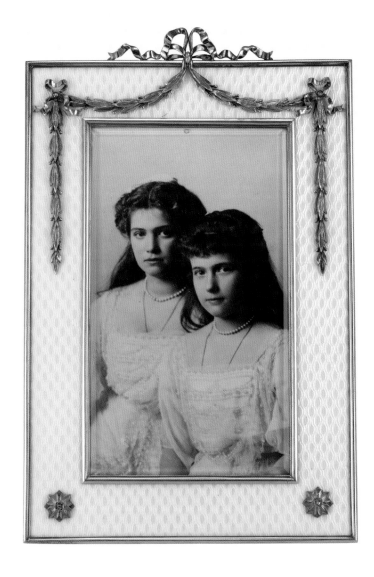

117

116 Frame

Silver gilt, gold, enamel, ivory

The frame of translucent dark-red enamel over a ground of stamped rosettes applied with gold rosettes and flower sprays has an inner dot-and-dash border, an outer border with bands of husks tied with ribbons, and an *A*-shaped strut. The photograph of Grand Duchess Anastasia and the crown were added later.

MARKS: Imperial warrant mark of K. Fabergé, assay mark of Moscow 1899–1908, 88 zolotnik, scratched inventory number 30075
DIMENSIONS: 4 ½ in. (11.4 cm)
PROVENANCE: Lillian Thomas Pratt
EXHIBITED: VMFA 1983
BIBLIOGRAPHY: Lesley 1976, cat. no. 181, p. 87, 86 (ill.)
BEQUEST OF LILLIAN THOMAS PRATT, 47.20.317

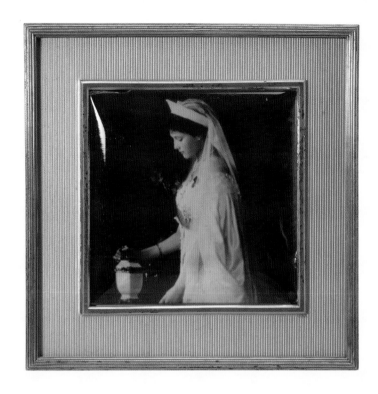

118

117 Frame

Gold, enamel, diamonds, ivory

The pale-blue guilloché enamel frame is applied with chased green-gold laurel festoons suspended from bowknots set with rose-cut diamonds. Diamond-set rosettes are applied at the lower corners. The reproduction photograph of Grand Duchesses Maria and Anastasia was added later.

MARKS: Imperial warrant mark of Fabergé, assay mark of Moscow 1899–1908, 56 zolotnik, scratched inventory number 54522
DIMENSIONS: 5 ½ in. (14 cm)
PROVENANCE: Lillian Thomas Pratt
EXHIBITED: VMFA 1983
BIBLIOGRAPHY: Lesley 1976, cat. no. 159, p. 77 (ill.)
BEQUEST OF LILLIAN THOMAS PRATT, 47.20.311

118 Frame

Silver gilt, enamel, glass, wood

The square frame of translucent pale-blue enamel over a reeded guilloché ground has a square aperture with a plain inner and ribbed outer border. The photograph of Grand Duchess Tatiana is a later addition.

MARKS: Imperial warrant mark of K. Fabergé, assay mark of Moscow 1908–17, 84 zolotnik
DIMENSIONS: 3 ⅝ in. (9.2 cm)
PROVENANCE: Lillian Thomas Pratt
EXHIBITED: PFAC 1981; VMFA 1983
BIBLIOGRAPHY: Lesley 1976, cat. no. 162, p. 77, p. 76 (ill.)
BEQUEST OF LILLIAN THOMAS PRATT, 47.20.332

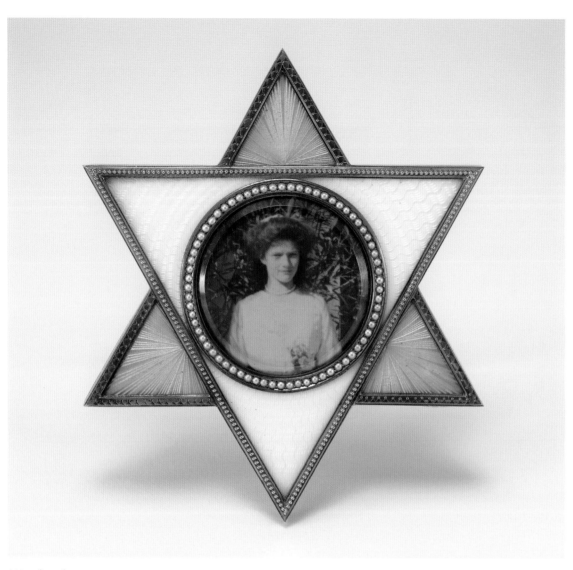

119 enlarged

Enamels: Mikhail Perkhin

119 Star Frame

Gold, enamel, pearls, glass, ivory

The frame is shaped as a six-pointed star formed of two superimposed triangles, one of opalescent-white sunray guilloché enamel with a gadrooned border, the other of yellow sunray guilloché enamel with a pointed scallop border. The circular bezel is set with seed pearls and contains an original photograph of Grand Duchess Tatiana.

MARKS: *Fabergé*, initials of workmaster Mikhail Perkhin, assay mark of St. Petersburg before 1899, 56 zolotnik, scratched inventory number 55135
DIMENSIONS: D 3 ⁵⁄₁₆ in. (7.7 cm)
PROVENANCE: Acquired jointly by Tsar Nicholas II and Tsaritsa Alexandra Feodorovna on December 3, 1896 ("Frame, star, with enamel and pearls"), invoiced separately, the empress's invoice in German, each invoice for 60 rubles; Hammer Galleries 1934, $375 ("inventory tag of the Alexander Palace Museum, #1487, list 104"); Lillian Thomas Pratt
EXHIBITED: VMFA 1983; FA 1996

BIBLIOGRAPHY: Hammer Galleries, catalogue 1934; Lesley 1976, cat. no. 195, p. 95, p. 93 (ill.); Habsburg 1996, cat. no. 137, p. 149 (ill.)
NOTE: A similar star-shaped frame is listed and illustrated as a pencil drawing among the objects inventoried at the Alexander Palace between 1917 and 1918, with a corresponding drawing and description that reads: "Frame, gold, shaped as two superimposed triangles with portrait of The Heir" (see Solodkoff 1995, p. 24) See next page for the history of this piece.
BEQUEST OF LILLIAN THOMAS PRATT, 47.20.352

A Silent Witness
The Hidden History of a Fabergé Frame

Lillian Thomas Pratt was fascinated by the Russian imperial family's patronage of Fabergé and the role the firm's work played in their lives. Her collecting focused on acquiring items with imperial provenances, and she was particularly fond of Fabergé photograph frames containing images of the tsar's children. Recent research has revealed that a frame in the Pratt collection has a hitherto hidden history that intimately links it to the Romanov family's tragic fate.

This most unusual frame is made from yellow gold in the form of a star and applied with silklike yellow-and-white enamels. It is centered with an aperture encircled by pearls and holds a faded sepia photograph of Grand Duchess Tatiana, the tsar's second daughter. The frame was bought from Fabergé by the tsar and tsaritsa on December 3, 1896, for the considerable sum of 120 rubles. Their choice of a star-shaped frame was significant: Fabergé frames of this type are rare, and its stellar form reflects the high esteem in which they held their daughter.

The tsar was emperor and autocrat of an empire reaching from the Pacific Ocean to the Baltic Sea, a dominion on which the sun never set. However, by 1917 his authority was waning and his grip on power had become precarious. In March of 1917, riots broke out on the streets of Petrograd and the rage of the mob, spurred by hunger and agitators, forced him to abdicate.

After the abdication, conditions for the imperial family worsened dramatically. Initially they were placed under house arrest in the Alexander Palace, but in August of 1917, the family was evacuated eastward to Toblosk in order to protect them from a surge in revolutionary activity. When the Bolsheviks seized power in October of 1917, talk grew of executing the family. In April of 1918 they were imprisoned within the grimly named "House of Special Purpose" in the Siberian town of Ekaterinburg. There they filled listless days playing bezique, attending masses, and praying for rescue. On July 26, their Soviet captors, alarmed by the approach of counter-revolutionaries, herded the family into the basement of the house and murdered them.

Following their deaths, Iakov Iurovskii, the commandant of the executioners, meticulously recorded the family's possessions. His inventories reveal that Pratt's star-shaped frame was inside the house when the family was shot. It was described by Iurovskii as a "Gold frame, star-shaped with white and yellow enamel" (Alexseev 1996). As every work by Fabergé is unique, the frame is undoubtedly the one acquired by Mrs. Pratt.

The inclusion of the frame on Iurovskii's list identifies it as one of the tsar and tsaritsa's most cherished possessions. As the revolution shunted them from location to location and stripped them of their privileges, they kept it with them as a memory of happier times. Many of the Fabergé pieces in the Pratt collection celebrated the joyous moments of the life of the imperial family. This frame, a silent witness to their deaths, demonstrates that Fabergé's work was also with them at their last and darkest moment.

—Kieran McCarthy

119 Detail of Grand Duchess Tatiana

120 reduced

121 enlarged

120 Frame

Silver gilt, enamel, pearls, rock crystal

The frame is of translucent pale-mauve enamel on a concentric engine-turned ground. The oval aperture has a beaded border and is covered with a rock-crystal plaque. The outer border is chased with husk. The photograph of the tsar with his son Aleksei was added later.

MARKS: *Fabergé*, initials of workmaster Mikhail Perkhin, assay mark of St. Petersburg before 1899, 88 zolotnik, scratched inventory number 57700
DIMENSIONS: 4⅝ in. (11.7 cm)
PROVENANCE: Hammer Galleries, #RH 1698-100, January 9, 1940 (from the "apartments of the Tsarina Aleksandra Feodorovna, wife of Nikolai II, in the Aleksandr Palace, Tsarskoye Selo"); Lillian Thomas Pratt
EXHIBITED: VMFA 1983
BIBLIOGRAPHY: Lesley 1976, cat. no. 173, p. 83, p. 82 (ill.)
BEQUEST OF LILLIAN THOMAS PRATT, 47.20.309

121 Frame

Gold, enamel, pearls, ivory, glass

The royal-blue guilloché enamel frame has an inner beaded border and an outer palm-leaf border. The photograph of the tsesarevich is a later addition.

MARKS: *Fabergé*, initials of workmaster Mikhail Perkhin, assay mark of St. Petersburg before 1899, 56 zolotnik, scratched inventory number 58898
DIMENSIONS: 3⅛ in. (3 cm)
PROVENANCE: Hammer Galleries #5808-1, December 4, 1940; Lillian Thomas Pratt
EXHIBITED: VMFA 1983
BIBLIOGRAPHY: Lesley 1976, cat. no. 161, p. 77, p. 75 (ill.)
BEQUEST OF LILLIAN THOMAS PRATT, 47.20.321

122

123

122 Frame

Gold, enamel, ivory, glass

The frame is decorated in steel-gray moiré guilloché enamel, applied with scroll, staff, and cartouche motifs, and has an inner bead-and-dart border and ovolo outer border. It contains a photograph (added later) of a pastel portrait of Grand Duchess Olga by Friedrich von Kaulbach that hung in her mother's Mauve Room in the Alexander Palace.

MARKS: *Fabergé*, early initials of workmaster Mikhail Perkhin, assay mark of St. Petersburg before 1899, 56 zolotnik, scratched inventory number 45843
DIMENSIONS: 3 ½ in. (8.9 cm)
PROVENANCE: Russian Imperial Treasures. "The Schaffer Collection," 1945?; Lillian Thomas Pratt
EXHIBITED: VMFA 1983; *FA* 1996
BIBLIOGRAPHY: Lesley 1976, cat. no. 160, p. 77, p. 75 (ill.); Habsburg 1996, cat. no. 141, p. 151 (ill.)
BEQUEST OF LILLIAN THOMAS PRATT, 47.20.318

123 Frame

Silver gilt, enamel, pearls, ivory

The upright rectangular frame of burnt-orange moiré guilloché enamel is applied on either side of the aperture with intertwined laurel sprays; crossed arrows and laurel wreaths are fashioned above and below. It also has a palm-leaf inner border, a reed-and-tie outer border, and a strut forming the letter *O*. The reproduction photograph of Grand Duchess Tatiana was added later.

MARKS: *Fabergé*, initials of workmaster Mikhail Perkhin, assay mark of St. Petersburg before 1899, 88 zolotnik
DIMENSIONS: 3 ½ in. (8.9 cm)
PROVENANCE: Lillian Thomas Pratt
EXHIBITED: VMFA 1983
BIBLIOGRAPHY: Lesley 1976, cat. no. 177, p. 83, p. 84 (ill.)
BEQUEST OF LILLIAN THOMAS PRATT, 47.20.315

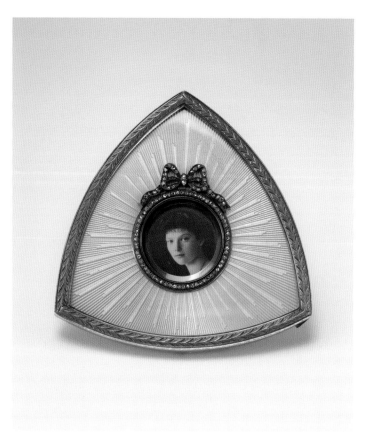

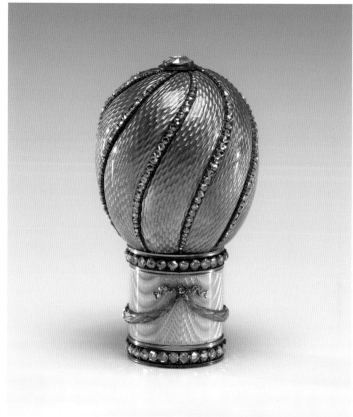

124 enlarged 125

124 Frame

Gold, enamel, diamonds, glass, ivory

The triangular frame has convex sides with palm-leaf borders and pale-blue translucent enamel decoration over a sunray guilloché ground. Its circular bezel is set with rose-cut diamonds and surmounted by a diamond-set bowknot. The reproduction photograph of Grand Duchess Maria is a later addition.

MARKS: *Fabergé*, initials of workmaster Mikhail Perkhin, assay mark of St. Petersburg before 1899, 56 zolotnik, scratched inventory number 54500

DIMENSIONS: 2⅝ in. (6.7 cm)

PROVENANCE: Russian Imperial Treasures. "The Schaffer Collection" (from the "Alexander Palace, Tsarskoe Selo"); Lillian Thomas Pratt

EXHIBITED: VMFA 1983; FA 1996

BIBLIOGRAPHY: Lesley 1976, cat. no. 167, p. 81, p. 78 (ill.); Habsburg 1996, cat. no. 145, p. 154 (ill.)

BEQUEST OF LILLIAN THOMAS PRATT, 47.20.349

125 Cane Handle

Gold, enamel, diamonds

The egg-shaped handle of mauve guilloché enamel is applied with swirling bands set with rose-cut diamonds. Its ferrule is of yellow moiré guilloché enamel applied with laurel swags of green- and red-gold suspended from diamonds. The borders are set with rose-cut diamonds.

MARKS: Initials of workmaster Mikhail Perkhin, assay mark of St. Petersburg before 1899, 56 zolotnik

DIMENSIONS: 3 in. (7.6 cm)

PROVENANCE: Hammer Galleries, December 6, 1939 (from the "collection of Prince Aleksandr Romanovski, Duke of Leuchtenberg"); Lillian Thomas Pratt

EXHIBITED: VMFA 1983; ALVR 1983; FA 1996

BIBLIOGRAPHY: Lesley 1976, cat. no. 213, p. 105 (ill.); ALVR 1983, cat. no. 226, p. 82, p. 81 (ill.) Curry 1995, cat. no. 16, pp. 32, 109 (ill.); Habsburg 1996, cat. no. 132, p. 146 (ill.)

BEQUEST OF LILLIAN THOMAS PRATT, 47.20.172

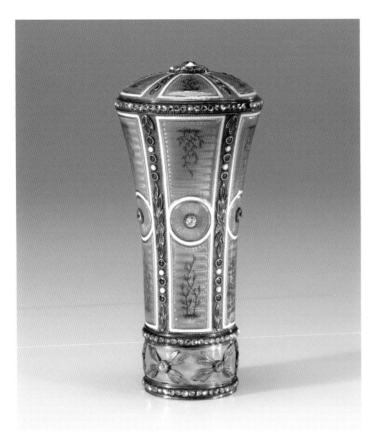

126

127 reduced

126 Parasol Handle

Bowenite, gold, diamonds, pearls, enamel

The tapering, pentagonal parasol handle
has panels of pink guilloché enamel painted
with dendritic motifs within opaque-white
enamel borders. A diamond is centered
on each panel and Louis XVI–style floral
decorations are set between the panels.
Atop the handle is a brilliant-cut diamond
finial in a rose-cut diamond surround with
diamond-set fillets.

MARKS: Early initials of workmaster Mikhail
Perkhin, assay mark of St. Petersburg before 1899,
56 zolotnik
DIMENSIONS: 3 ¼ in. (8.3 cm)
PROVENANCE: Hammer Galleries, December 6,
1939 (from the "collection of Prince Aleksandr
Romanovski, Duke of Leuchtenberg"); Lillian
Thomas Pratt
EXHIBITED: VMFA 1983; *FA* 1996 (VMFA only)
BIBLIOGRAPHY: Lesley 1976, cat. no. 214, p. 109,
p. 105 (ill.); Curry 1995, cat. no. 26, pp. 96, 110 (ill.)
BEQUEST OF LILLIAN THOMAS PRATT, 47.20.186

127 Cigarette Case

Silver, enamel, ruby

The white guilloché enamel case has a
cabochon-ruby push piece and the mono-
gram *MA* on the inside of the cover.

MARKS: *Fabergé*, initials of workmaster Mikhail
Perkhin, 88 zolotnik
DIMENSIONS: L 3 ⅞ in. (9.5 cm)
PROVENANCE: Furman Hebb
GIFT OF FURMAN HEBB, 84.49

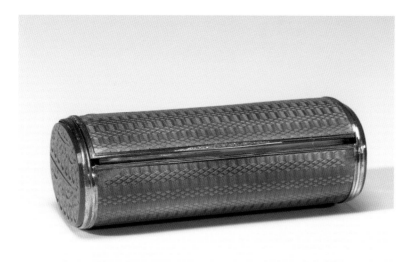

128

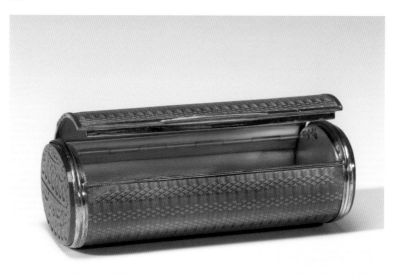

128

128 Cigarette Case

Silver, enamel, carnelian, diamonds

The green guilloché enamel case has a rose-cut diamond thumbpiece, and its sides are set with domed carnelians engraved with Arabic inscriptions from the Qur'an. One is inscribed with the Surat al-Kafirun ("The Unbelievers," Sura 109): "In the name of God, Most Merciful, Most Compassionate. Say: 'Unbelievers, I do not serve what you worship, nor do you serve what I worship. I shall never serve what you worship, nor will you ever serve what I worship. You have your own religion, and I have mine.'" The second carnelian is inscribed with a part of the Surat al-Talaq ("The Divorce," Sura 65): "He that fears God, God will give him a means of salvation and provide for him whence he does not reckon: God is all-sufficient for the man who puts his trust in Him. He will surely bring about what He decrees. He has set a measure for all things."

MARKS: *Fabergé*, initials of workmaster Mikhail Perkhin, assay mark of St. Petersburg before 1899, 84 zolotnik
DIMENSIONS: L 3 5/16 in. (8.5 cm)
PROVENANCE: Ailsa Mellon Bruce
GIFT OF THE ESTATE OF AILSA MELLON BRUCE, 70.9.46

129 Frame

Silver gilt, enamel, glass, ivory

The cinquefoil frame of emerald-green sunray guilloché enamel has five oval apertures around a circular one. Its outer border is composed of laurel swags tied with bowknots. The central reproduction photograph of Tsar Nicholas II and those of his five children are later additions.

MARKS: *Fabergé*, initials of workmaster Mikhail Perkhin, assay mark of St. Petersburg before 1899, 88 zolotnik
DIMENSIONS: D 5 ¾ in. (14.6 cm)
PROVENANCE: Lillian Thomas Pratt
EXHIBITED: VMFA 1983
BIBLIOGRAPHY: Lesley 1976, cat. no. 172, p. 81, p. 73 (ill.)
BEQUEST OF LILLIAN THOMAS PRATT, 47.20.350

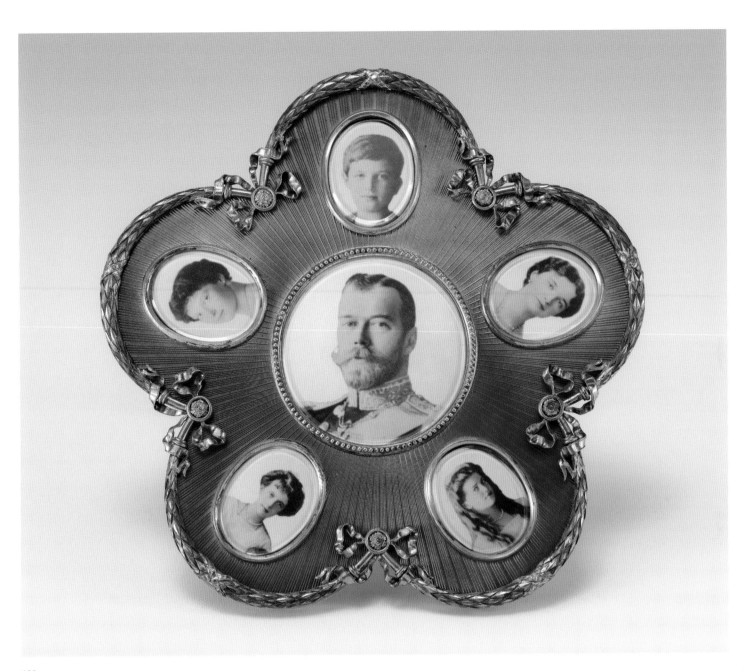

129

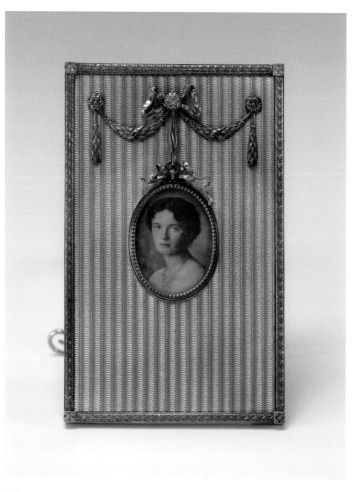

130

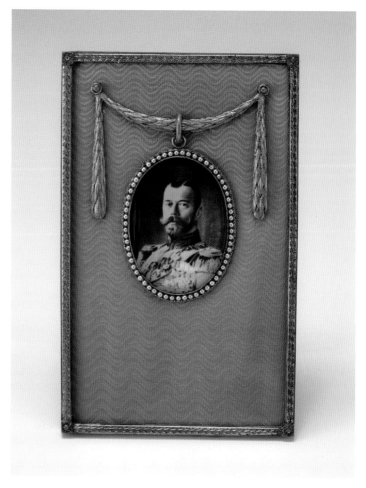

131

130 Frame

Gold, enamel, ivory, glass

The upright rectangular frame of mauve moiré guilloché enamel has an oval aperture with a beaded border suspended from laurel swags hung from rosettes and a bowknot, and an palm-leaf outer border. The photograph of Grand Duchess Olga is a later addition.

MARKS: *Fabergé*, initials of workmaster Mikhail Perkhin, assay mark of St. Petersburg 1899–1908, 56 zolotnik, scratched inventory number 2845
DIMENSIONS: 3 ¾ in. (9.5 cm)
PROVENANCE: Lillian Thomas Pratt
EXHIBITED: VMFA 1983
BIBLIOGRAPHY: Lesley 1976, cat. no. 175, p. 83, p. 83 (ill.)
BEQUEST OF LILLIAN THOMAS PRATT, 47.20.319

131 Frame

Silver gilt, enamel, pearls, ivory

The upright rectangular pale-pink moiré guilloché enamel frame has an original photograph of Tsar Nicholas II (added later).

MARKS: *Fabergé*, initials of workmaster Mikhail Perkhin, assay mark of St. Petersburg 1899–1908, 88 zolotnik, scratched inventory number 8918
DIMENSIONS: 4 in. (10.2 cm)
PROVENANCE: Lillian Thomas Pratt
EXHIBITED: VMFA 1983
BIBLIOGRAPHY: Lesley 1976, cat. no. 180, p. 87, p. 85 (ill.)
BEQUEST OF LILLIAN THOMAS PRATT, 47.20.313

132 enlarged

132 Box with Arabic Inscription

Gold, enamel, carnelian, diamonds

The cover of the hinged box is set with a carnelian and is incised in Arabic script with Verse 256 of Sura 2 of the Qur'an: "God, there is no God but He; the Living, the Self-subsisting. Neither slumber seizeth Him, nor sleep; His, whatsoever is in the Heavens and whatsoever is in the Earth! Who is he than can intercede with Him, but by His own permission? He knoweth what is present with His creatures, and what is yet to befall them; yet nought of His knowledge do they comprehend, save what He willeth. His Throne reacheth over the Heavens and the Earth, and the upholding of both burdeneth Him not; and He is the High, the Great!" (Rodwell 1909). The sides of the box are enameled with translucent emerald green over engine-turned zigzags and thin blue bands, and the borders are set with rose-cut diamonds.

MARKS: *Fabergé*, initials of workmaster Mikhail Perkhin, assay mark of St. Petersburg 1899–1908, 56 zolotnik, scratched inventory number 5805 (?)
DIMENSIONS: D 1⅜ in. (3.5 cm)
PROVENANCE: Russian Imperial Treasures. "The Schaffer Collection," 1936? ("Czarina Alexandra Feodorovna, Alexander Palace, Tsarskoie Selo"); Lillian Thomas Pratt
EXHIBITED: VMFA 1983; ALVR 1983; *FA* 1996
BIBLIOGRAPHY: Lesley 1976, cat. no. 292, p. 143, p. 142 (ill.); ALVR 1983, cat. no. 153, p. 66 (ill.); Habsburg 1996, cat. 134, p. 147 (ill.)
BEQUEST OF LILLIAN THOMAS PRATT, 47.20.276

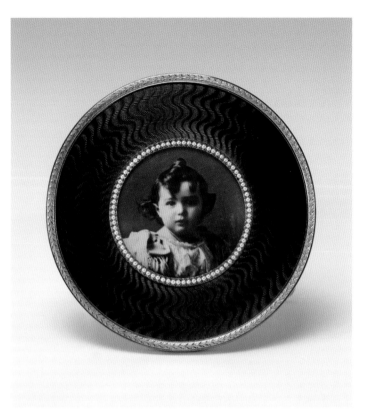

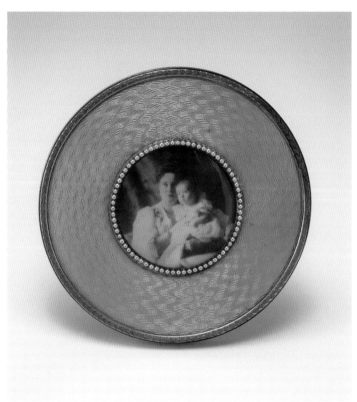

133 reduced

134

135

136

Enamels: Henrik Wigström

133 Frame

Gold, enamel, pearls, glass, ivory

The circular frame of deep-mauve enamel over a wavy guilloché ground has a circular aperture with a pearl-set bezel, an outer palm-leaf border, and a reproduction photograph of unidentified child.

MARKS: *Fabergé*, initials of workmaster Henrik Wigström, assay mark of St. Petersburg 1899–1908, 56 zolotnik
DIMENSIONS: D 3 ¼ in. (8.3 cm)
PROVENANCE: Lillian Thomas Pratt
EXHIBITED: VMFA 1983
BIBLIOGRAPHY: Lesley 1976, cat. no. 176, p. 83, p. 82 (ill.)
BEQUEST OF LILLIAN THOMAS PRATT, 47.20.337

134 Frame

Gold, enamel, pearls, glass, ivory

The circular frame of pale-green guilloché enamel has a pearl-set bezel to the aperture and an outer palm-leaf border. The photograph of Tsaritsa Alexandra Feodorovna holding an infant (probably Tsesarevich Aleksei) is a later addition.

MARKS: *Fabergé*, initials of workmaster Henrik Wigström, assay mark of St. Petersburg 1899–1908, 56 zolotnik
DIMENSIONS: D 3 in. (7.6 cm)
PROVENANCE: Lillian Thomas Pratt
EXHIBITED: VMFA 1983
BIBLIOGRAPHY: Lesley 1976, cat. no. 170, p. 81, p. 80 (ill.)
BEQUEST OF LILLIAN THOMAS PRATT, 47.20.338

135 Frame

Gold, enamel, pearls, glass, ivory

The circular frame of bluish-white guilloché enamel is painted with reddish coral-like growths. The circular aperture has a pearl-set bezel and an outer palm-leaf border. The reproduction photograph of Tsesarevich Aleksei is a later addition.

MARKS: *Fabergé*, initials of workmaster Henrik Wigström, assay mark of St. Petersburg 1899–1908, 56 zolotnik, scratched inventory number 11884
DIMENSIONS: D 3 ¼ in. (8.3 cm)
PROVENANCE: Russian Imperial Treasures. "The Schaffer Collection" (1935?) (from the "Alexander Palace, Tsarskoe Selo"); Lillian Thomas Pratt
EXHIBITED: VMFA 1983; *FA* 1996
BIBLIOGRAPHY: Lesley 1976, cat. no. 186, p. 91, p. 88 (ill.); Habsburg 1996, cat. no. 146, p. 155 (ill.)
BEQUEST OF LILLIAN THOMAS PRATT, 47.20.336

136 Frame

Gold, enamel, rubies, pearls, glass, ivory

The oval frame of white guilloché enamel has a bezel set with pearls, an outer palm-leaf border set with eight rubies, and bow-knot cresting. The engraving of Catherine the Great was added later.

MARKS: *Fabergé*, initials of workmaster Henrik Wigström, assay mark of St. Petersburg 1899–1908, 56 zolotnik
DIMENSIONS: 3 ⅛ in. (8 cm)
PROVENANCE: Lillian Thomas Pratt
EXHIBITED: VMFA 1983
BIBLIOGRAPHY: Lesley 1976, cat. no. 187, p. 91, p. 80 (ill.)
BEQUEST OF LILLIAN THOMAS PRATT, 47.20.344

137 enlarged

137 Tenth-Anniversary Frame

Gold, silver gilt, enamel, diamonds, glass, ivory

The square frame of transparent sky-blue opalescent enamel over a concentric guilloché ground has a circular aperture. Its bezel and outer border are set with a leaf-and-dart design, and a diamond-set Roman numeral *X* to commemorate a tenth-wedding anniversary has been placed above. The photograph of Tsaritsa Alexandra Feodorovna is a later addition.

MARKS: *Fabergé*, initials of workmaster Henrik Wigström, assay mark of St. Petersburg 1899–1908, 88 and 91 zolotnik, scratched inventory number 16167

DIMENSIONS: 3 ½ in. square (8.9 cm)

PROVENANCE: The Schaffer Collection of Russian Imperial Art Treasures, 1934 ("Presented by Czarina Alexandra Feodorovna to Czar Nicholas II, Alexander Palace, Tsarskoe Selo, on the tenth anniversary of their marriage"); Lillian Thomas Pratt

EXHIBITED: PFAC 1981; VMFA 1983; *FA* 1996

BIBLIOGRAPHY: Lesley 1976, cat. no. 163, p. 77, p. 76 (ill.); Habsburg 1996, cat. no. 140, p. 150 (ill.)

BEQUEST OF LILLIAN THOMAS PRATT, 47.20.333

138

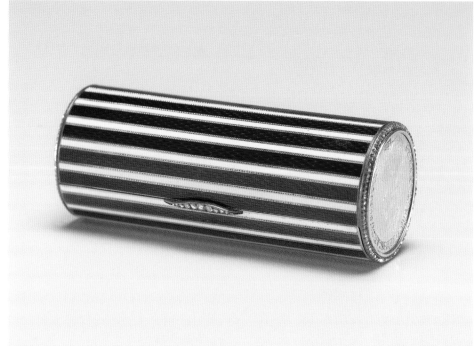

139

138 Parasol Handle

Gold, enamel, diamond

The tapering, cylindrical Louis XVI–style handle has steel-blue guilloché enamel panels framed in opaque white. The separating bands are chased and enameled with red-and-green foliage on a stippled ground, and a diamond finial tops the handle.

MARKS: *Fabergé*, initials of workmaster Henrik Wigström, assay mark of St. Petersburg 1899–1908, 72 zolotnik

DIMENSIONS: 3 in. (7.5 cm)

Original fitted case lining stamped with imperial warrant, St. Petersburg, Moscow

PROVENANCE: Hammer Galleries, #5450-6, January 5, 1940 (from the "Imperial Russian Collection"); Lillian Thomas Pratt

EXHIBITED: *FA* 1996

BIBLIOGRAPHY: Lesley 1976, cat. no. 216, p. 107 (ill.); Curry 1995, cat. no. 27, pp. 96, 110 (ill.); Habsburg 1996, cat. no. 133, p. 146 (ill.)

BEQUEST OF LILLIAN THOMAS PRATT, 47.20.199

139 Cigarette Case

Gold, enamel, diamonds, gold coins

The cylindrical case has alternating red guilloché enamel and opaque-white enamel stripes, and a diamond-set thumbpiece. Its ends are set with gold five-ruble coins of Catherine the Great within borders of rose-cut diamonds.

MARKS: *Fabergé*, initials of workmaster Henrik Wigström, assay mark of St. Petersburg 1899–1908, 72 zolotnik

DIMENSIONS: L 3⅜ in. (8.6 cm)

PROVENANCE: Ailsa Mellon Bruce

GIFT OF THE ESTATE OF AILSA MELLON BRUCE, 70.9.45

140 Frame

Silver gilt, enamel, ivory

The upright rectangular frame of pink guilloché enamel has an inner beaded border and outer palm-leaf border. The reproduction photograph of Grand Duchess Maria was added later.

MARKS: *Fabergé*, initials of workmaster Henrik Wigström, assay mark of St. Petersburg 1908–17, 88 zolotnik, scratched inventory number 22334

DIMENSIONS: 4⅝ in. (11.7 cm)

PROVENANCE: Lillian Thomas Pratt

EXHIBITED: VMFA 1983

BIBLIOGRAPHY: Lesley 1976, cat. no. 179, p. 83, p. 85 (ill.)

BEQUEST OF LILLIAN THOMAS PRATT, 47.20.310

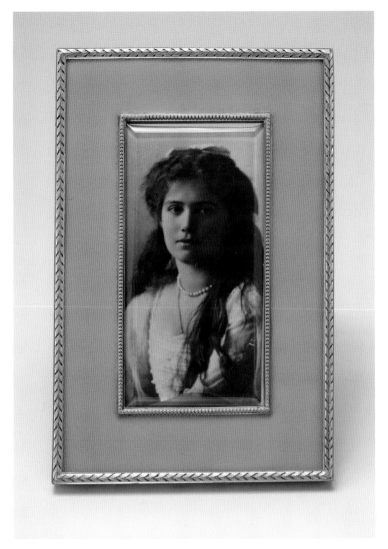

140

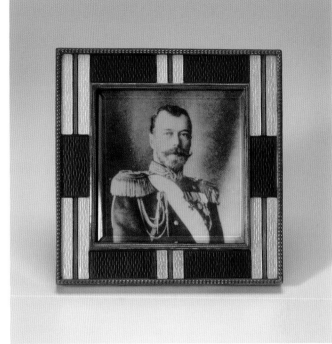

141

141 Frame

Gold, silver gilt, enamel, glass, ivory

The square aperture of the frame is surrounded by wide guilloché enamel bands of the red, white, and blue colors of a Russian regimental flag, which are framed by a reeded inner and beaded outer border. The photograph of Tsar Nicholas II is a later addition.

MARKS: *Fabergé*, initials of workmaster Henrik Wigström, assay mark of St. Petersburg 1908–17, 56 and 91 zolotnik, scratched inventory number 19762
DIMENSIONS: 2 7/16 in. square (6.2 cm)
PROVENANCE: Acquired by Lord Carnavon from Fabergé's London branch, January 14, 1910 for £20 10s; The Schaffer Collection of Russian Imperial Art Treasures; Lillian Thomas Pratt
EXHIBITED: VMFA 1983; *FA* 1996
BIBLIOGRAPHY: Lesley 1976, cat. no. 194, p. 95, p. 93 (ill.); Habsburg 1996, cat. no. 139, p. 150 (ill.)
BEQUEST OF LILLIAN THOMAS PRATT, 47.20.334

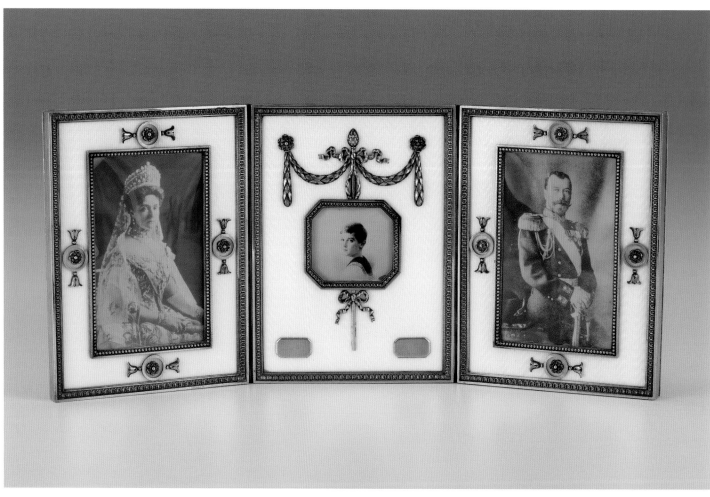

142 reduced

Enamels: Other Makers, Uncertain Attributions

142 Triptych Frame

Silver, enamel, wood

The central panel of the opalescent-white guilloché enamel frame has a small square aperture with chamfered corners. It is applied above with laurel swags suspended from rosettes and a vertical maenad's staff tied with a ribbon. The side panels have large apertures flanked on all sides with rosettes, husks, and stiff-leaf borders. The photographs of the tsar, tsaritsa, and tsesarevich are reproductions of paintings and were added later.

MARKS: *Fabergé*, initials of workmaster Hjalmar Armfelt, assay mark of St. Petersburg, 1899–1908, 88 zolotnik

DIMENSIONS: 4½ × 10⅛ in. (11.4 × 25.7 cm)
PROVENANCE: Lillian Thomas Pratt
BIBLIOGRAPHY: Lesley 1976, cat. no. 190, p. 91
BEQUEST OF LILLIAN THOMAS PRATT, 47.20.358

143 Reversible Frame

Silver gilt, enamel, glass

A silver-gilt support holds a double-sided frame, one side of which has an oval aperture in a reed-and-tie bezel within a mauve sunray guilloché enamel panel. The reverse side holds a rectangular aperture with a similar border, within which is a panel of pale-gray moiré guilloché enamel. The photograph of Grand Duke Mikhail Aleksandrovich and the reproduction portrait photograph of Natalia Sheremet'evskaia (later Countess Brasova), both dated 1909, were added later.

MARKS: *Fabergé*, initials of workmaster Hjalmar Armfelt, assay mark of St. Petersburg 1908–17, 88 zolotnik, scratched inventory number 18194
DIMENSIONS: 4½ in. (11.4 cm)
PROVENANCE: Russian Imperial Treasures. "The Schaffer Collection" 1939 (from the "apartments of Czar Nicholas II, Alexander Palace, Tsarskoie Selo"); Lillian Thomas Pratt

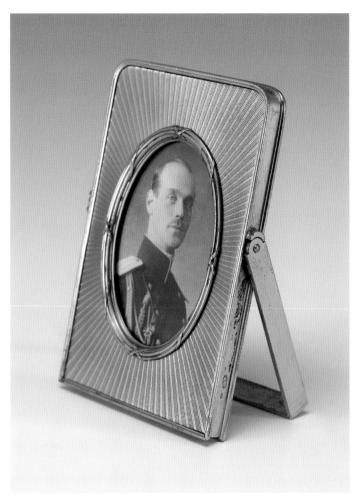

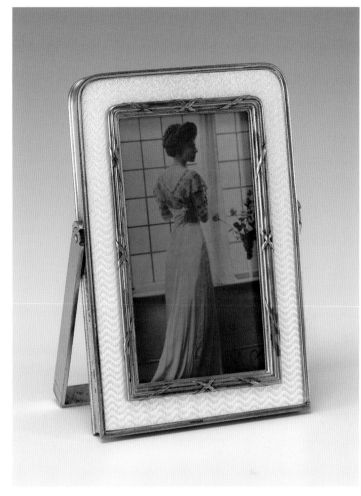

143 reduced 143 reduced

EXHIBITED: VMFA 1983; *FA* 1996

BIBLIOGRAPHY: Lesley 1976, cat. no. 192, p. 95,
p. 92 (ill.); Habsburg 1996, cat. no. 144, 153 (ill.)
NOTE: Grand Duke Mikhail Aleksandrovich
(1878–1918), younger brother of Tsar Nicholas, was
tsesarevich from 1899 until the birth of Nicholas's
son, Aleksei, in 1905. In 1909 he morganatically
married Natalia Sheremet'evskaia (1880–1952)
against the express order of the tsar (see Chapter 6
for their biography).
A very similar frame with two original photographs
of Tsesarevich Aleksei is in the Peterhof State
Museum Reserve (Habsburg and Lopato 1993)

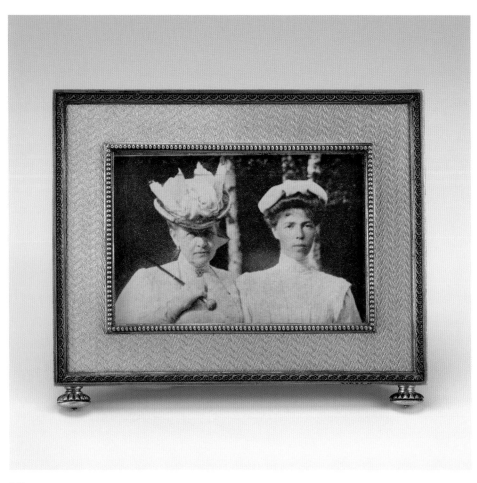

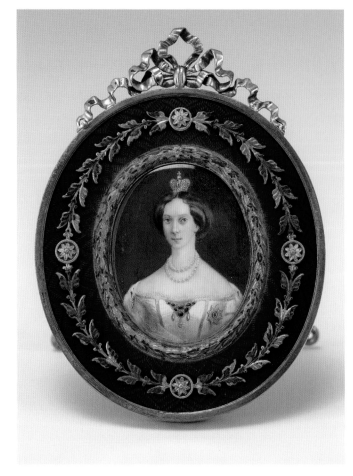

144

145

144 Frame

Silver gilt, enamel, wood

The mauve moiré guilloché enamel frame has a wooden back and silver strut. It holds a newspaper image of Grand Duchess Olga Nikolaevna and her mother, Tsaritsa Alexandra.

MARKS: *K. Fabergé*, with separate imperial warrant mark, initials of workmaster Antti Nevalainen, assay mark of St. Petersburg 1899–1908, 88 zolotnik, scratched inventory number 16133
DIMENSIONS: 3 ½ in. (8.9 cm)
PROVENANCE: Lillian Thomas Pratt
BEQUEST OF LILLIAN THOMAS PRATT, 47.20.496

145 Frame

Silver gilt, enamel, glass, wood

The oval frame of blue guilloché enamel has a laurel-wreath bezel, is applied with a continuous spray of foliage and berries, and is surmounted by bowknot cresting. The miniature-on-ivory is of Tsaritsa Maria Aleksandrovna.

MARKS: Initials of workmaster Antti Nevalainen, assay mark of St. Petersburg 1899–1908, 56 zolotnik
DIMENSIONS: 4 in. (10.2 cm)
PROVENANCE: Lillian Thomas Pratt
EXHIBITED: VMFA 1983
BIBLIOGRAPHY: Lesley 1976, cat. no. 165, p. 77, p. 76 (ill.)
NOTE: Tsaritsa Maria Aleksandrovna (1824–1880), née Princess of Hesse-Darmstadt, was the wife of Tsar Alexander II (1818–1881).
BEQUEST OF LILLIAN THOMAS PRATT, 47.20.346
WITH MINIATURE; 47.20.360 WITHIN FRAME

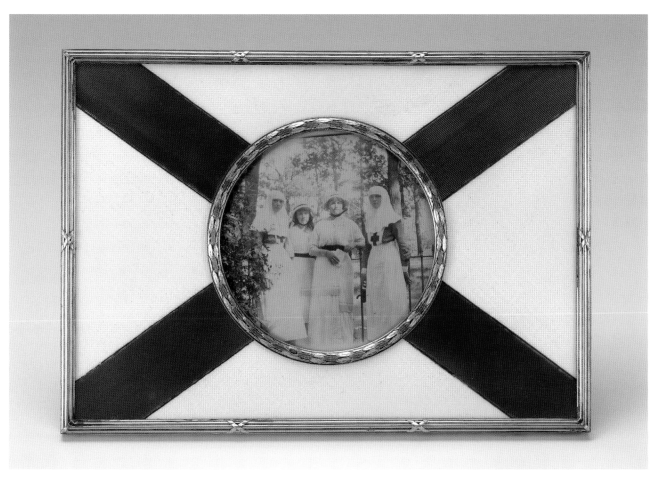

146 reduced

146 Cross of St. Andrew Frame

Silver gilt, enamel, wood

The central circular opening of the rectangular frame with its chased-foliate bezel is set within a panel of white guilloché enamel and a diagonal blue guilloché enamel cross, forming the saltire of the Cross of St. Andrew. It has a reed-and-tie outer border. The 1916 photograph of Grand Duchesses Olga and Tatiana as Sisters of Mercy and their younger sisters Maria and Anastasia is cut from a postcard.

MARKS: *K. Fabergé*, initials of workmaster Antti Nevalainen, assay mark of St. Petersburg 1899–1908, assay master A. Romanov, 91 zolotnik, scratched inventory number 15647

DIMENSIONS: H 5 ¾ × W 8 ¼ in. (14.6 cm × 21 cm) Original fitted case lining stamped with imperial warrant, St. Petersburg, Moscow, London

PROVENANCE: Acquired jointly by Tsar Nicholas II and Tsaritsa Alexandra Feodorovna on November 13, 1907, for a total of 135 rubles; Hammer Galleries 1933 (?) (from the "Winter Palace, St. Petersburg"); Lillian Thomas Pratt

EXHIBITED: L&T 1933; *FA* 1996

BIBLIOGRAPHY: Hammer Galleries, Lord & Taylor 1933, cat. no. 4404, p. 9; Lesley 1976, cat. no. 189, p. 91, p. 90 (ill.); Habsburg 1996, cat. no. 136, p. 48 (ill.)

NOTE: This heraldic saltire device stems from the Scottish version of St. Andrew's *X*-shaped cross and formed part of the Order of St. Andrew founded by Tsar Peter the Great in 1698. As tsar, Nicholas II was grand master of this, Russia's highest order. For two miniatures of Olga and Tatiana dressed as Sisters of Mercy, see the *Imperial Red Cross Easter Egg,* cat. no. 191.

BEQUEST OF LILLIAN THOMAS PRATT, 47.20.357

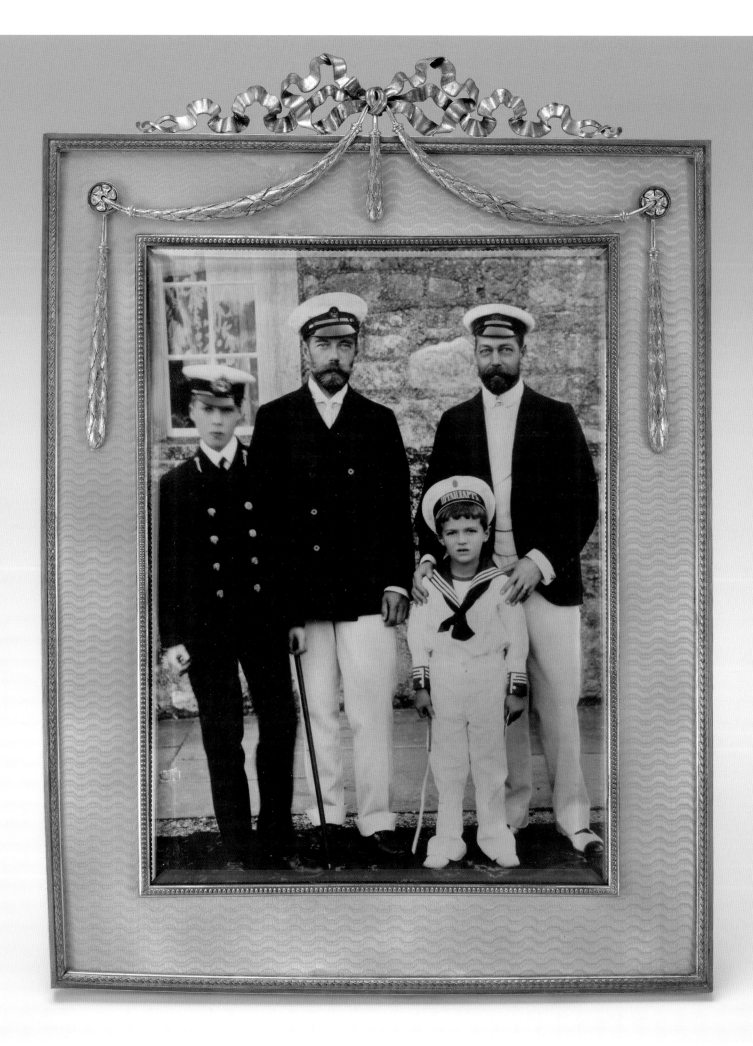

147 Frame

Silver gilt, enamel, hollywood

The frame of pale-blue moiré guilloché enamel is applied with laurel festoons suspended from rosettes and a large central gold bowknot. The photograph of King George V with the Prince of Wales (future King George VI), Tsar Nicholas II, and Tsesarevich Aleksei at a 1908 regatta in Cowles was added later.

MARKS: *K. Fabergé* with separate imperial warrant mark, initials of workmaster Antti Nevalainen, assay mark of St. Petersburg 1899–1908, assay master A. Romanov, 88 zolotnik
DIMENSIONS: 12 ¾ in. (32.4 cm)
PROVENANCE: Hammer Galleries 1933 (from the "Winter Palace, St. Petersburg"); Lillian Thomas Pratt
EXHIBITED: *FA* 1996 (VMFA only)
BIBLIOGRAPHY: Lesley 1976, cat. no. 168, p. 81, p. 79 (ill.); Curry 1995, cat. no. 20, pp. 36, 109 (ill.)
BEQUEST OF LILLIAN THOMAS PRATT, 47.20.413

148 Miniature Kovsh

Silver gilt, enamel, moonstone

The *kovsh* is of yellow guilloché enamel with a rosette and cabochon moonstones at the prow and the handle. It stands on three ball feet.

MARKS: *K. Fabergé*, with separate imperial warrant mark, initials of workmaster Antti Nevalainen (St. Petersburg), 1899–1908, 84 zolotnik, scratched inventory number 5964
DIMENSIONS: L 2 ¾ in. (7 cm)
PROVENANCE: Lillian Thomas Pratt
EXHIBITED: VMFA 1983
BIBLIOGRAPHY: Lesley 1976, cat. no. 319, p. 153, p. 152 (ill.)
BEQUEST OF LILLIAN THOMAS PRATT, 47.20.296

149 Vase

Silver gilt, enamel

The cylindrical vase of red guilloché enamel is applied with laurel swags and has a reed-and-tie rim and base.

MARKS: *K. Fabergé*, initials of workmaster Antti Nevalainen, separate imperial warrant mark (Moscow), 1899–1908, 88 zolotnik, scratched inventory number 18258, French import marks
DIMENSIONS: 3 ¾ × 2 ½ in. (9.5 × 6.4 cm)
PROVENANCE: Russian Imperial Treasures. "The Schaffer Collection," #997, n.d., $550; Lillian Thomas Pratt
EXHIBITED: VMFA 1983; *FA* 1996
BIBLIOGRAPHY: Lesley 1976, cat. no. 326, p. 157 (ill.); Habsburg 1996, cat. no. 135, p. 147
BEQUEST OF LILLIAN THOMAS PRATT, 47.20.291

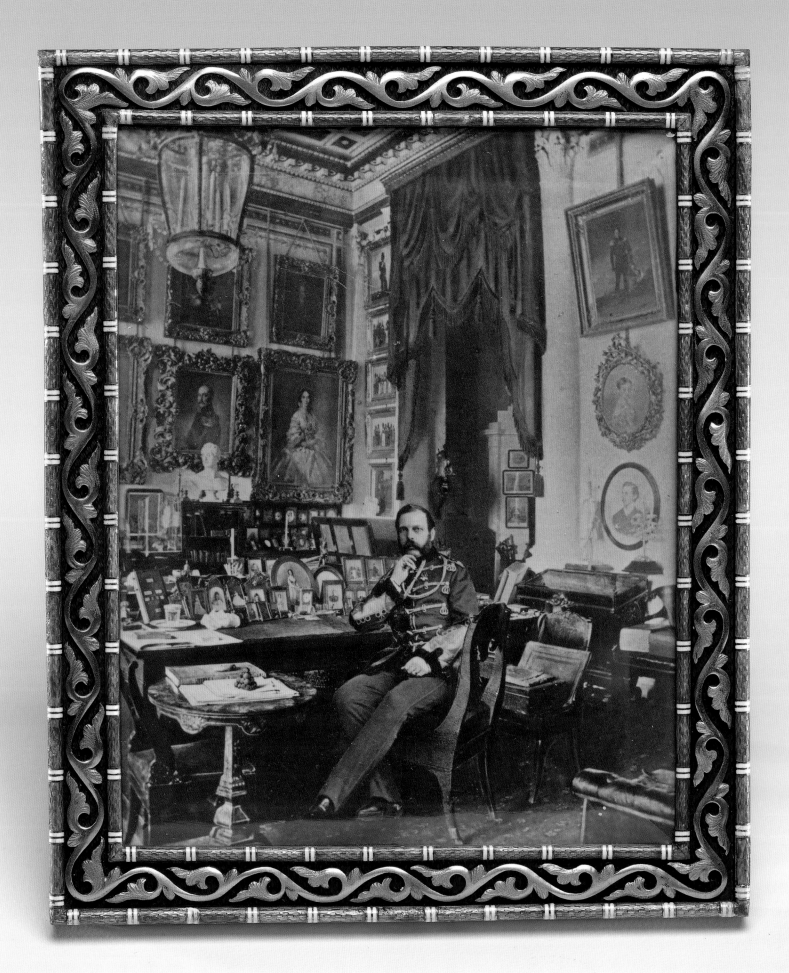

151 reduced

152 reduced

150 Frame

Silver gilt, enamel, wood

The frame has a border of dark-red guilloché enamel overlaid by a continuous openwork design of leafy sprays flanked by green enamel molding with white dividers. The original photograph of Tsar Alexander II in his study and the frame's wooden back were added later.

MARKS: *Fabergé*, initials of workmaster Victor Aarne, assay mark of St. Petersburg 1899–1908, 88 zolotnik
DIMENSIONS: 5 ½ in. (14 cm)
PROVENANCE: The Schaffer Collection of Russian Imperial Art Treasures, #2419, $200, December 28, 1939; Lillian Thomas Pratt
EXHIBITED: VMFA 1983; FA 1996
BIBLIOGRAPHY: Lesley 1976, cat. no. 178, p. 83, p. 84 (ill.); Curry 1995, cat. no. 23, pp. 44, 109 (ill.); Habsburg 1996, cat. no. 149, 157 (ill.)
NOTE: The same well-known photograph is also contained in an imperial family photograph album in the Pratt collection (47.20.376).
BEQUEST OF LILLIAN THOMAS PRATT, 47.20.308

151 Frame

Silver, enamel, pearls, glass, ivory

The triangular, deep-blue moiré guilloché enamel frame has a circular aperture with a pearl-set bezel and a gadrooned outer border. The reproduction photograph of Tsaritsa Alexandra Feodorovna was added later.

MARKS: *Fabergé*, initials of workmaster Viktor Aarne, assay mark of St. Petersburg before 1899, 88 zolotnik, scratched inventory number 59687
DIMENSIONS: 3 ⅛ in. (8 cm)
PROVENANCE: Lillian Thomas Pratt
EXHIBITED: VMFA 1983
BIBLIOGRAPHY: Lesley 1976, cat. no. 166, p. 81, p. 78 (ill.)
BEQUEST OF LILLIAN THOMAS PRATT, 47.20.348

152 Triptych Frame

Silver gilt, enamel, pearls, glass, paper, wood

The large rectangular triptych frame has a central oval aperture with a pearl-set bezel within a white sunray guilloché enamel panel with gadrooned borders. It is applied at the corners with winged cherub heads. The front and back of the side panels are of plain wood. A catch in the shape of a botonée cross holds the frame closed. Within the frame is a faint pencil drawing of an unknown deceased woman.

MARKS: *Fabergé*, initials of workmaster Victor Aarne, assay mark of St. Petersburg 1899–1908, 88 zolotnik
DIMENSIONS: 7 ⅜ in. (8.7 cm)
PROVENANCE: Lillian Thomas Pratt
BIBLIOGRAPHY: Lesley 1976, cat. no. 212, p. 103 (ill.)
BEQUEST OF LILLIAN THOMAS PRATT, 47.20.356 FRAME; 47.20.414 DRAWING

150 (left) enlarged

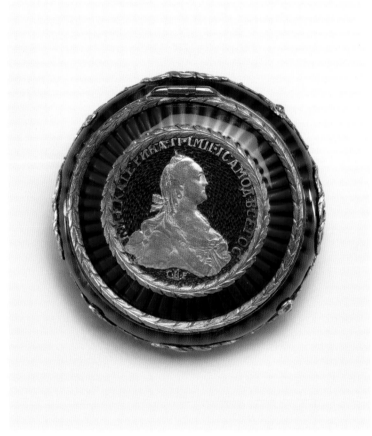

153

154 enlarged

153 Parasol Handle

Gold, enamel, topaz

The pink moiré guilloché enamel handle of irregular shape has four panels separated by chased stylized laurel-leaf borders and a topaz finial.

MARKS: Assay mark of St. Petersburg before 1899, 56 zolotnik

DIMENSIONS: 2⅝ in. (6.7 cm)

PROVENANCE: Lillian Thomas Pratt

EXHIBITED: VMFA 1983

BIBLIOGRAPHY: Lesley 1976, cat. no. 215, p. 107 (ill.)

BEQUEST OF LILLIAN THOMAS PRATT, 47.20.195

154 Bonbonnière

Gold, enamel, diamonds

The hinged cover of the dark-red guilloché enamel bonbonnière is inset with a gold ten-ruble coin of Catherine the Great dated 1773. The coin has a red guilloché enamel frame with chased palm-leaf borders. A diamond-set rosette adorns its chased-gold lip.

MARKS: *Fabergé*, initials of workmaster illegible, assay mark of St. Petersburg 1899–1908, 56 zolotnik

DIMENSIONS: D 2 in. (5.1 cm)

PROVENANCE: Russian Imperial Treasures. "The Schaffer Collection" #1376, October 2, 1939, $450; Lillian Thomas Pratt

EXHIBITED: VMFA 1983

BIBLIOGRAPHY: Lesley 1976, cat. no. 294, p. 147, p. 144 (ill.)

BEQUEST OF LILLIAN THOMAS PRATT, 47.20.278

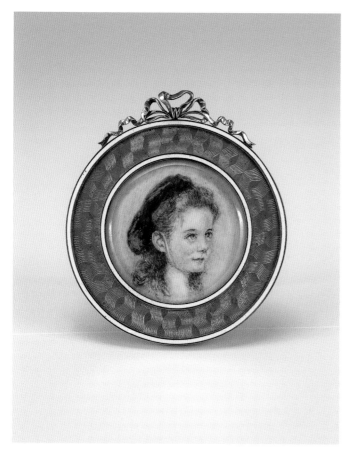

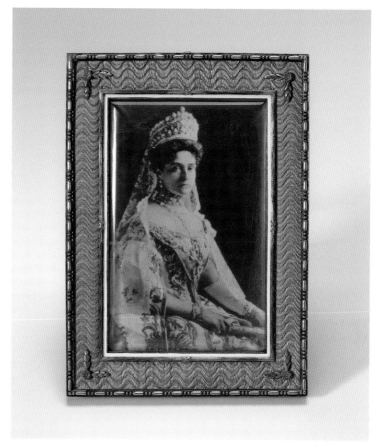

155 enlarged

156 reduced

155 Frame

Silver gilt, gold, enamel, glass, ivory

The circular frame of blue guilloché enamel between opalescent-white fillets is surmounted by a gold bowknot cresting and has a silver-gilt strut. It contains a miniature of Grand Duchess Tatiana after a pastel by Friedrich von Kaulbach that was kept in the Mauve Room at the Alexander Palace.

MARKS: *K. F.* for Karl Fabergé, assay mark of St. Petersburg 1899–1908, 56 and 84 zolotnik, scratched inventory number 25203
DIMENSIONS: D 1⅞ in. (4.7 cm)
PROVENANCE: Lillian Thomas Pratt
EXHIBITED: VMFA 1983
BIBLIOGRAPHY: Lesley 1976, cat. no. 164, p. 77, p. 79 (ill.)
BEQUEST OF LILLIAN THOMAS PRATT, 47.20.340
WITH MINIATURE; 47.20.362 WITHIN FRAME

156 Frame

Silver gilt, enamel, rock crystal, wood

The upright, rectangular frame is of mauve moiré guilloché enamel with an inner reed-and-tie border and outer egg-dart border. The name *Victoria* is spelled out on the easel. The reproduction photograph of Tsaritsa Alexandra Feodorovna was added later.

MARKS: *Fabergé*, initials of workmaster and assay mark illegible, 84 zolotnik
DIMENSIONS: 4 ½ in. (11.4 cm)
PROVENANCE: Russian Imperial Treasures. "The Schaffer Collection," (1936?) (from the "Alexander Palace, Tsarskoie Selo"); Lillian Thomas Pratt
EXHIBITED: VMFA 1983; FA 1996
BIBLIOGRAPHY: Lesley 1976, cat. no. 174, p. 83, p. 82 (ill.); Habsburg 1996, cat. no. 143, p. 152 (ill.)
NOTE: The nearest relative to the Romanovs bearing the name Victoria was Victoria Melita (1876–1936),

Princess of Saxe-Coburg and Gotha and of Great Britain, a granddaughter of Tsar Alexander II. In 1894 she married Ernest Ludwig, Grand Duke of Hessen, brother of Tsaritsa Alexandra Feodorovna. After divorcing him in 1905 (a major family scandal), she married Grand Duke Kirill Vladimirovich (1876–1938).

BEQUEST OF LILLIAN THOMAS PRATT, 47.20.314

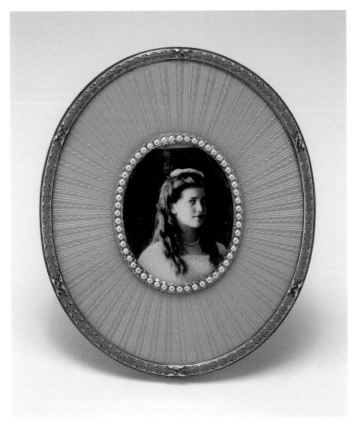

157 enlarged

157 Frame

Gold, enamel, pearls, glass, ivory

The oval frame has opalescent translucent pale-green enamel over a sunburst guilloché ground, a pearl-set bezel, and a palm-leaf outer border. The reproduction photograph of Grand Duchess Maria is a later addition.

MARKS: *Fabergé*, initials of workmaster illegible, St. Petersburg 1908–17, 56 zolotnik
DIMENSIONS: 3 in. (7.6 cm)
PROVENANCE: Lillian Thomas Pratt
EXHIBITED: VMFA 1983; *FA* 1996 (VMFA only)
BIBLIOGRAPHY: Lesley 1976, cat. no. 171, p. 81, p. 80 (ill.)
BEQUEST OF LILLIAN THOMAS PRATT, 47.20.343

158 Frame

Varicolored gold, platinum, enamel, ivory, watercolor

The frame is of opalescent-white enamel and is applied above with floral festoons in platinum and green, pink, and yellow gold suspended from a bowknot cresting and with laurel sprays beneath. The celluloid replacement back has both an easel and suspension ring for display. The miniature-on-ivory portrait is of Queen Alexandra of Great Britain.

UNMARKED
DIMENSIONS: D 2 ¼ in. (5.7 cm)
PROVENANCE: Hammer Galleries, February 26, 1941 (from the "collection of Prince Felix Youssopoff"); Lillian Thomas Pratt

EXHIBITED: VMFA 1983; *FA* 1996
BIBLIOGRAPHY: Lesley 1976, cat. no. 191, p. 91 (ill.); Habsburg 1996, cat. no. 47, p. 55 (ill.)
NOTE: Queen Alexandra (1844–1925), wife of King Edward VII of Great Britain, was the eldest daughter of King Christian IX of Denmark and Queen Louise (née Princess of Hesse-Cassel). Her sister was Dagmar (Maria Feorodovna), wife of Tsar Alexander III. Both sisters were avid collectors of Fabergé. Queen Alexandra acquired, or was given, many of the objects that are today in the collection of Queen Elizabeth II, while the collection of the dowager empress was dispersed.
BEQUEST OF LILLIAN THOMAS PRATT, 47.20.359 WITH MINIATURE; 47.20.365 WITHIN FRAME

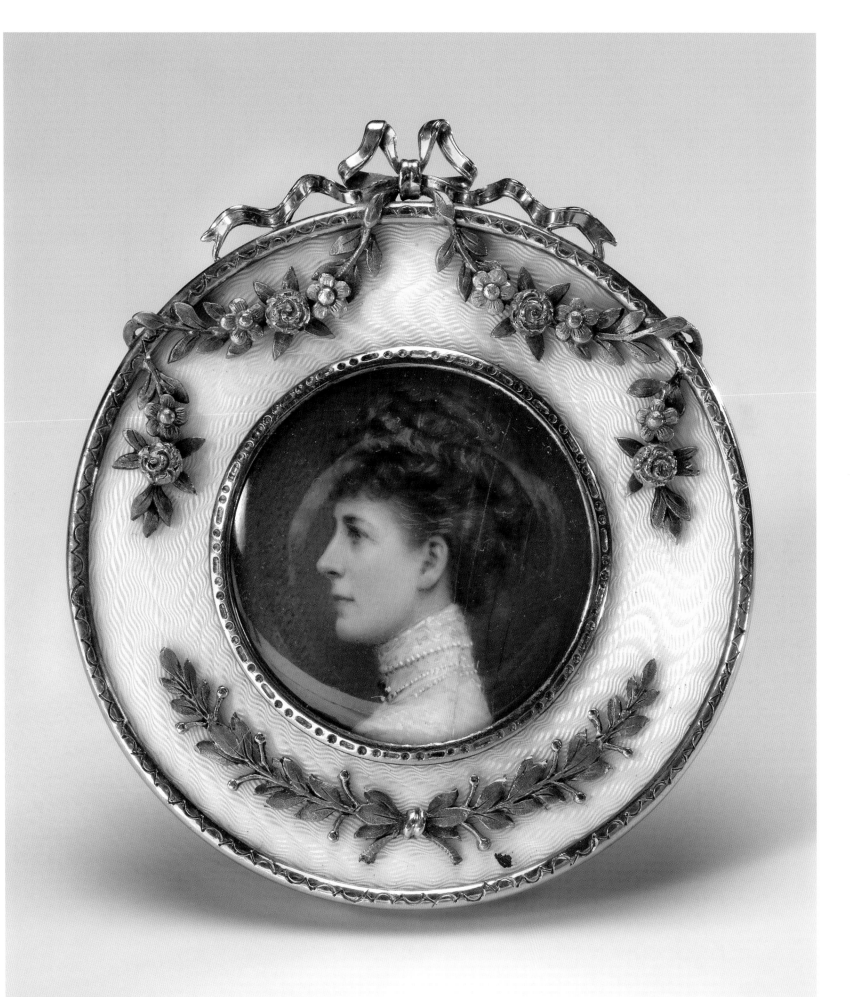

159 Bratina

Silver gilt, enamel, sapphires, emeralds, rubies, garnets, blue topaz (?), pearls

The *bratina,* or punch bowl, has a body of green guilloché enamel overlaid with scroll designs embellished in cloisonné and champlevé enamels. It is set with numerous precious and semiprecious stones in square mounts.

MARKS: *K. Fabergé,* separate imperial warrant, initials of workmaster Julius Rappoport, 88 zolotnik, scratched inventory number 8930
DIMENSIONS: 6 in. (15.2 cm)
PROVENANCE: The Schaffer Collection of Authentic Imperial Russian Art Treasures (1937?), #504; Lillian Thomas Pratt
EXHIBITED: VMFA 1983
BIBLIOGRAPHY: Schaffer Collection catalogue, 1937?; Lesley 1976, cat. no. 322, p. 153, p. 155 (ill.)
NOTE: This is a rare Moscow-type item in cloisonné and champlevé enamels made in St. Petersburg.
BEQUEST OF LILLIAN THOMAS PRATT, 47.20.287

159 (right)

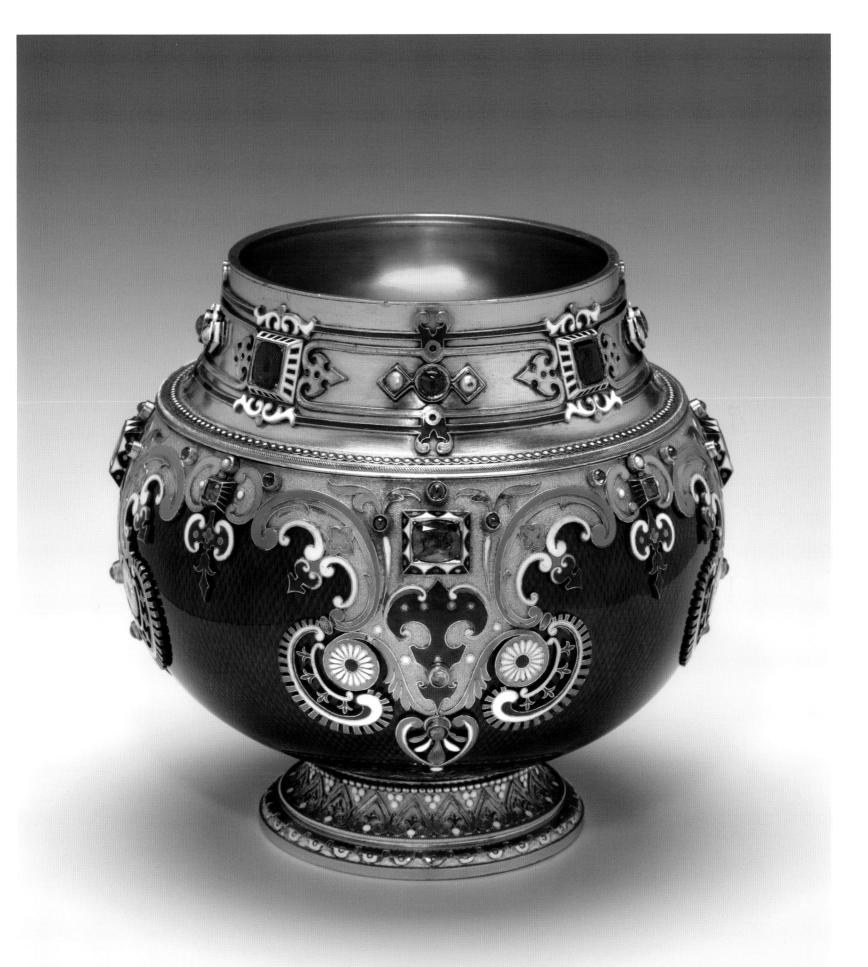

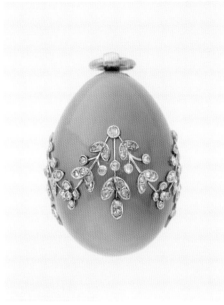

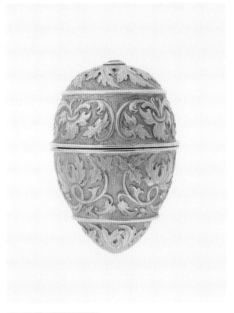

160 (above) enlarged
160 (left)

161 (above) enlarged
161 (left)

162 (above) enlarged
162 (left)

Miniature Easter Eggs

160 Miniature Easter Egg Pendant

Gold, enamel

The acorn-shaped purpurine egg has a gold-wire cap.

MARKS: Initials of workmaster Erik Kollin, assay mark of St. Petersburg before 1899, 56 zolotnik

DIMENSIONS: ¾ in. (1.9 cm)

PROVENANCE: The Schaffer Collection, 1935 (from the "apartments of Grand Duchess Tatiana, Alexander Palace, Tsarskoye Selo"); Lillian Thomas Pratt

BIBLIOGRAPHY: Lesley 1976, cat. no. 70, p. 53, p. 52 (ill.); Curry 1995, cat. no. 42a, p. 112, back cover (ill.)

EXHIBITED: VMFA 1983

BEQUEST OF LILLIAN THOMAS PRATT, 47.20.55

161 Miniature Easter Egg Pendant

Chalcedony, gold, diamonds

The bluish chrysocolla chalcedony egg is applied with white-gold floral swags with diamond-set flowers.

MARKS: Initials of workmaster Mikhail Perkhin, 56 zolotnik

DIMENSIONS: 1¼ in. (3.1 cm)

PROVENANCE: Lillian Thomas Pratt

BIBLIOGRAPHY: Lesley 1976, cat. no. 60, p. 50 (ill.)

BEQUEST OF LILLIAN THOMAS PRATT, 47.20.126

162 Ring Box

Gold, ruby, silk

The hinged gold egg is chased overall with bands of Louis XV scrolls and topped with a ruby finial.

MARKS: *Fabergé*, initials of workmaster Mikhail Perkhin, assay mark of St. Petersburg before 1899, 72 zolotnik

DIMENSIONS: 1 in. (2.5 cm)

PROVENANCE: Lillian Thomas Pratt

BIBLIOGRAPHY: Lesley 1976, cat. no. 59, p. 51, p. 50 (ill.); Curry 1995, cat. no. 8, pp. 4, 108 (ill.)

BEQUEST OF LILLIAN THOMAS PRATT, 47.20.46

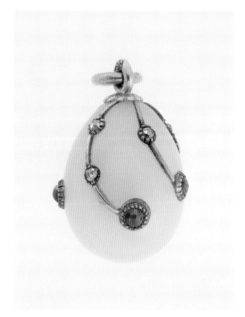

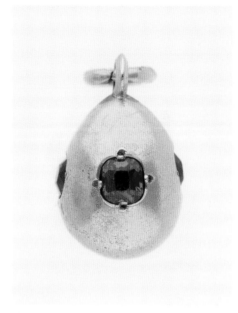

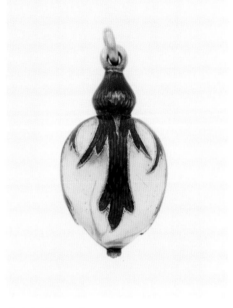

163 (above) enlarged
163 (left)

164 (above) enlarged
164 (left)

165 (above) enlarged
165 (left)

163 Miniature Easter Egg Pendant

Bowenite, gold, rubies, diamonds

The bowenite egg is applied with foliate motifs set with rose-cut diamonds and rubies.

MARKS: Initials of workmaster Mikhail Perkhin, 56 zolotnik

DIMENSIONS: ⅝ in. (1.6 cm)

PROVENANCE: Lillian Thomas Pratt

BIBLIOGRAPHY: Lesley 1976, cat. no. 119, p. 56, p. 57 (ill.); Curry 1995, cat. no. 42m, p. 113, back cover (ill.)

EXHIBITED: VMFA 1983; *FA* 1996 (VMFA only)

BEQUEST OF LILLIAN THOMAS PRATT, 47.20.108

164 Miniature Easter Egg Pendant

Gold, rubies

The burnished-gold egg is set with sapphires, a faceted emerald, and a ruby.

MARKS: Initials of workmaster Mikhail Perkhin, assay mark of St. Petersburg before 1899, 56 zolotnik

DIMENSIONS: 9/16 in. (1.4 cm)

PROVENANCE: Lillian Thomas Pratt

EXHIBITED: VMFA 1983

BIBLIOGRAPHY: Lesley 1976, cat. no. 113, p. 56 (ill.)

BEQUEST OF LILLIAN THOMAS PRATT, 47.20.101

165 Locket

Gold, enamel, diamond

The hinged locket is shaped as a rosebud, naturalistically enameled in white streaked with pink, and has green enamel leaves and a rose-cut diamond catch.

MARKS: Initials of workmaster Mikhail Perkhin, 56 zolotnik

DIMENSIONS: 1 in. (2.2 cm)

PROVENANCE: Lillian Thomas Pratt

BIBLIOGRAPHY: Lesley 1976, cat. no. 273, p. 137, p. 136 (ill.)

BEQUEST LILLIAN THOMAS PRATT 47.20.106

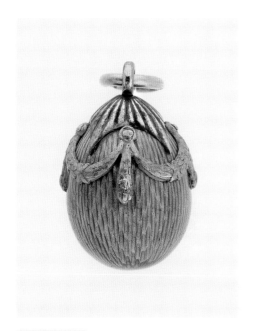

166 (above) enlarged
166 (left)

167 (above) enlarged
167 (left)

168 (above) enlarged
168 (left)

166 Miniature Easter Egg Pendant

Gold, enamel

The acorn-shaped green guilloché enamel egg has a fluted cap with applied laurel-leaf swags.

MARKS: Initials of workmaster Henrik Wigström, assay mark of St. Petersburg 1899–1908, assay master A. Romanov, 56 zolotnik
DIMENSIONS: ⅝ in. (1.6 cm)
PROVENANCE: Lillian Thomas Pratt
EXHIBITED: VMFA 1983
BIBLIOGRAPHY: Lesley 1976, cat. no. 114, p. 56 (ill.); Curry 1995, cat. no. 36f, pp. 105, 111 (ill.)
BEQUEST OF LILLIAN THOMAS PRATT, 47.20.102

167 Miniature Easter Egg Pendant

Silver, emerald

The silver-gilt wire egg is set with a cabochon emerald.

MARKS: Initials of workmaster August Holmström (?), 84 zolotnik
DIMENSIONS: ⅝ in. (1.6 cm)
PROVENANCE: Lillian Thomas Pratt
EXHIBITED: VMFA 1983
BIBLIOGRAPHY: Lesley 1976, cat. no. 71, p. 53, p. 52 (ill.)
BEQUEST OF LILLIAN THOMAS PRATT, 47.20.56

168 Miniature Easter Egg Pendant

White agate, gold, rubies

The agate egg is encased in a trellis of chased yellow- and red-gold leaves and set with four rubies.

MARKS: Initials of workmaster August Holmström (?), assay mark of St. Petersburg before 1899–1908, 56 zolotnik
DIMENSIONS: ⅝ in. (1.6 cm)
PROVENANCE: Lillian Thomas Pratt
EXHIBITED: VMFA 1983
BIBLIOGRAPHY: Lesley 1976, cat. no. 97, p. 55, p. 54 (ill.)
BEQUEST OF LILLIAN THOMAS PRATT, 47.20.84

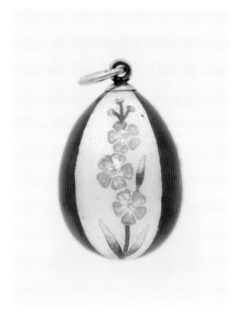

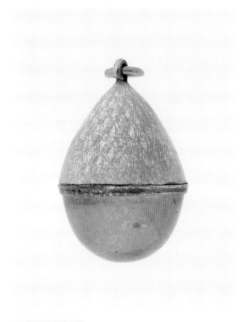

169 (above) enlarged
169 (left)

170 (above) enlarged
170 (left)

171 (above) enlarged
171 (left)

169 Miniature Easter Egg Pendant

Rhodonite, gold

The plain rhodonite egg is suspended from a gold loop.

MARKS: Initials of workmaster Fedor Afanas'ev, 56 zolotnik

DIMENSIONS: ⅝ in. (1.6 cm)

PROVENANCE: Lillian Thomas Pratt

EXHIBITED: VMFA 1983

BIBLIOGRAPHY: Lesley 1976, cat. no. 90, p. 54 (ill.)

BEQUEST OF LILLIAN THOMAS PRATT, 47.20.75

170 Miniature Easter Egg Pendant

Gold, enamel

The egg is decorated with alternating vertical segments of red guilloché enamel and opaque-white bands painted with forget-me-nots in turquoise and green.

MARKS: Initials of workmaster Fedor Afanas'ev, 56 zolotnik

DIMENSIONS: ⅝ in. (1.6 cm)

PROVENANCE: Lillian Thomas Pratt

EXHIBITED: VMFA 1983; *FA* 1996 (VMFA only)

BIBLIOGRAPHY: Lesley 1976, cat. no. 123, p. 56, p. 57 (ill.)

BEQUEST OF LILLIAN THOMAS PRATT, 47.20.113

171 Miniature Easter Egg Pendant

Gold, quartz, enamel

The upper half of the egg is enameled in translucent pale blue, the lower half is a pink quartz cabochon.

MARKS: Initials of workmaster Fedor Afanas'ev, 56 zolotnik

DIMENSIONS: ⅝ in. (1.6 cm)

PROVENANCE: Lillian Thomas Pratt

BIBLIOGRAPHY: Lesley 1976, cat. no. 118, p. 56

BEQUEST LILLIAN THOMAS PRATT 47.20.107

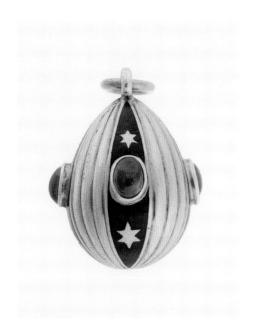

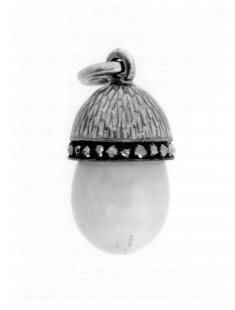

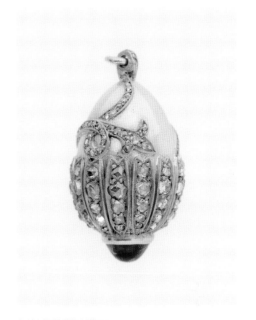

172 (above) enlarged
172 (left)

173 (above) enlarged
173 (left)

174 (above) enlarged
174 (left)

172 Miniature Easter Egg Pendant

Gold, enamel, rubies

The egg is vertically segmented with alternating bands of fluted gold and dark-blue guilloché enamel set with cabochon rubies between gold stars.

MARKS: Initials of workmaster Alfred Thielemann
DIMENSIONS: ⅝ in. (1.6 cm)
PROVENANCE: Lillian Thomas Pratt
EXHIBITED: VMFA 1983
BIBLIOGRAPHY: Lesley 1976, cat. no. 121, p. 56, p. 57 (ill.); Curry 1995, cat. no. 42j, p. 113, back cover (ill.)
BEQUEST OF LILLIAN THOMAS PRATT, 47.20.110

173 Miniature Easter Egg Pendant

Agate, gold, enamel, diamonds

The acorn-shaped agate egg has a cap of white and gray-green guilloché enamel and a rose-cut diamond border.

MARKS: Initials of workmaster Alfred Thielemann, assay mark of St. Petersburg 1899–1908, 56 zolotnik
DIMENSIONS: ⅝ in. (1.6 cm)
PROVENANCE: Lillian Thomas Pratt
EXHIBITED: VMFA 1983
BIBLIOGRAPHY: Lesley 1976, cat. no. 109, p. 55 (ill.); Curry 1995, cat. no. 36h, pp. 105, 111 (ill.)
BEQUEST OF LILLIAN THOMAS PRATT, 47.20.96

174 Miniature Easter Egg Pendant

Gold, diamonds, ruby

The silver-gilt egg is applied with bands of rose-cut diamonds and a single cabochon ruby.

MARKS: K. F. for Karl Fabergé, assay mark of St. Petersburg before 1899, 56 zolotnik
DIMENSIONS: 1⅛ in. (2.8 cm)
PROVENANCE: Lillian Thomas Pratt
EXHIBITED: VMFA 1983
BIBLIOGRAPHY: Lesley 1976, cat. no. 135, p. 57 (ill.)
BEQUEST OF LILLIAN THOMAS PRATT, 47.20.127

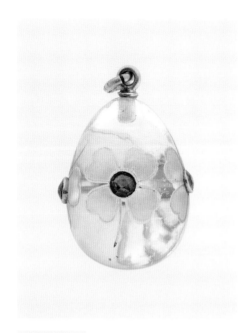

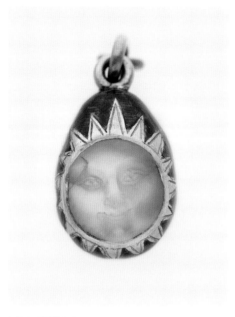

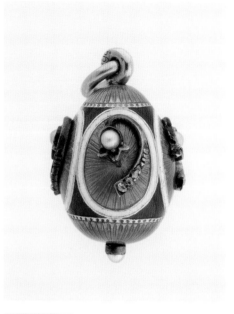

175 (above) enlarged
175 (left)

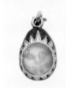

176 (above) enlarged
176 (left)

177 (above) enlarged
177 (left)

175 Miniature Easter Egg Pendant

Rock crystal, rubies, emeralds

The rock-crystal egg is etched with four-petal blooms set with rubies and emeralds.

MARKS: *K. F.* for Karl Fabergé, assay mark of St. Petersburg before 1899, 56 zolotnik

DIMENSIONS: ¾ in. (1.9 cm)

PROVENANCE: Lillian Thomas Pratt

EXHIBITED: VMFA 1983

BIBLIOGRAPHY: Lesley 1976, cat. no. 128, p. 57; Curry 1995, cat. no. 36l, pp. 105, 111 (ill.)

BEQUEST OF LILLIAN THOMAS PRATT, 47.20.119

176 Miniature Easter Egg Pendant

Gold, enamel, moonstone

The pale-blue guilloché enamel egg is set with a carved moonstone face within a gold sunburst.

MARKS: *K. F.* for Karl Fabergé, assay mark of St. Petersburg before 1899

DIMENSIONS: ⅝ in. (1.6 cm)

PROVENANCE: Ernest Hillman Jr.

GIFT OF THE ESTATE OF ERNEST HILLMAN JR., 2003.186

177 Miniature Easter Egg Pendant

Gold, enamel, pearls, diamonds

The turquoise guilloché enamel egg consists of oval panels bordered in white that contain pearl- and diamond-set flowers.

MARKS: *K. F.* for Karl Fabergé, 56 zolotnik

DIMENSIONS: ⅝ in. (1.6 cm)

PROVENANCE: Lillian Thomas Pratt

EXHIBITED: VMFA 1983

BIBLIOGRAPHY: Lesley 1976, cat. no. 116, p. 56; Curry 1995, cat. no. 42o, p. 113, back cover (ill.)

BEQUEST OF LILLIAN THOMAS PRATT, 47.20.104

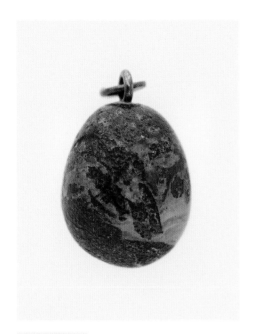

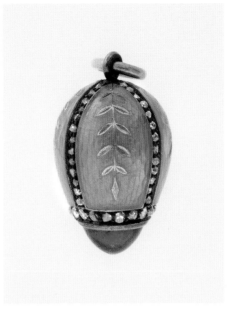

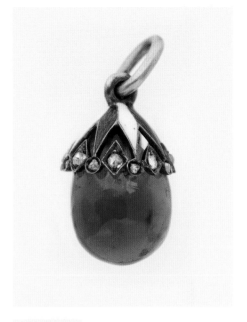

178 (above) enlarged
178 (left)

179 (above) enlarged
179 (left)

180 (above) enlarged
180 (left)

178 Miniature Easter Egg Pendant

Opal, enamel

The opal matrix egg is applied with blue- and green-translucent enamel foliage.

MARKS: *K. F.* for Karl Fabergé
DIMENSIONS: ⅝ in. (1.6 cm)
PROVENANCE: Lillian Thomas Pratt
BIBLIOGRAPHY: Lesley 1976, cat. no. 110, p. 55
EXHIBITED: VMFA 1983
BEQUEST OF LILLIAN THOMAS PRATT, 47.20.97

179 Miniature Easter Egg Pendant

Gold, enamel, diamonds

The segmented pink guilloché enamel egg is painted with flower sprays. It has rose-cut diamond borders and a cabochon-emerald finial in a rose-cut diamond mount.

UNMARKED
DIMENSIONS: ¾ in. (1.9 cm)
PROVENANCE: Lillian Thomas Pratt
EXHIBITED: VMFA 1983; *FA* 1996 (VMFA only)
BIBLIOGRAPHY: Lesley 1976, cat. no. 117, p. 56; Curry 1995, cat. no. 42h, p. 113, back cover (ill.)
BEQUEST OF LILLIAN THOMAS PRATT, 47.20.105

180 Miniature Easter Egg Pendant

Amber, gold, enamel, diamonds

The acorn-shaped topaz egg has a cap of red-and-white enamel with a border of rose-cut diamonds.

UNMARKED
DIMENSIONS: ⅝ in. (1.6 cm)
PROVENANCE: Lillian Thomas Pratt
EXHIBITED: VMFA 1983; *FA* 1996 (VMFA only)
BIBLIOGRAPHY: Lesley 1976, cat. no. 111, p. 55
BEQUEST OF LILLIAN THOMAS PRATT, 47.20.98

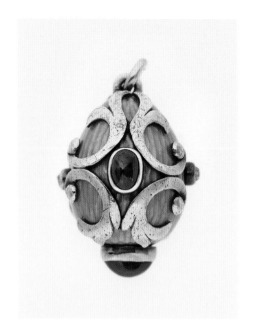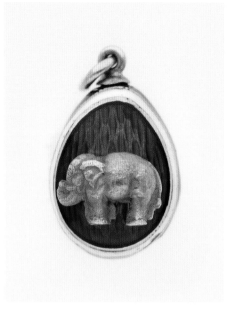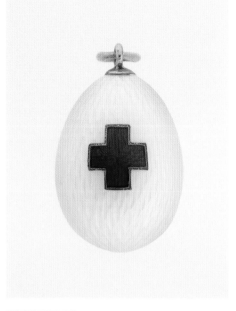

 181 (above) enlarged
181 (left)

 182 (above) enlarged
182 (left)

 183 (above) enlarged
183 (left)

181 Miniature Easter Egg Pendant

Gold, enamel, diamonds, sapphires

The egg of pink guilloché enamel is applied with gold strapwork and set with three cabochon sapphires.

MARKS: 56 zolotnik
DIMENSIONS: ¾ in. (1.9 cm)
PROVENANCE: Lillian Thomas Pratt
EXHIBITED: VMFA 1983
BIBLIOGRAPHY: Lesley 1976, cat. no. 87, p. 54, p. 52 (ill.); Curry 1995, cat. no. 42q, p. 113, back cover (ill.)
BEQUEST OF LILLIAN THOMAS PRATT, 47.20.72

182 Miniature Easter Egg Pendant

Gold, enamel

The red guilloché enamel egg is chased with a gold elephant and has an opaque-white enamel border.

MARKS: 56 zolotnik
DIMENSIONS: ⅝ in. (1.6 cm)
PROVENANCE: Lillian Thomas Pratt
EXHIBITED: VMFA 1983
BIBLIOGRAPHY: Lesley 1976, cat. no. 112, p. 56
BEQUEST OF LILLIAN THOMAS PRATT, 47.20.100

183 Miniature Easter Egg Pendant

Gold, enamel

The egg of white guilloché enamel is painted with a Red Cross.

MARKS: 56 zolotnik
DIMENSIONS: ¾ in. (1.9 cm)
PROVENANCE: Lillian Thomas Pratt
BIBLIOGRAPHY: Lesley 1976, cat. no. 89, p. 54, p. 52 (ill.); Curry 1995, cat. no. 42i, p. 113, back cover (ill.)
NOTE: Red Cross eggs were produced in large numbers during World War I.
BEQUEST OF LILLIAN THOMAS PRATT, 47.20.74

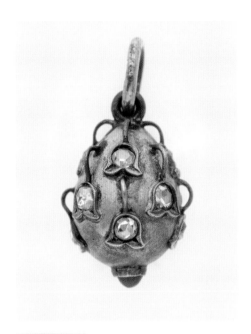

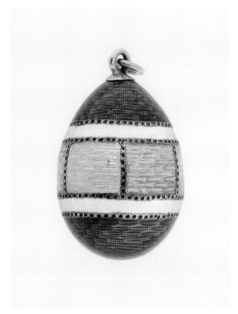

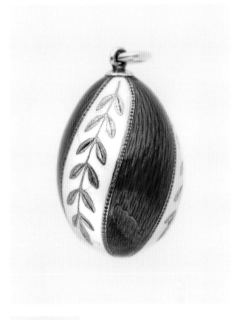

184 (above) enlarged
184 (left)

185 (above) enlarged
185 (left)

186 (above) enlarged
186 (left)

184 Miniature Easter Egg Pendant

Gold, enamel, sapphire

The gray guilloché enamel egg is applied with wirework lilies of the valley and is set with a cabochon sapphire.

MARKS: Marks illegible, 56 zolotnik
DIMENSIONS: 9/16 in. (1.4 cm)
PROVENANCE: Lillian Thomas Pratt
EXHIBITED: VMFA 1983
BIBLIOGRAPHY: Lesley 1976, cat. no. 88, p. 54, p. 52 (ill.)
BEQUEST OF LILLIAN THOMAS PRATT, 47.20.73

185 Miniature Easter Egg Pendant

Gold, enamel

The red enamel egg has a band of green-and-yellow enamel rectangles with white enamel borders.

MARKS: Workmaster's mark illegible, 72 zolotnik
DIMENSIONS: ¾ in. (1.9 cm)
PROVENANCE: Lillian Thomas Pratt
EXHIBITED: VMFA 1983
BIBLIOGRAPHY: Lesley 1976, cat. no. 69, p. 53, p. 52 (ill.); Curry 1995, cat. no. 36c, pp. 111, 104 (ill.)
BEQUEST OF LILLIAN THOMAS PRATT, 47.20.54

186 Miniature Easter Egg Pendant

Gold, enamel

The egg is decorated with swirling bands of red guilloché and opaque-white enamel, and is chased with gold laurel sprays.

MARKS: Maker's mark illegible, 56 zolotnik
DIMENSIONS: ¾ in. (1.9 cm)
PROVENANCE: Lillian Thomas Pratt
EXHIBITED: VMFA 1983
BIBLIOGRAPHY: Lesley 1976, cat. no. 72, p. 53, p. 52 (ill.)
BEQUEST OF LILLIAN THOMAS PRATT, 47.20.57

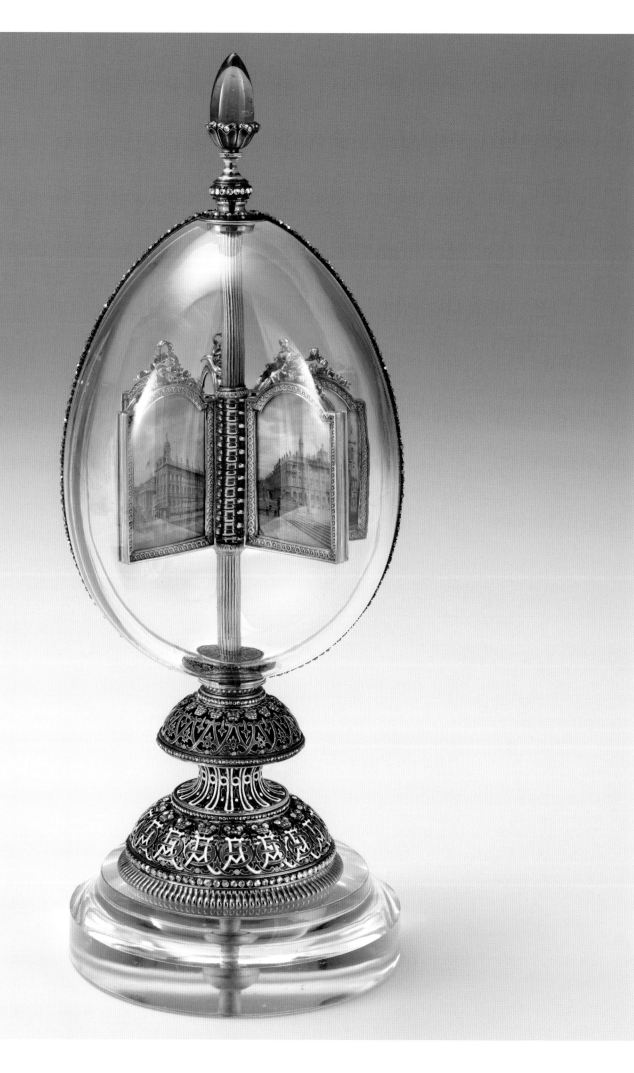

Imperial Easter Eggs

187 Imperial Rock-Crystal Easter Egg with Revolving Miniatures, 1896

Rock crystal, gold, enamel, sapphires, diamonds, emerald, watercolor, ivory

The two halves of the rock-crystal egg are joined by a green enamel band with rose-cut diamonds and are surmounted by a twenty-seven-carat Siberian cabochon emerald. The egg stands on a rock-crystal base decorated in champlevé enamels and is set with rose-cut diamonds forming the crowned monograms of Princess Alix of Hesse and by Rhine and of the later Tsaritsa Alexandra Feodorovna of Russia.

MARKS: Initials of workmaster Mikhail Perkhin, assay mark of St. Petersburg before 1899, 56 zolotnik; ten miniatures signed *Zehngraf*
DIMENSIONS: Egg: 9 ¾ in. (25.4 cm); miniatures: 1 × 1 ¹⁄₁₆ in. (2.5 × 2.8 cm)
Original fitted velvet case lining with imperial warrant mark of Fabergé, St. Petersburg, Moscow; the exterior stamped (later) with Cyrillic initials *AF* and no. 17546
PROVENANCE: Presented by Tsar Nicholas II to Tsaritsa Alexandra Feodorovna at Easter, March 1896 (kept in her study at the Winter Palace, 1896–1917); confiscated by order of the Provisional Government and sent to the Kremlin Armory for safekeeping in September 1917; sold by Antikvariat, Moscow, to Armand Hammer for 8,000 rubles in 1930; with Hammer Galleries, New York, between 1930 and around 1945 and advertised at $55,000; acquired by Mrs. Pratt in 1945
SELECTED BIBLIOGRAPHY: Hammer Galleries catalogue 1940?; Snowman 1968, pp. 85–86, 327–29 (ill.); Lesley 1976, cat. no. 46, p. 40, p. 37 (ill.); Solodkoff and Forbes 1984, p. 108, p. 72; Hill 1989, p. 14, pl. 39; Pfeffer 1990, pp. 13, 42, pl. 43; Curry 1995, frontispiece, pp. 12, 30–31, 36, 50–61, 107; Fabergé, Proler, and Skurlov 1997, pp. 10, 55, 68–69, 83, 124–25, 234, 241, 256, 259, 262
EXHIBITED: von Derwies Mansion 1902; Hammer Galleries 1937, 1939, 1943; VMFA 1947, 1948, 1954, 1983; V&A 1977; SAM 1984
NOTE: This was Nicholas's Easter present to Alexandra in 1896, two months before the coronation ceremonies. It cost 6,750 rubles.
The twelve miniature paintings on ivory represent some of Alexandra's favorite places (see next page): Neues Palais in Darmstadt (where she was born); Schloss Kranichstein (where she spent summer holidays); Altes Palais in Darmstadt (the official grand ducal residence); Rosenau in Coburg (where she accepted the proposal of Tsesarevich Nicholas); Alexander Palace, Tsarskoe Selo (still a modest residence in 1896, but where she and her family were to spend much of their time after 1905); Anichkov Palace, St. Petersburg (residence of the dowager empress, where the newlyweds Nicholas and Alexandra spent their first months together); Winter Palace, St. Petersburg (their official residence, and where they were married); Wolfsgarten near Darmstadt (one of the Hessian grand ducal residences, and where Alix received her Orthodox religious instruction); Palace Church, Coburg (where the young engaged couple spent their first days); Windsor Castle, near London (residence of Alexandra's grandmother, Queen Victoria, whom she and Nicholas visited in 1894); Balmoral Castle, Scotland (the British royal family's summer residence, which Alexandra and Nicholas visited in 1896 after their coronation); Osborne House, Isle of Wight (where Nicholas visited his fiancée and Queen Victoria in 1894).
BEQUEST OF LILLIAN THOMAS PRATT, 47.20.32 WITH MINIATURES; 47.20.369.1–.12 WITHIN

(left) The *Imperial Rock-Crystal Easter Egg* contains twelve miniatures.

IMPERIAL EASTER EGGS 265

(top) Neues Palais, Darmstadt

(above) Winter Palace, St. Petersburg

(top) Schloss Kranichstein, Darmstadt

(above) Wolfsgarten, Darmstadt

(top) Altes Palais, Darmstadt

(above) Palace Church, Coburg

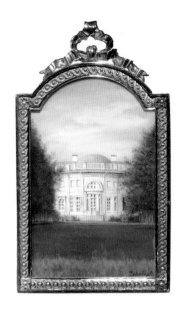

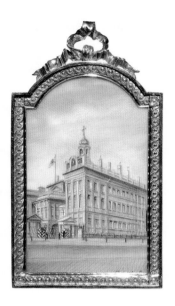

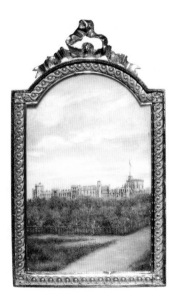

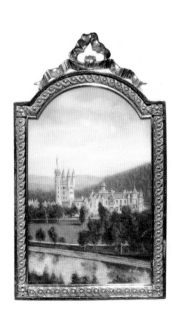

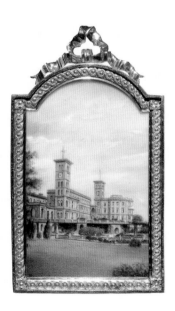

(top) Rosenau, Coburg

(above) Windsor Castle, near London

(top) Alexander Palace, Tsarskoe Selo

(above) Balmoral Castle, Scotland

(top) Anichkov Palace, St. Petersburg

(above) Osborne House, Isle of Wight

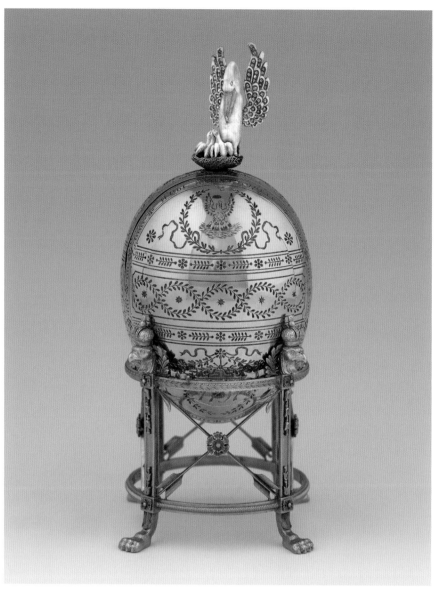

(above) *Imperial Pelican Easter Egg*, actual size

188 Imperial Pelican Easter Egg, 1897

Gold, diamonds, enamel, pearls, ivory, watercolor

The red-gold egg is engraved with Empire-style motifs, which include laurel wreaths surrounding the Pelican in Her Piety images and entwined laurel-leaf bands in the center. Other engravings include trophies of the Arts and Sciences, the date *1797–1897*, and the Cyrillic text translated on pages 272–3. The egg unfolds into eight oval panels graduated in size and rimmed with pearls. Each panel contains a miniature on ivory by Zehngraf of orphanages and educational institutions of which the dowager empress was patroness (see pp. 273–3). The frames surrounding the second and fifth miniatures are inscribed in Russian: *Visit this vine* (left), and *Ye shall dwell also* (right). The reverse of the miniatures (see pp. 274–5) are inscribed with the names of the institutions, the first and the last having two titles each. Between the fourth and fifth panels a gold leaf acts as an easel and a support for an enameled Pelican in Her Piety finial. The stand in which the egg rests has four paw feet with crowned eagle-head finials and crossed arrows.

(right) Pelican in Her Piety atop the *Imperial Pelican Easter Egg*

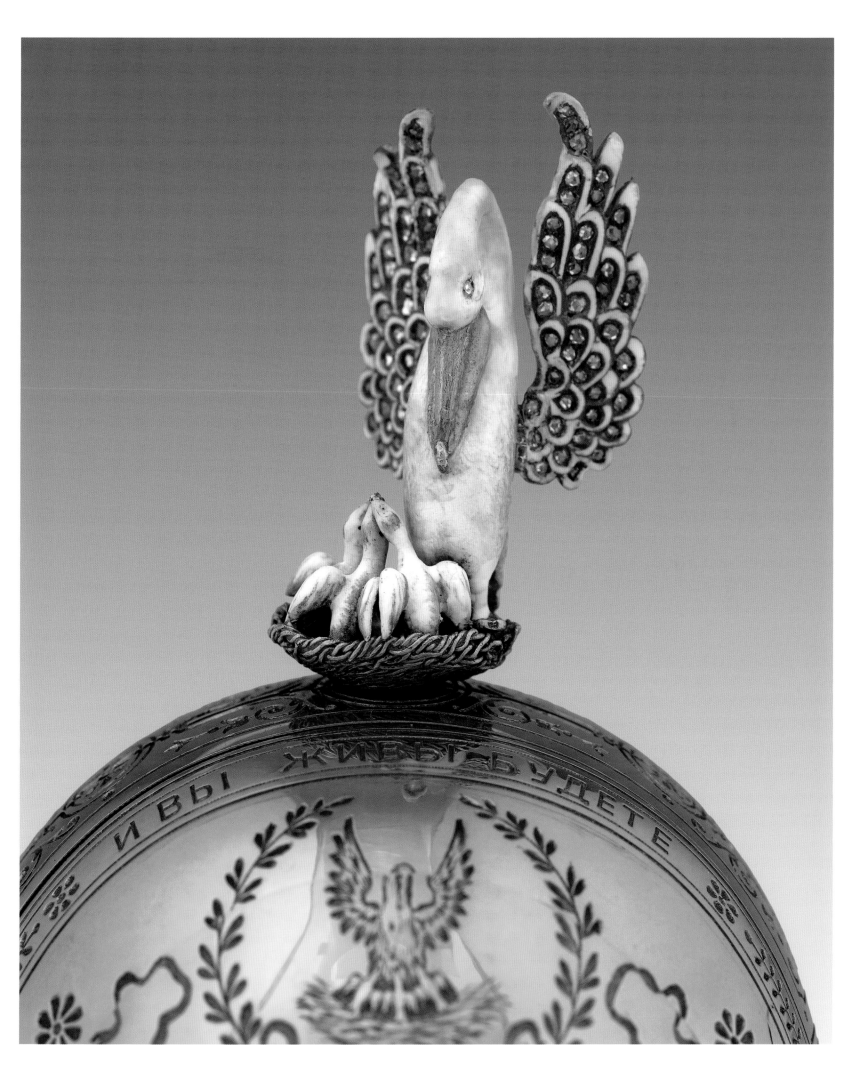

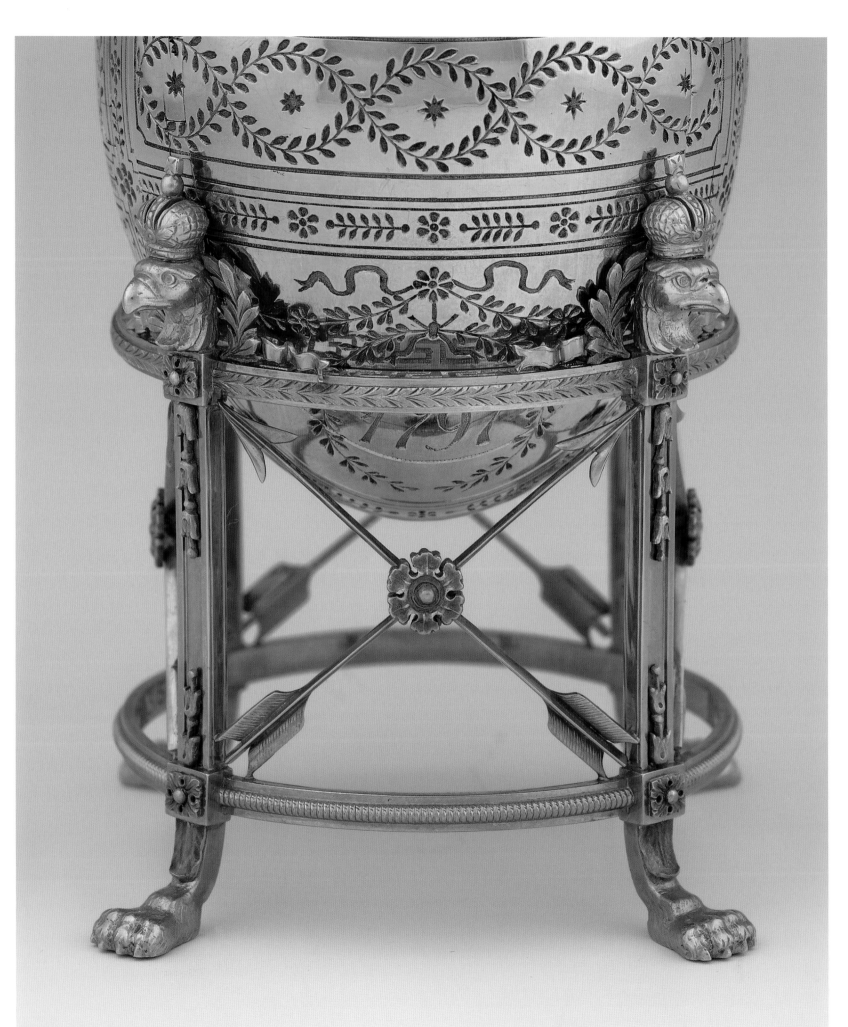

MARKS: Stamped *Fabergé*, initials of workmaster Mikhail Perkhin, assay mark of St. Petersburg before 1899, 56 zolotnik; miniatures signed *Zehngraf*

DIMENSIONS: Egg: 4 in. (10.1 cm); with stand: 5 ¼ in. (13.3 cm); four miniatures: 1 × 1 in. (4.4 × 3.2 cm), two miniatures: 2 × 1 in. (5.7 × 3.8 cm); two miniatures: 2 ⅛ × 1 ¹¹⁄₁₆ in. (5.4 × 4.3 cm)
Original fitted red-velvet case

PROVENANCE: Presented by Tsar Nicholas II to his mother, Dowager Empress Maria Feodorovna, in 1898 in her Anichkov Palace 1898–1917; confiscated by order of the Provisional Government and sent to the Kremlin Armory for safekeeping in 1917; sold by Antikvariat, Moscow, to Armand Hammer for 1,000 rubles in 1930; with Hammer Galleries, New York, between 1930 and 1936 to 1938; acquired by Mrs. Pratt between 1936 and 1938.

SELECT EXHIBITIONS: von Derwies Mansion 1902; Hammer Galleries, 1937, 1939; VMFA 1947, 1948, 1954, 1983; San Diego/Moscow 1989; *FA* 1996

SELECTED BIBLIOGRAPHY: Snowman 1962, pp. 87–88, pl. 330–1; Bainbridge 1968, pp. 66–67; Lesley 1976, cat. no. 49, p. 44, p. 45 (ill.); Hill 1989, pp. 33–34; Curry 1995, cat. no. 2, frontispiece, pp. 62–69, p. 107, p. 100 (ill.); Habsburg 1996, cat. no. 150, p. 159, p. 158 (ill.)

NOTE: The egg commemorates the 100th anniversary of the founding of the charities by Empress Maria Feodorovna. The Pelican in Her Piety is a symbol of charity that recalls the sacrifice of Christ: the pelican tears her flesh so that her children may feed and live.

BEQUEST OF LILLIAN THOMAS PRATT, 47.20.35 WITH MINIATURES; 47.20.370.1–.8 WITHIN

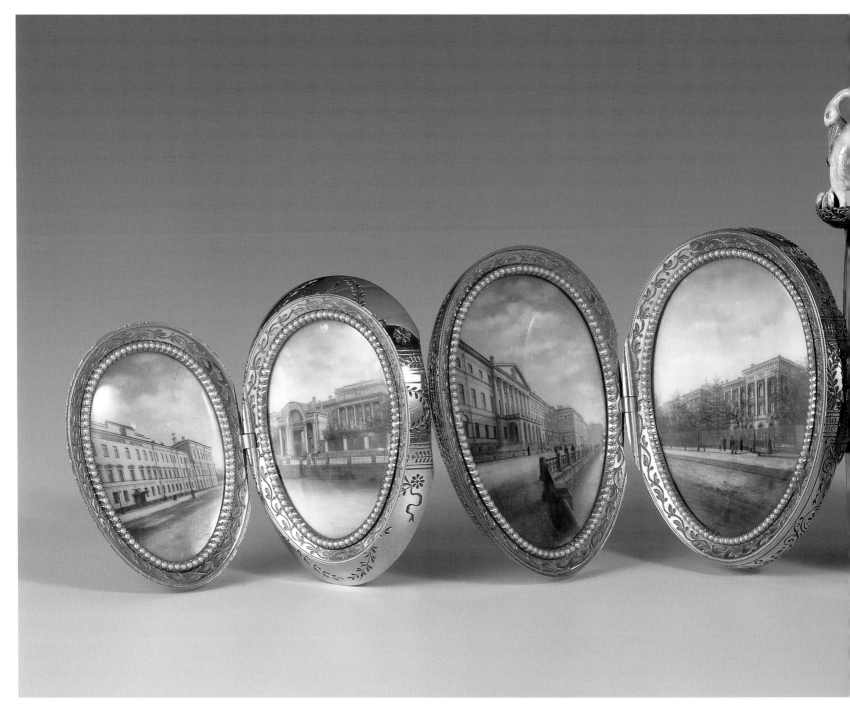

The Kseniinski Institute (1894)

The Moscow Nikolaevskii Orphanage (1837)

The Patriotic Institute (1827)

The Smol'nyi Institute (1764)

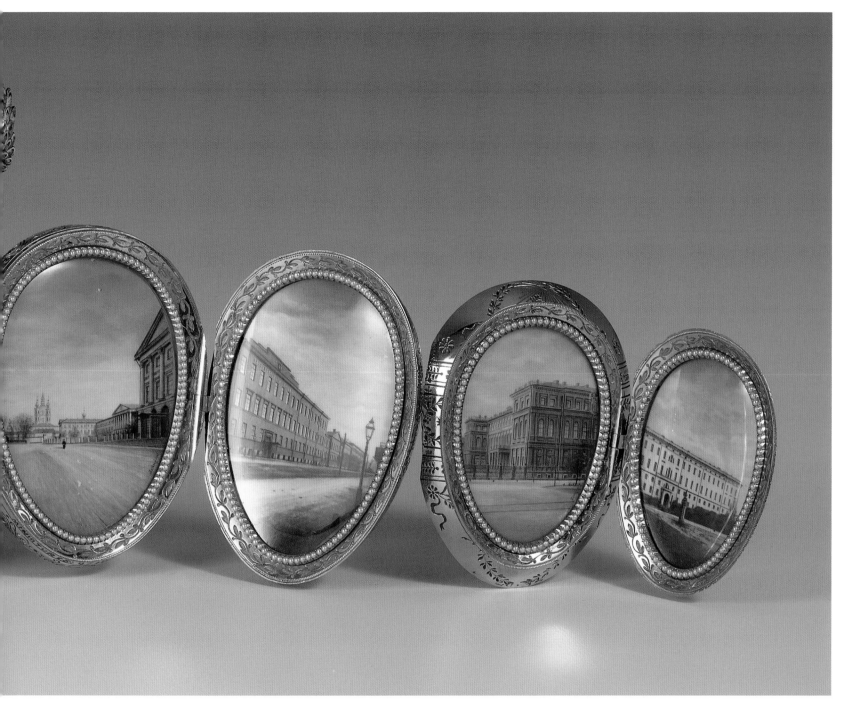

The Ekaterininski Institute (1798)

The Pavlovskii Institute (1898)

The St. Petersburg Nikolaevskii Orphanage (1837)

The Elisavetinskii Institute (1808)

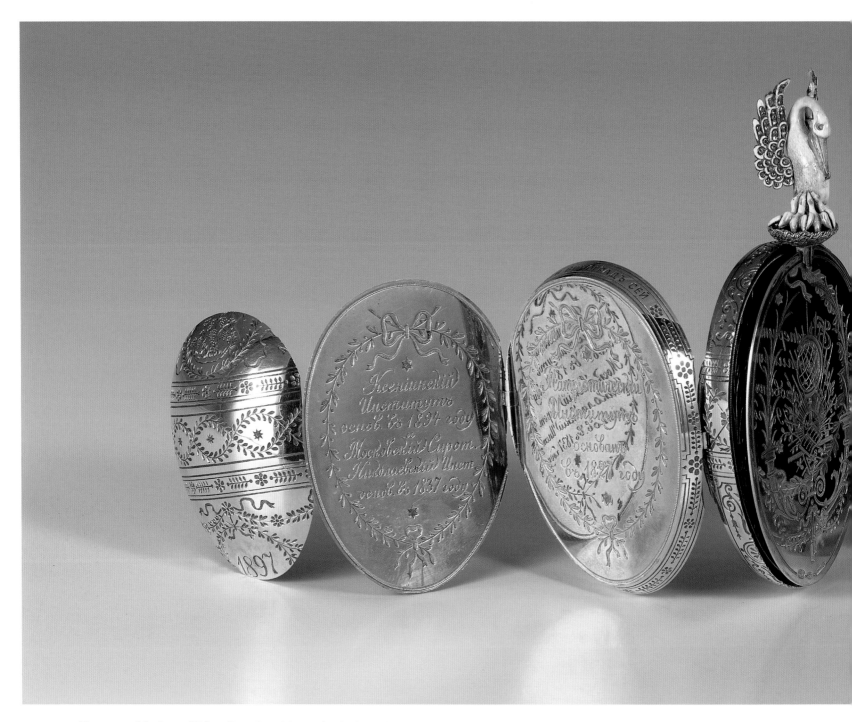

The reverse of the *Imperial Pelican Easter Egg* miniatures showing inscriptions

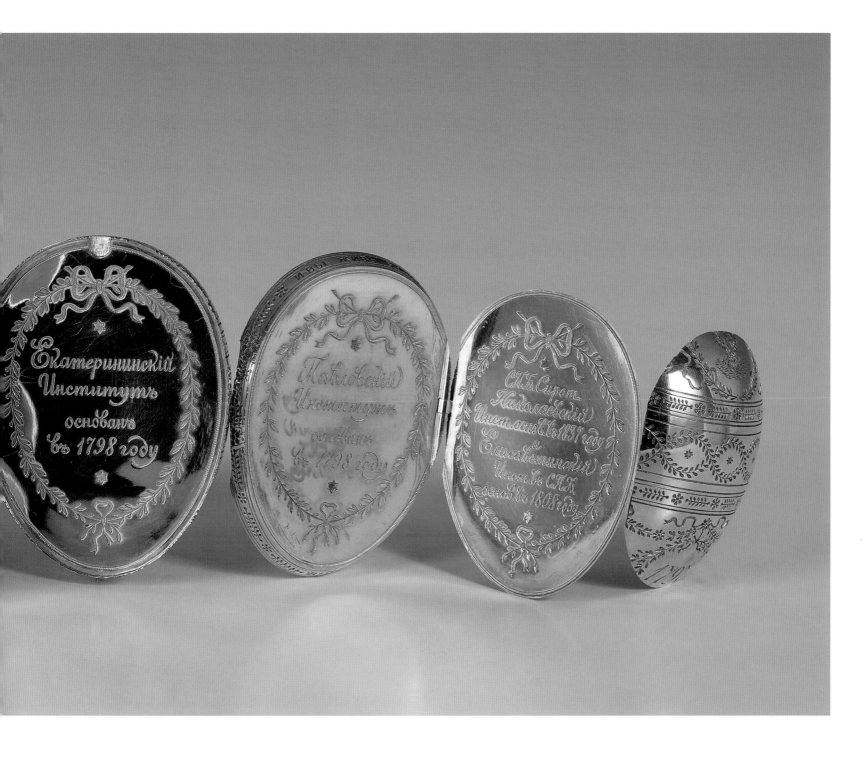

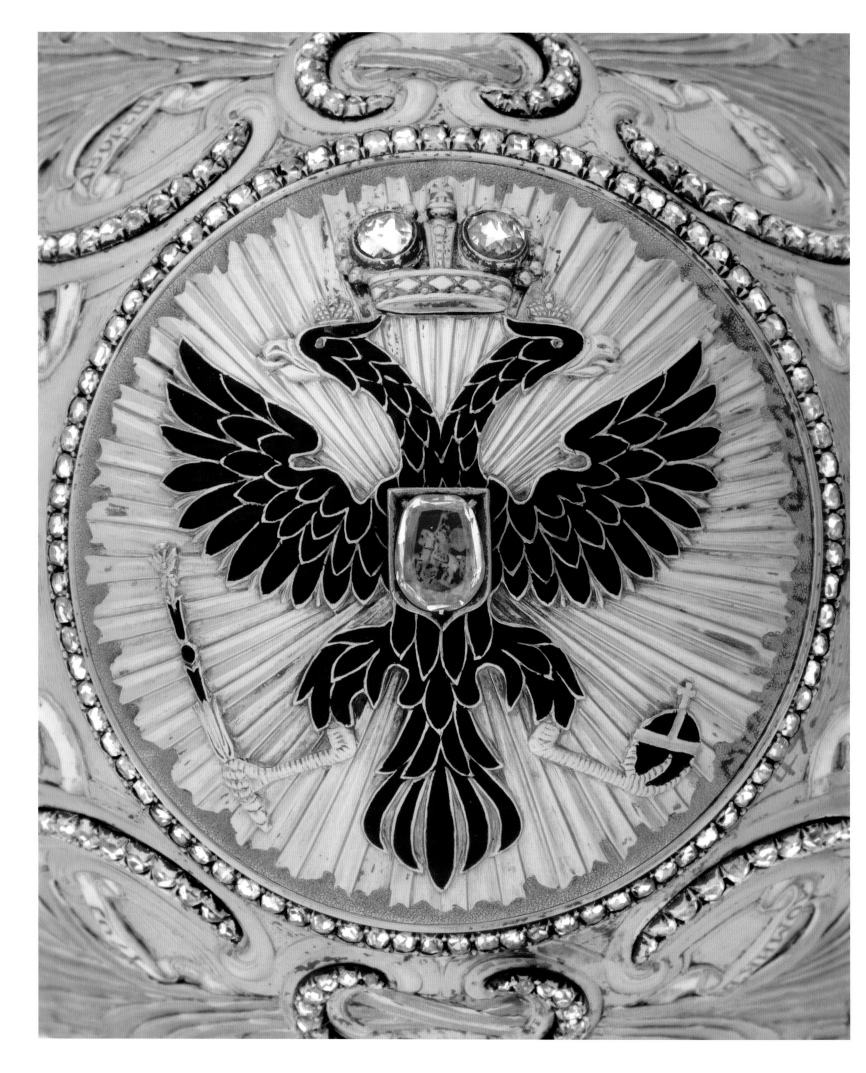

189 Imperial Peter the Great Easter Egg, 1903

Egg: Gold, platinum, diamonds, rubies, enamel, bronze, sapphire, watercolor, ivory, rock crystal; Statue: gilt bronze, sapphire

The egg is chased overall with four-colored rococo scrolls, shells, foliage, roses, laurel leaves, and bulrushes set with rubies and diamonds. Portrait miniatures on two opposite sides (see image right and on p. 278) correspond to the dates and contrasting royal residences on the other two sides: *1703* and Peter the Great's humble log hut versus *1903* and Tsar Nicholas II's Winter Palace (see images on p. 281). As the egg opens, a miniature replica of Etienne-Maurice Falconet's statue of Peter the Great on horseback rises out of the shell and is viewed against the yellow guilloché enamel interior of the cover (see p. 280).

MARKS: Stamped *K. Fabergé*, initials of workmaster Mikhail Perkhin, assay mark of St. Petersburg 1899–1908, assay master Iakov Liapunov, 56 and 72 zolotnik; one miniature signed *V. Zuev*
DIMENSIONS: Egg: 4⅛ (10.8 cm); statue: 1⁹⁄₁₆ (4 cm)
PROVENANCE: Presented by Tsar Nicholas II to Alexandra Feodorovna on Easter, 1903; in the Empress's study at the Winter Palace, 1903–17;

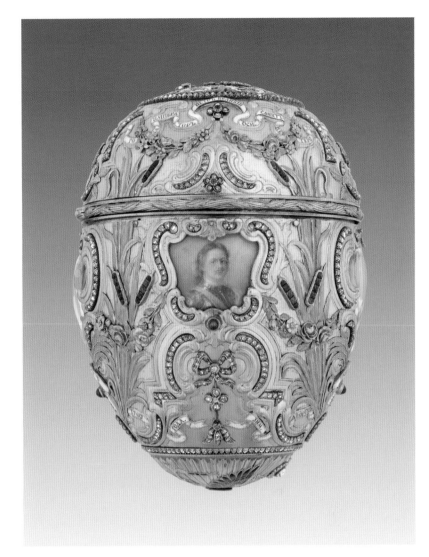

Portrait of Peter the Great. The egg is shown at actual size.

(left) Detail of the base of the *Imperial Peter the Great Easter Egg* features the imperial double-headed eagle and a miniature of St. George and the dragon.

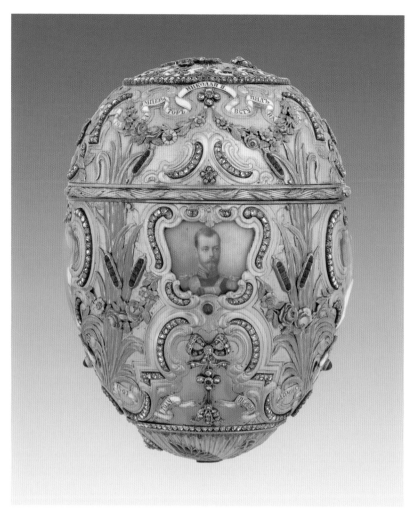

A miniature portrait of Nicholas II appears opposite Peter the Great's portrait.

confiscated by order of the Provisional Government and sent to the Kremlin Armory for safekeeping in 1917; sold by Antikvariat, Moscow, to an anonymous buyer (Alexander Schaffer?) for 4,000 rubles in 1933; with the Schaffer Collection of Russian Imperial Art Treasures, New York, between sometime in the 1930s to 1942; acquired by Mrs. Pratt in 1942.

SELECT EXHIBITIONS: V&A 1977; ALVR 1983; *FA* 1996; San Diego/Moscow 1989

SELECTED BIBLIOGRAPHY: Schaffer Collection catalogue, 1937?; Snowman 1962, pp. 93–94, p. 341; Bainbridge 1968, pl. 50; Lesley 1976, cat. no. 47, p. 40, p. 41 (ill.); Solodkoff and Forbes 1984, pp. 61, 64, 134–35, pl. 87; Hill 1989, p. 14, pl. 43/44; Curry 1995, cat. no. 3, frontispiece, viii, pp. 12–13, 36, 39, 70–77, 90, 93, 107; Habsburg 1996, cat. no. 152, pp. 162–63.

NOTE: Fabergé used a mid-18th-century egg-shaped *nécessaire* found in the Hermitage as a model for the *Imperial Peter the Great Easter Egg* (Habsburg 1986). The egg was created to commemorate the 200th anniversary (1703–1903) of the founding of St. Petersburg by Peter the Great. The colossal statue by Falconet (that inspired the poem "The Bronze Horseman" by Aleksandr Pushkin), used by Fabergé as a model for the egg's surprise, was erected by Catherine the Great in 1782, and it remains the outstanding landmark of the city on the Neva. In 1903 the egg cost 9,760 rubles, and in 1927 it was appraised at 16,008 rubles.

BEQUEST OF LILLIAN THOMAS PRATT, 47.20.33 WITH MINIATURES; 47.20.371.1–.4 WITHIN

(right) Detail of the Cyrillic initials of Nicholas II and Alexandra Feodorovna

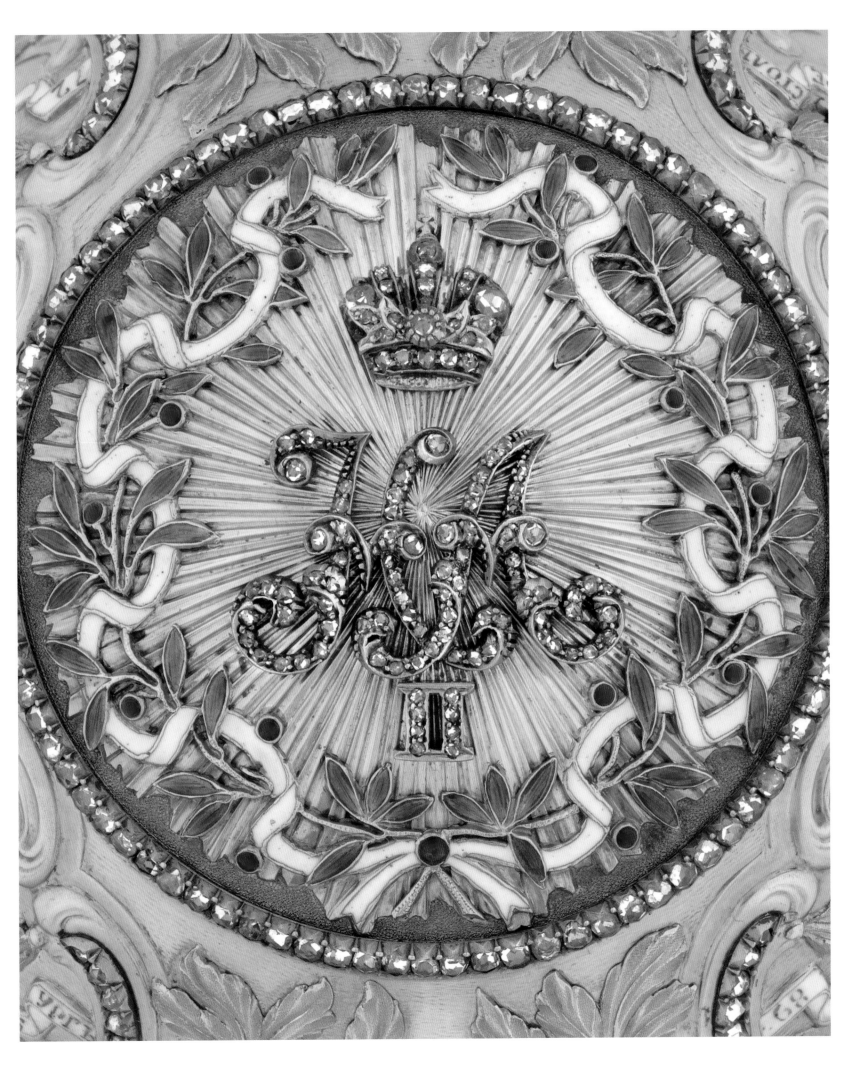

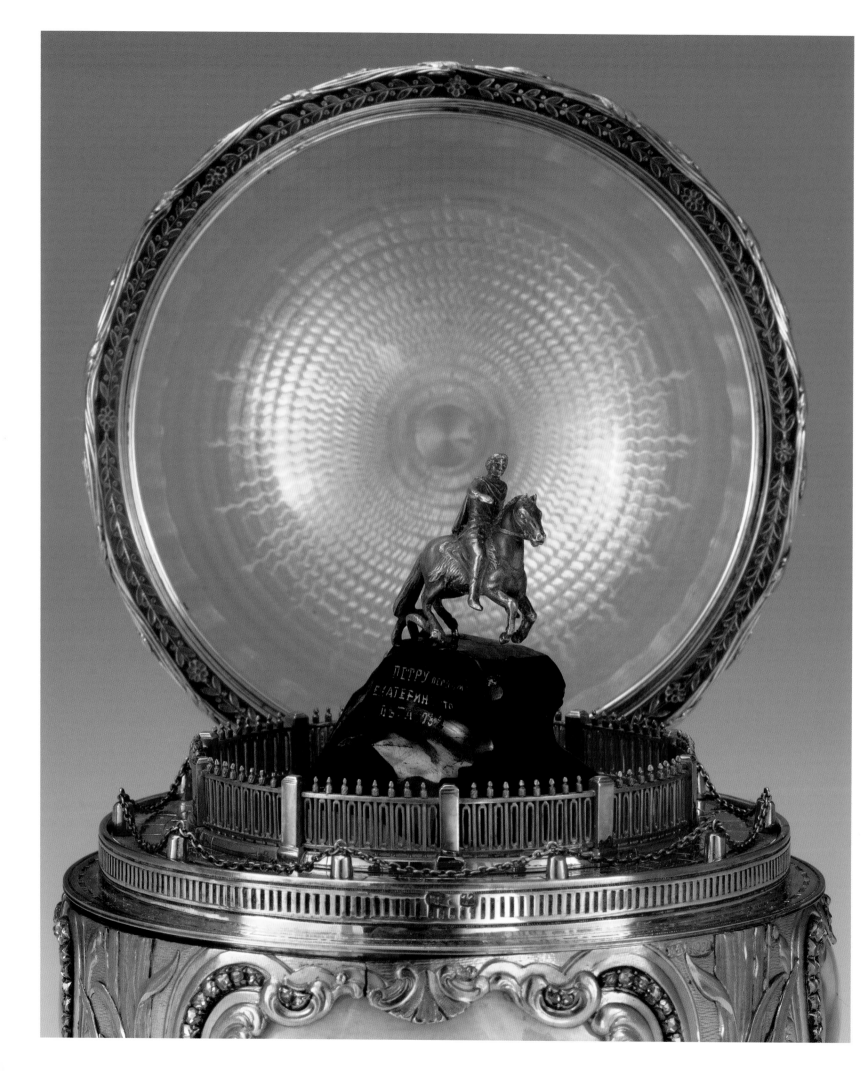

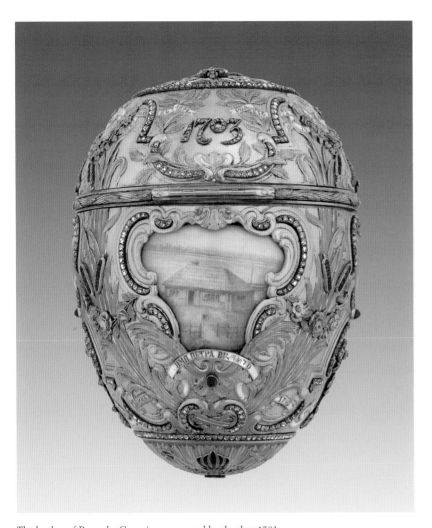

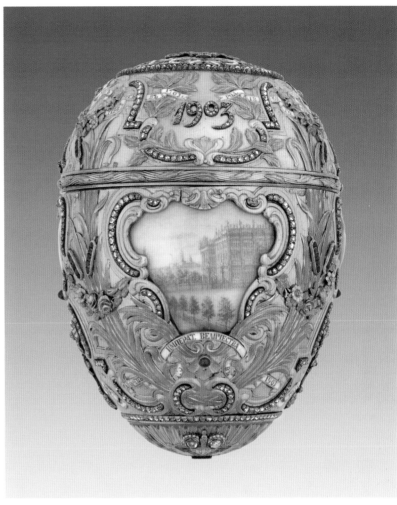

The log hut of Peter the Great is surmounted by the date 1703.

The Winter Palace of Nicholas II appears with the date 1903.

(left) When opened, a miniature of the Falconet statue of Peter the Great
rises from the imperial egg.

190 Imperial Tsesarevich Easter Egg, 1912

Egg: Lapis lazuli, gold, diamonds; Picture frame: platinum, lapis lazuli, diamonds, watercolor on ivory

The egg is formed of six lapis lazuli segments and is applied with a profuse gold Régence-style decoration of double-headed eagles, winged caryatids, hanging chinoiserie canopies, scrolls, flower baskets, and sprays concealing the joints. It is set with a large solitaire diamond at the base and a table diamond at the top over the Cyrillic monogram *AF* (for Alexandra Feodorovna) and the date of 1912. The surprise contained in the egg is a portrait painted on ivory, front and back, of the tsesarevich in a diamond-set, double-headed eagle standing on a lapis lazuli pedestal (see pp. 284–85).

MARKS: Stamped *Fabergé*, initials of workmaster Henrik Wigström

DIMENSIONS: Egg: 4 ¹⁵⁄₁₆ (12.5 cm); miniature with frame: 3 ¾ × 2 ¼ in. (9.5 × 5.7 cm)

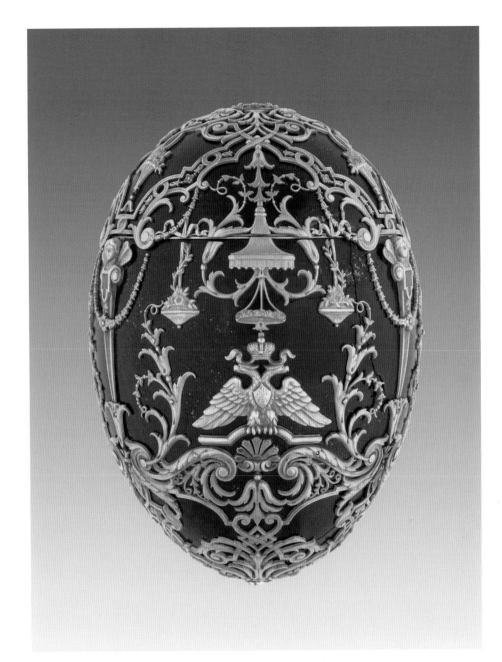

The front of the *Imperial Tsesarevich Easter Egg* is shown here at actual size.

(left) A detail of the Régence-style decoration inspired by Jean Bérain

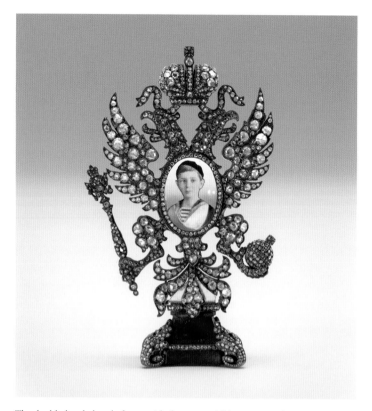

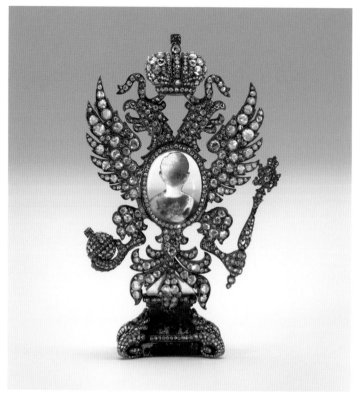

The double-headed eagle frame with the tsesarevich's portrait is the egg's surprise.

A further surprise is a view of the back of the tsesarevich.

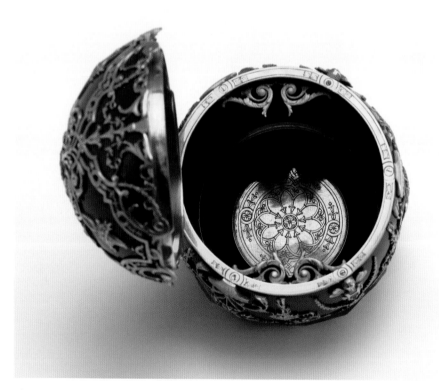

The interior of the imperial egg shows the platform on which the portrait frame rises.

PROVENANCE: Presented by Tsar Nicholas II to Tsaritsa Alexandra Feodorovna, Easter 1912; in the Empress's Mauve Room at the Alexander Palace, 1912–17; transferred by order of the Provisional Government to the Kremlin Armory for safekeeping in 1917; sold by Antikvariat, Moscow, to Armand Hammer for 8,000 rubles; with Hammer Galleries, New York, 1930–34; acquired by Mrs. Pratt in 1934 (from the "Collection of the Crown Jewels in the Alexander Palace, inv. 17547")

SELECT EXHIBITIONS: Hammer Galleries (Lord & Taylor) 1933, 1934, 1937, 1939; VMFA 1948, 1954, 1983; *FA* 1996

SELECTED BIBLIOGRAPHY: Bainbridge 1949, pp. 71–72, pl. 49; Snowman 1962, pp. 102–3, pl. 336–38; Lesley 1976, cat. no. 48, p. 43, p. 42 (ill.); Solodkoff and Forbes 1984, pp. 61, 64, 134–35, pl. 87; Hill 1989, p. 14, pl. 53; Curry 1995, cat. no. 4, front cover, viii, pp. 11, 29, 106–7; Habsburg 1996, cat. no. 151, p. 161, p. 160 (ill.)

NOTE: The original stand of the egg is lost. While the invoice for this egg is lost too, it and the *Napoleonic Egg* (in the Matilda Geddings Gray Foundation Collection) together cost 50,897 rubles, 50 kopecks in 1912.

BEQUEST OF LILLIAN THOMAS PRATT, 47.20.34 WITH MINIATURE; 47.20.368 WITHIN

(right) A miniature portrait of Tsesarevich Aleksei is revealed when the imperial egg is opened.

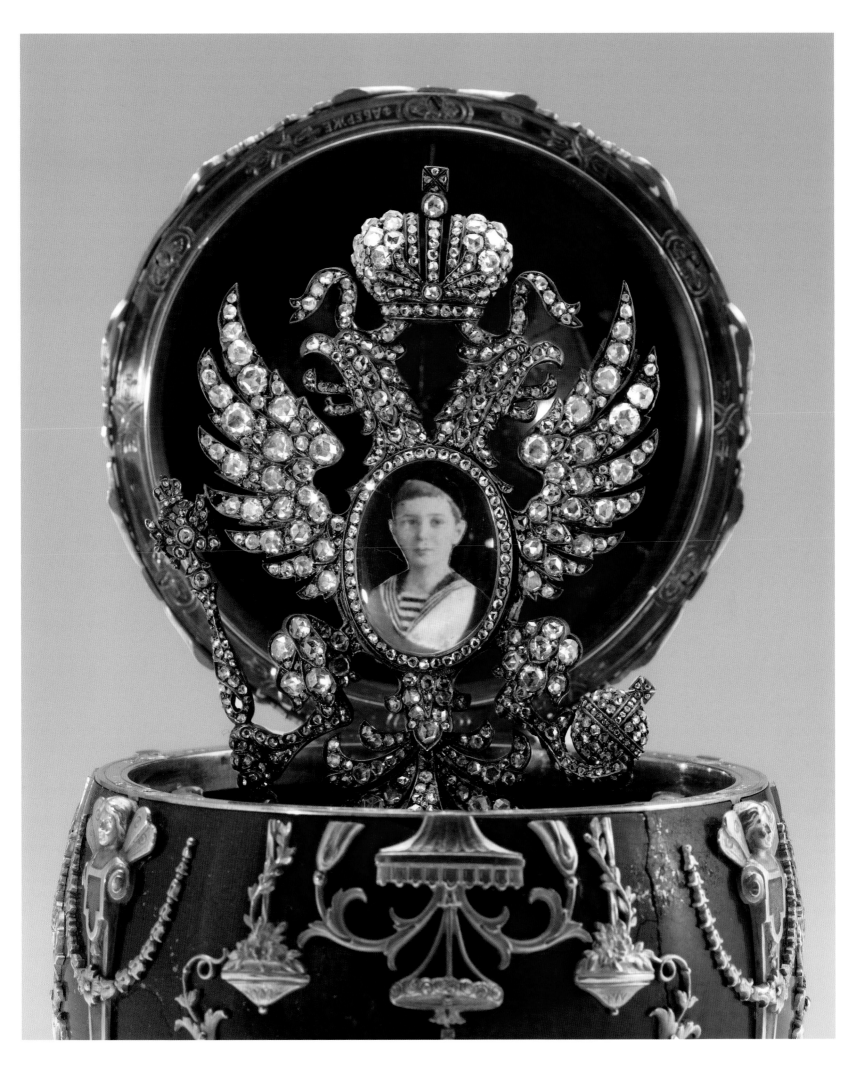

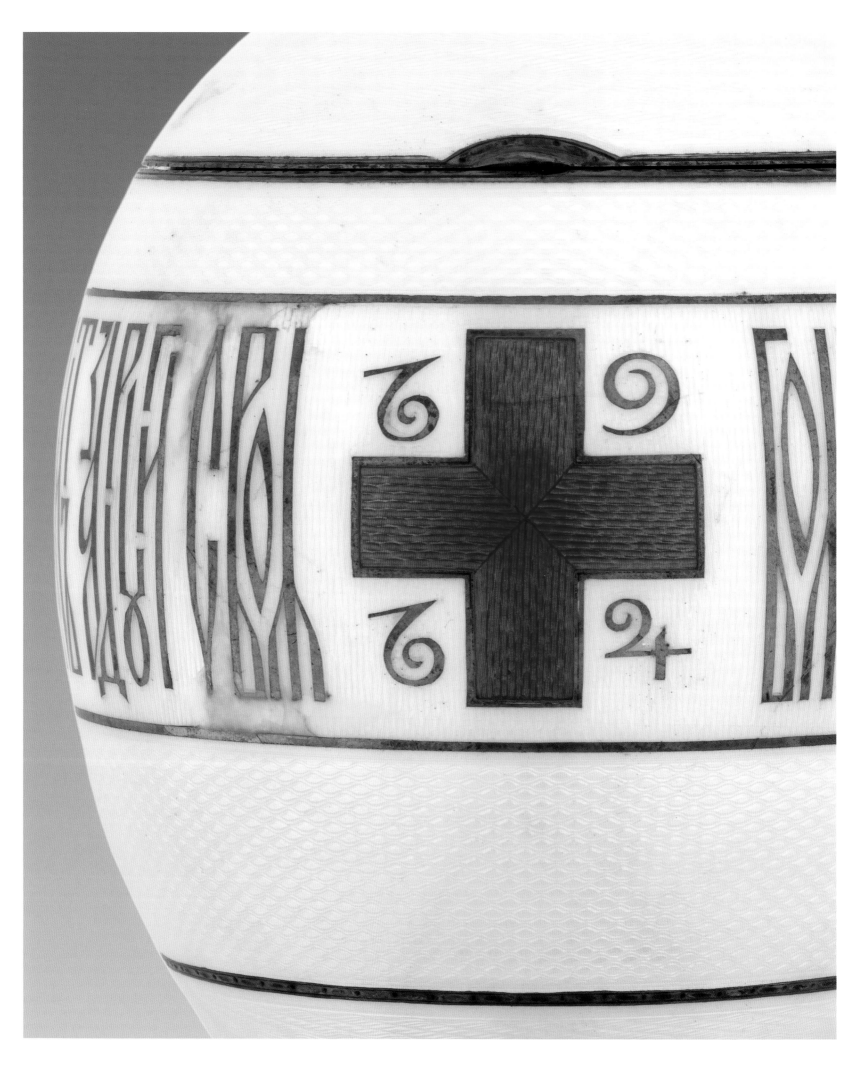

191 Imperial Red Cross Easter Egg with Portraits, 1915

Silver, gold, enamel, mother-of-pearl, watercolor on ivory

The egg is of opalescent-white guilloché enamel, is embellished with two opposing red guilloché enamel crosses bearing the dates *1914* and *1915*, and has a central band with a gilt Slavonic inscription: *Greater love hath no man than this, that a man lay down his life for his friends.* (John 15:13). The top of the egg has the crown and Cyrillic monogram *MF* for Dowager Empress Maria Feodorovna. The egg's surprise is a folding screen of oval portraits with gold borders within panels of white guilloché enamel. The backs are of mother-of-pearl and bear the monograms of the sitters who are dressed as Sisters of Mercy. They are (from left to right): Grand Duchess Olga, the tsar's sister; Grand Duchess Olga, eldest daughter of the tsar; Tsaritsa Alexandra Feodorovna; Grand Duchess Tatiana, the tsar's second daughter; Grand Duchess Maria Pavlovna, the tsar's first cousin (see p. 289).

MARKS: Stamped *Fabergé 1915*, initials of workmaster Henrik Wigström, assay mark of St. Petersburg 1908–17, miniatures signed Vasilii Zuev
DIMENSIONS: Egg: 3½ in, (8.9 cm); miniatures: 1 1/16 in. (2.7 cm)
PROVENANCE: Presented by Nicholas II to his mother, Maria Feodorovna, Easter 1915; probably in the dowager empress's Anichkov Palace until 1917; confiscated by order of the Provisional Government and sent to the Kremlin Armory for safekeeping in 1917; sold by Antikvariat, Moscow, to Armand Hammer in 1930; with Hammer Galleries, New York, 1930–33; acquired by Mrs. Pratt in 1933

The *Imperial Red Cross Easter Egg* is shown here at actual size.

The top of the egg displays the entwined Cyrillic initials of Dowager Empress Maria Feodorovna.

SELECT EXHIBITIONS: Hammer Galleries 1937, 1939; VMFA 1947, 1948, 1954, 1983; *FA* 1996

SELECTED BIBLIOGRAPHY: Bainbridge 1949, p. 73, pl. 56; Snowman 1962, pp. 38, 108, pl. 382; Lesley 1976, cat. no. 50, p. 47, p. 46 (ill.); Hill 1989, pp. 13–14, pl. 59; Curry 1995, cat. no. 5, frontispiece, pp. 11, 28, 45–47, 51, 84–89, 107; Habsburg 1996, cat. no. 153, pp. 164–65, p. 164 (ill.)

NOTE: The recipient of this egg, Dowager Empress Maria Feodorovna, was the president of the Red Cross. Her daughter-in-law Alexandra Feodorovna and her two eldest daughters tended the World War I wounded and the dying soldiers in a hospital organized by the tsaritsa at the Alexander Palace. Grand Duchess Maria Pavlovna ("the Younger," 1890–1958), daughter of Grand Duke Pavel Aleksandrovich, was married to Prince Wilhelm of Sweden in 1908, whom she divorced in 1913. She returned to Russia and served as a nurse during World War I. In 1915 Tsar Nicholas II presented his wife with a Red Cross egg (with an icon of the Resurrection) that forms part of the India Early Minshall Collection at the Cleveland Museum of Art (Fabergé, Proler, and Skurlov 1997).

BEQUEST OF LILLIAN THOMAS PRATT, 47.20.36 WITH MINIATURES; 47.20.372.1–5 WITHIN

(right) The hinged frames hold miniature portraits of the tsaritsa and grand duchesses (above); their initials appear on the back (below).

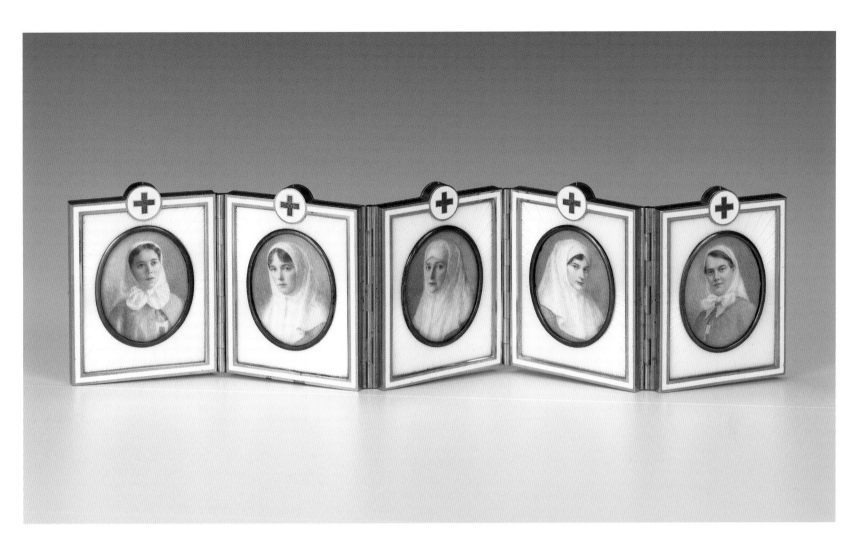

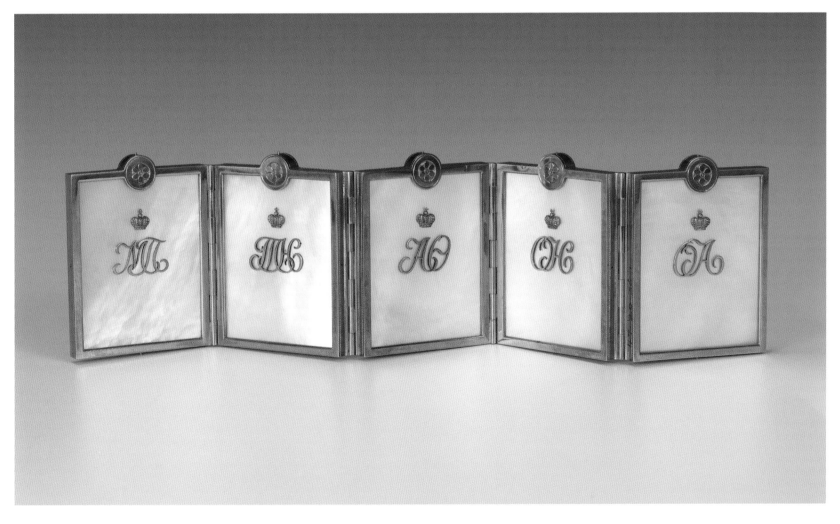

Catalogue: Other Makers

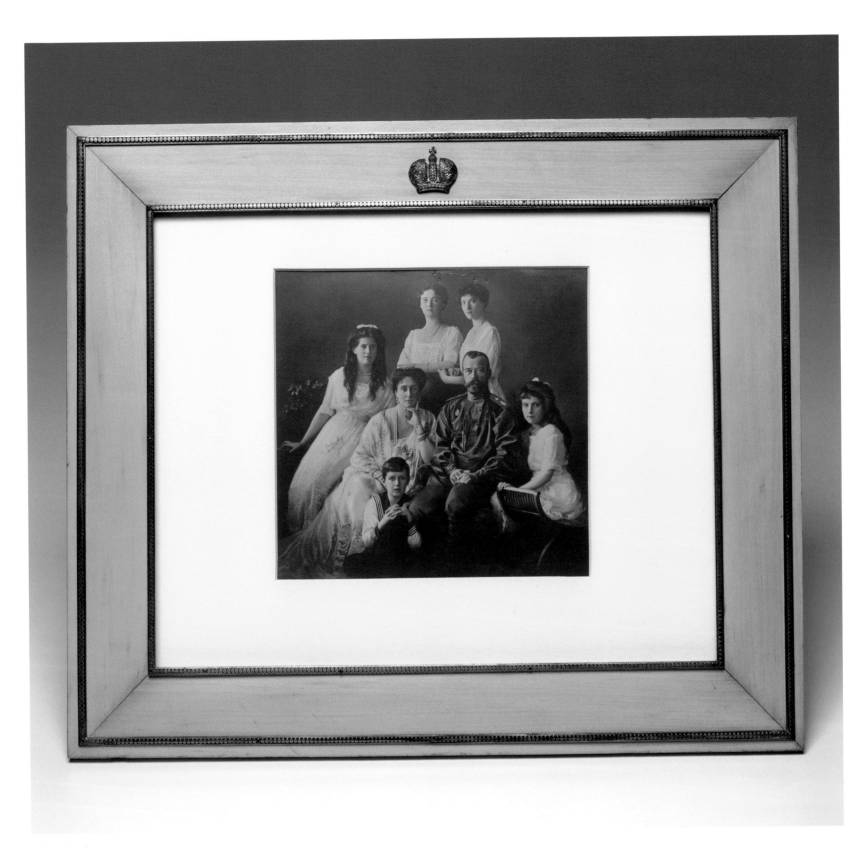

192 reduced

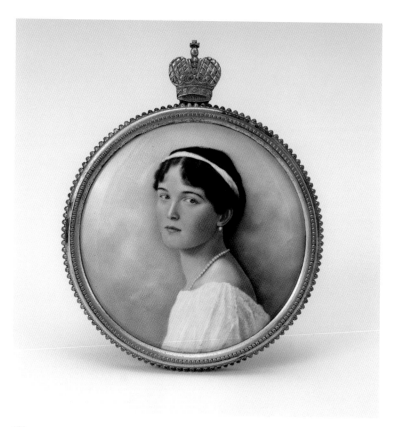

193

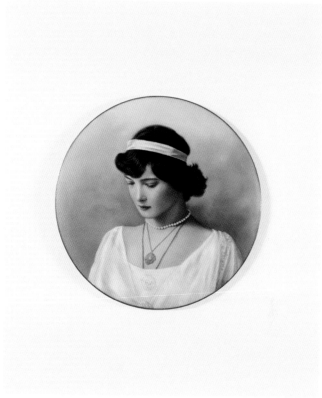

194

Base Materials

192 Birch-Wood Frame

Birch wood, silver

The ivory-colored frame is of birch wood and is applied with an imperial crown and beaded-silver borders. The frame originally contained a photograph of the imperial family, seen here, which later was replaced by a photograph of Karl Fabergé.

UNMARKED
DIMENSIONS: 12 ¼ in. (31.1 cm)
PROVENANCE: Lillian Thomas Pratt
BEQUEST OF LILLIAN THOMAS PRATT, 47.20.412

193 Frame

Silver gilt, enamel

The circular frame with its beaded border is surmounted by the imperial crown and has a silver-gilt strut. The miniature is of Grand Duchess Olga.

UNMARKED
DIMENSIONS: D 3 ½ in. (8.9 cm)
PROVENANCE: Lillian Thomas Pratt
EXHIBITED: VMFA 1983
BIBLIOGRAPHY: Lesley 1976, cat. no. 198, p. 95, p. 94 (ill.)
BEQUEST OF LILLIAN THOMAS PRATT, 47.20.341

194 Circular Miniature

Metal, enamel

The enamel miniature is of Grand Duchess Tatiana Nikolaevna (1897–1918), second daughter of Tsar Nicholas II.

UNMARKED
DIMENSIONS: D 2 ¼ in. (5.7 cm)
PROVENANCE: Lillian Thomas Pratt
BEQUEST OF LILLIAN THOMAS PRATT, 47.20.364

195 Imperial Paper Knife

Tortoise shell, gold

The polished blade is applied with a gold presentation inscription: *For Dear Alix from Misha.*

UNMARKED
DIMENSIONS: L 10 in. (25.3 cm)
PROVENANCE: Lillian Thomas Pratt
NOTE: "Misha" was Grand Duke Mikhail Aleksandrovich (1878–1904), who in 1911 morganatically married Natalia Sheremet'evskaia, later created Countess Brasova (see Chapter 6). The couple was expelled from Russia by the tsar, but Mikhail returned to fight bravely during the last years of the empire.
BEQUEST OF LILLIAN THOMAS PRATT, 47.20.396

196 Menu

Watercolor, ink, paper

The luncheon menu (*Oeufs de Sterletz, Vol au Vent aux Macarons, Beefsteaks grillés et Cotelettes, Punch à la romaine*), dated Ellenskoie, June 21, 1896, was written, painted, and signed by Grand Duchess Victoria Melita of Hesse and by Rhine. It is also signed by Tsar Nicholas II, Tsaritsa Alexandra Feodorovna, Grand Duke Sergii Aleksandrovich, Grand Duchess Elisaveta Feodorovna, Grand Duke Ernst-Ludwig of Hesse and by Rhine, and Princess Victoria of Battenberg.

DIMENSIONS: 8 1/16 × 10 7/8 (20.5 × 27.6 cm)
PROVENANCE: The Schaffer Collection of Russian Imperial Art Treasures, February 1, 1936, #1006; Lillian Thomas Pratt
BEQUEST OF LILLIAN THOMAS PRATT, 47.20.416

197 Beaker

Enamel, metal

This piece was created for the occasion of the coronation of Tsar Nicholas II in 1896.

UNMARKED
DIMENSIONS: 4 1/8 in. (10.5 cm)
PROVENANCE: Mrs. M. N. Blakemore
GIFT OF MRS. M. N. BLAKEMORE IN MEMORY OF HER HUSBAND, MAJOR MAURICE NEVILLE BLAKEMORE, 71.1.2

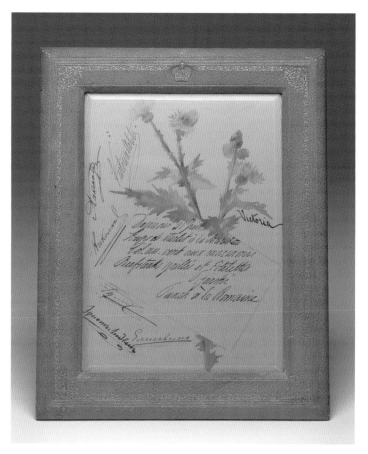

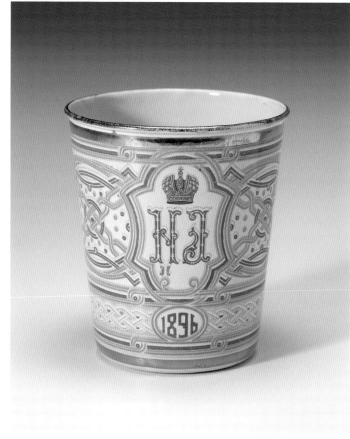

196 reduced

197 reduced

198 Photograph Album

NOT ILLUSTRATED

Leather, silver, albumen prints

The album bears the bookplate of Nicholas II and contains original photographs of the imperial family. It is bound in navy blue morocco and has white moiré paper doublures. It is applied with both a silver shield and clasp.

DIMENSIONS: 8 ½ in. (21.6 cm)

PROVENANCE: Said to have been found in the private study of Nicholas II in the Alexander Palace, Tsarskoe Selo; Lillian Thomas Pratt

NOTE: Sitters in the album are identified by Mrs. Pratt as Emperor Alexander II (photo 21640); Emperor Alexander II (photo 21641); Empress Marie Alexandrovna (photo 21642); Emperor Alexander II (photo 21643); Emperor Alexander II (photo 21644); Empress Marie Alexandrovna, wife of Alexander II (photo 21645); Emperor Alexander II (photo 21646); Alexander II and Marie Feodorovna (photo 21647); Empress Marie Feodorovna and Nicholai II (photo 21648); Emperor Alexander III (photo 21649); Grand Duchess Xenia, sister of Nicholai II (photo 21650); Three generations of German rulers. The infant is the present ex-crown Prince [as of 1947] (photo 21651); Empress Marie Feodorovna and Nicholai II (photo 21652); Nicholai II [Grand Duke Nicholai Alexandrovitch] (photo 21653); Grand Duke George Alexandrovitch [brother of Nicholai II] (photo 21654); Grand Duke Vladimir Alexandrovitch (photo 21655); Grand Duchess Marie Pavlovna, his wife (photo 21656); Grand Duchess Marie Pavlovna, wife of Grand Duke Vladimir, and her children (photo 21657); Grand Duke Vladimir and his sons, Kyril and Boris (photo 21658); Grand Duke Vladimir Alexandrovitch (photo 21659); Grand Duchess Marie Pavlovna, his wife (photo 21660); Grand Dukes Kyril and Boris Vladimirovitch (photo 21661); Grand Duke Kyril Vladimirovitch (photo 21662); Grand Duchess Marie Alexandrovna (photo 21663); Grand Duke Alexis Vladimirovitch (photo 21664); Grand Duke Serge Alexandrovitch (photo 21665); Grand Duke Paul Alexandrovitch (photo 21666); Grand Duke Paul Alexandrovitch (photo 21667); photo 21668 skipped on Mrs. Pratt's listing; Grand Dukes Paul and Alexis and Duke of Oldenburg (photo 21669); Grand Dukes Serge Alexandrovitch and Konstantin Konstantinovitch and the sister of Konstantin, Olga, later Queen of Greece (photo 21670); Grand Duke Nicholai Nicholaevitch (photo 21671); Grand Duchess Marie Pavlovna, wife of Grand Duke Vladimir (photo 21672); Grand Duke Nicholai Alexandrovitch [Nicholai II] (photo 21673); Grand Duchess Olga Konstantinovna, Queen of Greece (photo 21674); Grand Duchess Militza Nicholaevna (photo 21675); Duchess Alexandra of Aldenburg, 1st wife of Grand Duke Nicholai Nicholaevitch, died in 1900 (photo 21676); Grand Duke Serge Alexandrovitch and Duchess Elizabeth Fedorovna (photo 21677); Grand Duke Vyacheslav Konstantinovitch (photo 21678); Grand Duke Dmitri Konstantinovitch (photo 21679); Grand Duke Konstantin Konstantinovitch (photo 21680); and Grand Duchess Marie Alexandrovna, Duchess de Saxe-Coburg Gotha (photo 21681).

BEQUEST OF LILLIAN THOMAS PRATT, 47.20.376.1–42

199 reduced 200 reduced

199 Imperial Presentation Porcelain Easter Egg

Porcelain, silk ribbon

The glazed, bluish-white porcelain egg is gilded with the cypher of Tsar Alexander III and has a red silk ribbon.

Imperial Porcelain Manufactory, St. Petersburg
DIMENSIONS: 4½ × 3¼ in. (11.4 × 8.3 cm)
PROVENANCE: Mrs. K. R. Franklin
GIFT OF MRS. K. R. FRANKLIN IN MEMORY OF
EDGAR P. EVERHARD, 84.48

200 Imperial Presentation Porcelain Easter Egg

Porcelain, silk ribbon

The *sang de boeuf* egg bears the gilded cypher of Tsaritsa Maria Feodorovna and has a cream silk ribbon.

Imperial Porcelain Manufactory, St. Petersburg
DIMENSIONS: 4⅛ × 3 in. (10.5 × 7.6 cm)
PROVENANCE: Mrs. K. R. Franklin
GIFT OF MRS. K. R. FRANKLIN IN MEMORY OF
EDGAR P. EVERHARD, 84.83

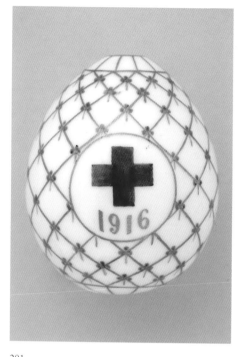

201

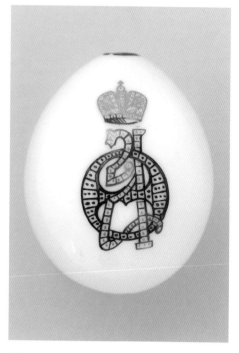

202

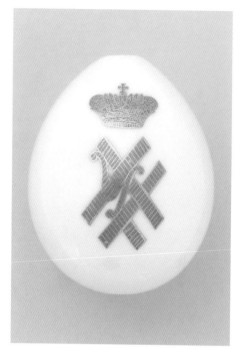

203

201 Imperial Presentation Porcelain Easter Egg

Porcelain

The egg is painted in an oval surround with the crowned cypher *MF* (for Dowager Empress Maria Feodorovna). The reverse side is painted with a red cross insignia and trelliswork.

Imperial Porcelain Manufactory, St. Petersburg 1914–16

DIMENSIONS: 2 ½ in. (6.3 cm)

PROVENANCE: Tsaritsa Maria Feodorovna; Lillian Thomas Pratt

BIBLIOGRAPHY: Lesley 1976, cat. no. 52, p. 49, p. 48 (ill.)

BEQUEST OF LILLIAN THOMAS PRATT, 47.20.38

202 Imperial Presentation Porcelain Easter Egg

Porcelain

The plain-white egg is painted with the crowned cypher *AF* (for Tsaritsa Alexandra Feodorovna) and the reverse with a red cross.

Imperial Porcelain Manufactory, St. Petersburg 1914–16

DIMENSIONS: 2 ½ in. (6.3 cm)

PROVENANCE: Tsaritsa Alexandra Feodorovna; Lillian Thomas Pratt

BIBLIOGRAPHY: Lesley 1976, cat. no. 53, p. 49, p. 48 (ill.)

BEQUEST OF LILLIAN THOMAS PRATT, 47.20.39

203 Imperial Presentation Porcelain Easter Egg

Porcelain

The plain-white porcelain egg is painted with the crowned gilded cypher *AN* (for Tsesarevich Aleksei Nikolaevich).

Imperial Porcelain Manufactory, St. Petersburg 1914–16

DIMENSIONS: 2 ½ in. (6.3 cm)

PROVENANCE: Tsesarevich Aleksei Nikolaievich; Lillian Thomas Pratt

BIBLIOGRAPHY: Lesley 1976, cat. no. 54, p. 49, p. 48 (ill.)

BEQUEST OF LILLIAN THOMAS PRATT, 47.20.40

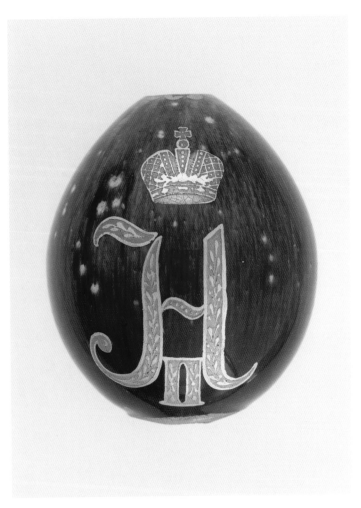

204

204

204 Two Imperial Presentation Porcelain Easter Eggs

Porcelain

The *sang de boeuf* egg (left) is gilt with the crowned cypher *NII* for Tsar Nicholas II. The royal-blue egg (right) bears the gilt crowned cypher *AF* for Tsaritsa Alexandra Feodorovna.

Imperial Porcelain Manufactory, St. Petersburg, ca. 1900
DIMENSIONS: 3 ½ in. (9 cm) each
PROVENANCE: Miss Alice Dodge
EXHIBITED: PFAC 1981
GIFT OF MISS ALICE DODGE IN MEMORY OF HER
PARENTS, HENRY PERCIVAL DODGE, AMERICAN
MINISTER TO PANAMA, 1911–13, AND MARGARET
ADAMS DODGE, 76.17.1–2

205 enlarged

206 reduced

205 Imperial Presentation Porcelain Easter Egg

Porcelain

An oval surround on the egg is painted with a crowned cypher *AF* (for Tsaritsa Alexandra Feodorovna) and with a band of roses.

Imperial Porcelain Manufactory, St. Petersburg, ca. 1900

DIMENSIONS: 3 ½ in. (9 cm)

PROVENANCE: Tsaritsa Alexandra Feodorovna; Lillian Thomas Pratt

BIBLIOGRAPHY: Lesley 1976, cat. no. 51, p. 49, p. 48 (ill.)

BEQUEST OF LILLIAN THOMAS PRATT, 47.20.37

206 Imperial Presentation Easter Egg

Rhodonite, silver gilt, gold

The pink rhodonite egg is applied with the crowned gold cypher *MF* (for Dowager Empress Maria Feodorovna) and has a silver-gilt bowknot above.

DIMENSIONS: 2 ⅝ in. (6.6 cm)

PROVENANCE: Dowager Empress Maria Feodorovna; Lillian Thomas Pratt

BIBLIOGRAPHY: Lesley 1976, cat. no. 57, p. 51, p. 49 (ill.)

BEQUEST OF LILLIAN THOMAS PRATT, 47.20.44

207 Case for an Easter Egg

NOT ILLUSTRATED

Ivory, satin

The egg-shaped ivory box opens to reveal a miniature nephrite egg.

UNMARKED

DIMENSIONS: 2 in. (5.1 cm)

PROVENANCE: Schaffer, April 2, 1936, #1179; Lillian Thomas Pratt

BEQUEST OF LILLIAN THOMAS PRATT, 47.20.42

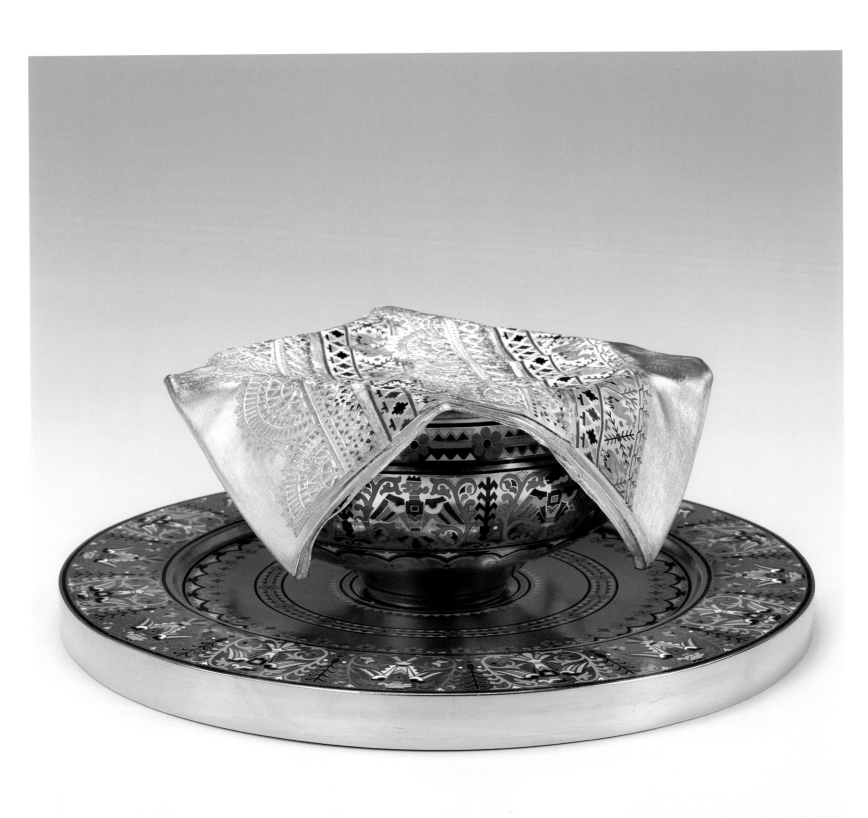

Champlevé and Cloisonné Enamel

208 Plate, Bowl, and Cover

Silver gilt, enamel

The plate and bowl are decorated with champlevé enamel bands of stylized birds and crowns in blue and red hues. The trompe l'oeil cover is shaped as a napkin "embroidered" with alternating bands of "lace" and colorful geometric ornaments and roosters.

MARKS: P. Ovchinnikov, assay mark of Moscow 1883, assay master Vasilii A. Petrov, 88 zolotnik
DIMENSIONS: Plate: D 11 in. (27.9 cm); bowl: 3 5/16 × D 6 in. (8.4 × 15.2 cm); cover: L 11 in. (27.9 cm)
PROVENANCE: Jerome and Rita Gans Collection of Russian Enamel
NOTE: Trompe l'oeil articles simulating basket weave, wood grain, and fabric were popular items for Russian 19th-century silversmiths working in the Russian Revival style. The cover to this set simulates the napkin that was used at a bread-and-salt ceremony.
JEROME AND RITA GANS COLLECTION OF RUSSIAN ENAMEL, 98.20a–c

209 Beaker

ILLUSTRATED ON PAGE 302

Silver gilt, enamel

The tall tapering beaker is applied with St. Petersburg's crowned coat of arms on a claret-red field. It is decorated with scrolling leaves and flowers in blues and violets in shaded cloisonné enamels on a stippled ground. An inscription on the interior of the beaker's lip reads: *a M Delcassé la Ville de St. Petersbourg.*

MARKS: Imperial warrant mark of P. Ovchinnikov, assay mark of Moscow before 1899, 84 zolotnik
DIMENSIONS: 11 3/8 in. (28.8 cm)
PROVENANCE: Presented by the City of St. Petersburg to Théophile Delcassé; Jerome and Rita Gans Collection of Russian Enamel
NOTE: The recipient, Théophile Delcassé (1852–1923), French statesman and minister of the colonies (1894–1895) under Prime Minister Dupuy and Minister of Foreign Affairs (1898–1899), was received in St. Petersburg in 1899 and again in 1901. Delcassé was also awarded a large diamond-set nephrite imperial portrait box by Tsar Nicholas II in 1901 (see Tillander-Godenhielm 2005).
JEROME AND RITA GANS COLLECTION OF RUSSIAN ENAMEL, 98.15

210 Tankard and Cover

ILLUSTRATED ON PAGE 303

Silver gilt, enamel

The octagonal tankard is of an architectural shape with arches supported by twisted columns at the bottom that are decorated in cloisonné enamel with scrolling foliage on a stippled-gold ground. Its circular upper half has braided filigree bands and alternating panels of foliage on a blue and green ground. The tankard's hinged cover is shaped as a crown with a ball finial and hook handle. The base is decorated with a red plique-à-jour firebird in a foliate surround.

MARKS: Maker's mark P. Ovchinnikov, assay mark of Moscow 1890, Cyrillic mark of assay master *LO*, 88 zolotnik
DIMENSIONS: 8 1/4 in. (21 cm)
PROVENANCE: Jerome and Rita Gans Collection of Russian Enamel
NOTE: The design of this tankard is based on a Turkish prototype formerly in the Kremlin Armory Museum, known to Russian silversmiths through the drawings published by Fedor Solntsev in his celebrated six-volume work *Antiquities of the Russian State 1849–1953.* A number of similar tankards were produced by the Ovchinnikov firm (Odom 1996).
JEROME AND RITA GANS COLLECTION OF RUSSIAN ENAMEL, 98.17

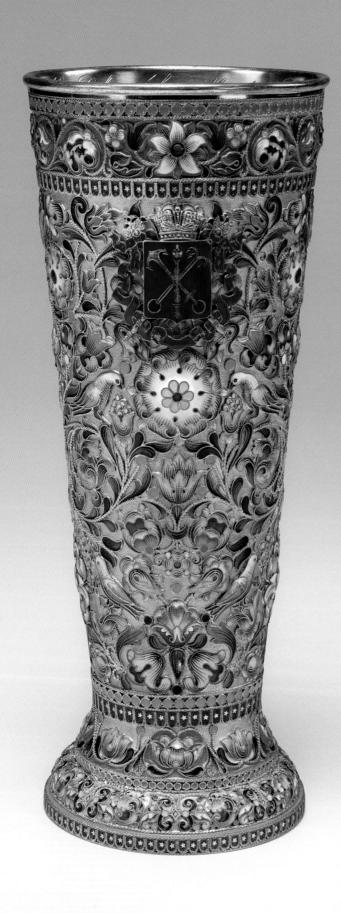

209 reduced

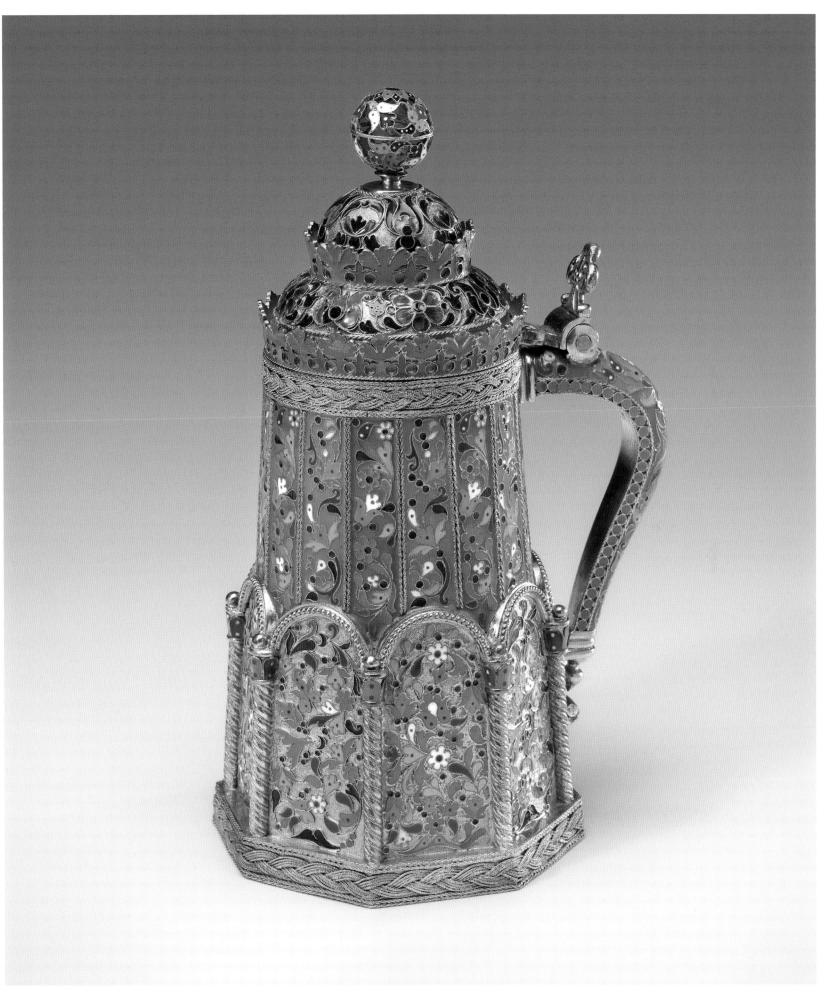

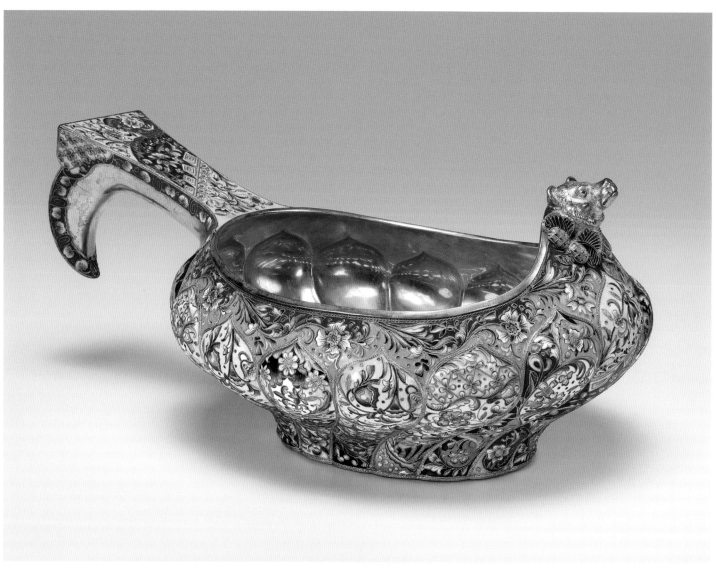

211 reduced

211 Kovsh

Silver gilt, enamel, Siberian hardstones

The large lobed ceremonial *kovsh* is decorated in shaded cloisonné enamels and its outer bosses with scrolling foliage on a cream ground surrounded by pastel floral patterns on a predominantly mint-green field. The hook handle and bear's-head prow are set with cabochon-hardstone eyes.

MARKS: Maker's initials *MS* for Maria Semenova, assay mark of Moscow 1908–17, 84 zolotnik

DIMENSIONS: L 16¼ in. (41.2 cm)

PROVENANCE: Jerome and Rita Gans Collection of Russian Enamel

JEROME AND RITA GANS COLLECTION OF RUSSIAN ENAMEL, 98.16

212 Pictorial Enamel Card Case

Silver gilt, enamel

The cover and back of this card case are painted *en plein* with the King of Hearts and the Queen of Spades surrounded by scrolling shaded cloisonné foliage. The ten of clubs, the ten of spades, and a Queen of Hearts appear on the top of the case.

MARKS: Maker's initials *IS* for Ivan Saltykov, assay mark of Moscow before 1899, 84 zolotnik

DIMENSIONS: 4 3⁄16 in. (10.4 cm)

PROVENANCE: Jerome and Rita Gans Collection of Russian Enamel

NOTE: The three cards on the top of the case were traditional fortune-telling cards.

JEROME AND RITA GANS COLLECTION OF RUSSIAN ENAMEL, 98.13

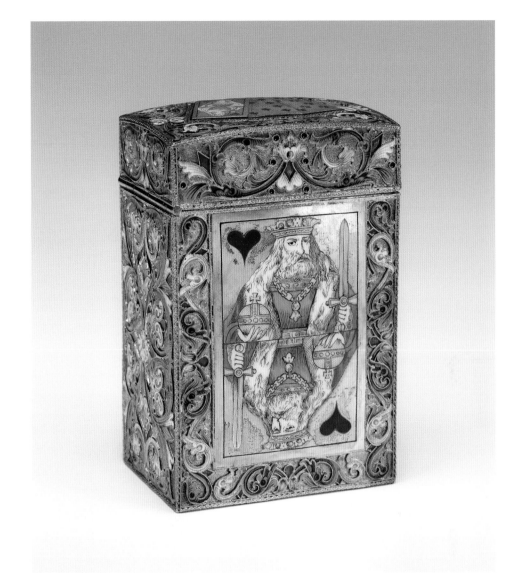

212

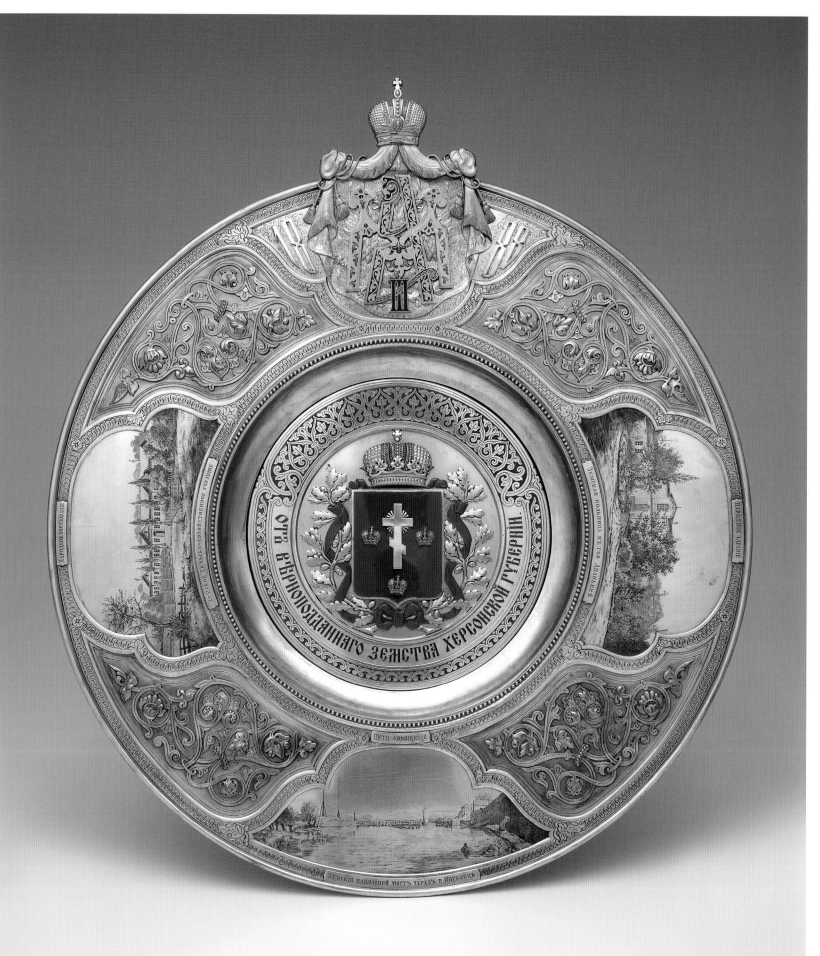

213 Bread-and-Salt Dish

Silver, enamel

The center of this presentation dish is applied with the enameled coat of arms of the Kherson province. The inscription reads: *From the loyal zemstvo of the Kherson Guberniia.* The border is applied with the crowned and enameled cypher of Tsar Alexander III and has three engraved topographical views interspersed with panels of repoussé scrolling foliage. The views are inscribed: *Education: Village Agricultural School; Transport: Village Ponton Bridge across River Inguletz;* and *Health: Hospital in City of Anayev.*

MARKS: Imperial warrant mark of I. Khlebnikov, assay mark of Moscow before 1899 (dated 1888), initials of assay master Cyrillic *IW*, 84 zolotnik
DIMENSIONS: D 21 in. (53 cm)
PROVENANCE: Presented to Tsar Alexander III and Tsaritsa Maria Feodorovna in 1888 at the occasion of their visit to the Kherson province; Lillian Thomas Pratt
NOTE: This is one of hundreds of such bread-and-salt dishes presented to the tsar and tsaritsa at their numerous visits throughout Russia. These *chleb i sol* presentation platters were displayed in the Antechamber and the Nicholas Hall of the Winter Palace. The central corridor of the private-apartment wing (left, or east wing) of the Alexander Palace was also lined with such presentation plates. The *zemstvo* was the elected body of local self-government in charge of education, transport, and health (information kindly provided by Dr. Stephen de Angelis).
BEQUEST OF LILLIAN THOMAS PRATT, 47.20.380

214 Sherbet Cup, Saucer, and Spoon

Silver gilt, enamels

The cup has a yellow guilloché enamel center and a plique-à-jour enamel border. The exterior, stem, and foot are decorated in champlevé enamel. The saucer has identical decoration. The spoon is not original to the set.

MARKS: Imperial warrant of Khlebnikov, assay mark of Moscow 1908–17, 88 zolotnik
DIMENSIONS: Cup: 6⅞ in. (17.5 cm); saucer: D 7½ in. (19.1 cm); spoon: 1⅜ × 5½ in. (3.5 × 14 cm)
PROVENANCE: Sarah McGowan
GIFT OF SARAH MCGOWAN, 86.174.1–3

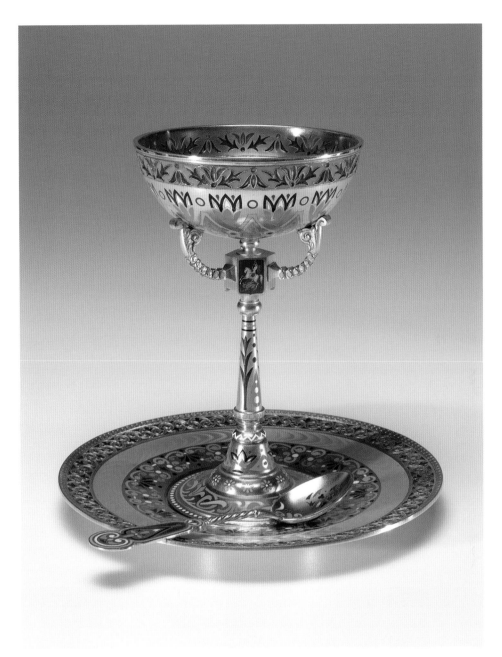

214 reduced

213 (left) reduced

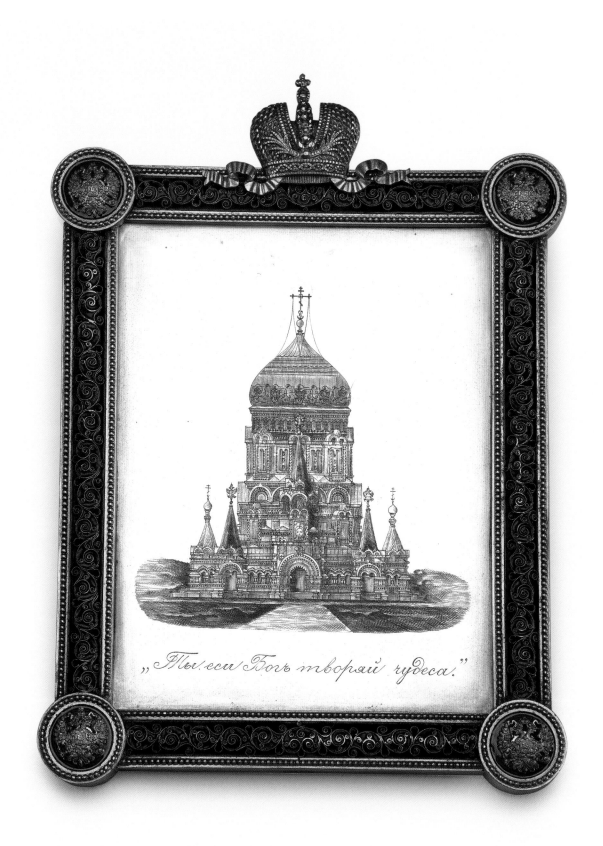

215 Commemorative Plaque

Silver, enamel

The silver plaque is engraved with a view of the Church of Christ the Saviour on the Moskva River and is surmounted by an imperial crown. Its borders are of dark-blue mat cloisonné enamel over filigree scrolls, and the corners have red-enamel medallions applied with double-headed eagles.

MARKS: Imperial warrant mark of Morozov
DIMENSIONS: 7 ¼ in. (18.4 cm)
PROVENANCE: Said to have been presented to Empress Maria Feodorovna to commemorate the erection of the Church of Christ the Saviour in Moscow; Lillian Thomas Pratt
NOTE: The construction of the Church of Christ the Saviour, the world's largest Russian Orthodox Church, was begun in 1839. It was consecrated on May 26, 1883, the day of the coronation of Tsar Alexander III. The church was dynamited in 1931, replaced by a public swimming pool, rebuilt between 1992 and 1996, and reconsecrated in 2000.
BEQUEST OF LILLIAN THOMAS PRATT, 47.20.387

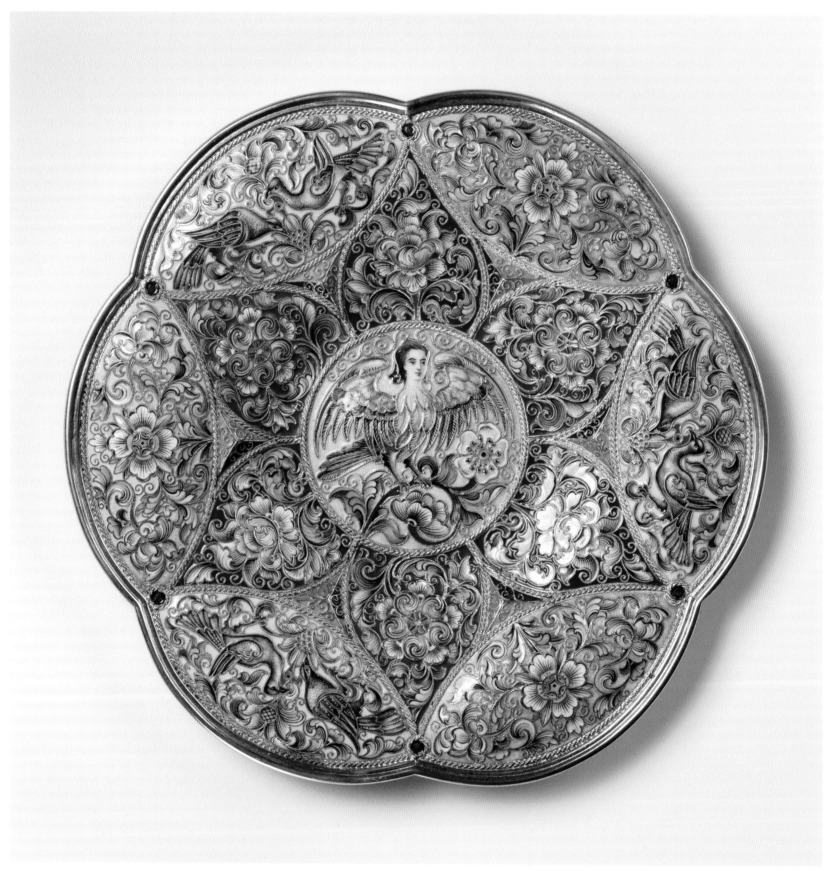

216 Plate

Silver gilt, enamel, Siberian hardstones

The hexafoil plate is decorated with shaded cloisonné enamels in the Old-Russian style. The lobes are decorated with alternating images of birds and flowers on pink and pale-blue grounds. They are interspersed with teardrop shapes enclosing stylized flowers on alternating brick-red and sea-green fields. The central boss depicts a harpy on a cream ground.

MARKS: Maker's initials *FR* for Fedor Rückert, assay mark of Moscow 1899–1908, scratched inventory number 2336
DIMENSIONS: D 7 ¼ in. (18.4 cm)
PROVENANCE: Jerome and Rita Gans Collection of Russian Enamel
JEROME AND RITA GANS COLLECTION OF RUSSIAN ENAMEL, 98.11

217 Cup and Cover

Silver gilt, enamel

The cup and cover are decorated with shaded cloisonné enamels in the Old-Russian style. The lobed bowl is decorated with animal, floral, and human subjects on alternating grounds of blue and white. The lobed cover has floral medallions around a brick-red band and a dome of sky blue. The finial is a silver-gilt double-headed eagle.

MARKS: Initials of maker *FR* for Fedor Rückert, 88 zolotnik
DIMENSIONS: 14 ⅜ in. (36.5 cm)
PROVENANCE: Jerome and Rita Gans Collection of Russian Enamel
JEROME AND RITA GANS COLLECTION OF RUSSIAN ENAMEL, 98.8a–b

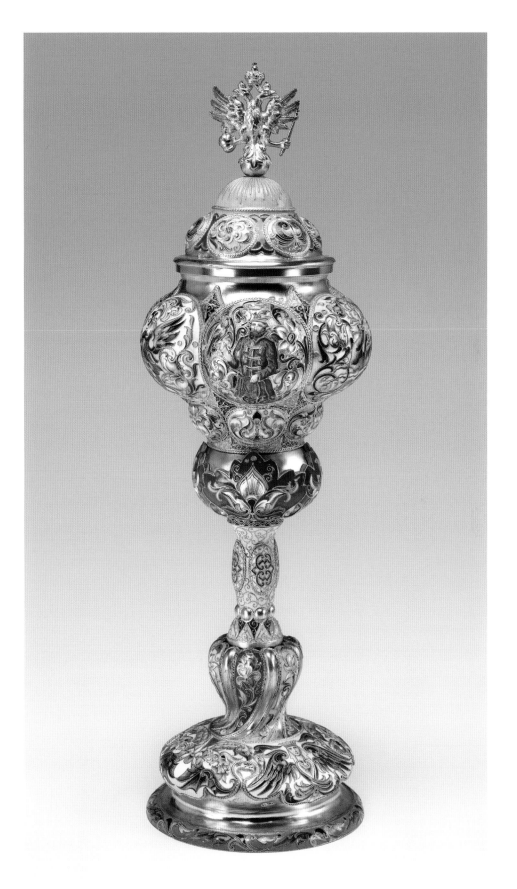

217 reduced

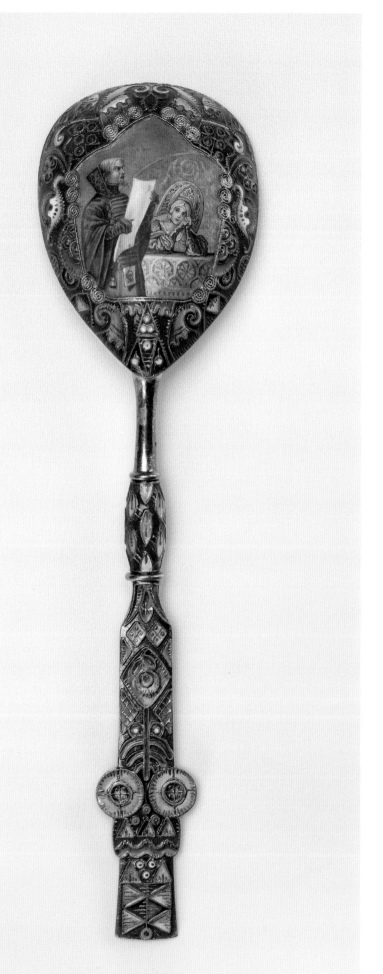

218 Serving Spoon

Silver gilt, enamel

The back of the spoon's bowl is painted *en plein* with a man in court dress reading a scroll to a *boyarina*. The spoon is further decorated with shaded cloisonné enamel ornamentation in hues of pink, blue, and green.

MARKS: Maker's initials *FR* for Fedor Rückert, assay mark of Moscow 1908–17, 88 zolotnik
DIMENSIONS: L 16¼ in. (41.3 cm)
PROVENANCE: Jerome and Rita Gans Collection of Russian Enamel
JEROME AND RITA GANS COLLECTION OF RUSSIAN ENAMEL, 98.19

219 Loving Cup

Silver gilt, enamel, garnets, Siberian hardstones

The three-handled lobed cup is decorated with *en plein* and shaded cloisonné enamels in the Old-Russian style. The lobed bowl has three pictorial panels painted with a *boyarina* offering a tray with a carafe and a cup, a boyar with a beard and a blue tunic holding a cup aloft, and a musician strumming an instrument. Each figure appears above a panel depicting a standing griffin. The handles of the cup are shaped as stylized dolphins with green-enamel tails and cabochon-garnet eyes.

MARKS: Maker's initials *FR* for Fedor Rückert, assay mark of Moscow, 1899–1908, 88 zolotnik
DIMENSIONS: 9½ in. (24 cm)
PROVENANCE: Jerome and Rita Gans Collection of Russian Enamel
JEROME AND RITA GANS COLLECTION OF RUSSIAN ENAMEL, 98.10

218 reduced

219 reduced

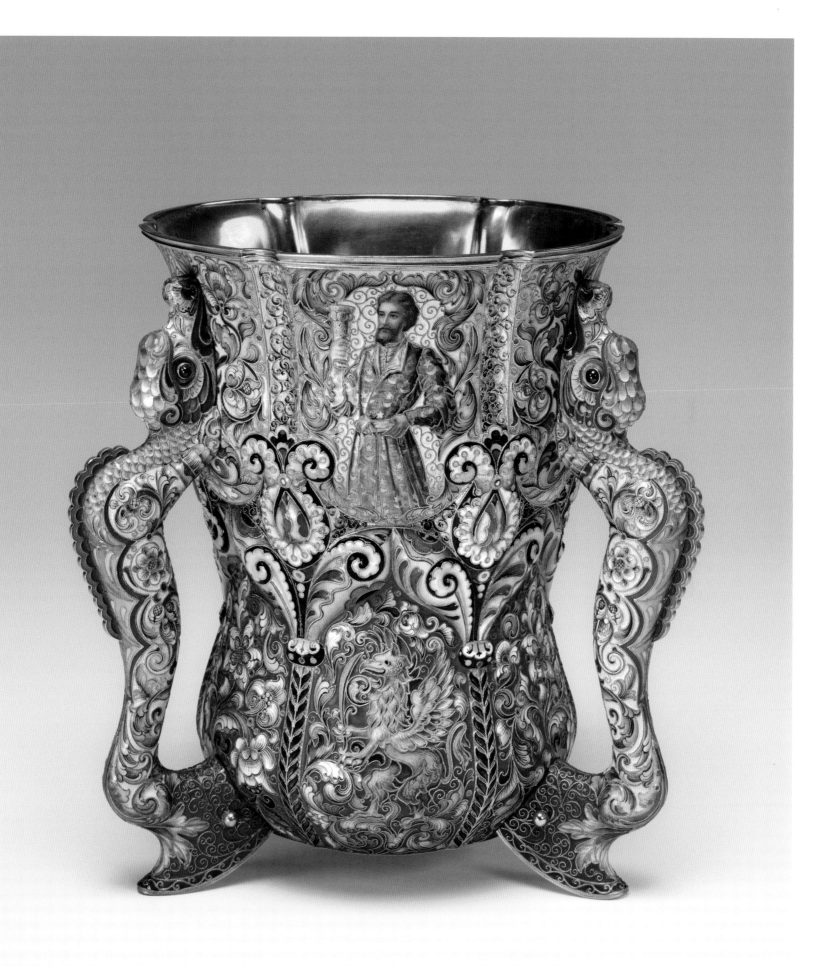

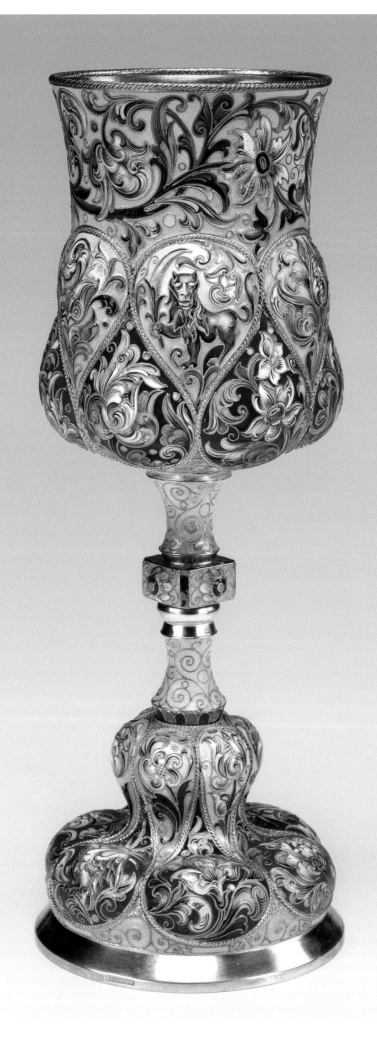

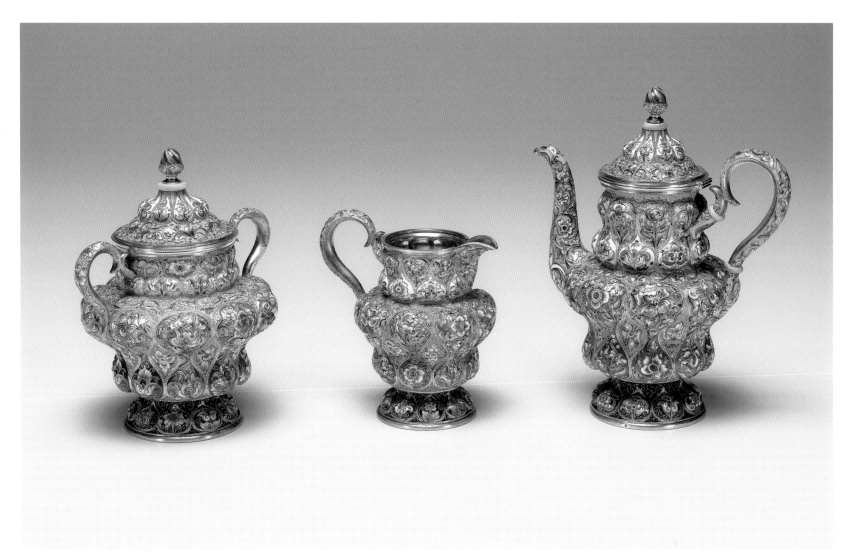

221 reduced

220 Cup

Silver gilt, enamel

The cup is decorated with shaded cloisonné enamels in the Old-Russian style. The lobed bowl and foot have stylized flowers and lions on bosses of alternating white, brick-red, sea-green, and deep-blue enamel. The shaft is of sky-blue enamel with a central square knob.

MARKS: Maker's initials *FR* for Fedor Rückert, assay mark of Moscow 1899–1908
DIMENSIONS: 9 3/16 in. (23.7 cm)
PROVENANCE: Jerome and Rita Gans Collection of Russian Enamel
JEROME AND RITA GANS COLLECTION OF RUSSIAN ENAMEL, 98.9

221 Three-Piece Coffee Set

Silver gilt, enamel

COFFEEPOT AND SUGAR BOWL ARE ILLUSTRATED
ON THE FOLLOWING TWO PAGES

The coffeepot, milk jug, and sugar bowl are repoussé with multiple bosses and decorated in shaded cloisonné enamels with flowers on grounds of aubergine, royal blue and sea green. The hinged covers to the coffeepot and sugar bowl have acorn finials.

MARKS: Master's initials *FR* for Fedor Rückert, assay mark of Moscow, 1908–17, 88 zolotnik
DIMENSIONS: Coffeepot: 8 1/2 in. (21.6 cm); milk jug: 5 1/4 in. (13.3 cm); sugar bowl: 7 1/4 in. (17.8 cm)
PROVENANCE: Jerome and Rita Gans Collection of Russian Enamel
JEROME AND RITA GANS COLLECTION OF RUSSIAN ENAMEL, 98.18.1–3a/b

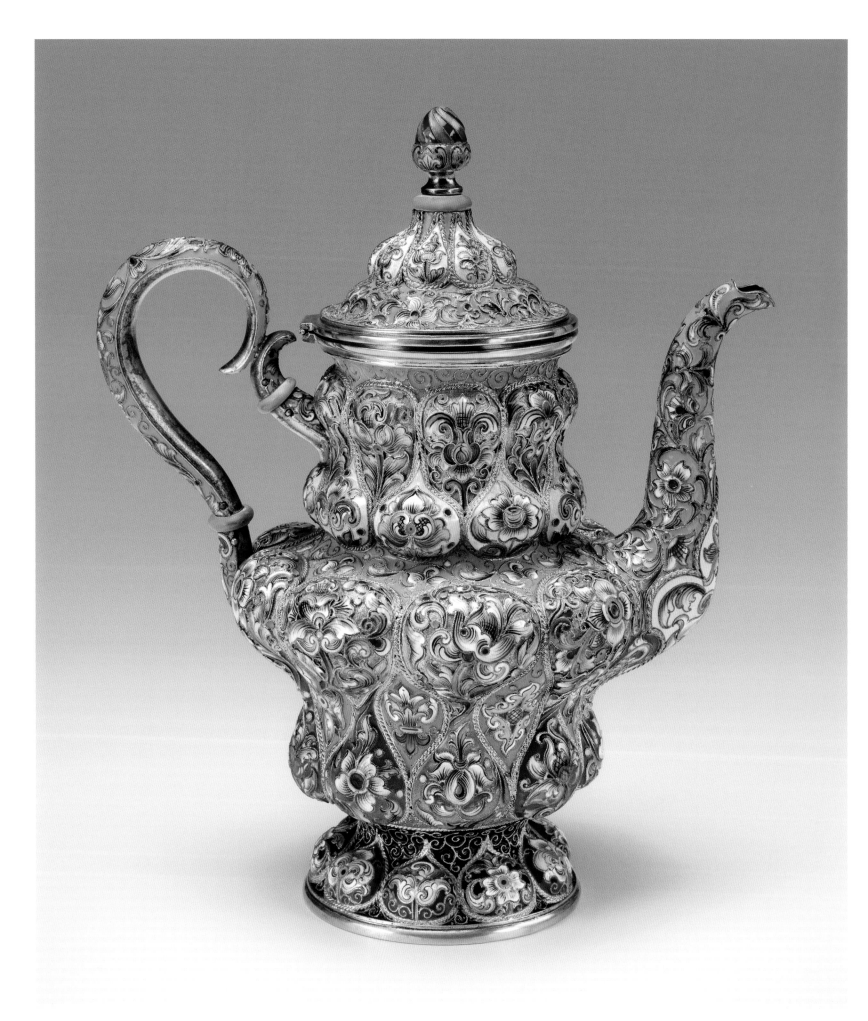

221

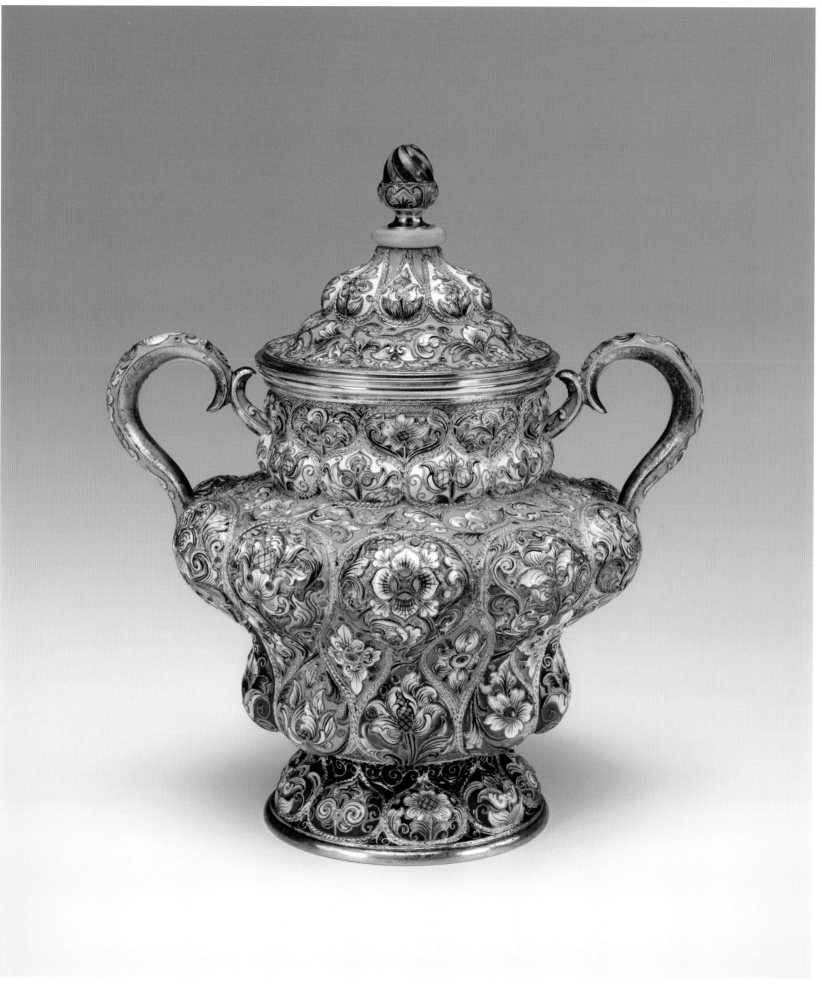

221

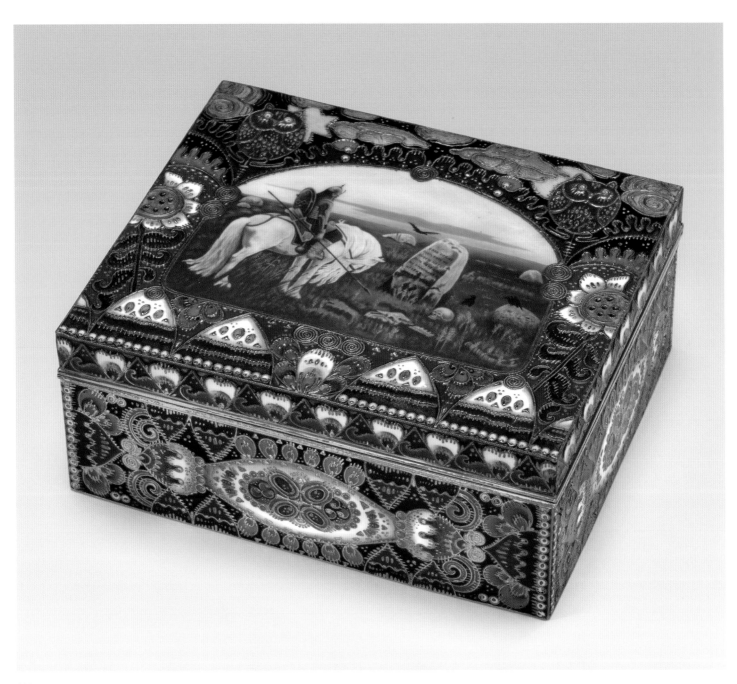

222

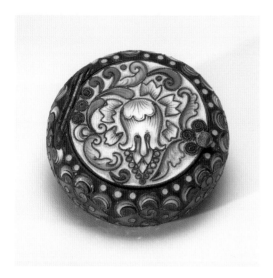

223

222 Box

Silver gilt, enamel

The cover of the box is painted *en plein* with a copy of Viktor Vasnetsov's famous 1882 *Bogatyr' at the Crossroads* (Russian Museum, St. Petersburg) under an arch and flanked by two stylized owls. The cover and sides of the box are further decorated with Old-Russian style motifs in shaded cloisonné enamel and muted colors.

MARKS: Maker's initials *FR* for Fedor Rückert, assay mark of Moscow 1908–17, 88 zolotnik
DIMENSIONS: L 5 ½ in. (14 cm)
PROVENANCE: Jerome and Rita Gans Collection of Russian Enamel
NOTE: Vasnetsov's painting is of the celebrated *bogatyr'* Il'ia Muromets, a Kievan Rus' epic hero thought to have been a 12th-century warrior. He is venerated as a minor saint by the Russian Orthodox Church.
JEROME AND RITA GANS COLLECTION OF RUSSIAN ENAMEL, 98.12

223 Bonbonnière

Silver, enamel

The round box is decorated with scrolling foliage and blossoms in shaded cloisonné enamel and has a hinged cover.

UNMARKED
DIMENSIONS: D 1 ⅞ in. (4.7 cm)
PROVENANCE: Mr. Arthur Glasgow
GIFT OF MR. ARTHUR GLASGOW, 56.2.11

224 Sugar Scoop

NOT ILLUSTRATED

Silver, enamel

The scoop is decorated in cloisonné enamel with traditional Russian motifs.

MARKS: Moscow before 1899, 88 zolotnik
DIMENSIONS: L 4 ¾ in. (12 cm)
PROVENANCE: Lillian Thomas Pratt
BEQUEST OF LILLIAN THOMAS PRATT, 47.20.382

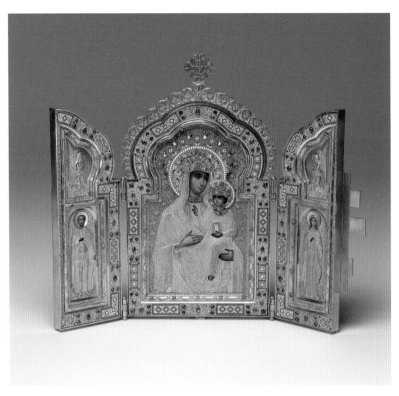

225 reduced

Icons

225 The Holy Virgin of Kazan, St. Prince Aleksandr Nevskii, St. Mary Magdalene Triptych

Oil on panel, silver gilt, gold, cloisonné enamel, pearls, precious stones

The Virgin of Kazan and Child appear in the center of the icon with St. Aleksandr Nevskii and St. Mary Magdalene in the side panels (left and right respectively). All figures are in repoussé silver robes. The Virgin and Child wear gold cloisonné-enamel haloes set with rose-cut diamonds, rubies, and emeralds, and are set on a turquoise cloisonné-enamel ground applied with gilt rosettes and bordered above with stylized openwork acanthus. A cross tops the icon above. The side panels have engine-turned backgrounds. All borders are set with cloisonné-enamel plaques and clusters of cabochon sapphires and rubies

with applied filigree scrolls. The clasp is a Russian Orthodox cross set with cabochon sapphires and rubies.

MARKS: Stamped with imperial warrant mark of P. Ovchinnikov, dated 1891, assay mark of Moscow before 1899, initials of assay master Anatolii A. Artsybashev, 84 zolotnik

DIMENSIONS: Open: H 12¾ × W 15¼ × D 1 in. (32.4 × 38.7 × 2.5 cm); closed: W 7⅛ in. (18.4 cm)

PROVENANCE: Tsar Alexander III and Tsaritsa Maria Feodorovna (the reverse inscribed: *To Their Imperial Majesties from the Nobility of Kharkoff 28 October 1866–1891*"; The Schaffer Collection (from the "Alexander Palace, Tsarskoye Selo"); Lillian Thomas Pratt

BIBLIOGRAPHY: Lesley 1976, cat. no. 257, p. 127, p. 121 (ill.)

NOTE: St. Prince Aleksandr Nevskii and St. Mary Magdalene were the patron saints of Tsar Alexander III and Tsaritsa Maria Feodorovna. It is not clear to what events the dates on the icon refer.

BEQUEST OF LILLIAN THOMAS PRATT, 47.20.16

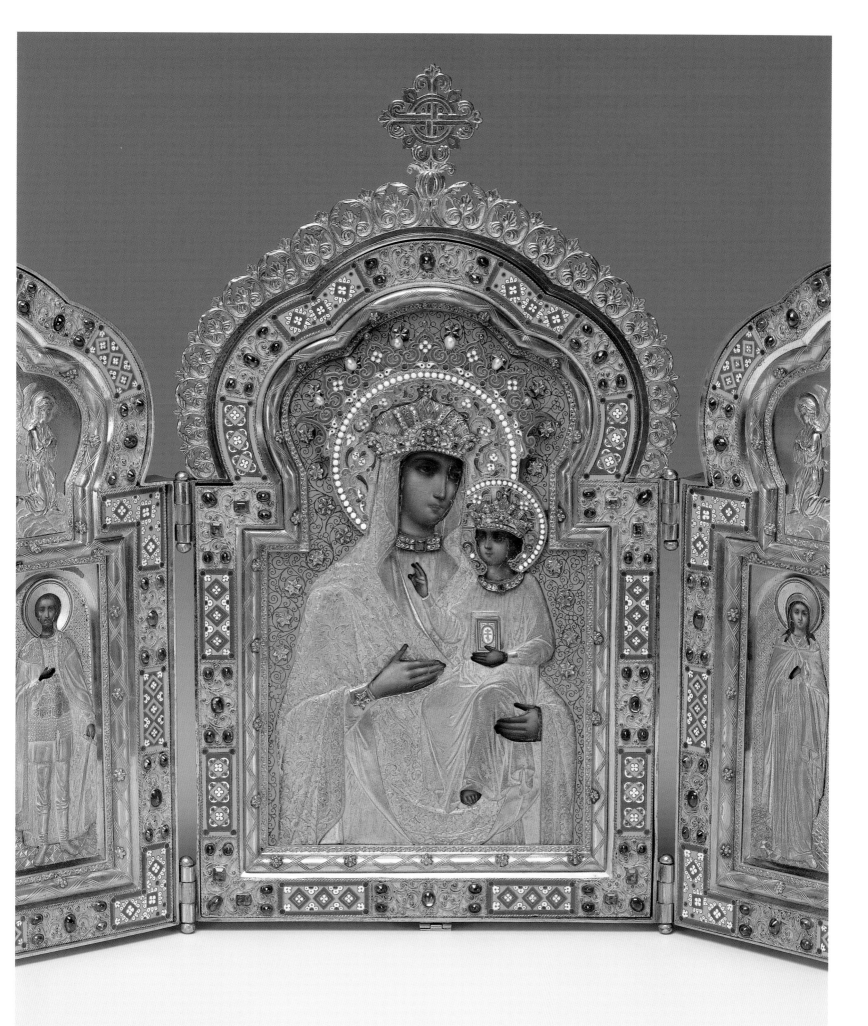

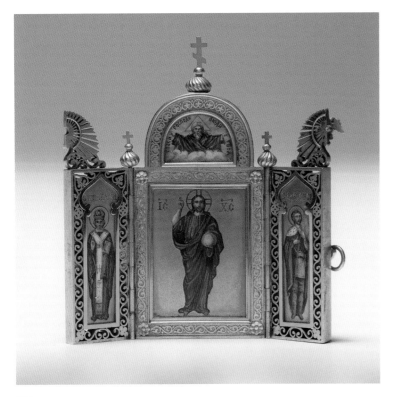

226

227 reduced

226 Christ Blessing the Universe Flanked by St. Nicholas the Miracle Worker and St. Prince Aleksandr Nevskii Triptych

Gold enamel

The icon is surmounted by a Russian Orthodox cross and enameled on gold with full-length figures of Christ and two saints on mat gold ground. God the Father appears in the lunette above. The borders are applied with scrolls.

MARKS: *K. Hahn*, initials of workmaster Alexander Treyden, assay mark of St. Petersburg before 1899, 56 zolotnik

DIMENSIONS: Open: H 3 ⅛ × W 3 × D ¼ in. (8 × 7.6 × 0.6 cm); closed: 1½ in (3.8 cm)

Original fitted box

PROVENANCE: Russian Imperial Treasures Inc. "The Schaffer Collection" #1022, September 3, 1940, $2,500; Lillian Thomas Pratt

EXHIBITED: VMFA 1983

BIBLIOGRAPHY: Lesley 1976, cat. no. 261, p. 129, p. 128 (ill.)

NOTE: These are probably the patron saints of Alexander III and Tsesarevich Nicholas Aleksandrovich (the future Tsar Nicholas II). This icon might have been given to Tsesarevich Nicholas at his Coming of Age ceremony in 1884 when he took the Oath of Loyalty to the tsar, his father, as required of all the young Romanov grand dukes at the age of sixteen.

BEQUEST OF LILLIAN THOMAS PRATT, 47.20.20

227 St. Martyr Tatiana

Oil and gold leaf on wood, silver gilt

A full-length portrait of St. Tatiana is painted on a gold ground. The silver-gilt frame is applied with oxidized silver, scrolling foliage, acanthus leaves, and angel heads at the corners. The reverse of the metal plaque is inscribed: *29 May 1897.*

MARKS: Maker's mark *Keibel,* assay mark of St. Petersburg before 1899

DIMENSIONS: 21⅜ in. (54.2 cm)

PROVENANCE: Grand Duchess Tatiana Nikolaevna; The Schaffer Collection; Lillian Thomas Pratt

NOTE: Grand Duchess Tatiana Nikolaevna was born at Peterhof on May 29, 1897. This could be her birth icon presented at her baptism in 1897.

BEQUEST OF LILLIAN THOMAS PRATT, 47.20.7

228 reduced

228 The Transfiguration, St. Elizabeth, St. Sergius of Radonezh Triptych

Oil on wood, silver, cloisonné enamel

The icon is painted with the transfigured Christ flanked by the prophets Moses and Elijah and the apostles Peter, John, and James below. The side panels are painted with the standing St. Elizabeth and St. Sergius. The doors have borders of geometric decoration in champlevé enamel and applied ears of corn; the back has an engraved inscription within a laurel crown.

MARKS: Maker's mark *K.A.*, dated 1884, assay mark of St. Petersburg before 1899, 84 zolotnik
DIMENSIONS: Open: H 7 ⅜ × W 10 ½ × D ½ in. (18.7 × 26.7 × 1.3 cm); closed: W 4 ¾ in. (12 cm)

PROVENANCE: Grand Duke Sergii Aleksandrovich and Grand Duchess Elisaveta Feodorovna, whose patron saints appear on the side panels; Russian Imperial Treasures Inc. "The Schaffer Collection," #1205, November 1, 1939, $1,800; Lillian Thomas Pratt
BIBLIOGRAPHY: Lesley 1976, cat. no. 258, p. 127, p. 126 (ill.)
NOTE: The triptych was presented by officers of the Preobrazhenskii Regiment on the occasion of the wedding of Grand Duke Sergii (1857–1905), brother of Tsar Alexander III, and Grand Duchess Elisaveta (1864–1918), sister of Princess Alix of Hesse and by Rhine, future Tsaritsa Alexandra Feodorovna, and is painted with the patron saints of the recipients. The reverse is inscribed: *Blessing of the Preobrazhenskii Regiment. June 3rd, 1884. A new commandment I give unto you that ye love one another as I loved you. (St. John, Chapter 13, Verse 34).* Also inscribed are

the very numerous signatures of the members of the regiment including General Major Obolenskii, Count von Pfeil, Count Murav'ev, and Count Loris Melikov.
BEQUEST OF LILLIAN THOMAS PRATT, 47.20.17

229 recto, reduced

229 verso, reduced

229 St. Mary Magdalene, St. Nicholas the Miracle Worker, St. Prince Aleksandr Nevskii

Silver, silver gilt

The oval icon pendant is repoussé with silver figures of three saints on gilt ground. The blessing Christ is above in the clouds. The frame is silver gilt.

MARKS: Initials of workmaster Vasilii Fedotov Il'in, assay mark of St. Petersburg before 1899, assay master Cyrillic *E. B.*
DIMENSIONS: 7 in. (17.8 cm)
PROVENANCE: Engraving on reverse reads: *To His Imperial Highness, The Sovereign Heir, Tsesarevich Nikolai Aleksandrovich in honor of his Coming of Age, 1859, 8th of September. This heartfelt offering from the Master Silversmith Vassilii Fedotov Il'in, made by his own hand;* Hammer Galleries (from the "quarters of the Dowager Empress, Maria Feodorovna, Alexander Palace, Tsarskoye Selo"); Lillian Thomas Pratt
NOTE: The saints represented on this icon are the patron saints of Tsesarevich Nikolai Aleksandrovich and of his parents, Empress Maria Aleksandrovnam and Emperor Alexander II. Nikolai, who received this icon, died of tubercular meningitis in Nice in 1865. He was engaged at the time to Princess Dagmar of Denmark who later married his younger brother, Grand Duke Aleksandr Aleksandrovich.
BEQUEST OF LILLIAN THOMAS PRATT, 47.20.11

230 St. Roman and Saints

Oil on wood, silver, enamel

The cloisonné enamel frame has scrolling foliage in dark-blue-and-green enamel, and flowers in turquoise enamel.

MARKS: Initials of workmaster P. R., assay mark of St. Petersburg before 1899, 84 zolotnik
DIMENSIONS: 8⅞ in. (22.5 cm)
PROVENANCE: Hammer Galleries, said to have been given to "Grand Duchess Tatiana Nikolaievna at the occasion of her birth from her Nanny." However, the reverse is inscribed: *In blessing to Libov' Stepanova, with love from Babushka Tatiana Petrovna Polejiava, 19 December 1894;* Lillian Thomas Pratt
NOTE: Grand Duchess Tatiana was born in 1897, not 1894.
BEQUEST OF LILLIAN THOMAS PRATT, 47.20.13

230 (right)

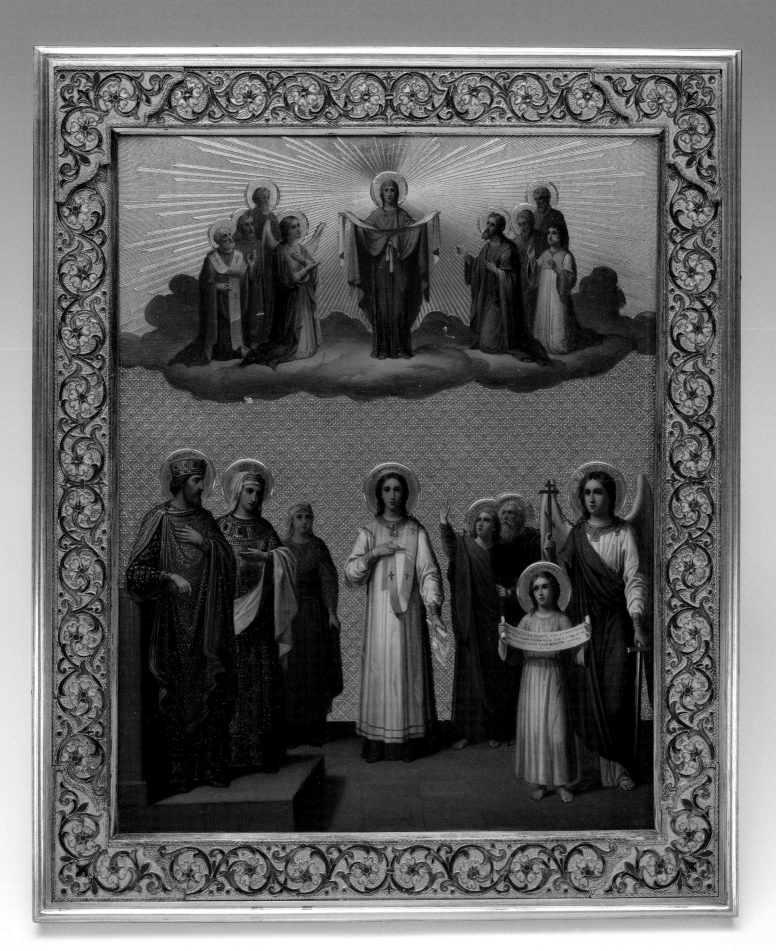

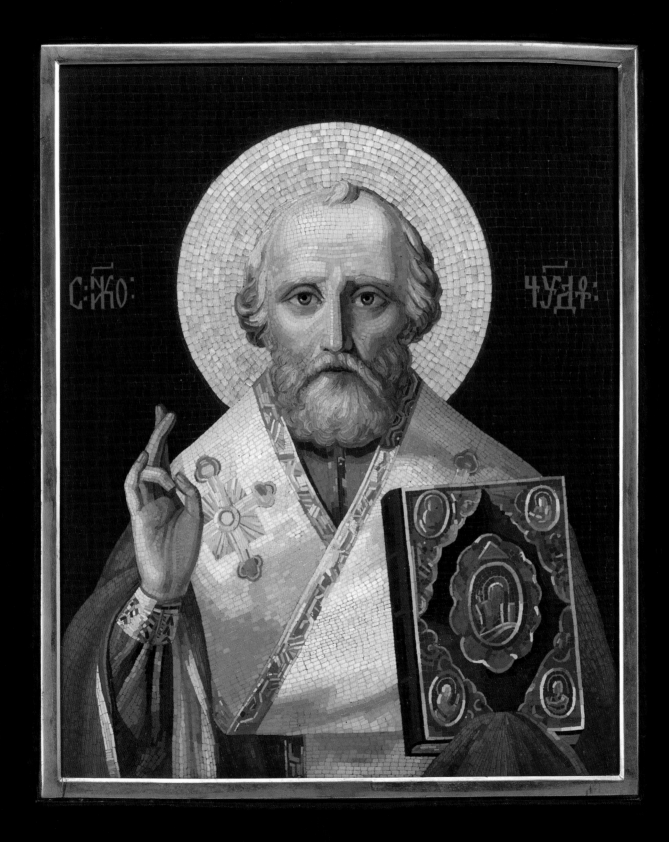

231 St. Nicholas the Miracle Worker

Mosaic, velvet, leather, brass

The micromosaic icon of the blessing St. Nicholas is in a red velvet border and has a brass frame, a leather back, and a strut.

Probably Peterhof Lapidary Works, circa 1900

DIMENSIONS: 15 in. (38.1 cm)

PROVENANCE: Hammer Galleries (as having belonged to "Czar Nicholas II, Alexander Palace, Tsarskoye Selo"); Lillian Thomas Pratt

BEQUEST OF LILLIAN THOMAS PRATT, 47.20.15

232 Miniature Icon Pendant of St. Nicholas the Miracle Worker

Gold, enamel, diamonds

The gold hunter cased medallion contains an enameled bust-length portrait of St. Nicholas with a rose-cut diamond border. The cover is applied with a chased imperial double-headed eagle. The reverse is engraved with a Russian Orthodox cross and the inscription in Church Slavonic reads: *May God bless you.*

UNMARKED

DIMENSIONS: 1⅝ × 1⅛ × ¼ in. (4.21 × 2.9 × 0.6 cm); chain: 18 in. (45.7 cm)

PROVENANCE: Lillian Thomas Pratt

BIBLIOGRAPHY: Lesley 1976, cat. no. 263, p. 131 (ill.)

NOTE: This object may have been destined for imperial presentation.

BEQUEST OF LILLIAN THOMAS PRATT, 47.20.23

232 enlarged

233 reduced

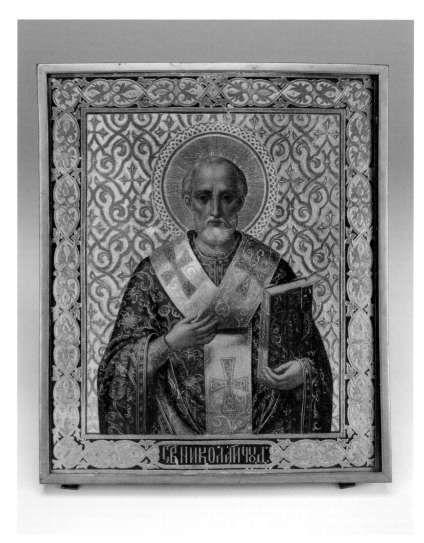

234 reduced

233 St. Nicholas the Miracle Worker

Oil and gold leaf on wood

St. Nicholas is depicted standing, full-length, flanked by Jesus and the Virgin Mary in roundels within a border of stylized foliage.

DIMENSIONS: 12⅜ in. (31.4 cm)
PROVENANCE: Grand Duke Nikolai Aleksandrovich, later Tsar Nicholas II (labels on reverse reads: *To the Grand Duke Nikolai Aleksandrovich, 19th July, 1882*; City Museum. Historic rooms of Anichkov Palace, No. 0 6819, (no. 19); Hammer Galleries; Lillian Thomas Pratt
BEQUEST OF LILLIAN THOMAS PRATT, 47.20.5

234 St. Nicholas the Miracle Worker

Oil and gold leaf on wood

St. Nicholas is shown half-length in a green robe against a tooled gold-leaf background within a border of stylized foliage.

DIMENSIONS: 8⅞ in. (22.3 cm)
Original fitted oak case with fuchsia cotton lining
PROVENANCE: Tsesarevich Nikolai Aleksandrovich (presentation inscription on reverse reads: *Presented to his Imperial Highness Tsarevich and Grand Duke Nikolai Aleksandrovich, from a peasant of the village of Materi, Province of Vladimir, Iosif Andreevich Pankryshev*); Lillian Thomas Pratt
BEQUEST OF LILLIAN THOMAS PRATT. 47.20.6

235 Twelve Saints

Oil and gold leaf on wood, gilt brass

The icon has two horizontal registers, each with six saints. The border above features the Virgin Hodigitria flanked by St. Ignatius and St. Olga. Other saints in the margins include St. Nikita Fedor; St. Alexis, man of God; and St. John the Warrior. A repoussé gilded-metal *oklad* accompanies the icon.

DIMENSIONS: Framed: 17½ × 15¾ in. (44.5 × 40 cm); unframed: 12⅜ × 10⅝ in. (31.4 × 27 cm)
PROVENANCE: Russian Imperial Exhibit, Moscow, no. 4830 ($250 price tag on reverse); Hammer Galleries (as having belonged to "Czar Nicholas II, Winter Palace, St. Petersburg"); Lillian Thomas Pratt
BEQUEST OF LILLIAN THOMAS PRATT, 47.20.9a/b

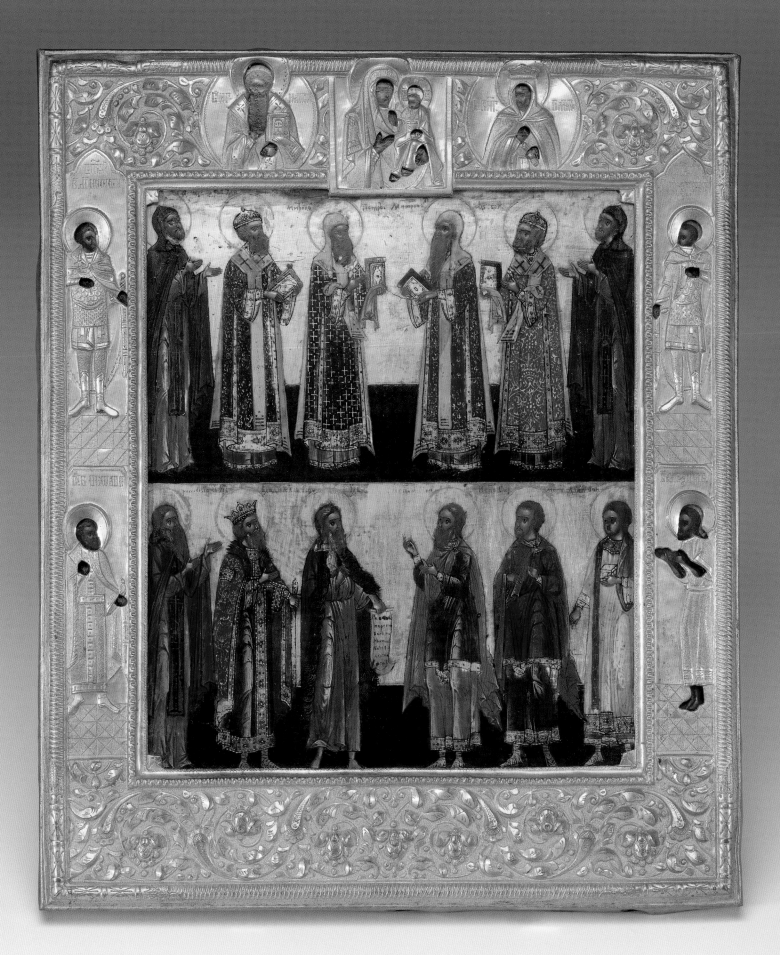

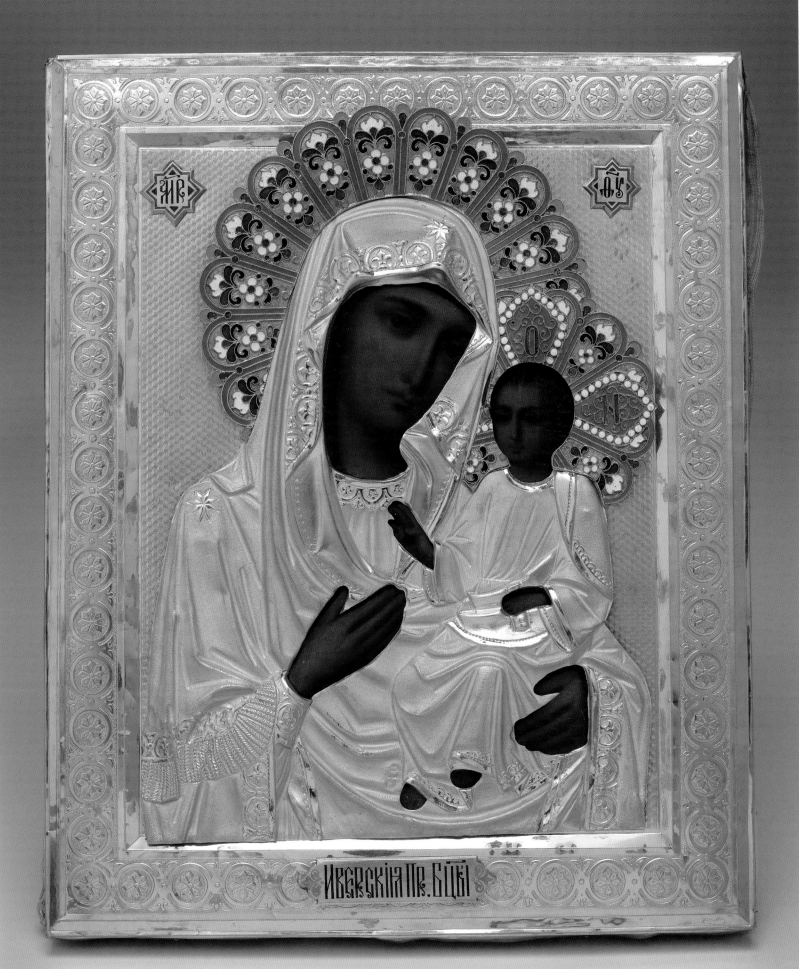

237

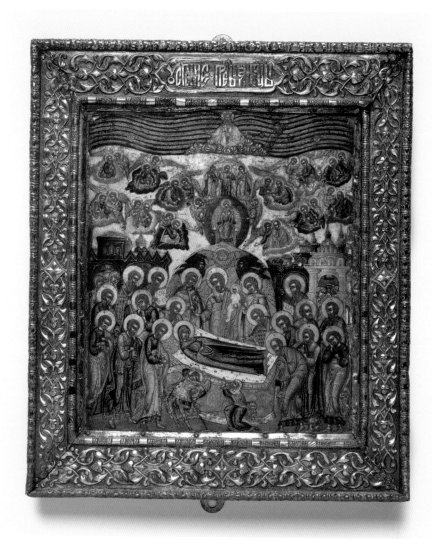

238 reduced

236 The Iverskaya Mother of God

Oil on panel, silver gilt, metal, cloisonné enamel

The icon has an engine-turned silver *oklad*. The Virgin and Child wear repoussé oxidized-silver robes and cloisonné enamel haloes.

MARKS: Initials of workmaster C. K. in Cyrillic, 84 zolotnik
DIMENSIONS: 10 ½ × 8 ¾ in. (26.7 × 22.2 cm)
PROVENANCE: Grand Duchess Tatiana, daughter of Tsar Nicholas II (presentation inscription on reverse reads: *To her Imperial Highness Grand Duchess Tatiana Nikolaevna from the Nobility of Moscow*); Lillian Thomas Pratt
BIBLIOGRAPHY: Lesley 1976, cat. no. 254, p. 124, p. 124 (ill.)
BEQUEST OF LILLIAN THOMAS PRATT, 47.20.4

237 Christ Pantocrator and the Virgin of Kazan Diptych

Oil and gold leaf on wood, silver gilt, gold

The miniature traveling icon is painted with bust-length figures within gold borders.

MARKS: Marks illegible, 84 zolotnik
DIMENSIONS: Open: H 1 ⅝ × W 2 ¼ in. (4.2 × 5.7 cm); closed: W 1 ⅛ in. (2.9 cm)
PROVENANCE: The Schaffer Collection; Lillian Thomas Pratt
EXHIBITED: PFAC 1981
BEQUEST OF LILLIAN THOMAS PRATT, 47.20.22

238 Dormition of the Virgin

Oil and gold leaf on wood, gilt metal

The painted icon has a gilt-metal *oklad* embossed with interlacing foliage.

UNMARKED
DIMENSIONS: 10 ¾ in. (27.3 cm)
PROVENANCE: Mosgostorg, Moscow; Hammer Galleries (as having belonged to "Czarina Alexandra, Winter Palace, St. Petersburg"); Lillian Thomas Pratt
BEQUEST OF LILLIAN THOMAS PRATT, 47.20.8

236 (left) reduced

239 St. Panteleimon

Oil on wood, silver gilt, enamel

The icon has an engine-turned oklad, and the frame has a cloisonné enamel and filigree border with a boss at each corner.

MARKS: Mark of A. I. Kuzmichev, assay mark of Moscow 1899–1908
DIMENSIONS: 12 ½ in. (31.7 cm)
Original fitted box with fuchsia silk lining stamped *Nemirov-Kolodkin, Moscow*
PROVENANCE: The Schaffer Collection ("Tsarevich Aleksei Nikolaievich, for his birthday"). The inscription on the reverse of the icon is written in Church Slavonic: *With the Blessing of the Russian Monastery of the Great Martyr and Healer Saint Panteleimon on Holy Mount Athos to His Imperial Highness, Heir and Grand Duke Alexei Nikolaevich for grace-filled help, protection, and intercession*; Lillian Thomas Pratt
NOTE: This icon can be seen in a period photograph of the tsesarevich's bedroom at the Alexander Palace, Tsarskoe Selo.
BEQUEST OF LILLIAN THOMAS PRATT, 47.20.14

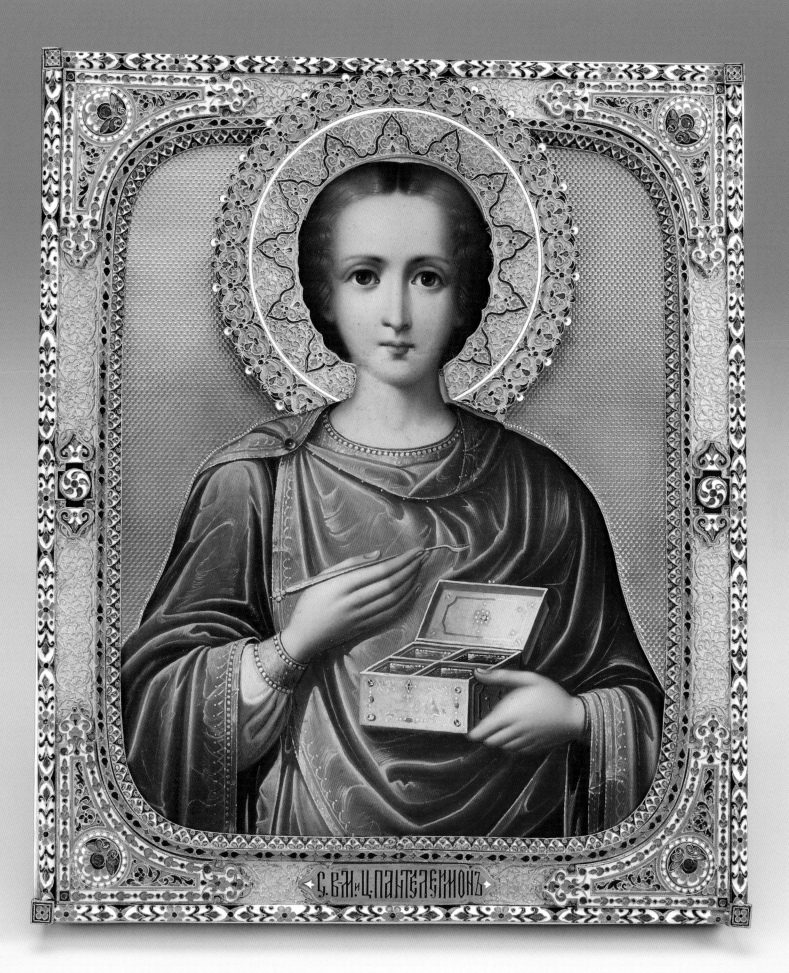

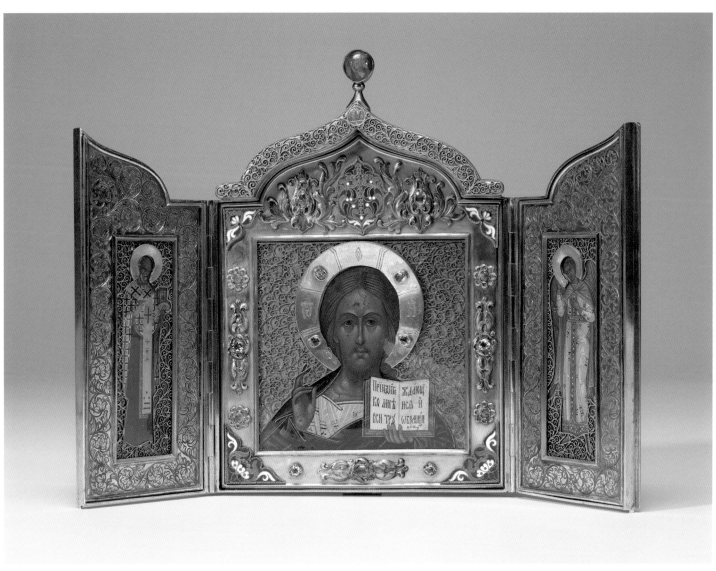

240 reduced

240 Christ Pantocrator Flanked by St. Nicholas the Miracle Worker and the Guardian Angel Triptych

Oil on wood, silver gilt, enamel, semiprecious stones

The bust-length figure of Christ is flanked by full-length figures of St. Nicholas (left) and the Guardian Angel (right). The central panel is applied with acanthus foliage, and the central motif and spandrels are in cloisonné enamel set with five cabochon emeralds. The borders are set with three garnets and six quartzes. The side-panel borders are applied with filigree scrolls. The entire piece is surmounted by a pear-shaped cabochon tourmaline.

MARKS: Unidentified maker's mark Cyrillic *boOCe*, assay mark of Moscow 1908–17
DIMENSIONS: Open: H 8 ¼ × W 10 ¾ × D ¼ in. (21 × 27.3 × 1.9 cm); closed: W 5 ½ in. (14 cm)
PROVENANCE: Hammer Galleries, Russian Imperial Exhibit #1000, February 17, 1933 (from the collection of "Alexandra Feodorovna, who was the wife of Nicholai II, the last Czar of Russia"); Lillian Thomas Pratt
BIBLIOGRAPHY: Lesley 1976, cat. no. 259, p. 129, p. 128 (ill.)
BEQUEST OF LILLIAN THOMAS PRATT, 47.20.18

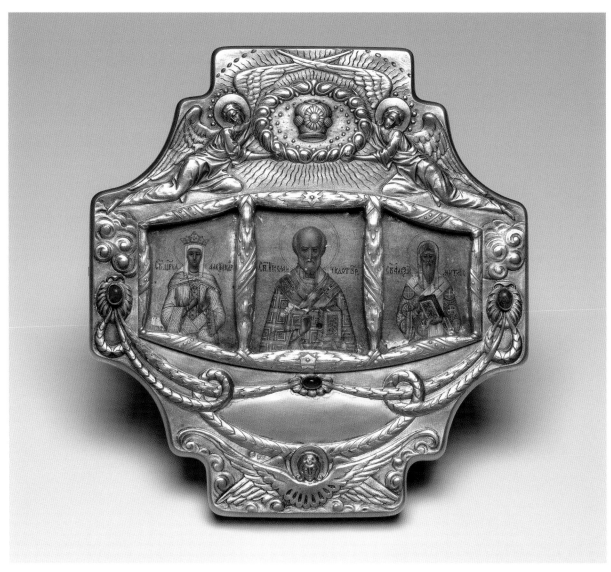

241 reduced

241 St. Nicholas, St. Alexandra, St. Alexis Triptych

Oil on panel, silver, emeralds

The cross-shaped pectoral icon with three apertures depicts St. Nicholas at the center, flanked by St. Alexandra and St. Alexis. The silver oklad is of repoussé with angels holding a crown above and cherubim below.

MARKS: Imperial warrant mark of Ivan Khlebnikov, initials of workmaster *I. Ch.*, assay mark of Moscow 1908–17, 84 zolotnik

DIMENSIONS: 6⅛ in. (15.6 cm)

PROVENANCE: Hammer Galleries ("Czar Nicholas II, Alexander Palace, Tsarskoye Selo"); Lillian Thomas Pratt

BIBLIOGRAPHY: Lesley 1976, cat. no. 255, p. 125, p. 124 (ill.)

NOTE: Since these saints were the patron saints of Tsar Nicholas, Tsaritsa Alexandra, and Tsesarevich Alexei, this icon may have belonged to the tsar.

BEQUEST OF LILLIAN THOMAS PRATT, 47.20.10

242

243

244

244 reduced

Panagias

242 Enthroned Pantocrator

Gold, silver gilt, enamel, seed pearls

The octagonal repoussé icon of the Savior is of gold and enamel within multiple seed-pearl borders.

Russian, 17th century
UNMARKED
DIMENSIONS: 4 ½ in. (11.4 cm)
PROVENANCE: Hammer Galleries (from the "Prie-Dieu of the Czarina Alexandra Feodorovna, wife of the last Czar Nicholas II, in the Imperial Chapel of Feodorovna at Tsarskoye Selo"); Lillian Thomas Pratt
EXHIBITED: PFAC 1981
NOTE: An engraved Holy Visage is set atop the icon within a silver-gilt frame. The reverse is engraved with a stylized cross.
BEQUEST OF LILLIAN THOMAS PRATT, 47.20.25

243 Christ Blessing the Universe

Silver, jasper, amethyst, tourmaline, aquamarine, pastes

The two-tone jasper cameo pendant is set in an elaborate openwork frame studded with amethysts, tourmalines, aquamarines, and pastes, and is attached to a 26-inch silver-gilt chain.

Moscow, early 19th century
UNMARKED
DIMENSIONS: 5 ⅞ in. (14.9 cm)
PROVENANCE: Lillian Thomas Pratt
BEQUEST OF LILLIAN THOMAS PRATT, 47.20.29

244 Virgin and Child Enthroned Pendant

Gold, enamel, sapphire, ruby, emerald, pearl

The Mother of God enamel icon pendant within a green enamel wreath is set with a sapphire, a ruby, an emerald, and a pearl. An inscription reads: *Save and Protect.*

MARKS: Maker's mark *M. Chuknovskii*, Moscow, early 19th century
DIMENSIONS: 2 ¼ × 1 ¼ × 3/16 in. (5.7 × 3.2 × 0.5 cm)
Original fitted leather case
PROVENANCE: Hammer Galleries (from the "personal belongings of Czarina Alexandra Feodorovna from the Alexander Palace at Tsarskoye Selo"); Lillian Thomas Pratt
EXHIBITED: PFAC 1981
BEQUEST OF LILLIAN THOMAS PRATT, 47.20.31

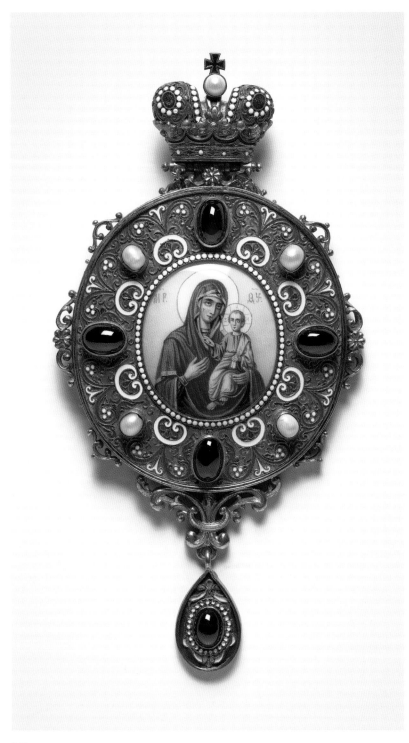

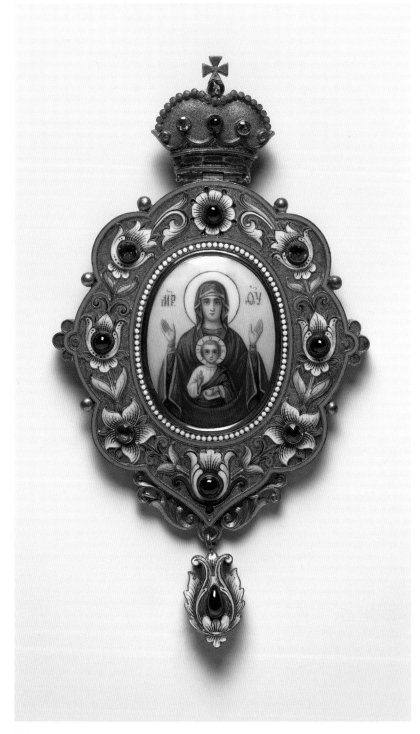

245

246

245 Virgin and Child

Silver gilt, enamel, pearls, garnets

The Mother of God is painted on enamel within a surround of cloisonné enamel on stippled ground. It is set with four alternating garnets and pearls.

MARKS: Moscow, early 19th c., 84 zolotnik
DIMENSIONS: 6½ in. (16.5 cm)
PROVENANCE: Hammer Galleries (as having belonged to "Grand Duchess Olga, Alexander Palace at Tsarskoye"); Lillian Thomas Pratt
EXHIBITED: PFAC 1981
BEQUEST OF LILLIAN THOMAS PRATT, 47.20.28

246 Virgin of the Sign

Silver gilt, enamel, precious stones

The Mother of God is painted on enamel and has a filigree surround that is painted with shaded enamel tulips and flowers. It is set with four alternating topazes and four garnets on a stippled ground, and is surmounted by a crown.

MARKS: Maker's mark N. K. for Nemirov-Kolodkin, assay mark of Moscow 1899–1908, 84 zolotnik
DIMENSIONS: 6¼ in. (15.9 cm)
PROVENANCE: Hammer Galleries (as having belonged to "Czarina Alexandra Feodorovna"); Lillian Thomas Pratt
EXHIBITED: PFAC 1981
BEQUEST OF LILLIAN THOMAS PRATT, 47.20.27

247 Virgin and Child

Enamel, gold, silver

The painted enamel icon is in an octagonal surround studded with turquoises and pearls; the frame is silver.

MARKS: Maker's mark of Nemirov-Kolodkin, assay mark of Moscow 1899–1908, 84 zolotnik
DIMENSIONS: 4¼ in. (10.8 cm)
PROVENANCE: Hammer Galleries (from the "private collection of Grand Duchess Tatiana, the second daughter of Nicholas II, the late Czar of Russia. From the Alexander Palace at Tsarskoye Selo"); Lillian Thomas Pratt
EXHIBITED: PFAC 1981
BEQUEST OF LILLIAN THOMAS PRATT, 47.20.26

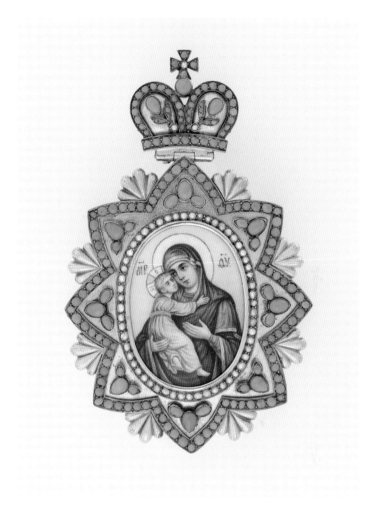

247

248 reduced

249

Gold

248 Ribbed Bell

Gold

The red-gold bell is horizontally ribbed and has a clapper shaped as an elongated teardrop.

MARKS: Maker's initials *S. A.* for Samuel Arnd, assay mark of St. Petersburg before 1899, 56 zolotnik
DIMENSIONS: 3 ½ × 2 ¾ in. (7.6 × 6.3 cm)
PROVENANCE: Hammer Galleries, #5839-12, December 4, 1940 ("fashioned by Fabergé"); Lillian Thomas Pratt
BIBLIOGRAPHY: Lesley 1976, cat. no. 297, p. 147, p. 144 (ill.)
BEQUEST OF LILLIAN THOMAS PRATT, 47.20.375

249 Charka

Gold, emerald

The *charka* is shaped as a miniature *bratina* and has a repoussé design of four double-headed eagles alternating with stylized foliage. The raised handle is set with a cabochon emerald.

MARKS: Initials of workmaster Alexander Treyden with imperial warrant, assay mark of St. Petersburg before 1899, 56 zolotnik
DIMENSIONS: 2 ½ in. (6.4 cm)
PROVENANCE: Lillian Thomas Pratt
BIBLIOGRAPHY: Lesley 1976, cat. no. 317, p. 153, p. 152 (ill.)
NOTE: Alexander Treyden worked for the firms of Hahn and Tillander. His mark has often been mistaken for that of Tillander.
BEQUEST OF LILLIAN THOMAS PRATT, 47.20.373

250 Charka

Gold, sapphires

The lower half of the *charka* is chased to simulate waves and is set with three cabochon sapphires carved to simulate fish.

The handle is an openwork fleur-de-lys.

MARKS: Initials of workmaster's Vasilii Finnikov, assay mark of St. Petersburg before 1899, 56 zolotnik, scratched inventory number 36643 (possibly made for Fabergé)
DIMENSIONS: D 2 in. (5.1 cm)
PROVENANCE: Russian Imperial Treasures. "The Schaffer Collection," #2497, May 1, 1940, $450; Lillian Thomas Pratt
EXHIBITED: VMFA 1983; FA 1996
BIBLIOGRAPHY: Lesley 1976, cat. no. 313, p. 151; Habsburg 1996, cat. no. 104, p. 131
NOTE: This *charka* is a characteristic creation of Finnikov, who also worked for Hahn, Bolin, and Fabergé.
BEQUEST OF LILLIAN THOMAS PRATT, 47.20.292

250 enlarged

251 enlarged

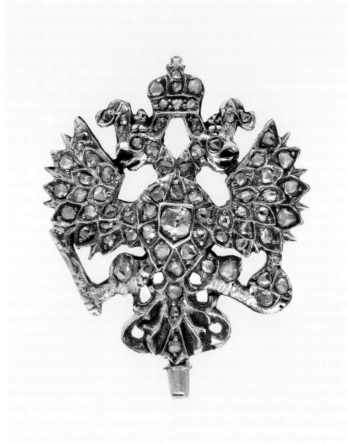

252 enlarged

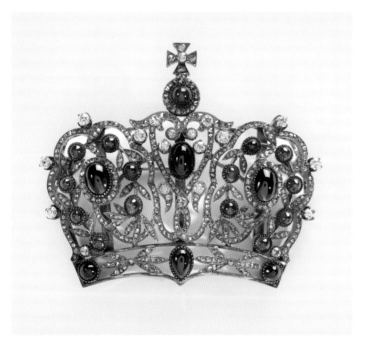

253 enlarged

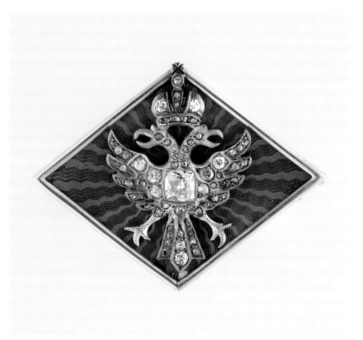

254 enlarged

Jewels

251 Brooch with Crowned *M*

Gold, diamonds, rubies

The green- and red-gold laurel wreath with diamond-set berries encloses a diamond-set letter *M* surmounted by a diamond-and-ruby-set imperial crown.

UNMARKED
DIMENSIONS: D 1¼ in. (3.2 cm)
PROVENANCE: Lillian Thomas Pratt
EXHIBITED: VMFA 1983
BIBLIOGRAPHY: Lesley 1976, cat. no. 268, p. 135, p. 134 (ill.)
NOTE: As the letter is in Latin script and without a patronymic, this was possibly a regimental badge.
BEQUEST OF LILLIAN THOMAS PRATT, 47.20.141

252 Diamond Pin

Gold, diamonds

The pin is shaped as an imperial double-headed eagle set with rose-cut diamonds.

UNMARKED
DIMENSIONS: 1 in. (2.5 cm)
PROVENANCE: Lillian Thomas Pratt
BEQUEST OF LILLIAN THOMAS PRATT, 47.20.497

253 Crown Brooch

Silver gilt, sapphires, rubies, diamonds

The openwork crown is set with cabochon sapphires, some of which are pear shaped; numerous cabochon rubies; and foliage set with rose-cut diamonds. A diamond-set cross surmounts the brooch.

UNMARKED
DIMENSIONS: W 3 in. (7.6 cm)
PROVENANCE: Russian Imperial Treasures Inc. "The Schaffer Collection" #1569, June 1, 1940, $1,800 (from the "personal belongings of Czarina Alexandra Feodorovna"); Lillian Thomas Pratt
EXHIBITED: VMFA 2005
BIBLIOGRAPHY: Lesley 1976, cat. no. 265, p. 135, p. 133 (ill.); Curry 1995, cat. no. 14, pp. 30, 108 (ill.)
NOTE: The brooch is probably the upper part of a panagia of the Virgin Mary.
BEQUEST OF LILLIAN THOMAS PRATT, 47.20.138

254 Imperial Diamond Brooch

Gold, enamel, diamonds

The lozenge-shaped brooch is applied with a double-headed eagle set with a central square diamond and brilliant- and rose-cut diamonds. It rests on a translucent-mauve panel of an engine-turned wavy sunburst. The border is plain gold.

MARKS: Initials of workmaster *I* or *N. Ch.*, 56 zolotnik
DIMENSIONS: W 1½ in. (3.8 cm)
PROVENANCE: Lillian Thomas Pratt
EXHIBITED: VMFA 1983; *FA* 1996 (VMFA only)
BIBLIOGRAPHY: Lesley 1976, cat. no. 267, p. 135, p. 134 (ill.)
BEQUEST OF LILLIAN THOMAS PRATT, 47.20.140

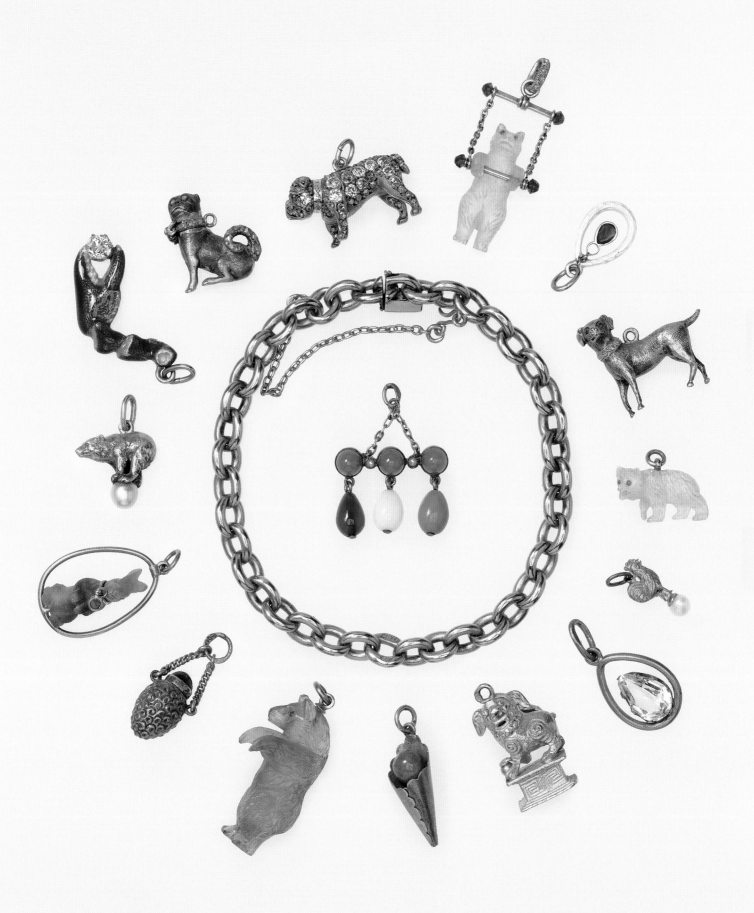

255 Charm Bracelet

Gold

The yellow-and-gold-link bracelet is attached with 15 charms.

MARKS: Initials of workmaster *A. E.*, 56 zolotnik
DIMENSIONS: Bracelet: 6 ½ in. (16.5 cm);
Charms: see below
PROVENANCE: Lillian Thomas Pratt
BIBLIOGRAPHY: Lesley 1976, cat. no. 284, p. 137, p. 136 (ill.)
BEQUEST OF LILLIAN THOMAS PRATT, 47.20.161

Charms (clockwise from top):

Bulldog, gold, silver, diamonds, ruby, ½ × 1 in.
 (1.3 × 2.5 cm), 47.20.131
Bear on Trapeze, chalcedony, silver, ruby, diamond,
 1 × ½ in. (2.5 × 1.3 cm), 47.20.129
Pendant, gold, enamel, ruby, ⅝ × ⅜ in. (1.6 × 1 cm),
 47.20.118
Dog, gold, ruby, ¾ × ⅜ in. (1.9 × 1 cm), 47.20.403
Bear, opal, ruby, gold, ½ × ¾ in. (1.3 × 1.9 cm),
 47.20.133
Rooster, gold, pearl, ½ × ¼ in. (1.3 × 0.6 cm),
 47.20.130
Pendant, gold, aquamarine, ¾ × ½ in. (1.9 × 1.3 cm),
 47.20.112
Foo Dog, gold, ¾ × ½ in. (1.9 × 1.3 cm), 47.20.402
Pendant, gold, turquoise, 1 × ⅜ in. (2.5 × 1 cm),
 47.20.83
Bear, amethyst ruby, gold, 1 ⅛ × ½ in. (2.9 × 1.3 cm),
 47.20.134
Miniature Scent Flask, gold, amethyst, ¾ × 5⁄16 in.
 (1.9 × 0.8 cm), 47.20.79
Rabbit, gold, red enamel, diamond, ⅝ × 1 in.
 (1.6 × 2.5 cm), 47.20.136
Bear, gold, pearl, ⅝ × ⅝ in. (1.6 × 1.6 cm), 47.20.132
Lobster Claw, gold, red enamel, diamond, ⅜ × 1 ⅛ in.
 (1 × 2.9 cm), 47.20.135
Bulldog, gold, diamonds, ¾ × ¾ in. (1.9 × 1.9 cm),
 47.20.206

256 enlarged

256 Lion Pendant

Topaz, gold, rubies, diamonds, rock crystal

An oval topaz is carved in high relief with a ruby-eyed lion's face that is encircled in a wreath of chased yellow- and red-gold. The lion holds a diamond-set gold ring in its mouth.

UNMARKED
DIMENSIONS: H 2 ¾ × W 2 in. (7 × 5.1 cm)
PROVENANCE: The Alexander Schaffer Collection of Russian Imperial Treasure, June 1, 1935, $850; Lillian Thomas Pratt
EXHIBITED: VMFA 1983; VMFA 2005
BIBLIOGRAPHY: Lesley 1976, cat. no. 266, p. 133, p. 135 (ill.)
BEQUEST OF LILLIAN THOMAS PRATT, 47.20.139

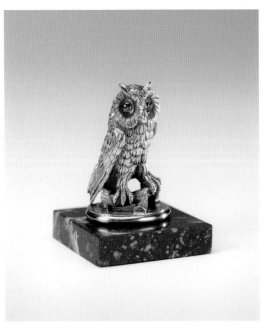

257

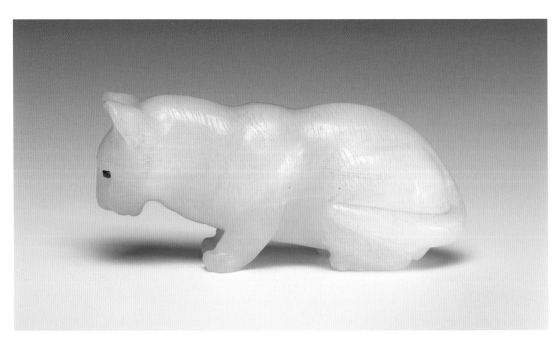

258

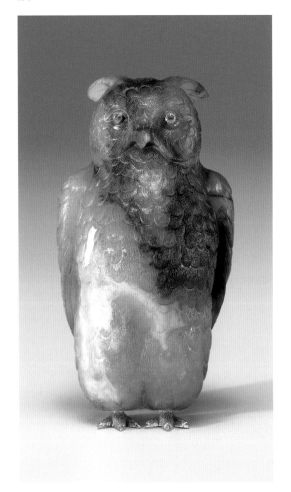

259

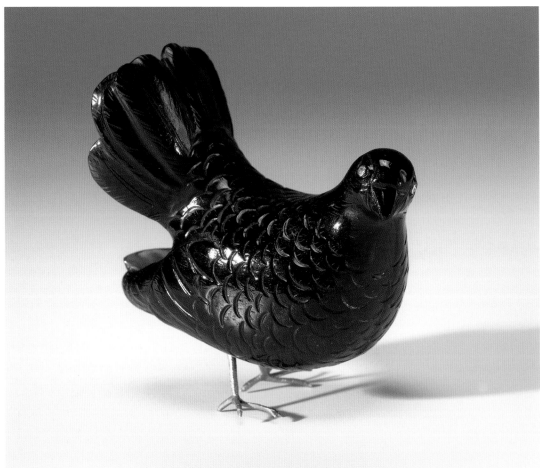

260

Hardstones: Animals

257 Owl

Silver gilt, lapis lazuli, rubies

The naturalistically chased owl with cabochon-ruby eyes is seated on a perch that rests on a lapis lazuli base.

French Restricted Guarantee, 1838–present
DIMENSIONS: 1⅝ in. (4.2 cm)
PROVENANCE: Lillian Thomas Pratt
BEQUEST OF LILLIAN THOMAS PRATT, 47.20.263

258 Cat

Alabaster, sapphires

The crouching white-alabaster cat has faceted-sapphire eyes.

DIMENSIONS: L 4 in. (10.2 cm)
PROVENANCE: Hammer Galleries, #1842/8, April 19, 1939 (from the "collection of the Grand Duchess Olga Nikolaevna, eldest daughter of Tsar Nikolai II, in the Aleksandr Palace, Tsarskoye Selo"); Lillian Thomas Pratt
BIBLIOGRAPHY: Lesley 1976, cat. no. 12, p. 21, p. 20 (ill.)
BEQUEST OF LILLIAN THOMAS PRATT, 47.20.247

259 Eagle Owl

Agate, topaz or citrine, gold

The eagle owl (*Bubo bubo*) of grayish agate has faceted citrine eyes and gold feet.

DIMENSIONS: 3 ¾ in. (9.5 cm)
PROVENANCE: The Schaffer Collection of Russian Imperial Art Treasures, #1537, March 19, 1937, $750 ("a most important miniature sculpture of a horned owl by Carl G. Fabergé"); Lillian Thomas Pratt
EXHIBITED: NCMA 1979; VMFA 1983
BIBLIOGRAPHY: Lesley 1976, cat. no. 38, p. 31, p. 30 (ill.)
NOTE: The excellent quality of the carving could indicate a Siberian (Ekaterinburg) origin.
BEQUEST OF LILLIAN THOMAS PRATT, 47.20.264

260 Black Grouse

Obsidian, diamonds, gold

The black grouse (*Tetrao tetrix)* has diamond eyes and gold feet.

FORGED MARKS: *Fabergé, H. W., 72*
DIMENSIONS: L 3 ⅞ in. (9.8 cm)
PROVENANCE: Hammer Galleries, #VD 5399/4, March 2, 1939, $875 ("Created by Carl Fabergé . . . it is hallmarked with his name and the initials of his leading master, Henrik Wigström. From the personal quarters of Tsar Nikolai II in the Aleksandr Palace, Tsarskoye Selo"); Lillian Thomas Pratt
BIBLIOGRAPHY: Hammer Galleries catalogue 1940?; Lesley 1976, cat. no. 30, p. 26
NOTE: The poor carving and the added spindly legs exclude an attribution to Fabergé. The hallmarks are identical to those used on the forged flowers.
BEQUEST OF LILLIAN THOMAS PRATT, 47.20.260

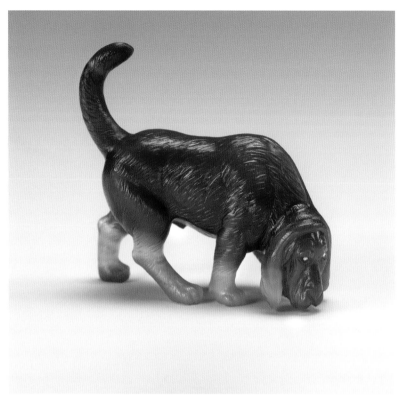

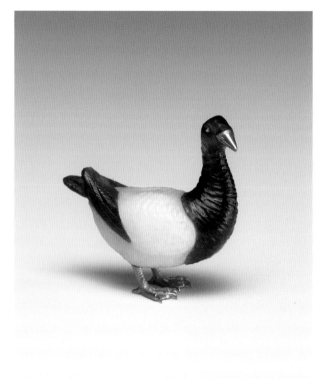

261

262

261 Bloodhound

Carnelian, diamonds

This prowling bloodhound of reddish agate has rose-cut diamond eyes.

DIMENSIONS: L 2¾ in. (7 cm)
PROVENANCE: Russian Imperial Treasures Inc.,
The Schaffer Collection of Russian Imperial Art,
#2322, February 1, 1940, $750; Lillian Thomas Pratt
EXHIBITED: VMFA 1983; FA 1996 (VMFA only)
BIBLIOGRAPHY: Lesley 1976, cat. no. 6, p. 19,
p. 18 (ill.); Curry 1995, cat. no. 35, p. 110, p. 104 (ill.)
NOTE: For a Fabergé connection to Idar-Oberstein,
see Habsburg 1986.
BEQUEST OF LILLIAN THOMAS PRATT, 47.20.240

262 Mallard Duck

Agate, obsidian, gold, diamonds

This composite duck has gold webbed feet and a replacement gold beak.

DIMENSIONS: 1¾ in. (4.5 cm)
PROVENANCE: Lillian Thomas Pratt
EXHIBITED: VMFA 1983; ALVR 1983
BIBLIOGRAPHY: Lesley 1976, cat. no. 28, p. 25,
p. 24 (ill.); ALVR 1983, cat. no. 441, p. 119
BEQUEST OF LILLIAN THOMAS PRATT, 47.20.258

263 Polar Bear

White onyx, emeralds

The naturalistically carved bear has emerald eyes.

UNMARKED: Attributed to Denisov-Ural'skii
DIMENSIONS: L 5¾ in. (14.6 cm)
PROVENANCE: Hammer Galleries, #RH-1842-12,
April 19, 1939 (from the "apartments of Czar
Nikolai II, Aleksandr Palace, Tsarskoye Selo");
Lillian Thomas Pratt
EXHIBITED: VMFA 1983; FA 1996
BIBLIOGRAPHY: Lesley 1976, cat. no. 5, p. 19,
p. 18 (ill.); Habsburg 1996, cat. no. 117, p. 138
NOTE: Attributed by Hammer to Petr Mikhailovich
Kremlev the Younger. The piece is possibly identical
to (or the same model as) *ours en onyx blanc yeux
émeraudes* (white onyx bear with emerald eyes),
one of Cartier's acquisitions from Denisov-Ural'skii
in 1911, depicted in Cartier's Russian ledgers as
"item 217" (see Chapter 4, p. 71).
BEQUEST OF LILLIAN THOMAS PRATT, 47.20.239

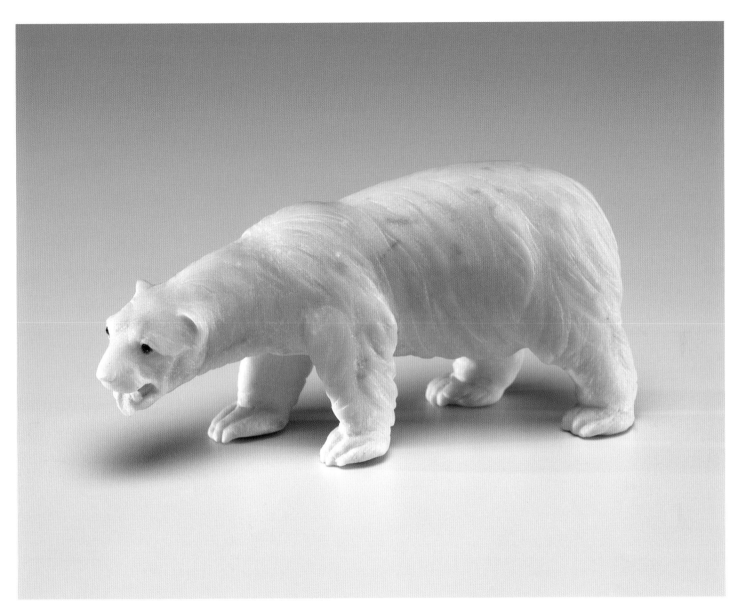

263

"Item 217" as seen in Cartier's acquisition ledger.

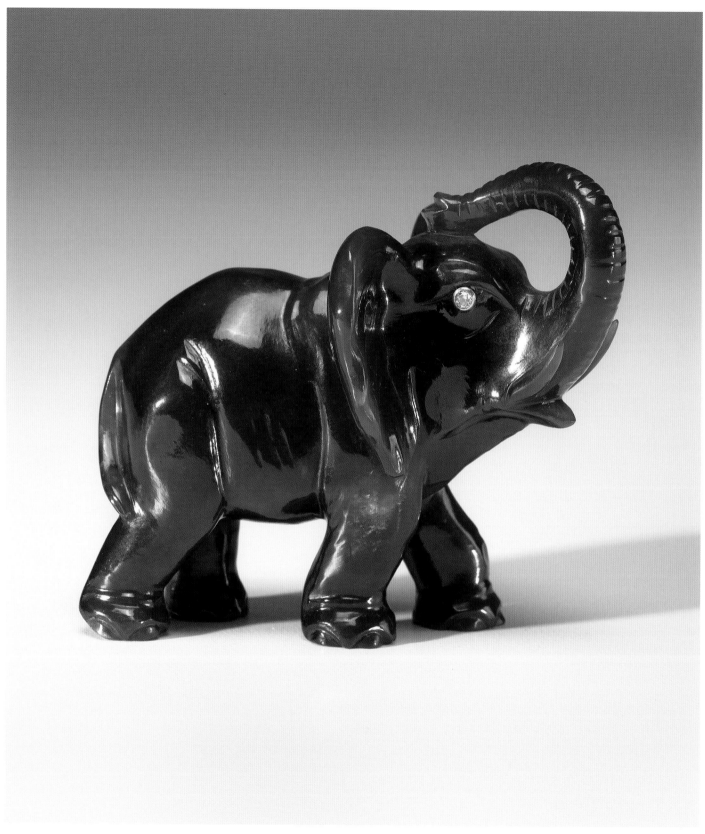

264 enlarged

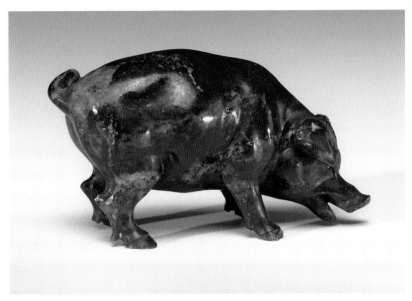

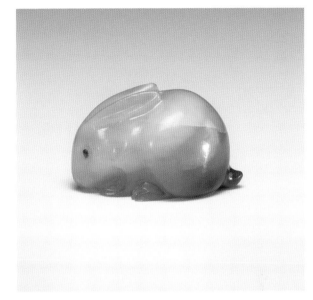

265

266

264 Elephant

Nephrite, diamonds

The charging African elephant with raised trunk is of nephrite and has circular-cut diamond eyes.

Russian or French, possibly retailed by Cartier
DIMENSIONS: 3 in. (8.9 cm)
PROVENANCE: Lillian Thomas Pratt
BIBLIOGRAPHY: Lesley 1976, cat. no. 18, p. 23, p. 22 (ill.)
NOTE: This example is possibly identical with one of Cartier's nephrite *éléphant en furie (grand)* [a large, furious elephant] acquired from Worth in Paris in 1905.
BEQUEST OF LILLIAN THOMAS PRATT, 47.20.251

265 Pig

Lapis lazuli, diamonds

The varicolored-lapis pig has rose-cut diamond eyes.

Russian or French, possibly retailed by Cartier
DIMENSIONS: L 3 ½ in. (8.9 cm)

PROVENANCE: Russian Imperial Treasures Inc., "The Schaffer Collection," $600; Lillian Thomas Pratt
EXHIBITED: NCMA 1979
BIBLIOGRAPHY: Lesley 1976, cat. no. 19, p. 23
BEQUEST OF LILLIAN THOMAS PRATT, 47.20.252

266 Rabbit

Nephrite jade, rubies

The crouching jade rabbit has faceted-ruby eyes.

Russian or French, possibly retailed by Cartier
DIMENSIONS: L 1 ¾ in. (4.5 cm)
PROVENANCE: Lillian Thomas Pratt
BIBLIOGRAPHY: Lesley 1976, cat. no. 23, p. 23
NOTE: The summary treatment of the animal would appear to indicate a French origin. Cartier commissioned a number of such rabbits from his Paris suppliers.
BEQUEST OF LILLIAN THOMAS PRATT, 47.20.253

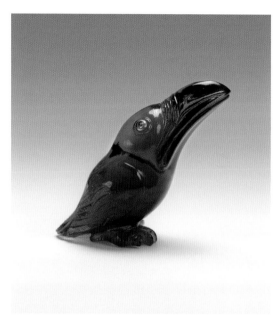

267

267 Hornbill

Obsidian, diamonds

The caricatured obsidian hornbill intently gazes upward with circular-cut diamond eyes.

Attributed to Cartier

DIMENSIONS: 1¾ in. (4.5 cm)

PROVENANCE: Russian Imperial Treasures Inc., "The Schaffer Collection," February 1, 1940, $300; Lillian Thomas Pratt

EXHIBITED: VMFA 1983; *FA* 1996 (VMFA only)

BIBLIOGRAPHY: Lesley 1976, cat. no. 26, p. 25, p. 24 (ill.); Curry 1995, cat. no. 33, p. 110, 102 (ill.)

NOTE: Numerous examples of this figure in varying colored hardstones were sold by Fabergé (see Christie's Geneva, November 9, 1977, lot 225 in lapis lazuli; Christie's Geneva, April 26, 1978, lot 332 in nephrite; Christie's Geneva, May 12, 1981, lot 110 in nephrite with original fitted case), but also by Cartier (see Habsburg 2003, p. 84, ill. 12).

BEQUEST OF LILLIAN THOMAS PRATT, 47.20.256

268 French Bulldog

Smoky quartz, sapphires

The seated bulldog has cabochon-sapphire eyes and a faceted-sapphire collar from which hangs an oval sapphire pendant.

Attributed to Cartier

DIMENSIONS: 3⅛ in. (7.9 cm)

PROVENANCE: Hammer Galleries, RH 5332/4, February 17, 1939, $875 ("These little sculptures are designed and executed with incomparable finesse. They are the creations of Carl Fabergé. The topaz dogs are from the collection of the Tsarina Aleksandra Feodorovna, wife of Tsar Nikolai II, in the Aleksandr Palace, Tsarskoye Selo."); Lillian Thomas Pratt

BIBLIOGRAPHY: Hammer Galleries catalogue 1940?, "Small Animal Sculptures," row 2, #5 (ill.); Lesley 1976, cat. no. 8, p. 19, p. 18 (ill.)

NOTE: Seated bulldogs of frosted smoky quartz are traditionally attributed to Cartier, although similar examples by Fabergé also exist. This bulldog and cat. no. 270 were sold as a pair by Hammer. A similar bulldog is in the Hillwood Museum in Washington, D.C. (Ross 1965).

BEQUEST OF LILLIAN THOMAS PRATT, 47.20.241

269 Hummingbird on a Perch

Agate, purpurine, gold, sapphires, diamonds, enamel

The agate bird has rose-cut diamond eyes and is preening an extended wing.

The crossbar of the gold perch on which the bird sits has rose-cut diamond and cabochon-sapphire terminals. The base of the stand is of opaque-white and orange guilloché enamel. The circular purpurine tray has a reed-and-tie border and stands on four ball feet.

FORGED MARKS: Fabergé and Russian hallmarks; attributed to Cartier.

DIMENSIONS: 7 in. (17.8 cm)

PROVENANCE: Hammer Galleries #5408-14, January 9, 1940 ("Exquisitely carved figure of a hummingbird . . . it was created by Karl Fabergé, world-famed court jeweler to Aleksandr III and Nikolai II of Russia."); Lillian Thomas Pratt

BIBLIOGRAPHY: Lesley 1976, cat. no. 33, p. 26, p. 27 (ill.)

BEQUEST OF LILLIAN THOMAS PRATT, 47.20.212

270 French Bulldog

Smoky quartz, sapphires, gold

The crouching bulldog with cabochon-sapphire eyes has a gold collar set with faceted sapphires.

Attributed to Cartier

DIMENSIONS: L 2¾ in. (7 cm)

PROVENANCE: Hammer Galleries, RH 5332/4, February 17, 1939 ("These little sculptures are designed and executed with incomparable finesse. They are the creations of Carl Fabergé. The topaz dogs are from the collection of the Tsarina Aleksandra Feodorovna, wife of Tsar Nikolai II, in the Aleksandr Palace, Tsarskoye Selo."); Lillian Thomas Pratt

EXHIBITED: VMFA 1983

BIBLIOGRAPHY: Lesley 1976, cat. no. 9, p. 19, p. 18 (ill.)

NOTE: This bulldog and cat. no. 268 were sold as a pair.

BEQUEST OF LILLIAN THOMAS PRATT, 47.20.242

271 French Bulldog

Smoky quartz, rubies, gold, pearl

The seated bulldog with faceted-ruby eyes has a gold collar from which is suspended a pearl pendant.

Attributed to Cartier

DIMENSIONS: 1⅝ in. (4.2 cm)

PROVENANCE: Lillian Thomas Pratt

BIBLIOGRAPHY: Lesley 1976, cat. no. 10, p. 21, p. 20 (ill.)

BEQUEST OF LILLIAN THOMAS PRATT, 47.20.243

268

269 reduced

270

271 enlarged

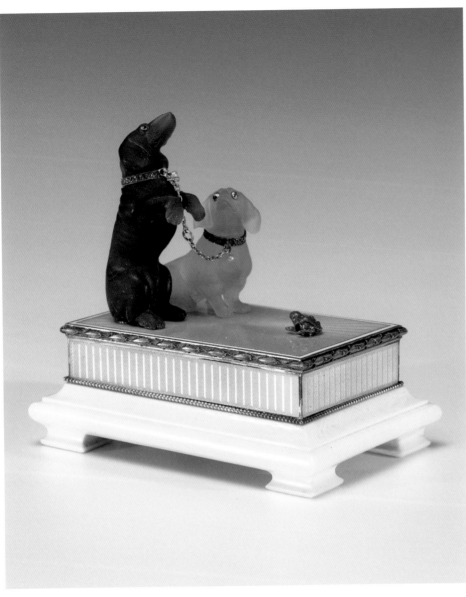

272 enlarged

272 Dachshund Bell Push

Silver, ivory, smoky topaz, enamel, rubies, emeralds, pearls

Begging for a treat, the smoky-quartz dachshund has ruby eyes and a collar set with demantoid garnets. It stands beside a seated gray smoky-quartz dachshund with demantoid garnet eyes and a ruby-set collar. Both are on a rectangular plinth decorated in pale-blue translucent enamel over a guilloché sunburst ground that stands on an ivory base. The engine-turned rays issue from a silver frog that acts as a push-piece.

By Cartier, ca. 1915
DIMENSIONS: L 3 ½ in. (8.9 cm)
PROVENANCE: Mr. Dimitry Troubs
EXHIBITED: PFAC 1981
NOTE: This whimsical Cartier creation is typical for the years following his "Russian" period.
GIFT OF MR. DIMITRY TROUBS, 71.7.61

273 Pair of Lovebirds on a Perch

Amethyst, nephrite, ivory, gold, enamel, topazes, diamonds

The pair of amethyst birds has rose-cut diamond eyes and is seated on an ivory perch. The crossbar has rose-cut diamond and cabochon-topaz terminals. The stand's base is set with a rose-cut diamond and orange guilloché enamel sleeve, and is attached to a circular nephrite tray.

FORGED MARKS: By Cartier; *Fabergé, H. W., 72*
DIMENSIONS: 4 ½ in. (11.4 cm)
PROVENANCE: Hammer Galleries #VD 5399/16, February 4, 1939, $1,800 ("Created by Carl Fabergé. From the Collection of Tsarina Aleksandra Feodorovna in the Aleksandr Palace, Tsarskoye Selo"); Lillian Thomas Pratt
EXHIBITED: VMFA 1983
BIBLIOGRAPHY: Lesley 1976, cat. no. 34, p. 31, p. 28 (ill.)
NOTE: Such lovebirds or parakeets standing on very similar perches are known from both Fabergé and Cartier examples. Two Fabergé examples are in the Walters Art Museum in Baltimore, Maryland (Sweezey 2003). The lesser quality of the carving indicates a French origin.
BEQUEST OF LILLIAN THOMAS PRATT, 47.20.211

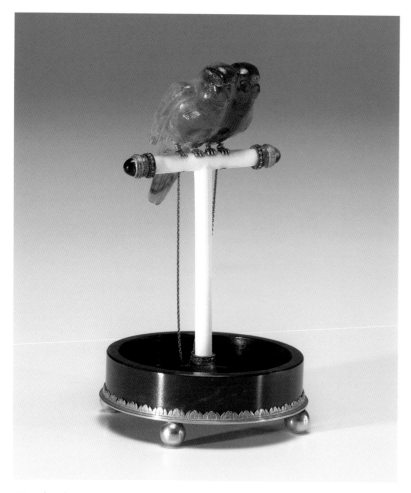

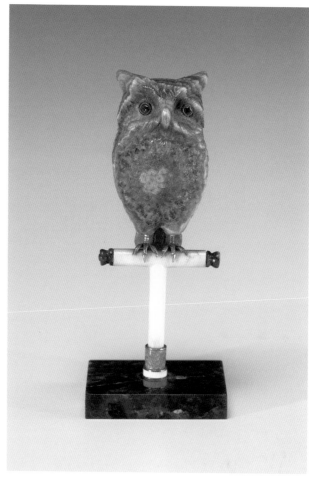

273 reduced

274

274 Owl

Agate, lapis lazuli, demantoid garnets, ivory, gold, enamel

The mottled, brownish-banded agate owl with demantoid garnet eyes is seated on an ivory perch with lapis terminals. The base has a pink guilloché enamel and opaque-white enamel gold ring and stands on a lapis base.

FORGED MARKS: By Cartier; *K. Fabergé* engraved on hardstone base
DIMENSIONS: 3 ⅜ in. (8.6 cm)
PROVENANCE: Russian Imperial Treasures. "The Schaffer Collection," #2454, March 1, 1941, $850; Lillian Thomas Pratt
BIBLIOGRAPHY: Lesley 1976, cat. no. 37, p. 31, p. 30 (ill.)
NOTE: For virtually identical Cartier owls see Habsburg 2003.
BEQUEST OF LILLIAN THOMAS PRATT, 47.20.216

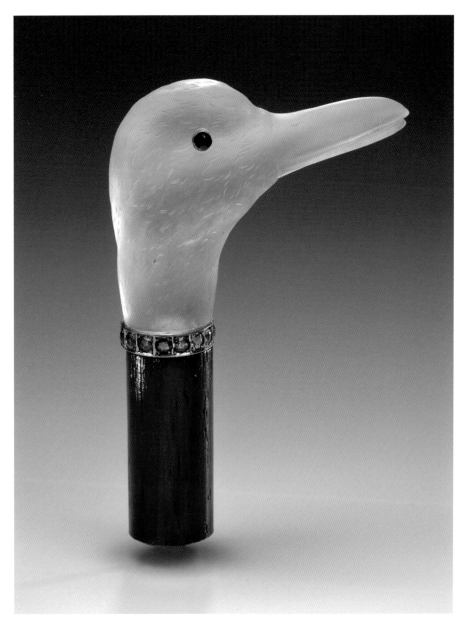

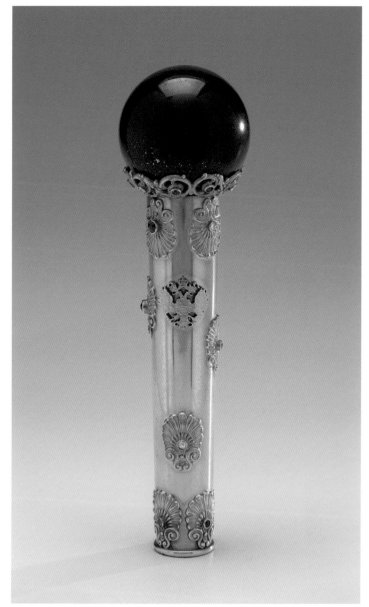

275 reduced

276

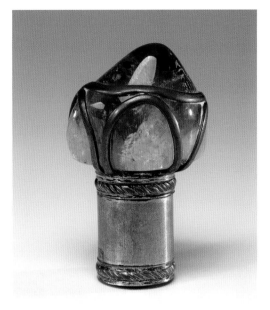

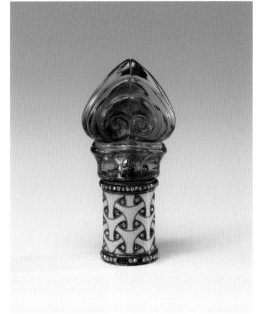

277

278

Hardstones: Handles

275 Parasol Handle

Rock crystal, gold, sapphires, tourmalines

The handle is realistically carved as a duck's head. The eyes are sapphire, and the gold collar is set with faceted tourmalines.

MARKS: Maker's mark illegible
DIMENSIONS: 12 ¾ × 2 ¾ in. (32.4 × 7 cm)
PROVENANCE: Hammer Galleries, #RH-5214/4, January 27, 1938 ("It was created by the celebrated Russian court jeweler to Nicholai II, Carl Fabergé, for Tsarina Alexandra Feodorovna and was found in her personal quarters in the Alexander Palace, Tsarskoye Selo."); Lillian Thomas Pratt
EXHIBITED: VMFA 1983
BIBLIOGRAPHY: Lesley 1976, cat. no. 234, p. 115, p. 114 (ill.)
BEQUEST OF LILLIAN THOMAS PRATT, 47.20.165

276 Parasol Handle

Lapis lazuli, gold, rubies, emeralds, sapphires, diamonds

The handle is shaped as a tapering gold column and is chased with shell motifs set with rose-cut diamonds and sapphires. A lapis lazuli ball tops the handle. The applied Russian imperial eagle is probably a later addition.

UNMARKED
DIMENSIONS: 4 ⅞ in. (12.4 cm)
PROVENANCE: Hammer Galleries, Russian Imperial Treasures, #AS-1312, May 1936 (from the "quarters of Czarina Alexandra Feodorovna, wife of Nicholai II, in the Alexander Palace, Tsarskoye Selo"); Lillian Thomas Pratt
EXHIBITED: VMFA 1983
BIBLIOGRAPHY: Lesley 1976, cat. no. 222, p. 111, p. 110 (ill.)
BEQUEST OF LILLIAN THOMAS PRATT, 47.20.179

277 Parasol Handle

Amethyst quartz, silver gilt

The irregular stone of the handle is held by silver-gilt bands. The plain silver-gilt ferrule has corded borders.

MARKS: Initials of workmaster G. S., assay mark of St. Petersburg 1908–17, 84 zolotnik

DIMENSIONS: 2 ½ in. (6.4 cm)
PROVENANCE: Lillian Thomas Pratt
BIBLIOGRAPHY: Lesley 1976, cat. no. 218, p. 109, p. 108 (ill.)
BEQUEST OF LILLIAN THOMAS PRATT, 47.20.189

278 Parasol Handle

Amethyst, gold, diamonds, enamel

The amethyst parasol handle is carved with two shells. The gold ferrule is decorated with opaque-white enamel strapwork on a chased ground, and is set with rose-cut diamonds. The borders are also set with rose-cut diamonds.

UNMARKED
DIMENSIONS: 2 in. (5.1 cm)
PROVENANCE: Lillian Thomas Pratt
EXHIBITED: VMFA 1983
BIBLIOGRAPHY: Lesley 1976, cat. no. 219, p. 109, p. 108 (ill.)
BEQUEST OF LILLIAN THOMAS PRATT, 47.20.193

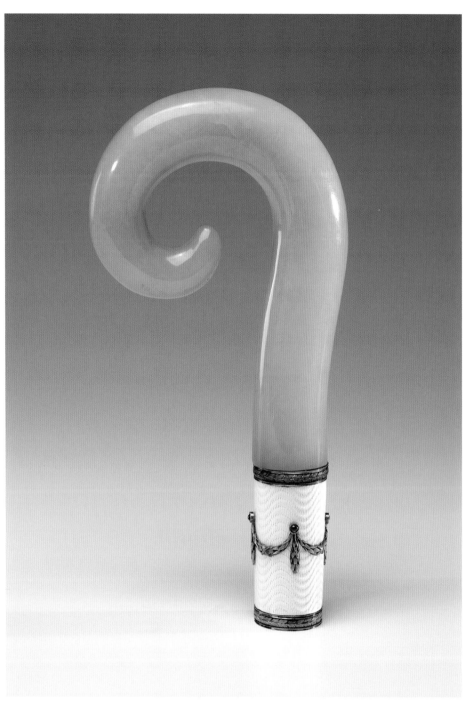

279

279 Parasol Handle

Bowenite, gold, rubies, enamel

The gold ferrule of the crook-shaped handle is of white moiré guilloché enamel and is applied with laurel swags suspended from cabochon rubies.

MARKS: Initials of workmaster *A?*, 56 zolotnik
DIMENSIONS: 5 ½ in. (14 cm)
PROVENANCE: Lillian Thomas Pratt
BIBLIOGRAPHY: Lesley 1976, cat. no. 239, p. 117, p. 116 (ill.)
EXHIBITED: VMFA 1983
BEQUEST OF LILLIAN THOMAS PRATT, 47.20.162

280 Parasol Handle

Bowenite, garnets, gold, enamel

The *L*-shaped handle is carved as an eagle's head with cabochon-garnet eyes. The ferrule is of white guilloché enamel and has palm-leaf borders.

UNMARKED
DIMENSIONS: 3 ½ in. (8.9 cm)
PROVENANCE: Russian Imperial Treasures. "The Schaffer Collection," #1749, September 3, 1940, $200; Lillian Thomas Pratt
BIBLIOGRAPHY: Lesley 1976, cat. no. 240, p. 117, p. 116 (ill.)
BEQUEST OF LILLIAN THOMAS PRATT, 47.20.163

281 Parasol Handle

Bowenite, gold

The egg-shaped bowenite handle is entwined by a chased-gold serpent and has a hammered-gold ferrule.

UNMARKED
DIMENSIONS: 2 ⅜ in. (6 cm)
PROVENANCE: Lillian Thomas Pratt
BIBLIOGRAPHY: Lesley 1976, cat. no. 247, p. 119, p. 118 (ill.)
BEQUEST OF LILLIAN THOMAS PRATT, 47.20.182

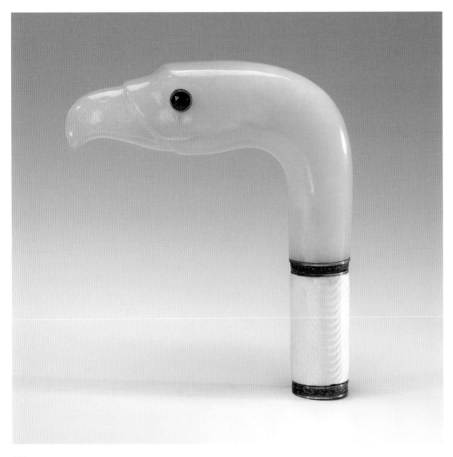

280

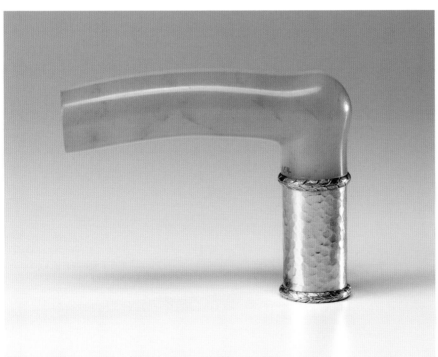

282

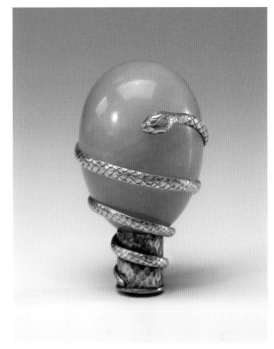

281

282 Parasol Handle

Bowenite, gold

The hammered-gold ferrule of the *L*-shaped bowenite handle has gold palm-leaf borders.

MARKS: Initials of workmaster illegible, St. Petersburg 1908–17, 56 zolotnik
DIMENSIONS: 2 ⅜ in. (6 cm)
PROVENANCE: Lillian Thomas Pratt
BIBLIOGRAPHY: Lesley 1976, cat. no. 241, p. 117, p. 116 (ill.)
BEQUEST OF LILLIAN THOMAS PRATT, 47.20.164

283 Parasol Handle

NOT ILLUSTRATED

Nephrite, silver gilt, sapphires

The slightly curved handle has silver-gilt bands engraved with Greek key patterns. The top is encrusted with light-blue faceted stones.

UNMARKED
DIMENSIONS: 12 × 1 ¼ in (30.5 × 3.2 cm)
PROVENANCE: Russian Imperial Treasure Inc. #572, $325; Lillian Thomas Pratt
EXHIBITED: VMFA 1983
BIBLIOGRAPHY: Lesley 1976, cat. no. 224, p. 111, p. 110 (ill.)
BEQUEST OF LILLIAN THOMAS PRATT, 47.20.167

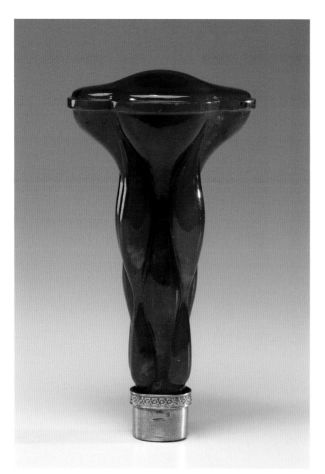

284

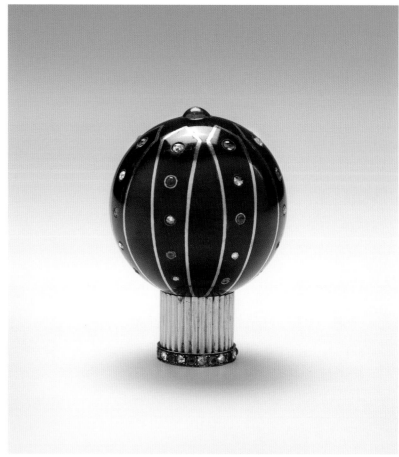

285

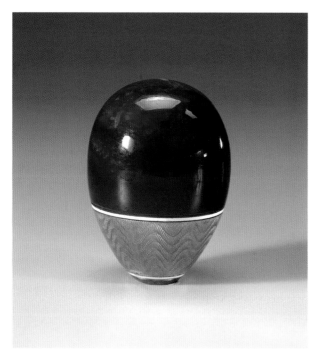

286

284 Parasol Handle

Nephrite, silver-gilt

The Art Nouveau style nephrite handle
has a stem of entwined bulbous shapes,
a convex quatrefoil top, and an engine-
turned ferrule.

DIMENSIONS: 4 in. (10.2 cm)
PROVENANCE: Lillian Thomas Pratt
BIBLIOGRAPHY: Lesley 1976, cat. no. 229
BEQUEST LILLIAN THOMAS PRATT 47.20.191

285 Cane Handle

Nephrite, gold, rubies, diamonds, rose quartz

The spherical nephrite handle is inlaid
with gold fillets set with alternating rubies
and diamonds. It has a rose-quartz finial

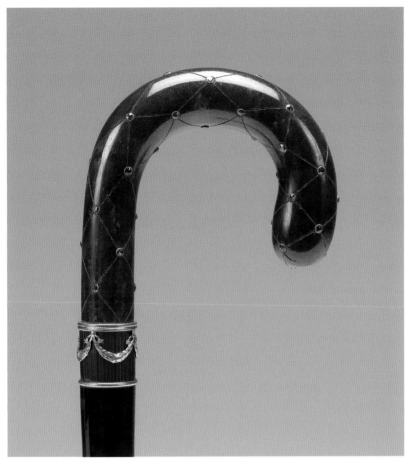

287 detail

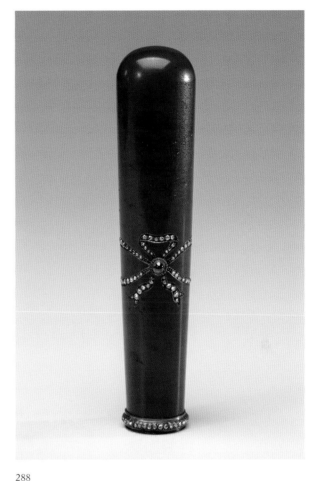

288

and a fluted gold ferrule. The lower border is set with diamonds and rubies.

MARKS: Workmaster's mark illegible, assay mark of St. Petersburg 1908–17, 56 zolotnik

DIMENSIONS: 2 ⅝ × 1 ¾ in. (6.7 × 4.4 cm)

PROVENANCE: Lillian Thomas Pratt

EXHIBITED: VMFA 1983

BIBLIOGRAPHY: Lesley 1976, cat. no. 230, p. 113, p. 112 (ill.)

BEQUEST OF LILLIAN THOMAS PRATT, 47.20.192

286 Cane Handle

Nephrite, silver, enamel

The egg-shaped parasol handle has a tapering ferrule of mauve enamel.

UNMARKED

DIMENSIONS: 2 in. (5.1 cm)

PROVENANCE: Lillian Thomas Pratt

BIBLIOGRAPHY: Lesley 1976, cat. no. 232, p. 113

BEQUEST OF LILLIAN THOMAS PRATT, 47.20.197

287 Cane Handle

Nephrite, gold, rubies, enamel

The curved handle is carved in a trellis pattern with rubies at the intersections. The gold ferrule of red moiré guilloché enamel is applied with chased-gold laurel swags.

UNMARKED

DIMENSIONS: 12 ¾ × 2 ¾ in. (32.4 × 7 cm)

PROVENANCE: Lillian Thomas Pratt

BIBLIOGRAPHY: Lesley 1976, cat. no. 223, p. 111, p. 110 (ill.)

EXHIBITED: VMFA 1983

BEQUEST OF LILLIAN THOMAS PRATT, 47.20.166

288 Parasol Handle

Nephrite, diamonds, rubies, gold

The cylindrical handle is applied with a tied ribbon set in rose-cut diamonds. A cabochon ruby is in the center of each bow. The ferrule is set with rose-cut diamonds.

UNMARKED

DIMENSIONS: 3 ⅞ in. (9.9 cm)

PROVENANCE: Hammer Galleries, #RH 5389/2, February 17, 1939 ("Created by Carl Fabergé for Tsarina Alexandra Feodorovna"); Lillian Thomas Pratt

BIBLIOGRAPHY: Lesley 1976, cat. no. 225, p. 111

EXHIBITED: VMFA 1983

BEQUEST OF LILLIAN THOMAS PRATT, 47.20.170

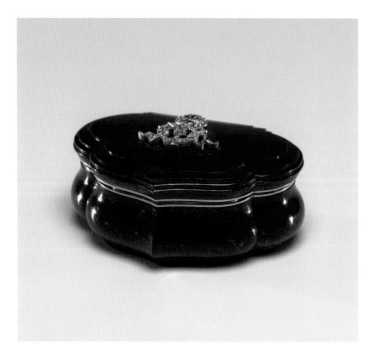

289

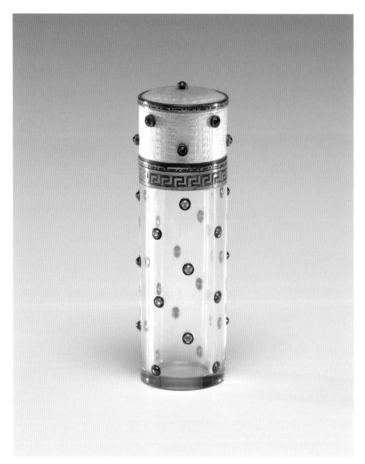

290

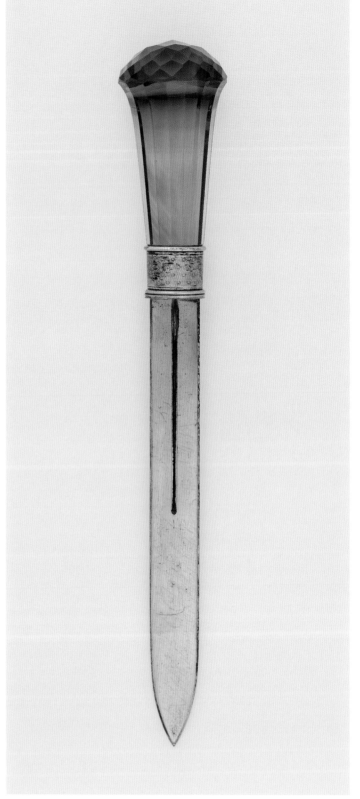

291 reduced

Hardstones: Other

289 Imperial Presentation Box

Lapis lazuli, gold, diamonds

The cover of this cartouche-shaped lapis lazuli snuffbox is applied with a diamond-set crowned Cyrillic cypher *MF* (for Tsaritsa Maria Feodorovna).

UNMARKED: ca. 1880
DIMENSIONS: L 2 ½ in. (6.3 cm)
PROVENANCE: Lillian Thomas Pratt
EXHIBITED: VMFA 1983
BIBLIOGRAPHY: Lesley 1976, cat. no. 289, p. 143, p. 142 (ill.);
BEQUEST OF LILLIAN THOMAS PRATT, 47.20.273

290 Perfume Vial

Rock crystal, gold, enamel, sapphires

The rock-crystal vial has a white guilloché-enamel cover studded with cabochon sapphires. The lip is chased with a Greek key pattern.

MARKS: Illegible
DIMENSIONS: 3 in. (7.6 cm)
PROVENANCE: The Alexander Schaffer Collection of Russian Imperial Treasure, #2247; Lillian Thomas Pratt
EXHIBITED: VMFA 1983; *FA* 1996 (VMFA only)
BIBLIOGRAPHY: Lesley 1976, cat. no. 328, p. 157; Curry 1995, cat. no. 41, p. 112, p. 120 (ill.)
BEQUEST OF LILLIAN THOMAS PRATT, 47.20.299

291 Paper Knife

Topaz, silver gilt

The paper knife with a faceted, tapering topaz handle and a plain silver-gilt blade was originally a cane handle.

UNMARKED
DIMENSIONS: L 8 ½ in. (21.6 cm)
The knife has a fitted case from A La Vieille Russie.
PROVENANCE: Lillian Thomas Pratt
BEQUEST OF LILLIAN THOMAS PRATT, 47.20.394

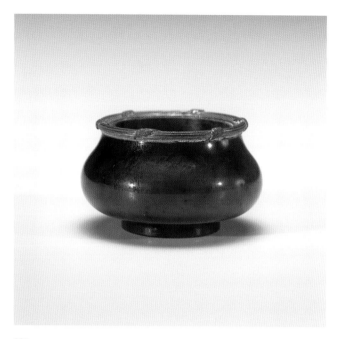

292

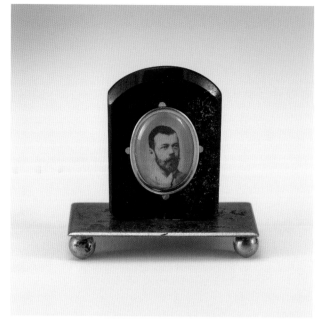

293 enlarged

292 Bowl

Nephrite, silver gilt

The bombé nephrite bowl has a reed-and-tie rim.

MARKS: Assay mark of St. Petersburg before 1899, 88 zolotnik
DIMENSIONS: 1⅛ in. (2.9 cm)
PROVENANCE: Lillian Thomas Pratt
BIBLIOGRAPHY: Lesley 1976, cat. no. 325, p. 157, p. 156 (ill.)
BEQUEST OF LILLIAN THOMAS PRATT, 47.20.290

293 Frame

Lapis lazuli, silver gilt

The lapis lazuli frame with an arched top has an oval aperture with a silver-gilt bezel. The image of Tsar Nicholas II was added later.

UNMARKED
DIMENSIONS: 1¼ in. (3.2 cm)
PROVENANCE: Lillian Thomas Pratt
EXHIBITED: PFAC 1981
BEQUEST OF LILLIAN THOMAS PRATT, 47.20.325

294 Seal

Lapis lazuli, gold, diamonds

The tapering, polygonal seal has lapis lazuli panels bound with gold bands topped by

diamonds. The sleeve comprises a scroll design encircled by two wires applied with lozenges and set with diamonds.

MARKS: Initials of workmaster *A. K.*
DIMENSIONS: 2½ in. (6.3 cm)
Fitted leather case
PROVENANCE: Lillian Thomas Pratt
BIBLIOGRAPHY: Lesley 1976, cat. no. 307, p. 149, p. 148 (ill.)
BEQUEST OF LILLIAN THOMAS PRATT, 47.20.203

295 Footed Bowl

Agate, turquoises, gold

Two bands of turquoise encircle the brown-and-white veined agate bowl.

UNMARKED
DIMENSIONS: 2 in. (5.1 cm)
PROVENANCE: Lillian Thomas Pratt
BIBLIOGRAPHY: Lesley 1976, cat. no. 324, p. 157, p. 156 (ill.)
BEQUEST OF LILLIAN THOMAS PRATT, 47.20.289

296 Frame

Gold, nephrite, enamel, pearls, rubies, glass, wood

The circular nephrite frame has a wide outer border of opalescent pale-pink guilloché enamel that is applied with intertwining bands of palm leaves.

The bowknot cresting is set with a ruby. The photograph of one of the grand duchesses was added later.

MARKS: Initials of unidentified workmaster *G. S,* (St. Petersburg) 1899–1908, 56 zolotnik
DIMENSIONS: D 2½ in. (6.3 cm)
PROVENANCE: Lillian Thomas Pratt
EXHIBITED: VMFA 1983
BIBLIOGRAPHY: Lesley 1976, cat. no. 184, p. 87
NOTE: The mark on this frame is possibly that of Geinrikh Geinrikhovich Skrivan (1832–1909), Supplier to the Imperial Court at 48 Nevskii Prospect. After his death in 1909, his widow continued the business until 1916 (see Ivanov 2003).
BEQUEST OF LILLIAN THOMAS PRATT, 47.20.339

297 Frame

Lapis lazuli, silver gilt

The small lapis lazuli frame has a silver-gilt bezel. The photograph of Tsaritsa Alexandra Feodorovna was added later.

MARKS: Initials of workmaster *G. S.,* 1908–17, 84 zolotnik
DIMENSIONS: 2½ in. (6.3 cm)
PROVENANCE: Lillian Thomas Pratt
EXHIBITED: PFAC 1981
BEQUEST OF LILLIAN THOMAS PRATT, 47.20.322

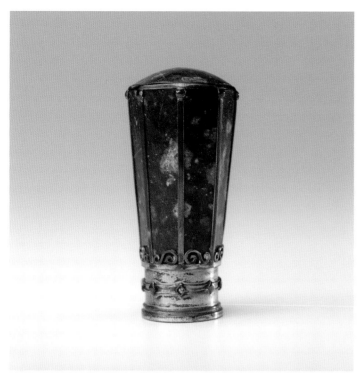

294

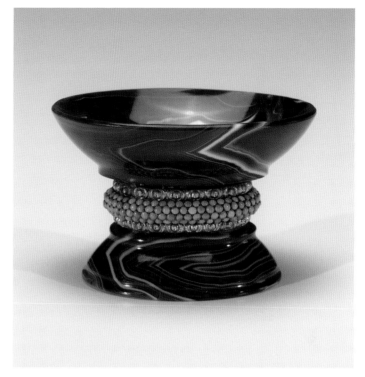

295

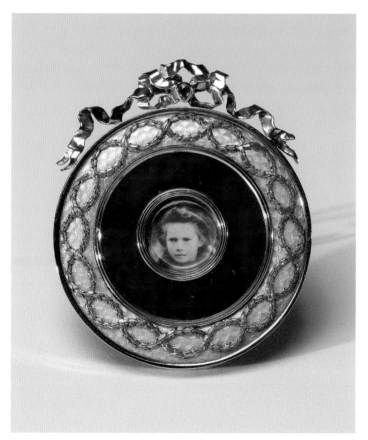

296 enlarged

297

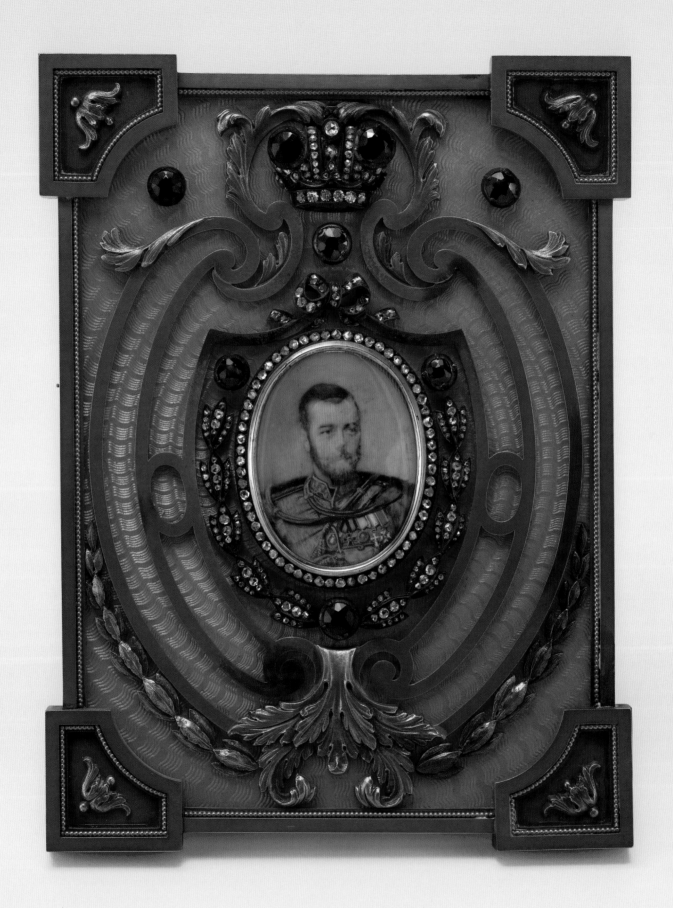

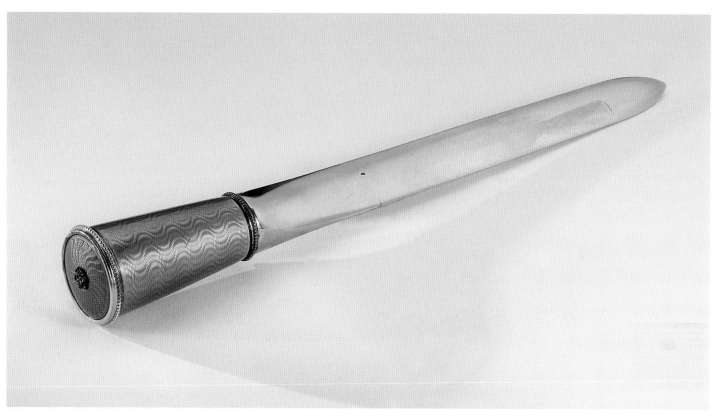

292 reduced

Enamels

298 Imperial Table Portrait

Gold, enamel, sapphires, diamonds, miniature

The elaborate mat gold frame of translucent-yellow enamel holds an oval miniature (faded) of Tsar Nicholas II within a rose-cut diamond border flanked by diamond-set husks and three cabochon sapphires. The crown above is set with diamonds and two cabochon sapphires. More are set below and beside the crown. The engine-turned frame is applied with gold ribs and is further embellished with chased-gold sprays of husks and acanthus foliage. Its easel is shaped as a monogram of Tsar Nicholas II.

MARKS: Workmaster's initials *F*K* for F. P. Koechly, assay mark of St. Petersburg 1899–1908, assay master A. Richter, 56 zolotnik
DIMENSIONS: 4¾ in. (12.1 cm)

Original fitted red Morocco case; lining stamped with gilt eagle and "Frid. Koechly," St. Petersburg
PROVENANCE: The Schaffer Collection of Russian Imperial Art Treasures, 1935; Lillian Thomas Pratt
BIBLIOGRAPHY: Lesley 1976, cat. no. 185, p. 87, p. 88 (ill.)
NOTE: According to information kindly provided by Dr. Ulla Tillander-Godenhielm, this table portrait was entered into the ledgers of the imperial cabinet on November 11, 1906, and was described as being made of gold, set with brilliants (no mention of cabochon sapphires, which may have been added later), and decorated in yellow enamel. Its cost was 1,800 rubles. On February 18, 1908, the frame was set with a 1906 miniature of Tsar Nicholas II by Zuev (#284, cost 200 rubles). On June 18, 1909, it was presented to Count Artur Pavlovich Cassini, minister of the imperial court, envoy extraordinaire, and minister plenipotentiary to the United States from 1898 to 1905. Its registered price was 2,000 rubles (see Tillander-Godenhielm 2005). Count Cassini was the personal representative of the tsar during the delicate negotiations leading up to the Treaty of Portsmouth in late 1905. Count Cassini was also the recipient of the diamond-set Order of St. Aleksandr Nevskii awarded for fifty years of service.
For a short biography of Friedrich Koechly (also known as Köchly) and other examples of his works, see Chapter 3, p. 53.
BEQUEST OF LILLIAN THOMAS PRATT, 47.20.307
FRAME WITH MINIATURE; 47.20.366 WITHIN FRAME

299 Paper Knife

Gold, enamel

The handle of this paper knife of apricot guilloché enamel was probably a parasol handle.

UNMARKED
DIMENSIONS: L 7½ in. (19 cm)
PROVENANCE: A La Vieille Russie; Ailsa Mellon Bruce
GIFT OF THE ESTATE OF AILSA MELLON BRUCE, 70.9.48

300 enlarged

302

303 reduced

300 Frame

Gold, enamel, ivory

The cartouche-shaped frame has an oval aperture and a decoration of scrolling foliage and flowers in blue, red, and green plique-à-jour enamel. The image of Tsar Nicholas II is a later addition.

MARKS: Initials of workmaster Alexander Treyden, assay mark of St. Petersburg before 1899, 56 zolotnik
DIMENSIONS: 3 ⅛ in. (7.9 cm)
PROVENANCE: Lillian Thomas Pratt
EXHIBITED: VMFA 1983
BIBLIOGRAPHY: Lesley 1976, cat. no. 193, p. 95, p. 92 (ill.)
NOTE: This frame and other similar examples are by Alexander Treyden, who worked for Tillander and Bolin.
BEQUEST OF LILLIAN THOMAS PRATT, 47.20.329

301 Cigarette Case

NOT ILLUSTRATED

Silver, enamel

The cover of the case is painted with an enamel miniature of Tsar Alexander II.

MARKS: Initials of workmaster HA, Moscow before 1899, 84 zolotnik
DIMENSIONS: ¾ × 3 ⅜ × 2 ¼ in. (1.9 × 8.6 × 5.7 cm)
PROVENANCE: Lillian Thomas Pratt
BEQUEST OF LILLIAN THOMAS PRATT, 47.20.280

302 Frame

Silver gilt, gold, enamel, glass

The frame is of translucent red enamel over a concentric zigzag-patterned ground and has a beaded aperture. Above, gold-laurel swags are suspended from bow-knots. Below, a dragon is entwined around a sword. The outer border is formed with palm leaves. The postcard photograph of Tsaritsa Alexandra Feodorovna is a later addition.

MARKS: Initials of unidentified workmaster I.A.P, 88 zolotnik
DIMENSIONS: 3 ¹¹⁄₁₆ in. (9.4 cm)
PROVENANCE: Hammer Galleries, November 12, 1936 (from the "personal quarters of Nicholai II in the Alexander Palace, Tsarskoye Selo"); Lillian Thomas Pratt
EXHIBITED: VMFA 1983
BIBLIOGRAPHY: Lesley 1976, cat. no. 182, p. 187, p. 186 (ill.)
BEQUEST OF LILLIAN THOMAS PRATT, 47.20.323

303 Frame

Silver gilt, rubies, sapphires

The oval frame with a rectangular aperture is applied with scrolls and its border is set with cabochon rubies and sapphires. The original photograph of Tsesarevich Aleksei was added later.

MARKS: Assay mark of Moscow 1908–17, 88 zolotnik
DIMENSIONS: 4 ¹³⁄₁₆ in. (12.2 cm)
PROVENANCE: Lillian Thomas Pratt
BEQUEST OF LILLIAN THOMAS PRATT, 47.20.345

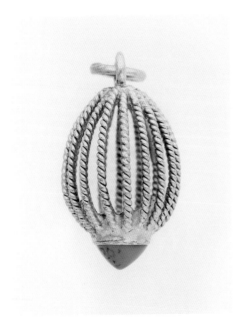

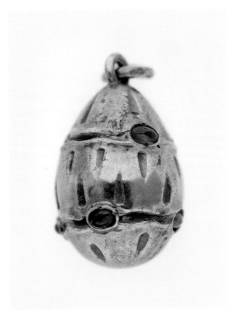

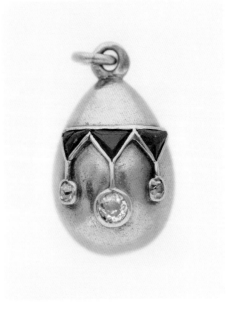

304 (above) enlarged
304 (left)

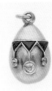

305 (above) enlarged
305 (left)

306 (above) enlarged
306 (left)

Miniature Easter Eggs

304 Miniature Easter Egg Pendant

Gold, turquoise

The egg of twisted-gold openwork wire is set with a cabochon turquoise.

MARKS: 56 zolotnik
DIMENSIONS: ⅝ in. (1.6 cm)
PROVENANCE: Lillian Thomas Pratt
EXHIBITED: VMFA 1983
BIBLIOGRAPHY: Lesley 1976, cat. no. 107, p. 55
BEQUEST OF LILLIAN THOMAS PRATT, 47.20.94

305 Miniature Easter Egg Pendant

Gold, rubies

The gold egg is set with seven cabochon rubies.

MARKS: Illegible, 56 zolotnik
DIMENSIONS: ¾ in. (1.9 cm)
PROVENANCE: Lillian Thomas Pratt
EXHIBITED: FA 1996 (VMFA only)
BIBLIOGRAPHY: Lesley 1976, cat. no. 136, p. 57
BEQUEST OF LILLIAN THOMAS PRATT, 47.20.493

306 Miniature Easter Egg Pendant

Gold, diamonds, sapphires

The gold egg is applied with three triangular sapphires from which are suspended three rose-cut diamonds.

MARKS: Initials of workmaster illegible, 56 zolotnik
DIMENSIONS: ¾ in. (1.9 cm)
PROVENANCE: Lillian Thomas Pratt
EXHIBITED: VMFA 1983
BIBLIOGRAPHY: Lesley 1976, cat. no. 132, p. 57
BEQUEST OF LILLIAN THOMAS PRATT, 47.20.123

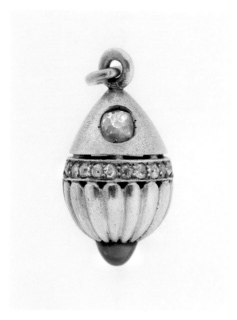

307 (above) enlarged
307 (left)

307 Miniature Easter
Egg Pendant

Gold, diamonds, sapphire

The gold egg's fluted lower half is set with
a cabochon sapphire. A median band
of rose-cut diamonds runs around the egg,
and a single diamond is placed above.

MARKS: 56 zolotnik
DIMENSIONS: ¾ in. (1.9 cm)
PROVENANCE: Lillian Thomas Pratt
BIBLIOGRAPHY: Lesley 1976, cat. no. 80, p. 53,
p. 52 (ill.); Curry 1995, cat. no. 421, p. 113, back cover
BEQUEST OF LILLIAN THOMAS PRATT, 47.20.65

308 Miniature Easter Egg

NOT ILLUSTRATED

Rose quartz, gold

The polished pink-quartz egg stands on
a gold tripod base.

UNMARKED
DIMENSIONS: 2 in. (5.1 cm)
PROVENANCE: Lillian Thomas Pratt
BIBLIOGRAPHY: Lesley 1976, cat. no. 56, p. 49
BEQUEST OF LILLIAN THOMAS PRATT, 47.20.43

309 Miniature Easter Egg

NOT ILLUSTRATED

Aventurine quartz, rock crystal, gold

The gold-mounted miniature egg of green
aventurine quartz has a central band of
faceted rock crystal.

UNMARKED
DIMENSIONS: 2 in. (5.1 cm)
PROVENANCE: Lillian Thomas Pratt
BIBLIOGRAPHY: Lesley 1976, cat. no. 55, p. 51,
p. 49 (ill.)
BEQUEST OF LILLIAN THOMAS PRATT, 47.20.41

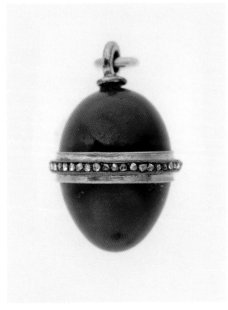

310 (above) enlarged
310 (left)

311 (above) enlarged
311 (left)

312 (above) enlarged
312 (left)

310 Miniature Easter Egg Pendant

Amethyst, rock crystal, gold

The two halves of the amethyst egg are joined by a central band of faceted rock crystal.

MARKS: Maker's mark illegible, 56 zolotnik
DIMENSIONS: ⅞ in. (2.2 cm)
PROVENANCE: Lillian Thomas Pratt
EXHIBITED: VMFA 1983
BIBLIOGRAPHY: Lesley 1976, cat. no. 122, p. 56, p. 57 (ill.)
BEQUEST OF LILLIAN THOMAS PRATT, 47.20.111

311 Miniature Easter Egg Pendant

Nephrite, gold, diamonds

The nephrite egg has a gold median band set with rose-cut diamonds.

UNMARKED
DIMENSIONS: ¾ in. (1.9 cm)
PROVENANCE: Lillian Thomas Pratt
EXHIBITED: VMFA 1983
BIBLIOGRAPHY: Lesley 1976, cat. no. 62, p. 53, p. 52 (ill.)
BEQUEST OF LILLIAN THOMAS PRATT, 47.20.47

312 Miniature Easter Egg Pendant

Lapis lazuli, gold

The elongated lapis lazuli egg has a gold suspension ring.

UNMARKED
DIMENSIONS: ¾ in. (1.9 cm)
PROVENANCE: Lillian Thomas Pratt
EXHIBITED: VMFA 1983
BIBLIOGRAPHY: Lesley 1976, cat. no. 74, p. 53, p. 52 (ill.)
BEQUEST OF LILLIAN THOMAS PRATT, 47.20.59

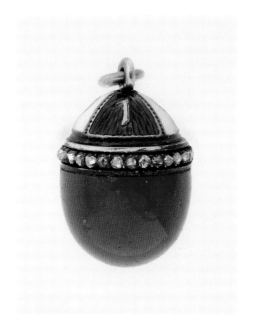

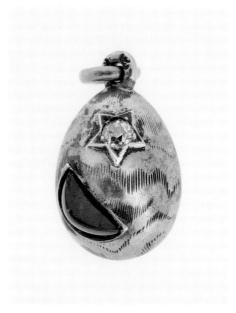

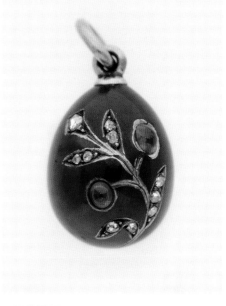

313 (above) enlarged
313 (left)

314 (above) enlarged
314 (left)

315 (above) enlarged
315 (left)

313 Miniature Easter Egg Pendant

Purpurine, gold, diamonds, enamel

The gold cap of this acorn-shaped pur-purine egg has a rose-cut diamond border and alternating green-and-white enamel segments. Each segment bears a number that, when put together, forms the date 1900.

UNMARKED

DIMENSIONS: ¾ in. (1.9 cm)

PROVENANCE: Lillian Thomas Pratt

EXHIBITED: VMFA 1983

BIBLIOGRAPHY: Lesley 1976, cat. no. 64, p. 53, p. 52 (ill.); Curry 1995, cat. no. 42r, p. 113, back cover

BEQUEST OF LILLIAN THOMAS PRATT, 47.20.49

314 Miniature Easter Egg Pendant

Gold, sapphires

The gold egg is chased with clouds and is set with a crescent-shaped sapphire and a rose-cut diamond in a star-shaped mount.

UNMARKED

DIMENSIONS: ¾ in. (1.9 cm)

PROVENANCE: Lillian Thomas Pratt

EXHIBITED: VMFA 1983

BIBLIOGRAPHY: Lesley 1976, cat. no. 63, p. 53, p. 52 (ill.); Curry 1995, cat. no. 42k, p. 113, back cover

BEQUEST OF LILLIAN THOMAS PRATT, 47.20.48

315 Miniature Easter Egg Pendant

Nephrite, diamonds, rubies

The nephrite egg is applied with a spray of rose-cut diamond leaves; the buds are set with cabochon rubies.

UNMARKED

DIMENSIONS: ⅝ in. (1.6 cm)

PROVENANCE: Lillian Thomas Pratt

EXHIBITED: VMFA 1983

BIBLIOGRAPHY: Lesley 1976, cat. no. 104, p. 55, p. 54 (ill.); Curry 1995, cat. no. 42p, p. 113, back cover

BEQUEST OF LILLIAN THOMAS PRATT, 47.20.91

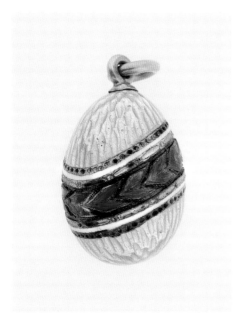

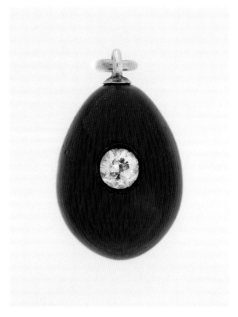

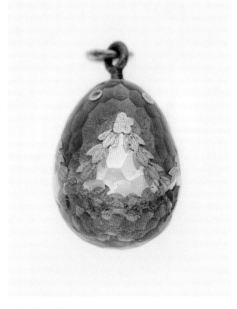

316 (above) enlarged
316 (left)

317 (above) enlarged
317 (left)

318 (above) enlarged
318 (left)

316 Miniature Easter Egg Pendant

Silver, enamel

The turquoise guilloché enamel egg has a central band chased with green-enameled laurel leaves.

MARKS: Illegible
DIMENSIONS: ⅝ in. (1.6 cm)
PROVENANCE: Lillian Thomas Pratt
EXHIBITED: VMFA 1983
BIBLIOGRAPHY: Lesley 1976, cat. no. 101, p. 55, p. 54 (ill.); Curry 1995, cat. no. 366, p. 111, p. 104 (ill.)
BEQUEST OF LILLIAN THOMAS PRATT, 47.20.88

317 Miniature Easter Egg Pendant

Silver, enamel, diamond

The blue guilloché enamel egg is set with a single diamond.

MARKS: 56 zolotnik
DIMENSIONS: ⅝ in. (1.6 cm)
PROVENANCE: Lillian Thomas Pratt
BIBLIOGRAPHY: Lesley 1976, cat. no. 83, p. 53, p. 52 (ill.); Curry 1995, cat. no. 42d, p. 112, back cover
BEQUEST OF LILLIAN THOMAS PRATT, 47.20.68

318 Miniature Easter Egg Pendant

Gold, enamel

The egg of red, white, and green enamel is painted with gold swags.

MARKS: Illegible
DIMENSIONS: ⅝ in. (1.6 cm)
PROVENANCE: Lillian Thomas Pratt
EXHIBITED: VMFA 1983
BIBLIOGRAPHY: Lesley 1976, cat. no. 78, p. 53, p. 52 (ill.)
BEQUEST OF LILLIAN THOMAS PRATT, 47.20.63

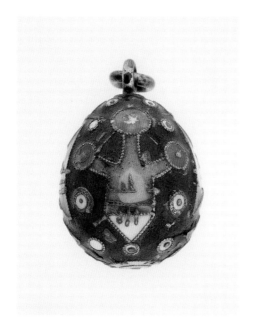

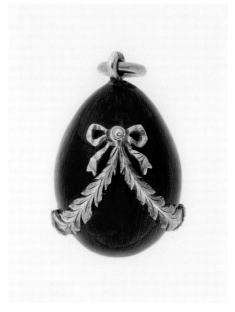

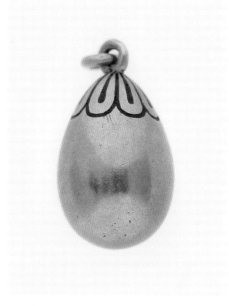

319 (above) enlarged
319 (left)

320 (above) enlarged
320 (left)

321 (above) enlarged
321 (left)

319 Miniature Easter Egg Pendant

Silver gilt, enamel

The egg is of blue, turquoise, white, orange, and beige cloisonné enamel.

UNMARKED

DIMENSIONS: ¾ in. (1.9 cm)

PROVENANCE: Lillian Thomas Pratt

EXHIBITED: VMFA 1983

BIBLIOGRAPHY: Lesley 1976, cat. no. 73, p. 53, p. 52 (ill.); Curry 1995, cat. no. 36j, p. 111, p. 105 (ill.)

BEQUEST OF LILLIAN THOMAS PRATT, 47.20.58

320 Miniature Easter Egg Pendant

Gold, enamel

The egg of royal-blue guilloché enamel is applied with green- and red-gold laurel-leaf swags suspended from tied bows.

MARKS: 56 zolotnik

DIMENSIONS: ¾ in. (1.9 cm)

PROVENANCE: Lillian Thomas Pratt

EXHIBITED: VMFA 1983

BIBLIOGRAPHY: Lesley 1976, cat. no. 86, p. 54, p. 52 (ill.); Curry 1995, cat. no. 42g, p. 113, back cover

BEQUEST OF LILLIAN THOMAS PRATT, 47.20.71

321 Miniature Easter Egg Pendant

Gold, enamel

The burnished-gold egg has a cap etched in blue champlevé enamel.

MARKS: 56 zolotnik

DIMENSIONS: ⅝ in. (1.6 cm)

PROVENANCE: Lillian Thomas Pratt

EXHIBITED: VMFA 1983

BIBLIOGRAPHY: Lesley 1976, cat. no. 134, p. 57 (ill.)

BEQUEST OF LILLIAN THOMAS PRATT, 47.20.125

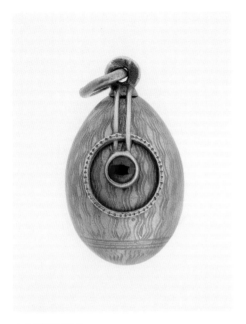

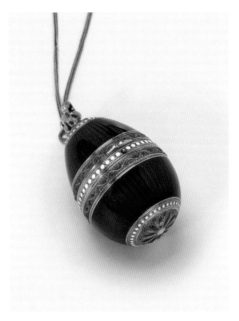

322 (above) enlarged
322 (left)

323 actual size

324 (above) enlarged
324 (left)

322 Miniature Easter Egg Pendant

Gold, enamel, ruby

The green guilloché enamel egg is set with a ruby in a surround of gold wire.

UNMARKED

DIMENSIONS: ¾ in. (1.9 cm)

PROVENANCE: Lillian Thomas Pratt

EXHIBITED: VMFA 1983

BIBLIOGRAPHY: Lesley 1976, cat. no. 66, p. 53, p. 52 (ill.); Curry 1995, cat. no. 36a, p. 111, p. 104 (ill.)

BEQUEST OF LILLIAN THOMAS PRATT, 47.20.51

323 Miniature Egg-Shaped Pendant

Gold, enamel

The egg-shaped locket of dark-blue guilloché enamel has a central band of enameled foliage and white enamel pellets on a stippled ground; *Christ is Risen* is inscribed in Cyrillic.

UNMARKED

DIMENSIONS: 1⅝ in. (4.1 cm)

PROVENANCE: Lillian Thomas Pratt

EXHIBITED: VMFA 1983

BIBLIOGRAPHY: Lesley 1976, cat. no. 61, p. 51, p. 50 (ill.); Curry 1995, cat. no. 37, p. 112, p. 114 (ill.)

BEQUEST OF LILLIAN THOMAS PRATT, 47.20.128

324 Miniature Easter Egg Pendant

Gold, enamel

The dark-blue guilloché enamel egg is chased with a swan.

MARKS: Illegible

DIMENSIONS: ⅝ in. (1.6 cm)

PROVENANCE: Lillian Thomas Pratt

EXHIBITED: VMFA 1983

BIBLIOGRAPHY: Lesley 1976, cat. no. 126, p. 57

BEQUEST OF LILLIAN THOMAS PRATT, 47.20.116

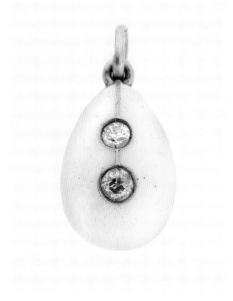

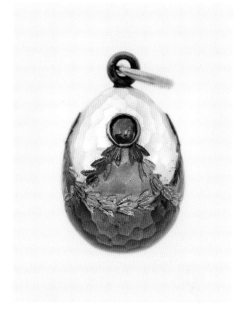

325 (above) enlarged
325 (left)

326 (above) enlarged
326 (left)

327 (above) enlarged
327 (left)

325 Miniature Easter Egg Pendant

Gold, enamel, pearl

The egg of dark-red guilloché enamel is set with a seed pearl on the front and a gold Cyrillic *XB* for *Christ is Risen* on the reverse.

MARKS: Maker's marks illegible, 56 zolotnik
DIMENSIONS: ⅝ in. (1.6 cm)
PROVENANCE: Lillian Thomas Pratt
EXHIBITED: VMFA 1983
BIBLIOGRAPHY: Lesley 1976, cat. no. 127, p. 57
BEQUEST OF LILLIAN THOMAS PRATT, 47.20.117

326 Miniature Easter Egg Pendant

Gold, enamel, diamonds

The white guilloché enamel egg is set with two superimposed diamonds.

MARKS: 56 zolotnik
DIMENSIONS: ⅝ in. (1.6 cm)
PROVENANCE: Lillian Thomas Pratt
EXHIBITED: VMFA 1983
BIBLIOGRAPHY: Lesley 1976, cat. no. 94, p. 54;
Curry 1995, cat. no. 36g, p. 111, p. 105 (ill.)
BEQUEST OF LILLIAN THOMAS PRATT, 47.20.80

327 Miniature Easter Egg Pendant

Gold, enamel, rubies

The hammered-gold egg with red- and blue-enamel and opaque silver is set with four cabochon rubies.

MARKS: 56 zolotnik
DIMENSIONS: ¾ in. (1.9 cm)
PROVENANCE: Lillian Thomas Pratt
EXHIBITED: VMFA 1983
BIBLIOGRAPHY: Lesley 1976, cat. no. 68, p. 53, p. 52 (ill.)
BEQUEST OF LILLIAN THOMAS PRATT, 47.20.53

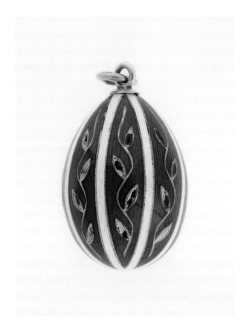

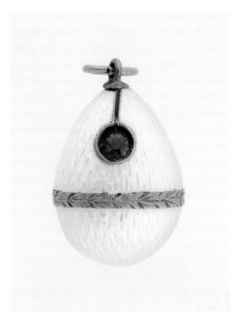

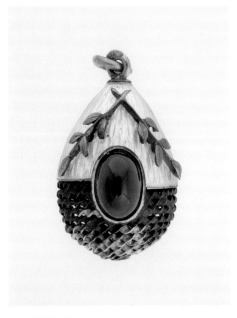

328 (above) enlarged
328 (left)

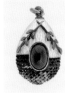

329 (above) enlarged
329 (left)

330 (above) enlarged
330 (left)

328 Miniature Easter Egg Pendant

Gold, enamel

The vertically segmented egg of red guilloché enamel is painted with silver sprays and opaque-white enamel borders.

MARKS: Illegible
DIMENSIONS: ⅝ in. (1.6 cm)
PROVENANCE: Lillian Thomas Pratt
EXHIBITED: VMFA 1983
BIBLIOGRAPHY: Lesley 1976, cat. no. 125, p. 56; Curry 1995, cat. no. 36k, p. 111, p. 105 (ill.)
BEQUEST OF LILLIAN THOMAS PRATT, 47.20.115

329 Miniature Easter Egg Pendant

Gold, enamel, rubies, diamond

The white guilloché enamel egg with a central chased-gold band is set with two garnets and a diamond.

MARKS: Illegible, 56 zolotnik
DIMENSIONS: ⅝ in. (1.6 cm)
PROVENANCE: Lillian Thomas Pratt
EXHIBITED: VMFA 1983
BIBLIOGRAPHY: Lesley 1976, cat. no. 99, p. 55, p. 54 (ill.); Curry 1995, cat. no. 36i, p. 111, p. 105 (ill.)
BEQUEST OF LILLIAN THOMAS PRATT, 47.20.86

330 Miniature Easter Egg Pendant

Gold, enamel, sapphire

The egg of white guilloché enamel, shaped as a wirework basket, is set with an oval sapphire under gold laurel leaves.

MARKS: 56 zolotnik
DIMENSIONS: ¾ in. (1.9 cm)
PROVENANCE: Lillian Thomas Pratt
BIBLIOGRAPHY: Lesley 1976, cat. no. 85, p. 54, p. 52 (ill.); Curry 1995, cat. no. 36d, p. 111, p. 104 (ill.)
BEQUEST OF LILLIAN THOMAS PRATT, 47.20.70

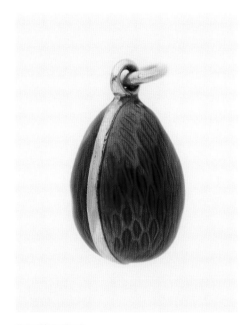

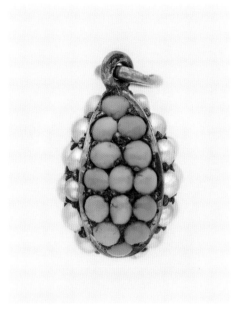

331 (above) enlarged
331 (left)

332 (above) enlarged
332 (left)

333 (above) enlarged
333 (left)

331 Miniature Easter Egg Pendant

Gold, enamel

The red guilloché enamel egg has a vertical gold circlet.

MARKS: Illegible, 56 zolotnik

DIMENSIONS: 7⁄16 in. (1.1 cm)

PROVENANCE: Lillian Thomas Pratt

EXHIBITED: VMFA 1983; *FA* 1996 (VMFA only)

BIBLIOGRAPHY: Lesley 1976, cat. no. 124, p. 56, p. 57 (ill.)

BEQUEST OF LILLIAN THOMAS PRATT, 47.20.114

332 Miniature Easter Egg Pendant

Turquoises, pearls, gold

The egg is formed of four vertical segments that are alternately studded with seed pearls and turquoises.

MARKS: Assay mark of St. Petersburg before 1899, 56 zolotnik

DIMENSIONS: ½ in. (1.3 cm)

PROVENANCE: Lillian Thomas Pratt

EXHIBITED: VMFA 1983

BIBLIOGRAPHY: Lesley 1976, cat. no. 106, p. 55

BEQUEST OF LILLIAN THOMAS PRATT, 47.20.93

333 Miniature Easter Egg Pendant

Agate, gold

The white agate egg is applied with a chased-gold band.

MARKS: Assay mark of St. Petersburg before 1899, 56 zolotnik

DIMENSIONS: ¾ in. (1.9 cm)

PROVENANCE: Lillian Thomas Pratt

EXHIBITED: VMFA 1983

BIBLIOGRAPHY: Lesley 1976, cat. no. 67, p. 53, p. 52 (ill.)

BEQUEST OF LILLIAN THOMAS PRATT, 47.20.52

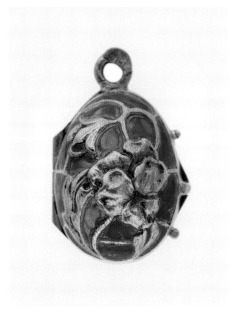

334 (above) enlarged
334 (left)

335 (above) enlarged
335 (left)

336 (above) enlarged
336 (left)

334 Miniature Easter Egg Pendant

Gold, diamonds

The gold egg is chased with scrolling ropework.

MARKS: Assay mark for 1899–1908, 56 zolotnik
DIMENSIONS: ⅝ in. (1.6 cm)
PROVENANCE: Lillian Thomas Pratt
EXHIBITED: VMFA 1983
BIBLIOGRAPHY: Lesley 1976, cat. no. 79, p. 53, p. 52 (ill.)
BEQUEST OF LILLIAN THOMAS PRATT, 47.20.64

335 Hinged Miniature Easter Egg Pendant

Silver, glass

The translucent-blue enamel egg has silver *cloisons* in the Art Nouveau style.

MARKS: Assay mark for 1899–1908, 84 zolotnik
DIMENSIONS: ¾ in. (1.9 cm)
PROVENANCE: Lillian Thomas Pratt
EXHIBITED: VMFA 1983
BIBLIOGRAPHY: Lesley 1976, cat. no. 76, p. 53, p. 52 (ill.)
BEQUEST OF LILLIAN THOMAS PRATT, 47.20.61

336 Miniature Easter Egg Pendant

Lapis lazuli, gold

The plain lapis lazuli egg has a gold suspension ring.

MARKS: Assay mark of St. Petersburg 1899–1908, 56 zolotnik
DIMENSIONS: ⅝ in. (1.6 cm)
PROVENANCE: Lillian Thomas Pratt
EXHIBITED: VMFA 1983
BIBLIOGRAPHY: Lesley 1976, cat. no. 108, p. 55
BEQUEST OF LILLIAN THOMAS PRATT, 47.20.95

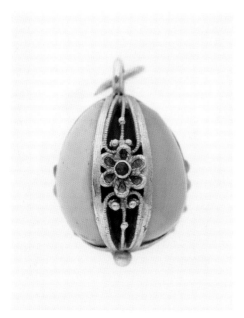

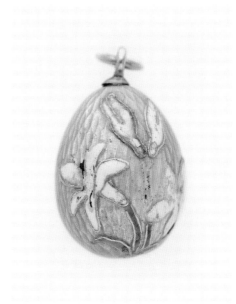

337 (above) enlarged
337 (left)

338 (above) enlarged
338 (left)

339 (above) enlarged
339 (left)

337 Miniature Easter Egg Pendant

Chalcedony, turquoise, gold, rubies

The vertical segments of this chalcedony and turquoise egg are bordered by a band of filigree gold chased with a rosette.

MARKS: Assay mark of St. Petersburg 1899–1908, 56 zolotnik
DIMENSIONS: 9/16 in. (1.5 cm)
PROVENANCE: Lillian Thomas Pratt
EXHIBITED: VMFA 1983
BIBLIOGRAPHY: Lesley 1976, cat. no. 98, p. 55, p. 54 (ill.)
BEQUEST OF LILLIAN THOMAS PRATT, 47.20.85

338 Miniature Easter Egg Pendant

Gold, enamel

The pale-green enamel egg is chased and painted with white lilies.

MARKS: Maker's mark illegible, assay mark of St. Petersburg 1899–1908, 56 zolotnik
DIMENSIONS: 5/8 in. (1.6 cm)
PROVENANCE: Lillian Thomas Pratt
BIBLIOGRAPHY: Lesley 1976, cat. no. 129, p. 57 (ill.)
BEQUEST OF LILLIAN THOMAS PRATT, 47.20.120

339 Miniature Easter Egg Pendant

Agate, gold, sapphire, diamonds

The egg of milky-white agate is applied with a diagonal gold ribbon, and is set with two cabochon-sapphire buds and two rose-cut diamond leaves.

MARKS: Initials of workmaster K. B., assay mark of St. Petersburg before 1899, 56 zolotnik
DIMENSIONS: 5/8 in. (1.6 cm)
PROVENANCE: Lillian Thomas Pratt
EXHIBITED: VMFA 1983
BIBLIOGRAPHY: Lesley 1976, cat. no. 91, p. 54
BEQUEST OF LILLIAN THOMAS PRATT, 47.20.76

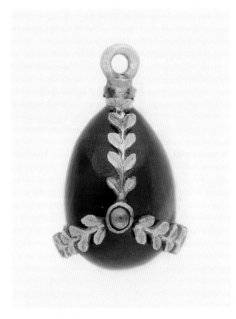

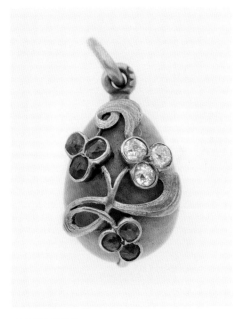

340 (above) enlarged
340 (left)

341 (above) enlarged
341 (left)

342 (above) enlarged
342 (left)

340 Miniature Easter Egg Pendant

Gold, sapphire

The horizontally ribbed egg is set with a spiraling band of sapphires.

MARKS: Initials of workmaster *AP* ?
DIMENSIONS: ⅝ in. (1.6 cm)
PROVENANCE: Lillian Thomas Pratt
EXHIBITED: VMFA 1983
BIBLIOGRAPHY: Lesley 1976, cat. no. 92, p. 54; Curry 1995, cat. no. 42c, p. 112, back cover
BEQUEST OF LILLIAN THOMAS PRATT, 47.20.77

341 Miniature Easter Egg Pendant

Nephrite, gold, rubies

The nephrite egg is encased in both vertical and horizontal bands of chased laurel leaves set with rubies.

MARKS: Initials of workmaster *F. G.*, 56 zolotnik
DIMENSIONS: ⅝ in. (1.6 cm)
PROVENANCE: Lillian Thomas Pratt
EXHIBITED: VMFA 1983
BIBLIOGRAPHY: Lesley 1976, cat. no. 130, p. 57
BEQUEST OF LILLIAN THOMAS PRATT, 47.20.121

342 Miniature Easter Egg Pendant

Amazonite, gold, rubies, diamonds, sapphires

The turquoise hardstone egg is applied with gold stems and has triple blossoms set with diamonds, cabochon rubies, and sapphires.

MARKS: Initials *M. L.*, 56 zolotnik
DIMENSIONS: ⅝ in. (1.6 cm)
PROVENANCE: Lillian Thomas Pratt
EXHIBITED: VMFA 1983; *FA* 1996 (VMFA only)
BIBLIOGRAPHY: Lesley 1976, cat. no. 95, p. 55, p. 54 (ill.)
BEQUEST OF LILLIAN THOMAS PRATT, 47.20.81

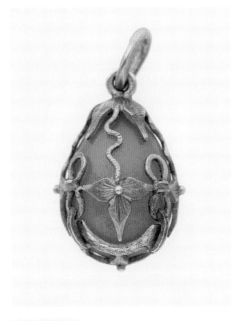

343 (above) enlarged

343 (left)

344 (above) enlarged

344 (left)

345 (above) enlarged

345 (left)

343 Miniature Easter Egg Pendant

Agate, gold, emerald

A gold snake with a faceted emerald eye is coiled around the egg.

MARKS: Initials of workmaster *G. D.*, 56 zolotnik
DIMENSIONS: ¾ in. (1.9 cm)
PROVENANCE: Lillian Thomas Pratt
EXHIBITED: VMFA 1983
BIBLIOGRAPHY: Lesley 1976, cat. no. 131, p. 57
BEQUEST OF LILLIAN THOMAS PRATT, 47.20.122

344 Miniature Easter Egg Pendant

Agate, gold, emerald

The dark-blue guilloché enamel egg is set with a rose-cut diamond.

MARKS: Initials of workmaster *G. D.*, 56 zolotnik
DIMENSIONS: ⅝ in. (1.6 cm)
PROVENANCE: Lillian Thomas Pratt
EXHIBITED: VMFA 1983; *FA* 1996 (VMFA only)
BIBLIOGRAPHY: Lesley 1976, cat. no. 133, p. 57;
Curry 1995, cat. no. 42n, p. 113, back cover
BEQUEST OF LILLIAN THOMAS PRATT, 47.20.124

345 Miniature Easter Egg Pendant

Chrysoprase, gold

The bluish stone egg is encased in a latticework of gold flowers and leaves.

MARKS: Initials of workmaster *D. K.*, 56 zolotnik
DIMENSIONS: ⅝ in. (1.6 cm)
PROVENANCE: Lillian Thomas Pratt
EXHIBITED: VMFA 1983
BIBLIOGRAPHY: Lesley 1976, cat. no. 102, p. 55,
p. 54 (ill.)
BEQUEST OF LILLIAN THOMAS PRATT, 47.20.89

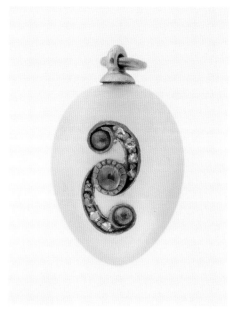

346 (above) enlarged
346 (left)

347 (above) enlarged
347 (left)

348 (above) enlarged
348 (left)

346 Miniature Easter Egg Pendant

Agate, diamonds, rubies

The milky-agate egg is applied with an inverted *S* and set with rose-cut diamonds and three cabochon rubies.

MARKS: Initials of workmaster *D. K.*, St. Petersburg 1899–1908, 56 zolotnik

DIMENSIONS: ¾ in. (1.9 cm)

PROVENANCE: Lillian Thomas Pratt

EXHIBITED: VMFA 1983

BIBLIOGRAPHY: Lesley 1976, cat. no. 103, p. 55, p. 54 (ill.); Curry 1995, cat. no. 42b, p. 112, back cover

BEQUEST OF LILLIAN THOMAS PRATT, 47.20.90

347 Miniature Easter Egg Pendant

Gold, rock crystal

The rock-crystal egg is applied with the crowned Cyrillic cypher *AF* for Tsaritsa Alexandra Feodorovna.

MARKS: Initials of workmaster *A. A.*, possibly for Andrei K. Adler, 56 zolotnik

DIMENSIONS: ⅝ in. (1.6 cm)

PROVENANCE: Tsarina Alexandra Feodorovna; Lillian Thomas Pratt

BIBLIOGRAPHY: Lesley 1976, cat. no. 84, p. 54, p. 52 (ill.); Curry 1995, cat. no. 425, p. 113, back cover

BEQUEST OF LILLIAN THOMAS PRATT, 47.20.69

348 Miniature Easter Egg Pendant

Agate, gold,

The agate egg is encased in a trellis of chased yellow- and red-gold leaves.

MARKS: Initials of workmasters *A. K.?*, assay mark of St. Petersburg before 1899–1908, 56 zolotnik

DIMENSIONS: ⅝ in. (1.6 cm)

PROVENANCE: Lillian Thomas Pratt

EXHIBITED: VMFA 1983

BIBLIOGRAPHY: Lesley 1976, cat. no. 96, p. 55, p. 54 (ill.)

BEQUEST OF LILLIAN THOMAS PRATT, 47.20.82

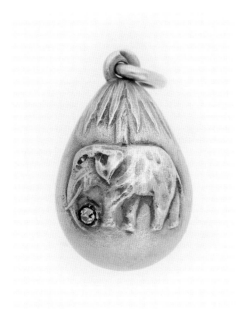

349 (above) enlarged
349 (left)

350 (above) enlarged
350 (left)

351 (above) enlarged
351 (left)

349 Miniature Easter Egg Pendant

Gold, diamond

The elephant on this burnished-gold egg has a rose-cut diamond set in its trunk.

MARKS: Workmaster's initials *K. I. K.*
DIMENSIONS: ¾ in. (1.9 cm)
PROVENANCE: Lillian Thomas Pratt
EXHIBITED: VMFA 1983
BIBLIOGRAPHY: Lesley 1976, cat. no. 65, p. 53, p. 52 (ill.)
BEQUEST OF LILLIAN THOMAS PRATT, 47.20.50

350 Miniature Egg-Shaped Pendant

Gold, agate

The gold egg with a diamond-set star and a single ruby hangs from a suspension chain and ring.

MARKS: Initials of workmaster inverted *A.V.*, 1899–1908, 56 zolotnik
DIMENSIONS: ¾ in. (1.9 cm)
PROVENANCE: Lillian Thomas Pratt
EXHIBITED: VMFA 1983
BIBLIOGRAPHY: Lesley 1976, cat. no. 75, p. 53, p. 52 (ill.)
BEQUEST OF LILLIAN THOMAS PRATT, 47.20.60

351 Miniature Easter Egg Pendant

Agate, gold

The pink agate egg is encased in gold wirework.

MARKS: Inverted initials *A.V.*, assay mark for 1908–17, 56 zolotnik
DIMENSIONS: ¾ in. (1.9 cm)
PROVENANCE: Lillian Thomas Pratt
BIBLIOGRAPHY: Lesley 1976, cat. no. 82, p. 53, p. 52 (ill.)
BEQUEST OF LILLIAN THOMAS PRATT, 47.20.67

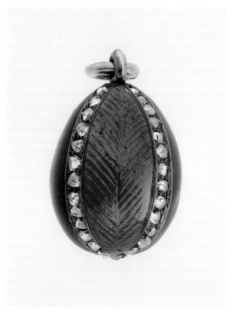

352 (above) enlarged
352 (left)

353 (above) enlarged
353 (left)

354 (above) enlarged
354 (left)

352 Miniature Easter Egg Pendant

Rock crystal, garnets, diamonds

One side of the horizontally segmented egg is rock crystal and the other side is garnet. Both halves are bordered vertically and horizontally with bands of rose-cut diamonds.

MARKS: Initials of workmaster Vasilii Finnikov
DIMENSIONS: ½ in. (1.3 cm)
PROVENANCE: Lillian Thomas Pratt
EXHIBITED: VMFA 1983
BIBLIOGRAPHY: Lesley 1976, cat. no. 105, p. 55
BEQUEST OF LILLIAN THOMAS PRATT, 47.20.92

353 Miniature Easter Egg Pendant

Gold, enamel, diamonds

The egg has alternating segments of red and dark-blue guilloché enamel and engraved leaves bordered by rose-cut-diamond bands.

MARKS: Initials of workmaster Vasilii Finnikov, assay mark of St. Petersburg before 1899, 56 zolotnik
DIMENSIONS: ⅝ in. (1.6 cm)
PROVENANCE: Lillian Thomas Pratt
EXHIBITED: VMFA 1983
BIBLIOGRAPHY: Lesley 1976, cat. no. 115, p. 56; Curry 1995, cat. no. 36e, p. 111, p. 104 (ill.)
BEQUEST OF LILLIAN THOMAS PRATT, 47.20.103

354 Miniature Easter Egg Pendant

Silver, enamel

The silver-gilt egg is decorated with blue champlevé and a *XB* for *Christ is Risen*.

MARKS: Initials of workmaster Vasilii Finnikov
DIMENSIONS: ¾ in. (1.9 cm)
PROVENANCE: Lillian Thomas Pratt
EXHIBITED: VMFA 1983
BIBLIOGRAPHY: Lesley 1976, cat. no. 81, p. 53, p. 52 (ill.)
BEQUEST OF LILLIAN THOMAS PRATT, 47.20.66

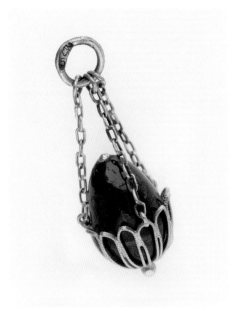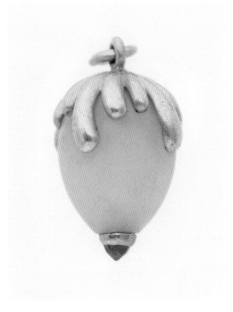

355 (above) enlarged
355 (left)

356 (above) enlarged
356 (left)

357 (above) enlarged
357 (left)

355 Miniature Egg-Shaped Charm

Garnet, gold

The acorn-shaped garnet egg has a gold wirework cap.

MARKS: Assay mark for 1899–1908, 56 zolotnik
DIMENSIONS: ⅞ in. (2.2 cm)
PROVENANCE: Lillian Thomas Pratt
EXHIBITED: VMFA 1983
BIBLIOGRAPHY: Lesley 1976, cat. no. 77, p. 53, p. 52 (ill.)
BEQUEST OF LILLIAN THOMAS PRATT, 47.20.62

356 Miniature Easter Egg Pendant

Rhodonite, gold

The rhodonite egg has a gold suspension ring.

MARKS: Initials of workmaster *A. P.* ?, 56 zolotnik
DIMENSIONS: ½ in. (1.3 cm)
PROVENANCE: Lillian Thomas Pratt
EXHIBITED: VMFA 1983
BIBLIOGRAPHY: Lesley 1976, cat. no. 120, p. 56, p. 57 (ill.)
BEQUEST OF LILLIAN THOMAS PRATT, 47.20.109

357 Miniature Easter Egg Pendant

Agate, gold

The acorn-shaped agate egg has a ribbed-gold cap and a cabochon-ruby finial.

MARKS: Initials of workmaster *A. K.* ?, assay mark of St. Petersburg before 1899–1908, 56 zolotnik
DIMENSIONS: ⅝ in. (1.6 cm)
PROVENANCE: Lillian Thomas Pratt
EXHIBITED: VMFA 1983
BIBLIOGRAPHY: Lesley 1976, cat. no. 93, p. 54
BEQUEST OF LILLIAN THOMAS PRATT, 47.20.78

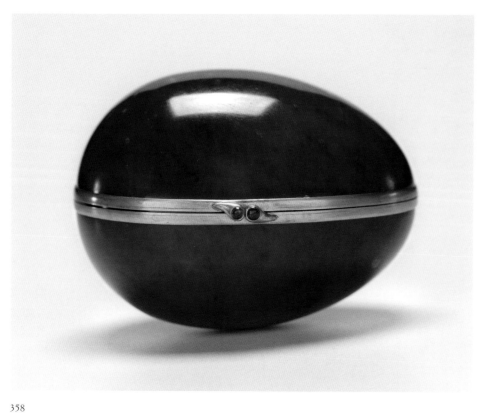

358

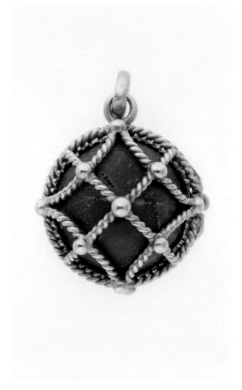

359 enlarged

358 Egg-Shaped Box

Nephrite, silver, rubies

The hinged nephrite egg has plain silver mounts and its clasp is set with two rubies.

Russian ?, ca. 1900

DIMENSIONS: 3 ⅝ × 2 ¾ in. (9.2 × 7 cm)

PROVENANCE: Lillian Thomas Pratt

EXHIBITED: VMFA 1983

BIBLIOGRAPHY: Lesley 1976, cat. no. 58, p. 51, p. 50 (ill.)

BEQUEST OF LILLIAN THOMAS PRATT, 47.20.45

359 Locket

Lapis lazuli, gold, glass

The ovoid lapis lazuli locket is encased in gold ropework and opens to reveal an in-miniature frame.

UNMARKED

DIMENSIONS: D ⅞ in. (2.2 cm)

PROVENANCE: Lillian Thomas Pratt

BIBLIOGRAPHY: Lesley 1976, cat. no. 275, p. 137, p. 136 (ill.)

BEQUEST OF LILLIAN THOMAS PRATT, 47.20.156

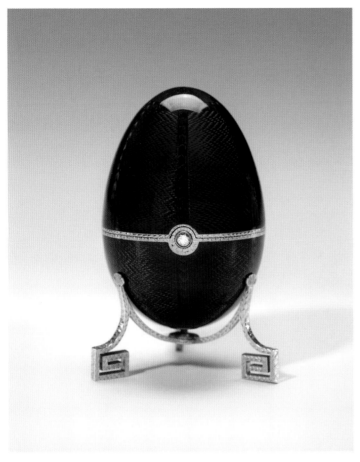

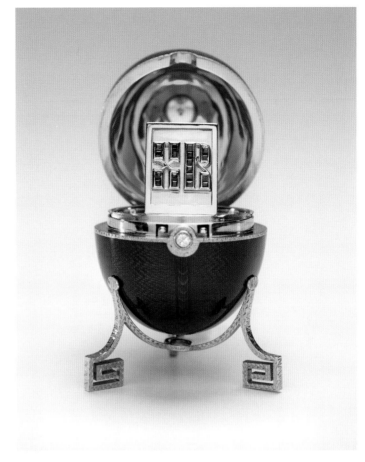

360 enlarged

360 enlarged

360 Easter Egg with Stand

Gold, enamel, rubies, diamond

The dark-red guilloché enamel egg is encircled with a gold rim. The thumbpiece is set with a brilliant-cut diamond. Its "surprise" is a tablet set with calibrated rubies forming the Cyrillic initials *XB* for *Christ is Risen*.

MARKS: Maker's mark *Z. C.* in lozenge, 750 cts., ca. 1910
DIMENSIONS: Egg: 2 in. (5.1 cm)
PROVENANCE: Ernest Hillman Jr.
NOTE: The egg is most likely French, made for the Russian market.

GIFT OF THE ESTATE OF ERNEST HILLMAN JR., 2003.185

Catalogue: Forgeries

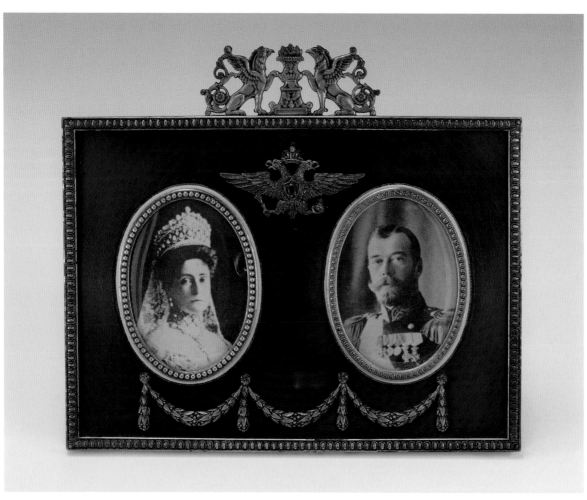

361

Objects

361 Double Frame

Silver gilt, enamel, rubies, ivory

The emerald-green guilloché enamel frame
has two oval apertures within beaded bor-
ders and is applied with a double-headed
eagle set with three rubies above, and
three laurel swags suspended from rosettes
below. It is surmounted by two griffins,
has an ovolo outer border, and a silver-gilt
strut. The images are of Tsar Nicholas II
and Tsaritsa Alexandra Feodorovna.

FORGED MARKS: Imperial warrant of K. Hahn,
French import mark, 88 zolotnik

DIMENSIONS: 4 1/16 × 6 in. (10.6 × 15.2 cm)

PROVENANCE: Hammer Galleries, #GT-1530/3,
November 9, 1936 (from the "quarters of the
Czarina Alexandra Feodorovna, in the Alexander
Palace, Tsarskoye Selo"); Lillian Thomas Pratt

BIBLIOGRAPHY: Lesley 1976, cat. no. 169, p. 81, p. 80
(ill.); Kurth 1995, p. 20

NOTE: The quality of this frame and of cat. no. 362,
both produced by the same hand, is too poor for
one of the leading workshops in St. Petersburg.
Both lack the usual workmaster's initials (CB for
Carl Blank or AT for Alexander Treyden).
The double-headed eagle or state emblem that would
denote an imperial presentation normally only
appears on cigarette cases or on items of jewelry,
but never on frames. Recent research (Tillander-
Godenhielm 2005) shows that the tsar did not award
imperial gifts of this kind. The only frames officially
presented or awarded by the tsar were portrait
frames with miniatures, of which only a small

number are recorded in the imperial cabinet's files
(for two examples see cat. nos. 27 and 298).
For more information on Karl Hahn see Chapter 3.

BEQUEST OF LILLIAN THOMAS PRATT, 47.20.330

362 Frame

Silver gilt, enamel, diamonds, sapphire, glass, ivory

The upright rectangular frame has an
arched top of pale-pink translucent enamel
over a concentric guilloché ground. It is
applied above with a double-headed eagle
set with diamonds and a sapphire, and be-
low with festoons suspended from ribbons.
It has an oak-leaf border and bowknot
cresting. The image is that of Tsaritsa
Alexandra Feodorovna.

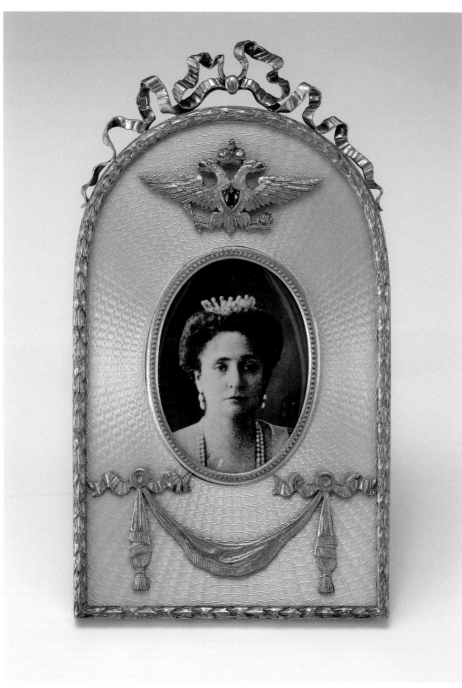

362

FORGED MARKS: Imperial warrant of K. Hahn, St. Petersburg 1908–17, 88 zolotnik
DIMENSIONS: 6 in. (15.2 cm)
PROVENANCE: Hammer Galleries, #1530/2, November 2, 1936 (from the "quarters of the Czarina Alexandra Feodorovna in the Alexander Palace, Tsarskoye Selo"); Lillian Thomas Pratt
EXHIBITED: FA 1996 (VMFA only)
BIBLIOGRAPHY: Lesley 1976, cat. no. 183, p. 87

NOTE: The quality of this frame and of cat. no. 361, both produced by the same hand, is too poor for one of the leading workshops in St. Petersburg. Neither object bears the usual workmaster's initials (*C. B.* for Carl Blank or *A. T.* for Alexander Treyden), which invariably appear on the firm's production after 1908. The double-headed eagle or state emblem denotes an imperial presentation and normally only appears on cigarette cases or on items of jewelry. Recent research (Tillander-Godenhielm 2005) shows that the tsar did not award imperial gifts of this kind. The only frames officially presented or awarded by the tsar were frames with his own portrait painted by a court miniaturist, but never a photograph. Only a small number of such portrait frames are recorded in the imperial cabinet's files (for two examples see cat. nos. 27 and 298).

For more information on Karl Hahn see Chapter 3 of this catalogue.

BEQUEST OF LILLIAN THOMAS PRATT, 47.20.326

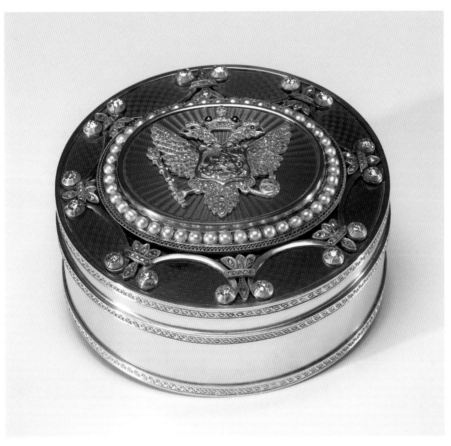

363

363 Jeweled and Enameled Gold Box

Gold, enamel, diamonds, rubies, pearls

The cover of this heavy gold box has a double-headed eagle set with a central diamond and a crown with two cabochon rubies. Its blue sunburst guilloché enamel ground has a border of pearls and an outer border of diamond-set motifs. The sides and base of the box are of plain burnished gold. The interior is engraved with a Romanov griffin under blue sunburst guilloché enamel.

FORGED MARKS: *K. Fabergé*, Cyrillic *M. P.*, St. Petersburg before 1899, 72
DIMENSIONS: D 3 ⅝ in. (9.2 cm)
PROVENANCE: Lillian Thomas Pratt
EXHIBITED: VMFA 1983
BIBLIOGRAPHY: Lesley 1976, cat. no. 286, p. 143, p. 141 (ill.)
NOTE: Fabergé's Moscow imperial warrant combined with the initials of St. Petersburg workmaster Mikhail Perkhin are not compatible. The style and workmanship of the box are not those of Fabergé: his boxes are invariably enameled on the sides, and never in the interior.
BEQUEST OF LILLIAN THOMAS PRATT, 47.20.270

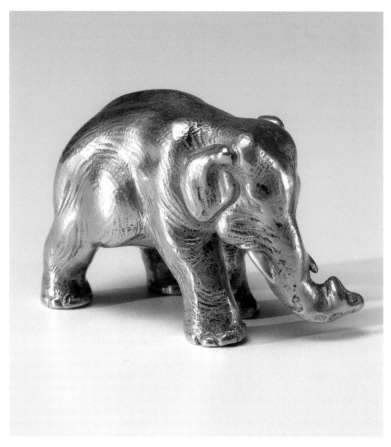

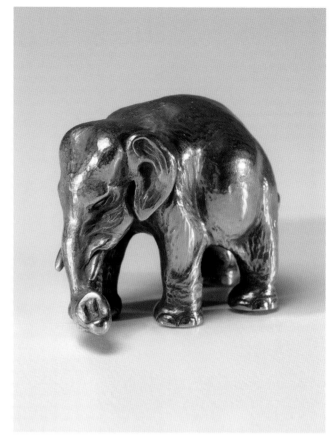

364 enlarged

365 enlarged

364 Elephant

Silver

The naturalistically modeled pachyderm is turned toward its left.

FORGED MARKS: *K. F.*, 84 zolotnik
DIMENSIONS: 1½ in. (3.8 cm)
BIBLIOGRAPHY: Lesley 1976, cat. no. 15
PROVENANCE: Russian Imperial Treasures. "The Schaffer Collection" #1768, December 30, 1944, $275; Lillian Thomas Pratt
BEQUEST OF LILLIAN THOMAS PRATT, 47.20.248

365 Elephant

Gold

UNMARKED
DIMENSIONS: 1½ in. (3.8 cm)
BIBLIOGRAPHY: Lesley 1976, cat. no. 16
PROVENANCE: Russian Imperial Treasures. "The Schaffer Collection" #2723, December 30, 1944, $600; Lillian Thomas Pratt

NOTE: The elephant was cast from the same mold as the preceding animal.
BEQUEST OF LILLIAN THOMAS PRATT, 47.20.249

366 Elephant

Gold, diamonds, ivory

NOT ILLUSTRATED

The gold elephant has a raised trunk, diamond eyes, and ivory tusks.

UNMARKED
DIMENSIONS: ¾ in. (1.9 cm)
PROVENANCE: Hammer Galleries #RH-5214/9, February 1, 1938 ("Created by Carl Fabergé the celebrated Russian court jeweler to Nicholai II, it was made to the special order of his mother, the Dowager Empress Marie Feodorovna. From the quarters of the Empress in the Anichkov Palace, St. Petersburg."); Lillian Thomas Pratt
BIBLIOGRAPHY: Lesley 1976, cat. no. 17, p. 21
BEQUEST OF LILLIAN THOMAS PRATT, 47.20.250

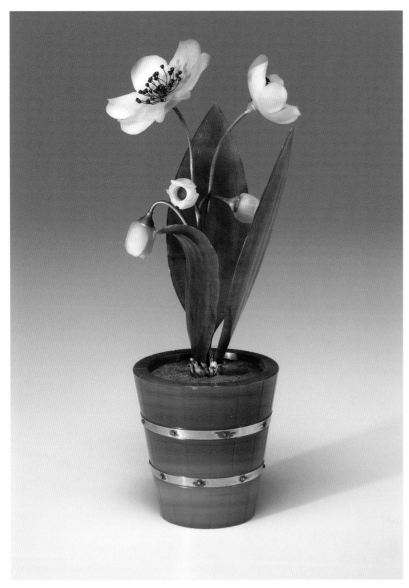

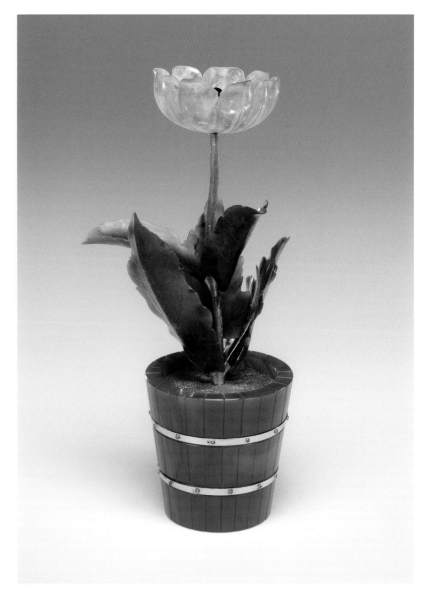

367 reduced

368 reduced

Flowers

367 Poppy

Chalcedony (jasper?), nephrite, agate, gold, sapphires, topaz, diamond

The flower has white chalcedony blooms with gold-wire stamens set with sapphires, three buds with topaz stamens, carved nephrite leaves, and gold stems. It stands in gold "earth" in a tub of banded agate encircled with two gold hoops.

FORGED MARKS: *Fabergé, H. W.,* 72
DIMENSIONS: 9¾ in. (24.8 cm)
PROVENANCE: Hammer Galleries ?; Lillian Thomas Pratt

BIBLIOGRAPHY: Lesley 1976, cat. no. 150, p. 67, p. 68 (ill.); Curry 1995, cat. no. 22, p. 109, pp. 44, 105 (ill.)
NOTE: A similar flower *(Gordonia)* with the same provenance is in the Matilda Geddings Gray Foundation Collection (see Keefe 2008).
BEQUEST OF LILLIAN THOMAS PRATT, 47.20.217

368 Poppy

Amethyst, nephrite, agate, rose-cut diamonds, gold

The flower has a pale amethystine-quartz blossom with diamond-pointed gold stamens, a cabochon-amethyst pistil, a gold stem, and carved-nephrite leaves. It stands in gold "earth" in a tub of banded agate encircled with two gold hoops.

FORGED MARKS: *Fabergé, H. W.,* 72
DIMENSIONS: 8⅜ in. (21.3 cm)
PROVENANCE: Hammer Galleries #RH 5413/4, ("Jeweled opium poppy . . . designed by Carl Fabergé. From the collection of a member of the Imperial Family."); Lillian Thomas Pratt
BIBLIOGRAPHY: Lesley 1976, cat. no. 151, p. 67, p. 69 (ill.)
NOTE: A similar poppy with the same provenance is in the Matilda Geddings Gray Foundation Collection (see Keefe 2008).
BEQUEST OF LILLIAN THOMAS PRATT, 47.20.218

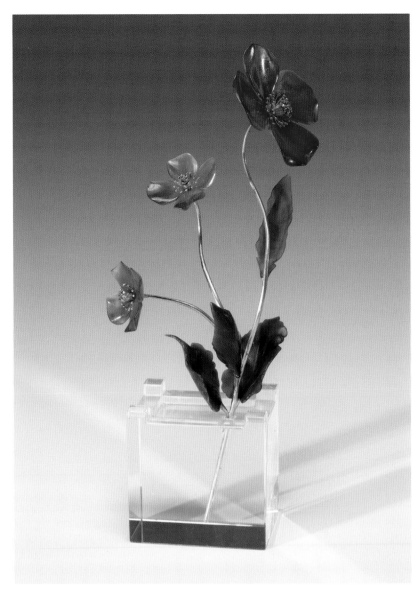

369

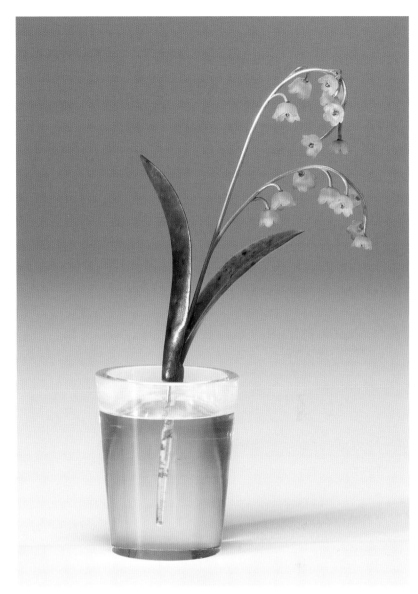

370 reduced

369 Primrose

Carnelian, nephrite, rock crystal, gold, diamonds

The flower has three carnelian blossoms with four leaves each, gold stamens, diamond-set pistils, carved-nephrite leaves, and a gold stem. It stands at an angle in a rectangular Japanese-style rock-crystal vase.

FORGED MARKS: *Fabergé, H. W.*, 72
DIMENSIONS: 5 ¾ in. (14.6 cm)
PROVENANCE: Hammer Galleries, #RH 5413-2, January 9, 1940 ("Karl Fabergé, Imperial Russia's greatest jeweler, designed the extraordinary fantasie. From the collection of a member of the Imperial Family."); Lillian Thomas Pratt

EXHIBITED: VMFA 1983
BIBLIOGRAPHY: Lesley 1976, cat. no. 152, p. 71, p. 59 (ill.)
BEQUEST OF LILLIAN THOMAS PRATT, 47.20.219

370 Lilies of the Valley

Frosted rock crystal, nephrite, gold

The flower has a double spray of fifteen chalcedony bells with gold centers, two carved-nephrite leaves, and a gold stem. It stands upright in a tapering rock-crystal vase.

FORGED MARKS: *Fabergé, H. W.*, 72
DIMENSIONS: 6 in. (15.2 cm)

PROVENANCE: Hammer Galleries, #RH 5380-9, January 9, 1940; Lillian Thomas Pratt
BIBLIOGRAPHY: Lesley 1976, cat. no. 144, p. 63, p. 64 (ill.)
NOTE: A similar, slightly smaller flower with the same provenance and the same number of bells is in the Matilda Geddings Gray Foundation (see Keefe 2008).
BEQUEST OF LILLIAN THOMAS PRATT, 47.20.220

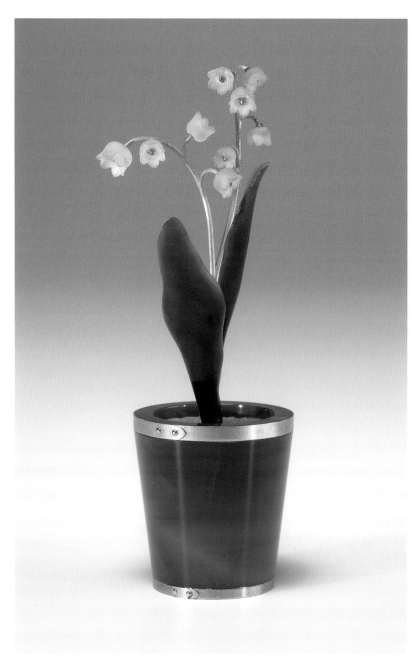

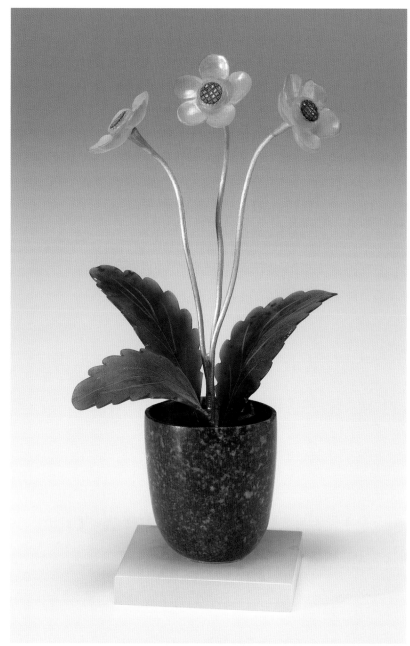

371 reduced

372

371 Lilies of the Valley

Frosted rock crystal, nephrite, agate, gold

The flower has a double spray of nine rock-crystal bells with gold centers, two carved-nephrite leaves, and a gold stem. It stands upright in "earth" in a tapering tub of banded agate encircled with gold hoops.

FORGED MARKS: *Fabergé, H. W.*, 72
DIMENSIONS: 6¼ in. (15.9 cm)
PROVENANCE: Hammer Galleries, #RH 5408, February. 24, 1939 ("Ethereal flower creation by Imperial Russia's foremost jeweler. From the collection of a member of the Imperial Family"); Lillian Thomas Pratt
BIBLIOGRAPHY: Lesley 1976, cat. no. 145, p. 67, P. 65 (ill.)
BEQUEST OF LILLIAN THOMAS PRATT, 47.20.221

372 Buttercup

Agate, nephrite, lapis lazuli, bowenite, gold, diamonds

Each of the flower's sprays has a five-petal translucent yellow-agate blossom, diamond-set pistils, three carved-nephrite leaves, and gold stems. It stands upright in "earth" in a lapis lazuli pot on a square bowenite base.

FORGED MARKS: *Fabergé, H. W.*, 72
DIMENSIONS: 5¾ in. (14.6 cm)
PROVENANCE: Hammer Galleries, #RH 5380-2, January 9, 1940, $1,275 ("From the collection of a member of the Imperial Family"); Lillian Thomas Pratt
BIBLIOGRAPHY: Hammer Galleries catalogue 1940?; Lesley 1976, cat. no. 138, p. 63, p. 62 (ill.)
BEQUEST OF LILLIAN THOMAS PRATT, 47.20.223

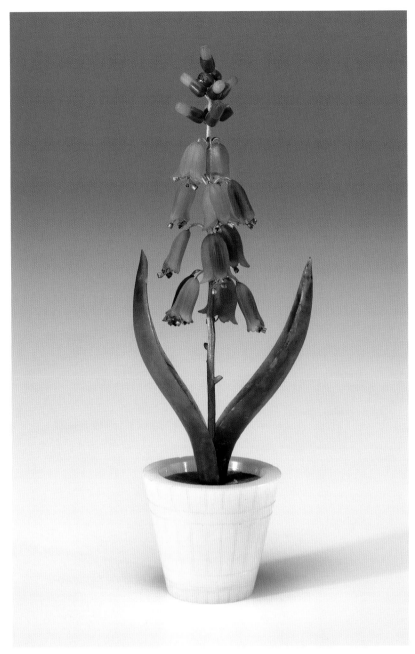

373 reduced

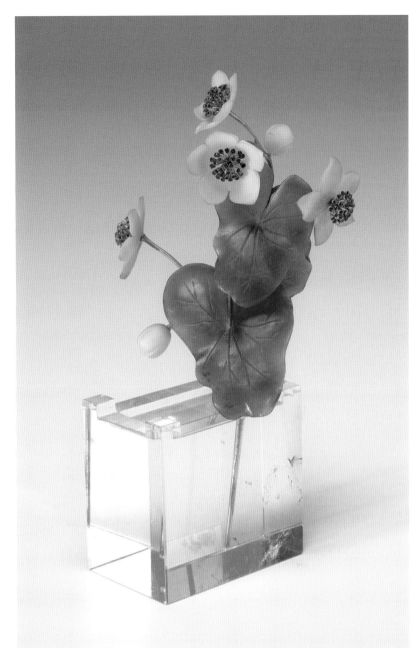

374 reduced

373 Bluebells

Chalcedony, nephrite, agate, gold, demantoid garnets

The flower's blue-dyed chalcedony bells have gold stamens set with green demantoid garnets, two carved-nephrite leaves, and a gold stem. It stands upright in "earth" in a tapering tub of milky-white agate.

FORGED MARKS: *Fabergé, H. W.*, 72
DIMENSIONS: 6⅜ in. (16.2 cm)
PROVENANCE: Hammer Galleries, #RH 5380/14, February 24, 1939 ("Dainty jeweled fantasy

of a small hyacinth plant. From the collection of a member of the Imperial Family.");
Lillian Thomas Pratt
BIBLIOGRAPHY: Lesley 1976, cat. no. 143, p. 63, p. 64 (ill.)
NOTE: Previously, this flower was incorrectly identified as a hyacinth.
BEQUEST OF LILLIAN THOMAS PRATT, 47.20.224

374 Water Lily

Agate, rock crystal, nephrite, gold, rubies

The lily has four open blossoms of white chalcedony, gold stamens set

with rubies, two chalcedony buds, carved-nephrite leaves, and gold stems. It stands upright in a rectangular Japanese-style rock-crystal vase.

FORGED MARKS: *Fabergé, H. W.*, 72
DIMENSIONS: 6⅜ in. (16.2 cm)
PROVENANCE: Hammer Galleries, #RH 5413-2, January 9, 1940 (from the "collection of a member of the Imperial Family"); Lillian Thomas Pratt
BIBLIOGRAPHY: Lesley 1976, cat. no. 158, p. 71, p. 70 (ill.)
BEQUEST OF LILLIAN THOMAS PRATT, 47.20.225

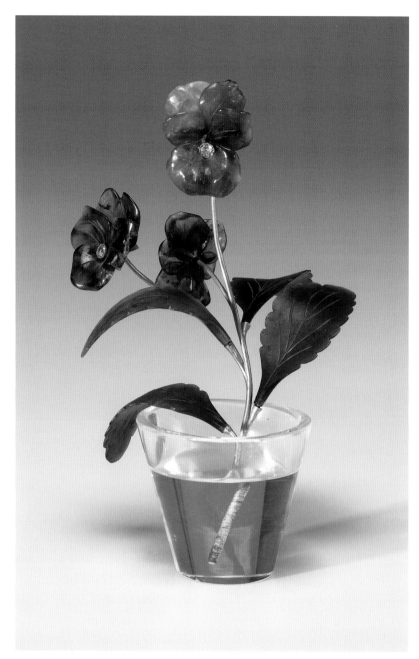

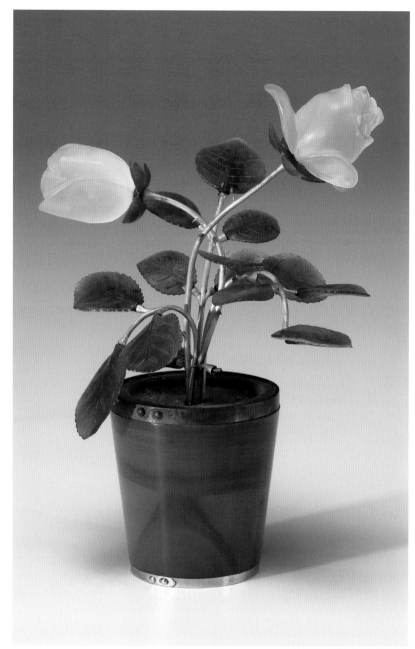

375

376 reduced

375 Pansies

Amethysts, nephrite, rock crystal, gold, diamonds

The flower has three amethystine-quartz blooms with diamond pistils, four carved-nephrite leaves, and a gold stem. It stands at an angle in a tapering rock-crystal vase.

APPARENTLY UNMARKED
DIMENSIONS: 5 ¼ in. (13.4 cm)
PROVENANCE: Hammer Galleries, #RH 5380-13, January 9, 1940 (from the "collection of a member of the Imperial Family"); Lillian Thomas Pratt
BIBLIOGRAPHY: Lesley 1976, cat. no. 148, p. 67, p. 66

NOTE: For a variant see cat. no 380.
BEQUEST OF LILLIAN THOMAS PRATT, 47.20.227

376 Roses

Rock crystal, nephrite, agate, gold

Two frosted rock-crystal rosebuds with carved-nephrite leaves, gold stems, and thorns stand in gold "earth" in an agate pot banded with gold hoops.

FORGED MARKS: *Fabergé, H. W.*, 72
DIMENSIONS: 5 ⅝ in. (14.3 cm)
PROVENANCE: Hammer Galleries, #RH 5408/11,

February 24, 1939 (from the "collection of a member of the Imperial Family"); Lillian Thomas Pratt
BIBLIOGRAPHY: Lesley 1976, cat. no. 153, p. 71, p. 69 (ill.)
NOTE: An almost identical rose, with amber-colored agate buds and the same provenance, is in the Matilda Geddings Gray Foundation Collection (see Keefe 2008).
BEQUEST OF LILLIAN THOMAS PRATT, 47.20.229

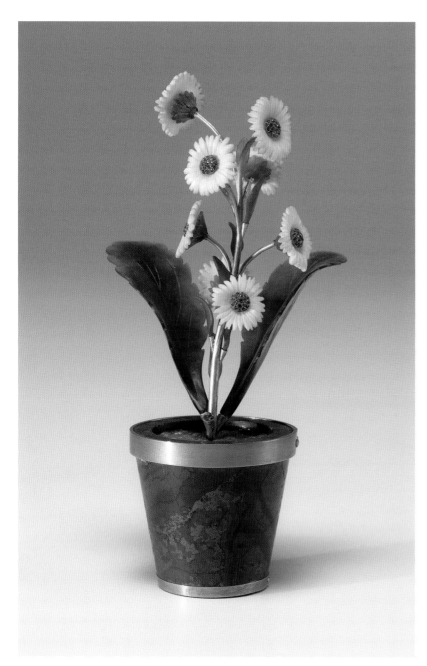

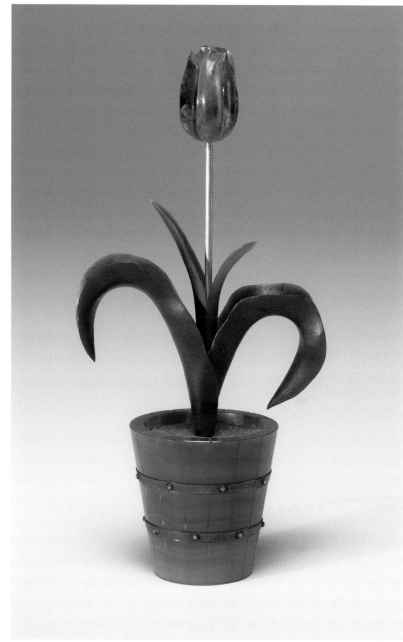

377 reduced

378 reduced

377 Aster

Chalcedony, nephrite, jasper, garnets, gold

The spray has eight blossoms of white chalcedony with gold and demantoid-garnet centers, two nephrite leaves, and gold stems. It stands in gold "earth" in a pot of speckled jasper banded with gold hoops.

FORGED MARKS: *Fabergé, H. W.*, 72
DIMENSIONS: 5⅞ in. (14.9 cm)
PROVENANCE: Hammer Galleries, #RH 55408/12, February 24, 1939 (from the "collection of a member of the Imperial Family"); Lillian Thomas Pratt
BIBLIOGRAPHY: Lesley 1976, cat no. 137, p. 63, p. 62 (ill.)
NOTE: A similar flower with larger blooms and the same provenance is in the Matilda Geddings Gray Foundation Collection (see Keefe 2008).
BEQUEST OF LILLIAN THOMAS PRATT, 47.20.230

378 Tulip

Amethyst quartz, nephrite, agate, gold, silver gilt, diamonds

The tulip has a pale-mauve amethystine-quartz bud, nephrite leaves, and a gold stem. It stands in gold "earth" in a agate pot banded with gold hoops.

FORGED MARKS: *Fabergé, H. W.*, 72
DIMENSIONS: 8¼ in. (21 cm)
PROVENANCE: Hammer Galleries, #RH 5408/10, January 31, 1939 (from the "collection of a member of the Imperial Family"); Lillian Thomas Pratt
BIBLIOGRAPHY: Lesley 1976, cat. no. 154, p. 71, p. 69 (ill.)
NOTE: A similar tulip with an agate bloom and the same provenance is in the Matilda Geddings Gray Foundation Collection (see Keefe 2008).
BEQUEST OF LILLIAN THOMAS PRATT, 47.20.231

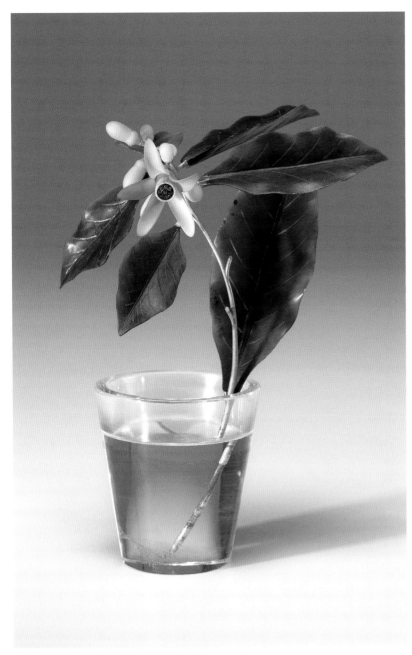

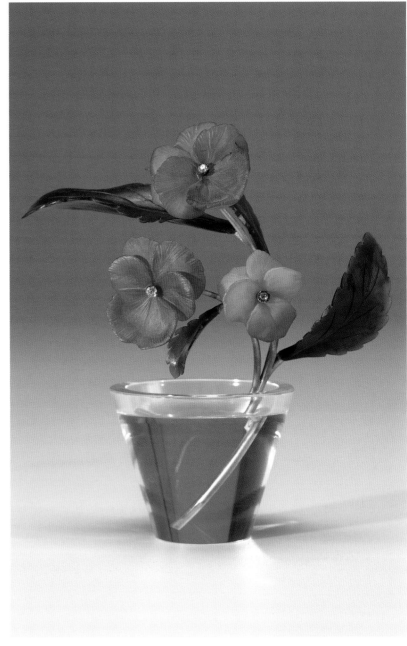

379 reduced

380 reduced

379 Orange Blossom

Chalcedony, nephrite, rock crystal, gold, demantoid garnets

The spray of two orange blossoms has chalcedony blooms with demantoid-garnet centers, six nephrite leaves, and a gold stem. It stands at an angle in a rock-crystal vase.

FORGED MARKS: *Fabergé, H. W.,* 72
DIMENSIONS: 6 ½ in. (16.5 cm)
PROVENANCE: Hammer Galleries, #RH 5380/10, February 24, 1939 (from the "collection of a member of the Imperial Family"); Lillian Thomas Pratt

BIBLIOGRAPHY: Lesley 1976, cat. no. 147, p. 67, p. 66 (ill.)
NOTE: A similar orange blossom with the same provenance is in the Matilda Geddings Gray Foundation Collection (see Keefe 2008).
BEQUEST OF LILLIAN THOMAS PRATT, 47.20.232

380 Pansies

Chalcedony, (jasper?), nephrite, rock crystal, diamonds

The flower has three carnelian-agate blooms with diamond centers, four serrated-nephrite leaves, and a gold stem. It stands at an angle in a tapering rock-crystal vase.

FORGED MARKS: *Fabergé, H. W.,* 72
DIMENSIONS: 4 ¾ in. (12.1 cm)
PROVENANCE: Hammer Galleries, #5509, January 9, 1940 (from the "collection of a member of the Imperial Family"); Lillian Thomas Pratt
BIBLIOGRAPHY: Lesley 1976, cat. no. 149, p. 67, p. 66 (ill.)
NOTE: For a variant see cat. no. 375.
BEQUEST OF LILLIAN THOMAS PRATT, 47.20.234

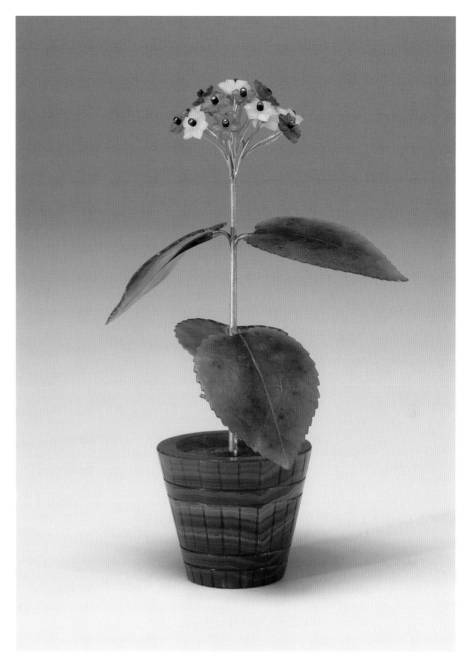

381

381 Verbena

Chalcedony, nephrite, agate, gold, diamonds

The single spray has blue-and-white-dyed blooms with rose-cut diamond centers, five serrated-nephrite leaves, and a gold stem. It is planted in "earth" in a tapering pot of banded agate.

FORGED MARKS: *Fabergé, H. W.*, 72
DIMENSIONS: 5 ¼ in. (13.3 cm)
PROVENANCE: Hammer Galleries, #RH 5380-6, January 9, 1940 (from the "collection of a member of the Imperial Family"); Lillian Thomas Pratt
BIBLIOGRAPHY: Lesley 1976, cat. no. 155, p. 71, p. 70 (ill.)
NOTE: A similar verbena with the same provenance is in the Matilda Geddings Gray Foundation Collection (see Keefe 2008).
BEQUEST OF LILLIAN THOMAS PRATT, 47.20.226

Glossary

anthemion flat ornament of stylized floral form

Antikvariat (Russian) authorized intermediary for sales of Russian art after the 1917 Revolution

assay mark control mark for purity of gold or silver

basse-taille (French) low-relief pattern engraved in metal covered with translucent enamel

bayadière (French) long, wide jeweled necklace or chain hanging in loose parallel strands

bijou (pl. *bijoux*; French) artistic jewelry of little intrinsic value

bogatyr (pl. *bogatyri*; Russian) mythological hero

Bol'shaia Morskaia (Russian) A main shopping street in St. Petersburg

boyar/boyarina member of the highest level of Russian aristocracy

bratina (pl. *bratiny*; Russian) a large spherical vessel

briolette oval or pear-shaped gemstone cut in triangular facets over its entire surface

cabochon gem cut in convex form and highly polished but not faceted

carnet de bal (French) a booklet container for dance cards

charka (pl. *charki*; Russian) small vessel for drinking vodka

chaton (French) setting of a ring

cloison (French) partition

collier de chien (French) dog-collar necklace

collier serre-cou (French) choker necklace

corbeille de marriage (French) dowry

cuppa (Latin) cup

doublure (French) lining

dowager empress the widow of a former emperor

en camaïeu (French) monochrome motif

en plein (French) painted enamel ring of metal around a slender shaft to strengthen it or prevent splitting

guilloché (French) engine turned; engraved on a metal surface mechanically

hunter case pocket watch with a spring-hinged metal lid that closes over the watch dial and crystal

jeton (French) counter, token, chip

joaillerie (French) jewelry, the value of which is based mainly on its precious stones

joyeau (pl. *joyaux*; French) jewel, the value of which is based mainly on its precious stones

Kievan Rus the name for the medieval state of Rus, which existed from circa 880 to the mid-thirteenth century after the Mongol invasion of 1237–40.

Chleb i Sol (Russian) bread and salt

kokoshnik (Russian) traditional Russian head-dress worn by women and girls; a circular hallmark of a head of a woman wearing a *kokoshnik* used for silver and gold between 1899 and 1917

kovsh (pl. *kovshi*; Russian) container for liquids with a boat-shaped body and single handle

millegrain (French; Engl. *milgrain*) beaded setting keeping a stone in place

nécessaire (French) small case to hold a necessities, especially a sewing kit

niello black enamel-like alloy (usually) silver, copper, and lead

objet d'art small article of high artistic value

object of vertu (or virtu) small precious object of art

oklad (Russian) metal cover protecting an icon

Old Russian nineteenth-century style based on the study of traditional peasant designs

paillon thin leaf of gold or silver foil shown through a layer of translucent enamel

panagia (Greek) image of Our Lady of the Sign

parure (French) matched set of jewelry

plique-é-jour (French) "window" or "see-through" enamel

repoussé (French) shaped or ornamented with patterns in relief made by hammering or pressing on the reverse side

ruble Russian currency. The exchange rate between the ruble and the British pound, U.S. dollar, and French franc remained unchanged from 1897 to 1913: 1 ruble = £0.43 = $2.1 = 2.5 francs.

sabot (French) hoof

sang de boeuf (French) blood-red color

sautoir (French) jeweled necklace or chain often attached to a locket or pendant

stomacher jewel or jeweled piece covering the front section of a dress

surtout de table (French) table center decoration

tazza shallow cup or vase on a pedestal

tsesarevich (Russian) title given the heir apparent in the Russian Empire

Tsarskoe Selo former Russian residence of the imperial family located fifteen miles south of Petersburg

warrant (imperial or royal) award to a purveyor to an imperial or royal family or court, allowing the recipient to use a State emblem on his or her work

zolotnik (Russian) Russian unit of weight. One *zolotnik* equals ¼ carat.

Concordance

| | | | | | | | | |
|---|---|---|---|---|---|---|---|
| 47.20.82 | 348 | Miniature Easter Egg Pendant | 47.20.118 | 255 | Pendant Charm | 47.20.166 | 287 | Cane Handle |
| 47.20.83 | 255 | Pendant Charm | 47.20.119 | 175 | Miniature Easter Egg Pendant | 47.20.167 | 283 | Parasol Handle |
| 47.20.84 | 168 | Miniature Easter Egg Pendant | 47.20.120 | 338 | Miniature Easter Egg Pendant | 47.20.168 | 50 | Parasol Handle |
| 47.20.85 | 337 | Miniature Easter Egg Pendant | 47.20.121 | 341 | Miniature Easter Egg Pendant | 47.20.169 | 47 | Parasol Handle |
| 47.20.86 | 329 | Miniature Easter Egg Pendant | 47.20.122 | 343 | Miniature Easter Egg Pendant | 47.20.170 | 288 | Parasol Handle |
| 47.20.88 | 316 | Miniature Easter Egg Pendant | 47.20.123 | 306 | Miniature Easter Egg Pendant | 47.20.171 | 80 | Parasol Handle |
| 47.20.89 | 345 | Miniature Easter Egg Pendant | 47.20.124 | 344 | Miniature Easter Egg Pendant | 47.20.172 | 125 | Parasol Handle |
| 47.20.90 | 346 | Miniature Easter Egg Pendant | 47.20.125 | 321 | Miniature Easter Egg Pendant | 47.20.173 | 78 | Cane Handle |
| 47.20.91 | 315 | Miniature Easter Egg Pendant | 47.20.126 | 161 | Miniature Easter Egg Pendant | 47.20.174 | 83 | Parasol Handle |
| 47.20.92 | 352 | Miniature Easter Egg Pendant | 47.20.127 | 174 | Miniature Easter Egg Pendant | 47.20.175 | 45 | Cane Handle |
| 47.20.93 | 332 | Miniature Easter Egg Pendant | 47.20.128 | 323 | Miniature Egg-Shaped Pendant | 47.20.177 | 33 | Cane Handle |
| 47.20.94 | 304 | Miniature Easter Egg Pendant | 47.20.129 | 255 | Bear on Trapeze Charm | 47.20.178 | 51 | Parasol Handle |
| 47.20.95 | 336 | Miniature Easter Egg Pendant | 47.20.130 | 255 | Rooster Charm | 47.20.179 | 276 | Parasol Handle |
| 47.20.96 | 173 | Miniature Easter Egg Pendant | 47.20.131 | 255 | Bulldog Charm | 47.20.180 | 68 | Parasol Handle |
| 47.20.97 | 178 | Miniature Easter Egg Pendant | 47.20.132 | 255 | Bear Charm | 47.20.181 | 52 | Cane Handle |
| 47.20.98 | 180 | Miniature Easter Egg Pendant | 47.20.133 | 255 | Bear Charm | 47.20.182 | 281 | Parasol Handle |
| 47.20.100 | 182 | Miniature Easter Egg Pendant | 47.20.134 | 255 | Bear Charm | 47.20.183 | 54 | Cane Handle |
| 47.20.101 | 164 | Miniature Easter Egg Pendant | 47.20.135 | 255 | Lobster Claw Charm | 47.20.184 | 49 | Parasol Handle |
| 47.20.102 | 166 | Miniature Easter Egg Pendant | 47.20.136 | 255 | Rabbit Charm | 47.20.185 | 35 | Parasol Handle |
| 47.20.103 | 353 | Miniature Easter Egg Pendant | 47.20.138 | 253 | Crowned Brooch | 47.20.186 | 126 | Parasol Handle |
| 47.20.104 | 177 | Miniature Easter Egg Pendant | 47.20.139 | 256 | Lion Pendant | 47.20.187 | 71 | Parasol Handle |
| 47.20.105 | 179 | Miniature Easter Egg Pendant | 47.20.140 | 254 | Imperial Diamond Brooch | 47.20.188 | 44 | Cane Handle |
| 47.20.106 | 165 | Locket | 47.20.141 | 251 | Brooch with Crowned *M* | 47.20.189 | 277 | Parasol Handle |
| 47.20.107 | 171 | Miniature Easter Egg Pendant | 47.20.142 | 28 | Tenth-Anniversary Brooch | 47.20.190 | 39 | Parasol Handle |
| 47.20.108 | 163 | Miniature Easter Egg Pendant | 47.20.143 | 30 | Scarab Brooch | 47.20.191 | 284 | Parasol Handle |
| 47.20.109 | 356 | Miniature Easter Egg Pendant | 47.20.144 | 107 | Wild Rose Brooch | 47.20.192 | 285 | Cane Handle |
| 47.20.110 | 172 | Miniature Easter Egg Pendant | 47.20.154 | 57 | Bookmark | 47.20.193 | 278 | Parasol Handle |
| 47.20.111 | 310 | Miniature Easter Egg Pendant | 47.20.155 | 29 | Locket | 47.20.194 | 81 | Parasol Handle |
| 47.20.112 | 255 | Pendant Charm | 47.20.156 | 359 | Locket | 47.20.195 | 153 | Parasol Handle |
| 47.20.113 | 170 | Miniature Easter Egg Pendant | 47.20.161 | 255 | Charm Bracelet | 47.20.196 | 87 | Parasol Handle |
| 47.20.114 | 331 | Miniature Easter Egg Pendant | 47.20.162 | 279 | Parasol Handle | 47.20.197 | 286 | Cane Handle |
| 47.20.115 | 328 | Miniature Easter Egg Pendant | 47.20.163 | 280 | Parasol Handle | 47.20.198 | 53 | Parasol Handle |
| 47.20.116 | 324 | Miniature Easter Egg Pendant | 47.20.164 | 282 | Parasol Handle | 47.20.199 | 138 | Parasol Handle |
| 47.20.117 | 325 | Miniature Easter Egg Pendant | 47.20.165 | 275 | Parasol Handle | 47.20.200 | 84 | Cane Handle |

47.20.201	46	Parasol Handle		47.20.242	270	French Bulldog		47.20.284	10	Beaker
47.20.202	63	Parasol Handle		47.20.243	271	French Bulldog		47.20.285	20	Terrestrial Globe
47.20.203	294	Seal		47.20.244	89	Dachshund		47.20.286	73	Perpetual Calendar
47.20.204	48	Seal		47.20.245	92	Dachshund		47.20.287	159	Bratina
47.20.205	43	Seal		47.20.246	91	English Bulldog		47.20.288	41	Bowl
47.20.206	255	Bulldog Charm		47.20.247	258	Cat		47.20.289	295	Footed Bowl
47.20.207	104	Songbird in a Cage		47.20.248	364	Elephant		47.20.290	292	Bowl
47.20.208	103	Parrot on a Perch		47.20.249	365	Elephant		47.20.291	149	Vase
47.20.209	105	Parrot on a Perch		47.20.250	366	Elephant		47.20.292	250	Charka
47.20.210	102	Parrot in a Cage		47.20.251	264	Elephant		47.20.293	38	Charka
47.20.211	273	Pair of Lovebirds on a Perch		47.20.252	265	Pig		47.20.294.a–b	64	Cup and Cover
47.20.212	269	Hummingbird on a Perch		47.20.253	266	Rabbit		47.20.295	75	Cup
47.20.213	7	Rabbit Bell Push		47.20.254	95	Chick		47.20.296	148	Miniature Kovsh
47.20.214	3	Rabbit Pitcher		47.20.255	94	Humboldt Penguin		47.20.297	36	Kovsh
47.20.216	274	Owl		47.20.256	267	Hornbill		47.20.298	23	Kovsh
47.20.217	367	Poppy		47.20.257	101	Eagle		47.20.299	290	Perfume Vial
47.20.218	368	Poppy		47.20.258	262	Mallard Duck		47.20.300a–b	61	Cup and Cover
47.20.219	369	Primrose		47.20.259	93	Chinese Swan Goose		47.20.301	79	Inkwell
47.20.220	370	Lilies of the Valley		47.20.260	260	Black Grouse		47.20.303	27	Imperial Column Portrait Frame (miniature 47.20.367)
47.20.221	371	Lilies of the Valley		47.20.261	97	Heron				
47.20.222	111	Cornflowers		47.20.262	98	Ostrich		47.20.304	74	Column Frame
47.20.223	372	Buttercup		47.20.263	257	Owl		47.20.305	70	Heart Frame
47.20.224	373	Bluebells		47.20.264	259	Eagle Owl		47.20.306	59	Double Frame
47.20.225	374	Waterlily		47.20.265	96	Owl		47.20.307	298	Imperial Table Portrait (miniature 47.20.366)
47.20.226	381	Verbena		47.20.266	99	Rooster				
47.20.227	375	Pansies		47.20.267	100	Rooster		47.20.308	150	Frame
47.20.228	112	English Hawthorn		47.20.268	88	Statuette of a Sailor		47.20.309	120	Frame
47.20.229	376	Roses		47.20.270	363	Jeweled and Enameled Gold Box		47.20.310	140	Frame
47.20.230	377	Aster						47.20.311	117	Frame
47.20.231	378	Tulip		47.20.271	62	Imperial Presentation Box		47.20.312	143	Reversible Frame
47.20.232	379	Orange Blossom		47.20.273	289	Imperial Presentation Box		47.20.313	131	Frame
47.20.233	106	Globeflowers		47.20.274	34	Snuffbox		47.20.314	156	Frame
47.20.234	380	Pansies		47.20.275	56	Bonbonnière		47.20.315	123	Frame
47.20.235	113	Dandelion		47.20.276	132	Box with Arabic Inscription		47.20.316	21	Frame
47.20.236	108	Pansy		47.20.277a–b	60	Elephant Box		47.20.317	116	Frame
47.20.237	110	Lilies of the Valley		47.20.278	154	Bonbonnière		47.20.318	122	Frame
47.20.238	109	Violet		47.20.279	115	Bonbonnière		47.20.319	130	Frame
47.20.239	263	Polar Bear		47.20.280	301	Cigarette Case		47.20.320	69	Frame
47.20.240	261	Bloodhound		47.20.281	25	Cigarette Case		47.20.321	121	Frame
47.20.241	268	French Bulldog		47.20.282	82	Bell Push		47.20.322	297	Frame
								47.20.323	302	Frame

47.20.324	72	Double Frame
47.20.325	293	Frame
47.20.326	362	Frame
47.20.327	55	Frame
47.20.328	85	Frame
47.20.329	300	Frame
47.20.330	361	Double Frame
47.20.332	118	Frame
47.20.333	137	Tenth-Anniversary Frame
47.20.334	141	Frame
47.20.335	58	Frame
47.20.336	135	Frame
47.20.337	133	Frame
47.20.338	134	Frame
47.20.339	296	Frame
47.20.340	155	Frame (miniature 47.20.362)
47.20.341	193	Frame
47.20.342	86	Frame
47.20.343	157	Frame
47.20.344	136	Frame
47.20.345	303	Frame
47.20.346	145	Frame (miniature 47.20.360)
47.20.347	114	Triple Frame
47.20.348	151	Frame
47.20.349	124	Frame
47.20.350	129	Frame
47.20.351	32	Art Nouveau Frame
47.20.352	119	Star Frame
47.20.353	77	Frame
47.20.354	76	Double Frame
47.20.355	6	Frame
47.20.356	152	Triptych Frame (drawing 47.20.414)
47.20.357	146	Cross of St. Andrew Frame
47.20.358	142	Triptych Frame
47.20.359	158	Frame
47.20.360	145	Miniature within 47.20.346
47.20.362	155	Miniature within 47.20.340
47.20.364	194	Circular Miniature
47.20.365	158	Miniature within 47.20.359

47.20.366	298	Imperial Table Portrait Miniature (see 47.20.307)
47.20.367	27	Imperial Column Portrait Frame Miniature
47.20.368	190	Imperial Tsesarevich Easter Egg Miniature (see 47.20.34)
47.20.369.1–.12	187	Imperial Rock-Crystal Easter Egg Miniatures (see 47.20.32)
47.20.370.1–.8	188	Imperial Pelican Easter Egg Miniatures (see 47.20.35)
47.20.371.1–.4	189	Imperial Peter the Great Easter Egg Miniatures (see 47.20.33)
47.20.372	191	Imperial Red Cross Easter Egg Miniatures (see 47.20.36)
47.20.373	249	Charka
47.20.374	22	Trefoil Cup
47.20.375	248	Ribbed Bell
47.20.376.1–.42	198	Photograph Album
47.20.380	213	Bread-and-Salt Dish
47.20.382	224	Sugar Scoop
47.20.385	9	Coin Vase
47.20.387	215	Commemorative Plaque
47.20.394	291	Paper Knife
47.20.396	195	Imperial Paper Knife
47.20.402	255	Foo Dog Charm
47.20.403	255	Dog Charm
47.20.412	192	Birch-Wood Frame
47.20.413	147	Frame
47.20.414	152	Triptych Frame Miniature (see 47.20.356)
47.20.416	196	Menu
47.20.493	305	Miniature Easter Egg Pendant
47.20.495	1	World War I Ashtray
47.20.496	144	Frame
47.20.497	252	Diamond Pin
56.2.11	223	Bonbonnière
70.9.45	139	Cigarette Case
70.9.46	128	Cigarette Case
70.9.48	299	Paper Knife
70.9.71	66	Box
70.9.72	65	Box
70.9.75	26	Cigarette Case
71.1.2	197	Beaker

71.7.61	272	Dachshund Bell Push
72.28.1–.18	12	Eighteen Demitasse Spoons
76.17.1–.2	204	Two Imperial Presentation Porcelain Easter Eggs
78.78.1–.2	24	Pair of Champagne Flutes
82.198	37	World War I Dish
83.150	31	Badge of the Imperial Orphanage
85.593	2	Gum Pot
84.48	199	Imperial Presentation Porcelain Easter Egg
84.49	127	Cigarette Case
84.83	200	Imperial Presentation Porcelain Easter Egg
86.174.1–.3	214	Sherbet Cup, Saucer, and Spoon
97.93	5	Monumental Kovsh
98.8a–b	217	Cup and Cover
98.9	220	Cup
98.10	219	Loving Cup
98.11	216	Plate
98.12	222	Box
98.13	212	Pictorial Enamel Card Case
98.14	11	Enamel Pictorial Box
98.15	209	Beaker
98.16	211	Kovsh
98.17	210	Tankard and Cover
98.18.1–3a–b	221	Three-Piece Coffee Set
98.19	218	Serving Spoon
98.20a–c	208	Plate, Bowl, and Cover
99.49	8	Silver-Mounted Gueridon
99.50	4	Imperial Silver Frame
99.198	42	Bonbonnière
2003.185	360	Easter Egg with Stand
2003.186	176	Miniature Easter Egg Pendant
2003.187	40	Miniature Tazza
2003.188	90	French Bulldog
2010.117	67	Charka

Bibliography

Abrikosov and Lensen 1864: Abrikosov, Dmitrii Ivanovich, and George Alexander Lensen. *Revelations of a Russian Diplomat: The Memoirs of Dmitrii I. Abrikossow*. Seattle: University of Washington Press, 1964.

ALVR 1983: A La Vielle Russie. *Fabergé*. Exh. cat. New York: A La Vielle Russie, 1983.

Bainbridge 1949: Bainbridge, Henry. *Peter Carl Fabergé, Goldsmith and Jeweller to the Russian Imperial Court and the Principal Crowned Heads of Europe; an Illustrated Record and Review of His Life and Work, A.D. 1846–1920*. New York: B. T. Batsford, 1949.

Bainbridge 1966: Bainbridge, Henry Charles. *Peter Carl Fabergé, Goldsmith and Jeweller to the Russian Imperial Court: His Life and Work*. London: Spring Books, 1966.

Bainbridge 1968: Bainbridge, Henry. *Peter Carl Fabergé, Goldsmith and Jeweller to the Russian Imperial Court: His Life and Work*. London: Spring Books, 1968.

Birbaum, Fabergé, and Skurlov 1992: Birbaum, Franz P., Tatiana F. Fabergé, and Valentin V. Skurlov. *The History of the House of Fabergé*. St. Petersburg: Tatiana F. Fabergé and Valentin V. Skurlov, 1992.

Blumay and Edwards 1992: Blumay, Carl, and Henry Edwards, eds. *The Dark Side of Power: The Real Armand Hammer*. New York: Simon & Schuster, 1992.

Brokhin 1975: Brokhin, Yuri. *Hustling on Gorky Street: Sex and Crime in Russia Today*. New York: Dial Press, 1975.

Brunhammer 2007: Brunhammer, Yvonne, ed. *René Lalique: Exceptional Jewellery, 1890–1912*. Exh. cat. Milan: Skira Editore; London: Thames and Hudson; and New York: Rizzoli International, 2007.

Clarke 2009: Clarke, William. *Hidden Treasures from the Romanovs: Saving the Royal Jewels*. Edinburgh: National Museums Scotland Enterprises, 2009.

Crawford and Crawford 1997: Crawford, Donald, and Rosemary Crawford. *Michael and Natasha: The Life and Love of Michael II, the Last of the Romanov Tsars*. New York: Scribner, 1997.

Curry 1995: Curry, David Park. *Fabergé: Virginia Museum of Fine Arts*. Richmond: Virginia Museum of Fine Arts, 1995.

Epstein and Hammer 1996: Epstein, Edward Jay, and Armand Hammer. *Dossier: The Secret History of Armand Hammer*. New York: Random House, 1996.

Fabergé, Proler, and Skurlov 1997: Fabergé, Tatiana, Lynette Proler, and Valentin Skurlov. *The Fabergé Imperial Easter Eggs*. London: Christie, Manson and Woods, 1997.

Fersman 1925: Fersman, A. E. *Les Joyaux du Trésor de Russie*. Moscow: Commissariat National des Finances, 1925.

Fitzlyon and Browning 1978 : Fitzlyon, Kyril, and Tatiana Browning. *Before the Revolution: A View of Russia under the Last Tsar*. Woodstock, N.Y.: Overlook Press, 1978.

Forbes and Tromeur 1999: Forbes, Christopher, and Robyn Tromeur. *Fabergé: The Forbes Collection*. New York: Hugh Lauter Levin, 1999.

Gafilullin et al. 2003: Gafilullin, R. R., Luibov Goriacheva, Mikhail Katin-Iartsev, and A. A. Shumkov. *Costume Ball in the Winter Palace*. Moscow: Russky Antiquariat, 2003.

Gray 1976: Gray, Pauline. *The Grand Duke's Woman: The Story of the Morganatic Marriage of Michael Romanoff, the Tsar Nicholas II's Brother, and Nathalia Cheremetevskaya*. London: Macdonald and Jane's, 1976.

Guitaut 2003: Guitaut, Caroline de. *Fabergé in the Royal Collection*. London: Royal Collection Enterprises, 2003.

Habsburg 2003: Habsburg, Géza von. *Fabergé–Cartier: Rivalen am Zarenhof*. Munich: Hirmer Verlag, 2003.

Habsburg 1986: Habsburg, Géza von, ed. *Fabergé: Hofjuwelier der Zaren*. Munich: Hirmer Verlag, 1986.

Habsburg 2000: Habsburg, Géza von, ed. *Fabergé: Imperial Craftsman and His World*. Exh. cat. London: Booth-Clibborn, 2000.

Habsburg 1996: Habsburg, Géza von, ed. *Fabergé in America*. Exh. cat. San Francisco: Fine Arts Museums of San Francisco, in association with Thames and Hudson, 1996.

Habsburg 2004: Habsburg, Géza von. *Fabergé: Treasures of Imperial Russia*. Moscow: Link of Times Foundation, 2004.

Habsburg and Forbes 1987: Habsburg, Géza von, and Christopher Forbes. *Fabergé: Court Jeweler of the Tsars*. New York: Vendome, 1987.

Habsburg and Lopato 1993: Habsburg, Géza von, and Marina Lopato. *Fabergé: Imperial Jeweller*. Exh. cat. St. Petersburg: State Hermitage Museum and Washington, D.C.: Fabergé Arts Foundation, in association with Abrams, 1993.

Habsburg and Solodkoff 1979: Habsburg, Géza von, and Alexander von Solodkoff. *Fabergé: Court Jeweler to the Tsars*. New York: Rizzoli, 1979.

Hammer 1932: Hammer, Armand. *The Quest of the Romanov Treasure, vol. 1–2*. New York: William Farquhar Payson, 1932.

Hammer Galleries 1937: Hammer Galleries. *Fabergé: His Works*. Exh. cat. New York: Hammer Galleries, 1937.

Harrison, Ducamp, and Falino 2008: Harrison, Stephen, Emmanuel Ducamp, and Jeannine Falino, eds. *Artistic Luxury: Fabergé, Tiffany, Lalique*. Exh. cat. Cleveland, Ohio: Cleveland Museum of Art, in association with Yale University Press, 2008.

Hawley 1967: Hawley, Henry. *Fabergé and His Contemporaries: The India Early Minshall Collection of the Cleveland Museum of Art*. Cleveland: Cleveland Museum of Art, 1967.

Hill 1989: Hill, Gerard. *Fabergé and the Russian Master Goldsmiths*. New York: Wing Books, 1989.

Houston Museum 1994: Houston Museum of Natural Science. *The World of Fabergé: Russian Gems and Jewels*. Exh. cat. Houston: Houston Museum of Natural Science, 1994.

Iusupov 1998: Iusupov, Prince Feliks Feliksovich. *Memuary* [Memoires]. Moscow: Zakharov i Vagrius, 1998.

Ivanov 2002: Ivanov, Aleksandr Nikolaevic. *Gold and Silversmiths in Russia (1600–1926): A Guide for Experts*. Moscow: Russian National Museum, 2002.

Johnston 2003: Johnston, William R. *The Fabergé Menagerie*. London: Philip Wilson, 2003.

Kaurinkoski et al. 1991: Kaurinkoski, Kaarina, et al. *Pietarin kultainen katu* [Golden Streets of St. Petersburg]. Helsinki: Otava, 1991.

Keefe 2008: Keefe, John Webster. *Fabergé: The Hodges Family Collection*. Exh. cat. New Orleans, LA: New Orleans Museum of Art, 2008.

Kostiuk 2000: Kostiuk, Olga. *St. Petersburg Jewellers: 18th–19th Centuries.* St. Petersburg: State Hermitage Museum, 2000.

Krairiksh 1984: Krairiksh, Busaya. *Fabergé in the Royal Collection.* Bangkok: n.p., 1984.

Krog et al. 2002: Krog, Ole Villumsen, et al. *Treasures of Russia—Imperial Gifts.* Exh. cat. Copenhagen: Royal Silver Room, 2002.

Kurth 1995: Kurth, Peter. *Tsar: The Lost World of Nicholas and Alexandra.* Boston: Little, Brown, 1995.

Larionov, Nosovitch, and Znamenov 1997: Larionov, A.L., Tamara N. Nosovitch, and Vadim V. Znamenov. *Russian Imperial Yachts: Late 17th Century–Early 20th Century.* St. Petersburg: Izd-vo "EGO," 1997.

Leite 2009: Leite, Maria Fernanda Passos. *René Lalique at the Calouste Gulbenkian Museum.* Milan: Skira Editore; London: Thames and Hudson; and New York: Rizzoli, 2009.

Lesley 1976: Lesley, Parker. *Fabergé: A Catalog of the Lillian Thomas Pratt Collection of Russian Imperial Jewels.* Richmond: Virginia Museum of Fine Arts, 1976.

Lowes and McCanless 2001: Lowes, Will, and Christel Ludewig McCanless. *Fabergé Eggs: A Retrospective Encyclopedia.* Lanham, MD, and London: Scarecrow Press, 2001.

Majolier 1940: Majolier, Nathalie Mamontova. *Step-Daughter of Imperial Russia.* London: S. Paul & Co., 1940.

McCanless 1994: McCanless, Christel Ludewig. *Fabergé and His Works: An Annotated Bibliography of the First Century of His Art.* Metuchen, N.J., and London: Scarecrow Press, 1994.

Meylan 2009: Meylan, Vincent. *Archives Secrètes Boucheron: 1858–à nos jours.* Paris: SW-Télémaque, 2009.

Muntian 2000: Muntian, Tatiana N. *The World of Fabergé.* Moscow: Red Square Publishers, 2000.

Muntian, Guitaut, and Krog 2005: Muntian, Tatiana, Caroline de Guitaut, and Ole Villumsen Krog, eds. *Fabergé: Joaillier des Romanov.* Exh. cat. Brussels: Europalia, 2005.

Nadelhoffer 1984: Nadelhoffer, Hans. *Cartier: Jewelers Extraordinary.* New York: Abrams, 1984.

Néret 1988: Néret, Gilles. *Boucheron: Histoire d'une dynastie de joailliers.* Fribourg, Switzerland: Pont Royal, 1988.

Pfeffer 1990: Pfeffer, Susanna. *Fabergé Eggs: Masterpieces from Czarist Russia.* New York: Hugh Lauter Levin, 1990.

Ribbing 1996: Ribbing, Magdalena. *Smycken & Silver för Tsarer, Drottningar och Andra—W. A. Bolin 200 Ar* [Jewellery & silver for tsars, queens and others: W. A. Bolin 200 years]. St. Petersburg, Moscow, and Stockholm: Bolin, 1996.

Ross 2005: Ross, Nicolas. *Saint-Alexandre-sur-Seine: L'église russe de Paris et ses fidèles: Des Origines à 1917.* Paris: le Cerf: Institut d'études slaves, 2005.

Rudoe 1997: Rudoe, Judy. *Cartier, 1900–1939.* Paris: Somogy, 1997.

Scarisbrick 1995: Scarisbrick, Diana. *Chaumet: Master Jewellers since 1780.* Paris: Alain de Gourcuff Éditeur, 1995.

Snowman 1953: Snowman, A. Kenneth. *The Art of Carl Fabergé.* London: Faber and Faber, 1953.

Snowman 1962: Snowman, A. Kenneth. *The Art of Carl Fabergé.* Rev. and enl. ed. London: Faber and Faber, 1962.

Snowman 1968: Snowman, A. Kenneth. *The Art of Carl Fabergé.* 3rd ed. 1964. Reprint, London: Faber and Faber, 1968.

Snowman 1990: Snowman, A. Kenneth, ed. *The Master Jewelers.* London: Thames and Hudson, 1990.

Snowman 1993: Snowman, A. Kenneth. *Fabergé, Lost and Found: The Recently Discovered Jewelry Designs from the St. Petersburg Archives.* London; New York: Wartski, in association with Abrams, 1993.

Solodkoff 1987: Solodkoff, Alexander von. *Fabergé Clocks.* London: Ermitage, 1987.

Solodkoff 1988: Solodkoff, Alexander von. *The Art of Carl Fabergé.* New York: Crown Publishers, 1988.

Solodkoff 1995: Solodkoff, Alexander von. *Fabergé: Juwelier des Zarenhofes.* Exh. cat. Hamburg: Museum für Kunst und Gewerbe, in association with Braus, 1995.

Solodkoff 1997: Solodkoff, Alexander von. *The Jewel Album of Tsar Nicholas II.* London: Ermitage, 1997.

Solodkoff and Forbes 1984: Solodkoff, Alexander von, and Christopher Forbes, eds. *Masterpieces from the House of Fabergé.* New York: Abrams, 1984.

[Stopford] 1919: [Stopford, Albert]. 1919. *The Russian Diary of an Englishman.* London: W. Heineman, 1919.

Swezey 2004: Swezey, Marilyn P. *Fabergé Flowers.* New York: Harry N. Abrams, 2004.

The Link of Times Foundation. "Treasures of Imperial Russia." Accessed October 2010. http://www.treasuresofimperialrussia.com/e_home.html

Thiébaut 2007: Thiébaut, Philippe. *Correspondance d'un bijoutier Art Nouveau, 1890–1908.* Lausanne, Switzerland: La Bibliothèque des Arts, 2007.

Tillander-Godenhielm 2008: Tillander-Godenhielm, Ulla. *Fabergén suomalaiset mestarit* [Fabergé's Finnish workmasters]. Helsinki: Tammi, 2008.

Tillander-Godenhielm 2005: Tillander-Godenhielm, Ulla. *The Russian Imperial Award System during the Reign of Nicholas II: 1894–1917.* Helsinki: Journal of the Finnish Antiquarian Society, 2005.

Tillander-Godenhielm et al. 1980: Tillander-Godenhielm, Ulla, Christina Ehrnrooth, Pekka Kiviluoto, Raimo Nieminen, and Ulf-Jarl Pettersson. *Carl Fabergé and His Contemporaries.* Exh. cat. Helsinki: Museum of Applied Arts and A. Tillander, in association with Kirjapaino Oy Tieto Boktryckeri, 1980.

Tillander-Godenhielm et al. 2000: Tillander-Godenhielm, Ulla, Alice M. Ilich, Mark A. Schaffer, and Peter L. Schaffer. *Golden Years of Fabergé: Drawings and Objects from the Wigström Workshop.* Paris: A La Vieille Russie, in association with Gourcuff, 2000.

Velichenko and Miroliubova 1997: Velichenko, M. N., and G. A. Miroliubova. *Dvorets Velikogo Knyazya Vladimira Aleksandrovicha* [Palace of Grand Prince Vladimir Alexandrovich]. St. Petersburg: Almaz, 1997.

Welander-Berggren 1997: Welander-Berggren, Elsebeth, ed. *Carl Fabergé: Goldsmith to the Tsar.* Exh. cat. Stockholm: Nationalmuseum, 1997.

Index

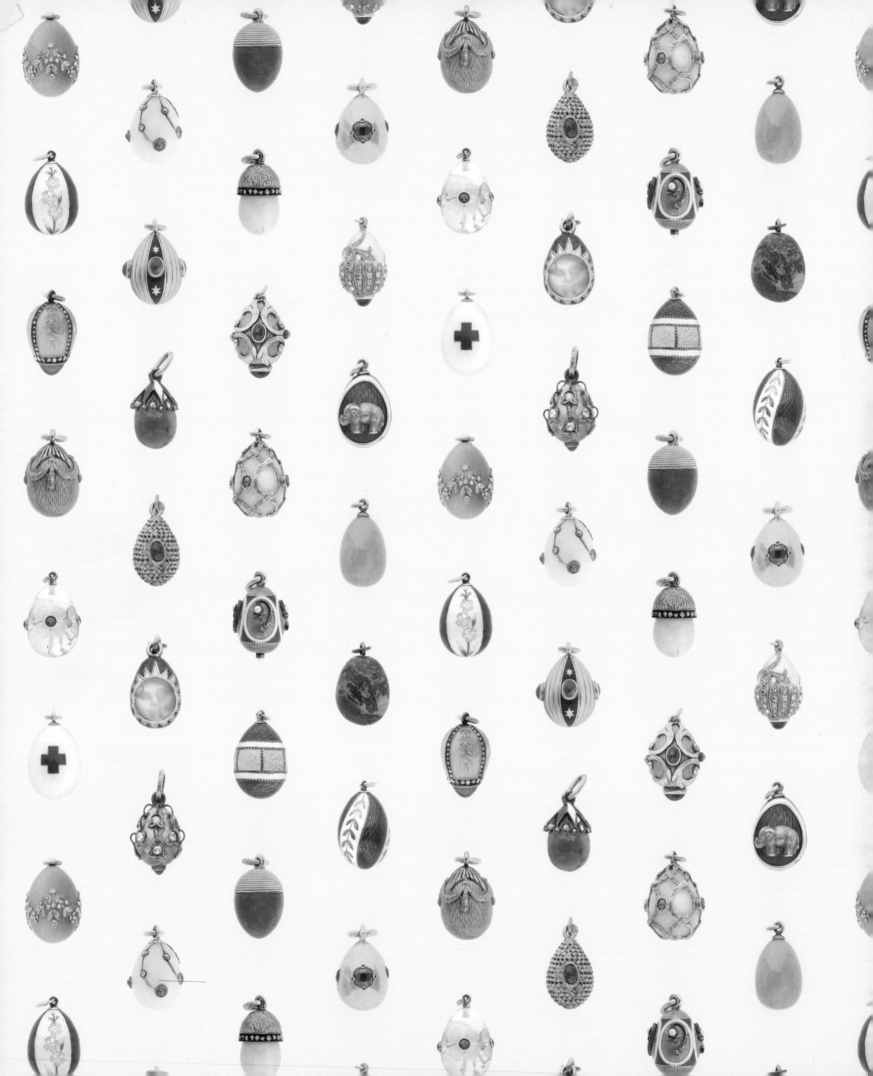